Walter Benjamin

SELECTED WRITINGS

Michael W. Jennings
General Editor

Marcus Bullock, Howard Eiland, Gary Smith
Editorial Board

Walter Benjamin

SELECTED WRITINGS
VOLUME 4
1938–1940

Translated by Edmund Jephcott
and Others

Edited by Howard Eiland and
Michael W. Jennings

THE BELKNAP PRESS OF HARVARD UNIVERSITY PRESS

Cambridge, Massachusetts, and London, England 2003

Copyright © 2003 by the President and Fellows of Harvard College
All rights reserved
Printed in the United States of America

This work is a translation of selections from Walter Benjamin, *Gesammelte Schriften, Unter Mit-wirkung von Theodor W. Adorno und Gershom Scholem, herausgegeben von Rolf Tiedemann und Hermann Schweppenhäuser,* copyright © 1972, 1974, 1977, 1982, 1985, 1989 by Suhrkamp Verlag. Some of the pieces in this volume were previously published in English, as follows: "The Paris of the Second Empire in Baudelaire" appeared in Walter Benjamin, *Charles Baudelaire: A Lyric Poet in the Era of High Capitalism* (London: NLB/Verso, 1973). "The Work of Art in the Age of Its Technological Reproducibility (Third Version)," "On Some Motifs in Baudelaire," "On the Concept of History," and "What Is the Epic Theater?" appeared in Walter Benjamin, *Illuminations,* ed. Hannah Arendt, copyright © 1968 by Harcourt Brace Jovanovich, Inc. Translations published by arrangement with Harcourt Brace Jovanovich, Inc.

Publication of this book has been aided by a grant from Inter Nationes, Bonn.

Frontispiece: Walter Benjamin at the Abbey of Pontigny, 1938. Photo by Gisèle Freund. Copyright © Gisèle Freund / Agence Nina Beskow.

Library of Congress Cataloging-in-Publication Data

Benjamin, Walter, 1892–1940.
[Selections. English. 2003]
Selected writings / Walter Benjamin; edited by Howard Eiland and Michael W. Jennings
 p. cm.
"This work is a translation of selections from Walter Benjamin, *Gesammelte Schriften* . . . copyright 1972 . . . by Suhrkamp Verlag"—T.p. verso.
Includes index.
Contents: v. 1. 1913–1926.—v. 2. 1927–1934.—v. 3. 1935–1938.—v. 4. 1938–1940
ISBN 0-674-94585-9 (v. 1: alk. paper) ISBN 0-674-94586-7 (v. 2: alk. paper)
ISBN 0-674-00896-0 (v. 3: alk. paper) ISBN 0-674-01076-0 (v. 4: alk. paper)
I. Eiland, Howard. II. Jennings, Michael William. III. Title.
PT2603.E455A26 1996
833'.91209—dc20 96–23027

Designed by Gwen Nefsky Frankfeldt

Contents

MATERIALIST THEOLOGY, 1940

Fruits of Exile, 1938 (Part 2)

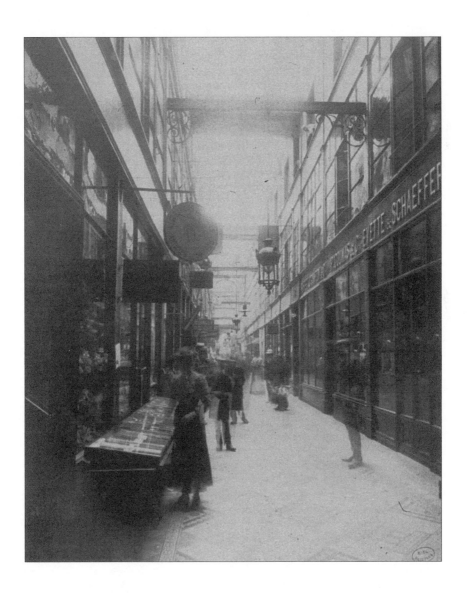

The Passage du Grand Cerf, rue Saint-Denis, Paris, 1907. Photo by Eugène Atget. Courtesy of the Bibliothèque Historique de la Ville de Paris.

The Paris of the Second Empire in Baudelaire

Une capitale n'est pas absolument nécessaire à l'homme.
—Senancour[1]

I. THE *BOHÈME*

The *bohème* appears in a suggestive context in the writings of Marx. In this category he includes the professional conspirators he talks about in his detailed note on the memoirs of the police agent de La Hodde—a piece that appeared in the *Neue Rheinische Zeitung* in 1850.[2] To evoke the physiognomy of Baudelaire means to speak of the way in which he resembles this political type. Marx outlines this type as follows:

> The development of proletarian conspiracies produced a need for a division of labor. Their members were divided into *conspirateurs d'occasion* [occasional conspirators]—that is, workers who carried on conspiracies only in addition to their other employment, who merely attended the meetings and kept themselves in readiness to appear at the assembly point upon orders from the leader—and professional conspirators, who devoted themselves entirely to the conspiracy and made a living from it. . . . The social position of this class determined its whole character. . . . Their uncertain existence, which in specific cases depended more on chance than on their activities; their irregular life, whose only fixed stations were the taverns of the wine dealers (the gathering places of the conspirators); and their inevitable acquaintance with all sorts of dubious people place them in that social sphere which in Paris is called *la bohème*."[3]

In passing, it should be noted that Napoleon III himself began his rise in a milieu related to the one described above. It is well known that one of the tools of his presidential period was the Society of the Tenth of December, whose cadres, according to Marx, were supplied by "the whole indeterminate, disintegrated, fluctuating mass which the French call the *bohème*."[4]

As emperor, Napoleon continued to develop his conspiratorial habits. Surprising proclamations and mystery-mongering, sudden sallies, and impenetrable irony were part of the *raison d'état* of the Second Empire. The same traits are found in Baudelaire's theoretical writings. He usually presents his views apodictically. Discussion is not his style; he avoids it even when the glaring contradictions in the theses he continually appropriates require discussion. He dedicated his "Salon de 1846" to all "bourgeois"; he appears as their advocate, and his manner is not that of an *advocatus diaboli*. Later—for example, in his invectives against the school of *bon sens*—he attacks the "'honnête' bourgeoise" and the notary (the person such a woman holds in respect), as if he were the most rabid *bohémien*.[5] Around 1850 he proclaimed that art could not be separated from utility; a few years thereafter he championed *l'art pour l'art* [art for art's sake].[6] In all this, he was no more concerned with playing a mediating role for his public than Napoleon III was when he switched, almost overnight and behind the French parliament's back, from protective tariffs to free trade. These traits, at any rate, make it understandable that exponents of official criticism—above all, Jules Lemaître—perceived very little of the theoretical energy latent in Baudelaire's prose.[7]

Marx continues his description of the *conspirateurs de profession* as follows:

> For them, the only condition for revolution is the effective organization of their conspiracy. . . . They embrace inventions which are supposed to perform revolutionary miracles: fire bombs, destructive machines with magical effects, riots that are to be the more miraculous and surprising the less rational their foundation. Occupying themselves with such projects, they have no other aim but the immediate one of overthrowing the existing government, and they profoundly despise the more theoretical enlightenment of the workers regarding their class interests. Hence their anger—not proletarian but plebeian—at the *habits noirs* [black coats], the more or less educated people who represent that side of the movement and of whom they can never become entirely independent, since these are the official representatives of the party.[8]

Ultimately, Baudelaire's political insights do not go beyond those of these professional conspirators. Whether he bestows his sympathies on clerical reaction or on the Revolution of 1848, their expression remains unmediated and their foundation fragile. The image he presented in the February days—brandishing a rifle on some Paris street corner and shouting "Down with General Aupick!"—is a case in point.[9] He could, in any case, have adopted Flaubert's statement, "Of all of politics, I understand only one thing: revolt." It could then have been understood in the sense of the final passage in a note which has come down to us together with his sketches on Belgium: "I say 'Long live the revolution!' as I would say 'Long live destruction! Long live penance! Long live chastisement! Long live death!' I would

be happy not only as a victim; it would not displease me to play the hangman as well—so as to feel the revolution from both sides! All of us have the republican spirit in our blood, just as we have syphilis in our bones. We have a democratic and syphilitic infection."[10]

What Baudelaire thus expresses could be called the metaphysics of the *provocateur*. In Belgium, where he wrote this note, he was for a while regarded as a French police spy. Actually, such arrangements were hardly considered strange; on December 20, 1855, Baudelaire wrote to his mother with reference to the literary men who were working as agents for the police: "My name will never appear in their shameful registers."[11] What earned Baudelaire such a reputation in Belgium can hardly have been only his manifest hostility toward Hugo, who was proscribed in France but acclaimed in Belgium.[12] His devastating irony contributed to the origin of that rumor; he may have taken pleasure in spreading it himself. The seeds of the *culte de la blague,* which reappears in Georges Sorel and has become an integral part of fascist propaganda, are first found in Baudelaire.[13] The spirit in which Céline wrote his *Bagatelles pour un massacre,* and its very title, go back directly to a diary entry by Baudelaire: "A fine conspiracy could be organized for the purpose of exterminating the Jewish race."[14] The Blanquist Rigault, who ended his conspiratory career as police chief of the Paris Commune, seems to have had the same macabre sense of humor frequently mentioned in documents about Baudelaire.[15] In Charles Prolès' *Hommes de la Révolution de 1871,* we read that "Rigault, despite his extreme coldbloodedness, was also something of a coarse jokester. That was an integral part of him, down to his fanaticism."[16] Even the terrorist pipe-dream which Marx encountered among the *conspirateurs* has its counterpart in Baudelaire. "If I ever regain the vigor and energy which I had on a few occasions," he wrote to his mother on December 23, 1865, "I will vent my anger in terrifying books. I want to turn the whole human race against me. The delight this would give me would console me for everything."[17] This grim rage—*la rogne*—was the emotion which a half-century of barricade fights had nurtured in Parisian professional conspirators.

"It is they," writes Marx about these conspirators, "who erect the first barricades and command them."[18] The barricade was indeed at the center of the conspiratorial movement. It had revolutionary tradition on its side. More than four thousand barricades had studded the city during the July Revolution.[19] When Fourier looked for an example of *travail non salarié mais passionné,* he found none that was more obvious than the building of barricades.[20] In his novel *Les Misérables,* Hugo gives an impressive picture of those barricades, while leaving the people who manned them in the shadows. "Everywhere an invisible police force within the rebellion was on guard. It maintained order—that is, the night. . . . Eyes that might have looked down on these towering shadows from above would have encoun-

tered here and there an indistinct glow revealing broken, irregular outlines, profiles of strange constructions. In these ruins something resembling lights moved. In these places stood the barricades."[21] In the fragmentary "Address to Paris" which was to have concluded *Les Fleurs du mal*, Baudelaire does not say farewell to the city without invoking its barricades; he remembers its "magic cobblestones which rise up to form fortresses."[22] These stones, to be sure, are "magic" because Baudelaire's poem says nothing about the hands which set them in motion. But this very pathos is probably indebted to Blanquism, for the Blanquist Tridon cries out in a similar vein: "O force, reine des barricades, toi qui brille dans l'éclair et dans l'émeute, . . . c'est vers toi que les prisonniers tendent leurs mains enchaînées."[23] After the demise of the Commune, the proletariat groped its way behind the barricades as a mortally wounded animal withdraws to its lair. The fact that the workers, who had been trained in barricade fighting, did not favor the open battle which was bound to block Thiers's path was partly to blame for their defeat.[24] As a recent historian of the Commune writes, these workers "preferred battle in their own quarters to an encounter in the open field, . . . and if it had to be, they preferred to die behind a barricade built of cobblestones from a Paris street."[25]

In those days Blanqui, the most important of the Paris barricade chiefs, sat in his last prison, the Fort du Taureau.[26] He and his associates, claimed Marx in his analysis of the June Insurrection, were "the true leaders of the proletarian party."[27] It is hardly possible to overestimate the revolutionary prestige which Blanqui possessed at that time and preserved up to his death. Before Lenin, there was no one else who had a clearer profile among the proletariat. His features were engraved in Baudelaire's mind. Baudelaire's manuscripts include a page that bears a sketch of Blanqui's head, in addition to other improvised drawings.—The concepts Marx uses in his depiction of the conspiratorial milieu in Paris clearly bring out Blanqui's ambiguous position in it. There are good reasons for the traditional view of Blanqui as a putschist. In this view he constitutes the type of politician who, as Marx said, regards it as his task "to anticipate the revolutionary developmental process, bring it artificially to a head, and improvise a revolution without the conditions for one."[28] If, by contrast, we look at existing descriptions of Blanqui, he seems to resemble one of the *habits noirs* who were the hated rivals of those professional conspirators. An eyewitness has given the following description of Blanqui's Club des Halles:

> If one wishes to get an accurate idea of the impression made at the outset by Blanqui's revolutionary club, in comparison with the two clubs which the Party of Order then had, one should imagine an audience watching the Comédie Française present a play by Racine or Corneille and should contrast this audience with the crowd that fills a circus in which acrobats are performing breakneck feats. A member of Blanqui's club was, as it were, in a chapel devoted to

the orthodox rites of conspiracy. The doors were open to all, but only the initiates came back. After a wearisome litany by the oppressed, . . . the priest of this place arose. His pretext was that he was going to give a résumé of the complaints of his clients, of the people represented by the half-dozen presumptuous and irritated blockheads who had just been heard from. In reality, he gave an analysis of the situation. His outward appearance was distinguished; his clothes were immaculate. He had a finely formed head, and his facial expression was calm. Only the wild flashing of his eyes sometimes portended trouble; his eyes were narrow, small, and penetrating, and usually they looked kind rather than hard. His speech was measured, fatherly, and distinct—next to the oratorical style of Thiers, the least declamatory I have heard.[29]

In this account, Blanqui appears as a doctrinaire. The *signalement* [description] of the *habit noir* is accurate even in its smallest details. It was well known that "the old man" was in the habit of wearing black gloves while lecturing.[30] But the measured seriousness and the impenetrability which were part of Blanqui's makeup appear different in the light of a statement by Marx. With reference to these professional conspirators, he writes: "They are the alchemists of the revolution and fully share the disintegration of ideas, the narrow-mindedness, and the obsessions of the earlier alchemists."[31] This almost automatically yields the image of Baudelaire: the enigmatic stuff of allegory in one, the mystery-mongering of the conspirator in the other.

As is to be expected, Marx makes deprecatory remarks about the taverns in which the low conspirators felt at home. The miasma that prevailed there was familiar to Baudelaire. This was the atmosphere that gave rise to the great poem entitled "Le Vin des chiffonniers" [The Ragpickers' Wine], which can be dated to the middle of the century. At that time, motifs which appear in this poem were being publicly discussed. One thing under discussion was the tax on wine. The Constituent Assembly of the Republic had promised its repeal, the same promise that had been made in 1830. In his *Klassenkämpfe in Frankreich* [Class Struggles in France], Marx showed how the repeal of this tax represented both a demand by the urban proletariat and a concurrent demand by the peasants. The tax was equally high on everyday wines and on the finest wines, and it decreased consumption "by setting up *octrois* [toll houses] at the gates of all cities with more than 4,000 inhabitants and changing every town into a foreign country with protective tariffs on French wine."[32] "Through the wine tax," wrote Marx, "the peasants tested the bouquet of the government." But this tax also harmed the city-dwellers and forced them to go to taverns outside the city limits in their search for cheap wine. There the tax-free wine which was called *le vin de la barrière* was dispensed. If one can believe H.-A. Frégier, section head at police headquarters, workers who imbibed that wine displayed their enjoyment—full of pride and defiance—as the only enjoyment granted them.

"There are women who do not hesitate to follow their husbands to the *barrière* [town gate] with their children who are old enough to work. . . . Afterward they start their way home half-drunk and act more drunk than they are, so that everyone may notice that they have drunk quite a bit. Sometimes the children follow their parents' example."[33] "One thing is certain," wrote a contemporary observer. "The wine of the *barrières* has saved the governmental structure from quite a few blows."[34] The wine gave the disinherited access to dreams of future revenge and future glory. Thus, in "The Ragpickers' Wine":

> On voit un chiffonnier qui vient, hochant la tête,
> Buttant, et se cognant aux murs comme un poète,
> Et, sans prendre souci des mouchards, ses sujets,
> Epanche tout son coeur en glorieux projets.
>
> Il prête des serments, dicte des lois sublimes,
> Terrasse les méchants, relève les victimes,
> Et sous le firmament comme un dais suspendu
> S'enivre des splendeurs de sa propre vertu.[35]

[One sees a ragpicker coming—shaking his head, / Stumbling, and colliding against walls like a poet; / And, heedless of police informers, his humble subjects, / He pours out his heart in glorious devisings.

He swears solemn oaths, dispenses laws sublime, / Lays low the wicked, raises up the victims, / And under a sky suspended like a canopy / Becomes intoxicated on the splendors of his own virtue.]

When the new industrial processes gave refuse a certain value, ragpickers appeared in the cities in larger numbers. They worked for middlemen and constituted a sort of cottage industry located in the streets. The ragpicker fascinated his epoch. The eyes of the first investigators of pauperism were fixed on him with the mute question: Where does the limit of human misery lie? In his book *Des Classes dangereuses de la population*, Frégier devotes six pages to the ragpicker. Le Play gives the budget of a Paris ragpicker and his family for the period 1849–1850, presumably the time when Baudelaire's poem was written.[36]

A ragpicker cannot, of course, be considered a member of the *bohème*. But from the littérateur to the professional conspirator, everyone who belonged to the *bohème* could recognize a bit of himself in the ragpicker. Each person was in a more or less blunted state of revolt against society and faced a more or less precarious future. At the proper time, he was able to sympathize with those who were shaking the foundations of this society. The ragpicker was not alone in his dream. He was accompanied by comrades; they, too, reeked of wine casks, and they, too, had turned gray in bat-

tles. His moustache drooped like an old flag. On his rounds he encountered the *mouchards,* the police informers whom he dominated in his dreams.[37] Social motifs from everyday Parisian life had already appeared in Sainte-Beuve, where they had been captured by lyric poetry but were not necessarily understood. Penury and alcohol combined in the mind of the cultured man of leisure in a way that differed substantially from the combination in the mind of a Baudelaire.

> Dans ce cabriolet de classe j'examine
> L'homme qui me conduit, qui n'est plus que machine,
> Hideux, à barbe épaisse, à longs cheveux collés;
> Vice, et vin, et sommeil chargent ses yeux soûlés.
>
> Comment l'homme peut-il ainsi tomber? pensais-je,
> Et je me reculais à l'autre coin du siège.[38]

[In this fine cab I examine / The man who is driving me, / Who is no more than a machine, / Hideous, with a thick beard and long, dirty hair. / Vice, wine, and sleep make his drunken eyes heavy.

How can man deteriorate that way? So I thought, / And I drew back to the other corner of the seat.]

This is the beginning of the poem; what follows is an edifying interpretation. Sainte-Beuve asks himself whether his own soul is not almost as neglected as the soul of the coachman.

The litany entitled "Abel et Cain" shows the basis for Baudelaire's view of the disinherited, which was freer and more reasonable than Sainte-Beuve's. The poem turns the contest between the biblical brothers into one between eternally irreconcilable races.

> Race d'Abel, dors, bois et mange;
> Dieu te sourit complaisamment.
>
> Race de Caïn, dans la fange
> Rampe et meurs misérablement.[39]

[Race of Abel, sleep, drink, and eat; / God smiles on you indulgently.

Race of Cain, in the mire / Grovel and die miserably.]

The poem consists of sixteen distichs; every second distich begins the same way. Cain, the ancestor of the disinherited, appears as the founder of a race, and this race can be none other than the proletariat. In 1838, Granier de Cassagnac published his *Histoire des classes ouvrières et des classes bourgeoises.*[40] This work claimed to trace the origin of the proletarians: they form a class of subhumans which sprang from the crossing of robbers

with prostitutes. Did Baudelaire know these speculations? Quite possibly. What is certain is that Marx, who hailed Granier de Cassagnac as "the thinker" of Bonapartist reaction, had encountered them. In his book *Capital,* he parried this racial theory by developing the concept of a "peculiar race of commodity-owners,"[41] by which he meant the proletariat. The race descended from Cain appears in Baudelaire in precisely this sense, though admittedly he would not have been able to define it. It is the race of those who possess no commodity but their labor power.

Baudelaire's poem is part of the cycle entitled "Révolte."[42] Its three parts are blasphemous in tone. Baudelaire's satanism must not be taken too seriously. If it has some significance, it is as the only attitude in which Baudelaire was able to sustain a nonconformist position for any length of time. The last poem in the cycle, "Les Litanies de Satan" [Satanic Litanies], is, by virtue of its theological content, the *miserere* of an ophiolatrous liturgy. Satan appears with his Luciferian halo as the keeper of profound knowledge, as an instructor in Promethean skills, as the patron saint of the stubborn and unyielding. Between the lines flashes the dark head of Blanqui.

> Toi qui fais au proscrit ce regard calme et haut
> Qui damne tout un peuple autour d'un échafaud.[43]

> [You who give the outlaw that calm, proud look / Which can damn an entire multitude gathered around a scaffold.]

This Satan, whom the chain of invocations also terms the "father confessor . . . of the conspirator," is different from the infernal intriguer who is called Satan Trismegistos the Demon in the poems, and appears in the prose pieces as His Highness, whose subterranean dwelling lies in the vicinity of the boulevard. Lemaître has pointed out the dichotomy which makes the devil "in one place the author of all evil and in others the great vanquished, the great victim."[44] It is merely a different view of the problem if one asks what impelled Baudelaire to give a radical theological form to his radical rejection of those in power.

After the defeat of the proletariat in the June struggles, the protest against bourgeois ideas of order and respectability was waged more effectively by the ruling classes than by the oppressed.[45] Those who espoused freedom and justice saw Napoleon III not as the soldier-king that he wanted to be, following in his uncle's footsteps, but as a confidence man favored by fortune. This is how he is portrayed in *Les Châtiments.*[46] The *bohème dorée,* for its part, viewed his sumptuous feasts and the splendor with which he surrounded himself as a realization of their dreams of a "free" life. The memoirs of Count Viel-Castel, in which he described the emperor's sur-

roundings, make a Mimi and a Schaunard appear quite respectable and philistine by comparison.[47] Among the upper classes, cynicism was part of the accepted style; in the lower classes, a rebellious argumentativeness was the norm. In his *Eloa,* Vigny had, in the tradition of Byron, paid homage to Lucifer (the fallen angel) in the gnostic sense.[48] Barthélemy, on the other hand, in his *Némésis,* had associated satanism with the ruling classes; he had a *Messe des agios* celebrated and a psalm about annuities sung.[49] Baudelaire was thoroughly familiar with this dual aspect of Satan. To him, Satan spoke not only for the upper crust but for the lower classes as well. Marx could hardly have wished for a better reader of the following lines from *Der achtzehnte Brumaire:* "When the Puritans complained at the Council of Constance about the wicked lives of the popes, . . . Cardinal Pierre d'Ailly thundered at them: 'Only the devil incarnate can save the Catholic church, and you demand angels!' Thus, the French bourgeoisie cried after the coup d'état: 'Only the head of the Society of the Tenth of December can save bourgeois society! Only theft can save property, perjury religion, bastardy the family, and disorder order.'"[50] Even in his rebellious hours, Baudelaire, an admirer of the Jesuits, did not wish to renounce this savior completely and forever. His verses hold in reserve what his prose did not deny itself; this is why Satan appears in them. From Satan they derive their subtle power to avoid forswearing all loyalty to that which understanding and humaneness rebelled against—even though such loyalty may be expressed in desperate protests. Almost always the confession of piousness comes from Baudelaire like a battle cry. He will not give up his Satan. Satan is the real stake in the struggle which Baudelaire had to carry on with his unbelief. It is a matter not of sacraments and prayers, but of the Luciferian privilege of blaspheming the Satan to whom one has fallen prey.

Baudelaire intended his friendship with Pierre Dupont to indicate that he was a social poet.[51] The critical writings of Barbey d'Aurevilly contain a sketch of that author: "In this talent and this mind, Cain has the upper hand over the gentle Abel—the brutal, starved, envious, wild Cain who has gone to the cities to consume the sediment of rancor which has accumulated in them and participate in the false ideas which triumph there."[52] This characterization expresses exactly what gave Baudelaire solidarity with Dupont. Like Cain, Dupont had "gone to the cities" and turned away from the idyllic. "He has absolutely no connection with poems as our fathers conceived of them, . . . even with simple romances."[53] Dupont sensed the approaching crisis of lyric poetry as the rift between city and country grew wider. One of his verses contains an awkward admission of this: Dupont says that the poet "lends his ear alternately to the forests and to the masses." The masses rewarded him for his attention: around 1848 Dupont was the talk of the town. As the achievements of the Revolution were being lost one after another, Dupont wrote his "Chant du vote" [Song of Suffrage]. There are few

things in the political literature of those days that can rival its refrain. It is a leaf in that laurel crown which Karl Marx claimed for the "threateningly dark brows"[54] of the June fighters.

Fais voir, en déjouant la ruse,
O République! à ces pervers,
Ta grande face de Méduse
Au milieu de rouges éclairs![55]

[In foiling their plots, show / To these evildoers, O Republic, / your great Medusa face / Ringed by red lightning!]

The introduction which Baudelaire contributed to a collection of Dupont's poetry in 1851 was an act of literary strategy. It contains the following remarkable statement: "The puerile utopia of the school of *l'art pour l'art* excluded morality and often even passion, and this necessarily made it sterile." And with an obvious reference to Auguste Barbier, he goes on to say: "When a poet appeared who, despite occasional ineptitude, almost always proved to be great, and who in flaming language proclaimed the sacredness of the 1830 insurrection and sang the misery of England and Ireland, . . . the question was settled once and for all, and henceforth art was inseparable from both morality and utility."[56] This has nothing of the profound duplicity which animates Baudelaire's own poetry. His verse supported the oppressed, though it espoused not only their cause but their illusions as well. It had an ear for the songs of the revolution and also for the "higher voice" which spoke from the drumroll of the executions. When Bonaparte came to power through a coup d'état, Baudelaire was momentarily enraged. "Then he looked at events from a 'providential point of view' and submitted like a monk."[57] "Theocracy and communism"[58] were, to him, not convictions but insinuations which vied for his attention; the one was not as seraphic and the other not as Luciferian as he probably thought. It did not take long for Baudelaire to abandon his revolutionary manifesto, and a number of years later he wrote: "Dupont owed his first poems to the grace and feminine delicacy of his nature. Fortunately, the revolutionary activity which in those days carried almost everyone away did not entirely deflect him from his *natural* course."[59] Baudelaire's abrupt break with *l'art pour l'art* was of value to him only as an attitude. It permitted him to announce the latitude which was at his disposal as a man of letters. In this he was ahead of the writers of his time, including the greatest. This makes it evident in what respects he was above the literary activity which surrounded him.

For a century and a half, the literary life of the day had been centered around journals. Toward the end of the third decade of the century, this began to change. The feuilleton provided a market for *belles-lettres* in the

daily newspaper. The introduction of this cultural section epitomized the changes which the July Revolution had wrought in the press.[60] During the restoration period, single copies of newspapers could not be sold; people had to subscribe to obtain a paper. Anyone who could not pay the high price of eighty francs for a year's subscription had to go to a café, where often several people stood around reading one copy. In 1824, there were 47,000 newspaper subscribers in Paris; in 1836, there were 70,000; and in 1846, there were 200,000. Girardin's paper, *La Presse,* played a decisive part in this rise.[61] It brought about three important innovations: a lower subscription price of forty francs, advertisements, and the serial novel. At the same time, short, abrupt news items began to compete with detailed reports. These news items caught on because they could be employed commercially. The so-called *réclame* paved the way for them; this was an apparently independent notice which was actually paid for by a publisher and which appeared in the editorial section of the newspaper, referring to a book that had been advertised the day before or in the same issue. As early as 1839, Sainte-Beuve complained about the demoralizing effect of the *réclame:* "How could they damn a product [in a critical review] when the same product was described two inches below as being a wonder of the age? The attraction of the ever larger type-size in which advertisements were printed gained the upper hand; they constituted a magnetic mountain which deflected the compass."[62] The *réclame* marked the beginning of a development which culminated with the stock-exchange notices that appeared in the journals and were paid for by interested persons. It is virtually impossible to write a history of information separately from a history of the corruption of the press.

These informative items required little space. They, and not the political editorials or the serialized novels, enabled a newspaper to have a different look every day—an appearance that was cleverly varied when the pages were made up and constituted part of the paper's attractiveness. These items had to be constantly replenished. City gossip, theatrical intrigues, and "things worth knowing" were their most popular sources. Their intrinsic cheap elegance, a quality that became so characteristic of the feuilleton section, was in evidence from the beginning. In her *Letters from Paris,* Madame de Girardin welcomed photography as follows: "At present, much attention is being paid to Monsieur Daguerre's invention, and nothing is more comical than the serious elucidations of it that our salon scholars are providing. Monsieur Daguerre need not worry; no one is going to steal his secret from him. . . . Truly, his invention is wonderful; but people do not understand it—there have been too many explanations of it."[63] The feuilleton style was not accepted immediately or everywhere. In 1860 and 1868, the two volumes of Baron Gaston de Flotte's *Bévues parisiennes* appeared in Marseilles and Paris.[64] They set about combating the carelessness with

which historical information was given, particularly in the feuilleton section of the Parisian press.—The news fillers originated in cafés, over apéritifs. "The custom of taking an apéritif . . . arose with the boulevard press. When there were only the large, serious papers, . . . cocktail hours were unknown. The cocktail hour is the logical consequence of the 'Paris timetable' and of city gossip."[65] Through coffeehouse life, editors became accustomed to the rhythm of the news service even before its machinery had been developed. When the electric telegraph came into use toward the end of the Second Empire, the boulevards lost their monopoly. News of accidents and crimes could now be obtained from all over the world.

The assimilation of a man of letters to the society in which he lived took place on the boulevard, in the following way. On the boulevard, he kept himself in readiness for the next incident, witticism, or rumor. There he unfolded the full drapery of his connections with colleagues and men-about-town, and he was as much dependent on their results as the cocottes were on their disguises.[66] On the boulevards he spent his hours of idleness, which he displayed before people as part of his working hours. He behaved as if he had learned from Marx that the value of a commodity is determined by the worktime needed from society to produce it. In view of the protracted periods of idleness which in the eyes of the public were necessary for the realization of his own labor power, its value became almost fantastic. This high valuation was not limited to the public. The high payments for feuilletons at that time indicate that they were grounded in social conditions. There was in fact a connection between the decrease in the cost of newspaper subscriptions, the increase in advertising, and the growing importance of the feuilleton section.

"In the light of the new arrangements [the lowering of subscription rates], newspapers had to live on advertising revenues. . . . In order to obtain as many advertisements as possible, the quarter-page which had become a poster had to be seen by as many subscribers as possible. It was necessary to have a lure which was directed at all regardless of their private opinion and which replaced politics with curiosity. . . . Once the point of departure existed (the subscription rate of 40 francs), there was an almost inevitable progression from advertisements to serialized novels."[67] This very fact explains the large fees paid for such contributions. In 1845, Dumas signed a contract with *Le Constitutionnel* and *La Presse* guaranteeing him a minimum annual payment of 63,000 francs for supplying at least eighteen installments a year.[68] For his *Mystères de Paris,* Eugène Sue received an advance of 100,000 francs.[69] Lamartine's income has been estimated at 5 million francs for the period from 1838 to 1851. He received 600,000 francs for his *Histoire des Girondins,* which first appeared in the feuilleton section.[70] The generous fees paid for everyday literary merchandise necessarily led to abuses. When publishers acquired manuscripts, they occasionally re-

served the right to print them under the name of a writer of their choice. This was predicated on the fact that some successful novelists were not fussy about the use of their names. Some details about this can be found in a lampoon entitled *Fabrique de romans: Maison Alexandre Dumas et C^ie*.[71] The *Revue des Deux Mondes* commented at that time: "Who knows the titles of all the books written by Monsieur Dumas? Does he know them himself? Unless he keeps a ledger with a 'Debit' and a 'Credit' side, he surely has forgotten more than one of his legitimate, illegitimate, or adopted children."[72] It was said that Dumas employed a whole army of poor writers in his cellars. As late as 1855, ten years after this commentary by the great review, a small organ of the *bohème* printed the following picturesque scene from the life of a successful novelist whom the author calls de Sanctis: "When he arrived home, Monsieur de Sanctis carefully locked the door . . . and opened a small door hidden behind his books. He found himself in a rather dirty, poorly lit little room. There sat a man with disheveled hair who looked sullen but obsequious and had a long goose-quill in his hand. Even from a distance, it was apparent he was a born novelist, though he was only a former ministry-employee who had learned the art of Balzac from reading *Le Constitutionnel*. He is the real author of *The Chamber of Skulls;* he is the novelist."[73] During the Second Republic, the French parliament tried to combat the proliferation of the feuilleton; each installment of a serial novel was taxed one centime. After a short time this regulation was rescinded, since the reactionary press laws which curtailed freedom of opinion enhanced the value of the feuilleton.

The generous remuneration for feuilletons coupled with their large market helped the writers who supplied them to build great reputations. It was natural for an individual to exploit his reputation together with his financial resources; a political career opened up for him almost automatically. This led to new forms of corruption, which were more consequential than the misuse of well-known writers' names. Once the political ambition of a writer had been aroused, it was natural for the regime to show him the right road. In 1846 Salvandy, the minister of colonies, invited Alexandre Dumas to take a trip to Tunis at government expense—estimated at 10,000 francs—to publicize the colonies.[74] The expedition was unsuccessful, cost a lot of money, and ended with a brief inquest in the Chamber of Deputies. Sue had more luck; on the strength of the success of his *Mystères de Paris,* he not only increased the number of *Le Constitutionnel*'s subscribers from 3,600 to 20,000, but was elected a deputy in 1850 with the votes of 130,000 Parisian workingmen. It was not much of a gain for the proletarian voters; Marx called his election "a sentimentally belittling commentary"[75] on the seats previously won. If literature was able to open a political career to favored writers, this career in turn may be used for a critical evaluation of their writings. Lamartine constitutes a case in point.

Lamartine's decisive successes, the *Méditations* and the *Harmonies*, hark back to a time when France's peasants were still able to enjoy the fruits of their agricultural labors. In a naive poem addressed to Alphonse Karr, the poet equated his creativity with that of a vineyard owner:[76]

> Tout homme avec fierté peut vendre sa sueur!
> Je vends ma grappe en fruit comme tu vends ta fleur,
> Heureux quand son nectar, sous mon pied qui la foule,
> Dans mes tonneaux nombreux en ruisseaux d'ambre coule,
> Produisant à son maître ivre de sa cherté,
> Beaucoup d'or pour payer beaucoup de liberté![77]

> [Every man can sell his sweat with pride! / I sell my bunch of grapes as you sell your flowers, / Happy when its nectar, under my foot which tramples it, / Flows into my many casks in amber streams, / Producing for its master, who is intoxicated by its high price, / A lot of gold to pay for a lot of freedom!]

These lines, in which Lamartine praises his prosperity as rustic and boasts of the fees which his produce obtains on the market, are revealing if one reads them less from the viewpoint of morality[78] than as an expression of Lamartine's class feeling—that of a peasant with a plot of land. This is part of the history of Lamartine's poetry. By the 1840s, the situation of the smallholder peasant had become critical. He was in debt; his plot "no longer lay in the so-called fatherland—it lay in the register of mortgages."[79] This meant the decline of rural optimism, the basis of the transfiguring view of nature which is characteristic of Lamartine's poetry. "But while the newly created small holding—in its harmony with society, its dependence on the forces of nature, and its subjection to the authority which protected it from above—was inherently religious, the small holding ruined by debts, at odds with society and authority, and driven beyond its own limits is inherently irreligious. Heaven was quite a nice supplement to the newly acquired strip of land, especially because heaven controls the weather; it becomes an insult when it is forced on people as a substitute for a plot of land."[80] Lamartine's poems had been cloud formations in that very heaven. As Sainte-Beuve wrote in 1830, "The poetry of André Chénier . . . is, so to speak, the landscape over which Lamartine has spread the heavens."[81] This heaven collapsed forever in 1848, when the French peasants voted for Bonaparte as president. Lamartine had helped to prepare the way for that vote.[82] On Lamartine's role in the revolution, Sainte-Beuve commented: "He probably never thought he was destined to become the Orpheus who would guide and moderate that invasion of barbarians with his golden lyre."[83] Baudelaire dryly calls him "a bit whorish, a bit prostituted."[84]

Virtually no one had a keener eye for the problematic sides of this splendid figure than Baudelaire. This may be due to the fact that he himself had

always felt little splendor attaching to his own person. Porché believes it looks as though Baudelaire had no choice about where he could place his manuscripts.[85] Ernest Raynaud writes: "Baudelaire had to be prepared for unethical practices. He was dealing with publishers who counted on the vanity of sophisticated people, amateurs, and beginners, and who accepted manuscripts only if a subscription was purchased."[86] Baudelaire's actions were in keeping with this state of affairs. He offered the same manuscript to several papers at the same time and authorized reprints without indicating them as such. From his early period on, he viewed the literary market without any illusions. In 1846 he wrote: "No matter how beautiful a house may be, it is primarily, and before one dwells on its beauty, so-and-so many meters high and so-and-so many meters long. In the same way, literature, which constitutes the most inestimable substance, is primarily a matter of filling up lines; and a literary architect whose mere name does not guarantee a profit must sell at any price."[87] Until his dying day, Baudelaire had little status in the literary marketplace. It has been calculated that he earned no more than 15,000 francs from all his writings.

"Balzac is ruining himself with coffee; Musset is dulling himself by drinking absinthe. . . . Murger is dying in a sanatorium, as is now Baudelaire. And not one of these writers has been a socialist!"[88] Thus wrote Sainte-Beuve's private secretary, Jules Troubat. Baudelaire surely deserved the recognition intended by the last sentence. But this does not mean that he lacked insight into the true situation of a man of letters. He often confronted the writer, first and foremost himself, with the figure of the whore. His sonnet to the venal muse—"La Muse vénale"—speaks of this. His great introductory poem "Au Lecteur" presents the poet in the unflattering position of someone who takes cold cash for his confessions. One of his earliest poems, which figures among those excluded from *Les Fleurs du mal,* is addressed to a streetwalker. This is its second stanza:

Pour avoir des souliers, elle a vendu son âme;
Mais le bon Dieu rirait si, près de cette infâme,
Je tranchais du Tartufe et singeais la hauteur,
Moi qui vends ma pensée et qui veux être auteur.[89]

[In order to have shoes, she has sold her soul; / But the Good Lord would laugh if, in the presence of that vile woman, / I played the hypocrite and acted lofty— / I who sell my thought and wish to be an author.]

The last stanza, "Cette bohème-là, c'est mon tout" ["That bohemian woman—she means everything to me"], casually includes this creature in the brotherhood of the *bohème.* Baudelaire knew the true situation of the man of letters: he goes to the marketplace as a flâneur, supposedly to take a look at it but in reality to find a buyer.

II. THE FLÂNEUR

Once a writer had entered the marketplace, he looked around as if in a panorama.[90] A special literary genre has captured the writer's first attempts to orient himself. This is the genre of panoramic literature. It was no accident that *Le Livre des cent-et-un, Les Français peints par eux-mêmes, Le Diable à Paris,* and *La Grande Ville* were popular in the capital city at the same time as the panoramas.[91] These works consist of individual sketches which, as it were, reproduce the dynamic foreground of those panoramas with their anecdotal form and the sweeping background of the panoramas with their store of information. Numerous authors contributed to the volumes. Thus, these anthologies are products of the same collective belletristic endeavor for which Girardin had provided an outlet in the feuilleton. They were the salon attire of a literature which was basically designed to be sold on the street. In this literature, the inconspicuous, paperback, pocket-size volumes called "physiologies" had pride of place. They investigated the human types that a person taking a look at the marketplace might encounter. From the itinerant street vendor of the boulevards to the dandy in the opera-house foyer, there was not a figure of Paris life that was not sketched by a *physiologue.* The great flowering of the genre came in the early 1840s—the period that marked the *haute école* of the feuilleton. Baudelaire's generation went through it. The fact that it meant little to Baudelaire himself indicates the early age at which he went his own way.

In 1841 there were seventy-six new physiologies.[92] After that year the genre declined, and it disappeared together with the reign of the Citizen King, Louis Philippe. It was a petty-bourgeois genre from the ground up. Monnier, its master, was a philistine endowed with an uncommon capacity for self-observation.[93] Nowhere did these physiologies break through the most limited horizon. After each human type had been covered, the physiology of the city had its turn. There appeared *Paris la nuit, Paris à table, Paris dans l'eau, Paris à cheval, Paris pittoresque, Paris marié.*[94] When this vein, too, was exhausted, a "physiology" of the nations was attempted. Nor was the "physiology" of animals neglected, for animals have always been an innocuous subject. Innocuousness was of the essence. In his studies on the history of caricature, Eduard Fuchs points out that the beginning of the physiologies coincided with the so-called September Laws, the tightened censorship of 1836.[95] These laws summarily forced out of politics an array of capable artists with a background in satire. If that could be done in the graphic arts, the government's maneuver was bound to be all the more successful in literature, for there was no political energy there that could compare with that of a Daumier. Reaction, then, was the principle "which explains the colossal parade of bourgeois life that . . . began in France. . . . Everything passed in review. . . . Days of celebration and days of mourning,

work and play, conjugal customs and bachelors' practices, the family, the home, children, school, society, the theater, character types, professions."[96]

The leisurely quality of these descriptions fits the style of the flâneur who goes botanizing on the asphalt. But even in those days it was impossible to stroll about everywhere in the city. Before Haussmann, wide pavements were rare; the narrow ones afforded little protection from vehicles.[97] Flânerie could hardly have assumed the importance it did without the arcades. "These arcades, a recent invention of industrial luxury," says an illustrated guide to Paris of 1852, "are glass-roofed, marble-paneled corridors extending through whole blocks of buildings, whose owners have joined together for such enterprises. Lining both sides of these corridors, which get their light from above, are the most elegant shops, so that the *passage* is a city, a world in miniature." It is in this world that the flâneur is at home; he provides the arcade—"the favorite venue of strollers and smokers, the haunt of all sorts of little *métiers*"[98]—with its chronicler and philosopher. As for himself, the arcade provides him with an unfailing remedy for the kind of boredom that easily arises under the baleful eye of a sated reactionary regime. In the words of Guys as quoted by Baudelaire, "Anyone who is capable of being bored in a crowd is a blockhead. I repeat: a blockhead, and a contemptible one."[99] The arcades are something between a street and an *intérieur*. If one can say that the physiologies employ an artistic device, it is the proven device of the feuilleton—namely, the transformation of the boulevard into an *intérieur*. The street becomes a dwelling place for the flâneur; he is as much at home among house façades as a citizen is within his four walls. To him, a shiny enameled shop sign is at least as good a wall ornament as an oil painting is to a bourgeois in his living room. Buildings' walls are the desk against which he presses his notebooks; newsstands are his libraries; and café terraces are the balconies from which he looks down on his household after his work is done. That life in all its variety and inexhaustible wealth of permutations can thrive only among the gray cobblestones and against the gray background of despotism was the political secret of the literature to which the physiologies belonged.

These writings were socially dubious, as well. The long series of eccentric or appealingly simple or severe figures which the physiologies presented to the public in character sketches had one thing in common: they were harmless and perfectly affable. Such a view of one's fellow man was so remote from experience that there were bound to be uncommonly weighty motives for it. The reason was an uneasiness of a special sort. People had to adapt themselves to a new and rather strange situation, one that is peculiar to big cities. Simmel has provided an excellent formulation of what was involved here.[100] "Someone who sees without hearing is much more uneasy than someone who hears without seeing. In this, there is something characteristic of the sociology of the big city. Interpersonal relationships in big cities are

distinguished by a marked preponderance of visual activity over aural activity. The main reason for this is the public means of transportation. Before the development of buses, railroads, and trams in the nineteenth century, people had never been in situations where they had to look at one another for long minutes or even hours without speaking to one another."[101] These new situations were, as Simmel recognized, not pleasant. In his *Eugene Aram,* Bulwer-Lytton orchestrated his description of big-city dwellers with a reference to Goethe's remark that each person, the most worthy as well as the most despicable, carries around a secret which would make him hateful to everyone else if it became known.[102] The physiologies were just the thing to brush such disquieting notions aside as insignificant. They constituted, so to speak, the blinkers of the "narrow-minded city animal" that Marx wrote about.[103] A description of the proletarian in Foucaud's *Physiologie de l'industrie française* shows what a thoroughly limited vision these physiologies offered when the need arose: "Quiet enjoyment is almost exhausting for a workingman. The house in which he lives may be surrounded by greenery under a cloudless sky; it may be fragrant with flowers and enlivened by the chirping of birds. But if a worker is idle, he will remain inaccessible to the charms of solitude. On the other hand, if a loud noise or a whistle from a distant factory happens to hit his ear, if he so much as hears the monotonous clattering of the machines in a factory, his face immediately brightens. He no longer senses the choice fragrance of flowers. The smoke from the tall factory chimney, the booming blows on the anvil, make him tremble with joy. He remembers the happy days of his labors, which were guided by the spirit of the inventor."[104] The entrepreneur who read this description may have gone to bed more relaxed than usual.

It was indeed the most obvious thing to give people a friendly picture of one another. Thus, the physiologies helped fashion the phantasmagoria of Parisian life in their own way. But their method could not get them very far. People knew one another as debtors and creditors, salesmen and customers, employers and employees, and above all as competitors. In the long run, it seemed quite unlikely that they could be made to believe their associates were harmless oddballs. So these writings soon developed another view of the matter which was much more bracing. They went back to the physiognomists of the eighteenth century, although they had little to do with the more solid endeavors of those earlier authors. In Lavater and Gall there was, in addition to speculative and visionary impulses, genuine empiricism.[105] The physiologies eroded the reputation of this empiricism without adding anything of their own. They assured people that everyone could— unencumbered by any factual knowledge—make out the profession, character, background, and lifestyle of passers-by. The physiologies present this ability as a gift which a good fairy lays in the cradle of the big-city dweller. With such certainties, Balzac, more than anyone else, was in his element.

They encouraged his predilection for unqualified statements. "Genius," he wrote, "is so visible in a person that even the least educated man walking around in Paris will, when he comes across a great artist, know immediately what he has found."[106] Delvau, Baudelaire's friend and the most interesting among the minor masters of the feuilleton, claimed that he could divide the Parisian public according to its various strata as easily as a geologist distinguishes the layers in rocks. If that sort of thing could be done, then life in the big city was surely not as disquieting as it probably seemed to people. And the following questions by Baudelaire were just empty phrases: "What are the dangers of the forest and the prairie, compared with the daily shocks and conflicts of civilization? Whether a man grabs his victim on a boulevard or stabs his quarry in unknown woods—does he not remain both here and there the most perfect of all beasts of prey?"[107]

For this victim, Baudelaire uses the term *dupe*. The word refers to someone who is cheated or fooled, and such a person is the antithesis of a connoisseur of human nature. The more alien a big city becomes, the more knowledge of human nature—so it was thought—one needs to operate in it. In actuality, the intensified struggle for survival led an individual to make an imperious proclamation of his interests. When it is a matter of evaluating a person's behavior, intimate familiarity with these interests will often be much more useful than familiarity with his character. The ability the flâneur prides himself on is, therefore, more likely to be one of the idols Bacon already located in the marketplace. Baudelaire hardly paid homage to this idol. His belief in original sin made him immune to belief in a knowledge of human nature. He sided with de Maistre, who had combined a study of dogma with a study of Bacon.[108]

The soothing little remedies that the physiologists offered for sale were soon outmoded. On the other hand, the literature concerned with the disquieting and threatening aspects of urban life was destined for a great future. This literature, too, dealt with the masses, but its method was different from that of the physiologies. It cared little about the definition of types; rather, it investigated the functions which are peculiar to the masses in a big city. One of these claimed particular attention; it had been emphasized in a police report as early as the turn of the nineteenth century. "It is almost impossible," wrote a Parisian secret agent in 1798, "to maintain good behavior in a thickly populated area where an individual is, so to speak, unknown to everyone else and thus does not have to blush in front of anyone."[109] Here the masses appear as the asylum that shields an asocial person from his persecutors. Of all the menacing aspects of the masses, this one became apparent first. It lies at the origin of the detective story.

In times of terror, when everyone is something of a conspirator, everybody will be in the position of having to play detective. Flânerie gives the individual the best prospects of doing so. Baudelaire wrote: "An observer is a

prince who is everywhere in possession of his incognito."[110] If the flâneur is thus turned into an unwilling detective, it does him a lot of good socially, for it legitimates his idleness. His indolence is only apparent, for behind this indolence there is the watchfulness of an observer who does not take his eyes off a miscreant. Thus, the detective sees rather wide areas opening up to his self-esteem. He develops reactions that are in keeping with the tempo of a big city. He catches things in flight; this enables him to dream that he is like an artist. Everyone praises the swift crayon of the graphic artist. Balzac claims that artistry as such is linked to quick grasp.[111]—Forensic knowledge coupled with the pleasant nonchalance of the flâneur: this is the essence of Dumas' *Mohicans de Paris.* The hero of this book decides to go in search of adventure by following a scrap of paper which he has given to the wind as a plaything. No matter what trace the flâneur may follow, every one of them will lead him to a crime. This is an indication of how the detective story, regardless of its sober calculations, also participates in the phantasmagoria of Parisian life. It does not yet glorify the criminal, though it does glorify his adversaries and, above all, the hunting grounds where they pursue him. Messac has shown how writers have attempted to bring in echoes of Cooper.[112] The most interesting thing about Cooper's influence is that it is not concealed but displayed. In the aforementioned *Mohicans de Paris,* this display is in the very title; the author promises readers that he will open a primeval forest and a prairie for them in Paris. The woodcut used as a frontispiece in the third volume shows a street overgrown with trees and shrubs that was little frequented in those days; the caption under this picture reads: "The primeval forest on the rue d'Enfer." The publisher's brochure for this volume limns the connection with a magnificent phrase which reveals the author's enthusiasm for himself: "'Paris' and 'Mohicans': . . . these two names clash like the *qui vive* of two gigantic unknowns. An abyss separates the two; across it flashes a spark of that electric light which has its source in Alexandre Dumas." Even earlier, Féval had involved a redskin in the adventures of a metropolis.[113] While riding in a fiacre, this man, whose name is Tovah, manages to scalp his four white companions so stealthily that the coachman suspects nothing. *Les Mystères de Paris* refers to Cooper in its opening pages, promising that its heroes from the Parisian underworld "are no less removed from civilization than the savages who are so splendidly depicted by Cooper." But it is Balzac who, above all, never tires of referring to Cooper as his model. "The poetry of terror that pervades the American woods, with their clashes between tribes on the warpath—this poetry which stood Cooper in such good stead attaches in the same way to the smallest details of Parisian life. The pedestrians, the shops, the hired coaches, a man leaning against a window—all this was of the same burning interest to the members of Peyrade's bodyguard as a tree stump, a beaver's den, a rock, a buffalo skin, a motionless canoe, or a floating leaf was to the reader of a

novel by Cooper."[114] Balzac's intrigue is rich in forms that fall somewhere between tales of Indians and detective stories. At an early date, there were objections to his "Mohicans in spencer jackets" and "Hurons in frock coats."[115] On the other hand, Hippolyte Babou, who was close to Baudelaire, wrote retrospectively in 1857: "When Balzac breaks through walls to give free rein to observation, people listen at the doors. . . . In short, they behave, as our prudish English neighbors phrase it, like *police detectives.*"[116]

The detective story, whose interest lies in its logical structure (which the crime story as such need not have), appeared in France for the first time when Poe's stories "The Mystery of Marie Roget," "The Murders in the Rue Morgue," and "The Purloined Letter" were translated. With his translations of these models, Baudelaire adopted the genre. Poe's work was definitely absorbed in his own, and Baudelaire emphasizes this fact by stating his solidarity with the method in which the individual genres that Poe embraced harmonize. Poe was one of the greatest technicians of modern literature. As Valéry pointed out,[117] he was the first to attempt the scientific story, the modern cosmogony, and the description of pathological phenomena. These genres he regarded as exact products of a method for which he claimed universal validity. Baudelaire sided with him on this point, and in Poe's spirit he wrote: "The time is approaching when it will be understood that a literature which refuses to proceed in brotherly concord with science and philosophy is a murderous and suicidal literature."[118] The detective story, the most momentous of Poe's technical achievements, belonged to a literature that satisfied Baudelaire's postulate. Its analysis constitutes part of the analysis of Baudelaire's own work, despite the fact that Baudelaire wrote no stories of this type. *Les Fleurs du mal* incorporates three of its decisive elements as *disjecta membra:* the victim and the scene of the crime ("Une Martyre"), the murderer ("Le Vin de l'assassin"), and the masses ("Le Crépuscule du soir"). The fourth element is lacking—the one that permits the intellect to break through this emotion-laden atmosphere. Baudelaire wrote no detective story because, given the structure of his drives, it was impossible for him to identify with the detective. In him, the calculating, constructive element was on the side of the asocial and had become an integral part of cruelty. Baudelaire was too good a reader of the Marquis de Sade to be able to compete with Poe.[119]

The original social content of the detective story focused on the obliteration of the individual's traces in the big-city crowd. Poe concerns himself with this motif in detail in "The Mystery of Marie Roget," the longest of his detective stories. At the same time, this story is the prototype for the way journalistic information is used in solving crimes. Poe's detective, the Chevalier Dupin, here works not with personal observation but with reports from the daily press. The critical analysis of these reports constitutes the

scaffolding in the story. Among other things, the time of the crime has to be established. One paper, *Le Commercial*, expresses the view that Marie Roget, the murdered woman, was done away with immediately after she left her mother's apartment. Poe writes:

> "It is impossible . . . that a person so well known to thousands as this young woman was, should have passed three blocks without some one having seen her." This is the way of thinking of a man long resident in Paris—a public man—and one whose walks to and fro in the city have been mostly limited to the vicinity of the public offices. . . . He passes to and fro, at regular intervals, within a confined periphery, abounding in individuals who are led to observation of his person through interest in the kindred nature of his occupation with their own. But the walks of Marie may, in general, be supposed discursive. In this particular instance it will be understood as most probable that she proceeded upon a route of more than average diversity from her accustomed ones. The parallel which we imagine to have existed in the mind of *Le Commercial* would only be sustained in the event of the two individuals traversing the whole city. In this case, granting the personal acquaintances to be equal, the chances would be also equal that an equal number of personal *rencontres* would be made. For my own part, I should hold it not only as possible, but as far more than probable, that Marie might have proceeded, at any given period, by any one of the many routes between her own residence and that of her aunt, without meeting a single individual whom she knew, or by whom she was known. In viewing this question in its full and proper light, we must hold steadily in mind the great disproportion between the personal acquaintances of even the most noted individual in Paris, and the entire population of Paris itself.

If one disregards the context which gives rise to these reflections in Poe, the detective loses his competence but the problem does not lose its validity. A variation of it forms the basis of one of the most famous poems in *Les Fleurs du mal*, the sonnet entitled "A une passante" [To a Passer-by].

La rue assourdissante autour de moi hurlait.
Longue, mince, en grand deuil, douleur majestueuse,
Une femme passa, d'une main fastueuse
Soulevant, balançant le feston et l'ourlet;

Agile et noble, avec sa jambe de statue.
Moi, je buvais, crispé comme un extravagant,
Dans son oeil, ciel livide où germe l'ouragan,
La douceur qui fascine et le plaisir qui tue.

Un éclair . . . puis la nuit!—Fugitive beauté
Dont le regard m'a fait soudainement renaître,
Ne te verrai-je plus que dans l'éternité?

Ailleurs, bien loin d'ici! trop tard! *jamais* peut-être!
Car j'ignore où tu fuis, tu ne sais où je vais,
O toi que j'eusse aimée, ô toi qui le savais![120]

[The street around me roared, deafening. / Tall, slender, in deep mourning, majestic in her grief, / A woman passed—with imposing hand / Gathering up a scalloped hem—

Agile and noble, her leg like a statue's. / And as for me, twitching like one possessed, I drank / From her eyes—livid sky brewing a storm— / The sweetness that fascinates and the pleasure that kills.

A lightning flash . . . then night!—Fugitive beauty, / Whose gaze has suddenly given me new life, / Will I see you again before the close of eternity?

Elsewhere, very far from here! Too late! Perhaps *never!* / For where you're off to I'll never know, nor do you know where I'm going— / O you whom I could have loved, O you who knew it too!]

This sonnet presents the crowd not as the refuge of a criminal but as the refuge of love which flees from the poet. One may say that it deals with the function of the crowd not in the life of the citizen but in the life of the eroticist. At first glance this function appears to be a negative one, but it is not. Far from eluding the eroticist in the crowd, the apparition which fascinates him is brought to him by this very crowd. The delight of the city-dweller is not so much love at first sight as love at last sight. The word "jamais" marks the high point of the encounter, when the poet's passion seems to be frustrated but in reality bursts out of him like a flame. He is seared by this flame, but no phoenix arises from it. The rebirth in the first tercet reveals a view of the event which in the light of the preceding stanza seems very problematic. What makes his body twitch spasmodically is not the excitement of a man in whom an image has taken possession of every fiber of his being; it partakes more of the shock with which an imperious desire suddenly overcomes a lonely man. The phrase "comme un extravagant" almost expresses this; the poet's emphasis on the fact that the female apparition is in mourning is not designed to conceal it. In reality, there is a profound gulf between the quatrains which present the occurrence and the tercets which transfigure it. When Thibaudet says that these verses "could only have been written in a big city,"[121] he does not penetrate beneath their surface. The inner form of these verses is revealed in the fact that they depict love itself as being stigmatized by the big city.[122]

Since the days of Louis Philippe, the bourgeoisie has endeavored to compensate itself for the fact that private life leaves no traces in the big city. It seeks such compensation within its four walls—as if it were striving, as a matter of honor, to prevent the traces, if not of its days on earth then at

least of its possessions and requisites of daily life, from disappearing forever. The bourgeoisie unabashedly makes impressions of a host of objects. For slippers and pocket watches, thermometers and egg cups, cutlery and umbrellas, it tries to get covers and cases. It prefers velvet and plush covers, which preserve the impression of every touch. For the Makart style, the style of the end of the Second Empire, a dwelling becomes a kind of casing.[123] This style views it as a case for a person and embeds him in it, together with all his appurtenances, tending his traces as nature tends dead fauna embedded in granite. One must note that there are two sides to this process. The real or sentimental value of the objects thus preserved is emphasized. They are removed from the profane gaze of nonowners; in particular, their outlines are blurred in a characteristic way. It is no accident that resistance to controls, something that becomes second nature to asocial persons, displays a resurgence in the propertied bourgeoisie.—In such customs, one can see the dialectical illustration of a text which appeared in many installments in the *Journal Officiel*.[124] As early as 1836, Balzac wrote in *Modeste Mignon*: "Poor women of France! You would probably like to remain unknown, so that you can carry on your little romances. But how can you manage this in a civilization which registers the departures and arrivals of coaches in public places, counts letters and stamps them when they are posted and again when they are delivered, assigns numbers to houses, and will soon have the whole country, down to the smallest plot of land, in its registers?"[125] Since the French Revolution, an extensive network of controls had been bringing bourgeois life ever more tightly into its meshes. The numbering of houses in the big cities may be used to document the progressive standardization. Napoleon's administration had made such numbering obligatory for Paris in 1805. In proletarian neighborhoods, to be sure, this simple police measure had encountered resistance. As late as 1864, the following was reported about Saint-Antoine, the carpenters' neighborhood: "If one asks an inhabitant of this suburb what his address is, he will always give the name of his house and not its cold, official number."[126] In the long run, of course, such resistance was of no avail against the government's effort to establish a multifarious web of registrations—a means of compensating for the elimination of traces that takes place when people disappear into the masses of the big cities. Baudelaire found this effort as much of an encroachment as did any criminal. Trying to evade his creditors, he went to cafés or reading circles. Sometimes he had two domiciles at the same time—but on days when the rent was due, he often spent the night at a third place with friends. So he roamed about in the city, which had long since ceased to be home for the flâneur. Every bed in which he lay became a "lit 'hasardeux'"[127] for him. Crépet has counted fourteen Paris addresses for Baudelaire in the years 1842 to 1858.

Technical measures had to come to the aid of the administrative control

process. In the early days of the process of identification, whose current standard derives from the Bertillon method, the identity of a person was established through his signature.[128] The invention of photography was a turning point in the history of this process. It was no less significant for criminology than the invention of the printing press was for literature. Photography made it possible for the first time to preserve permanent and unmistakable traces of a human being. The detective story came into being when this most decisive of all conquests of a person's incognito had been accomplished. Since that time, there has been no end to the efforts to capture [dingfest machen] a man in his speech and actions.

Poe's famous tale "The Man of the Crowd" is something like an X-ray of a detective story. It does away with all the drapery that a crime represents. Only the armature remains: the pursuer, the crowd, and an unknown man who manages to walk through London in such a way that he always remains in the middle of the crowd. This unknown man is the flâneur. That is how Baudelaire understood him when, in his essay on Guys, he called the flâneur "l'homme des foules" [the man of the crowd]. But Poe's description of this figure is devoid of the connivance which Baudelaire's notion included. To Poe the flâneur was, above all, someone who does not feel comfortable in his own company. This is why he seeks out the crowd; the reason he hides in it is probably close at hand. Poe purposely blurs the difference between the asocial person and the flâneur. The harder a man is to find, the more suspicious he becomes. Refraining from a prolonged pursuit, the narrator quietly sums up his insight as follows: "'This old man is the embodiment and the spirit of crime,' I said to myself. 'He refuses to be alone. *He is the man of the crowd.*'"

The author does not demand the reader's interest in this man alone; his description of the crowd will claim at least as much interest, for documentary as well as artistic reasons. In both respects, the crowd stands out. The first thing that strikes one is the rapt attention with which the narrator follows the spectacle of the crowd. This same spectacle is followed, in a well-known story by E. T. A. Hoffmann, by the "cousin at his corner window."[129] But this man, who is in his own home, views the crowd with great circumspection, whereas the man who stares through the window of a coffeehouse has a penetrating gaze. In the difference between the two observation posts lies the difference between Berlin and London. On the one hand, there is the man of leisure. He sits in his alcove as in a box at the theater; when he wants to take a closer look at the marketplace, he has opera glasses at hand. On the other hand, there is the anonymous consumer who enters a café and will shortly leave it again, attracted by the magnet of the mass which constantly has him in its range. On the one side, there is a multiplicity of little genre pictures which together constitute an album of colored engravings; on the other side, there is a view which could inspire a

great etcher: an enormous crowd in which no one is either quite transparent or quite opaque to everyone else. A German petty bourgeois is subject to very narrow limits, yet Hoffmann by nature belonged to the family of the Poes and Baudelaires. In the biographical notes to the original edition of his last writings, we read: "Hoffmann was never especially fond of nature. He valued people—communication with them, observations about them, merely seeing them—more than anything else. If he went for a walk in summer, something that he did every day toward evening in fine weather, there was hardly a wine tavern or a confectioner's shop that he did not look in on, to see whether anyone was inside and who might be there."[130] At a later date, when Dickens went traveling, he repeatedly complained about the lack of street noises, which were indispensable to him for his work. "I cannot express how much I want these [the streets]," he wrote in 1846 from Lausanne while he was working on *Dombey and Son*. "It seems as if they supplied something to my brain, which it cannot bear, when busy, to lose. For a week or a fortnight I can write prodigiously in a retired place, . . . and a day in London sets me up again and starts me. But the toil and labor of writing, day after day, without that magic lantern, is *immense*. . . . *My figures seem disposed to stagnate without crowds about them*."[131] Among the many things that Baudelaire criticized about Brussels, a city he hated, was something that filled him with particular rage: "No shopwindows. Strolling—something that nations with imagination love—is impossible in Brussels. There is nothing to see, and the streets are unusable."[132] Baudelaire loved solitude, but he wanted it in a crowd.

Poe, in the course of his story, lets darkness fall. He lingers over the city by gaslight. The appearance of the street as an *intérieur* in which the phantasmagoria of the flâneur is concentrated is hard to separate from the gas lighting. The first gas lamps burned in the arcades. The attempt to use them under the open sky was made in Baudelaire's childhood; candelabra-shaped lights were installed on the Place Vendôme. Under Napoleon III, the number of gas lamps in Paris grew rapidly.[133] This way of increasing safety in the city made the crowds feel at home in the open streets even at night, and removed the starry sky from the ambience of the big city more effectively than tall buildings had ever done. "I draw the curtain over the sun; now it has been put to bed, as is proper. Henceforth I shall see no other light but that of the gas flame."[134] The moon and the stars are no longer worth mentioning.

In the heyday of the Second Empire, the shops in the main streets did not close before ten o'clock at night. It was the great age of *noctambulisme*. In the chapter of his *Heures parisiennes* which is devoted to the second hour after midnight, Delvau wrote: "A person may take a rest from time to time; he is permitted stops and resting places. But he has no right to sleep."[135] On Lake Geneva, Dickens nostalgically remembered Genoa, where two miles

of lighted streets had enabled him to roam about at night. Later, when flânerie went out of style with the extinction of the arcades and gaslight was no longer considered fashionable, a last flâneur strolling sadly through the empty Passage Colbert had the impression that the flickering of the gas lamps indicated merely the flame's own fear that the gas bill would not be paid at the end of the month.[136] This is when Stevenson wrote his plaint about the disappearance of the gas lamps. He muses particularly on the rhythm with which lamplighters would go through the streets and light one lamp after another. From the outset, this rhythm contrasted with the uniformity of the dusk, but now the contrast becomes brutally shocking with the spectacle of entire cities suddenly being illuminated by electric light. "Such a light as this should shine only on murders and public crime, or along the corridors of lunatic asylums, a horror to heighten horror."[137] There is some indication that only in its late stages did people take an idyllic view of gaslight such as the one presented by Stevenson, who wrote its obituary. The above-mentioned story by Poe is a good case in point. There can hardly be a more uncanny description of this light: "The rays of the gas lamps, feeble at first in their struggle with the dying day, had now at length gained ascendancy, and threw over every thing a fitful and garish lustre. All was dark yet splendid—as that ebony to which has been likened the style of Tertullian."[138] "Inside a house," wrote Poe elsewhere, "gas is definitely inadmissible. Its flickering, harsh light offends the eye."

The London crowd seems as gloomy and confused as the light in which it moves. This is true not only of the rabble that crawls "out of its dens" at night. The clerks of higher rank are described by Poe as follows: "They had all slightly bald heads, from which the right ears, long used to pen-holding, had an odd habit of standing off on end. I observed that they always removed or settled their hats with both hands, and wore watches, with short gold chains of a substantial and ancient pattern." In his description, Poe did not aim at any direct observation. The uniformities to which the petty bourgeois are subjected by virtue of being part of the crowd are exaggerated; their appearance is not far from being uniform. Even more astonishing is the description of the way the crowd moves.

By far the greater number of those who went by had a satisfied business-like demeanor, and seemed to be thinking only of making their way through the press. Their brows were knit, and their eyes rolled quickly; when pushed against by fellow-wayfarers they evinced no symptom of impatience, but adjusted their clothes and hurried on. Others, still a numerous class, were restless in their movements, had flushed faces, and talked and gesticulated to themselves, as if feeling in solitude on account of the very denseness of the company around. When impeded in their progress, these people suddenly ceased muttering, but redoubled their gesticulations, and awaited, with an absent and overdone smile upon the lips, the course of the persons impeding them. If jostled,

they bowed profusely to the jostlers, and appeared overwhelmed with con-
fusion.[139]

One might think he was speaking of half-drunken wretches. Actually, they
were "noblemen, merchants, attorneys, tradesmen, stock-jobbers."[140]
Something other than a psychology of the classes is involved here.[141]

There is a lithograph by Senefelder which represents a gambling club.[142]
Not one of the individuals depicted is pursuing the game in the customary
fashion. Each man is dominated by his affect: one shows unrestrained joy;
another, distrust of his partner; a third, dull despair; a fourth evinces bellig-
erence; another is preparing to take leave of the world. In its extravagance,
this lithograph is reminiscent of Poe. Poe's subject, to be sure, is greater, and
his means are in keeping with this. His masterly stroke in the above descrip-
tion is that he does not show the hopeless isolation of men within their pri-
vate concerns through the variety of their behavior, as does Senefelder, but
expresses this isolation in absurd uniformities of dress or conduct. The ser-
vility with which those pushed even go on to apologize shows where the de-
vices Poe employs here come from. They derive from the repertoire of
clowns, and Poe uses them in a fashion similar to that later employed by
clowns. In the performance of a clown, there is an obvious reference to eco-
nomic mechanisms. With his abrupt movements, he imitates both the ma-
chines which push the material and the economic boom which pushes the
merchandise. The segments of the crowd described by Poe enact a similar
mimesis of the "feverish . . . pace of material production," along with the
forms of business that go with it. What the fun fair, which turned the aver-
age man into a clown, later accomplished with its bumper cars and related
amusements is anticipated in Poe's description. The people in his story be-
have as if they can no longer express themselves through anything but reflex
actions. These goings-on seem even more dehumanized because Poe talks
only about people. If the crowd becomes jammed up, this is not because it is
being impeded by vehicular traffic—there is no mention of vehicles any-
where—but because it is being blocked by other crowds. In a mass of this
nature, flânerie could never flourish.

In Baudelaire's Paris, things had not yet come to such a pass. Ferries were
still crossing the Seine at points where later there would be bridges. In the
year of Baudelaire's death, an entrepreneur could still cater to the comfort
of the well-to-do with a fleet of five hundred sedan chairs circulating about
the city. Arcades where the flâneur would not be exposed to the sight of car-
riages—which scorned to recognize pedestrians as rivals—were enjoying
undiminished popularity. There was the pedestrian who wedged himself
into the crowd, but there was also the flâneur who demanded elbow room
and was unwilling to forgo the life of a gentleman of leisure. He goes his lei-
surely way as a personality; in this manner he protests against the division

of labor which makes people into specialists. He protests no less against their industriousness. Around 1840 it was briefly fashionable to take turtles for a walk in the arcades. The flâneurs liked to have the turtles set the pace for them. If they had had their way, progress would have been obliged to accommodate itself to this pace. But this attitude did not prevail; Taylor, who popularized the catchphrase "Down with dawdling!" carried the day.[143] Some people sought to anticipate coming developments while there was still time. Rattier wrote in 1857 in his utopia *Paris n'existe pas:* "The flâneur whom we used to encounter on the sidewalks and in front of shopwindows, this nonentity, this constant rubberneck, this inconsequential type who was always in search of cheap emotions and knew about nothing but cobblestones, fiacres, and gas lamps, . . . has now become a farmer, a vintner, a linen manufacturer, a sugar refiner, a steel magnate."[144]

On his peregrinations, at a late hour, the man of the crowd winds up in a department store where there still are many customers. He moves about like someone who knows his way around the place. Were there multi-level department stores in Poe's day? No matter; Poe lets the restless man spend an "hour and a half, or thereabouts" in this bazaar. "He entered shop after shop, priced nothing, spoke no word, and looked at all objects with a wild and vacant stare." If the arcade is the classical form of the *intérieur*—and this is the way the street presents itself to the flâneur—the department store is the form of the *intérieur*'s decay. The department store is the last promenade for the flâneur. If in the beginning the street had become an *intérieur* for him, now this *intérieur* turned into a street, and he roamed through the labyrinth of commodities as he had once roamed through the labyrinth of the city. A magnificent touch in Poe's story is that it not only contains the earliest description of the flâneur but also prefigures his end.

Jules Laforgue said that Baudelaire was the first to speak of Paris "as someone condemned to live in the capital day after day."[145] He might have said that Baudelaire was also the first to speak of the opiate that afforded relief to men so condemned, and only to them. The crowd is not only the newest asylum of outlaws; it is also the latest narcotic for people who have been abandoned. The flâneur is someone abandoned in the crowd. He is thus in the same situation as the commodity. He is unaware of this special situation, but this does not diminish its effect on him; it permeates him blissfully, like a narcotic that can compensate him for many humiliations. The intoxication to which the flâneur surrenders is the intoxication of the commodity immersed in a surging stream of customers.

If there were such a thing as a commodity-soul (a notion that Marx occasionally mentions in jest),[146] it would be the most empathetic ever encountered in the realm of souls, for it would be bound to see every individual as a buyer in whose hand and house it wants to nestle. Empathy is the nature of the intoxication to which the flâneur abandons himself in the crowd.

"The poet enjoys the incomparable privilege of being himself and someone else, as he sees fit. Like those roving souls in search of a body, he enters another person whenever he wishes. For him alone, all is open; and if certain places seem closed to him, it is because in his view they are not worth visiting."[147] The commodity itself is the speaker here. Yes, the last words give a rather accurate idea of what the commodity whispers to a poor wretch who passes a shopwindow containing beautiful and expensive things. These objects are not interested in this person; they do not empathize with him. In the important prose poem "Les Foules," we hear the voice—speaking in different words—of the fetish itself, which Baudelaire's sensitive disposition resonated with so powerfully: that empathy with inorganic things which was one of his sources of inspiration.[148]

Baudelaire was a connoisseur of narcotics, yet one of their most important social effects probably escaped him. It consists in the charm displayed by addicts under the influence of drugs. Commodities derive the same effect from the crowd that surges around and intoxicates them. The concentration of customers which makes up the market, which in turn makes the commodity a commodity, enhances its attractiveness to the average buyer. When Baudelaire speaks of "the religious intoxication of great cities,"[149] the commodity is probably the unnamed subject of this state. And the "holy prostitution of the soul," next to which "what people call love is quite small, quite limited, and quite feeble,"[150] really can be nothing other than the prostitution of the commodity's soul—if the comparison with love retains its meaning. Baudelaire speaks of "cette sainte prostitution de l'âme qui se donne tout entière, poésie et charité, à l'imprévu qui se montre, à l'inconnu qui passe."[151] It is this very *poésie* and this very *charité* which prostitutes claim for themselves. They tried the secrets of the free market; in this respect, commodities had no advantage over them. Some of the commodity's charms were based on the market, and each of these turned into a means of power. As such, they were noted by Baudelaire in his "Crépuscule du soir":

A travers les lueurs que tourmente le vent
La Prostitution s'allume dans les rues;
Comme une fourmilière elle ouvre ses issues;
Partout elle se fraye un occulte chemin,
Ainsi que l'ennemi qui tente un coup de main;
Elle remue au sein de la cité de fange
Comme un ver qui dérobe à l'Homme ce qu'il mange.[152]

[Through the flickering light tormented by the wind / Prostitution flares up in the streets; / Like an anthill it opens its outlets / Everywhere it follows a devious path / Like an enemy bent on a surprise attack; / It stirs at the heart of the city of mire / Like a worm that takes its food from Man.]

Only the mass of inhabitants permits prostitution to spread over large parts of the city. And only the mass enables the sexual object to become intoxicated with the hundred stimuli which that object produces.

Not everyone found the spectacle offered by the crowds in big-city streets intoxicating. Long before Baudelaire wrote his prose poem "Les Foules," Friedrich Engels had undertaken to describe the bustle in the streets of London.

> A city such as London, where a man might wander for hours at a time without reaching the beginning of the end, without meeting the slightest hint which could lead to the inference that there is open country within reach, is a strange thing. This colossal centralization, this heaping together of two and a half million human beings in one place, has multiplied the power of this two and a half million a hundredfold. . . . But the sacrifices which all this has cost become apparent later. After roaming the streets of the capital for a day or two, making headway with difficulty through the human turmoil and the endless lines of vehicles, after visiting the slums of the metropolis, one realizes for the first time that these Londoners have been forced to sacrifice the best qualities of their human nature, in order to bring about all the marvels of civilization which crowd their city. . . . The very turmoil of the streets has something repulsive about it, something against which human nature rebels. The hundreds of thousands of people from every class and rank crowding past each other—are they not all human beings with the same qualities and powers, and with the same interest in being happy? . . . And still they crowd by one another as though they had nothing in common, nothing to do with one another, and their only agreement is the tacit one that each keep to his own side of the pavement, so as not to delay the opposing stream of the crowd, while no man thinks to honor another with so much as a glance. The brutal indifference, the unfeeling isolation of each within his private concerns, becomes the more repellent and offensive the more these individuals are crowded together in a limited space.[153]

The flâneur only seems to break through this "unfeeling isolation of each within his private concerns," by filling the hollow space created in him by such isolation with the borrowed—and fictitious—isolations of strangers. Next to Engels' lucid description, it sounds obscure when Baudelaire writes: "The pleasure of being in a crowd is a mysterious expression of the enjoyment of the multiplication of number."[154] But this statement becomes clear if one imagines it spoken not only from the viewpoint of a person but also from that of a commodity. To be sure, insofar as a person, as labor power, is a commodity, there is no need for him to identify himself as such. The more conscious he becomes of his mode of existence, the mode imposed on him by the system of production, the more he proletarianizes himself, the more he will be gripped by the chilly breath of the commodity economy, and the less he will feel like empathizing with commodities. But things had not yet reached that point with the class of the petty bourgeoisie to which

Baudelaire belonged. On the scale we are dealing with here, this class was only at the beginning of its decline. Inevitably, many of its members would one day become aware of the commodity nature of their labor power. But this day had not yet come; until then, they were permitted (if one may put it this way) to pass the time. The very fact that their share could, at best, be enjoyment, but never power, made the period which history gave them a space for passing time. Anyone who sets out to while away time seeks enjoyment. It was self-evident, however, that the more this class wanted to have its enjoyment *in* this society, the more limited this enjoyment would be. The enjoyment promised to be less limited if this class found enjoyment *of* this society possible. If it wanted to achieve virtuosity in this kind of enjoyment, it could not spurn empathizing with commodities. It had to enjoy this identification with all the pleasure and uneasiness which derived from a presentiment of its own determination as a class. Finally, it had to approach this determination with a sensitivity that perceives charm even in damaged and decaying goods. Baudelaire, who in a poem to a courtesan called her heart "bruised like a peach, ripe like her body, for the lore of love," possessed that sensitivity. This is what made possible his enjoyment of society as someone who had already half withdrawn from it.

In the attitude of someone who enjoyed in this way, he let the spectacle of the crowd act on him. The deepest fascination of this spectacle lay in the fact that, even as it intoxicated him, it did not blind him to the horrible social reality. He remained conscious of it, though only in the way in which intoxicated people are "still" aware of reality. This is why in Baudelaire the big city almost never finds expression through a direct presentation of its inhabitants. The directness and harshness with which Shelley captured London through the depiction of its people could not benefit Baudelaire's Paris.

> Hell is a city much like London,
> A populous and a smoky city;
> There are all sorts of people undone,
> And there is little or no fun done;
> Small justice shown, and still less pity.[155]

For the flâneur, there is a veil over this picture. This veil is formed by the masses; it billows "in the twisting folds of the old metropolises."[156] Because of it, horrors have an enchanting effect upon him.[157] Only when this veil tears and reveals to the flâneur "one of the populous squares . . . which are empty during street fighting"[158] does he, too, get an undistorted view of the big city.

If any proof were needed of the force with which the experience of the crowd moved Baudelaire, it would be the fact that he undertook to vie with Hugo in this experience. That Hugo's strength lay here, if anywhere, was

evident to Baudelaire. He praises the "caractère poétique . . . interrogatif"[159] of Hugo's work, and says that Hugo not only knows how to reproduce clear things sharply and distinctly but also reproduces with appropriate obscurity what has manifested itself only dimly and indistinctly. One of the three poems in "Tableaux parisiens" which are dedicated to Hugo begins with an invocation of the crowded city: "Teeming city, city full of dreams."[160] Another follows old women in the "teeming tableau"[161] of the city, as they move through the crowd.[162] The crowd is a new subject in lyric poetry. Someone once remarked that "the crowd was unbearable" for the innovator Sainte-Beuve, and this was said appreciatively, as something fitting and proper for a poet.[163] During his exile in Jersey, Hugo opened this subject up for poetry. On his walks along the coast, the topic took shape for him, thanks to one of the extreme antitheses that were necessary for his inspiration. In Hugo, the crowd enters literature as an object of contemplation. The surging ocean is its model, and the thinker who reflects on this eternal spectacle is the true explorer of the crowd, in which he loses himself as he loses himself in the roaring of the sea. "As the exile on his lonely cliff looks out toward the great nations destined for momentous things, he looks down into the past of their peoples. . . . He carries himself and his destiny into the fullness of events; they become alive in him and blend with the life of the natural forces—with the sea, the crumbling rocks, the shifting clouds, and the other exalted things that are part of a lonely, quiet life in communion with nature."[164] "L'océan même s'est ennuyé de lui,"[165] said Baudelaire about Hugo, touching the man brooding on the cliffs with the light-pencil of his irony. Baudelaire did not feel inclined to follow the spectacle of nature. His experience of the crowd bore the traces of the "heartache and the thousand natural shocks" which a pedestrian suffers in the bustle of a city and which keep his self-awareness all the more alert. (Basically it is this very self-awareness that he lends to the strolling commodity.) For Baudelaire, the crowd never was a stimulus to casting the plumb-line of his thought into the depths of the world. Hugo, on the other hand, writes, "Les profondeurs sont des multitudes,"[166] and thereby gives enormous scope to his thinking. The natural supernatural which affected Hugo in the form of the crowd shows itself in the forest, in the animal kingdom, and by the surging sea; in any of these places, the physiognomy of a big city can flash up for a few moments. "La Pente de la rêverie" gives a splendid idea of the promiscuity at work among the multitude of living things.

La nuit avec la foule, en ce rêve hideux,
Venait, s'épaississant ensemble toutes deux,
Et, dans ces régions que nul regard ne sonde,
Plus l'homme était nombreux,
 plus l'ombre était profonde.[167]

[In that hideous dream, night together with the crowd / Arrived, both growing ever thicker; / And in those regions which no gaze can fathom, / The more numerous were the people, / the deeper was the darkness.]

And:

Foule sans nom! chaos! des voix, des yeux, des pas.
Ceux qu'on n'a jamais vu, ceux qu'on ne connaît pas.
Tous les vivants!—cités bourdonnantes aux oreilles
Plus qu'un bois d'Amérique ou une ruche d'abeilles.[168]

[Nameless mob! chaos! voices, eyes, footsteps. / Those one has never seen, those one does not know. / All the living!—cities buzzing in our ears / Louder than an American forest or a hive full of bees.]

With the crowd, nature exercises its fundamental rights over the city. But it is not nature alone which exercises its rights in this way. There is an astonishing place in *Les Misérables* where the web of the woods appears as the archetype of mass existence. "What had happened on this street would not have astonished a forest. The tree trunks and the underbrush, the weeds, the inextricably entwined branches, and the tall grasses lead an obscure kind of existence. Invisible things flit through the teeming immensity. What is below human beings perceives, through a fog, that which is above them."[169] This description contains the characteristics of Hugo's experience with the crowd. In the crowd, that which is below a person comes in contact with what holds sway above him. This promiscuity encompasses all others. In Hugo, the crowd appears as a bastard form which shapeless, superhuman powers create from those creatures that are below human beings. In the visionary strain that runs through Hugo's conception of the crowd, social reality gets its due more than it does in the "realistic" treatment which he gave the crowd in politics. For the crowd really is a spectacle of nature—if one may apply this term to social conditions. A street, a conflagration, or a traffic accident assembles people who are not defined along class lines. They present themselves as concrete gatherings, but socially they remain abstract—namely, in their isolated private concerns. Their models are the customers who, each acting in his private interest, gather at the market around their "common cause." In many cases, such gatherings have only a statistical existence. This existence conceals the really monstrous thing about them: that the concentration of private persons as such is an accident resulting from their private concerns. But if these concentrations become evident—and totalitarian states see to this by making the concentration of their citizens permanent and obligatory for all their purposes—their hybrid character is clearly manifest, particularly to those who are involved. They rationalize the accident of the market economy

which brings them together in this way as "fate" in which "the race" is re-united. In doing so, they give free rein to both the herd instinct and to reflective action. The peoples who are in the foreground of the western European stage make the acquaintance of the supernatural which confronted Hugo in the crowd. Hugo, to be sure, was unable to assess the historical significance of this force. But it left its imprint on his work as a strange distortion: a set of spiritualistic protocols.

Hugo's contact with the spirit world—which, as we know, profoundly affected both his life and his writing on the Isle of Jersey—was, strange though this may seem, primarily a contact with the masses, which the poet necessarily missed in exile. For the crowd is the spirit world's mode of existence. Thus, Hugo saw himself primarily as a genius in a great assembly of geniuses who were his ancestors. In his *William Shakespeare,* he devoted one rhapsodic page after another to the procession of those aristocrats of the intellect, beginning with Moses and ending with Hugo. But they constitute only a small group in the tremendous multitude of the departed. To Hugo's chthonian mind, the *ad plures ire*[170] of the Romans was not an empty phrase.—In his last séance, the spirits of the dead came late, as messengers of the night. Hugo's Jersey notes have preserved their messages:

> Every great man works on two works: the work he creates as a living person and his spirit-work. A living man devotes himself to the first work. But in the deep still of the night, the spirit-creator—oh, horror!—awakens in him. "What?!" cries the person. "Isn't that all?" "No," replies the spirit. "Arise." The storm is raging, dogs and foxes are howling, darkness is everywhere, nature shudders and winces under the whip of God. . . . The spirit-creator sees the phantom idea. The words bristle and the sentence shudders . . . The window-panes get fogged and dull, the lamp is seized with fear. . . . Watch out, living person, man of a century, you vassal of an idea that comes from the earth. For this is madness, this is the grave, this is infinity, this is a phantom idea.[171]

The cosmic shudder induced by the experience of the invisible—the shudder that Hugo preserves here—bears no similarity to the naked terror which overcame Baudelaire in his moments of "spleen." Also, Baudelaire mustered little sympathy for Hugo's undertaking. "True civilization," he said, "does not lie in table-turning." But Hugo was not concerned with civilization. He felt truly at home in the spirit world. One could say that it was the cosmic complement of a household that comprised horror as an integral part. His intimate acquaintance with the apparitions removes much of their frightening quality. Such intimacy is not without its labored quality and brings out the threadbare nature of the apparitions. The counterparts of these nocturnal ghosts are the meaningless abstractions—the more or less ingenious embodiments—that are inscribed on the monuments of that period. In the Jersey protocols, "Drama," "Poetry," "Literature," "Thought,"

and many other terms of this type are often heard in conjunction with the voices of chaos.

For Hugo, the immense throngs of the spirit world are—and this may bring the riddle closer to a solution—primarily an audience. The fact that his work absorbed motifs of the talking table is less strange than the fact that he customarily produced it in front of this table. The unstinting acclaim provided by the Beyond while he was in exile gave him a foretaste of the boundless acclaim that would await him at home in his old age. When, on his seventieth birthday, the population of the capital streamed toward his house on the avenue d'Eylau, the image of the wave surging against the cliffs was realized and the message of the spirit world was fulfilled.

In the final analysis, the impenetrable obscurity of mass existence was also the source of Victor Hugo's revolutionary speculations. In *Les Châtiments,* the day of liberation is described as

Le jour où nos pillards, où nos tyrans sans nombre
Comprendront que quelqu'un remue au fond de l'ombre.[172]

[The day when our pillagers, our tyrants without number, / Will understand that there is someone stirring deep in the darkness.]

Could there be a reliable revolutionary judgment in keeping with this view of the suppressed masses, this view based on the crowd? Wasn't this perspective, rather, clear evidence of the limitation of such a judgment, no matter what its origin? On November 25, 1848, in a debate in the Chamber of Deputies, Hugo inveighed against Cavaignac's barbaric suppression of the June revolt.[173] But on June 20, in the discussion of the *ateliers nationaux,* he had said: "The monarchy had its idlers; the republic has its petty thieves."[174] Hugo reflected the superficial views of the day, as well as a blind faith in the future, but he also had a profound vision of the life that was forming in the womb of nature and in the womb of the people. Hugo never succeeded in fashioning a bridge between these two. He saw no need for such a bridge, and this explains the tremendous aspirations and scope of his work, and presumably also the tremendous influence of his oeuvre on his contemporaries. In the chapter of *Les Misérables* entitled "L'Argot," the two conflicting sides of his nature confront each other with impressive harshness. After a bold look into the linguistic workshop of the lower classes, the poet concludes by writing: "Since 1789, the entire nation, as a people, has unfolded in the purified individual. There is no poor man who does not have his rights, and thus his own moment in the limelight. Every poor wretch bears the honor of France inside him. The dignity of each citizen is an inner bulwark. Anyone who is free is conscientious, and everyone who has the vote rules."[175] Victor Hugo saw things the way the experience

gleaned from a successful literary and political career presented them to him. He was the first great writer whose works have collective titles: *Les Misérables, Les Travailleurs de la mer.* To him the crowd meant, almost in the ancient sense, the crowd of his constituents—that is, the masses of his readers and his voters. Hugo was, in a word, no flâneur.

For the crowd that kept company with Hugo, and with which he kept company, there was no Baudelaire. But this crowd did exist for Baudelaire. Every day, the sight of it caused him to plumb the depths of his failure, and this probably was not the least of the reasons he wanted to gaze at it. The desperate pride he thus felt—in bursts, as it were—was fed by the fame of Victor Hugo. But he was probably spurred on even more strongly by Hugo's political creed, the creed of the *citoyen*.[176] The masses of the big city could not disconcert him. He recognized the urban crowds and wanted to be flesh of their flesh. Secularism, Progress, and Democracy were inscribed on the banner which he waved over their heads. This banner transfigured mass existence. It was the canopy over the threshold which separated the individual from the crowd. Baudelaire guarded this threshold, and that differentiated him from Victor Hugo. But he resembled him too, since he, like Hugo, failed to see through the social semblance [*Schein*] which is precipitated in the crowd. He therefore placed it in opposition to a model which was as uncritical as Hugo's conception of the crowd. This model was the hero. While Victor Hugo was celebrating the crowd as the hero of a modern epic, Baudelaire was seeking a refuge for the hero among the masses of the big city. Hugo placed himself in the crowd as a *citoyen;* Baudelaire divorced himself from the crowd as a hero.

III. MODERNITY

Baudelaire patterned his image of the artist after an image of the hero. From the beginning, each is an advocate of the other. In "Salon de 1845" he wrote: "The artist's will must be strongly developed, and always very fruitful, in order to give the stamp of uniqueness even to second-rate works. . . . The viewer enjoys the effort, and his eye drinks the sweat."[177] In his *Conseils aux jeunes littérateurs* of the following year, there is a fine formula in which the "contemplation opiniâtre de l'oeuvre de demain"[178] appears as the guarantee of inspiration. Baudelaire is familiar with the "indolence naturelle des inspirés";[179] Musset—so he says—never understood how much work it takes "to let a work of art emerge from a daydream."[180] He, on the other hand, comes before the public from the outset with his own code, precepts, and taboos. Barrès claimed that he could recognize "in every

little word by Baudelaire a trace of the toil that helped him achieve such great things."[181] "Even in his nervous crises," writes Gourmont, "Baudelaire retains something healthy."[182] The most felicitous formulation is given by the symbolist Gustave Kahn when he says that "with Baudelaire, poetic work resembled physical effort."[183] Proof of this is found in his work—in a metaphor worth closer inspection.

It is the metaphor of the fencer. Baudelaire was fond of using it to present martial elements as artistic elements. When he describes Constantin Guys, whom he admired, he captures him at a moment when everyone else is asleep. How Guys stands there "bent over his table, scrutinizing the sheet of paper just as intently as he does the objects around him by day; how he uses his pencil, his pen, his brush like a rapier, spurts water from his glass to the ceiling and tries his pen on his shirt; how he pursues his work swiftly and intensely, as though afraid that his images might escape him. Thus he is combative, even when alone, and parries his own blows."[184] In the opening stanza of his poem "Le Soleil," Baudelaire portrayed himself in the throes of just such a "fantastic battle," and this is probably the only place in *Les Fleurs du mal* where he is shown at his poetic labors. The duel in which every artist is engaged and in which he "screams with fear before he is vanquished"[185] is framed as an idyll; its violence recedes into the background and its charm is manifest.

> Le long du vieux faubourg, où pendent aux masures
> Les persiennes, abri des secrètes luxures,
> Quand le soleil cruel frappe à traits redoublés
> Sur la ville et les champs, sur les toits et les blés,
> Je vais m'exercer seul à ma fantasque escrime,
> Flairant dans tous les coins les hasards de la rime,
> Trébuchant sur les mots comme sur les pavés,
> Heurtant parfois des vers depuis longtemps rêvés.[186]

[Through decrepit neighborhoods on the outskirts of town, where / Slatted shutters hang at the windows of hovels that shelter secret lusts; / At a time when the cruel sun beats down with redoubled force / On city and countryside, on rooftops and cornfields, / I go out alone to practice my fantastical fencing, / Scenting opportunities for rhyme on every streetcorner, / Stumbling over words as though they were cobblestones, / Sometimes knocking up against verses dreamed long ago.]

To give these prosodic experiences their due in prose as well was one of the intentions Baudelaire had pursued in *Le Spleen de Paris,* his poems in prose. In his dedication of this collection to Arsène Houssaye, the editor-in-chief of *La Presse,* Baudelaire expresses, in addition to this intention, what was really at the bottom of those experiences.[187] "Who among us has not

dreamed, in his ambitious moments, of the miracle of a poetic prose, musical, yet without rhythm and without rhyme, supple and darting enough to adapt to the lyrical stirrings of the soul, the undulations of reverie, and the sudden leaps of consciousness? This obsessive ideal is born, above all, from the experience of giant cities, from the intersecting of their myriad relations."[188]

If one tries to imagine this rhythm and investigate this mode of work, it turns out that Baudelaire's flâneur was not a self-portrait of the poet to the extent that this might be assumed. An important trait of the real-life Baudelaire—that is, of the man committed to his work—has been omitted from this portrayal: his absentmindedness.—In the flâneur, the joy of watching prevails over all. It can concentrate on observation; the result is the amateur detective. Or it can stagnate in the rubbernecker; then the flâneur has turned into a *badaud*.[189] The revealing representations of the big city have come from neither. They are the work of those who have traversed the city absently, as it were, lost in thought or worry. The image of "fantasque escrime" ["fantastical fencing"] does justice to these individuals; Baudelaire is thinking of their condition, which is anything but the condition of the observer. In his book on Dickens, Chesterton has masterfully captured the man who roams the big city lost in thought.[190] Charles Dickens' constant peregrinations began in his childhood. "Whenever he had done drudging, he had no other resource but drifting, and he drifted over half London. He was a dreamy child, thinking mostly of his own dreary prospects. . . . He walked in darkness under the lamps of Holborn, and was crucified at Charing Cross. . . . He did not go in for 'observation,' a priggish habit; he did not look at Charing Cross to improve his mind or count the lamp-posts in Holborn to practise his arithmetic. . . . Dickens did not stamp these places on his mind; he stamped his mind on these places."[191]

In his later years, Baudelaire did not often have the opportunity to stroll through the streets of Paris. His creditors were pursuing him; the symptoms of his illness were becoming more severe; and there was strife between him and his mistress. The shocks that his worries caused him and the myriad ideas with which he parried them were reproduced by Baudelaire the poet in the feints of his prosody. Recognizing the labor that he devoted to his poems under the image of fencing means learning to comprehend them as a continual series of tiny improvisations. The variants of his poems indicate how diligently he was working and how greatly he was concerned with even the most minor of them. The expeditions on which he encountered his poetic "problem children" on the street corners of Paris were not always undertaken voluntarily. In the early years of his life as a man of letters, when he was living at the Hotel Pimodan, his friends had occasion to admire the discretion with which he banned all traces of work from his room, beginning with the top of his desk.[192] In those days, he set out to conquer the

streets—in images. Later, when he abandoned one part of his bourgeois existence after another, the street increasingly became a place of refuge for him. But in flânerie, there was from the outset an awareness of the fragility of this existence. It makes a virtue out of necessity, and in this it displays the structure which is in every way characteristic of Baudelaire's conception of the hero.

The necessity which is here disguised is not only a material one; it concerns poetic production. The stereotypes in Baudelaire's experiences, the lack of mediation among his ideas, and the frozen unrest in his features indicate that he did not possess the reserves which an individual acquires from great knowledge and a comprehensive view of history. "Baudelaire had what is a great defect in a writer, a defect he was unaware of: he was ignorant. What he knew, he knew thoroughly; but he knew little. He remained unacquainted with history, physiology, archaeology, and philosophy. . . . He had little interest in the outside world; he may have been aware of it, but he certainly did not study it."[193] By way of countering this and similar criticisms,[194] one might naturally and legitimately point out that a working poet could find it necessary and useful to keep his distance from the world, and that idiosyncratic elements are essential to all productivity. But there is another side to the situation, one that favors the overtaxing of the productive person in the name of a principle: the principle of "creativity." This overtaxing is all the more dangerous because, even as it flatters the self-esteem of the productive person, it effectively protects the interests of a social order that is hostile to him. The lifestyle of the bohemian has fostered a superstition about creativeness—a superstition Marx countered with an observation that applies equally to intellectual and to manual labor. The opening sentence of his draft of the Gotha program, "Labor is the source of all wealth and all culture," is accompanied by this critical note: "The bourgeois have very good reasons for imputing supernatural creative power to labor, since the fact that labor depends on nature has a direct correlate: a man whose only property is his labor must, in all societies and civilizations, be the slave of other people who have become proprietors of the material working conditions."[195] Baudelaire owned few of the material conditions for intellectual labor. A personal library, an apartment of his own—there was nothing he did not have to do without in the course of his life, which was equally precarious in Paris and outside the city. On December 26, 1853, he wrote to his mother: "I am used to a certain measure of physical suffering. I am adept at making do with two shirts layered under torn trousers and a jacket which lets in the wind, and I am so experienced at using straw or even paper to plug up the holes in my shoes that moral suffering is almost the only kind I perceive as suffering. Yet I must admit that I have reached the point where I don't make any sudden movements or walk a lot, because I fear that I might tear my clothes even more."[196] Among the

experiences which Baudelaire has transfigured in the image of the hero, experiences of this kind were the least equivocal.

Around the same time, the dispossessed person makes another appearance in the guise of the hero, this incarnation an ironic one and in a different place—namely, in the writings of Marx. Marx speaks of the ideas of Napoleon I and says: "The *idées napoléoniennes* culminate in the preponderance of the army. The army was the *point d'honneur* of small-holding farmers who were transformed into heroes." Now, however, under Napoleon III the army "is no longer the flower of farm youth, but is the swamp flower of the peasant *lumpenproletariat*. It consists largely of *remplaçants,* . . . just as the second Bonaparte is himself a *remplaçant,* a substitute for Napoleon."[197] If one turns away from this view and returns to the image of the fencing poet, one will find another image momentarily superimposed upon it: the image of the marauder, the soldier who roams through the countryside.[198] Above all, however, two of Baudelaire's famous lines, with their subtle syncope, resound more distinctly over the socially empty space that Marx mentions. They conclude the second stanza of the third poem of "Les Petites Vieilles." Proust accompanies them with the words "il semble impossible d'aller au-delà."[199]

Ah! que j'en ai suivi, de ces petites vieilles!
Une, entre autres, à l'heure où le soleil tombant
Ensanglante le ciel de blessures vermeilles,
Pensive, s'asseyait à l'écart sur un banc,

Pour entendre un de ces concerts, riches de cuivre,
Dont les soldats parfois inondent nos jardins,
Et qui, dans ces soirs d'or où l'on se sent revivre,
Versent quelque héroïsme au coeur des citadins.[200]

[Ah, how many of those little old women I have followed! / There was one who—at that hour when the setting sun / Bloodies the sky with bright red wounds— / Was sitting alone, pensive, on a park bench,

Listening to the sounds of one of those brass-band concerts / With which soldiers sometimes flood our public gardens, / And which, on those golden evenings when you feel yourself reviving, / Instill a bit of heroism in citizens' hearts.]

The brass bands made up of the sons of impoverished peasants, playing their melodies for the city's poor—these represent the heroism that shyly hides its threadbare quality in the word "quelque" ["a bit of"] and that, in this very gesture, shows itself to be genuine and the only kind that is still produced by this society. In the hearts of its heroes, there is no emotion that

would not also find a place in the hearts of the little people who gather round a military band.

The public gardens—the poem refers to them as "nos jardins"—are those open to city-dwellers whose longing is directed in vain at the large, closed parks. The people that come to these public gardens are not entirely the crowd that swirls about the flâneur. "No matter what party one may belong to," wrote Baudelaire in 1851, "it is impossible not to be gripped by the spectacle of this sickly population, which swallows the dust of the factories, breathes in particles of cotton, and lets its tissues be permeated by white lead, mercury, and all the poisons needed for the production of master-pieces . . . ; the spectacle of this languishing and pining population to whom *the earth owes its wonders, who feel hot, crimson blood coursing through their veins,* and who cast a long, sorrowful look at the sunlight and shadows of the great parks."[201] This population is the background which casts the outlines of the hero into bold relief. Baudelaire supplied his own caption for the image he presents. Beneath it he wrote the words: "La Modernité."

The hero is the true subject of *la modernité.* In other words, it takes a heroic constitution to live modernity. This was Balzac's opinion as well. Balzac and Baudelaire are opposed to Romanticism on this point. They transfigure passions and resolution; the Romantics transfigured renunciation and surrender. But the new way of looking at things is far more variegated and expressed with many more reservations in a poet than in a novelist. Two figures of speech will demonstrate this. Both introduce the reader to the hero in his modern manifestation. In Balzac, the gladiator becomes a *commis voyageur.* The great traveling salesman Gaudissart is getting ready to work the Touraine region. Balzac describes his preparations and interrupts himself to exclaim: "What an athlete! What an arena! And what weapons: he, the world, and his glib tongue!"[202] Baudelaire, on the other hand, recognizes the fencing slave in the proletarian. Of the promises which the wine gives the disinherited, the fifth stanza of the poem "L'Ame du vin" names the following:

> J'allumerai les yeux de ta femme ravie;
> A ton fils je rendrai sa force et ses couleurs
> Et serai pour ce frêle athlète de la vie
> L'huile qui raffermit les muscles des lutteurs.[203]

[I shall brighten your delighted wife's eyes; / To your son I'll restore strength and color, / And for this frail athlete of life be / The oil that fortifies wrestlers' muscles.]

What the wage-earner achieves through his daily labors is no less impressive than what helped a gladiator win applause and fame in ancient times. This image is of the stuff of Baudelaire's best insights; it derives from his re-

flection about his own situation. A passage from the "Salon de 1859" indicates how he wished it to be viewed. "When I hear how a Raphael or a Veronese is glorified with the veiled intention of denigrating what came after them, . . . I ask myself whether an achievement which must be rated *at least* equal to theirs . . . is not infinitely *more meritorious,* because it triumphed in a hostile atmosphere and place."[204]—Baudelaire was fond of contextualizing his theses crassly—placing them in baroque lighting, as it were. It was part of his theoretical *raison d'état* to obscure the connections among them—wherever connections existed. Such obscure passages [*Schattenpartien*] can almost always be illuminated by his letters. Without having to resort to such a procedure, one can see a clear link between the above passage from 1859 and another passage that was written ten years earlier and is particularly strange. The following chain of reflections will reconstruct this link.

The resistance that modernity offers to the natural productive élan of an individual is out of all proportion to his strength. It is understandable if a person becomes exhausted and takes refuge in death. Modernity must stand under the sign of suicide, an act which seals a heroic will that makes no concessions to a mentality inimical toward this will. Such a suicide is not resignation but heroic passion. It is *the* achievement of modernity in the realm of the passions.[205] In this form, as the *passion particulière de la vie moderne,* suicide appears in the classic passage devoted to the theory of the modern. The voluntary suicide of heroes in the ancient world is an exception. "Apart from Heracles on Mount Oeta, Cato of Utica, and Cleopatra, . . . where does one find suicides in ancient accounts?"[206] Not that Baudelaire could find them in modern accounts; the reference to Rousseau and Balzac which follows this sentence is a meager one. But modernity does keep the raw material for such presentations in readiness, and it awaits its master. This raw material has deposited itself in those very strata that have turned out to be the foundation of modernity. The first notes on the theory of the modern were made in 1845. Around that time, the idea of suicide became familiar to the working masses. "People are scrambling for copies of a lithograph depicting an English worker who is taking his life because he despairs of earning a livelihood. One worker even goes to Eugène Sue's apartment and hangs himself there. In his hand is a slip of paper with this note: 'I thought dying would be easier for me if I died under the roof of a man who stands up for us and loves us.'"[207] In 1841 Adolphe Boyer, a printer, published a small book entitled *De l'état des ouvriers et de son amélioration par l'organisation du travail.* Taking a moderate approach, it sought to recruit for the workers' associations the old corporations of itinerant journeymen which stuck to guild practices. His work was unsuccessful. The author took his own life and in an open letter invited his companions in misfortune to follow suit. Someone like Baudelaire could very well have viewed suicide as

the only heroic act still available to the *multitudes maladives* of the cities in reactionary times. Perhaps he saw Rethel's *Dance of Death,* which he greatly admired, as the work of a subtle artist who stood before an easel sketching on a canvas the ways in which suicides died.[208] As to the colors of Rethel's images, fashion offered its palette.

With the July Monarchy, blacks and grays began to predominate in men's clothes. Baudelaire concerned himself with this innovation in "Salon de 1845," his first work. In the conclusion to that piece, he wrote: "More than anyone else, *the* painter, the true painter, will be the man who extracts from present-day life its epic aspects and teaches us in lines and colors to understand how great and poetic we are in our patent-leather shoes and our neckties.—May the real pioneers next year give us the exquisite pleasure of being allowed to celebrate the advent of the *new.*"[209] One year later, he wrote: "Regarding the attire, the covering of the modern hero, . . . does it not have a beauty and a charm of its own? . . . Is this not an attire that is needed by our age, which is suffering, and dressed up to its thin black narrow shoulders in the symbol of constant mourning? The black suit and the frock coat not only have their political beauty as an expression of general equality, but also their poetic beauty as an expression of the public mentality: an immense cortège of undertakers—political undertakers, amorous undertakers, bourgeois undertakers. We are all attendants at some kind of funeral.—The unvarying livery of hopelessness testifies to equality. . . . And don't the folds in the material—those folds that make grimaces and drape themselves around mortified flesh like snakes—have their own secret charm?"[210] These mental images are part of the profound fascination which the *femme passante* dressed in mourning—the passer-by in his sonnet—exerted upon the poet. The text of 1846 concludes as follows: "For the heroes of the *Iliad* cannot hold a candle to you, O Vautrin, O Rastignac, O Birotteau; or to you, O Fontanarès, who did not dare to confess publicly the sorrows you were feeling under the macabre frock coat which seems tightened as if by a cramp, the frock coat which all of us wear; or to you, O Honoré de Balzac, the most heroic, the most singular, the most romantic, and the most poetic of all the characters you have drawn from your fertile bosom."[211]

Fifteen years later, the southern-German Democrat Friedrich Theodor Vischer wrote a critique of men's fashion in which he arrived at insights similar to Baudelaire's.[212] But his work has a different emphasis. What provides a hue for the dusky prospectus of the modern in Baudelaire is a shiny argument of political struggle in Vischer. Contemplating the reaction that had held sway since 1850, Vischer writes: "To show one's true colors is regarded as ridiculous; to be trim is thought to be childish. Then how could clothes keep from becoming colorless, slack, and tight at the same time?"[213] The extremes meet where the matter is expressed metaphorically; Vischer's political critique overlaps with an early image of Baudelaire's. In his sonnet

"The Albatross"—inspired by the overseas trip which, it was hoped, would reform the young poet—Baudelaire recognizes himself in these birds, describing their awkwardness on the deck where the crew has put them:

A peine les ont-ils déposés sur les planches,
Que ces rois de l'azur, maladroits et honteux,
Laissent piteusement leurs grandes ailes blanches
Comme des avirons trainer à côté d'eux.

Ce voyageur ailé, comme il est gauche et veule![214]

[Hardly have they been set down on the planks of the deck—deposed, / These monarchs of the blue—than, awkward and ashamed, / They let their great white wings drag piteously / At their sides, like oars.

This winged voyager—how clumsy and enfeebled he is!]

Vischer writes as follows about the type of man's jacket whose wide sleeves cover the wrists: "Those are not arms any more but the rudiments of wings—stumps of penguin wings and fins of fishes. And the movements of the shapeless appendages when a man walks look like foolish, silly gesticulating, shoving, rowing."[215] The same view of the matter, and the same image.

Baudelaire more clearly defines the face of the modern, without denying the mark of Cain on its brow: "The majority of the writers who have concerned themselves with really modern subjects have contented themselves with the certified, official subjects, with our victories and our political heroism. They do this reluctantly, and only because the government orders them and pays them for it. Yet there are subjects from private life which are heroic in quite another way. The spectacle of elegant life and of the thousands of marginal existences eked out in the basements of a big city by criminals and kept women: *La Gazette des Tribunaux* and *Le Moniteur* demonstrate that we need only open our eyes to recognize our heroism."[216] The image of the hero here includes the apache. He represents the characteristics which Bounoure sees in Baudelaire's solitude—"a *noli me tangere,* an encapsulation of the individual in his difference."[217] The apache abjures virtue and laws; he terminates the *contrat social* forever. Thus, he sees himself as a world away from the bourgeois and fails to recognize in him the features of the philistine accomplice which Hugo was soon to describe with such powerful effect in *Les Châtiments.* Baudelaire's illusions, to be sure, were destined to have far greater staying power. They engendered the poetry of apachedom and contributed to a genre which has lasted more than eighty years. Baudelaire was the first to tap this vein. Poe's hero is not the criminal but the detective. Balzac, for his part, knows only the great outsiders of so-

ciety. Vautrin experiences a rise and a fall; he has a career, just as all of Balzac's heroes do. A criminal career is a career like any other. Ferragus, too, has big ideas and makes long-range plans; he is a Carbonari type.[218] Before Baudelaire, the apache, who lived out his life within the precincts of society and of the big city, had had no place in literature. The most striking depiction of this subject in *Les Fleurs du mal,* "Le Vin de l'assassin," inaugurated a Parisian genre. The café known as Le Chat Noir became its "artistic headquarters." "Passant, sois moderne!" was the inscription it bore during its early, heroic period.[219]

The poets find the refuse of society on their streets and derive their heroic subject from this very refuse. This means that a common type is, as it were, superimposed upon their illustrious type. This new type is permeated by the features of the ragpicker, who made frequent appearances in Baudelaire's work. One year before Baudelaire wrote "Le Vin des chiffonniers," he published a prose description of the figure: "Here we have a man whose job it is to gather the day's refuse in the capital. Everything that the big city has thrown away, everything it has lost, everything it has scorned, everything it has crushed underfoot he catalogues and collects. He collates the annals of intemperance, the capharnaum of waste. He sorts things out and selects judiciously; he collects, like a miser guarding a treasure, refuse which will assume the shape of useful or gratifying objects between the jaws of the goddess of Industry."[220] This description is one extended metaphor for the poetic method, as Baudelaire practiced it. Ragpicker and poet: both are concerned with refuse, and both go about their solitary business while other citizens are sleeping; they even move in the same way. Nadar speaks of Baudelaire's "pas saccadé.".[221] This is the gait of the poet who roams the city in search of rhyme-booty; it is also the gait of the ragpicker, who is obliged to come to a halt every few moments to gather up the refuse he encounters. There is much evidence indicating that Baudelaire secretly wished to develop this analogy. It contains a prophecy in any case. Sixty years later a brother of the poet—a kinsman who has deteriorated into a ragpicker—appears in Apollinaire. His name is Croniamantal, the *poète assassiné,* the first victim of the pogrom that is aimed at annihilating the entire race of lyric poets from the world.[222]

The poetry of apachedom appears in an uncertain light. Do the dregs of society supply the heroes of the big city? Or is the hero the poet who fashions his work from such material?[223]—The theory of the modern admits both. But in a late poem, "Les Plaintes d'un Icare," the aging Baudelaire indicates that he no longer relates to the kind of people among whom he sought heroes in his youth.

Les amants des prostituées
Sont heureux, dispos et repus;

Quant à moi, mes bras sont rompus
Pour avoir étreint des nuées.[224]

[Lovers of whores / Are happy—fit and satisfied; / As for me, my arms are broken / from having clasped the clouds.]

The poet, who, as the poem's title indicates, is a stand-in for the hero of ancient times, has had to give way to the modern hero whose deeds are reported by *La Gazette des Tribunaux*.[225] In truth, this abstinence is already inherent in the concept of the modern hero. He is destined for doom, and no tragic poet need come forward to explain the conditions for this downfall. But once modernity has received its due, its time will have run out. Then it will be put to the test. After its end, it will be seen whether it itself will ever be able to become antiquity.

Baudelaire always remained aware of this question. He took the ancient claim to immortality as his claim to being read as an ancient writer someday. "That all modernity is really worthy of becoming antiquity someday"[226]—to him, this defined the artistic mission generally. In Baudelaire, Gustave Kahn very aptly noticed a "refus de l'occasion, tendu par la nature du prétexte lyrique."[227] What made him indifferent toward opportunities and occasions was his awareness of that mission. In the period in which he lived, nothing came closer to the "task" of the ancient hero—to the "labors" of a Hercules—than the task imposed upon him as his very own: to give shape to modernity.

Among all the relations that have involved modernity, its relation to classical antiquity stands out. Baudelaire thought this was clearly apparent in the works of Victor Hugo: "Fate led him . . . to remodel the classical ode and classical tragedy . . . into the poems and dramas he has given us."[228] "Modernity" designates an epoch; it also denotes the energies which are at work in this epoch to bring it close [*anverwandeln*] to antiquity. Baudelaire conceded such energies to Hugo reluctantly and in only a few cases. Wagner, on the other hand, seemed to him an unbounded, unadulterated effusion of this energy. "If in his choice of subjects and his dramatic method Wagner approaches classical antiquity, his passionate power of expression makes him the most important representative of modernity at the present time."[229] This sentence contains Baudelaire's theory of modern art in a nutshell. In his view, antiquity can serve as a model only where construction is concerned; the substance and the inspiration of a work are the concern of modernity. "Woe to him who studies aspects of antiquity other than pure art, logic, or general method! He who becomes excessively absorbed in antiquity . . . forfeits the privileges opportunity offers him."[230] And in the final passage of his essay on Guys, he says: "Everywhere he sought the transitory, fleeting beauty of our present life—the character of what the reader has per-

mitted us to call *modernity*."[231] In summary form, his doctrine reads: "A constant, immutable element . . . and a relative, limited element cooperate to produce beauty. . . . The latter element is supplied by the period, by fashion, by morality, and by the passions. Without this second element, . . . the first would be unassimilable."[232] One cannot say that this is a profound analysis.

In Baudelaire's view of modernity, the theory of modern art is the weakest point. His general view brings out the modern themes; his theory of art should probably have concerned itself with classical art, but Baudelaire never attempted anything of the kind. His theory did not come to grips with the renunciation which, in his work, appears as a loss of nature and naïveté. Its dependence on Poe—right down to its formulation—is one mark of its limitations. Its polemical orientation is another; it stands out against the gray background of historicism, against the academic Alexandrism which was favored by Villemain and Cousin.[233] None of their aesthetic reflections showed modernity in its interpenetration with classical antiquity—something that occurs in certain poems of *Les Fleurs du mal*.

Among these, "Le Cygne" is paramount. It is no accident that this poem is allegorical. The ever-changing city grows rigid. It becomes as brittle as glass—and as transparent, insofar as its meaning is concerned. "La forme d'une ville / Change plus vite, hélas! que le coeur d'un mortel."[234] The condition of Paris is fragile; it is surrounded by symbols of fragility—living creatures (the black woman and the swan) and historical figures (Andromache, "widow of Hector and wife of Helenus"). What they share are mourning for what was and lack of hope for what is to come. In the final analysis, this decrepitude constitutes the closest link between modernity and antiquity. Wherever Paris appears in *Les Fleurs du mal*, it gives evidence of this decrepitude. "Le Crépuscule du matin" consists of the sobs of an awakening person as these are reproduced through the material of a city. "Le Soleil" shows the city threadbare, like a bit of worn fabric in the sunlight. The old man who resignedly reaches for his tools day after day because even in his old age he has not been freed from want is an allegory of the city; and among its inhabitants, old women—"Les Petites Vieilles"—are the only spiritualized ones. That these poems have traveled through the decades unchallenged is the result of a certain reservation which protects them. It is a reservation about the big city, and it distinguishes these poems from almost all later big-city poetry. A stanza by Verhaeren suffices for us to understand what is involved here.

> Et qu'importent les maux et les heures démentes
> Et les cuves de vice où la cité fermente
> Si quelque jour, du fond des brouillards et des voiles
> Surgit un nouveau Christ, en lumière sculpté

Qui soulève vers lui l'humanité
Et la baptise au feu de nouvelles étoiles.[235]

[And of what consequence are the evils and the lunatic hours / And the vats of vice in which the city ferments, / If someday a new Christ, sculpted of light, / Arises from the fog and the veils, / Lifts humanity toward himself, / And baptizes it by the fire of new stars?]

Baudelaire knows no such perspectives. His idea of the decrepitude of the big city is the basis for the permanence of the poems he has written about Paris.

The poem "Le Cygne," too, is dedicated to Hugo, one of the few men whose work, it seemed to Baudelaire, produced a new antiquity. To the extent that one can speak of a source of inspiration in Hugo's case, it was fundamentally different from Baudelaire's. Hugo did not have the capacity to become rigid which—if a biological term may be used—manifests itself a hundredfold in Baudelaire's writings as a kind of mimesis of death. On the other hand, one could speak of Hugo's chthonian bent. Although it is not specifically mentioned, it is brought out in the following remarks by Charles Péguy, which reveal where the difference between Hugo's and Baudelaire's conceptions of classical antiquity lies. "One thing is certain: when Hugo saw a beggar by the road, he saw him the way he is, really saw him the way he really is, . . . saw him, the ancient beggar, the ancient supplicant, on the ancient road. When he saw the marble inlay of one of our fireplaces or the cemented bricks on one of our modern fireplaces, he saw them as what they are—namely, the stones from the hearth, the stones from the ancient hearth. When he saw the door of a house and the threshold, which is usually a squared stone, he recognized in this squared stone the antique line, the line of the sacred threshold that it is."[236] There is no better commentary on the following passage of *Les Misérables*: "The taverns of the Faubourg Saint-Antoine resembled the taverns of the Aventine, which are built over the sibyl's cave and are connected with sacred inspiration; the tables of these taverns were almost tripods, and Ennius speaks of the sibylline wine that was drunk there."[237] The same way of viewing things engendered the work in which the first image of a "Parisian antiquity" appears: Hugo's poetic cycle "A l'Arc de Triomphe." The glorification of this architectural monument proceeds from the vision of a Paris Campagna, an "immense campagne" in which only three monuments of the vanished city have survived: the Sainte-Chapelle, the Vendôme column, and the Arc de Triomphe. The great significance of this cycle in Hugo's work derives from its role in the genesis of a picture of Paris in the nineteenth century which is modeled upon classical antiquity. Baudelaire undoubtedly knew this cycle, which was written in 1837.

Seven years earlier, in his letters from Paris and France in the year 1830,

the historian Friedrich von Raumer had written: "Yesterday I surveyed the enormous city from the Notre Dame tower. Who built the first house? When will the last one collapse and the ground of Paris look like the ground of Thebes and Babylon?"[238] Hugo has described this soil as it will be one day, when "this bank where the water surges against echoing bridge-arches will have been restored to the murmuring, bending reeds":[239]

> Mais non, tout sera mort. Plus rien dans cette plaine
> Qu'un peuple évanoui dont elle est encore pleine.[240]

> [But no, everything will be dead. Nothing more on this plain / Than a vanished people, with which it is still pregnant.]

One hundred years after Raumer, Léon Daudet took a look at Paris from the church of Sacré-Coeur, another elevated place in the city. In his eyes the history of "modernity" up to that time was mirrored in a frightening contraction:

> From above, one looks down on this agglomeration of palaces, monuments, houses, and barracks, and one gets the feeling that they are destined for catastrophe, or several catastrophes—natural or social. . . . I have spent hours on Fourvières with a view of Lyons, on Notre-Dame de la Garde with a view of Marseilles, on Sacré-Coeur with a view of Paris. . . . What becomes most apparent from these heights is a threat. The agglomerations of human beings are threatening. . . . A man needs work—that is correct. But he has other needs, too. . . . Among his other needs is suicide, something that is inherent in him and in the society which forms him, and it is stronger than his drive for self-preservation. Thus, when one stands on Sacré-Coeur, Fourvières, and Notre-Dame de la Garde and looks down, one is surprised that Paris, Lyons, and Marseilles are still there.[241]

This is the face that the *passion moderne* which Baudelaire recognized in suicide has received in this century.

The city of Paris entered the twentieth century in the form which Haussmann gave it. He revolutionized the physiognomy of the city with the humblest means imaginable: spades, pickaxes, crowbars, and the like. What destruction was caused by even these crude tools! And as the big cities grew, the means of razing them developed in tandem. What visions of the future this evokes!—Haussmann's activity was at its height and entire neighborhoods were being torn down when Maxime Du Camp found himself on the Pont Neuf one afternoon in 1862.[242] He was near an optician's shop, waiting for his eyeglasses.

> The author, who was at the threshold of old age, experienced one of those moments when a man who thinks about his past life finds his own melancholy reflected in everything. The slight deterioration of his eyesight which had been

demonstrated on his visit to the optician reminded him of the law of the inevitable infirmity of all human things. . . . It suddenly occurred to this man—who had traveled widely in the Orient, who was acquainted with the desert sands made of the dust of the dead—that this city, too, the city bustling all around him, would have to die someday, the way so many capitals had died. It occurred to him how extraordinarily interesting an accurate description of Athens at the time of Pericles, Carthage at the time of Barca, Alexandria at the time of the Ptolemies, and Rome at the time of the Caesars would be to us today. . . . In a flash of inspiration, the kind that occasionally furnishes one with an extraordinary subject, he resolved to write the kind of book about Paris that the historians of antiquity had failed to write about their cities. . . . In his mind's eye, he could see the work of his mature old age.[243]

In Hugo's sequence "A l'Arc de Triomphe" and in Du Camp's great portrait of his city from the administrative point of view, one discerns the same inspiration that became decisive for Baudelaire's idea of modernity.

Haussmann set to work in 1859. His project had long been regarded as necessary, and the way for it had been prepared by legislation. "After 1848," wrote Du Camp in the above-mentioned book, "Paris was on the verge of becoming uninhabitable. The constant expansion of the railway network . . . brought increases in traffic and in the city's population. The people were choking in the narrow, dirty, convoluted old streets, where they remained packed in because there was no alternative."[244] At the beginning of the 1850s, the population of Paris began to get used to the idea that a great face-cleaning of the city was inevitable. In its incubation period, this cleanup could presumably have had at least as great an effect on a fertile imagination as the work of urban renewal itself. "Les poètes sont plus inspirés par les images que par la présence même des objets," said Joubert.[245] The same is true of artists. When one knows that something will soon be removed from one's gaze, that thing becomes an image. Presumably this is what happened to the streets of Paris at that time. In any case, the work that undoubtedly had the closest subterranean connection to the great transformation of Paris was finished a few years before this urban renewal began. The work was Meryon's sequence of engraved views of Paris.[246] No one was more impressed with them than Baudelaire. To him, the archaeological view of future catastrophe, the basis of Hugo's dreams, was not the really moving one. He envisioned antiquity as springing suddenly from an intact modernity, like an Athena from the head of an unharmed Zeus. Meryon brought out the ancient face of the city without abandoning a single cobblestone. It was this view of the matter that Baudelaire had unceasingly pursued in the idea of la modernité. He was a passionate admirer of Meryon.

The two men had an elective affinity to each other. They were born in the same year, and their deaths occurred only months apart. Both died lonely

and deeply disturbed—Meryon as a deranged patient at Charenton, Baudelaire speechless in a private clinic. Both were late in achieving fame.[247] Baudelaire was virtually the only person who championed Meryon in the latter's lifetime. Few of his prose works are as fine as his short piece on Meryon. In its treatment of Meryon it pays homage to modernity, but it also pays homage to aspects of antiquity in modernity. For in Meryon, too, there is an interpenetration of classical antiquity and modernity, and in him, too, the form of this superimposition—allegory—appears unmistakably. The captions under his etchings are significant. If the texts are touched by madness, their obscurity only underlines their "meaning." As an interpretation, Meryon's lines under his view of the Pont Neuf are, despite their sophistry, closely related to the "Squelette laboureur":

Ci-gît du vieux Pont-Neuf
L'exacte ressemblance
Tout radoubé de neuf
Par récente ordonnance.
O savants médecins,
Habiles chirurgiens,
De nous pourquoi ne faire
Comme du pont de pierre.[248]

[Here lies the old Pont Neuf's / Exact likeness, / All newly refurbished / In accord with a recent ordinance. / O learned physicians / And skillful surgeons, why not do with us / As was done with this stone bridge.]

Geffroy sees the uniqueness of these pictures in the fact "that, although they are made directly from life, they give an impression of expired life, something that is dead or on the verge of dying."[249] He thus shows that he understands the essence of Meryon's work, as well as its relationship to Baudelaire, and he is particularly aware of the faithfulness with which Meryon reproduces Paris—a city that was soon to be pocked with mounds of rubble. Baudelaire's Meryon essay contains a subtle reference to the significance of this Parisian antiquity. "Seldom has the natural solemnity of a great city been depicted with more poetic power: the majesty of the piles of stone; those spires pointing their fingers at the sky; the obelisks of industry vomiting their legions of smoke against the heavens;[250] the enormous scaffolds encircling monuments under repair, pressing the paradoxical beauty of their spider-web tracery against the monuments' solid bodies; the steamy sky, pregnant with rage and heavy with rancor; and the wide vistas whose poetry resides in the dramas that one imparts to them in one's imagination—none of the complex elements that compose the painful and glorious décor of civilization has been forgotten."[251] Among the plans whose failure one can mourn like a loss is that of the publisher Delâtre, who

wanted to issue Meryon's series with texts by Baudelaire. That these texts were never written was the fault of the artist: he was unable to conceive of Baudelaire's task as anything other than an inventory of the houses and streets he had depicted. If Baudelaire had undertaken that project, Proust's remark about "the role of ancient cities in the work of Baudelaire and the scarlet color they occasionally give it"[252] would make more sense than it does today. Among these cities, Rome was paramount for him. In a letter to Leconte de Lisle, he confesses his "natural predilection" for that city.[253] This attraction was probably inspired by Piranesi's *Vedute,* in which the unrestored ruins and the new city still appear as an integrated whole.[254]

The thirty-ninth poem of *Les Fleurs du mal*—a sonnet—begins as follows:

Je te donne ces vers afin que si mon nom
Aborde heureusement aux époques lointaines,
Et fait rêver un soir les cervelles humaines,
Vaisseau favorisé par un grand aquilon,

Ta mémoire, pareille aux fables incertaines,
Fatigue le lecteur ainsi qu'un tympanon.[255]

[I give you these verses so that, if my name / Should arrive safely on the shores of a far-distant future / And set men's minds to dreaming after dark— / Vessel favored by a good north wind—

Then the memory of you, like some old tale that won't come clear, / Will nag at the reader's spirits as might the song of a dulcimer.]

Baudelaire wanted to be read like a classical poet. With astonishing speed his claim was made good, for the distant future, that of the "époques lointaines" mentioned in the sonnet, has arrived—mere decades after his death, though he may have envisioned as many centuries elapsing. To be sure, Paris is still standing and the great tendencies of social development are still the same. But the more constant they have remained, the more everything that stood under the sign of the "truly new" has been rendered obsolete by the experience of them. Modernity has changed most of all, and the antiquity it was supposed to contain really presents a picture of the obsolete. "Herculaneum is found again under the ashes—yet a few years are enough to bury the mores of a society more effectively than all the dust of the volcanoes."[256]

Baudelaire's antiquity is Roman antiquity. In only one place does Greek antiquity extend into his world: Greece supplies him with the image of the heroine which seemed to him worthy and capable of being carried over into modern times. In one of the greatest and most famous poems of *Les Fleurs du mal,* the women bear Greek names, Delphine and Hippolyte. The poem

is devoted to lesbian love. The lesbian is the heroine of *la modernité*. In her, one of Baudelaire's erotic ideals—the woman who signifies hardness and virility—has combined with a historical ideal, that of greatness in the ancient world. This makes the position of the lesbian in *Les Fleurs du mal* unmistakable. It explains why Baudelaire long considered using the title "Les Lesbiennes." Incidentally, he was by no means the first to bring the lesbian into art. Balzac had already done this in his *Fille aux yeux d'or,* and so had Gautier in *Mademoiselle de Maupin* and Delatouche in *Fragoletta.* Baudelaire also encountered her in the work of Delacroix; in a critique of Delacroix's paintings, he speaks, somewhat elliptically, of "the modern woman in her heroic manifestation, in the sense of infernal or divine."[257]

The motif is found in Saint-Simonianism, which in its cultic imaginings often used the idea of the androgyne. One of these is the temple that was to be a showpiece of Duveyrier's "New City."[258] A disciple of the school wrote about it as follows: "The temple must represent an androgyne, a man and a woman. . . . The same division must be planned for the entire city—indeed, for the entire kingdom and the whole earth. There will be a hemisphere of man and a hemisphere of woman."[259] So far as its anthropological content is concerned, the Saint-Simonian utopia is more comprehensible in the ideas of Claire Démar than in this structure, which was never built. Over the grandiloquent fantasies of Enfantin, Claire Démar has been forgotten.[260] Yet the manifesto that she left behind is closer to the essence of Saint-Simonian theory—the hypostatization of industry as the force that moves the world—than is Enfantin's mother-myth. Her text is likewise concerned with the mother, but in a sense substantially different from those who set out from France to seek "the Mother" in the Orient. In the widely ramified literature of those days which deals with the future of women, Démar's manifesto is unique in its power and passion. It appeared under the title *Ma loi d'avenir.* In the concluding section, she writes: "No more motherhood! No law of the blood. I say: no more motherhood. Once a woman has been freed from men who pay her the price of her body, . . . she will owe her existence . . . only to her own creativity. To this end, she must devote herself to a task and fulfill a function. . . . So you will have to resolve to take a newborn child from the breast of its natural mother and place it in the hands of a social mother, a nurse employed by the state. In this way, the child will be brought up more effectively. . . . Only then and not earlier will men, women, and children be freed from the law of blood, the law of mankind's self-exploitation."[261]

Here the image of the heroic woman—an image that Baudelaire absorbed—is seen in its original version. Its lesbian variant was not the work of writers but a product of the Saint-Simonian circle. Whatever documentation is involved here surely was not in the best of hands with the chroniclers of this school. Yet we do have the following peculiar confession by a

woman who was an adherent of Saint-Simon's doctrine: "I began to love my fellow woman as much as I loved my fellow man. . . . I conceded the physical strength of men, as well as the kind of intelligence that is peculiar to them, but I placed alongside men's qualities, as their equal, the physical beauty of women and the intellectual gifts peculiar to them."[262] A surprising critical reflection by Baudelaire sounds like an echo of this confession. It deals with Flaubert's first heroine. "In her optimal vigor and her most ambitious goals, as well as in her deepest dreams, Madame Bovary . . . has remained a man. Like Pallas Athena, who sprang from the head of Zeus, this strange androgyne has been given all the seductive power of a masculine spirit in an enchanting woman's body."[263] And about the author himself, he writes: "All *intellectual* women will be grateful to him for having raised the 'little woman' to such a high level . . . and for endowing her with the dual nature that makes up a perfect human being: a nature that is as capable of calculation as of dreaming."[264] With the kind of *coup de main* that was typical of him, Baudelaire raises Flaubert's petty-bourgeois wife to the status of a heroine.

There are a number of important and even obvious facts about Baudelaire's work that have gone unnoticed. Among them is the antithetical relation between the two lesbian poems that appear one after the other in the sequence titled "Les Epaves." "Lesbos" is a hymn to lesbian love; "Femmes damnées: Delphine et Hippolyte," on the other hand, is a condemnation of this passion, whatever the nature of the compassion that infuses the reproach.

> Que nous veulent les lois du juste et de l'injuste?
> Vierges au coeur sublime, honneur de l'Archipel,
> Votre religion comme une autre est auguste,
> Et l'amour se rira de l'Enfer et du Ciel![265]

[What do laws of right and wrong have to do with us? / You virgins sublime of heart, who do honor to the Archipelago, / Your religion is venerable as any other, / And love makes sport of Hell as much as Heaven!]

These lines are taken from the first poem. In the second poem Baudelaire says:

> —Descendez, descendez, lamentables victimes,
> Descendez le chemin de l'enfer éternel![266]

[—Descend, descend, lamentable victims, / Follow the pathway to everlasting hell!]

This striking dichotomy may be explained as follows. Just as Baudelaire did not view the lesbian as either a social or a physical problem, he had, as it

were, no attitude toward her in real life. He found room for her within the image of modernity, but did not recognize her in reality. This is why he could say casually: "We have known the female philanthropist who was a writer, . . . the republican poetess, the poetess of the future, be she a Fourierist or a Saint-Simonian.[267] But we have never been able to accustom our eyes . . . to all this solemn and repulsive behavior, . . . these sacrilegious imitations of the masculine spirit."[268] It would be wrong to assume that Baudelaire ever thought of championing lesbians publicly in his writings. This is proved by the proposals he made to his attorney for the latter's plea in the *Fleurs du mal* trial. To him, social ostracism was inseparable from the heroic nature of lesbian passion. "Descendez, descendez, lamentables victimes" were the last words that Baudelaire addressed to lesbians. He abandoned them to their doom, and they could not be saved, because Baudelaire's conception of them comprises elements that are inextricably tangled.

During the nineteenth century, women were for the first time used in large numbers in the production process outside the home. This was done for the most part in a primitive way, by employing them in factories. As a result, masculine traits were bound to appear in these women eventually. These were caused, in particular, by the distorting influence of factory work. Higher forms of production, as well as the political struggle per se, fostered masculine characteristics of a more refined nature. The Vésuviennes movement can perhaps be understood in such a way. It supplied the February Revolution with a corps composed of women. "We call ourselves Vésuviennes," it says in the statutes, "to indicate that a revolutionary volcano is at work in every woman who belongs to our group."[269] Such a change in the feminine habitus brought out tendencies capable of firing Baudelaire's imagination. It would not be surprising if his profound antipathy to pregnancy was a factor here.[270] The masculinization of woman was in keeping with this, so Baudelaire approved of the process. At the same time, however, he sought to free it from economic bondage. Thus, he reached the point where he gave a purely sexual emphasis to this development. What he could not forgive George Sand was, perhaps, that she had desecrated the image of the lesbian through her affair with Musset.[271]

The deterioration of the "realistic" element in Baudelaire's attitude toward lesbians is characteristic of him in other things as well. It struck attentive observers as strange. In 1895, Jules Lemaître wrote:

One confronts a work full of artifice and intentional contradictions. . . . Even as he gives the rawest descriptions of the bleakest details of reality, he indulges in a spiritualism which greatly distracts us from the immediate impression that things make upon us. . . . Baudelaire regards a woman as a slave or animal, but he renders her the same homage as he does the Holy Virgin. . . . He curses "progress," he loathes the century's industrial activity, yet he enjoys the special

flavor that this industrial activity has imparted to contemporary life. . . . What is uniquely Baudelairean, I believe, is the readiness always to unite two opposite modes of reaction . . . One could call these a past mode and a present mode. A masterpiece of the will, . . . the latest innovation in the sphere of emotional life.[272]

To present this attitude as a great achievement of the will accorded with Baudelaire's spirit. But the other side of the coin is a lack of conviction, insight, and steadiness. In all his endeavors, Baudelaire was subject to abrupt, shock-like changes; his vision of another way of living life to extremes was thus all the more alluring. This way becomes apparent in the incantations which emanate from many of his perfect verses; in some of them, it even gives its name.

> Vois sur ces canaux
> Dormir ces vaisseaux
> Dont l'humeur est vagabonde;
> C'est pour assouvir
> Ton moindre désir
> Qu'ils viennent du bout du monde.[273]

[See, on the canals, / Those sleeping ships— / They have a vagabond spirit. / It is to satisfy / Your least desire / That they come from the ends of the earth.]

This famous stanza has a rocking rhythm; its movement seizes the ships which lie moored in the canals. To be rocked between extremes: this is the privilege of ships, and this is what Baudelaire longed for. The ships emerge at the site of the profound, secret, and paradoxical image of his dreams: the vision of being supported and sheltered by greatness. "These beautiful big ships that lie on the still water imperceptibly rocking, these strong ships that look so idle and so nostalgic—are they not asking us in a mute language: When do we set sail for happiness?"[274] The ships combine airy casualness with readiness for the utmost exertion. This gives them a secret significance. There is a special constellation in which greatness and indolence meet in human beings, too. This constellation governed Baudelaire's life. He deciphered it and called it "modernity." When he loses himself in the spectacle of the ships lying at anchor, he does so in order to derive a parable from them. The hero is as strong, as ingenious, as harmonious, and as well-built as those boats. But the high seas beckon to him in vain, for his life is under the sway of an ill star. Modernity turns out to be his doom. There are no provisions for him in it; it has no use for his type. It moors him fast in the secure harbor forever and abandons him to everlasting idleness. Here, in his last incarnation, the hero appears as a dandy. If you encounter one of these figures, who thanks to their strength and composure are perfect in their every gesture, you say to yourself: "Here is perhaps a rich man—but more

certainly a Hercules with no labors to accomplish."[275] The dandy seems to be supported by his greatness. Hence it is understandable that at certain times Baudelaire thought his flânerie was endowed with the same dignity as the exertion of his poetic powers.

To Baudelaire, the dandy appeared to be a descendant of great ancestors. Dandyism, he thought, was "the last gleam of the heroic in times of decadence."[276] It pleased him to discover in Chateaubriand a reference to American Indian dandies—evidence of a past flowering of those tribes.[277] Indeed, the features that combine in the dandy bear a very definite historical stamp. The dandy is a creation of the English, who were leaders in world trade. The trade network that spans the globe was in the hands of the London stock exchange; its meshes were subject to extraordinarily varied, numerous, and unforeseeable tremors. A merchant had to react to these, but he could not publicly display his reactions. The dandies took over the management of the conflicts thus created. They developed the ingenious training necessary to overcome these conflicts. They combined extremely quick reactions with a relaxed, even slack demeanor and facial expression. The tic, which for a time was regarded as fashionable, is, as it were, a clumsy, inferior manifestation of the problem. The following statement is very revealing: "The face of an elegant man must always have something convulsive and distorted about it. Such a grimace can, if one wishes, be ascribed to a natural satanism."[278] This is how the figure of the London dandy appeared in the mind of a Paris boulevardier, and this was its physiognomic reflection in Baudelaire. His love for dandyism was unsuccessful. He did not have the gift of pleasing, which is such an important element in the dandy's art of not pleasing. There were traits inherent in his character that were bound to strike people as strange; turning these traits into mannerisms, he became profoundly lonely, particularly since his inaccessibility increased as he became more isolated.

Unlike Gautier, Baudelaire found nothing to like about the age he lived in, and unlike Leconte de Lisle he was unable to deceive himself about it. He did not have the humanitarian idealism of a Lamartine or a Hugo, and it was not given to him, as it was to Verlaine, to take refuge in religious devotion. Because he did not have any convictions, he assumed ever new forms himself. Flâneur, apache, dandy, and ragpicker were so many roles to him. For the modern hero is no hero; he is a portrayer of heroes. Heroic modernity turns out to be a *Trauerspiel* in which the hero's part is available.[279] Baudelaire indicated this, half-hidden in a *remarque*, in his poem "Les Sept Vieillards."

Un matin, cependant que dans la triste rue
Les maisons, dont la brume allongeait la hauteur,
Simulaient les deux quais d'une rivière accrue,
Et que, décor semblable à l'âme de l'acteur,

Un brouillard sale et jaune inondait tout l'espace,
Je suivais, roidissant mes nerfs comme un héros
Et discutant avec mon âme déjà lasse,
Le faubourg secoué pas les lourds tombereaux.[280]

[One morning, when in the dreary street / The houses, made taller by the mist, / Simulated the two quays of a river in flood, / And when—scenery resembling the actor's soul—

A dirty yellow fog filled all the space, / I took my way—steeling my nerves like a hero / And pursuing a dialogue with my already weary soul— / Through the outlying neighborhoods shaken by the passage of heavy carts.]

The scenery, the actor, and the hero meet in these stanzas in an unmistakable way. Baudelaire's contemporaries did not need the reference. When Courbet was painting Baudelaire, he complained that his subject looked different every day. And Champfleury said that Baudelaire had the ability to change his facial expression like a fugitive from a chain gang.[281] Vallès, in a malicious obituary that displays a fair amount of acuity, called Baudelaire a *cabotin.*[282]

Behind the masks which he used to their fullest extent, the poet in Baudelaire preserved his incognito. He was as circumspect in his work as he was capable of seeming provocative in his personal associations. The incognito was the law of his poetry. His prosody is like the map of a big city in which one can move about inconspicuously, shielded by blocks of houses, gateways, courtyards. On this map, words are given clearly designated positions, just as conspirators are given designated positions before the outbreak of a revolt. Baudelaire conspires with language itself. He calculates its effects step by step. That he always avoided revealing himself to the reader has been emphasized by the most competent observers. Gide noticed a very calculated disharmony between the image and the object.[283] Rivière has emphasized how Baudelaire proceeds from the remote word—how he teaches it to tread softly as he cautiously brings it closer to the object.[284] Lemaître speaks of forms that are designed to check an eruption of passion.[285] And Laforgue focuses on Baudelaire's similes, which, as it were, belie the poet's lyrical façade and get into the text as disturbing intruders. Laforgue quotes "La nuit s'épaississait ainsi qu'une cloison,"[286] and adds: "A wealth of other examples could be found."[287]

The segregation of words into those that seemed suitable for elevated speech and those that were to be excluded from it influenced poetic production generally, and from the beginning applied to tragedy no less than to lyric poetry. In the first decades of the nineteenth century, this convention was in undisputed force. When Lebrun's *Cid* was performed, the word *chambre* evoked mutterings of disapproval.[288] *Othello,* in Alfred de Vigny's translation, failed because of the word *mouchoir*—a term that seemed intol-

erable in a tragedy. Victor Hugo had begun smoothing out, in literature, the difference between words of colloquial language and those of elevated speech. Sainte-Beuve had proceeded in a similar fashion. In his life of Joseph Delorme, he explained: "I have tried to be original in my own way, in a modest, homely way. I called the things of intimate life by their names; but when I did so, a hut was closer to me than a boudoir."[289] Baudelaire transcended both Victor Hugo's linguistic Jacobinism and Sainte-Beuve's bucolic liberties. His images are original because the objects they bring into relation are so humble. He is on the lookout for banal incidents in order to liken them to poetic events. He speaks of "les vagues terreurs de ces affreuses nuits / Qui compriment le coeur comme un papier qu'on froisse."[290] This linguistic gesture, characteristic of the artist in Baudelaire, becomes truly significant only in the allegorist. It gives his type of allegory the disconcerting quality that distinguishes it from the ordinary kind. Lemercier had been the last to populate the Parnassus of the Empire with such ordinary allegories, thus marking the nadir of neoclassical literature.[291] Baudelaire was unconcerned about that. He took up myriad allegories and altered their character fundamentally by virtue of the linguistic context in which he placed them. *Les Fleurs du mal* is the first book of poetry to use not only words of ordinary provenance but words of urban origin as well. Yet Baudelaire by no means avoids locutions which, free from any poetic patina, strike one with the brilliance of their coinage. He uses *quinquet, wagon, omnibus,* and does not shrink from *bilan, réverbère, voirie.* This is the nature of the lyric vocabulary, in which allegory may appear suddenly and without prior preparation. If Baudelaire's linguistic spirit can be perceived anywhere, it is in such abrupt contrasts. Claudel gave it its definitive formulation when he said that Baudelaire combined the style of Racine with the style of a journalist of the Second Empire.[292] Not a word of his vocabulary is intended for allegory from the outset. A word receives this charge in a particular case, depending on what is involved, on which topic is in line to be reconnoitered, besieged, and occupied. For the *coup de main* which Baudelaire calls writing poetry, he takes allegories into his confidence. They alone have been let in on the secret. Wherever one comes across *la Mort* or *le Souvenir, le Repentir* or *le Mal,* one finds a locus of poetic strategy. The lightning-like flashing up of these charges—recognizable by their capitalization—in a text which does not disdain the most banal word betrays Baudelaire's hand. His technique is the technique of the putsch.

A few years after Baudelaire's death, Blanqui crowned his career as a conspirator with a memorable feat. It was after the murder of Victor Noir.[293] Blanqui wished to take an inventory of his troops. He knew only his lieutenants personally, and it is not certain how many of his other men knew him. He communicated with Granger, his adjutant, who made arrangements for a review of the Blanquists.[294] Geffroy has described it as follows:

Blanqui left his house armed, said goodbye to his sisters, and took up his post on the Champs-Elysées. According to his agreement with Granger, the troops serving under the mysterious General Blanqui were to pass in review. He knew his subcommanders, and now he was supposed to see, following each of them, their people march past him in regular formation. It all took place as arranged. Blanqui held his review without anyone's having an inkling of the strange spectacle. The old man stood leaning against a tree among a crowd of people, who were watching just as he was, and paid close attention to his friends; they marched past in columns, approaching silently amid a murmuring that was continually interrupted by shouts.[295]

Baudelaire's poetry has preserved in words the strength that made such a thing possible.

On some occasions, Baudelaire tried to discern the image of the modern hero in the conspirator as well. "No more tragedies!" he wrote in *Le Salut public* during the February days. "No more histories of ancient Rome! Aren't we today greater than Brutus?"[296] "Greater than Brutus" was, to be sure, less than great. For when Napoleon III came to power, Baudelaire did not recognize the Caesar in him. In this, Blanqui was more perceptive than he was. But the differences between them are superficial compared to their profound similarities: their obstinacy and their impatience, the power of their indignation and their hatred, as well as the impotence which was their common lot. In a famous line, Baudelaire lightheartedly bids farewell to "a world in which action is not the sister of dreams."[297] His dream was not as hopeless as it seemed to him. Blanqui's action was the sister of Baudelaire's dream. The two are conjoined. They are the joined hands on the stone under which Napoleon III buried the hopes of the June fighters.

Addenda

Sundering truth from falsehood is the goal of the materialist method, not its point of departure.[298] In other words, its point of departure is the object riddled with error, with *doxa*.[299] The distinctions that form the basis of the materialist method, which is discriminative from the outset, are distinctions within this extremely heterogeneous object; it would be impossible to present this object as too heterogeneous or too uncritical. If the materialist method claimed to approach the matter [*die Sache*] "in truth," it would do nothing but greatly reduce its chances of success. These chances, however, are considerably augmented if the materialist method increasingly abandons such a claim, thus preparing for the insight that "the matter in itself" is not "in truth."

Of course, one is tempted to pursue "the matter in itself." In the case of Baudelaire, it offers itself in profusion. The sources flow as abundantly as one could wish, and where they converge to form the stream of tradition,

they flow along between well-laid-out slopes as far as the eye can reach. Historical materialism is not led astray by this spectacle. It does not seek the image of the clouds in this stream, but neither does it turn away from the stream to drink "from the source" and pursue "the matter itself" behind men's backs. Whose mills does this stream drive? Who is utilizing its power? Who dammed it? These are the questions that historical materialism asks, changing our impressions of the landscape by naming the forces that have been operative in it.

This seems like a complex process, and it is. Isn't there a more direct, more decisive one? Why not simply confront the poet Baudelaire with present-day society and determine what he has to say to this society's progressive cadres by referring to his works—without, to be sure, failing to consider whether he has anything to say to them at all? What contravenes this is precisely that when we read Baudelaire, we are given a course of historical lessons by bourgeois society. These lessons can never be ignored. A critical reading of Baudelaire and a critical revision of these lessons are one and the same thing. For it is an illusion of vulgar Marxism that one can determine the social function of a material or intellectual product without reference to the circumstances and the bearers of its tradition. "The concept of culture—as the embodiment of creations considered independent, if not of the production process in which they originate, then of a production process in which they continue to survive—has a fetishistic quality."[300] The tradition of Baudelaire's works is a very brief one, but it already bears historical scars which cannot but be of interest to critical observers.

Taste

Taste develops when commodity production clearly surpasses any other kind of production. The manufacture of products as commodities for a market ensures that the conditions of their production—not only societal conditions, in the form of exploitation, but technological ones as well—will gradually vanish from the perceived world of the people. The consumer, who is more or less expert when he gives an order to an artisan (in individual cases, he is advised by the master craftsman himself), is not usually knowledgeable when he acts as a buyer. Added to this is the fact that mass production, which aims at turning out inexpensive commodities, must strive to disguise bad quality. In most cases, mass production actually benefits when the buyer has little expertise. The more industry progresses, the more perfect are the imitations it offers on the market. A profane glimmer [*Schein*] makes the commodity phosphorescent; this has nothing in common with the semblance that produces its "theological niceties."[301] Yet it is of some importance to society. On July 17, 1824, in a speech about trademarks, Chaptal said: "Don't tell me that in the final analysis a shopper

will know about the different qualities of a material. No, gentlemen, a consumer is no judge of them; he will go only by the appearance of the commodity. But are looking and touching enough to determine the permanence of colors, the fineness of a material, or the quality and nature of its finish?"[302]

As the expertness of a customer declines, the importance of his taste increases proportionately—both for him and for the manufacturer. For the consumer, it serves as a more or less elaborate masking of his lack of expertness. For the manufacturer, it serves as a fresh stimulus to consumption, which in some cases is satisfied at the expense of other consumer needs that would be more costly for the manufacturer to meet.

It is precisely this development which literature reflects in *l'art pour l'art*.[303] This doctrine and its corresponding practice for the first time give taste a dominant position in poetry. (To be sure, taste does not seem to be the object there; it is not mentioned anywhere. But this is no more significant than the fact that taste was often discussed in the aesthetic debates of the eighteenth century. Actually, these debates centered on content.) In *l'art pour l'art*, the poet for the first time faces language the way the buyer faces the commodity on the open market. To an extreme extent, he has ceased to be familiar with the process of its production. The poets of *l'art pour l'art* are the last poets who can be said to have come "from the people." They have nothing to say with such urgency that it could determine the *coining* of their words. Rather, they are forced to choose their words. The "chosen word" soon became the motto of Jugendstil literature.[304] The poet of *l'art pour l'art* wanted to bring *himself* to language above all else—with all the idiosyncrasies, nuances, and imponderabilities of his nature. These elements are precipitated in taste. The poet's taste guides him in his choice of words. But the choice is made only among words which have not already been stamped by the *matter* itself—that is, which have not been included in its process of production.

Actually, the theory of *l'art pour l'art* assumed decisive importance around 1852, at a time when the bourgeoisie sought to wrest its "cause" from the hands of the writers and the poets. In *The Eighteenth Brumaire*, Marx recollects this moment, when "the extra-parliamentary masses of the bourgeoisie, . . . through the brutal abuse of their own press," called upon Napoleon III "to destroy their speaking and writing segment, their politicians and literati, so that they might confidently pursue their private affairs under the protection of a strong and untrammeled government." At the end of this development, we find Mallarmé and the theory of *la poésie pure*. Here the poet has become so far removed from the cause of his own class that the problem of a literature without an object becomes the center of discussion. This discussion is clearly evident in Mallarmé's poems, which revolve around *blanc, absence, silence, vide*. This, to be sure—particularly in

Mallarmé—is the face of a coin whose obverse is by no means insignificant. It shows that the poet no longer supports any of the causes pursued by the class to which he belongs. To found a production process on such a basic renunciation of all the manifest experiences of this class engenders specific and considerable difficulties—difficulties that make this poetry highly esoteric. Baudelaire's works are not esoteric. The social experiences which are precipitated in his work are, to be sure, nowhere derived from the production process—least of all in its most advanced form, the industrial process; without exception, they all originated in long, roundabout ways. But these roundabout ways are quite apparent in his works. The most important are the experiences of the neurasthenic, of the big-city dweller, and of the retail customer.

Written in the summer and fall of 1938; unpublished in Benjamin's lifetime. *Gesammelte Schriften*, I, 511–604, 1160–61, 1167–69. Translated by Harry Zohn.

Notes

In 1937 Benjamin agreed, at the urging of Max Horkheimer and his associates at the Institute of Social Research, to prepare some part of his work on the Paris arcades for publication. Drawing on the mass of material and ideas he had assembled beginning in the late 1920s, Benjamin set about writing a book-length study of Paris after 1848 organized around the figure of Baudelaire. He produced a detailed outline, which organized excerpts from the Arcades Project under section and chapter headings. The book, which bore the working title *Charles Baudelaire: Ein Lyriker im Zeitalter des Hochkapitalismus* (Charles Baudelaire: A Lyric Poet in the Era of High Capitalism) but which was never completed, would have had three parts: (1) Baudelaire as Allegorist; (2) The Paris of the Second Empire in Baudelaire; (3) The Commodity as Poetic Object. Benjamin completed the second part—the present essay—and submitted it for publication to the *Zeitschrift für Sozialforschung* in 1938.

Benjamin's references to Baudelaire's *Oeuvres* have been fleshed out by the editors with titles of Baudelaire's works.

1. "A capital is not absolutely necessary for man." Etienne Pivert de Senancour (1770–1846), French author, is best known for *Obermann* (1804), a novel that describes the sufferings of a hero who is tormented by a Rousseau-like sensitivity to the inroads of civilization upon human nature.

2. Lucien de La Hodde (1808–1865), French journalist, poet, historian, and police agent. His works include, aside from the eight volumes of memoirs mentioned here (*Histoires des sociétés secrètes et du parti républicain de 1830 à 1848*; 1850), numerous articles in the journals *Charivari* and *La Réforme*, several volumes of poetry, and a history of the Revolution of 1848.

3. Karl Marx and Friedrich Engels, Review of Adolphe Chenu, *Les Conspirateurs* (Paris, 1850), and of Lucien de La Hodde, *La Naissance de la République en février 1848* (Paris, 1850); quoted from *Die neue Zeit*, 4 (1886): 555. Proudhon, who wanted to dissociate himself from the professional conspirators, occasion-

ally called himself a "new man—a man whose style is not the barricades but discussion, a man who could sit at a table with the chief of police every evening and could take all the de La Hoddes of the world into his confidence." Quoted in Gustave Geffroy, *L'Enfermé* (Paris, 1897), pp. 180ff. [Benjamin's note. Pierre-Joseph Proudhon (1809–1865), a political thinker regarded today as the father of anarchism, advocated a localized mutualist world federation to be achieved through economic action rather than violent revolution. He was the author of *Qu'est-ce que la propriété?* (1840) and other works.—*Trans.*]

4. Karl Marx, *Der achtzehnte Brumaire des Louis Bonaparte* [The Eighteenth Brumaire of Louis Bonaparte], ed. David Riazanov (Vienna, 1917), p. 73. [Benjamin's note. Napoleon III (Charles Louis Napoléon Bonaparte; 1808–1873), nephew of Napoleon Bonaparte, was president of the Second Republic from 1850 to 1852 and thereafter emperor of France. His reign combined authoritarianism and economic liberalism; it ended with France's defeat in the Franco–Prussian War of 1870–1871.

 The text by Marx that Benjamin is quoting from throws a revealing light on the subject of the *bohème.* The full passage runs as follows: "Alongside decayed roués with doubtful means of subsistence and of doubtful origin, alongside ruined and adventurous offshoots of the bourgeoisie, were vagabonds, discharged soldiers, discharged jail-birds, escaped galley slaves, swindlers, mountebanks, *lazzaroni* [idlers], pickpockets, tricksters, gamblers, *maquereaux* [pimps], brothel-keepers, porters, literati, organ-grinders, rag-pickers, knife-grinders, tinkers, beggars—in short, the whole indeterminate, disintegrated, fluctuating mass which the French call the *bohème.*" Marx, *The Eighteenth Brumaire of Louis Napoleon,* trans. Joseph Weydemeyer (New York: International Publishers, 1963), section V, paragraph 4.—*Trans.*]

5. Charles Baudelaire, *Oeuvres,* ed. Yves-Gérard Le Dantec, 2 vols., Bibliothèque de la Pléiade, nos. 1 and 7 (Paris, 1931–1932), vol. 2, p. 415: *L'Art romantique,* "Les Drames et les romans honnêtes." [Benjamin's note]

6. The idea that the work of art is autonomous and self-sufficient can be traced back to Kant's emphasis on the "pure" and disinterested existence of the artwork. In France, the phrase *l'art pour l'art* was used by the philosopher Victor Cousin in his 1818 lecture "Du vrai, du beau, et du bien" (On the True, the Beautiful, and the Good), and the idea of "art for art's sake" was taken up by the writers Victor Hugo and Théophile Gautier. It was from Gautier, together with Edgar Allan Poe, that Baudelaire derived his own doctrine of aesthetic experience and the sovereignty of the creative imagination.

7. Jules Lemaître (1853–1914) was a French author and critic whose highly influential evaluations of his contemporaries led to his election to the Académie Française in 1895. In later years he adopted the right-wing stance of the monarchist, anti-Semitic political group Action Française.

8. Marx and Engels, Review of Chenu and of de La Hodde, p. 556. [Benjamin's note]

9. Jacques Aupick (1789–1857), Baudelaire's stepfather, was a career soldier who rose to the rank of general. He later served as French ambassador to the Ottoman Empire and Spain, before becoming a senator under the Second Empire.

 The phrase "February days" refers to the overthrow of Louis Philippe's constitutional monarchy in February 1848 (also known as the February Revolution).

10. Baudelaire, *Oeuvres*, vol. 2, p. 728: "Argument du livre sur la Belgique," last page ("Note detachée"). [Benjamin's note]
11. Baudelaire, *Lettres à sa mère* (Paris: Calmann-Lévy, 1932), p. 83. [Benjamin's note]
12. Victor Hugo (1802–1885), French dramatist, novelist, and poet, was the leading figure among the Romantic writers. Though his novels (such as *Les Misérables*, 1862; and *Notre-Dame de Paris*, 1831) remain his best-known works, his legacy to the nineteenth century was his lyric poetry.
13. Georges-Eugène Sorel (1847–1922), French socialist and revolutionary syndicalist, developed an original and provocative theory on the positive, even creative, role of myth and violence in the historical process. Turning to history and politics rather late in life, he discovered Marxism in 1893. His best-known work, *Réflexions sur la violence* (Reflections on Violence; 1908), exerted an important influence on Benjamin, whose essay of 1921, "Critique of Violence," is in part a response to Sorel. *Culte de la blague* means "cult of the joke." The origin of the phrase is obscure.
14. Baudelaire, *Oeuvres*, vol. 2, p. 666 ("Mon coeur mis à nu"). [Benjamin's note. Céline (pseudonym of Louis-Ferdinand Destouches; 1894–1961), French author best known for the novel *Voyage au bout de la nuit* (Journey to the End of Night; 1932), remained to the end of his life a notorious anti-Semite and nationalist. His *Bagatelles pour un massacre* (Bagatelles for a Massacre), a diatribe that blends anti-Semitism and pacifism, appeared in 1937.—*Trans.*]
15. Raoul Georges Adolphe Rigault (1846–1871), an official in the Paris Commune, was executed following the recapture of the city by government forces. Blanquists were followers of Louis-Auguste Blanqui (1805–1881), French revolutionary socialist and militant anticlerical. Blanqui was active in all three major upheavals in nineteenth-century France—the revolutions of 1830 and 1848 and the Paris Commune of 1871—and was imprisoned following each series of events. Quotations from Blanqui and Benjamin's commentary on him play a key role in *The Arcades Project*.
16. Charles Prolès, *Les hommes de la Révolution de 1871: Raoul Rigault* (Paris, 1898), p. 9. [Benjamin's note. For more on Rigault, see Benjamin, *The Arcades Project*, trans. Howard Eiland and Kevin McLaughlin (Cambridge, Mass.: Harvard University Press, 1999), p. 618 (Convolute V9a,2.)—*Trans.*]
17. Baudelaire, *Lettres à sa mere*, p. 278. [Benjamin's note]
18. Marx and Engels, Review of Chenu and of de La Hodde, p. 556. [Benjamin's note]
19. See Ajasson de Grandsagne and Maurice Plaut, *Révolution de 1830: Plan des combats de Paris aux 27, 28 et 29 juillet* (Paris, n.d.). [Benjamin's note. The July Revolution, directed against the regime of Charles X, led to the accession of Louis Philippe. He was dubbed the Citizen King and his reign became known as the July Monarchy.—*Trans.*]
20. The French phrase means "unpaid but impassioned work." Charles Fourier (1772–1837), French social theorist and reformer, called for a reorganization of society based on communal agrarian associations which he called "phalansteries." In each community, the members would continually change roles within different systems of production. Like Blanqui, Fourier figures crucially in *The Arcades Project* (see Convolute W).

21. Victor Hugo, *Oeuvres complètes: Edition définitive,* novels, vol. 8, *Les Misérables* (Paris, 1881), pp. 522ff. [Benjamin's note]
22. Baudelaire, *Oeuvres,* vol. 1, p. 229. [Benjamin's note. The quotation is line 25 from the poem that begins, "Tranquille comme un sage et doux comme un maudit," and ends, "Tu m'as donné ta boue et j'en ai fait de l'or."—*Trans.*]
23. Quoted in Charles Benoist, "Le 'Mythe' de la classe ouvrière," in *Revue des Deux Mondes,* March 1, 1914, p. 105. [Benjamin's note. "O force, queen of the barricades, you who shine in lightning and in riots, . . . it is toward you that prisoners stretch out their shackled hands." Gustave Tridon (1841–1871) was a French socialist and a supporter of the Republic.—*Trans.*]
24. Adolphe Thiers (1797–1877), historian and journalist, was a leading politician and minister during Louis Philippe's reign (1830–1848). He was an opponent of the Second Empire, and subsequently served as president of France from 1871 to 1873.
25. Georges Laronze, *Histoire de la Commune de 1871* (Paris, 1928), p. 532. [Benjamin's note]
26. On Louis Auguste Blanqui, see note 15 above.
27. Marx, *Der achtzehnte Brumaire des Louis Bonaparte,* p. 28. [Benjamin's note. During the insurrection of June 23–26, 1848, workers in Paris were joined by students and artisans in spontaneous demonstrations against the newly elected conservative majority. The insurgents were suppressed in bloody battles on the barricades.—*Trans.*]
28. Marx and Engels, Review of Chenu and of de La Hodde, p. 556. [Benjamin's note]
29. Report by J.-J. Weiss, quoted in Gustave Geffroy, *L'Enfermé* (Paris, 1897), pp. 346ff. [Benjamin's note. The passage is quoted at greater length in *The Arcades Project,* pp. 616–617 (Convolute V8a).—*Trans.*]
30. Baudelaire appreciated such details. "Why," he wrote, "don't the poor put on gloves when they go begging? They would make a fortune" (*Oeuvres,* vol. 2, p. 424: *L'Art romantique,* "L'Ecole païenne," last page). He attributes this statement to an unnamed person, but it bears the stamp of Baudelaire himself. [Benjamin's note]
31. Marx and Engels, Review of Chenu and of de La Hodde, p. 556. [Benjamin's note]
32. Karl Marx, *Die Klassenkämpfe in Frankreich, 1848 bis 1850* (Berlin, 1895), p. 87. [Benjamin's note]
33. H.-A. Frégier, *Des Classes dangereuses de la population dans les grandes villes et des moyens de les rendre meilleures* (Paris, 1840), vol. 1, p. 86. [Benjamin's note]
34. Edouard Foucaud, *Paris inventeur: Physiologie de l'industrie française* (Paris, 1844), p. 10. [Benjamin's note]
35. Baudelaire, *Oeuvres,* vol. 1, p. 120. [Benjamin's note]
36. This budget is a social document not only because it investigates a particular family but also because it attempts to make abject misery appear less objectionable by neatly arranging it under rubrics. With the intent of leaving no inhumanity undocumented by the law whose observance it indicates, the totalitarian states have fostered the flowering of a seed which, as one may surmise, was already present in an earlier stage of capitalism. The fourth section of this budget

of a ragpicker—cultural needs, entertainment, and hygiene—looks as follows: "Education of the children: tuition (paid by the employer), 48 francs; book purchases, 1.45 francs. Charitable contributions: workers of this class usually make none. Feasts and holidays—meals taken by the entire family at one of the *barrières* of Paris (eight excursions a year): wine, bread, and roast potatoes, 8 francs. Meals consisting of macaroni prepared with butter and cheese, plus wine on Christmas Day, Shrove Tuesday, Easter, and Whitsun: these expenses are given in the first section. Chewing tobacco for the husband (cigar stubs collected by the workingman himself), representing 5 to 34 francs. Snuff for the wife (bought), 18.66 francs. Toys and other presents for the child, 1 franc. Correspondence with relatives: letters from the workingman's brothers who live in Italy, one per year on the average . . ." "Addendum: The family's most important resource in case of accident is private charity. . . ." "Annual savings (the worker makes no provision whatever; he is primarily concerned with giving his wife and his little daughter all the comforts that are compatible with their situation; he amasses no savings, but every day spends whatever he earns)." (Frédéric Le Play, *Les Ouvriers européens* [Paris, 1855], pp. 274ff.) A sarcastic remark by Buret serves to illustrate the spirit of such an investigation: "Since humaneness, even plain decency, forbids one to let human beings die like animals, one cannot deny them the charity of a coffin." (Eugène Buret, *De la misère des classes laborieuses en Angleterre et en France: De la nature de la misère, de son existence, de ses effets, de ses causes, et de l'insuffisance des remèdes qu'on lui a opposés jusqu'ici; avec l'indication des moyens propres à en affranchir les sociétés* [Paris, 1840], vol. 1, p. 266.) [Benjamin's note]

37. It is fascinating to observe how the rebellion gradually comes to the fore in the various versions of the poem's concluding stanzas. In the first version, these read as follows:

> C'est ainsi que le vin règne par ses bienfaits,
> Et chante ses exploits par le gosier de l'homme.
> Grandeur de la bonté de Celui que tout nomme,
> Qui nous avait déjà donné le doux sommeil,
> Et voulut ajouter le Vin, fils du Soleil,
> Pour réchauffer le coeur et calmer la souffrance
> De tous les malheureux qui meurent en silence.
>
> (*Oeuvres*, vol. 1, p. 605)

[Thus, wine reigns by virtue of its benefits / And sings of its exploits through the throats of men. / How great is the kindness of Him whom all things name, / Who had already given us sweet sleep / And who wished to add Wine, the son of the Sun, / To warm the heart and alleviate the suffering / Of all the unfortunates who die in silence.]

The 1852 version reads as follows:

> Pour apaiser le coeur et calmer la souffrance
> De tous ces innocents qui meurent en silence,
> Dieu leur avait déjà donné le doux sommeil;
> Il ajouta le vin, fils sacré du Soleil.
>
> (*Oeuvres*, vol. 1, p. 606)

[To ease the heart and alleviate the suffering / Of all those innocents who die in silence, / God had already given them sweet sleep; / He added wine, sacred son of the Sun.]

The final version of 1857 shows a radical change of meaning, and reads as follows:

Pour noyer la rancoeur et bercer l'indolence
De tous ces vieux maudits qui meurent en silence,
Dieu, touché de remords, avait fait le sommeil;
L'Homme ajouta le Vin, fils sacré du Soleil!

(*Oeuvres*, vol. 1, p. 121)

[To drown the bitterness and lull the indolence / Of all those old wretches who die in silence, / God, in remorse, created sleep; / Man added wine, sacred son of the Sun!]

One may clearly observe how the stanza receives its definite form only as the sense becomes blasphemous. [Benjamin's note]

38. Charles-Augustin Sainte-Beuve, *Les Consolations; Pensées d'août* (Paris, 1863), p. 193. [Benjamin's note. Charles-Augustin Sainte-Beuve (1804–1869), French critic and writer, developed a literary critical method based on insight into psychology and biography. His criticism, which originally appeared in major reviews, is collected in *Causeries du lundi* (15 vols., 1851–1862; translated as *Monday Chats*, 1877). He considered his great work to be *Port-Royal* (1840–1859), a history of Jansenism and, more generally, of France in the seventeenth century. He was elected to the Académie Française in 1844, taught at the Ecole Normale Supérieure from 1857, and became a senator in 1865.—*Trans.*]

39. Baudelaire, *Oeuvres*, vol. 1, p. 136. [Benjamin's note]

40. "History of the Working Classes and the Bourgeois Classes." Adolphe Granier de Cassagnac (1806–1880) was a legislative deputy and semi-autonomous journalist; he was a prominent adherent of conservative Bonapartism in the Second Empire.

41. Marx, *Das Kapital*, ed. Karl Korsch (Berlin, 1932), p. 173. [Benjamin's note. For an English version, see *Capital*, vol. 1 (London, 1967), p. 172.—*Trans.*]

42. The title is followed by a prefatory note which was suppressed in the later editions. This note claims that the poems of the group are a highly literary simulation of "the sophisms of ignorance and anger." In truth, it is not a simulation at all. The public prosecutors of the Second Empire understood this, and so do their successors. Baron Seillière indicates this quite casually in his interpretation of the first poem in the series "Révolte." It is entitled "Le Reniement de Saint Pierre" [The Denial of Saint Peter] and includes the following lines:

Rêvais-tu de ces jours . . .

Où, le coeur tout gonflé d'espoir et de vaillance,
Tu fouettais tous ces vils marchands à tour de bras,
Où tu fus maître enfin? Le remords n'a-t-il pas
Pénétré dans ton flanc plus avant que la lance?

(*Oeuvres*, vol. 1, p. 136)

[Did you dream of those days . . . // When, your heart swelling with hope and cour-
age, / You used to drive out all those abject moneylenders with your blows— / When
you were finally master? Has not remorse / Pierced your side deeper than the spear?]

In this remorse, the ironic interpreter sees self-reproaches for "having missed
such a good opportunity to establish the dictatorship of the proletariat" (Ernest
Seillière, *Baudelaire* [Paris, 1931], p. 193). [Benjamin's note. Compare *The Ar-
cades Project,* Convolute J21,4.—*Trans.*]

43. Baudelaire, *Oeuvres,* vol. 1, p. 138. [Benjamin's note]

44. Jules Lemaître, *Les Contemporains,* 4th series (Paris, 1895), p. 30. [Benjamin's
note]

45. On the June Insurrection of 1848, see note 27 above.

46. *Les Châtiments* (The Chastisements; 1853) consists of a series of satirical po-
ems that Hugo wrote in heated response to the coup d'état of Napoleon III,
whom he saw as the archetypal tyrant.

47. Mimi and Schaunard are two characters in Puccini's opera *La Bohème,* which is
based on Henri Murger's book *Scènes de la vie de Bohème* (1848).

48. Alfred-Victor, comte de Vigny (1797–1863) was a French Romantic poet, dra-
matist, and novelist. He introduced the French to poetry in a Byronic mode and
novels in the style of Walter Scott.

49. See Auguste-Marseille Barthélemy, *Némésis: Satire hebdomadaire* (Paris, 1834),
vol. 1, p. 225 ("L'Archevêché et la bourse"). [Benjamin's note. Auguste-Mar-
seille Barthélemy (1796–1867) was a liberal poet and satirist who wrote in col-
laboration with J. P. A. Méry in opposition to the Bourbons and Louis Philippe.
In 1831 the two poets started *Némésis,* a satirical weekly opposing the new re-
gime. A year later Louis Philippe purchased Barthélemy's silence with a gener-
ous pension. Loosely translated, *Messe des agios* means "Mass of the Profits."
The word "agio," from the Italian, technically refers to the premium (profit)
made from currency exchange and stock speculation.—*Trans.*]

50. Marx, *Der achtzehnte Brumaire des Louis Bonaparte,* p. 124. [Benjamin's note]

51. Pierre-Antoine Dupont (1821–1870) was a popular poet and republican song-
writer whose socialist humanism stopped short of full political opposition. Un-
til 1852 he associated with Hugo, Gautier, and Baudelaire. Baudelaire in partic-
ular praised Dupont's devotion to liberty. After the coup d'état of December 2,
1851, Dupont—who had avoided arrest by leaving for Savoy—was condemned
in absentia to seven years of exile. Impoverished without the support of his Pa-
risian audience, Dupont pledged allegiance to the regime in 1852 and lived qui-
etly thereafter in Paris.

52. Jules-Amédée Barbey d'Aurevilly, *Le XIXe siècle: Les Oeuvres et les hommes,*
1st series, part 3: *Les Poètes* (Paris, 1862), p. 242. [Benjamin's note. Jules-
Amédée Barbey d'Aurevilly (1808–1889), French novelist and critic, was a prin-
cipal arbiter of social fashion and literary taste. His reviews alternated with
those of Saint-Beuve in *Le Constitutionnel,* and on Saint-Beuve's death in 1869
he became sole critic. He was known for his attacks on Zola and the Natural-
ists, and for his defense of Balzac, Stendhal, and Baudelaire.—*Trans.*]

53. Pierre Larousse, *Grand Dictionnaire universel du XIX siècle,* vol. 6 (Paris,
1870), p. 1413 (article on Dupont). [Benjamin's note]

54. Marx, *Dem Andenken der Junikämpfer;* see also D. Riazanov, ed., *Karl Marx als Denker, Mensch und Revolutionär* (Vienna, 1928), p. 40. [Benjamin's note]

55. Pierre Dupont, "Le Chant du vote" (Paris, 1850; unpaginated). [Benjamin's note]

56. Baudelaire, *Oeuvres,* vol. 2, pp. 403ff.: *L'Art romantique,* "Pierre Dupont." [Benjamin's note. The French poet Auguste Barbier (1805–1882), became famous after the Revolution of 1830 for his satirical poems directed against moral decay and the cult of Napoleon. He was elected to the Académie Française in 1869.—*Trans.*]

57. Paul Desjardins, "Charles Baudelaire," in *La Revue Bleue* (Paris, 1887), p. 19. [Benjamin's note]

58. Baudelaire, *Oeuvres,* vol. 2, p. 659: "Mon coeur mis à nu," sect. 59. [Benjamin's note]

59. Ibid., p. 555: *L'Art romantique,* "Pierre Dupont." [Benjamin's note]

60. On the July Revolution (July 27–29, 1830), see note 19 above.

61. Emile de Girardin (1806–1881), French journalist, launched France's first mass-circulation newspaper, *La Presse,* in 1836. *La Presse* brought a number of innovations: it mixed traditional coverage of politics and the arts with elements of fashion, gossip, and scandal, and, above all, introduced the *roman-feuilleton,* the serial novel, which supplied a new mass readership with escapism, adventure, and sentimentality.

62. Sainte-Beuve, "De la littérature industrielle," in *Revue des Deux Mondes* (1839), pp. 682ff. [Benjamin's note]

63. Madame Emile de Girardin (née Delphine Gay), *Oeuvres complètes,* vol. 4: *Lettres parisiennes, 1836–1840* (Paris, 1860), pp. 289ff. [Benjamin's note. Madame de Girardin (1804–1855) published novels, comedies, and verse under the pseudonym Charles de Launay. Louis Jacques Mandé Daguerre (1787–1851), French painter and physicist, contributed significantly to the invention of the photographic process. He refined the work of his partner, Joseph Nicéphore Niépce (1765–1833), reducing the exposure time of the photographic plate from eight hours to twenty minutes. His work was recognized by the French government in 1839, at which time he was declared the inventor of photography.—*Trans.*]

64. *Bévues parisiennes* (Parisian Blunders) was a book that collected and published the errors found in the Parisian press.

65. Gabriel Guillemot, *La Bohème* (Paris, 1868), p. 72. [Benjamin's note]

66. "It does not take much acuteness to perceive that a girl who at eight o'clock may be seen sumptuously dressed in an elegant costume is the same who appears as a shopgirl at nine o'clock and as a peasant girl at ten." F.-F.-A. Béraud, *Les filles publiques de Paris et la police qui les régit* (Paris and Leipzig, 1839), vol. 1, pp. 51ff. [Benjamin's note]

67. Alfred Nettement, *Histoire de la littérature française sous le Gouvernement de Juillet* (Paris, 1859), vol. 1, pp. 301ff. [Benjamin's note]

68. See S. Charléty, "La Monarchie de Juillet," in Ernest Lavisse, *Histoire de France contemporaine depuis la Révolution jusqu'à la paix de 1919* (Paris, 1921–1922), vol. 4, p. 352. [Benjamin's note. Alexandre Dumas *père* (1802–1870), French dramatist and novelist, was best known for *The Count of Monte Cristo*

(1844), *The Three Musketeers* (1844), and *The Man in the Iron Mask* (1848). *Le Constitutionnel,* first published in 1815, was the largest and most successful opposition paper under the Restoration; it declined under the July Monarchy but was revived in 1847.—*Trans.*]

69. Eugène Sue (1804–1857), French novelist, found enormous success with the ten volumes of *Les Mystères de Paris* (1842–1843), melodramatic tales of the sufferings and daily lives of the city's underclass during the July Monarchy.

70. Alphonse Marie Louis de Lamartine (1790–1869), French Romantic poet, novelist, and statesman, was best known for his *Méditations poétiques* (1820), which included the famous poem "Le Lac." He served as foreign minister in the Provisional Government following the Revolution of 1848. His *Histoire des Girondins* (History of the Girondists) appeared in 1847.

71. See Eugène de (Jacquot) Mirecourt, *Fabrique de romans: Maison Alexandre Dumas et C^{ie}* [Factory of Novels: The Firm of Alexandre Dumas and Co.] (Paris, 1845). [Benjamin's note]

72. Paulin Limayrac, "Du roman actuel et de nos romanciers," in *Revue des Deux Mondes* (1845), pp. 953ff. [Benjamin's note]

73. Paul Saulnier, "Du roman en général et du romancier moderne en particulier," in *La Bohème* (1855), vol. 1, p. 3. The use of ghostwriters was not confined to serial novels. Eugène Scribe employed a number of anonymous collaborators for the dialogue of his plays. [Benjamin's note]

74. Narcisse-Achille de Salvandy (1795–1856), journalist, historian, and politician, also served for a time as minister of public instruction. He was best known for the caustic political pamphlets he wrote early in his career.

75. Marx, *Der achtzehnte Brumaire des Louis Bonaparte,* p. 68. [Benjamin's note]

76. Alphonse Karr (1808–1890), French journalist and novelist, was best known for his satirical monthly pamphlets, *Les Guêpes* (1839–1876). In later life, he moved to Nice and took up flower farming.

77. Alphonse de Lamartine, "Lettre à Alphonse Karr, Jardinier" in *Oeuvres poétiques complètes,* ed. Guyard (Paris, 1963), p. 1506.

78. In an open letter to Lamartine, the Ultramontane Louis Veuillot wrote: "Could it be that you really don't know that 'to be free' means to despise gold? And in order to obtain the kind of freedom that is bought with gold, you produce your books in the same commercial fashion as you produce your vegetables or your wine!" Louis Veuillot, *Pages choisies,* ed. Albalat (Lyons, 1906), p. 31. [Benjamin's note. An Ultramontane was a supporter of papal policy in ecclesiastical and political matters.—*Trans.*]

79. Marx, *Der achtzehnte Brumaire,* p. 123. [Benjamin's note]

80. Ibid., p. 122. [Benjamin's note]

81. Sainte-Beuve, *Vie, poésies et pensées de Joseph Delorme* (Paris, 1863), p. 170. [Benjamin's note. André-Marie de Chénier (1762–1794), French poet and journalist, sought to revitalize French poetry through the imitation of Greek lyric forms.—*Trans.*]

82. On the basis of reports from Kisselyev, who at that time was Russia's ambassador in Paris, Pokrewski has demonstrated that things happened as Marx had outlined them in his *Klassenkämpfe in Frankreich.* On April 6, 1849, Lamartine

had assured the ambassador that he would concentrate troops in the capital—a measure which the bourgeoisie later attempted to justify by pointing to the workers' demonstrations of April 16. Lamartine's remark that it would take him about ten days to concentrate the troops indeed puts those demonstrations in an ambiguous light. See Mikhail N. Pokrewski, *Historische Aufsätze* (Vienna, 1928), pp. 108ff. [Benjamin's note. For an excerpt from Pokrewski's account, see *The Arcades Project,* p. 767 (Convolute d12,2).—*Trans.*]

83. Sainte-Beuve, *Les Consolations,* p. 118. [Benjamin's note]
84. Quoted in Françoise Porché, *La Vie douloureuse de Charles Baudelaire* (Paris, 1926), p. 248. [Benjamin's note]
85. Ibid., p. 156. [Benjamin's note]
86. Ernest Raynaud, *Charles Baudelaire* (Paris, 1922), p. 319. [Benjamin's note]
87. Baudelaire, *Oeuvres,* vol. 2, p. 385: *L'Art romantique,* "Conseils aux jeunes littérateurs" ("Des salaires"). [Benjamin's note]
88. Quoted in Eugène Crépet, *Charles Baudelaire* (Paris, 1906), pp. 196ff. [Benjamin's note]
89. Baudelaire, *Oeuvres,* vol. 1, p. 209. [Benjamin's note. This poem, which begins "Je n'ai pas pour maîtresse une lionne illustre," first appeared in *Paris à l'eau forte* (Paris in Etchings) on October 17, 1875. In editions of Baudelaire's works, it is included under "Poèmes divers." See *Les Fleurs du mal,* ed. Antoine Adam (Paris: Garnier Frères, 1961), pp. 224–226, 464.—*Trans.*]
90. Panoramas were large circular tableaux, usually displaying scenes of battles and cities, painted in trompe l'oeil and designed to be viewed from the center of a rotunda. They were introduced in France in 1799 by the American engineer Robert Fulton. Subsequent forms included the Diorama (opened by Louis Daguerre and Charles Bouton in 1822 in Paris), in which pictures were painted on cloth transparencies that, by 1831, were being used with various lighting effects.
91. *Le Livre des cent-et-un,* 15 vols. (Paris: Ladvocat, 1831–1834); *Les Français peints par eux-mêmes,* 8 vols. (Paris: L. Curmer, 1839–1842); *Le Diable à Paris,* 2 vols. (Paris: Hetzel, 1845–1846); *La Grande Ville,* 2 vols. (Paris: Bureau Central des Publications Nouvelles, 1842–1844).
92. Charles Louandre, "Statistique littéraire de la production intellectuelle en France depuis quinze ans," in *Revue des Deux Mondes* (November 15, 1847), pp. 686ff. [Benjamin's note]
93. Henri Monnier (1799–1877), French satirist, was known for his *Scènes populaires* (1830), which introduced the character of Joseph Prudhomme, the typical bourgeois: well-meaning but stupid, pretentious, and verbose. In *Les Bourgeois de Paris* (1834) and *Mémoires de Joseph Prudhomme* (1857), Monnier extended his satirical portrait of the middle class.
94. Paris at Night, Dining in Paris, Paris by Water, Paris by Horseback, Picturesque Paris, Marriage in Paris.
95. On the history of caricature by Eduard Fuchs, see the essay "Eduard Fuchs, Collector and Historian," in Walter Benjamin, *Selected Writings, Volume 3: 1935–1938,* ed. Howard Eiland and Michael W. Jennings (Cambridge, Mass.: Harvard University Press, 2002). The September Laws mandated a

significantly more vigilant censorship and led to the virtual elimination of the opposition press. The laws were enacted in 1835, not 1836 as Benjamin indicates.

96. Eduard Fuchs, *Die Karikatur der europäischen Völker* (Munich, 1921), vol. 1, p. 362. [Benjamin's note. Honoré Daumier (1808–1879), French caricaturist, painter, and sculptor, was initially a political caracaturist. After the September Laws eliminated most venues for publishing his political work, he turned to the representation of scenes from everyday life.—*Trans.*]

97. Georges-Eugène, Baron Haussmann (1809–1891), French administrator and urban planner, oversaw the transformation of Paris from feudal city to modern metropolis. After studying law, he entered the civil service in 1831 and rose quickly, serving as prefect of the Seine *département* from 1853 to 1870. Working closely with Napoleon III, Haussmann supervised the rapid introduction of many new features: he cut broad, straight avenues through tangles of medieval streets; modernized the city's water supply and drainage system; built large parks in the city center; and supervised the completion of a number of major public buildings, including the Opéra and the marketplace of Les Halles.

98. Ferdinand von Gall, *Paris und seine Salons* (Oldenburg, 1845), vol. 2, pp. 22ff. [Benjamin's note]

99. Baudelaire, *Oeuvres,* vol. 2, p. 333: "Le Peintre de la vie moderne," sect. 3. [Benjamin's note. Constantin Guys (1805–1892), French painter and the subject of Baudelaire's essay "Le Peintre de la vie moderne" (The Painter of Modern Life; 1859), produced watercolors, engravings, and drawings of café life, military scenes, and the fashionable Parisian society of the Second Empire. For Baudelaire, Guys became the representative modern artist by virtue of his ability to capture and combine the ephemeral and the eternal in the modern world.—*Trans.*]

100. Georg Simmel (1858–1918), German sociologist and neo-Kantian philosopher, developed a theory of modernity, starting with his *Philosophie des Geldes* (Philosophy of Money; 1900) and continuing through classic essays such as "Die Großstadt und das Geistesleben" (The Metropolis and Mental Life; 1903). His work exerted an enormous influence on the next generation of social philosophers, some of whom were his students: Georg Lukács, Ernst Cassirer, Ernst Bloch, Siegfried Kracauer, and Benjamin.

101. Georg Simmel, *Soziologie,* 4th ed. (Berlin, 1958), p. 486. [Benjamin's note]

102. See Bulwer-Lytton, *Eugene Aram: A Tale* (Paris, 1832), p. 314. [Benjamin's note. Edward George Earle Bulwer-Lytton (1803–1873), British novelist, produced a series of reform-minded moral tales. *Eugene Aram* presents the story of a repentant murderer.—*Trans.*]

103. Marx and Engels on Feuerbach, in *Marx-Engels-Archiv: Zeitschrift des Marx-Engels-Instituts,* ed. David Riazanov (Frankfurt, 1926), vol. 1, pp. 271ff. [Benjamin's note]

104. Edouard Foucaud, *Paris inventeur: Physiologie de l'industrie française* (Paris, 1844), pp. 222ff. [Benjamin's note]

105. Johann Kaspar Lavater (1741–1801) was a Swiss writer and Protestant pastor whose theories of physiognomy were widely influential in the late eighteenth

century. His *Physiognomische Fragmente zur Beförderung der Menschen-kenntnis und Menschenliebe* (4 vols., 1775–1778; translated as *Essays on Physiognomy*, 1789–1798) were founded on the conviction that a person's mental faculties and character leave their mark on his or her physical features. Franz Joseph Gall (1758–1828), German physician, founded an institute in Vienna for the study of the brain and skull. His doctrines, which were later dubbed "phrenology" by one of his students, were enormously controversial in their day, and were in fact banned in Germany in 1802. His enormous collection of skulls and plaster casts is now at the Musée de l'Homme in Paris.

106. Honoré de Balzac, *Le Cousin Pons* (Paris, 1914), p. 130. [Benjamin's note]

107. Baudelaire, *Oeuvres*, vol. 2, p. 637: *Journaux intimes*, "Fusées," sect. 21. [Benjamin's note]

108. Joseph de Maistre (1753–1821), French essayist and diplomat, combined a vast store of knowledge and a potent style in a series of invectives against Enlightenment rationalism. In his principal works *Du pape* (On the Pope; 1819) and *Les Soirées de Saint-Pétersbourg* (Discussions in St. Petersburg; 1821), he put forth his arguments for a world united under the spiritual rule of the pope. His *Examen de la philosophie de Bacon* appeared posthumously, in 1845. Francis Bacon (1561–1626), English philosopher and writer, sought, in his chief work *Novum Organum* (1620), to replace the deductive logic of Aristotle with an inductive method for interpreting nature.

109. Quoted in Adolphe Schmidt, *Tableaux de la révolution française, publiées sur les papers inédits du département et de la police secrète de Paris*, vol. 3 (Leipzig, 1870), p. 337. [Benjamin's note]

110. Baudelaire, *Oeuvres*, vol. 2, p. 333: "Le Peintre de la vie moderne," sect. 3. [Benjamin's note]

111. In his novel *Séraphita*, Balzac speaks of "a quick look whose perceptions in rapid succession placed the most antithetical landscapes of the earth at the disposal of the imagination." [Benjamin's note]

112. See Régis Messac, *Le "Detective Novel" et l'influence de la pensée scientifique* (Paris, 1929). [Benjamin's note. James Fenimore Cooper (1789–1851), American novelist, was best known for his Leatherstocking Tales, featuring the wilderness scout called Natty Bumppo, or Hawkeye. They include *The Pioneers* (1823), *The Last of the Mohicans* (1826), *The Prairie* (1827), *The Pathfinder* (1840), and *The Deerslayer* (1841).—*Trans.*]

113. Paul Féval (1817–1887), French novelist, was the author of serial novels that rivaled those of Dumas in popularity. His most successful novel was *Le Bossu* (The Hunchback; 1857).

114. See Honoré de Balzac, *Splendeurs et misères des courtisanes*, part 2, in *Oeuvres complètes*, vol. 15 (Paris, 1913), pp. 310–311. In English, *A Harlot High and Low*, trans. Rayner Heppenstall (Harmondsworth: Penguin, 1970), p. 270.

115. See André Le Breton, *Balzac* (Paris, 1905), p. 83. [Benjamin's note]

116. Hippolyte Babou, *La Vérité sur le cas de M. Champfleury* (Paris, 1857), p. 30. [Benjamin's note]

117. See Baudelaire, *Les Fleurs du mal* (Paris, 1928), introduction by Paul Valéry. [Benjamin's note. Paul Valéry (1871–1945), French poet and essayist, is best

known for essayistic fictions such as *La Soirée avec Monsieur Teste* (1896) and major poems of the Symbolist and post-Symbolist period.—*Trans.*]

118. Baudelaire, *Oeuvres*, vol. 2, p. 424: *L'Art romantique,* "L'Ecole païenne," last para. [Benjamin's note]

119. "One always has to go back to Sade . . . to explain evil" (ibid., p. 694: "Fragments"—*Le Fou raisonnable et la belle aventurière*). [Benjamin's note. Count Donatien Alphonse François de Sade, better known as the Marquis de Sade (1740–1814), was the author of erotic writings that affirm the liberation of instincts even to the point of crime. In the course of a life that scandalized his contemporaries, he lived out many forms of his compulsions.—*Trans.*]

120. Ibid., vol. 1, p. 106. [Benjamin's note]

121. Albert Thibaudet, *Intérieurs* (Paris, 1924), p. 22. [Benjamin's note. Albert Thibaudet (1874–1946), French critic, was a principal contributor to the *Nouvelle Revue Française*. His range and discernment made him one of the leading critical voices of the interwar years.—*Trans.*]

122. The motif of love for a woman passing by is taken up in an early poem by Stefan George. But George misses the important thing: the stream in which the woman moves past, borne along by the crowd. The result is a self-conscious elegy. The poet's glances—so he must confess to his lady—have "moved away, moist with longing / before they dared mingle with yours" [feucht vor sehnen fortgezogen / eh sie in deine sich zu tauchen trauten]. (Stefan George, *Hymnen; Pilgerfahrten; Algabal,* 7th ed. [Berlin, 1922], p. 23.) Baudelaire leaves no doubt that he looked deep into the eyes of the passer-by. [Benjamin's note]

123. Hans Makart (1840–1884) was an Austrian painter who made his reputation with vast historical and allegorical canvases. His name became a byword for empty monumentality.

124. The *Journal Officiel* was founded in 1869 by Eugène Rouher (1814–1884), minister, senator, and key political figure in the last years of the Second Empire. The journal, though semi-autonomous, followed a rigorous government line.

125. Balzac, *Modeste Mignon,* Editions du Siècle (Paris, 1850), p. 99. [Benjamin's note]

126. Sigmund Engländer, *Geschichte der französischen Arbeiter-Associationen,* 4 vols. (Hamburg, 1863–1864), vol. 3, p. 126. [Benjamin's note]

127. Baudelaire, *Oeuvres,* vol. 1, p. 115. [Benjamin's note. The phrase is from the poem "Brumes et pluies" (Mists and Showers), in the "Tableaux parisiens" section of *Les Fleurs du mal.*—*Trans.*]

128. Alphonse Bertillon (1853–1914), who became chief of criminal identification for the Paris police in 1880, developed an identification system known as anthropometry, or "the Bertillon system." The system is based on precise bodily measurements, physical descriptions, and photographs.

129. Hoffmann's story "Des Vetters Eckfenster" (1822) has been translated by Ritchie Robertson as "My Cousin's Corner Window," in Hoffmann, *"The Golden Pot" and Other Tales* (New York: Oxford University Press, 1992), pp. 377–401.

130. E. T. A. Hoffmann, *Ausgewählte Schriften,* vol. 15: *Leben und Nachlass,* ed.

and with biographical notes by Julius Eduard Hitzig, vol. 3 (Stuttgart, 1839), pp. 32ff. [Benjamin's note]

131. Franz Mehring, "Charles Dickens," in *Die neue Zeit,* 30, no. 1 (1911–1912): 621ff. [Benjamin's note. See *The Letters of Charles Dickens,* ed. Walter Dexter, vol. 1: 1832–1846 (London, 1938), p. 782.—*Trans.*]

132. Baudelaire, *Oeuvres,* vol. 2, p. 710: "Argument du livre sur la Belgique," sect. 2. [Benjamin's note]

133. See *La Transformation de Paris sous le Second Empire: Exposition de la Bibliothèque et des travaux historiques de la ville de Paris,* ed. Marcel Poëte, E. Clouzot, and G. Henriot (Paris, 1910), p. 65. [Benjamin's note]

134. Julien Lemer, *Paris au gaz* (Paris, 1861), p. 10. The same image is found in "Le Crépuscule du soir": the sky "slowly closes like an enormous alcove" (see Baudelaire, *Oeuvres,* vol. 1, p. 108). [Benjamin's note]

135. Alfred Delvau, *Les Heures parisiennes* (Paris, 1866), p. 206. [Benjamin's note]

136. See Louis Veuillot, *Les Odeurs de Paris* (Paris, 1914), p. 182. [Benjamin's note]

137. Robert Louis Stevenson, "A Plea for Gas Lamps," in *Virginibus Puerisque and Other Papers,* in Stevenson, *Works,* Tusitala Edition, vol. 25 (London, 1924), p. 132. [Benjamin's note]

138. There is a parallel to this passage in "Un Jour de pluie." Even though this poem bears another man's name, it can be ascribed to Baudelaire (see Charles Baudelaire, *Vers retrouvés,* ed. Julius Mouquet [Paris, 1929]). The analogy between the last stanza and Poe's mention of Tertullian is all the more remarkable because the poem was written in 1843 at the latest, at a time when Baudelaire did not know Poe.

> Chacun, nous coudoyant sur le trottoir glissant,
> Egoïste et brutal, passe et nous éclabousse,
> Ou, pour courir plus vite, en s'éloignant nous pousse.
> Partout fange, déluge, obscurité du ciel:
> Noir tableau qu'eût rêvé le noir Ezéchiel!
>
> (Baudelaire, *Oeuvres,* vol. 1, p. 211)

[Benjamin's note. The verse translates as: "Each one, elbowing us on the slippery sidewalk, / Selfish and savage, goes by and splashes us, / Or, to run the faster, gives us a push as he makes off. / Everywhere mud, deluge, darkness in the sky. / A somber scene that Ezekiel the somber might have dreamed." Quintus Septimus Florens Tertullianus (ca. 155/160 A.D.–ca. 220 A.D.) was an early Christian theologian and polemicist who, as the first practitioner of ecclesiastical Latin, exerted a profound influence on the ideas and rhetoric of Western Christianity.—*Trans.*]

139. Poe, *Nouvelles histoires extraordinaires,* p. 89. [Benjamin's note]

140. Ibid., pp. 89–90. [Benjamin's note]

141. The image of America which Marx had seems to be of the same stuff as Poe's description. He emphasizes the "feverishly youthful pace of material production" in the States and blames this very pace for the fact that there was "neither time nor opportunity . . . to abolish the old spirit world" (Marx, *Der*

achtzehnte Brumaire des Louis Bonaparte, p. 30). In Poe, there is something demonic even about the physiognomy of the businessmen. Baudelaire describes how, as darkness descends, "baleful demons awaken sluggishly" in the air "like a bunch of businessmen" (*Oeuvres,* vol. 1, p. 108). This passage in "Le Crépuscule du soir" may have been inspired by Poe's text. [Benjamin's note]

142. Alois Senefelder (1771–1834) was the German inventor of the lithographic process.

143. See Georges Friedmann, *La Crise du progrès* (Paris, 1936), p. 76. [Benjamin's note. Frederick Winslow Taylor (1856–1915) established the discipline of business administration and pioneered in the study of rationalization and management efficiency. "Taylorism" and "Taylorization" were slogans, particularly in Europe, for a more general industrial modernization.—*Trans.*]

144. Paul Ernest de Rattier, *Paris n'existe plus* (Paris, 1857), pp. 74ff. [Benjamin's note]

145. Jules Laforgue, *Mélanges posthumes* (Paris, 1903), p. 111. [Benjamin's note. Jules Laforgue (1860–1887), French poet and critic, was a Symbolist master of lyrical irony.

146. See Marx, *Das Kapital,* ed. Karl Korsch (Berlin, 1932), p. 95. [Benjamin's note. In English in *Capital,* vol. 1 (London, 1967), p. 84.—*Trans.*]

147. Baudelaire, *Oeuvres,* vol. 1, pp. 420–421: *Le Spleen de Paris,* "Les Foules." [Benjamin's note]

148. On this point, the second "Spleen" poem is the most important addition to the documentation assembled in the first part of this essay. There is scarcely a single poet before Baudelaire who wrote a verse anything like "Je suis un vieux boudoir plein de roses fanées" (*Oeuvres,* vol. 1, p. 86) ["I am an old boudoir full of faded roses"]. The poem is entirely based on empathy with the material, which is dead in a dual sense. It is inorganic matter, matter that has been eliminated from the circulation process.

> Désormais tu n'es plus, ô matière vivante!
> Qu'un granit entouré d'une vague épouvante,
> Assoupi dans le fond d'un Sahara brumeux;
> Un vieux sphinx ignoré du monde insoucieux,
> Oublié sur la carte, et dont l'humeur farouche
> Ne chante qu'aux rayons du soleil qui se couche.
>
> (Baudelaire, *Oeuvres,* vol. 1, p. 86: "Spleen [II]")

> [Henceforth you are nothing more, O living matter, / Than a piece of granite enveloped in a vague sense of horror, / Slumbering in the depths of some misty Sahara— / An old sphinx ignored by the careless world, / Erased from the map, and whose fierce nature / Sings only to the rays of the setting sun.]

The image of the Sphinx which concludes the poem has the gloomy beauty of the white elephants that are still found in some arcades. [Benjamin's note]

149. Baudelaire, *Oeuvres,* vol. 2, p. 627: *Journaux intimes,* "Fusées," sect. 2. [Benjamin's note]

150. Ibid., vol. 1, p. 421. [Benjamin's note. The phrases are from the prose poem "Les Foules," in *Le Spleen de Paris.*—*Trans.*]

151. Ibid. [Benjamin's note. "That holy prostitution of the soul which gives itself completely, poetry and charity, to the unexpected that appears, to the unknown that passes."—*Trans.*]

152. Ibid., p. 108. [Benjamin's note]

153. Engels, *Die Lage der arbeitenden Klasse in England* (Leipzig, 1848), pp. 36ff. [Benjamin's note. English translation: *The Condition of the Working-Class in England in 1844* (orig. pub. 1887), in Karl Marx and Friedrich Engels, *On Britain* (Moscow, 1962), pp. 56–57.—*Trans.*]

154. Baudelaire, *Oeuvres,* vol. 2, p. 626: *Journaux intimes,* "Fusées," sect. 1. [Benjamin's note]

155. Percy Bysshe Shelley, "Peter Bell the Third Part," *Complete Poetical Works* (London, 1932), p. 346. [Benjamin's note. Benjamin quotes this verse in a German translation by Brecht; see, on this point, the February 1939 exchange of letters between Benjamin and Theodor Adorno, in this volume. The whole of Shelley's poem is quoted in Convolute M18 in *The Arcades Project* (pp. 449–450).—*Trans.*]

156. Baudelaire, *Oeuvres,* vol. 1, p. 102. [Benjamin's note. This is the first line of "Les Petites Vieilles."—*Trans.*]

157. Ibid. [Benjamin's note]

158. Ibid., vol. 2, p. 193: *Curiosités esthétiques, "Quelques caricaturistes français,"* sect. 1. [Benjamin's note]

159. Ibid., p. 522: *L'Art romantique,* sect. 19.1, "Victor Hugo." [Benjamin's note]

160. Ibid., vol. 1, p. 100. [Benjamin's note. The poem is "Les Sept Vieillards."—*Trans.*]

161. Ibid., p. 103. [Benjamin's note. The phrase is from "Les Petites Vieilles."—*Trans.*]

162. The third poem in the cycle devoted to Hugo, "Les Petites Vieilles," underlines the rivalry by following verbatim the third poem in Hugo's cycle "Fantômes." Thus, there is a correspondence between one of Baudelaire's most perfect poems and one of Hugo's weakest. [Benjamin's note]

163. Sainte-Beuve, *Les Consolations; Pensées d'août* (Paris, 1863), p. 125. The remark, published by Sainte-Beuve from the manuscript, is by Farcy. [Benjamin's note]

164. Hugo von Hofmannsthal, *Versuch über Victor Hugo* (Munich, 1925), p. 49. [Benjamin's note]

165. "The ocean itself got bored with him."

166. Quoted in Gabriel Bounoure, "Abîmes de Victor Hugo," in *Mesures* (July 15, 1936), p. 39. [Benjamin's note. The French translates as "The depths are crowds."—*Trans.*]

167. Victor Hugo, *Oeuvres complètes: Edition définitive,* poetry, vol. 2, *Les Orientales; Les Feuilles d'automne* (Paris, 1880), pp. 365ff. [Benjamin's note]

168. Ibid., p. 363. [Benjamin's note]

169. Hugo, *Oeuvres complètes,* novels, vol. 8, *Les Misérables* (Paris, 1881). [Benjamin's note]

170. "To go to the many," "to join the multitude"—i.e., "to die."

171. Gustave Simon, *Chez Victor Hugo: Les Tables tournantes de Jersey* (Paris, 1923), pp. 306ff. [Benjamin's note]

172. Hugo, *Oeuvres complètes*, poetry, vol. 4, *Les Châtiments* (Paris, 1882), "La Caravane IV." [Benjamin's note]
173. Louis-Eugène Cavaignac (1802–1857), French army general, crushed the insurrection of the Paris workers during the June Days of 1848 and remained chief executive of France until the election of Louis-Napoleon Bonaparte as president in December 1848.
174. Pélin, a typical representative of the lower *bohème*, wrote about this speech in his paper "Les Boulets rouges: Feuille du Club Pacifique des Droits de l'Homme": "*Citoyen* Hugo has made his debut in the National Assembly. As had been expected, he turned out to be a declaimer, a gesticulator, and a phrase-monger. In the vein of his latest crafty and defamatory poster, he spoke of the idlers, the poor, the loafers, the *lazzaroni*, the praetorians of the revolution, and the condottieri—in a word, he exhausted the stock of metaphors and ended with an attack on the *ateliers nationaux*" (*Les Boulets rouges*, First year, June 22–24). In his *Histoire parlementaire de la Seconde République* (Paris, 1891), Eugène Spuller writes: "Victor Hugo had been elected with reactionary votes. . . . He had always voted with the rightists, except for one or two occasions when politics did not matter" (pp. 111 and 266). [Benjamin's note. The *ateliers nationaux*, or "national workshops," provided relief from the deepening economic crisis of 1848. The workshops were closed following the failure of the June Insurrection.—*Trans.*]
175. Hugo, *Les Misérables*, p. 306. [Benjamin's note]
176. Since the days of the French Revolution, the word *citoyen* ("citizen") has carried distinctly revolutionary connotations.
177. Baudelaire, *Oeuvres*, vol. 2, p. 26: "Salon de 1845," sect. 2 ("Robert Fleury"). [Benjamin's note]
178. Ibid., p. 388: *L'Art romantique*, "Conseils aux jeunes littérateurs," sect. 6. [Benjamin's note. The French phrase translates as "the stubborn contemplation of tomorrow's work" (*Advice to Young Men of Letters*).—*Trans.*]
179. Ibid., p. 531: *L'Art romantique*, sect. 19.2 ("Auguste Barbier"). [Benjamin's note. The French translates as "the natural indolence of those who live in a state of inspiration."—*Trans.*]
180. Albert Thibaudet, *Intérieurs* (Paris, 1924), p. 15. [Benjamin's note. Louis Charles Alfred de Musset (1810–1857), French poet, playwright, and translator, ranks alongside Hugo, Lamartine, and Vigny as one of the great Romantic poets. He combined an intense lyricism with a propensity to shock through revelation of his vices: laziness, self-indulgence, a facile talent, and an attraction to opium.—*Trans.*]
181. Quoted in André Gide, "Baudelaire et M. Faguet," in *Nouvelle Revue Française* (November 1, 1910), p. 513. [Benjamin's note. Maurice Barrès (1862–1923) was a French writer and politician whose fervent individualism and nationalism made his ideas a rallying point for the Right.—*Trans.*]
182. Rémy de Gourmont, *Promenades littéraires*, 2nd series (Paris, 1906), pp. 85ff. [Benjamin's note]
183. Preface by Gustave Kahn in Baudelaire, *Mon Coeur mis à nu; Fusées* (Paris, 1909), p. 6. [Benjamin's note. The French poet Gustave Kahn (1859–1936) played a significant role in the early days of the Symbolist movement.

Cofounder of the journal *Le Symboliste,* he emerged as an important theorist of poetry.—*Trans.*]

184. Baudelaire, *Oeuvres,* vol. 2, p. 334: "Le Peintre de la vie moderne," sect. 3 (last para.). [Benjamin's note]

185. Quoted in Ernest Raynaud, *Charles Baudelaire* (Paris, 1922), pp. 317ff. [Benjamin's note]

186. Baudelaire, *Oeuvres,* vol. 1, p. 96. [Benjamin's note]

187. François-Arsène Houssaye (1815–1897), French journalist, was befriended by Théophile Gautier and met, through him, the leading writers of his day. His criticism appeared in virtually every leading newspaper and journal.

188. Baudelaire, *Oeuvres,* vol. 1, pp. 405–406. [Benjamin's note. The passage is from the dedicatory essay "A Arsène Houssaye," in *Le Spleen de Paris.*— *Trans.*]

189. "The flâneur must not be confused with the *badaud* [onlooker; rubberneck]; a nuance should be noted here. . . . The simple flâneur is always in full possession of his individuality, whereas the individuality of the *badaud* disappears. It is absorbed by the outside world, . . . which intoxicates him to the point where he forgets himself. Under the influence of the spectacle which appears before him, the *badaud* becomes an impersonal creature. He is no longer a human being; he is part of the public, of the crowd." Victor Fournel, *Ce qu'on voit dans les rues de Paris* (Paris, 1858), p. 263. [Benjamin's note]

190. G. K. Chesterton (1874–1936), English novelist, is best known for his "Father Brown" novels, which use the figure of the sleuthing priest to mix detective fiction and social analysis.

191. G. K. Chesterton, *Dickens* (Paris, 1927), p. 30. [Benjamin's note. Benjamin translates the passage into German from a French version. We cite the original English from *Charles Dickens* (1906; rpt. New York: Schocken, 1965), pp. 45–46.—*Trans.*]

192. Recalling the period around 1845, Prarond, a friend of Baudelaire's from their youth, wrote: "We seldom used desks at which to reflect and write." Referring to Baudelaire, he continues: "I for my part was more likely to see him composing his verses in a hurry, rushing up and down the street; I never saw him sitting before a ream of paper." (Quoted in Alphonse Séché, *La Vie des Fleurs du mal* [Paris, 1928], p. 84.) Banville makes a similar report about the Hotel Pimodan: "When I visited there for the first time, I found neither encyclopedias nor a study nor a writing desk. Nor was there a sideboard, a dining room, or anything resembling the furnishings of a middle-class apartment." (Théodore de Banville, *Mes souvenirs* [Paris, 1882], p. 82.) [Benjamin's note]

193. Maxime Du Camp, *Souvenirs littéraires,* vol. 2 (Paris, 1906), p. 65. [Benjamin's note]

194. See Georges Rency, *Physiognomies littéraires* (Brussels, 1907), p. 288. [Benjamin's note]

195. Marx, *Randglossen zum Programm der Deutschen Arbeiterpartei,* ed. Karl Korsch (Berlin, 1922), p. 22. [Benjamin's note. See, in English, *Marginal Notes on the Programme of the German Workers' Party,* trans. Peter Ross and Betty Ross, in Karl Marx and Friedrich Engels, *Collected Works,* vol. 24 (New York: International Publishers, 1989), p. 81. In 1875, Gotha, a city in the east-

central German province of Thuringia, was the scene of the congress that united the Eisenach and the Lassalle political groups into the Socialist Labor Party of Germany. The new party adopted the Gotha Program, which was sharply criticized by Karl Marx for its reformism and moderation.—*Trans.*]

196. Baudelaire, *Dernières lettres inédites à sa mère* (Paris: Crépet, 1926), pp. 44–45. [Benjamin's note]

197. Marx, *Der achtzehnte Brumaire des Louis Bonaparte,* pp. 122ff. [Benjamin's note]

198. See "Pour toi, vieux maraudeur, / L'amour n'a plus de goût, non plus que la dispute" ["For you, old marauder / Love has lost its savor, and quarreling as well"] (Baudelaire, *Oeuvres,* vol. 1, p. 89 ["Le Goût du néant"]).—One of the few repulsive phenomena in the extensive, mostly colorless literature about Baudelaire is a book by one Peter Klassen. This book, which is written in the depraved terminology of the George circle and, as it were, presents Baudelaire under a steel helmet, typically claims that the center of his life was the Ultramontane restoration—that is, the day "when, in the spirit of the restored divine right of kings, the Holy of Holies was carried through the streets of Paris surrounded by gleaming armaments. This may have been one of the decisive moments of his life, because it involved his very essence." (Peter Klassen, *Baudelaire* [Weimar, 1931], p. 9). Baudelaire was six years old at the time. [Benjamin's note]

199. Marcel Proust, "A propos de Baudelaire," in *Nouvelle Revue Française* (June 1, 1921), p. 646. [Benjamin's note. Proust's remark translates as, "It seems impossible to go beyond this."—*Trans.*]

200. Baudelaire, *Oeuvres,* vol. 1, p. 104. [Benjamin's note]

201. Ibid., vol. 2, p. 408: *L'Art romantique,* "Pierre Dupont." [Benjamin's note. The italics are Baudelaire's.—*Trans.*]

202. Balzac, *L'Illustre Gaudissart* (Paris: Calmann-Lévy, 1892), p. 5. [Benjamin's note]

203. Baudelaire, *Oeuvres,* vol. 1, p. 119. [Benjamin's note]

204. Ibid., vol. 2, p. 239: "Salon de 1859," sect. 5. [Benjamin's note]

205. Nietzsche later took a similar view of suicide. "One cannot condemn Christianity enough, because it devalued the *value* of a . . . great *purging* nihilistic movement which may have been in train, . . . and always devalued it by opposing the *deed of nihilism,* suicide." Cited in Karl Löwith, *Nietzsches Philosophie der ewigen Wiederkunft des Gleichen* (Berlin, 1935), p. 108. [Benjamin's note. See Friedrich Nietzsche, *Werke,* ed. Karl Schlechta (Munich: Ullstein, 1956), vol. 3, pp. 792–793. In English as *The Will to Power,* trans. Walter Kaufmann and R. J. Hollingdale (New York: Random House, 1967), p. 143 (March–June 1888).—*Trans.*]

206. Baudelaire, *Oeuvres,* vol. 2, pp. 133–134: "Salon de 1846," sect. 18 ("De l'héroisme de la vie moderne"). [Benjamin's note. Heracles built his own funeral pyre and threw himself on it in order to relieve the anguish caused by the poisoned garment sent to him by his wife. Marcus Porcius Cato (Cato the Younger; 95 B.C.–46 B.C.) was a Roman patriot and Stoic philosopher who sided with Pompey against Caesar in the civil war in 49 B.C. He committed suicide on receiving news of Caesar's victory at Thapsus. Although there are sev-

eral suicides named Cleopatra in the ancient world, Benjamin presumably refers to Cleopatra VII (69 B.C.–30 B.C.), last Macedonian queen of Egypt and lover of Mark Antony. Following the defeat of their fleet at the hands of Octavian, Antony killed himself on hearing a false report of her death. She followed him rather than be displayed in Octavian's triumphal procession in Rome.—Trans.]

207. Charles Benoist, "L'Homme de 1848, II: Comment il s'est développé le communisme, l'organisation du travail, la réforme," Revue des Deux Mondes (February 1914), p. 667. [Benjamin's note]

208. Alfred Rethel (1816–1859), German painter, was inspired by the Revolution of 1848 to do a series of highly original and moving woodcuts in the tradition of the late medieval Dance of Death. The series was titled Auch ein Totentanz (1849).

209. Baudelaire, Oeuvres, vol. 2, pp. 54–55: "Salon de 1845," last para. [Benjamin's note]

210. Ibid., p. 134: "Salon de 1846" ("De l'héroïsme de la vie moderne"). [Benjamin's note]

211. Ibid., p. 136: "De l'héroisme de la vie moderne," last para. [Benjamin's note. Vautrin and Rastignac are characters in Balzac's novel Le Père Goriot (1834–1835); Birotteau, a character in Histoire de la grandeur et de la décadence de César Birotteau (1838). Fontanarès is the hero of Balzac's play Les Ressources de Quinola (1842), set in the sixteenth century.—Trans.]

212. Friedrich Theodor Vischer (1807–1887) was a leading liberal politician who is best remembered for his championing of literary realism at midcentury.

213. Friedrich Theodor Vischer, Vernünftige Gedanken über die jetzige Mode: Kritische Gänge, new series, book 3 (Stuttgart, 1861), p. 117. [Benjamin's note]

214. Baudelaire, Oeuvres, vol. 1, p. 22. [Benjamin's note]

215. Vischer, Vernünftige Gedanken, p. 111. [Benjamin's note]

216. Baudelaire, Oeuvres, vol. 2, pp. 134ff. [Benjamin's note. La Gazette des Tribunaux was a semi-official daily paper founded in 1825; it covered trials and legal matters, often with verbatim accounts. Le Moniteur, founded in 1789 and later published under a variety of names, was the official government organ for edicts, laws, and the presentation of policy.—Trans.]

217. Gabriel Bounoure, "Abîmes de Victor Hugo," in Mesures (July 15, 1936), p. 40. [Benjamin's note]

218. Ferragus is the main character in Balzac's novel of the same name. The Carbonari were an Italian revolutionary group organized in about 1811 to establish a united republican Italy. French Carbonarism, directed against the Bourbon Restoration, was initiated in 1820 by young republican militants.

219. The French phrase means "Passerby, be modern!" It was inscribed over the door of the old Chat Noir café, located in Montmartre. See The Arcades Project, Convolute S5a,4; S5a,1; and J55a,7

220. Baudelaire, Oeuvres, vol. 1, pp. 249ff. [Benjamin's note]

221. Quoted in Firmin Maillard, La Cité des intellectuels: Scènes cruelles et plaisantes de la vie littéraires des gens de lettres au XIXe siècle (Paris, 1905), p. 362. [Benjamin's note. "Pas saccadé" translates as "jerky gait." Benjamin

says here that poet and ragpicker share the same "gestus," borrowing a term from Brecht. Nadar (pseudonym of Gaspard-Félix Tournachon; 1820–1910), French writer, caricaturist, and photographer, emerged from a large group of Parisian studio portraitists as one of the great portraitists of the century. Among his many innovations are his natural posing of his subjects, a patent on the use of photographs in mapmaking and surveying, the first aerial photograph (from a balloon), and the first photographic interview: twenty-one images of the scientist Eugène Chevreul, accompanied by text.—*Trans.*]

222. Guillaume Apollinaire (pseudonym of Wilhelm Apollinaris de Kostrowitzki; 1880–1918), French poet and critic, was the driving force in the French avant-garde until his early death. His most important works include the pioneering essay "Peintures cubistes" (Cubist Painters; 1913), the poem collections *Alcools* (1913) and *Calligrammes* (1918), the story "Le Poète assassiné" (The Poet Assassinated; 1916), and the play *Les Mamelles de Tirésias* (The Breasts of Tiresias; staged in 1917). Croniamantal is the poet-protagonist in *Le Poète assassiné.*

223. Baudelaire long planned to write novels set in this milieu. His posthumous papers contain the vestiges of such projects, in the form of titles: *Les Enseignements d'un monstre* (The Teachings of a Monster); *L'Entreteneur* (The Keeper); *La Femme malhonnête* (The Dishonest Woman). [Benjamin's note. See *The Arcades Project*, p. 283 (Convolute J30,12).—*Trans.*]

224. Baudelaire, *Oeuvres,* vol. 1, p. 193. [Benjamin's note]

225. Three-quarters of a century later, the antagonism between the pimp and the man of letters was revived. When the writers were driven out of Germany, a Horst Wessel legend entered German literature. [Benjamin's note. Horst Wessel (1907–1930), a pimp who lived in a Berlin slum with a former prostitute, joined the Nazi party in 1926 and became a storm trooper. After he was killed in a fight in his apartment, he was glorified as a martyr for the Nazi cause. A poem he had published in Joseph Goebbels' *Der Angriff* was set to the tune of a cabaret song and became the official Nazi anthem.—*Trans.*]

226. Baudelaire, *Oeuvres,* vol. 2, p. 336 ("Le Peintre de la vie moderne"). [Benjamin's note. See Baudelaire, *"The Painter of Modern Life" and Other Essays,* trans. Jonathan Mayne (1964; rpt. New York: Da Capo, 1986), pp. 13–14. See also *The Arcades Project*, Convolute J6a,2 and J6a,3.—*Trans.*]

227. Kahn, Preface in Baudelaire, *Mon coeur mis à nu; Fusées* (Paris, 1909), p. 15. [Benjamin's note. The French phrase translates as "a refusal to take the opportunity offered by the nature of the lyric pretext."—*Trans.*]

228. Baudelaire, *Oeuvres,* vol. 2, p. 580: *L'Art romantique,* "Les Misérables," sect. 3. [Benjamin's note]

229. Ibid., p. 508: *L'Art romantique,* "Richard Wagner et Tannhäuser," sect. 4, para. 1. [Benjamin's note]

230. Ibid., p. 337: "Le Peintre de la vie moderne," sect. 4. [Benjamin's note]

231. Ibid., p. 363: "Le Peintre de la vie moderne," sect. 13. [Benjamin's note]

232. Ibid., p. 326: "Le Peintre de la vie moderne," sect. 1. [Benjamin's note]

233. The term "Alexandrism" was originally applied to a soft and sentimental tendency in Hellenistic sculpture. Abel-François Villemain (1790–1870) was a French politician and literary critic. Victor Cousin (1792–1867) was a politi-

cian and philosopher who attempted to integrate a number of philosophical doctrines in a movement called "eclecticism." He introduced Hegel's thought to France.

234. Baudelaire, *Oeuvres,* vol. 1, p. 99. [Benjamin's note. "The form of a city, alas, changes more quickly than a mortal's heart."—*Trans.*]

235. Emile Verhaeren, *Les Villes tentaculaires* (Paris, 1904), p. 119, "L'Ame de la ville." [Benjamin's note. Verhaeren (1855–1916), a Belgian poet who wrote in French, created a body of work noted for its range. His collections include *Les Flamandes* (1883), *Les Moines* (1886), *Les Soirs* (1887), *Les Debâcles* (1888), *Les Flambeaux noirs* (1890), *Au Bord de la route* (1891), and *Les Campagnes hallucinées* (1893).—*Trans.*]

236. Charles Péguy, *Oeuvres de prose* (Paris, 1916), pp. 388ff. [Benjamin's note. Charles Péguy (1873–1914) was a French poet and philosopher whose work brought together Christianity, socialism, and French nationalism.—*Trans.*]

237. Victor Hugo, *Les Misérables* (Paris, 1881), p. 55ff. [Benjamin's note. The sibyl at Delphi sat on a golden tripod when she made her prophecies.—*Trans.*]

238. Friedrich von Raumer, *Briefe aus Paris und Frankreich im Jahre 1830* (Leipzig, 1831), vol. 2, p. 127. [Benjamin's note. Friedrich von Raumer (1781–1873), German historian, is best known for his *Geschichte der Hohenstaufen und ihrer Zeit* (History of the Hohenstaufens and Their Time; 6 volumes, 1924).—*Trans.*]

239. Hugo, *Oeuvres complètes,* poetry, vol. 3 (Paris, 1880). [Benjamin's note]

240. Ibid. [Benjamin's note]

241. Léon Daudet, *Paris vécu* (Paris, 1929), vol. 1, p. 220ff. [Benjamin's note. Léon Daudet (1867–1942) edited the right-wing Catholic journal *L'Action Française,* organ of the eponymous nationalist political movement that he founded with Charles Maurras in 1898. The journal was noted for its antidemocratic and anti-Semitic views.—*Trans.*]

242. Maxime Du Camp (1822–1894), French writer and photographer, first became known for *Egypte, Nubie, Palestine et Syrie* (1852), based on his travels with Gustave Flaubert and one of the first travel books illustrated with photographs. He subsequently forged a career as a publisher and produced work in virtually every genre. His *Paris: Ses organes, ses fonctions et sa vie dans la seconde moitié du XIXe siècle* (6 vols., 1869–1875) mixes a vivid account of everyday life in Paris with technical details of urban administration.

243. Paul Bourget, "Discours académique du 13 juin 1895: Succession à Maxime Du Camp," in *L'Anthologie de l'Académie Française* (Paris, 1921), vol. 2, pp. 191ff. [Benjamin's note]

244. Maxime Du Camp, *Paris: Ses organes, ses functions et sa vie dans la seconde moitié du XIX siècle,* vol. 6 (Paris, 1886), p. 253. [Benjamin's note]

245. Joseph Joubert, *Pensées, précédées de sa correspondance* (Paris, 1883), vol. 2, p. 267. [Benjamin's note. "Poets are inspired more by the image than by the actual presence of objects." The French writer Joseph Joubert (1754–1824) is best known for his brilliant private journals, which were not originally intended for publication. Chateaubriand published them in 1838 under the title *Pensées.*—*Trans.*]

246. Charles Meryon (1821–1868), French engraver and painter, turned to engrav-

ing in part because of his color-blindness. He is best known for his series of highly detailed city views which have a kind of hallucinatory clarity, especially the series *Eaux-fortes sur Paris* (Etchings of Paris; 1852–1854, reworked 1861). After 1858 he suffered from symptoms of madness.

247. In the twentieth century, Meryon found a biographer in Gustave Geffroy. It is no accident that Geffroy's masterpiece is a biography of Blanqui. [Benjamin's note. Gustave Geffroy (1830–1896), French writer and critic, was a contributor to Georges Clemenceau's newspaper *La Justice;* his essays championed the Impressionists and the Naturalists. His biography of Blanqui is entitled *L'Enfermé* (1897).—*Trans.*]

248. Quoted in Gustave Geffroy, *Charles Meryon* (Paris, 1926), p. 2. Meryon began as a naval officer. His last etching depicts the naval ministry on the Place de la Concorde. A procession of horses, carriages, and dolphins is shown in the clouds, rushing toward the ministry. There are ships and sea serpents, too, and some human-like forms can be seen in the crowd. Geffroy easily finds the "meaning" of this image without dwelling on the form or the allegory: "His dreams hastened to this building, which was as solid as a fortress. This is where the record of his career had been entered in his youth, when he was still engaging in far-flung travels. And now he bids farewell to this city and this building, which have caused him so much suffering." Ibid., p. 161. [Benjamin's note. "Le Squelette laboureur" (The Laborer-Skeleton) is a poem in *Les Fleurs du mal.*—*Trans.*]

249. Ibid. The will to preserve "traces" is most decisively involved in this art. Meryon's title page for his series of etchings shows a split rock bearing the imprinted traces of ancient plant forms. [Benjamin's note]

250. See Pierre Hamp's reproachful remark: "The artist . . . admires the column of a Babylonian temple and despises the factory chimney." Pierre Hamp, "La Littérature, image de la société," *Encyclopédie française,* vol. 16: *Arts et littératures dans la société contemporaine,* I (Paris, 1935), fasc. 16.64-1. [Benjamin's note]

251. Baudelaire, *Oeuvres,* vol. 2, p. 293: *Curiosités esthétiques,* sect. 11, "Peintres et aqua-fortistes." [Benjamin's note]

252. Proust, "A propos de Baudelaire," *Nouvelle Revue Française* (June 1, 1921), p. 656. [Benjamin's note]

253. Charles Marie Leconte de Lisle (pseudonym of Charles Marie Lecomte; 1818–1894), French poet and a leading figure among the group of writers called the Parnassians, is renowned for his translations of Homer, Aeschylus, and Euripides. He was elected to the Académie Française in 1886.

254. Giovanni Battista Piranesi (1720–1778) was an Italian etcher, archaeologist, and architect. His *Vedute di Roma* (Views of Rome; published in stages after 1745), consisting of 137 etchings of ancient and modern Rome, with their poetic treatment of ruins, had a great effect on the Romantic idea of Rome.

255. Baudelaire, *Oeuvres,* vol. 1, p. 53. [Benjamin's note]

256. Barbey d'Aurevilly, "Du dandysme et de G. Brummel," in *Memoranda* (Paris, 1887), p. 30. [Benjamin's note]

257. Baudelaire, *Oeuvres,* vol. 2, p. 162: *Curiosités esthétiques,* "Exposition universelle, 1855" ("Eugéne Delacroix"). [Benjamin's note. Eugène Delacroix (1798–1863), foremost French Romantic painter, had his most profound ef-

fect as a colorist. Théophile Gautier (1811–1872), French man of letters, was a leader of the Parnassians and a friend of Baudelaire's. He published the novel *Mademoiselle de Maupin* in 1835. Hyacinthe Delatouche (1785–1851) published his novel *Fragoletta,* which concerns a hermaphrodite, in 1829.—*Trans.*]

258. Henri de Saint-Simon (1760–1825), French social theorist, is credited with founding Christian socialism. His most important work, *Le Nouveau Christianisme* (The New Christianity; 1825), insisted that human fraternity must accompany any scientific restructuring of society. Charles Duveyrier (1803–1866) was the editor of *L'Organisateur,* a weekly journal published by the Saint-Simonians between 1829 and 1831. Duveyrier's "Ville Nouvelle" (New City) appeared in *Le Livre des Cent-et-un* in 1832; it attempts to reanimate a moribund Paris through the vision of Paris as global metropolis combining the populations and best features of all continents.

259. Henry-René d'Allemagne, *Les Saint-Simoniens, 1827–1837* (Paris, 1930), p. 310. [Benjamin's note]

260. Claire Démar (ca. 1800–1833), French woman of letters, was a passionate advocate of Saint-Simonianism. She committed suicide. See *The Arcades Project,* Convolute U14,5 and p2,4ff. Barthélemy Prosper Enfantin (1796–1864), eccentric French social, political, and economic theorist, was a leading member of the Saint-Simonian movement.

261. Claire Démar, *Ma loi d'avenir: Ouvrage posthume publié par Suzanne* (Paris, 1834), pp. 58ff. [Benjamin's note]

262. Quoted in Maillard, *La Légende de la femme émancipée* (Paris, n.d.), p. 65. [Benjamin's note]

263. Baudelaire, *Oeuvres,* vol. 2, p. 445: *L'Art romantique,* "Madame Bovary," sect. 3, last para. [Benjamin's note]

264. Ibid., p. 448: *L'Art romantique,* "Madame Bovary," sect. 5. [Benjamin's note]

265. Ibid., vol. 1, p. 157. [Benjamin's note]

266. Ibid., p. 161. [Benjamin's note]

267. This may be an allusion to Claire Démar's *Ma loi d'avenir.* [Benjamin's note. On Fourier, see note 20 above.—*Trans.*]

268. Baudelaire, *Oeuvres,* vol. 2, p. 534: *L'Art romantique,* sect. 19.3 ("Marceline Desbordes-Valmore"). [Benjamin's note]

269. *Paris sous la République de 1848: Exposition de la Bibliothèque et des travaux historiques de la ville de Paris* (Paris, 1909), p. 28. [Benjamin's note. Les Vésuviennes was the name given to a group of women of unconventional morals who formed a political association in 1848. See *The Arcades Project,* Convolute V9,3; p5,1; and p2,2.—*Trans.*]

270. A fragment from 1844 (*Oeuvres,* vol. 1, p. 213) seems pertinent here. Baudelaire's well-known drawing of his mistress shows her walking in a way that bears a striking resemblance to the gait of a pregnant woman. This does not disprove his antipathy. [Benjamin's note. The 1844 fragment begins, "Noble femme au bras fort," and ends, "Tant tu crains et tu fuis le stigmate alarmant / Que la vertu creusa de son sec infamant / Au flanc des matrones enceintes."—*Trans.*]

271. George Sand (pen name of Aurore Dupin, baronne Dudevant; 1804–1876), French writer, published more than eighty novels. A Romantic early in her ca-

reer, she later developed a concern for social issues. Her liaisons with Jules Sandeau, Alfred de Musset, and Frédéric Chopin were open and notorious.

272. Jules Lemaître, *Les Contemporains* (Paris, 1895), pp. 29ff. [Benjamin's note. On Lemaître, see note 7 above.—*Trans.*]

273. Baudelaire, *Oeuvres,* vol. 1, p. 67 ("L'Invitation au voyage"). [Benjamin's note]

274. Ibid., vol. 2, p. 630: *Journaux intimes,* "Fusées," sect. 11. [Benjamin's note]

275. Ibid., p. 352: "Le Peintre de la vie moderne," sect. 9 ("Le Dandy"). [Benjamin's note]

276. Ibid., p. 351. [Benjamin's note]

277. François-René, vicomte de Chateaubriand (1768–1848), French writer and statesman, was the foremost French Romantic author. His great stylistic gift, and especially his musical prose, produced a series of masterly essays, histories, and apologies for Christianity.

278. Taxile Delord et al., *Les Petits-Paris: Par les auteurs des "Mémoires de Bilboquet"* (Paris, 1854), vol. 10: *Paris, viveur,* pp. 25ff. [Benjamin's note]

279. The term *Trauerspiel,* which means literally "mourning play," "play of sorrow," designates in particular a genre of royal martyr drama popular in sixteenth- and seventeenth-century Europe, a genre analyzed by Benjamin in his book *Ursprung des deutschen Trauerspiels* (Origin of the German *Trauerspiel;* written 1924–1925). According to Benjamin, Shakespeare's *Hamlet* is a supreme example of *Trauerspiel.*

280. Baudelaire, *Oeuvres,* vol. 1, p. 101. [Benjamin's note]

281. See Champfleury, *Souvenirs et portraits de jeunesse* (Paris, 1872), p. 135. [Benjamin's note. Champfleury (pen name of Jules Husson; 1821–1889) was a prominent theorist and practitioner of French literary realism.—*Trans.*]

282. Reprinted from *La Situation,* in André Billy, *Les Ecrivains de combat* (Paris, 1931), p. 189. [Benjamin's note. A *cabotin* is a ham actor. Jules Vallès (1832–1885), French novelist and journalist, is remembered above all as the author of autobiographical novels.—*Trans.*]

283. See Gide, "Baudelaire et M. Faguet," in *Nouvelle Revue Française* (November 1, 1910), p. 29. [Benjamin's note. André Gide (1869–1951), French writer, humanist, and moralist, produced a series of remarkable novels, including *L'Immoraliste* (The Immoralist; 1902) and *Les Faux Monnayeurs* (The Counterfeiters; 1926). A cofounder of the *Nouvelle Revue Française,* he received the Nobel Prize for literature in 1947. See "André Gide and Germany" and "Conversation with André Gide" in Volume 2 of this edition.—*Trans.*]

284. See Jacques Rivière, *Etudes* (Paris, 1948), p. 15. [Benjamin's note. Jacques Rivière (1886–1925), French man of letters, edited the *Nouvelle Revue Française* from 1919 until his death.—*Trans.*]

285. See Lemaître, *Les Contemporains,* p. 29. [Benjamin's note]

286. Jules Laforgue, *Mélanges posthumes* (Paris, 1903), p. 113. [Benjamin's note. The line is from Baudelaire's poem "Le Balcon." On Laforgue, see note 145 above.—*Trans.*]

287. From this wealth, the following may be cited:
 "Nous volons au passage un plaisir clandestin / Que nous pressons bien fort comme une vieille orange [We hastily steal a clandestine pleasure, / Which we

squeeze very hard like an old orange]" (Baudelaire, *Oeuvres,* vol. 1, p. 17: "Au Lecteur").

"Ta gorge triomphante est une belle armoire [Your triumphant bosom is a fine wardrobe]" (Ibid., p. 65: "Le Beau Navire").

"Comme un sanglot coupé par un sang écumeux / Le chant du coq au loin déchirait l'air brumeux [Like a sob stifled by frothy blood, / The distant cock-crow was rending the hazy air]" (ibid., p. 118: "Le Crépuscule du matin").

"La tête, avec l'amas de sa crinière sombre / Et de ses bijoux précieux, / Sur la table de nuit, comme une renoncule, / Repose [The head, with the mass of its dark mane / And its precious jewels, / Rests on the night-table / Like a ranunculus]" (ibid., p. 126: "Une Martyre"). [Benjamin's note]

288. Pierre Antoine Lebrun (1785–1873), French classicistic tragedian and poet, wrote *Le Cid d'Andalousie* (1825). *Chambre* ("bedroom") and *mouchoir* ("handkerchief") were words deemed inappropriate to the elevated language of tragic drama.

289. Charles-Augustin Sainte-Beuve, *Vie, poésies et pensées de Joseph Delorme* (Paris, 1863), vol. 1, p. 170. [Benjamin's note. "Joseph Delorme" is Sainte-Beuve's pseudonym.—*Trans.*]

290. Baudelaire, *Oeuvres,* vol. 1, p. 57. [Benjamin's note. "The vague terrors of those frightful nights which compress the heart the way one crumples a piece of paper." These lines are from the poem "Réversibilité," in *Les Fleurs du mal* ("Spleen et idéal").—*Trans.*]

291. Népomucène Lemercier (1771–1840), French neoclassical dramatist and novelist, is considered a forerunner of Romanticism.

292. Quoted in Rivière, *Etudes* (Paris, 1948), p. 15. [Benjamin's note. Paul Claudel (1868–1955), poet, playwright, and essayist, was an important force in French letters at the turn of the century. The tone and lyricism of his work owe much to his deeply felt Catholicism.—*Trans.*]

293. On January 10, 1870, Prince Pierre Bonaparte, Napoleon III's rather unstable cousin, killed a young journalist in the heat of a quarrel concerning alleged published insults. The journalist, Yvan Salmon, went by the name Victor Noir. The prince was acquitted of murder by a special high court of justice at Tours. The affair and its outcome contributed significantly to the unpopularity of the imperial family and to the growth of a revolutionary party.

294. Ernest Henri Granger (1844–1914), a wealthy French lawyer, allied himself with Blanqui in 1865 and rose to become a trusted deputy.

295. Gustave Geffroy, *L'Enfermé* (Paris, 1897), pp. 276ff. [Benjamin's note]

296. Quoted in Eugène Crépet, *Charles Baudelaire* (Paris, 1906), p. 81. [Benjamin's note. *Le Salut Public* was a short-lived newspaper founded by Baudelaire, Champfleury, and Charles Toubin. Two issues appeared, in February and March 1848. The name, recalling the infamous Committee of Public Safety formed under the Terror in 1793, came from Baudelaire. Its brief, unsigned articles were full of revolutionary enthusiasm for "the people," its republic, and a socialist Christ.—*Trans.*]

297. Baudelaire, *Oeuvres,* vol. 1, p. 136. [Benjamin's note. "Un monde où l'action n'est pas la soeur du rêve": the line is from the poem "Le Reniement de Saint Pierre," in *Les Fleurs du mal.—Trans.*]

298. The following three paragraphs on method, as well as the section entitled "Taste" which follows them, were evidently composed as portions of an introduction to the book—tentatively titled *Charles Baudelaire: A Lyric Poet in the Era of High Capitalism*—that Benjamin intended to write but never completed. See the first note to this chapter.

299. *Doxa* is Greek for "opinion," "false judgment." In *The Republic,* Plato posits an intermediate stage between true knowledge and ignorance. This quasi-knowledge of quasi-being is *doxa;* its objects are the data of sense perception and the commonly held opinions of human beings.

300. The incalculable consequences of the more resolute procedure are rather forbidding in other respects as well. There is little point in trying to include the position of a Baudelaire in the fabric of the most advanced position in mankind's struggle for liberation. From the outset, it seems more promising to investigate his machinations where he was undoubtedly at home: in the enemy camp. Very rarely are they a blessing for the other side. Baudelaire was a secret agent—an agent of the secret discontent of his class with its own rule. [Benjamin's note. The quotation to which this note is appended comes from Benjamin's own essay "Eduard Fuchs, Collector and Historian," in Volume 3 of this edition.—*Trans.*]

301. This is Marx's description of the commodity in the section of *Capital* entitled "The Fetishism of Commodities and Its Secret." The sentence reads: "At first sight, a commodity appears a very trivial thing, easily understood. Analysis shows that it is, in reality, a very queer thing, abounding in metaphysical subtleties and theological niceties."

302. Jean Antoine Claude Chaptal, comte de Chanteloup (1756–1832), was a French chemist, physician, and politician. He played a significant role in the development of the chemical industry in France, and in European industrial expansion in general.

303. On *l'art pour l'art,* see note 6 above.

304. "Pierre Louÿs écrit: le throne; on trouve partout des abymes, des ymages, ennuy des fleurs, etc. . . . Triomphe de l'*y.*" [Benjamin's note. "Pierre Louÿs writes 'le throne'[with the older Latinate spelling]; everywhere one finds abysses, ymages, ennuy of flowers, and the like. . . . The triumph of the *y.*" Benjamin is quoting from Paul Morand, *1900* (Paris, 1931), pp. 180–181.—*Trans.*]

Blanqui

During the Commune, Blanqui was held prisoner in the fortress of Taureau.[1] There he wrote *L'Eternité par les astres*. The book consummates the constellations of phantasmagorias, the magical images of the century, in a final phantasmagoria. It is conceived on a cosmic plane and contains a bitter critique of the other magical images. The naïve reflections of an autodidact, which form the principal portion of this work, open the way to merciless speculations that give the lie to the author's revolutionary élan. The conception of the universe which Blanqui develops in this book, taking his basic premises from the mechanistic natural sciences, proves to be a vision of hell. It is the necessary complement of precisely that society whose triumph Blanqui at the end of his life could no longer deny. The unconscious irony of Blanqui's elaborate enterprise is that the terrible accusation he directs against society takes on the form of unconditional acquiescence to its tendencies. The book proclaims the idea of the eternal return ten years before Nietzsche's *Zarathustra*, with hardly less pathos and with truly hallucinatory power.

The impression left by the book is depressing rather than triumphal. Blanqui's aim is to sketch an image of progress. It turns out to be a magical image of history itself, as immemorial antiquity dressed up in ultramodern garb. The most important passage is as follows:

> The whole universe consists of astral systems. To create them, nature has only one hundred elements at its disposal. Despite all its ingenuity and the infinite

number of combinations available to its fertility, the result is necessarily a finite number, like the number of the elements themselves. To fill up space, nature must repeat its original combinations and types ad infinitum. Accordingly, each star must exist in time and space an infinite number of times, not just as it appears once, but at each moment of its duration from its genesis to its death. The earth is such a star. Hence, each human being, too, is eternal at each moment of its existence. What I am writing at this moment in a cell in the Fort Du Taureau I have written and will write throughout eternity—at a table, with a pen, in circumstances absolutely identical to the present ones. It is the same for everyone. . . . We have innumerable doubles in time and space. . . . These doubles have flesh and blood, trousers and overcoats, crinolines and chignons. They are not phantoms but eternalized reality. One thing, to be sure, is lacking in them: progress. What we call by that name is walled up in each earth and passes away with it. Always and everywhere on the earth, the same drama, the same setting, on the same narrow stage—a clamorous humanity intoxicated with its greatness. Always and everywhere it believes itself the universe, living in its prison as if it were immeasurable, only to sink—along with the terrestrial globe itself—into the shadows which soon put an end to its arrogance. The same monotony, the same immobility on the other stars. The universe repeats itself endlessly, marking time on the spot. Unwaveringly, eternity performs the same play over and over again, in infinity.[2]

This renunciation without hope is the last word of the great revolutionary. The century was incapable of responding to the new technological possibilities with a new social order.

Fragment written in early 1938; unpublished in Benjamin's lifetime. *Gesammelte Schriften*, I, 1153–54. Translated by Edmund Jephcott.

Notes

This fragment is part of a larger complex of material extracted from the Arcades Project (see in this case the Conclusion to the "Exposé of 1939") and expanded in preparation for the writing of a book which bore the working title *Charles Baudelaire: Ein Lyriker im Zeitalter des Hochkapitalismus* (Charles Baudelaire: A Lyric Poet in the Age of High Capitalism). The book was never completed. Blanqui would have played, along with Nietzsche, a key role in the book's third and final section, which Benjamin called "The Commodity as Poetic Object."

1. Louis-Auguste Blanqui (1805–1881) was a French revolutionary socialist and militant anticlerical. He was active in all three major upheavals in nineteenth-century France—the revolutions of 1830 and 1848 and the Paris Commune of 1871—and was imprisoned following each series of events. His book *L'Eternité par les astres* (Eternity via the Stars) was published in 1872.

2. Louis-Auguste Blanqui, *Instructions pour une prise d'armes, L'Eternité par les astres, Hypothèse astronomique, et autres textes* (Paris: Société Encyclopédique Française, 1972), pp. 167–169.

The Study Begins with Some Reflections on the Influence of *Les Fleurs du mal*

The study begins with some reflections on the influence [*Nachwirkung*] of *Les Fleurs du mal,* which is almost without parallel. The obvious reasons for this lasting impact are briefly discussed, while the deeper ones, especially the question of what *Les Fleurs du Mal* has to say to the contemporary reader, are the subject of the entire treatise.

The literature on Baudelaire is characterized. It gives only a faint idea of the profound nature of the work's influence, still less of the reasons for this influence. Aesthetic theory has been interested mainly in Baudelaire's doctrine of *correspondances,* but without deciphering it.

Baudelaire's own interpretation of his work is only indirectly illuminating, as will be explained. His view of the Catholic temper of his poetry has been adopted rather uncritically by literary historians.

The decisive difference between a "rescue" [*Rettung*] and an "apologia" will be dealt with in a methodological excursus. The investigations into the approach to history first laid out in the essay on Fuchs will be taken further here.[1]

My account of Baudelaire's allegorical mode of apprehension will form the core of the first part. The peculiar structure of this form of perception, which might be called three-dimensional, will be examined. Baudelaire's poetic sensibility, which up to now has been almost the sole focus of studies of his poetry, is only one of these dimensions. It is significant primarily on account of its polarity. Baudelaire's sensibility is divided between a spiritual, even seraphic pole on one side and an idiosyncratic pole on the other; one is represented by the seraph, the other by the *fetish.*

Yet the sensitive side, for all its richness, gives only a faint idea of Baudelaire's poetic genius. One must also take account of his melancholy

genius. Here, too, a clear polarization is evident. Baudelaire's mind is not philosophical; nevertheless, he depicts the nature of the brooding melancholic with uncommon penetration. His melancholy is the sort that was characterized by the Renaissance as heroic. It is polarized between idea and image. That is to say, in his work the image is never a reflection of sensibility alone, while the idea is never a mere artifact of thought. Idea and image play into each other, as is characteristic of the brooder. Through his use of intoxicants, Baudelaire exploited this disposition in a special way. An excursus on the interweaving of images and ideas peculiar to hashish will follow at this point.

The allegorical mode of apprehension is always built on a devalued world of appearances. The specific devaluation of the world of things, as manifested in the commodity, is the foundation of Baudelaire's allegorical intention. As an embodiment of the commodity, the whore has a central place in his poetry. From another point of view, the whore is allegory incarnate. The props with which fashion equips her are her allegorical emblems. The hallmark of genuineness for the commodity is the fetish; for the allegory, it is the emblem. In the soulless body, which is still devoted to providing pleasure, allegory and commodity are wed. The poem "Une Martyre" holds a central place in Baudelaire's work. It presents the masterpiece on which the *apparat de la destruction* has done its work. This devaluation of the human environment by the commodity economy penetrates deeply into the poet's historical experience. What results is the "ever-selfsame." Spleen is nothing other than the quintessence of historical experience.

Nothing seems more contemptible than to invoke the idea of progress against this experience. Furthermore, in representing a continuum it radically contradicts Baudelaire's destructive impulse, which is, on the contrary, inspired by a mechanical conception of time. Nothing can be pitted against the overwhelming power of spleen except the new, and deploying the new is the true task of the modern hero. Indeed, the supreme originality of Baudelaire's poetry lies in the way it elevates *l'héroïsme dans la vie moderne* to exemplary status. His poems are tasks, and even his discouragement and lassitude are heroic acts.

The modernity which is manifested in Baudelaire's work can be situated historically. Baudelaire is a forerunner of Jugendstil, and *Les Fleurs du mal* are the first ornaments of this movement.

Crucially, however, the new, in whose name the poet seeks to withstand despondency, itself bears the stigma—in the highest degree—of the reality he rebels against. The new, as a conscious aim of artistic production, goes no further back than the nineteenth century. Baudelaire's work is not concerned with the attempt, decisive in all the arts, to engender new forms or to reveal new aspects of things; its interest is in the fundamentally new object, whose power resides solely in the fact that it is new, no matter how repul-

sive or bleak it may be. This trait has been correctly assessed by a number of commentators, above all Jules Laforgue and Valéry, with regard to its special significance for Baudelaire.[2]

Baudelaire's project takes on historical significance, however, only when the experience of the ever-same, which provides the standard for assessing that project, is given its historical signature. This happens in Nietzsche and in Blanqui.[3] Here, the idea of the eternal return is the "new," which breaks the cycle of the eternal return by confirming it. This conjunction with Nietzsche, and above all with Blanqui, who developed the theory of eternal return ten years earlier, shows Baudelaire's work in a new light.

It is now possible to address the abyss, whose nearness Baudelaire felt throughout his life. Blanqui saw the eternity of the world and of human beings—the eversame—as guaranteed by the order of the stars. Baudelaire's abyss is starless. Indeed, his lyric poetry is the first in which the stars do not appear. The line "dont la lumière parle un langage connu" is the key to this poetry.[4] In its destructive energy, not only does it break, through its allegorical conception, with the nature of poetic inspiration, and, through its evocation of the city, with the rural nature of the idyll; but, through the heroic resolution with which it makes lyric poetry at home in the heart of reification, it also breaks with the nature of things. Its locus is the point where the nature of things is overwhelmed and transformed[5] by the nature of human beings. Subsequent history has shown that, in his effort to bring this about, he was right not to rely on technological progress.

Fragment written in early 1938; unpublished in Benjamin's lifetime. *Gesammelte Schriften*, I, 1150–52. Translated by Edmund Jephcott.

Notes

This fragment is part of a larger complex of material extracted from the Arcades Project and expanded in preparation for the writing of a book which bore the working title *Charles Baudelaire: Ein Lyriker im Zeitalter des Hochkapitalismus* (Charles Baudelaire: A Lyric Poet in the Age of High Capitalism). The fragment represents Benjamin's working notes toward the overall structure of that book, which was never completed.

1. See the essay "Eduard Fuchs, Collector and Historian," in Volume 3 of this edition.
2. Jules Laforgue (1860–1887), French poet and critic, was one of the most distinguished of the Symbolists. Paul Valéry (1871–1945), French man of letters also associated with the Symbolist group, published books of verse and prose. Among the former are *Aurore* (1917) and *Le Cimetière marin* (1920), and among the latter are *Soirée avec M. Teste* (1895), *L'Ame et la danse* (1924), and *Analecta* (1927). He was elected to the Académie Française in 1925.

3. Friedrich Nietzsche (1844–1900), German philosopher and professor of classical philology at Basel (1869–1879), introduced the idea of eternal return in his books *Die fröhliche Wissenschaft* (The Gay Science; 1882) and *Also sprach Zarathustra* (Thus Spoke Zarathustra; written 1883–1885, published 1883–1884, 1892), and developed it in later writings. See Benjamin's *Arcades Project*, Convolute D8,1–D10a,5. Louis-Auguste Blanqui (1805–1881) was a French revolutionary socialist and militant anticlerical. He was active in all three major upheavals in nineteenth-century France—the revolutions of 1830 and 1848 and the Paris Commune of 1871—and was imprisoned following each series of events.

4. The line comes from the third stanza of Baudelaire's poem "Obsession" in *Les Fleurs du mal:* "Comme tu me plairais, ô nuit! sans ces étoiles / Dont la lumière parle un langage connu! / Car je cherche le vide, et le noir, et le nu!" ("How you would please me, O night, without those stars / Whose light speaks a language I know too well! / For I seek the blank, and the black, and the bare!").

5. The reading of this word *(umgeschaffen)* in the manuscript is uncertain.

Exchange with Theodor W. Adorno on "The Paris of the Second Empire in Baudelaire"

<div align="right">[New York], November 10, 1938</div>

Dear Walter,

My delay in writing to you exposes me and all of us here to dire accusations.[1] But perhaps these may be mixed with a grain of self-justification. For it goes without saying that my month-long delay in responding to your Baudelaire essay is not the result of indolence.

The reasons are purely practical. They stem from the reaction that all of us had to the manuscript, and from mine in particular. I can say this without immodesty, given my engagement with the question of the Arcades Project.[2] I looked forward to the arrival of the Baudelaire with great eagerness, and literally devoured it. I'm full of admiration for your achievement in completing the work on schedule. And this admiration makes it all the more difficult for me to talk about the discrepancy I found between my passionate expectations and the text itself.

I took extremely seriously your idea of considering the Baudelaire piece as a model for the Arcades, and approached the satanic spot not unlike Faust as he drew near the phantasmagoria of the Brocken, expecting to find many a riddle solved.[3] Will you forgive me for responding, like Mephisto, that many a riddle knots itself anew? Can you understand that a reading of the treatise, one chapter of which is entitled "The Flâneur" and another actually "Modernity," caused me a certain disappointment?

This disappointment springs primarily from the fact that the parts of the work known to me represent not so much a model for the Arcades as a prelude.[4] Motifs are assembled but not worked through. In your cover letter to Max[5] you presented this as your express intention, and I do not underestimate the ascetic discipline to which you've subjected yourself in omitting all

the crucial theoretical answers, and even in making the questions invisible to all but initiates. But I would ask whether such abstinence can be maintained toward this subject, and in a context which makes such imperious inner demands. As a true connoisseur of your writings, I am aware that there is no lack of precedents for such a procedure in your oeuvre. I recall such instances in your essays on Proust and on Surrealism in *Die literarische Welt*.[6] But can this procedure be applied to the Arcades complex? Panorama and "trace," flâneur and arcades, modernity and the ever-same, *without* theoretical interpretation: Is this "material" that can wait patiently for interpretation without being consumed by its own aura? On the contrary, doesn't the pragmatic content of these subjects, if isolated, conspire almost demonically against the possibility of its interpretation? During our unforgettable conversations in Königstein, you once remarked that each of the ideas in the Arcades would actually have to be torn from a realm in which madness reigned.[7] I wonder whether this is made easier by blockading the ideas behind impenetrable walls of material, as your ascetic discipline requires. In your present text, the arcades are introduced by a reference to the narrowness of the sidewalks, which hinders the flâneur in the streets. This pragmatic introduction seems to me to prejudice the objectivity of the phantasmagoria that I insisted on so stubbornly in our Hornberg correspondence;[8] the tendency of the first chapter to reduce the phantasmagoria to modes of behavior among the literary *bohème* has the same effect. Do you not fear—I'll say it outright—that the phantasmagoria will survive unmediated in your work, or even that the work itself might take on a phantasmagoric character? A profound and thorough liquidation of the phantasmagoria can succeed only if it is conceived as an objective category of the history of philosophy, but not if it is conceived as the "view" of social characters. On this particular point, your approach diverges from any other attempt to elucidate the nineteenth century. But the proof of your hypothesis cannot be deferred *ad calendas Graecas*,[9] or the ground for it "prepared" with a less contentious presentation of the subject matter. That is my objection. And when, in Part III (to use the old formulation once more), the primal history [*Urgeschichte*] *of* the nineteenth century is replaced by primal history *in* the nineteenth century (the old formulation once more)—most clearly in the quotation from Péguy on Victor Hugo—that is just another manifestation of the same situation.[10]

This objection seems to me to concern not merely the questionable status of your "abstention" on a subject which, precisely through *askesis* from interpretation, appears to be transported into a realm toward which *askesis* should be directed: the realm where history and magic oscillate. Rather, the moments in which the text falls short of its own *a priori* potential seem to me closely bound up with its relation to dialectical materialism. It is precisely on this point that I speak not only for myself but for Max, with

whom I have discussed this question in the greatest detail. Let me express myself in the simplest and most Hegelian manner possible. If I am not much mistaken, this dialectic lacks one thing: mediation. There is a persistent tendency to relate the pragmatic content of Baudelaire's work directly to adjacent features of the social history of his time, especially economic ones. I'm thinking, for example, of the passage on the wine tax, some reflections on the barricades, or the aforementioned remark about the arcades. This seems to me particularly problematic, since the transition from an inherently theoretical consideration of physiologies to the "concrete" portrayal of the flâneur is especially tenuous.

I have this sense of artificiality wherever the work substitutes a metaphorical statement for a bindingly literal one. This applies above all to the passage on the transformation of the city into an *intérieur* for the flâneur, where one of the grandest conceptions in your work seems to me to take the form of a mere "as if." In the face of such materialist excursuses, one cannot quite shake off the trepidation one feels on behalf of a goose-pimply swimmer plunging into icy water. They are intimately connected to the appeal to concrete forms of behavior, like the behavior of the flâneur in this instance, or, later, in the passage on the relationship between sight and hearing in the city, which not quite fortuitously includes a quotation from Simmel.[11] All this makes me uneasy. Don't be afraid that I shall take the opportunity it gives me to mount my hobbyhorse. I'll content myself with feeding him a lump of sugar in passing, and will try to indicate the theoretical reason for my aversion to that particular form of the concrete and its behaviorist traits. The reason is that I regard it as methodologically unsound to use single obvious features from the superstructure "materialistically" by placing them in direct or even causal relation to corresponding features of the base. The materialist determination of cultural characteristics is possible only when mediated through the *process as a whole*.

Regardless of the extent to which Baudelaire's wine poems may have been inspired by the wine tax and the *barrières,* the recurrence of these motifs in his oeuvre can be determined only by the general social and economic tendency of his age, *sensu strictissimo* through an analysis of the commodity form in Baudelaire's epoch. That is the question posed by your work. No one knows better than I do the difficulties this entails; you doubtless did not find the chapter on phantasmagoria in my Wagner book equal to them.[12] The Arcades in its definitive form will not be able to evade that obligation. The direct connection drawn between the wine tax and "L'Ame du vin"[13] ascribes to phenomena the very spontaneity, tangibility, and density that capitalism has stripped from them. In this kind of unmediated—I would almost say anthropological—materialism lurks a deeply Romantic element, which becomes clearer to me the more straightforwardly and starkly you juxtapose Baudelaire's world of forms with the neediness of life. Now, the

"mediation" I find lacking, and obscured by materialist-historiographic in-vocation, is nothing other than the theorizing from which your work ab-stains. The exclusion of theory confirms the empirical. It gives it a delusively epic character on the one hand, and on the other deprives phenomena, as mere objects of subjective experience, of their true historico-philosophical weight. This could also be expressed by saying that the theological motif of calling things by their names is inherently prone to lapse into a wide-eyed presentation of mere facticity. If one wished to give the matter really drastic expression, one might say that the work has situated itself at the crossroads of magic and positivism. This site is bewitched. Only theory could break the spell: your own relentless theory, speculative in the best sense. It is only the interests of that theory that I am defending against you.

Forgive me if this leads to a subject that cannot help being of special con-cern to me after my experience with the Wagner book. I'm referring to the ragpicker. To define him as the figure marking the lower limit of poverty simply does not seem to fulfill what the word "ragpicker" promises when it appears in your texts. It conveys nothing of the cringing, the sack slung over the shoulder; nothing of the voice that provides, as it were, the black light-source for a whole opera, as in Charpentier's *Louise;*[14] nothing of the comet-tail of jeering children following the old man. If I may venture once more into the realm of the Arcades: for me, a discussion of the ragpicker would have been the place to decipher theoretically the equivalence of sewer and catacomb. But am I going too far in assuming that this deficiency is linked to the fact that the capitalist function of the ragpicker—to subject even begging to exchange value—is unarticulated? At this point, the work's asceticism reaches a pitch worthy of Savonarola.[15] The reprise of the ragpicker in the quotation from Baudelaire in Part III brings this link close enough to be grasped. What must it have cost you not to grasp it!

I think I am touching here on the central point. The effect produced by the whole work—and not just on me, with my Arcades orthodoxy—is that you have done violence to yourself in it. Your solidarity with the institute, which pleases no one more than me, has caused you to pay tribute to Marx-ism; but such tribute satisfies neither it nor you. It fails to do justice to Marxism because it omits the mediation by the total societal process and because, almost superstitiously, it attributes to materialist enumeration powers of illumination which are reserved solely to theoretical interpreta-tion and never to pragmatic pointing. And it fails what is most distinctive and substantial about your project in that—if only by the postponement I have referred to—you have placed your boldest and most fertile ideas under the prohibition of a kind of precensorship by materialist categories (which by no means coincide with those of Marxism). I speak not only for myself, incompetent as I am, but for Horkheimer and the others when I say we are all convinced that not only would it benefit "your" production if you could

elaborate your ideas without recourse to such considerations (in San Remo you raised counter-objections to this charge,[16] and I am taking them very seriously), but that it would also prove most beneficial to the cause of dialectical materialism and the theoretical interests represented by the institute if you surrendered to your own specific insights and conclusions without combining them with other ingredients, which you obviously find so distasteful to swallow that I cannot expect anything good to come of it. There is, in heaven's name, only the one truth; and even if your intellectual powers apprehend this truth in categories which may seem to you apocryphal according to your conception of materialism, you will capture more of it with them than by using a thought-mechanism which is always at odds with the natural movement of your hand. In the end, there is more of that one truth in Nietzsche's *Genealogy of Morals* than in Bukharin's *ABC*.[17] I think that this thesis, as I express it, cannot be suspected of laxity and eclecticism. Your study of Goethe's *Elective Affinities* and your book on the Baroque are better Marxism than your discussion of the wine tax and your derivation of phantasmagoria from the practices of the feuilletonists. You may be confident that we are prepared to make your most extreme theoretical incursions our own. But we are equally confident, for our part, that you will actually make these incursions. Gretel[18] once said in jest that you inhabit the deep caverns of the Arcades and shrink from completing the work because you are afraid of having to leave the burrow. So let us encourage you to give us access to the holy of holies. I do not think you need fear either the collapse of the structure or a profaning of it.

Now, as regards the fate of the work, a rather peculiar situation has arisen in which I have had to conduct myself like the singer accompanied by the muffled drum.[19] Publication in the next issue of the *Zeitschrift* will not be possible, because the week-long discussions about your work would have meant an intolerable delay in printing. Then there was a plan to print the second chapter in full and the third in part—Leo Löwenthal especially favored this.[20] I myself am unequivocally against it. Not for editorial reasons, but for your sake and for that of the Baudelaire piece. The work does not represent you as this work in particular must represent you. But as I am firmly and staunchly convinced that you are capable of producing an extremely powerful and penetrating manuscript on Baudelaire, I would ask you most earnestly not to press for publication of the present version but to write that other one. Whether it should have a new formal structure or would be based essentially on the projected last part of your Baudelaire *book* is not for me to surmise. You alone can decide that. I would also like to say expressly that this is a request from me, not an editorial decision or a rejection.

I still need to explain why it is I who have written to you rather than Max, who was the one to whom the manuscript was addressed. At the mo-

ment, his time is taken up with heavy commitments related to his projected move to Scarsdale. He wants to free himself of all administrative work, so that over the next few years he can devote every bit of his energy to the book on dialectic.[21] This means that he must "slough off" all his ongoing obligations. I myself haven't seen him for two weeks. He asked me, as a sort of "sponsor" of the Baudelaire, to write to you instead. His request accorded with my own intention.

I'll give a more detailed account of my own work in my next letter. Publication of the Husserl book has been delayed yet again. Right after his return in mid-September, Max asked me to pursue my long-planned project instead and write the essay "On the Fetish Character of Music and the Regression of Listening." I completed the manuscript a mere three days before your own arrived. It has now gone to press, and I've instructed Brill to send you the galley proofs, along with those of my polemical piece on Sibelius.[22] The work certainly bears the marks of its hasty composition; but perhaps this is not altogether a bad thing. I'm especially eager to hear your response to my theory that nowadays exchange value itself is being consumed. The tension between this theory and your own concerning the buyer's empathy with the soul of the commodity could prove to be quite fruitful. By the way, I think I can add the hope that the far more innocuous character of my piece will allow you to read it more leniently than I was permitted to do with yours.

We've seen Ernst Bloch a few times.[23] The impression he made was extremely negative. The way the corrupted "Popular Front" mentality has mutated into a kind of diligent stupidity can be studied more clearly in him than in any other German I know. Things got heated on two occasions, though not with any significant effects. When we visit him, we do so under the motto: "The finest place on earth, to me, is the grassy mound on my parents' grave."[24]

Let me close with a few epilegomena on the Baudelaire work. First, a stanza from Hugo's second "Mazeppa" poem (the man who is to see all this is Mazeppa, tied on the back of a horse):[25]

> The six moons of Herschel, old Saturn's ring,
> The pole, with night's aurora encircling
> > Its boreal brow:
> All this he sees, and your tireless flight
> Forever expands this limitless world's
> > Ideal horizon.

Then, the tendency to make "unrestricted statements" that you observed in Balzac and in the description of the clerk in "The Man of the Crowd" applies, surprisingly enough, to Sade. Concerning one of Justine's first tormen-

tors, a banker, we read: "Monsieur Dubourg—fat, short, and insolent, like all financiers."[26] The motif of the unknown beloved appears in rudimentary form in Hebbel, in a poem to an unknown woman, which contains the curious lines: "And as I cannot give you form or figure, no form shall snatch you to the grave."[27]—Finally, a few sentences from Jean Paul's *Herbstblumine,* which are probably a real *trouvaille:*

> A single sun was given to the day, but the night was given a thousand suns, and the endless blue sea of the ether seems to float down to us in a filmy shower of light. How many street lamps shimmer all along the Milky Way! And these are always lit, whether in summer or by moonlight. Yet not only does the night adorn itself with the mantle of stars ascribed to it by the ancients, and which I, more tastefully, would call its *spiritual* raiment rather than its ducal cloak; it takes its embellishment much further by imitating the women of Spain, who, when darkness falls, replace the jewels in their headdresses with fireflies. Like those women, night spangles the lower part of its cloak—on which no stars gleam—with similar creatures, which children delight in capturing.[28]

The following sentences—from a quite different piece in the same collection—seem to fit this context:

> And so on. For not only did I notice that to us poor ice-bound people Italy seems a moonlit Eden . . . , because we find the universal youthful dream of night-long rambling and singing fulfilled there every day and every night in real life; I also asked why people wandered and sang in the streets merely as sullen night-watchmen, instead of coming together throughout the dusk and dawn portions as well, blissfully parading, men and maids together (for each soul was in love), amid the glorious woodlands and the moonlight bright with flowers, adding to their harmonious joy two fluted adornments—by which I mean they extended the brief night at each end by the sunrise and sunset and the two attendant twilights.

The idea that the longing for Italy is a longing for a country where one does not need to sleep is closely related to the later image of the roofed-over city. But the light which falls equally on both images is doubtless none other than that of the gas lamp, which was unknown to Jean Paul.

Yours *tout entier,*
Teddie

Paris, December 9, 1938

Dear Teddie,

I am sure you are not surprised that I've needed more than a few moments to formulate a response to your letter of November 10. Although its

contents were to some extent foreseeable because it was so long in coming, it nevertheless dealt me a blow. Apart from that, I wanted to wait for the proofs you said were on the way, but they didn't arrive until December 6.[29] The time thus gained gave me a chance to reflect on your critique as calmly as possible. I am far from considering it unfruitful, still less incomprehensible. I shall try to respond to the principles underlying it.

I shall take as my guiding thread a statement on the first page of your letter. You write: "Panorama and 'trace,' flâneur and arcades, modernity and the ever-same *without* theoretical interpretation—is this 'material' that can wait patiently for interpretation?" The understandable impatience with which you scanned the manuscript for a specific statement has caused you, in my view, to miss the point in some important respects. In particular, you were bound to be disappointed by the third section when you failed to notice that it contains not a single reference to modernity as the "ever-same," or that this key concept is not dealt with at all in the part of the work already written.

As the sentence quoted is in a sense a compendium of your entire exposition, I'd like to go through it word by word. First, you mention panorama. In my text it is incidental. In fact, the concept of the panorama is not really applicable at all in the context of Baudelaire. Since this reference is not intended to find correspondences in either the first or the third part, perhaps it would be best to delete the passage.—The second item on your list is the trace. I wrote in my accompanying letter that one could not get an overview of the philosophical foundations of the book from the standpoint of the second part. If a concept like the trace was to be interpreted in a compelling way, it would have to be first introduced quite casually on the empirical level. I have now been able to do this even more convincingly. In fact, the first thing I did when I returned was to track down a passage from Poe which is crucial to my interpretation of the detective story; it deals with the effacing or fixing of the traces of the individual in the urban crowd. But the treatment of the trace must remain at this level in the second part if it is to be illumined as by a lightning flash in the decisive contexts later. This illumination is already planned. The concept of the trace finds its philosophical determination in opposition to the concept of the aura.

The next term in the sentence I am concerned with is "flâneur." I'm well aware of the deep sympathy, both professional and personal, underlying your objections—but your negative reaction here threatens to pull the ground from under my feet. There is—thank goodness—one branch I can cling to, and it seems to be of sound wood. It is your allusion, at a different point, to the fertile tension which exists between your theory of the consumption of exchange value and my theory of empathy with the commodity's soul. I, too, believe this to be a theory in the strict sense of the word, and it serves as the culmination for the section on the flâneur. This is the

point—and the only one in this part—where theory comes into its own in an *undistorted* way. It's like a single ray of light breaking into an artificially darkened room. But this ray, refracted through a prism, is enough to give an idea of the composition of the light that comes to a focus in the third part of the book. For this reason, the theory of the flâneur—though it can be improved in detail, as discussed below—does essentially fulfill the aspiration I have had for many years with regard to the portrayal of this figure.

Next I come to the term "arcade." I really do not wish to say much about this, particularly since you are aware of the abyssal bonhomie with which it is used. Why do you take exception? Unless I am entirely mistaken, the arcade is not meant to appear in the Baudelaire context except in this casual form. Here, it is like the image of a mountain stream engraved on a drinking glass. For the same reason, the priceless passage from Jean Paul you bring to my attention will probably not have a place in the Baudelaire essay. As for "modernity"—the last term—it is, as the text makes clear, one that is used by Baudelaire himself. The section under this heading should not extend beyond the limits set by Baudelaire's use of the word. You will recall from San Remo that these limits are by no means final. The philosophical reconnoitering of modernity is reserved for the third part, where the subject will be approached via the concept of Jugendstil and brought to a conclusion in the dialectic of the new and the ever-same.

Since I've evoked our conversations in San Remo, I'd like to talk about the passage where you do the same.[30] If, in those discussions, I refused, in the name of my own production-interests, to develop my ideas in an esoteric direction and thereby to address the issues of the day at the expense of dialectical materialism and the institute, that was not just out of solidarity with the institute or loyalty to dialectical materialism but also out of solidarity with the experiences we have all shared over the past fifteen years. My most personal production-interests are likewise at stake here; I will not deny that they sometimes try to do violence to the project's original interests. An antagonism between them does exist, but I have no wish to escape it even in dreams. Resolving it is the central problem of this work, and it is a problem of construction [*Konstruktion*]. I believe that the bold flights of speculation which are required cannot possibly succeed unless—instead of donning the waxen wings of the esoteric—they make construction their sole power-source. The book's structure [*Konstruktion*] dictated that the second part should consist essentially of philological material. This had less to do with "ascetic discipline" than with methodological considerations. Moreover, this philological section was the only one that could be conceived as autonomous from the outset—a circumstance I had to respect.

When you speak of "a wide-eyed presentation of facticity" you are in fact describing the proper philological attitude. It was necessary to adopt this, not just for its results, but for its role in the essay's construction. The non-

differentiation between magic and positivism, as you aptly formulate it, must indeed be liquidated. In other words, the author's philological interpretation is to be sublated by dialectical materialists in the Hegelian manner.—The philological approach entails examining the text detail by detail, leading the reader to fixate magically on the text. That which Faust takes home in black and white, and Grimm's veneration of the minuscule [*Kleinen*], are closely related.[31] They have in common the magical element, which it is left to philosophy—here, the concluding part—to exorcise.

Amazement, you write in your book on Kierkegaard, reflects "the deepest insight into the relation between dialectic, myth, and image."[32] I'm tempted to enlist support from this passage. Instead, I will suggest a correction to it (as, incidentally, I plan to do on another occasion with regard to the accompanying definition of the dialectical image). I think the sentence ought to read: amazement is a primary *object* of such insight. The appearance of self-contained facticity that emanates from philological study and casts its spell on the scholar is dispelled according to the degree to which the object is constructed in historical perspective. The lines of perspective in this construction, receding to the vanishing point, converge in our own historical experience. In this way, the object is constituted as a monad. In the monad, the textual detail which was frozen in a mythical rigidity comes alive. It therefore seems to me to be a misunderstanding of the situation to find in the text, as you do, a "direct connection between 'L'Ame du vin' and the wine tax." Rather, the link has been legitimately established in the philological context—much as one would have to do when interpreting an ancient classical writer. This gives the poem the specific gravity it takes on through a genuine reading—something which has not generally been applied to Baudelaire up to now. It is only when this specific gravity is registered in the poem that the work can be impacted—not to say shattered—by interpretation. In the case of the poem in question, this would link it not to tax questions but to the meaning that Baudelaire attached to intoxication.

If you recall other works of mine, you will find that the critique of the attitude of the philologist is an old concern, and in its innermost core identical to the critique of myth. It provokes, in each case, the application of philological techniques. To use the language of elective affinities: it aims to open up the material content, from which the truth content can then be plucked off historically like petals. I can understand that this aspect of the work did not catch your attention. But some important interpretations eluded you along with it. I'm referring not only to those of certain poems (such as "A une passante") and prose pieces (like "The Man of the Crowd"), but above all to the elucidation of the concept of modernity. Here I was particularly concerned to keep it within philological bounds.

Incidentally, the Péguy quotation—which you criticize as evoking primal history in the nineteenth century—was placed in that position to set the

stage for a particular argument: that an interpretation of Baudelaire should not fall back on chthonic elements. (I tried to make the same point in the exposé for the Arcades.)[33] For this reason, I do not think the catacombs have a place in this interpretation, any more than do the sewers. On the other hand, the opera by Charpentier seems a highly promising suggestion; I'll follow up on it when the opportunity arises.[34] The figure of the ragpicker is of hellish provenance. It will reappear in the third part, set off against the chthonic figure of Hugo's beggar.

I had been worrying for some time about the long-delayed arrival of your letter, as you can imagine, when I came across a passage in Regius just before hearing from you.[35] Under the title "Waiting," it reads as follows: "Most people wait for a letter every morning. That no letter arrives—or, if one does arrive, it contains only a rejection of some kind—generally holds true for those who are sad already." When I came across this passage, I already felt sad enough to take it as a foretaste or presentiment of your own letter. If, ultimately, there was something encouraging for me in the letter (I say nothing about the unchanged perspective it expresses), then it is the fact that your objections, however staunchly they may be shared by other friends, should not be interpreted as a rejection.

Allow me to say one thing quite openly: I think it would be harmful to the Baudelaire essay—the product of an effort for which I find hardly any parallels in my earlier literary works—if none of its parts were published in the *Zeitschrift*. First of all, the distance conferred by the printed form has incomparable value for the author. In addition, the text in printed form could become a subject for discussion—however inadequate the discussants over here might be—and this would compensate somewhat for the isolation in which I work. To my mind, the focal point of such a publication would be the theory of the flâneur, which I see as an integrating element in the Baudelaire piece. I'm by no means thinking that the text should stay unrevised. The critique of the concept of the masses, as they manifest themselves in the modern city, needs to be made more clearly central than it is at present. This critique, whose groundwork is laid in the sections on Hugo, would be implemented through the interpretation of important literary documents. As a model for this, I have in mind the section on "The Man of the Crowd." The euphemistic interpretation of the masses—that is, the physiognomic one—would be illustrated by the E. T. A. Hoffmann story mentioned in the text. I still have to clarify Hugo more thoroughly. What is crucial is to maintain the theoretical continuity of these views of the masses; the climax is hinted at in the text, but not given sufficient prominence. At the end of this progression stands Hugo, not Baudelaire. He came closest to the present-day experience of the masses. Demagoguery was an intrinsic part of his genius.

You will see from this that I find your critique convincing at some points.

But I'm afraid that to revise the text *directly* in the way you indicate would be very hazardous. The lack of theoretical transparency you rightly point to is by no means a *necessary* consequence of the philological procedure used throughout this section. I see it, rather, as resulting from the fact that the use of this procedure is not made explicit. This omission is explained in part by my audacious venture in writing the second part of the book before the first. Only this could have given the impression, moreover, that the phantasmagoria was being merely described, not dissolved in the construction.— The revisions you mention will benefit the second part only if it is firmly anchored on all sides within the overall context. Thus, my first task will be to verify the overall construction.

Concerning the sadness I mentioned earlier, there are reasons enough for it, even apart from the premonitions I mentioned at the outset. First, there is the situation of the Jews in Germany, which none of us can hide from. Added to this is the grave illness of my sister. At the age of thirty-seven, she is suffering from a hereditary form of arteriosclerosis. She is almost incapable of moving, and thus of earning a living (although she still has some minimal savings). At her age, the prognosis is practically hopeless. Apart from all this, it isn't always easy to breathe freely here. I am, of course, making every effort to obtain my naturalization papers. Unfortunately, the necessary *démarches* cost not only much time, but a good deal of money. So on that side, too, the horizon looks rather threatening.

The enclosed extract from a letter to Max of November 17, 1938, and the attached message from Brill,[36] concern a matter which could cause my application for naturalization to be rejected. You can see from this how important they are. Could I ask you to take them in hand and ask Max to authorize Brill without delay, preferably by telegraph, to publish my review in the next issue under the pseudonym "Hans Fellner"?

Now I come to your new work,[37] and thus to the sunnier side of my letter. It directly affects my own work in two respects—both of which you note. First, in the sections that relate certain features of the contemporary acoustic apperception of jazz to the optical ones I describe with regard to film. I can't decide without further reflection whether the different distribution of light and shade in our respective essays stems from a divergence of theory. Possibly it is the result of differences in perspective which are merely apparent and actually apply just as well to different subject matter. I do not mean to suggest that acoustic and optical apperceptions are equally susceptible to a revolutionary upheaval. The fact that the reference to rapidly changing hearing, which closes your essay, may not be quite clear (at least to someone without a profound understanding of Mahler) may be connected to this.

In my piece, I tried to articulate the positive moments of this upheaval as clearly as you have done for the negative ones.[38] I thus see a strength in your work where there was a weakness in mine. Your analysis of the psychologi-

cal types generated by industry, and your account of how they are gener-
ated, is most successful. Had I paid more attention to this aspect of the mat-
ter, my essay would have had a sharper historical profile. It is becoming
ever clearer to me that the launching of the sound film must be seen as the
industry's effort to end the revolutionary hegemony of silent film, which
tended to evoke reactions that were difficult to control and therefore politi-
cally dangerous. An analysis of sound film would yield a critique of present-
day art that would mediate in a dialectical way between your perspective
and mine.

What especially appealed to me at the end of your piece were your veiled
reservations about the concept of "progress." These are first indicated in
passing, in your reference to the history of the term. I would like to get at its
root and its origins, but I don't underestimate the difficulties this would
entail.

I come finally to your question about how the views you develop in this
essay relate to the ones set out in the section on the flâneur. To self-observa-
tion or inner experience, empathy with the commodity presents itself as em-
pathy with inorganic matter; apart from Baudelaire, the principal witness is
Flaubert, with his *Tentation*.[39] Empathy with the commodity might well, in
principle, be empathy with exchange value itself. In fact, it is difficult to
take "consumption" of exchange value to mean anything other than empa-
thy with exchange value. You say that "what the consumer really worships
is the money he has spent on the ticket for the Toscanini concert." Empathy
with the exchange value of guns would make them an even more desirable
object of consumption than butter. If one can say, in the vernacular, that
someone is "fünf Millionen Mark schwer,"[40] then the national populace
currently feels as if it weighs some hundreds of billions. It empathizes with
these hundreds of billions. If I formulate the matter thus, I will perhaps ar-
rive at the general principle underlying this form of behavior. I'm thinking
of the principle of games of chance. The gambler empathizes directly with
the sums with which he challenges the bank or his partner. Gambling, in the
form of stock-market speculation, has played the same pioneering role for
empathy with exchange value as have world exhibitions. (The latter were
training schools in which the masses, excluded from consumption, learned
empathy with exchange value.)[41]

I would like to leave a particularly important question for a later letter,
not to say a meeting. What really goes on when music, and lyric poetry, be-
come comic? I find it difficult to imagine that this is a purely negative phe-
nomenon. Or do you see something positive in the "decay of sacred concili-
ation"? I confess that I'm slightly at a loss here. Perhaps you'll find an
opportunity to come back to this question.

In any case, I hope to hear from you soon. Could you please ask Felizitas
to send me Hauff's fairy tales when she has a chance? I like them because of

Sonderland's illustrations.[42] I'll write to her presently, but would like to hear from her too.

Yours ever most cordially,
Walter

Both letters from Theodor W. Adorno and Walter Benjamin, *Briefwechsel, 1928–1940* (Frankfurt: Suhrkamp, 1994), pp. 364–386. Translated by Edmund Jephcott and Michael Jennings.

Notes

1. Benjamin had submitted the essay "Das Paris des Second Empire bei Baudelaire" (The Paris of the Second Empire in Baudelaire) to the *Zeitschrift für Sozialforschung* at the end of September 1938, and followed this up with a letter to Adorno on October 4. Adorno was one of the editors of the periodical, which in 1938 was being published by the Institute of Social Research in New York (formerly the Institut für Sozialforschung in Frankfurt).
2. See Walter Benjamin, *The Arcades Project,* trans. Howard Eiland and Kevin McLaughlin (Cambridge, Mass.: Harvard University Press, 1999).
3. The Brocken, a mountain in the Harz chain in central Germany, provides the setting for the Walpurgis Night scene in Goethe's *Faust, Part I.*
4. "The Paris of the Second Empire in Baudelaire" was the second part of a planned tripartite book on Baudelaire that bore the working title *Charles Baudelaire: Ein Lyriker im Zeitalter des Hochkapitalismus* (Charles Baudelaire: A Lyric Poet in the Era of High Capitalism).
5. Max Horkheimer was the director of the Institute of Social Research and an editor of the *Zeitschrift für Sozialforschung,* for which Benjamin's first Baudelaire essay was intended. The letter, dated September 28, 1938, appears in *The Correspondence of Walter Benjamin: 1910–1940,* ed. Gershom Scholem and Theodor W. Adorno, trans. Manfred R. Jacobson and Evelyn M. Jacobson (Chicago: University of Chicago Press, 1994), pp. 572–575.
6. Walter Benjamin, "Der Sürrealismus: Die letzte Momentaufnahme der europäischen Intelligenz," *Die literarische Welt,* February 1929; and "Zum Bilde Prousts," ibid., June–July 1929. In English as "Surrealism: The Last Snapshot of the European Intelligentsia" and "On the Image of Proust," in Benjamin, *Selected Writings, Volume 2: 1927–1934* (Cambridge, Mass.: Harvard University Press, 1999), pp. 207–221 and 237–247, respectively.
7. Benjamin had occasionally visited the Adornos in Königstein-im-Taunus from 1928 to 1930. Adorno refers here to a visit, probably in autumn 1929, during which Benjamin read passages from the earliest drafts of the Arcades Project to the Adornos and Max Horkheimer. Compare *The Arcades Project,* pp. 842 (G°,13) and 456 (N1,4).
8. In the summer of 1935, the Adornos and Benjamin had exchanged an important series of letters regarding Benjamin's first exposé for the Arcades Project. See "Paris, the Capital of the Nineteenth Century" and the letter of August 2, 1935,

from Adorno to Benjamin, in Benjamin, *Selected Writings, Volume 3: 1935–1938* (Cambridge, Mass.: Harvard University Press, 2002).

9. *Ad calendas Graecas* means "at the Greek calends"—that is, never. The Greeks had no calends (the day of the new moon) in their mode of reckoning.

10. Charles Péguy (1873–1914), French poet, philosopher, and critic, explored the tenets of Christianity, socialism, and nationalism in his work.

11. Georg Simmel (1858–1918), German sociologist and philosopher, developed a highly influential theory of modernity in such works as *Philosophie des Geldes* (Philosophy of Money) and "Die Großstadt und das Geistesleben" (The Metropolis and Mental Life). His work and his university teaching had a profound effect on the next generation of social philosophers, including Benjamin, Georg Lukács, Ernst Cassirer, Ernst Bloch, and Siegfried Kracauer.

12. See Theodor Adorno, *In Search of Wagner,* trans. Rodney Livingstone (London: New Left Books, 1981). Originally published as *Versuch über Wagner* (1952).

13. A poem in Baudelaire's *Les Fleurs du mal.* The title translates as "The Soul of Wine."

14. Gustave Charpentier (1860–1956) was a French composer. His opera *Louise* dates from 1900.

15. Girolamo Savonarola (1452–1498), an Italian reformer and member of the Dominican order, vehemently denounced corruption in secular and clerical institutions. After the overthrow of the Medicis, he exercised virtual dictatorship in Florence, crusading for the establishment of an ideal Christian state. He was eventually tried for sedition and heresy, tortured, and burned at the stake.

16. The Adornos had visited Benjamin while he was staying at his former wife's pension in San Remo, Italy, in early January 1938.

17. Nikolai Bukharin (1888–1938), Russian Bolshevik, journalist, and economic theorist, was an early ally of Lenin and rose to become chairman of the Comintern's executive committee under Stalin. He fell victim to Stalin's purge trials in 1938 and was secretly executed. His *ABC of Communism,* an important treatise on Communist economic theory, was published in 1921.

18. Gretel Karplus Adorno was Theodor Adorno's wife and Benjamin's friend.

19. The reference is to Adelbert Chamisso's poem "Nach dem Dänischen von Andersen" (After Andersen's Danish), published in 1833: "Es geht bei gedämpfter Trommel Klang" ("We march to the sound of muffled drums").

20. Leo Löwenthal (1900–1993), German philosopher, critic, and editor, joined the Institute of Social Research in 1930 and became the principal editor of the institute's *Zeitschrift für Sozialforschung.* He remained in America after his emigration, and taught at the University of California, Berkeley.

21. Adorno is referring to *Dialektik der Aufklärung* (Dialectic of Enlightenment), originally published in 1947 under the title *Philosophische Fragmente.* This was the major work that grew out of Adorno and Horkheimer's discussions in the late 1930s.

22. Adorno's essay "Über den Fetischcharakter in der Musik und die Regression des Hörens" appeared in the *Zeitschrift für Sozialforschung* in 1938. His "Glosse über Sibelius," to which he presumably refers in the letter, was first published in 1968.

23. Ernst Bloch (1885–1977), German Marxist philosopher, had been Benjamin's friend and his partner in intellectual exchange since the years of the First World War. Benjamin had written a now-lost review of Bloch's first important work, *Der Geist der Utopie* (The Spirit of Utopia). Bloch taught at the University of Leipzig from 1918 to 1933. He fled the Nazis in 1933, moving first to Switzerland and then to the United States. His major work, *Das Prinzip Hoffnung* (translated as *The Principle of Hope*; 3 vols., 1952–1959), appeared after his return to Leipzig in 1948, where he remained until conflict with Communist Party officials led him to defect to West Germany (1961). There he taught at the University of Tübingen.

24. A reference to the poem "Am Elterngrab" (Before My Parents' Grave; 1874), by Marie Eichenberg.

25. See Victor Hugo, *Oeuvres complètes: Edition définitive d'après les manuscrits originaux*, poetry, vol. 2, *Les Orientales; Les Feuilles d'automne* (Paris, 1880), p. 184.

26. Marquis de Sade, *Histoire de Justine, ou Les Malheurs de la vertu*, vol. 1 (Printed in Holland, 1797), p. 13.

27. Friedrich Hebbel (1813–1863), German dramatist and poet, is best-known for his bourgeois tragedies: *Judith* (1841), *Herodes und Mariamne* (1850), and *Agnes Bernauer* (1855). The poem referred to here is called "Auf eine Unbekannte" (To an Unknown Woman); see Friedrich Hebbel, *Sämtliche Werke: Historisch-kritische Ausgabe*, ed. Richard Maria Werner, vol. 6: *Demetrius—Gedichte I und II* (Berlin, 1904), pp. 206–207.

28. Jean Paul Richter (1763–1825), who used the pen name Jean Paul, is remembered for his wildly extravagant, humorous novels that combine fantasy and realism. *Herbstblumine* (1810) is a novel of this sort.

29. Benjamin is referring to the proofs for Adorno's essay "Über den Fetischcharakter in der Musik und die Regression des Hörens" (On the Fetish Character of Music and the Regression of Listening), which appeared in the *Zeitschrift für Sozialforschung* in late 1938.

30. See note 16 above.

31. Benjamin was probably thinking of a remark by Jacob Grimm, which he had already quoted in his commentary on Grimm's letter to Friedrich Christoph Dahlmann in *German Men and Women*: "Our aim was to elevate, interpret, and purify our vocabulary, for collection without understanding leaves us empty; uncritical German etymology achieves nothing; and anyone for whom clear writing is inconsequential [*ein Kleines*] cannot love or recognize what is great in language either." See Benjamin, *Selected Writings, Volume 3*, p. 210.

32. Theodor W. Adorno, *Kierkegaard: Konstruktion des Aesthetischen* (Frankfurt: Suhrkamp, 1962), p. 80. In English, *Kierkegaard: Construction of the Aesthetic*, trans. Robert Hullot-Kentor (Minneapolis: University of Minnesota Press, 1989), p. 54.

33. See "Paris, the Capital of the Nineteenth Century," section V, in Benjamin, *Selected Writings, Volume 3*, pp. 39–41.

34. See note 14 above.

35. "Heinrich Regius" was the literary pseudonym of Max Horkheimer. The passage in question is from Horkheimer's *Dämmerung* (Twilight).

36. Hans Klaus Brill helped run the Paris branch of the Institute of Social Research until its closing at the outbreak of World War II. At issue in this paragraph is Benjamin's review of Roger Caillois' essay "L'Aridité" (among other works).
37. "On the Fetish Character of Music and the Regression of Listening."
38. Benjamin is referring to his essay "Das Kunstwerk im Zeitalter seiner technischen Reproduzierbarkeit." In English as "The Work of Art in the Age of Its Technological Reproducibility," in this volume.
39. Gustave Flaubert published his novel *La Tentation de Saint Antoine* (The Temptation of Saint Anthony) in 1874.
40. The German phrase means "weighs five million marks."
41. Benjamin's formulation is echoed in his study of the arcades. See *The Arcades Project,* p. 201 (Convolute G16,6); see also p. 18.
42. "Felizitas" was Benjamin's nickname for Gretel Adorno. Benjamin was a life-long collector of children's books, and the fairy tales of Wilhelm Hauff (1802–1827), in an edition illustrated by Sonderland, remained among his favorite volumes. See *Märchen von Wilhelm Hauff, mit 6 Radierungen von Johann Baptist Sonderland,* 8th ed. (Stuttgart, 1853).

Review of Renéville's *Expérience poétique*

Rolland de Renéville, *L'Expérience poétique* [The Poetic Experience] (Paris: Gallimard, 1938), 196 pages.

German Romantic literature has been denied the secular fulfillment that French Romantic literature achieved in Victor Hugo. Only the work of E. T. A. Hoffmann is known outside Germany.[1] His reception in France was both tumultuous and prompt. The motifs forming what might be seen as the incandescent core of German Romanticism took longer to enter European consciousness. This core is located in the poetic theories developed by the first generation of German Romantics. These theories did not always attain a clearcut form, and it would be difficult to name a single product of German Romanticism which fully realizes them. Nevertheless, it is primarily to them that German Romanticism owes its place in world literature. This is borne out by the fact that Novalis is the Romantic master best known outside Germany.[2] The Blue Flower pursued by Heinrich von Ofterdingen has become the emblem of the movement. The radiance with which it shines through the Germanic mists is that of Novalis' mystical theory.[3]

"Poetry is the protagonist of philosophy. Philosophy elevates poetry into its principle. It reveals the value of poetry to us. Philosophy is the theory of poetry. It shows us what poetry is: that it is one thing and everything" (Novalis, *Schriften,* ed. J. Minor, vol. 2 [Jena, 1907], p. 301). These words perfectly define what Renéville means by "poetic experience." Of his frequent quotations from Novalis, the one from the seventy-first aphorism in the collection of fragments *Blütenstaub* is particularly apt: "Originally,

poets and priests were one; only in later times were they separated. But the true poet has always remained a priest, just as the true priest has remained a poet" (ibid., p. 126). These statements mark out the field of esoteric poetry. In Nerval's enigmatic sonnet cycle *Les Chimères*, Novalis would probably have found his poetic ideal more fully embodied than in almost any other work.[4] The commentary on the thirteenth poem in this sequence is one of the high points of Renéville's book.

We do not yet have a history of esoteric poetry. Renéville supplies some prolegomena for such a work. His subject consists of the "correspondences" underlying this poetry—correspondences that he traces in the *Tibetan Book of the Dead* and the Kaballah, in Saint John of the Cross and the visions of Anne Catherine Emmerich, in William Blake and Walt Whitman.[5] He takes account of the concepts of Lévy-Bruhl and of recent research in child psychology.[6] His theory of images is related to Jung's theory of archetypes.[7] He attaches particular importance to the prophetic qualities of the unconscious. The image world that gives rise to inspiration is eternally present; it allows the mind to transcend the limits of past and future. "The primitive, the child, the mystic, and the poet move in an eternal present." Again, one is reminded of Novalis: "Inward leads the mysterious path. Within us, or nowhere, is eternity with its worlds, the past and the future" (ibid., p. 114). The last chapter of the book, entitled "The Function of the Poet," culminates in the image of "communication with the celestial spheres"—a spectacle that exerts a vatic fascination for the poet.

Historical contingencies are excluded from Renéville's study. This engenders a programmatic attitude that rises at times to the level of a confession. A true history of esoteric poetry would not be able to linger permanently in the sphere of inspiration. It could not ignore questions of poetic craft or, indeed, of convention. One of the first experts on the Provençal *chanson de geste,* Erich Auerbach, writes of this thoroughly esoteric poetry:[8] "All the poets of the new style have a mystical beloved; all of them experience roughly the same, exceedingly strange amorous adventures; *amore* grants or denies all of them gifts that resemble illumination rather than sensual pleasure; and they all belong to a kind of secret association that determines their inner life and perhaps their outer one as well." In short, the poetic material [*Faktur*], as well as inspiration, has an important role to play in esoteric poetry. Nothing could provide a more striking illustration of this than the invaluable account Renéville gives of Mallarmé's poetic procedure.[9]

The closest friends of the poet knew that he owned a working instrument for poetry in the form of a card file. It was made up of little slips of paper. No one knew what was written on them, and questioning him achieved nothing. One day, Viélé-Griffin entered Mallarmé's study and surprised the poet consulting one of his slips.[10] Mallarmé's gaze lingered on it briefly, then he murmured pensively to himself: "I no longer dare tell them even that.

Even that would give too much away." Viélé-Griffin stepped closer. Peering over the poet's shoulder, he saw a single syllable written on the paper: *quel* [which].

This report is anecdotal. It is a negative theology *in nuce*. Renéville has acutely recognized that the wave which rose up in the mid-nineteenth century as *l'art pour l'art* laid bare an esoteric poetry. He has begun a book on Rimbaud. He proposes to write a study on the worldview of Stéphane Mallarmé. One hopes that his investigations will soon coalesce into a history of esoteric poetry in its most recent phase.

Published in *Zeitschrift für freie deutsche Forschung*, 1938. *Gesammelte Schriften*, III, 553–555. Translated by Edmund Jephcott.

Notes

1. Ernst Theodor Amadeus Hoffmann (1776–1822) turned to writing only after careers in the Prussian civil service (1796–1806) and in the theaters of Bamberg and Dresden as an orchestra conductor (1806–1816). Beginning with musical reviews, he soon turned to short fiction and produced some of the masterpieces of the nineteenth century. His best-known works include "Der Sandmann" (The Sandman), "Der goldne Topf" (The Golden Pot), and "Die Bergwerke zu Falun" (The Mines at Falun).
2. "Novalis" was the pseudonym of Friedrich, Freiherr von Hardenberg (1772–1801). His career as a writer was astonishingly short. It began in 1798 with a sequence of aphorisms, *Blütenstaub* (Pollen), published in the journal *Das Athenäum* edited by the Schlegel brothers, and ended with his death from tuberculosis. In the last years of his life he lived near Jena, in close contact with Friedrich and August Wilhelm Schlegel and the philosopher Friedrich Schelling. In this period he produced the lyric cycle *Hymnen an die Nacht* (Hymns to the Night; 1800), which commemorates the death of his young fiancé, Sophie von Kühn; two fragmentary novels, *Heinrich von Ofterdingen* (1802) and *Die Lehrlinge zu Sais* (The Apprentices at Sais; written 1798); a number of important essays; and a remarkable body of philosophical and literary notes and fragments.
3. The protagonist of Novalis' eponymous novel is a medieval poet in search of the mysterious Blue Flower, which shows the face of his unknown beloved. This central image became a pervasive symbol of the longing for the numinous that characterized German Romanticism.
4. Gérard de Nerval (pseudonym of Gérard Labrunie; 1808–1855) was a poet, traveler, and story writer. *Les Chimères* (The Chimeras; 1854) is a cycle of sonnets in which each poem is centered on a female figure.
5. The *Tibetan Book of the Dead* is the central text of Tibetan philosophy; it is commonly recited to or by a person about to die, providing interpretations of experiences and leading toward the liberation of a safe rebirth. "Kaballah" is the collective name given to the oral and written traditions of Jewish mysticism from

the twelfth century on; Kaballah claims to give access to divine revelation. Saint John of the Cross (Juan de Yepes; 1542–1591) was a late medieval Spanish mystic and the founder of the Discalced Carmelites, a severely ascetic monastic order. He is regarded as one of Spain's finest lyric poets. His works include the prose treatises *Ascent of Mount Carmel* and *Dark Night of the Soul,* and the verse collection *Spiritual Canticle.* Anne Catherine Emmerich (1774–1824) was a German stigmatic and mystic whose visions and experiences were recorded by the Romantic poet Clemens von Brentano (1778–1842) in the volumes *Das bittere Leiden unseres Herrn Jesu Christi* (The Dolorous Passion of our Lord and Savior Jesus Christ; 1833) and *Das Leben der heiligen Jungfrau Maria* (The Life of the Blessed Virgin Mary; 1852).

6. Lucien Lévy-Bruhl (1857–1939), French philosopher and psychologist, studied the psychology of primitive peoples. His writings, such as *Les Fonctions mentales dans les sociétés primitives* (1910) and *La Mentalité primitive* (1922), lent decisive impulses to modern anthropology.

7. C. G. Jung (1875–1961), German psychologist, was an early collaborator with Freud. They broke irreparably over the importance ascribed to sexuality in Freud's theories. Jung's psychology is founded on the notion of a collective unconscious made up of primordial, universally shared image patterns and situations.

8. Erich Auerbach (1892–1957), German literary critic and scholar of Romance literatures, is best known for *Mimesis* (1946). The *chansons de geste* are the Old French epic poems, more than eighty in number, that treat the reign and legend of Charlemagne.

9. Stéphane Mallarmé (1842–1898), French poet, was a principal voice of the Symbolist movement.

10. Francis Viélé-Griffin (pseudonym of Egbert Ludovicus Viele; 1864–1937), American-born French poet, became a prominent Symbolist poet in the circle around Mallarmé.

Review of Freund's *Photographie en France au dix-neuvième siècle*

Gisèle Freund, *La Photographie en France au dix-neuvième siècle: Essai de sociologie et d'esthétique* [Photography in France in the Nineteenth Century: An Essay in Sociology and Aesthetics] (Paris: La Maison des Amis du Livre, 1936), 154 pages.

Study of the history of photography began about eight or ten years ago. We have a number of publications, mostly illustrated, on its infancy and its early masters. But only this most recent study has treated the subject in conjunction with the history of painting. Gisèle Freund's study describes the rise of photography as conditioned by that of the bourgeoisie, successfully illustrating the causal connection by examining the history of the portrait.[1] Starting from the expensive ivory miniature (the portrait technique most widely used under the *ancien régime*), the author describes the various procedures which contributed to making portrait production quicker and cheaper, and therefore more widespread, around 1780, sixty years before the invention of photography. Her description of the "physiognotrace" as an intermediate form between the portrait miniature and the photograph shows in exemplary fashion how technical factors can be made socially transparent.[2] The author then explains how, with photography, technical development in art converged with the general technical standard of society, bringing the portrait within the means of wider bourgeois strata. She shows that the miniaturists were the first painters to fall victim to photography. Finally, she reports on the theoretical dispute between painting and photography around the middle of the century.

The question of whether photography was an art was debated at that time, with passionate contributions from Lamartine, Delacroix, and Baudelaire.[3] But the more fundamental question—whether the invention of photography had not changed the entire character of art—was not raised. The author has perceived the decisive issue clearly. She notes the high artistic standard of a number of early photographers, who went about their work without artistic pretensions and were known to only a small circle of friends. "Photography's claim to be an art was raised precisely by those who were turning photography into a business" (p. 49). In other words, photography's claim to be an art is contemporaneous with its emergence as a commodity. This is consistent with the influence which photography, as a technique of reproduction, had on art itself. It isolated art from the patron, delivering it up to the anonymous market and its demand.

The book's method is based on the materialist dialectic, and discussion of the volume could further development of the latter. For this reason, I would touch on an objection which might also help to define the position of Freund's research in scholarship. "The greater the genius of an artist," writes the author, "the better his work reflects the tendencies in the society of his time—and precisely through what is original in the form of his work" (p. 4). What seems dubious about this statement is not the attempt to relate the artistic scope of a work to the social structure at the time of its production, but the assumption that this structure appears always with the same configuration. In reality, its configuration is likely to change with the different periods in which it is observed. Defining the significance of an artwork in relation to the social structure that prevailed at the time it was produced therefore amounts to determining a distinctive capability of the artwork—namely, its ability to make the period of its production accessible to the most remote and alien epochs—in terms of the history of its influence. Dante's poem, for example, manifested such a capability for the twelfth century, just as Shakespeare's work did for the Elizabethan period.

Clarification of the question touched upon here is all the more important since Freund's formulation threatens to lead straight back to the position which was given its most radical, and questionable, expression by Plekhanov. "The greater a writer is," Plekhanov wrote in his polemic against Lanson, "the more strongly and clearly the character of his work depends on the character of his time, *or, in other words* (reviewer's italics): the less the element which might be called the 'personal' can be found in his works."[4]

Written ca. November 1937; published in the *Zeitschrift für Sozialforschung*, fall 1938. *Gesammelte Schriften*, III, 542–544. Translated by Edmund Jephcott.

Notes

1. This review is an adaptation of a section of Benjamin's "Letter from Paris (2)," written in 1936; see *Selected Writings, Volume 3: 1935–1938* (Cambridge, Mass.: Harvard University Press, 2002), pp. 239–240. Gisèle Freund (1908–2000) studied sociology with Norbert Elias and Karl Mannheim before working as a photographer in Berlin. She emigrated to France in 1933, becoming friends with Benjamin, whom she photographed. During World War II, she lived in Argentina and Mexico, returning to Paris in 1952. There she became one of Europe's most eminent photographers, esteemed for her portraits of literary figures. She is the author of *Photography and Society* (1974) and *Three Days with Joyce* (1983).
2. The physiognotrace, invented in 1783–1784 by Gilles-Louis Chrétien, was a machine for tracing a subject's profile, which it reproduced mechanically on a piece of paper affixed to the center of the instrument.
3. Alphonse Prat de Lamartine (1790–1869) was a popular poet and orator who helped shape the Romantic movement in France and was foreign minister in the Provisional Government of 1848. Among his works are *Méditations poétiques* (1820) and *Histoire des Girondins* (1846). Eugène Delacroix (1798–1863), French painter, was a leader of the Romantic school in painting. His great murals hang in the Louvre, in the library of the Chamber of Deputies, and in the Paris city hall. Charles Baudelaire (1821–1867), French poet, critic, and translator, decisively influenced the course of European literature with his volume of verse *Les Fleurs du mal* (Flowers of Evil; 1857) and with his essays on modern culture, first collected in *Curiosités esthétiques* and *L'Art romantique* (both 1868). His art and life are the subject of Convolute J in Benjamin's *Passagen-Werk* (Arcades Project); on the debate about the artistic status of photography, see Convolute Y, 4a,2 and 4a,4 (on Delacroix), and 10a,1–11,1 (on Baudelaire).
4. In his "Letter from Paris (2)," Benjamin cites a French translation of the polemic in question: Georgi Plekhanov, "Les Jugements de Lanson sur Balzac et Corneille," *Commune*, 16, series 2 (December 1934): 306. Georgi Plekhanov (1857–1918) was a Russian political philosopher who, after forty years in exile, became the intellectual leader of the Russian Social Democratic movement, influencing the thought of Lenin. Gustave Lanson (1857–1934), French critic, was the author of *Histoire de la littérature française* (1894) and other works of literary history.

Review of Francesco's *Macht des Charlatans*

Grete de Francesco, *Die Macht des Charlatans* [The Power of the Charlatan] (Basel: Benno Schwabe, 1937), 258 pages, 69 illustrations.

The means by which people or groups can influence the masses is a relatively recent topic of study. From antiquity to the early nineteenth century, oratory was the only means of this type to receive close attention. By the end of the nineteenth century, photography, the rotary printing machine, film, and radio had made possible the circulation of demands, information, and opinions, together with images reinforcing them, among larger and larger numbers of people. The beneficiaries of this included advertising. The more widespread advertising became, the more clearly one could see that rhetoric had lost its earlier monopoly. Anyone promoting an industrial product in a filmed advertisement can learn more from a market crier than from Cicero.

In the course of this technological and economic development, the question of how the masses are influenced has been raised with increasing urgency. Politics ensures that this urgency persists. Grete de Francesco's study is topical in this sense.[1] She is concerned with the means by which the charlatan exercises power. Once the monopoly of rhetoric had been curtailed, attention was immediately directed at forms of mass influence which had always existed beside it. To write the history of the charlatan is to describe the prehistory of advertising. This is underscored by the revealing pictorial documentation, largely unknown up to now, that de Francesco includes in her volume. The book shows the charlatan to be midway between a conjurer and a comedian; the soapbox on which he performs is half podium,

half stage. Heralds and harlequins are his staff; flags and baldachins accompany him; processions lead him through the town.

The author acquaints the reader with the figures who appeared amid such display, which today has been so notably enriched. In addition to character studies of the alchemists Bragadino and Thurneisser, there is a portrait of Mondor, the quack whose fame lives on in the name of his jester Tabarin. These are supplemented by a portrayal of Eisenbarth. The chapters on the charlatans of the eighteenth century, such as Cagliostro and Saint-Germain, form a high point of the book.[2] The development of the charlatan introduced motifs—experimentally, one might say—which would be extended further by the coming industrial and political publicity machines. From this perspective, the figure of the charlatan takes on a clear historical outline.

Not without some risk of blurring this image, the author seeks to place the charlatan more directly before us. In this effort, she is guided by a polemical interest. Her aim is to hold up a mirror to those segments of the masses which are being misled today—a mirror consisting of the masses who submitted to the power of charlatans in centuries past. This leads her, from topical motives, to characterize the charlatan as a counterfeiter. "The charlatan's power lay in his ability . . . to use forgery of every kind to exploit the uncertainties in a situation, in order to produce a value system which converted his own worthlessness into something of value" (p. 97). These fakers succeeded in duping the "great majority of the people" (p. 18)—referred to at one point as the "half-educated" (p. 24). But does such a description have any proper meaning prior to the introduction of compulsory education? In contrast to these masses are "the small minority of the immune" (p. 18). "The immune," writes de Francesco, "were always in the minority, yet they alone succeeded in shaking the charlatan's sinister power, . . . by asserting the fact of their lives and their actions as the concrete emblem of a world in which the value of truth reigned unchallenged" (p. 245).

Such an apotheosis is foreign to the historian, and so too, therefore, is the charlatan as he appears in the foreground here—a rogue cast down and rendered innocuous. The influencing of the masses is not a black art that one must ward off by appealing to the white art of the elites. It is a historical task; and much in de Francesco's well-researched and informative book suggests that, in his time, the charlatan performed this task in his own way. Which was not always, to be sure, the most unsullied way. But attempts to impart profane knowledge to the masses have never been disinterested. Still, they did represent progress. The charlatan was often of service even where he pursued his own advantage most ruthlessly. A Cagliostro and a Saint-Germain got revenge against the ruling caste on behalf of the Third Estate. They were true contemporaries of Beaumarchais.[3]

Written ca. November 1937; published in the *Zeitschrift für Sozialforschung,* fall 1938. *Gesammelte Schriften,* III, 544–546. Translated by Edmund Jephcott.

Notes

1. The study has been translated by Miriam Beard as *The Power of the Charlatan* (New Haven: Yale University Press, 1939). Grete de Francesco, an acquaintance of Benjamin's, was an Austrian writer and journalist who wrote for the *Frankfurter Zeitung.*

2. Marc Antonio Bragadino, an Italian swindler who posed as an alchemist, was tortured and beheaded in Munich in 1590 or 1591. Leonhard Thurneisser zum Thurn (1530?–1596) was a Swiss adventurer and charlatan who traveled widely in the guise of an alchemist, finally settling in Berlin, where he made a fortune practicing medicine; he is the author of writings on astrological botany. Mondor was a famous vendor of quack medicines during the reign of Charles IX in France (1550–1574). His valet Tabarin (Antoine Girard) would improvise monologues full of coarse wit and lively antics to help draw a crowd. Both master and servant grew rich, and Tabarin bought a chateau in Dauphiné, where he was murdered in 1626 by jealous aristocrats. His jests and witty sayings were collected in 1622. Johann Andreas Eisenbarth (1663–1727) was a successful oculist and surgeon, who was denounced as a charlatan by the medical establishment of his day. He is the subject of a popular folksong ("Ich bin der Dr. Eisenbarth"), an opera (1921), and a novel (1928). Count Alessandro di Cagliostro (real name Giuseppe Balsamo; 1743–1795), born of poor parentage, picked up some knowledge of chemistry and medicine assisting an apothecary in a monastery; he traveled throughout Europe, posing as a physician, alchemist, necromancer, and freemason, and practicing fraud to obtain money. He was sentenced to life imprisonment in Rome for being a heretic. The comte de Saint-Germain, a Paris adventurer, claimed to possess the philosopher's stone and the elixir of life. He was employed by Louis XV as a diplomat on confidential missions and was involved in many political intrigues of the day. He retired to Schleswig-Holstein in 1775 to study occult sciences with the Landgrave Charles of Hesse, and died around 1784.

3. Pierre Augustin Caron de Beaumarchais (1732–1799), French playwright, first attracted public attention with his four *Mémoires,* wittily attacking judicial injustice. He is chiefly known as the author of *Le Barbier de Séville* (1775) and *Le Mariage de Figaro* (1784), comedies which later inspired operas by Rossini and Mozart.

A Chronicle of Germany's Unemployed

Anna Seghers' novel *Die Rettung*

Anna Seghers, *Die Rettung: Roman* [The Rescue: A Novel] (Amsterdam: Querido Verlag, 1937), 512 pages.

Attempts by writers to report on the lives and living conditions of the proletariat have been hindered by prejudices impossible to overcome in a day.[1] According to one of the most persistent of them, the proletarian is a "simple man of the people," contrasted not so much with the educated man as with the individuated member of a higher class. To see in the oppressed person a child of nature was the stock reaction of the rising bourgeoisie in the eighteenth century. After that class had triumphed, it ceased to contrast the oppressed, whose place it had now ceded to the proletariat, with feudal degeneracy, and henceforth set them in opposition to its own finely shaded bourgeois individuality. The form in which this was manifest was the bourgeois novel; its subject was the incalculable "fate" of the individual, for whom any enlightenment was to prove inadequate.

Around the turn of the nineteenth century, a number of novelists violated this bourgeois privilege. It cannot be denied that Hamsun, among others, put an end to the figure of the "simple man" in his books, and that his successes were due in part to the very complex natures of his little country folk.[2] In the following period, social processes further undermined the prejudice in question. War broke out, and in the postwar years "pension neurosis" became a psychiatric category in which the "man of the people" was featured more than he might have wished. A few years later, mass unemployment came on the scene. As this new misery spread, new imbalances, new delusions, and new abnormalities manifested themselves in the behav-

ior of those affected. Individuals who had once been political subjects were frequently turned into the pathological objects of demagogues. The "simple man of the people" was resurrected as the "national comrade" [*Volksgenosse*]—molded from the stuff of neurosis, malnutrition, and misfortune.

A condition that fostered the growth of National Socialism was, indeed, the erosion of class-consciousness, an erosion that was hastened in the proletariat by unemployment. The new book by Anna Seghers is concerned with this process. Its setting is a mining village in Upper Silesia, and it tells of what happens there after the closing of its mine. Seen from above, what happens is little enough. Here, too, injustice prevails, and rebellion is rare. "Even the most extreme and uncontrollable Reds, who wanted to smash the whole intolerable world to pieces, said openly: 'Now we've got to eat turnips again,' or 'The radio's on the blink.' But such words had no place in their mouths, thought Bentsch; they were meaningless" (p. 97). Bentsch's voice is that of Anna Seghers. He is the main character in her story. We first meet him as an older, law-abiding mineworker who will hear nothing against his God or his priest. By nature, he is not politically inclined, and least of all a radical. One has to give him credit: he goes his way alone. Today, many must do the same. Including proletarians, to whom the hollow subtlety of the bourgeois is as foreign as the false simplicity of the "national comrade." And it is a long road. It takes Bentsch into the camp of those waging the class struggle.

The book treats the political circumstances with utmost caution. They can be compared to a root structure. Wherever the author gently lifts them from the ground, we find adhering to them the humus of private relationships—neighborly, erotic, familial.

With their ever-shrinking income, these proletarians must confine themselves to an ever-diminishing experience. They fall into trivial habits; they become overpunctilious; they keep a record of every penny in their attenuated psychic economy. Then they compensate themselves with heady excitements, for which they find dubious justifications and threadbare pleasures ready to hand. They become unstable, volatile, unpredictable. Their attempt to live like other people only makes them more unlike them, and the same thing happens to them as to their mining village, Findlingen. "People had begun to till the soil in odd places, to grow a few bean or rhubarb plants; but this made Findlingen seem less and less like a proper village" (p. 100).

One of the many blessings of working is that toil alone makes perceptible the bliss of doing nothing. Kant calls the weariness at the end of the workday one of the supreme pleasures of the senses. But idleness without work is a torment. This is yet one more deprivation amid the many that the unemployed have to suffer. They are subjected to the passage of time like an incu-

bus that impregnates them against their will. They do not give birth, but they have the eccentric desires of a pregnant woman. Each such desire reveals more about unemployment than any official inquiry could. "When his last guests had left, Bentsch always felt a desire to run out into the street himself, and to lock his kitchen door not from the inside but from the outside. Yet this wish seemed so odd and senseless even to him, that he would just yawn quickly, or say, 'Well, they've gone at last!'" (p. 115). One is astonished at how much homelessness the narrator has allowed to take shelter in this kitchen. This room becomes the counterpart of the "large, little-used area of the Bismarckplatz" (p. 320), which lies under the "stiff, yellowish" sky (p. 44). People no more have a roof over their heads in their kitchen than they do on the public square. This is why Bentsch cannot bring himself to go to bed, and often sits in his dark kitchen as if sitting on the Bismarckplatz. Then it occurs to him that fifteen years have passed since the outbreak of the war. "They had passed quickly. He was not shocked; he was just surprised that that had been all. It puzzled him. There was one, surely, who knew who he was. Why did He not have something else in store for him?" (p. 115).

While thoughts of the laid-off workers still circle round their mine, a decisive process largely unknown to the workers has begun. In the larger world, what is at issue is no longer one mine more or less. The survival of capitalism itself is at stake. Economists are beginning to explore the theory of structural unemployment. But the theory which the people of Findlingen have to make their own is a different one: to be able to descend into the mine again, they will have to defeat the state. This truth has to overcome endless difficulties before it can make its way into their heads. So far it has reached only a few. They are represented by Lorenz—a jobless young man who, before he is murdered, leaves behind in the village a shining trail that Bentsch will never forget.

These few are the hope of the people. And Anna Seghers reports on the people. But it does not form her readership. Still less can it speak to her today. Only a whisper from it can reach her. The narrator never loses sight of this fact for a moment. She narrates with interruptions, like someone secretly waiting for invited listeners to arrive; and to gain time, she sometimes pauses. "The later they arrive, the finer the guests." This tension runs through the book. The narration is far removed from the immediacy of on-the-spot reportage, which cares little about its audience. It is equally removed from the novel, which really thinks only of the *reader*. The narrative voice has not left its post. The book is interspersed with many stories waiting for a *listener.*

The wealth of figures peopling this book does not exemplify the general law of the novel, in which episodic figures appear through the medium of a main character. That medium—the character's "fate"—is absent. Bentsch

has no fate: if he had, it would be done away with at the moment when, at the end of the story, he disappears namelessly among the future members of the still illegal party. The acquaintances the reader makes will be remembered primarily as witnesses. They are martyrs in a very literal sense ("martyr," in Greek, means "witness"). The report on them is a chronicle. Anna Seghers is the chronicler of the German unemployed. The basis of her chronicle is a fable that forms what one might call the novelistic element of the book. On November 19, 1929, fifty-three miners are trapped in a collapsed tunnel, and only seven are brought out alive. This is "the rescue." It is the basis of the association formed by these seven. The narrator follows them with a tacit question: What experience could ever match that of the miners lost below in the shaft, when they shared their last drops of water and their last morsels of bread with each other? Will they be able to maintain the solidarity they demonstrated during the natural catastrophe as they undergo the societal catastrophe?—They have not yet left the hospital when the first dim rumors of the latter reach them. "Perhaps the owners will do what they did over in L. The mine doesn't yield much any more. They've applied to close it down" (p. 31).

The application is made and its provisions are complied with. "For twenty-six weeks, you get eleven marks thirty-five unemployment support; then you get eight marks eighty for at least twenty-six weeks—the duration depends on the local government. That's for the crisis. Then comes the welfare: six marks fifty, with two marks a month supplement per child. After that, there's nothing at all" (p. 94). Readers learn this from the book; the people affected learn it from the mouth of a certain Katharina, who is presented throughout the story as the girl from elsewhere. She is an outsider in more than one sense. And so this information, delivered with the "unfamiliar sound" of a calm voice, resembles a judgment passed on the unemployed men from a great distance. From now on, it determines the lives they have rescued from the mine.

The dismal course of these lives is interrupted by the first anniversary of the event called "the rescue"—an anniversary that brings the downfall of the very people who were rescued. "Was it only a year ago?" they ask. The past year has seemed longer to the jobless men than any of the years they spent laboring at their shift. They are sitting in Aldinger's pub.

> "Bentsch, you talked at us till you were blue in the face. To get us out of that rat-hole. If you'd known that things would turn out as they have up here, would you still have taken the trouble?"
>
> "Yes." He had never thought about it, but he knew all the same.
>
> "Yes?" said Sadovski in amazement. People at nearby tables were pricking up their ears.
>
> "Of course. One always wants to get out. To be with everyone else." Bentsch gestured with his arm at the people sitting around." (Pp. 219–220)

Hardly less mute than the tacit question mentioned above is the answer it is given here.

The chronicle differs from historiography in the modern sense in that it lacks a temporal perspective. Its descriptions resemble the types of painting that existed prior to the discovery of perspective. When the figures in miniatures or early panel paintings appear before the viewer against their gold background, their features are as sharply defined as if the painter had placed them in a natural setting or in a cabinet. They are seen against a transfigured space, yet they do not lose precision. Likewise, the characters in a medieval chronicle are seen against a transfigured time which can rudely interrupt their actions. The Kingdom of God comes upon them as a catastrophe. To be sure, this is not the catastrophe that awaits the unemployed chronicled in *Die Rettung*. But it is something like its counterpart: the coming of the Antichrist. This, as we know, mimics the blessing promised by the coming of the Messiah. In the same way, the Third Reich mimics socialism. Unemployment comes to an end because forced labor is made legal. The book devotes only a few pages to the "awakening of the nation." But they evoke the horror of the Nazi dungeons better than almost any other text has done, though they reveal no more about what goes on there than a girl can learn when she asks at an SA barracks after her boyfriend, who was a Communist.[3]

The narrator dares to look squarely at the defeat suffered by the revolution in Germany—a courageous stance which is more necessary than widespread. This attitude also characterizes her work in other ways. She has no urge to wallow in depictions of misery. She combines respect for her readers, which forbids cheap appeals to their compassion, with respect for the degraded people who were her models. Because of this reserve, the linguistic resources of the people are at her disposal when she does call things by their names. When a jobless man from another village, who has to get in line for his stamp at Findlingen, sums up his situation by saying, "It stank just the same here as at Kalingen," the class-structured society is made tangible at a stroke. Above all, the author is able to use language in a way that has nothing in common with the false simplicity of modern *Heimatkunst*.[4] Her style is more reminiscent of genuine popular art—which the Blaue Reiter[5] movement harked back to earlier—in its ability to gain access to forgotten chambers of the everyday world through slight shifts in the commonplace. While the police are searching Bentsch's room, his wife exchanges a glance with him. "He gave a slight smile. It was as if they had been together all these years only as a rehearsal for this moment" (pp. 498–499). Or: "Katharina did not blow things out of proportion, any more than a cat might do" (p. 118).

The person referred to is the odd creature, Bentsch's stepdaughter, who is

a guest in his family. But she is no more at home than the fairy Melusine, who lives briefly with a husband yet is eventually drawn back to her palace in the deep waters below the spring.[6] In the same way, Katharina yearns for home. But the mortal child has no home. She works at cleaning the window: "Where were the panes that could not be polished shiny enough, so that a clear, soft light would be shed into all the corners of the room, in which the table was laid and the bed stood ready, not in this hasty, makeshift way, but from the first and for always—the place where she would at last be Katharina!" (p. 118). She dies of an abortion that has been arranged for her. She has come mutely to the end of her narrow life-path before anyone has noticed. She came, was unable to protect herself, and vanished. Yet this Katharina would not be what she is, and would be bereft of what is finest in her, if she weren't just as far beyond worldly wisdom as she falls short of it. In this respect, she is the sister of "Katherlieschen"—the fairytale character who serves to make so beautifully clear the promise that foolish virgins hold for wise folk. Their smiles are out of step with the world, and they are out of step with themselves. They have no desire to feel at home, so long as the heart is merely a refuge in the world and not its center.

"I must think of something I can ask his advice about," thinks Katharina, who has just heard Bentsch giving wise counsel to someone else. "She tried to think of something, but could not. She had no hopes which were threatened with failure. She lacked nothing and had nothing. She had not the slightest plan on which she might have needed advice. She was completely at a loss" (p. 120).[7] These words reveal the epic nature of the book. Being at a loss is the distinguishing mark of the incommensurable figure who serves as hero of the bourgeois novel. The novel, it has been said, is concerned with the individual in his aloneness—unable to express himself in any exemplary way about his most important affairs, lacking advice from others and incapable of giving any himself. This book touches, even if unconsciously, on this enigma; and as it does so, it reveals—like almost all the significant novels of recent years—that the form of the novel itself is being altered.

The work's structure manifests this in many ways. It is not organized in terms of episodes and a principal plot-line. It tends toward earlier epic forms, toward the chronicle and the primer. It contains an abundance of short episodes often building to a climax. One of these occurs on November 19, 1932, when the anniversary of the rescue comes round for the last time in the narrative. That no one celebrates it any more suggests what it once meant. For these unemployed men, it stands for everything which ever brought light into their lives. They might have said that this day was their Easter, Pentecost, and Christmas all rolled into one. Now it has lapsed into oblivion, and utter darkness has fallen.

The time when they usually began the celebration had long passed. Really, they've forgotten me, thought Zabusch. Or they want to be by themselves. Well, I won't play along.

"Switch the light on," said his wife.

"Switch it on yourself," said Zabusch.

So it stayed off.

In the end, he can't stand to sit in the dark any more. He walks down Findlinger Strasse and flings open the door of the inn.

"Ale? Beer?"

Zabusch didn't answer the innkeeper—just looked at him distractedly. He first thought he had opened the wrong door. But Aldinger's was the only tavern on Findlinger Strasse. And this was Aldinger himself; he recognized him. But the barroom had been exchanged for another—he didn't see a single face he knew. People started laughing . . .

"Come on in—there's still room! Sit down, Comrade!"

All these Nazi youths filled the chairs and benches (that corner seat hadn't been there last year), sticking out their knees and elbows like locals. (Pp. 450–451)

The ground seems suddenly to open beneath the man no one needs, whose days even the calendar stops counting, revealing to this abandoned abyss-dweller a still deeper abyss: the shining Nazi hell where abandonment holds a festival, celebrating itself. This precipitous fall concentrates the years the book describes in the horror of a single moment.

Will these people *liberate* themselves? One catches oneself thinking that, for them, as for lost souls, there is now only *redemption*. The author hints at the direction from which it must come, and she does this at the points in her report where she speaks of children. No reader will quickly forget the proletarian children she describes.

In those days, one often came across children like Franz. Someone brought his own child with him, or they came by themselves from the neighborhood, or from somewhere quite different. They could just peer over the edge of the table on which the pamphlets were being folded; they got under your feet, or ran panting to deliver a letter or a pile of newspapers, or to fetch someone who was needed just then. Dragged along by a father . . . or attracted by curiosity or whatever it is that attracts people, and perhaps already bound together till death. (Pp. 440–441)

Anna Seghers builds on these children. Perhaps their recollections of the unemployed who engendered them will one day include recollections of their chronicler too. Certainly their eyes will reflect the gleam of the window-panes that inspire Katharina's dreams as she works—the panes "that could not be polished shiny enough, so that a clear, soft light would be shed into all the corners of the room, in which the table was laid and the bed

stood ready, not in this hasty, makeshift way, but from the first and for always."

Published, in abbreviated form, in *Die neue Weltbühne,* May 1938; *Gesammelte Schriften,* III, 530–538. Translated by Edmund Jephcott.

Notes

1. Anna Seghers (1900–1983) was a German leftist novelist and short-story writer. After study at Heidelberg, she joined the Communist party in 1929. Following her emigration in 1933 to France (where she came to know Benjamin), her books were banned by the National Socialists. She spent time in Spain during the Spanish Civil War, supporting the Republicans, and subsequently escaped from France to Mexico, where she lived until her return to East Germany in 1947. She remained a vocal supporter of the regime in the German Democratic Republic until her death. Her best-known works include the novels *Das siebte Kreuz* (The Seventh Cross; 1942), *Transit* (1944), and *Die Toten bleiben Jung* (The Dead Stay Young; 1947).
2. Knut Hamsun (1859–1952) was a Norwegian novelist whose works idealized rural existence. He supported the German invasion of Norway and was charged with treason in 1947. His most popular work is the novel *Hunger* (1890).
3. The SA, or Sturmabteilung (assault division)—also known as the Brownshirts—was a paramilitary organization which played a key role in Hitler's rise to power. Led after 1931 by Ernst Röhm, the SA specialized in street violence and physical intimidation of the opponents of Nazism. Under Röhm, SA membership swelled to 400,000 by 1932 and perhaps to 2,000,000 by 1933. Röhm pressed Hitler repeatedly for a "second Nazi revolution" that would impose a socialist regime and merge the SA with the regular army under his leadership. On June 30, 1934 (the "Night of the Long Knives"), Hitler—using members of the elite quasi-military unit of the Nazi party that served as his personal guard and as a special security force, the SS or Schutzstaffel (defense echelon)—purged the SA leadership through the summary execution of Röhm and dozens of SA leaders.
4. "Homeland art" strives to reproduce the life and atmosphere of the provinces, with special emphasis on the daily life of the Alpine peoples.
5. The Blaue Reiter (Blue Rider) was an artists' organization founded in 1911 in Munich. Its founding members, Wassily Kandinsky and Franz Marc, coedited an influential volume of essays and reproductions that was entitled *Der blaue Reiter,* a name that derived from a painting by Kandinsky. Often considered part of German Expressionism, the artists of the Blaue Reiter favored a lyrical abstraction influenced by Cubism and Futurism, but also by folk and primitive art.
6. Mélusine, in French folklore, was a tutelary fairy who was condemned to become a fish from the waist downward every Saturday. She married and lived happily until her husband discovered her in her transformed state; she then left him, with a scream of despair, and returned to the sea. The legend is related in a long prose romance written by Jean d'Arras (1387) and in verse by the fifteenth-

century French poet Couldrette. Benjamin's reference to the "waters below the spring" makes it clear that he is alluding to Goethe's revision of the tale, "Die neue Melusine" (The New Melusine), which he inserted into his novel *Wilhelm Meisters Wanderjahre* (Wilhelm Meister's Wanderings). In Goethe's version, the husband discovers that the fairy is a tiny dwarf. He nonetheless elects to join her in her kingdom, accepting dwarf form, but soon tires of this and returns to human form—alone.

7. *Ratlos,* "at a loss," is the term used here; but the word's root is *Rat,* "counsel" or "advice." Benjamin plays here with ideas first discussed in his essays on Johann Peter Hebel; they were taken up again in his essay "The Storyteller." See "Johann Peter Hebel (I)" and "Johann Peter Hebel (II)," in Benjamin, *Selected Writings, Volume 1: 1913–1926* (Cambridge, Mass.: Harvard University Press, 1996), pp. 428–434; and "The Storyteller," in *Selected Writings, Volume 3: 1935–1938* (Cambridge, Mass.: Harvard University Press, 2002), pp. 143–166.

A Novel of German Jews

Stephan Lackner, *Jan Heimatlos: Roman* [Johnny Homeless: A Novel] (Zurich, 1939), 222 pages.

While the ties between the German people and the German Jews are being annihilated for an unforeseeable time to come, a novel has been published which sets out to depict the nature of these ties. It tells the story of a well-to-do assimilated family. The head of the family is an architect; we should picture him as belonging to the generation born around 1860. His artistic inspiration is drawn from the Wilhelmine era; a certain Bodo Ebhardt, who carried out the renovation of the Hohkönigsburg, might have been the model for this character.[1] His wife is non-Jewish; the son, who left the country in 1933 and became an engineer, is the biological child of the mother but not of the father. The Nuremberg Laws induce the mother, without too much difficulty, to confess that her son is the outcome of an indiscretion and therefore of non-Jewish descent.

The desire to be reunited with a former sweetheart and to persuade his parents to leave Germany causes the young man to return to his homeland in 1936. He arrives just as machinations to expropriate his father are under way. His mother's confession enables him to intervene as an "Aryan" between the old man and his creditors. He devotes all his energy to the commercial future. The erotic sphere seems closed to him; his former sweetheart has been so indoctrinated with racial theories that she is unable to revive her original feelings. Later, when fleeing the country, she will demonstrate them.—The path to the brilliant career which beckons to the young man when he takes over his father's firm leads to another tie. This tie (which, to

use a phrase of Paul Heyse, causes the falcon to take flight in Lackner's novel)[2] is with the daughter of the financial magnate who is the young man's biological father. This seems to be setting the stage for the most banal dénouement: the knot unwittingly tied can be only tragically undone. It is a mark of the author's sure touch and good faith that he avoids this path. The young people are fully aware of their situation. "'Aren't you appalled?' asked Jan in a voice drained of all expression. 'I'm not appalled by anything in this world. Why should I be concerned with taboos created in primeval times?'" In the racially purified fatherland—this is the satirical core of the story—the demands of commercial life can lead to an incestuous relationship. The "keen wind" blowing through Germany pays little heed to this.

But ultimately, even this professional accomplishment has no useful effect. The young man realizes that he has no future in Germany. He returns to his original sweetheart, is picked up by an SS detachment, and barely escapes with his life. On the same day, the man he has long regarded as his father takes his own. "My ancestors have lived on the Rhine since Roman times," he tells the young man at the start of the novel. "What the Austrian and Levantine scoundrels who have taken over this pitiful Reich may have to say about me is no concern of mine. We'll wait it out here until the Germans come back to their senses, or until we go under." Now that the second of these alternatives threatens to come to pass, the novel takes on documentary significance. It concludes with a second homecoming—which no longer concerns the young sweethearts, who have now emigrated; instead, it relates to the struggle for the liberation of all the oppressed in the Third Reich. Lackner's book demonstrates that the school of exile can do little harm to a young writer, provided he has determination and talent.

Published in *Die neue Weltbühne*, December 1938. *Gesammelte Schriften*, III, 546–548. Translated by Edmund Jephcott.

Notes

1. Bodo Ebhardt (1865–1945), a German architect known for his neo-Gothic and neoclassical restoration work, restored the royal castle at Hohkönigsburg (Alsace) in the years 1899–1908 under a commission from Wilhelm II.
2. A reference to the famous claim by Paul Heyse (1830–1914), in the introduction to his twenty-four-volume collection of German novellas, *Deutscher Novellenschatz* (1870–1876), that each novella should have a narrative shape distinguishing it from all others, a shape capable of the sort of symbolic summary evident in the falcon imagery in the *Decameron*. Heyse, a thoroughgoing traditionalist as a writer, received the Nobel Prize for Literature in 1910.

Theory of Remembrance, 1939

Review of Hönigswald's *Philosophie und Sprache*

Richard Hönigswald, *Philosophie und Sprache: Problemkritik und System* [Philosophy and Language: Problem-Critique and System] (Basel, 1937), 461 pages.

Kant set out to resolve the problems of philosophy within a closely defined field, precisely marked out in logical terms.[1] Seeking the foundation of the theory of all knowledge in the basic principles of the exact sciences, he conceived these sciences in opposition to dogmatism, especially the dogmatic claims of religion. His carefully argued rejection of these claims is the outcome of his critical examination of metaphysics. As for the neo-Kantian school, it is distinguished by the fact that it continued to use the battle plan set out in Kant's thought, though the adversary now lay in an entirely different quarter.[2] For the methods of the exact sciences—which nurtured the growth of critical thinking—had changed in the meantime. Positivism now seemed the last word in the field of science.[3] In the early period of the German bourgeoisie, the exact sciences had combined to form a worldview whose vanishing point lay in the realm of freedom and perpetual peace. This offered a perspective on the plane of history which was in no way inferior to the one sketched by Kant and Laplace on the plane of cosmology.[4] The concept of the sublime is founded on the equivalence between these two realms. "The sublime," Kant writes, "can be described thus: it is an object (of nature) which, *if pictured by the mind, causes the mind to conceive of the unattainability of nature as a representation of ideas*" (Kant, *Werke*, ed. Cassirer, vol. 5 [Berlin, 1922], p. 340). In the worldview of Helmholtz, Du Bois–Reymond, and Haeckel, nature had ceased to be a tool for human liberation.[5] It was no longer the stuff of duty but the instrument of a control

which extended ever farther across the globe as the groups that wielded it became ever smaller. Peoples and races, dispersed across paradisal spaces in the vision of the Enlightenment, became the compact mass of consumers in the world market. The glory of their origin faded within them, and with it the promise of a better future which that origin had held.

This was the oppressive constellation in which the revival of Kantian thought occurred. One may surmise that the weakness of neo-Kantianism lies in its unconscious complicity with positivism—a complicity which it has always denied. This weakness is evident above all in its concept of the system. Kant's originality is at its most striking in his *Kritik der Urteilskraft* [Critique of Judgment]. Shortly before his death, the names of the great German classicists were inscribed on this keystone of his system. Hermann Cohen's aesthetics lack such a precise historical imagination. In his work, the concept of the system functions only as a means of interpretation, no longer as a means of planning. The critical and imaginative energies decline to the same degree and for the same reason: for those in power, it takes little effort to adapt themselves to the established order. This picture became thoroughly depressing when Cohen's rigid grasp of the strategic positions of the eighteenth century began to loosen. Cohen's essay "Über das Eigentümliche des deutschen Geistes" and Natorp's *Deutscher Weltberuf* mark a threshold in this decline.[6] Age-enfeebled criticism[7] began to clutch at language and history—in whose name the historical school had once drawn up a wholesale indictment of criticism and the Enlightenment. By then, history and philology had emerged from their Romantic period—but this had not brought them any closer to criticism. Indeed, the more energetically these disciplines vied with the rigor of the exact sciences, the more promptly and discreetly they could comply with official demands, using the over-meticulous study of sources as their alibi. Two circumstances thus inaugurated "critical philosophy" in language and history: the withering of the bourgeoisie's oppositional resolve, and the withering of the historical ambition which had lived in that resolve.

From Natorp, the path led—via Cassirer's *Philosophie der symbolischen Formen*—to Hönigswald.[8] Along the way, the transcendental questioning had gradually been transformed into a ceremony no longer animated by any real intellectual effort. In Hönigswald, the transcendental unity of apperception has become the unity of cultural consciousness, precipitated in language. This view of things has its Magna Carta in the notion of a continuum—that of language—on which the given facts are gently borne along. "These include everything that (to express it rather tritely and briefly) 'just cannot be changed,' everything that simply 'is so,' . . . faith and state, law, morality, language, nature, the inner life, and so on. All these are finally 'given'" (p. 32). "Both creating culture and being nurtured by culture," humanity is carried along by this stream.

The book maintains an astronomical distance from all the concrete questions currently raised by philology.[9] Insofar as it contributes to any process of thought, it contributes to a thoroughly reified one. Hönigswald's definition of the human being is revealing here. That it appears somewhat ludicrous at first sight is certainly the least of its faults. From the standpoint of language theory, the concept of the "human being" is said to comprise "certain organized bodies, each of which is linked possessively to 'someone,' 'belongs' to someone, and each of which, more precisely, is actually defined as an organized body by the fact that it must belong to 'someone'" (p. 274). This approach might lead somewhere if it did not aim at a definition of both "human being" and "property." It includes a critique of property in the commonly used sense, pointing to a limit in this relationship which the body imposes on its owner. It would be in keeping with critical thought to focus on this view of the matter; but such is not the case with Hönigswald. His definition takes him in circles: "someone" is just a human being and nothing else, unless designated by a name. This could bring the question of naming into play. Naming and designating are the poles between which the philosophy of language seeks to strike a spark, as its history since the *Cratylus* teaches us.[10] This is scarcely reflected in the book. The work is "systematic" in the dubious sense that it leaves aside inquiry into the historical conditions of any earlier knowledge on this subject, or of its own knowledge.

Hönigswald's conceptual definition of history in no way compensates for this lack of historical perspective on the questions raised. Its engaging glibness is in keeping with the formalism it is intended to support. "In all historiography," we read in Hönigswald, "description and confession are welded into an indissoluble . . . community sure of its subject matter" (p. 260). As soon as one realizes that the "clear definitions" preceding the definition of "human being" converge in this highly unclear concept of history,[11] one can grasp the definition mentioned above in all its vacuousness. The author duly clarifies it by saying: "The word 'someone' takes on the sense of 'human being' as soon as the experiential center referred to attains an 'unmediated' relationship to 'word' and 'culture'—that is, to history" (p. 274).

Such definitions give a glimpse of parts of the "system of objects themselves" which takes shape within language, "according to extremely complex . . . conditions. Language determines . . . the object; like causality, it is one of the conditions of the object's inexhaustible determinateness" (p. 23). By an irony less tragic than sad, this critical philosophy [*Kritizismus*], which claims to have brought to light the foundation charter of objectivity [*Gegenständlichkeit*] in language, employs gibberish to make its discovery known. Dignity, for example, "means . . . that the community-related 'person' is defined only in terms of the quality of value-dependent 'dignity'— that is, in terms of the possibility of that person's 'action.' In this sense, as

the subject of action, the person is functionally dependent on that value of all values. . . . Through his awareness of being bound to a highest value, the person becomes 'free'—that is, takes on the valence of 'personality' which determines the concept of him as 'person'" (pp. 238–239).

Faced by such obscurities, in which the vocabulary of practical reason leads a spectral existence stripped of its methodological skeleton, one realizes that its fate is not fundamentally different from that of the great thinkers conjured up in spiritualist séances. Disconnected from their work, they must submit to a fake apotheosis. Thus have the terms of transcendental philosophy fallen. How could this happen? Kant wanted to provide a ground for knowledge, to the extent that its structure rested on pure reason. The aims of his epigones are not so narrow. Lacking the strength to exclude anything, they "ground" everything and anything. Their arguments are devoid of the critical cunning deployed so triumphantly in Kant's transcendental dialectic.[12] Hence, the thought of these latecomers serves only to prettify "what can't be changed in any case." Words which are forced to serve everyone could indeed seem ready-made to vindicate this obsequious philosophy.

Written in 1938 and January 1939; submitted to the *Zeitschrift für Sozialforschung* in late 1939, but unpublished in Benjamin's lifetime. *Gesammelte Schriften*, III, 564–569. Translated by Edmund Jephcott.

Notes

1. Richard Hönigswald (1875–1947), German academic philosopher, attempted to reconcile neo-Kantian epistemology with contemporary ontology. After teaching at the universities of Breslau and Munich, Hönigswald was forced to retire in 1933 as a result of Nazi racial policy; he was interned at Dachau in 1938, but allowed to emigrate to America in 1939.
2. The Neo-Kantian school of philosophy sought to replace the materialism of late-nineteenth century positivism with a philosophical foundation based on Kant's critical philosophy. Neo-Kantianism developed along a number of only partially compatible paths; Benjamin himself had been trained within the so-called Marburg school, which had originated with Hermann Cohen, who argued in *Kant's Theory of Experience* (1871) that the transcendental subject is to be regarded not as a psychic being but as a logical function of thought that constructs both the form *and* the content of knowledge.
3. Positivism was the dominant philosophical form in the late nineteenth century. The basic tenets of positivism are contained in an implicit form in the works of Francis Bacon, George Berkeley, and David Hume, but the term is specifically applied to the system of Auguste Comte, who developed the coherent doctrine. In denying the validity of metaphysics, it attempts to replace speculation with

scientific knowledge. Positivism was closely tied to bourgeois concepts of progress, whether scientific, industrial, or social.

4. Pierre Laplace (1749–1827), French astronomer and mathematician, was the author of *Théorie des attractions des sphéroïdes et de la figure des planètes* (1785) and *Essai philosophique sur les probabilités* (1814).

5. Hermann Ludwig Ferdinand von Helmholtz (1821–1894), German scientist and philosopher, made important contributions to a number of fields: physiology, thermodynamics, electrodynamics, and acoustics. Helmholtz, in attempting to define his thought against Kant's theory of perception, also provided decisive early impulses to the rediscovery of Kant that produced Neo-Kantianism. Emil Du Bois–Reymond (1818–1896) was a German physiologist of French descent. A pupil and successor (after 1858) of Johannes Müller at the University of Berlin, he is known especially for his studies of nerve and muscle action, in which he demonstrated that electrical changes accompany muscle action. Ernst Heinrich Haeckel (1834–1919), German biologist and philosopher, developed a mechanistic form of monism based on his interpretation of Darwin's theories. He is known also for his research on the genetic development of marine life.

6. Hermann Cohen (1842–1918), German philosopher, is best known as a founder of the Marburg school of Neo-Kantianism. His essay "Über das Eigentümliche des deutschen Geistes" (On the Particularity of the German Spirit) dates from 1914. Paul Gerhard Natorp (1854–1924), a German philosopher and a colleague of Cohen's at Marburg, attempted to integrate modern psychology into Neo-Kantianism. His book *Deutscher Weltberuf* (German World-Mission) was published in 1918.

7. Benjamin uses the term *Kritizismus,* referring to critical philosophy in the Kantian sense.

8. Ernst Alfred Cassirer (1874–1945) was a German philosopher whose early interest in the problem of knowledge produced the monumental *Erkenntnisproblem in der Philosophie und Wissenschaft der neueren Zeit* (The Problem of Knowledge in Recent Philosophy and Science; 3 vols., 1906–1920). *Die Philosophie der symbolischen Formen* (The Philosophy of Symbolic Forms; 3 vols., 1923–1929) is his major work, an application of Neo-Kantian philosophy to an original critique of culture. His view that all cultural achievements (including language, myth, and science) are the results of humans' symbolic activity led Cassirer to a new conception of the human being as the "symbolic animal." He taught at Hamburg, Oxford, Yale, and Columbia.

9. In this respect, it contrasts sharply with Bühler's fundamental *Sprachtheorie,* published three years earlier (see [Benjamin, "Probleme der Sprachsoziologie,"] *Zeitschrift für Sozialforschung,* 4 [1935], pp. 260ff.). Bühler's study takes account of the latest investigations into the language of animals and of children, mimetic expression and aphasia. This is not the case with Hönigswald, as illustrated by the problem of onomatopoeia, which is easily isolated. The relevant passage in Bühler reads: "If language is put aside, it is easy enough to produce onomatopoeic effects; the only question is how to do this within language. There are certain joints and gaps within the structure of language where this can be done. What cannot be done, however, is to fuse these scattered, sporadic areas where degrees of freedom exist into a coherent representational field" (Karl

Bühler, *Sprachtheorie* [Jena, 1934], p. 196). Hönigswald's treatment of this problem culminates in observations which combine a minimum of intelligibility with a maximum of banality. Onomatopoeia, he writes, "raises the question of the natural events whose acoustic valences recur in certain words. The fact that these valences are presented within historically determined language systems, and the way this takes place, appear to be the truly fundamental problems of onomatopoeia—and the most difficult" (p. 321). [Benjamin's note. Karl Bühler (1879–1963), a professor of psychology at Vienna, fled in 1939 to the United States, where his *Sprachtheorie: Die Darstellungsfunktion der Sprache* (1934) was translated as *Theory of Language* in 1990. See Benjamin's "Problems in the Sociology of Language," in *Selected Writings, Volume 3: 1935–1938,* ed. Howard Eiland and Michael W. Jennings (Cambridge, Mass.: Harvard University Press, 2002).—*Trans.*]

10. Plato's dialogue *Cratylus,* on language and grammar, was written ca. 360 B.C.

11. The definition of historical source runs as follows: an object "can be called a source insofar as it appears definable as representing something from the viewpoint of only a single intention. . . . This . . . gives the source its unique objectivity, which exists only according to the conditions of that 'representation' for which it is to serve as documentation, while itself being conditioned by representation. Its objective significance can be judged only in terms of the aim of representation, which in turn depends on the representational qualities of the source" (pp. 221–222). [Benjamin's note]

12. In Kant's system, transcendental logic is divided into transcendental analytic and transcendental dialectic. Transcendental analytic is a logic of truth, and is intended to furnish a canon of criticism. When logic is used to judge not analytically but synthetically—to make judgments about objects in general—it is called transcendental dialectic, which serves as a protection against sophistic fallacy.

Review of Sternberger's *Panorama*

Dolf Sternberger, *Panorama, oder Ansichten vom 19. Jahrhundert* [Panorama, or Views of the Nineteenth Century] (Hamburg, 1938), 238 pages.

Among the contradictions which are not unified but which are provisionally clamped together in Germany today are the reactions provoked by recollection of the Bismarck era.[1] At that time, the petty bourgeoisie entered into an apprenticeship to the powers-that-be, one which has been revived and extended under National Socialism. By comparison, the middle bourgeois strata still enjoyed much greater political power at that time. Only when they had relinquished that power was the way cleared for monopoly capitalism, and with it the national renewal. National Socialism is thus ambivalent toward the age of Bismarck. It boasts of having eradicated the slovenliness of the age—with some justification, if one considers the average level of security enjoyed by the lower classes in those days. On the other hand, the National Socialist party is well aware that it is perpetuating Wilhelmine imperialism and that the Third Reich is basking in the reflected glory of the Second. Its training of the petty bourgeoisie is based on this awareness. Thus, we have on one side the eyes raised deferentially to those above, but on the other the critical reserve (an ambivalence aptly illustrated by the way the leaders of the new Reich view those of the old army.)

Imagine this situation as a mirror image—that is, symmetrically inverted—and you have the outline of Sternberger's book.[2] Its attitude is likewise ambivalent, but in the opposite direction. When he probes the age of Bismarck critically, he touches on the features with which one feels solidarity today. And when he seems to be soliciting the reader's good opinion of

it, he clings to a solid, moderate standard of bourgeois morality which to-day's Germany has turned its back on. In other words, the critic in Sternberger can reveal his insights, and the historian his sympathies, only with the utmost caution.

This might not have been a hopeless task. But the author's aspirations went further. He wanted to fill a breach. The copious production of writings by academics eager to toe the line has its counterpart in an exodus from fields that, unnoticed by orthodox scholarship, used to be occupied by an avant-garde. This avant-garde liked to present its ideas in the form of es-says. Sternberger's astonishing enterprise is to revive the form and thematic content of such works. As the book's title indicates, he wanted not to draw a map of his subject matter but to survey it from serene heights. This is confirmed by the sequence of chapters. In his efforts to maintain an essay-istic stance no matter what the cost, the author casts about in all directions. The less capable he is of coming to terms with his subject matter method-ologically, the more insistently he enlarges it, and the more ambitious and comprehensive it becomes.

The question of whether people's visual impressions are determined only by natural constants, or additionally by historical variables, is at the very leading edge of research. To move an inch closer to an answer is a hard-won advance. Sternberger takes this problem in his stride. Had he focused on it closely and said, for example, that light impinges on human experience only in a manner permitted by the historical constellation, one would have ea-gerly awaited the elaboration of this idea. Sternberger does indeed say this (p. 159), but merely in order to have his piece on this gameboard as well. His treatment of the question is hedged about with appositions, subsidiary clauses, and parentheses in which the content is lost. Moreover, he refuses to have any truck with those who, if they were allowed to do so, might ex-press interest in an issue closely related to this question: namely, in the fact that the natural conditions of human existence are altered by human means of production.

Many topics gain a hearing, but not the one they deserve. It is often in-structive to refer back to works in which motifs such as genre, allegory, and Jugendstil are dealt with in rigorous contexts.[3] Adorno, for example, has demonstrated that a late form of allegorical vision is found in Kierkegaard's writings;[4] Giedion, in his studies of architectural history, showed that the nineteenth century felt a need to conceal its architectural achievements be-hind a mask of imitation;[5] Salvador Dalí interpreted Jugendstil in terms of Surrealism. Sternberger deals with all of these subjects. But in his book they form motifs, in the sense of whimsically arranged ornamentation.

The essayist likes to think of himself as an artist. He can then yield to the temptation to substitute empathy (with an epoch no less than with a way of thinking) for theory. The symptoms of this dubious state of affairs are evi-

dent in Sternberger's language. An elevated, pretentious style of German is allied to the moral affectation that was characteristic of the ingratiating family novel of the 1860s. This stylistic mimicry gives rise to the most convoluted phrasing. "Since then, in general," is a favorite (vacuous) construction; "of this kind and extent" mistakes redundancy for a transition. Phrases such as "it's time to bring this digression to a close," "let us move on, however," and "it would ill befit the author" usher the reader through the book as if through a suite of stately rooms. The author's language is a vehicle of regression.

Nowadays, regression to remote spheres that do not invite political intervention is widespread in Germany. Childhood recollections and the cult of Rilke, spiritualism and Romantic medicine succeed one another as intellectual fads.[6] Sternberger regresses while holding on to the motifs of the avantgarde. His book is truly a classic case of retreating forward. Naturally, he cannot avoid colliding with the enemy. Above all, he has to contend with those who hesitate to cast a critical vote on the Gründerzeit in pursuit of their own interests.[7] The barbarism of the present was already germinating in that period, whose concept of beauty showed the same devotion to the licked-clean which the carnivore displays toward its prey. With the advent of National Socialism, a bright light is cast on the second half of the nineteenth century. Those years marked the first attempts to turn the petty bourgeoisie into a party and harness it to precise political purposes. This was done by Stoecker, in the interests of the big landowners.[8] Hitler's mandate came from a different group. Nevertheless, his ideological nucleus remained that of Stoecker's movement fifty years earlier. In the struggle against an internally colonized people, the Jews, the fawning petty bourgeois came to see himself as a member of a ruling caste and unleashed his imperial instincts. With National Socialism, a program came into force which imposed the ideals of the Gründerzeit—glowing warmly in the light of world conflagration—on the German domestic sphere, especially that of women. On July 18, 1937, in a speech delivered by the head of the party and inveighing against "degenerate art," the orientation of Germany's culture was aligned with its most servile and inferior stratum, and laid down with the authority of the state.[9] In the *Frankfurter Zeitung* on July 19, Sternberger wrote that this speech "settled accounts . . . with the attitudes and theories that established the public tone in the art world in the era which is now behind us." This "settling of accounts," he added, is "not yet completed." He also claimed that it had been conducted "with the weapons of cutting irony and the methods of philosophical discussion." The same cannot be said of this ramble through its more distant historical background.

Sternberger's book is ornate and difficult. It diligently seeks out the arcane subject, but lacks the conceptual force to hold it together. He is unable to formulate definitions[10]—a failing that makes him all the more inclined to

present the *disjecta membra* of his text to the reader as a meaningful symbol. This tendency is exacerbated by his disturbing fixation on the "allegorical." Allegory is surrounded by emblems forming a "patchwork" at its feet. Sternberger uses the term matter-of-factly in this sense, though it carries no such elaborate connotations in normal usage. The attributes he ascribes to it make us doubt whether he associates it with any clear meaning. Under the heading "The Allegory of the Steam Engine," he assembles a number of clichés extolling the locomotive: as swift as an eagle, an iron horse, a racehorse on wheels. Such clichés, he believes, create "an allegorical poetry . . . in the precise sense that elements of technology, when fused with others from living nature, take on a new, autonomous existence as a Janus figure" (p. 26). This has nothing to do with allegory. The taste guiding such language reflected the need to escape a threat. This threat was thought to lie in the "rigid," "mechanical" qualities associated with technical forms. (In reality, it was of a different kind.) What was generally felt was the oppression emanating from technology, and refuge from it was sought in Ludwig Knaus's paintings of groups of children, Grützner's monks, Warthmüller's rococo figurines, and Defregger's villagers.[11] The railway was invited to join the ensemble—but it was the ensemble of the genre painting. Genre painting documents the failed reception of technology. Sternberger introduces the concept, but his interpretation of it is entirely flawed. "In genre painting," he writes, "the onlooker's interest . . . is always actively engaged. Just as the scene that has been frozen, the living image, needs completion, so this interested onlooker is eager to fill the gaps in the painting's patchwork . . . with the joys or tears it evokes" (p. 64). As I have said, the origin of genre painting is more tangible. When the bourgeoisie lost the ability to conceive great plans for the future, it echoed the words of the aged Faust: "Linger awhile! Thou art so fair."[12] In genre painting it captured and fixed the present moment, in order to be rid of the image of its future. Genre painting was an art which refused to know anything of history. Its infatuation with the moment is the most precise complement to the chimera of the Thousand-Year Reich. The connection between the aesthetic ideals of the Gründerzeit and the vaulting artistic aims of the National Socialist party has its basis here.[13]

Sternberger has not broken the theoretical monopoly of National Socialism. It distorts his ideas, falsifies his intentions. The falsification is manifest most clearly in his view of the dispute over vivisection in the 1870s. In the pamphlets which set off the controversy, certain errors by the vivisectors provided the catchwords for a obstinate rancor against science itself. The movement against vivisection was an offshoot of petty-bourgeois interest groups, including the opponents of immunization, who revealed their colors so openly in the attack on Calmette.[14] These groups provided recruits

for "the movement." The basis for Sternberger's critical stance can be found here. Under the Third Reich, animal protection laws have been passed almost as fast as concentration camps have been opened. There is much evidence to suggest that such fanatical groups serve as cocoons for the sadomasochistic character in its pupal phase. A study that concerns itself with this but refuses to recognize the death's-head moth which has emerged from the chrysalis must expect to go astray. That is what happens in Sternberger's case. He finds no other way to attack the opponents of vivisection than to denigrate pity as such. Since animal protection is the last refuge the powers-that-be have left for pity, they are unlikely to be offended by its defamation. But in reality they have not left it even this refuge. For them, animal rights are founded on the mysticism of blood and soil.[15] National Socialism, which has evoked so much animality in human beings, thinks that it has been surreptitiously encircled by beasts. Its protection of animals springs from a superstitious fear.

One does not need to subscribe to Schopenhauer's view of pity—namely, that it is the source of people's humanity—to be suspicious of a definition which says that "altruism is as far removed from pity" as "revelation is from feeling" (p. 84).[16] At any rate, one would do better to speak of true humanity before deriding what flows from pity as "genre-painting humanity" (p. 229). Any reader who peruses the discussion of these matters—the chapter entitled "The Religion of Tears"—and attempts to extract its philosophical content will have little to show. He will have to content himself with the assertion that pity is nothing but the "inner side or the correlative of the anger . . . felt by anyone who witnesses a scene of cruelty" (p. 87). The sentence is obscure. All the clearer, however, is the fact that pity is mere froth for the person who washes his hands in innocence.

The unmistakable aim of this book, the cause to which the author has subscribed, can be summed up in a word: it is the art of covering traces. The trace of the origins of his ideas, the trace of the secret reservations underlying his conformist statements, and finally the trace of conformism itself, which is the hardest of all to erase. Ambiguity is Sternberger's element. He elevates it to the method that guides his investigations: "Constraint and action, compulsion and freedom, matter and spirit, innocence and guilt cannot be disentangled in the past, whose unalterable testimony, however scattered and incomplete, we have before us here. These things are always thoroughly interwoven, but the pattern woven[17] can be described" (p. 7).—Sternberger's situation can be described as follows: he confiscated his ideas, and then had them confiscated. No wonder they have a boarded-up look, just as one can speak of a "shuttered" gaze. These views of the nineteenth century seem designed to block insights into the twentieth.

Written in 1938 and January 1939; submitted to the *Zeitschrift für Sozialforschung* in late 1939 but unpublished in Benjamin's lifetime. *Gesammelte Schriften,* III, 572–579. Translated by Edmund Jephcott.

Notes

1. Dolf Sternberger (1907–1989), German journalist and political scientist, was a former student of Adorno's and personally acquainted with Benjamin. He served after the war as president of the West German chapter of PEN (an international association of poets, playwrights, editors, essayists, and novelists).
2. Much of the tone of this review is explained by Benjamin's conviction, expressed in a letter to Adorno and in the draft of a letter to Sternberger himself, that the book is little more than plagiarism. Sternberger knew Benjamin personally; both had contributed to the *Frankfurter Zeitung,* as well as to Frankfurt radio. And he had studied with Adorno at the University of Frankfurt. In the letter to Adorno, Benjamin claims that Sternberger had lifted not only the topic of the study but also its methodology from Adorno, Bloch, and especially Benjamin himself. In the draft letter to Sternberger, Benjamin writes: "You succeed, in your book, in producing a synthesis between an older world of thought (which you share with Adolf Hitler) and a newer one (which you share with me). You have rendered unto the kaiser that which is the kaiser's, and taken from the exile that which you could use" (*Gesammelte Schriften,* III, 701).
3. Jugendstil is the German and Austrian variant of the Art Nouveau style of the 1890s. The movement took its name from the Munich journal *Die Jugend* (Youth).
4. Adorno does this in his book *Kierkegaard: Konstruktion des Ästhetischen* (1933); in English as *Kierkegaard: Construction of the Aesthetic,* trans. Robert Hullot-Kentor (Minneapolis: University of Minnesota Press, 1989).
5. Siegfried Giedion (1888–1968) was a Swiss architect and architectural historian whose *Bauen in Frankreich* (Construction in France; 1928) exerted a deep influence on Benjamin. He taught at Harvard after 1938.
6. Rainer Maria Rilke (1875–1926), Austro-German writer born in Prague, was one of the great lyric poets in the German language. His *Duineser Elegien* (Duino Elegies) and *Sonette an Orpheus* (Sonnets to Orpheus) were published in 1923.
7. The Gründerzeit is the period 1871–1874 in Germany, years of rapid industrial expansion and reckless financial speculation following the Franco-Prussian War and the foundation of the German empire.
8. Adolf Stoecker (1835–1909), protestant theologian and politician, founded the profoundly conservative Christlich-soziale Arbeiterpartei (Christian-Socialist Workers' Party) in 1878. Stoecker sought to convert German workers to the virtues of a monarchical nationalism. He is primarily remembered, however, for his virulent anti-Semitism.
9. Hitler had delivered a programmatic speech on Nazi art and cultural policy one day before the opening of the "Große Deutsche Kunstausstellung" (Great German Art Exhibition) at the Haus der Deutschen Kunst (House of German Art) in

Munich. An exhibition titled "Entartete Kunst" (Degenerate Art) ran concurrently with "Great German Art"; it displayed 650 works confiscated from 32 German museums. Examples of Expressionism, Cubism, Dada, Surrealism, and Neue Sachlichkeit hung alongside drawings by the mentally ill and photographs of handicapped individuals.

10. Sternberger is in the invidious position of having to break off the process of thinking just where it might become fruitful. In the end, this damages his capacity for thought, as we can see from a single sentence: "It is all too easy to laugh at something which in any case is over and done with, and should therefore be regarded as a waste of wit, since wit tends to gain in brilliance as it becomes rarer" (p. 158). The first main clause contains two offenses against clearly ordered thought. First, "in any case" is out of place, because laughter does not alter the temporal location of its object. Second, the word "easy" is inappropriate. For while it might be said to be too easy to laugh about something (for example, a non sequitur) which ought rather to be analyzed by a difficult process of thought, it can never be "all too easy" to make something insignificant the subject of laughter. Laughter is not a task in which one gains credit by overcoming difficulties. In the next clause, the talk about a "waste of wit" makes any sense, however meager, only if "wit" is used to mean "intelligence," as in the eighteenth century. One might well speak of a waste of intelligence, but one could not imagine that the person doing the wasting would laugh as a result. Probably however, the word is not being used with this old-fashioned meaning. It is more likely that, for Sternberger, the idea that wit is rare is confused with the idea that the case in question is not a subject for joking. Now, first of all, not everything one laughs about is a joke. Second, the rarity and terseness of wit cannot be used as a reason that people should find fewer occasions for laughter—even at jokes. Finally, to say that wit tends to gain brilliance [*Brillanz*] through rarity is clear but contrary to language. *Brillant* in German has only one derivation: from Brilliantine. [Benjamin's note. Brilliantine was an oily perfumed preparation designed to make hair smooth and glossy.—*Trans.*]

11. Ludwig Knaus (1829–1910), German genre painter, was a professor at the Kunstakademie in Düsseldorf; groups of children recur as a kind of signature in his art. Eduard von Grützner (1846–1925), another German genre painter, was best known for his studies of drinking and hunting scenes, as well as his depictions of monastery life. Robert Warthmüller (1859–1895), was a German genre painter who specialized in historical events of the eighteenth century, particularly the life of Frederick the Great. Franz von Defregger (1835–1921) was a German genre painter best known for his monumental history scenes, especially representations of the Tirolean war of independence.

12. Faust's wager with Mephistopheles turns on Faust's restless quest for experience. In the first part of Goethe's drama, Faust utters the famous lines, "If I say to any moment / Linger awhile! Thou art so fair! / Then you may cast me in chains." Late in life, Faust is indeed tricked into uttering these words, but is nonetheless redeemed by divine intervention.

13. Sternberger attempts to trace the triumph of genre painting in Nietzsche's writings on the revaluation of values. In referring at this point to a "recurrence of genre painting," he introduces what might have been a constructive moment.

But he does nothing to develop it. He fails to decipher the historical signature of the "inverted genre," with which Nietzsche set himself in opposition to his contemporaries. This signature is to be found in Jugendstil. Against the naive vitality of genre painting, Jugendstil set the mediumistic floral arabesque; on the banality of the everyday, it turned a gaze which had just plumbed the abysses of evil; and to philistine complacency, it opposed a longing whose arms forever remain empty. [Benjamin's note]

14. Albert Léon Charles Calmette (1863–1933), French bacteriologist, developed an antitoxin for vaccination of newborn infants against tuberculosis.

15. "Blut und Boden" ("Blood and Soil") became a slogan of the National Socialists. They derived the phrase from the reactionary journal of the same name, first published in 1929.

16. Arthur Schopenhauer (1788–1860), German philosopher, developed a philosophy of profound pessimism. His major work was *Die Welt als Wille und Vorstellung* (The World as Will and Representation; 1818). In his view, consciousness arises as an instrument in the service of the first, universal principle, which he called the will. Conflict between individual wills is the cause of continual strife and frustration. The world, therefore, is a locus of pain and unsatisfied wants. The only possible escape is the renunciation of desire, a negation of the will. Temporary relief is found only in philosophy or, especially, art.

17. Sternberger's term here is *das Verwirkte,* which also means "what is impounded."

Review of Béguin's *Ame romantique et le rêve*

Albert Béguin, *L'Ame romantique et le rêve: Essai sur le romantisme allemand et la poésie française,* 2 vols. (Marseilles, 1937), 304 pages and 482 pages.

The major part of Béguin's lengthy work is devoted to German Romanticism.[1] Although a briefer characterization of the French Romantics is added at the end, this is not prompted by the interests of comparative literary history (a field whose methods Béguin states are not his own; see vol. 2, p. 320). The author sees German Romanticism not as the mother of French Romanticism but as the Romantic phenomenon par excellence, and thus as the basis for any initiation into the movement. And Béguin's work is indeed an initiation. The subject, he writes, interests "that most secret part of our selves . . . where we feel only a wish: the wish to understand the language of hints and portents, so that we can experience the amazement that fills anyone who briefly gazes on life, with all its strangeness, its dangers, its anxiety, its beauty, and its melancholy limits" (p. xvii). Reflections on Surrealist poetry in the concluding section determine the author's approach from the outset—another indication of how strongly he wishes to venture beyond the bounds of academic research. It should be added that his use of the apparatus of scholarship, if not its method, fulfills the most rigorous academic standards. This is an exemplary book, written with precision and without learned pomposity. That it is often as original as it is appealing in its detailed observations is due in part to these features of its style, despite some problematic aspects of its basic position.

The weaknesses of the work are clearly revealed in its straightforward formulations. The author writes: "Objectivity, which certainly can and

must provide the law for descriptive sciences, cannot fruitfully guide the humanities. In the latter sphere, any 'disinterested' research implies an unforgivable betrayal of one's own self and of the 'object' of investigation" (p. xvii). No one would find fault with this. The error begins to appear when an intense interest is equated with an unmediated one. Unmediated interest is always subjective, and has no more rights in the humanities than in any other discipline. One cannot directly ask whether the Romantics' theories of dream were "correct." The question must be directed at the historical constellation from which these Romantic enterprises arose. Our own current concern with the topic is expressed more legitimately by such mediated interest—directed primarily at the historical context of the Romantics' aims—than by an appeal to an inwardness that directly interrogates the texts in order to reveal their truth. By starting out from such an appeal, Béguin's book may have fostered misunderstandings.

André Thérive, whose book reviews in *Le Temps* reflect a traditional secular viewpoint,[2] remarks that our reaction to Béguin's volume will depend on our opinion of his definition of man—on whether we agree with or vehemently reject the idea that "only in darkness will the mind reach the place where joy, poetry, and secret mastery of the universe can be found" (*Le Temps,* August 1937). One should perhaps note that the testimony of initiates from earlier times can be useful to the adept only if these witnesses are true authorities. In the case of poets, we know of very few such authorities; and in the case of Romantic poets, we know of none. Only Ritter could be seen as an initiator in the stricter sense.[3] Such a view is sanctioned by the way in which he shaped not only his thoughts but especially his life. One might also think of Novalis and Caroline von Günderode;[4] most of the Romantics were too deeply embroiled in the business of literature to figure as "guardians of the threshold." In view of this, Béguin often has to fall back on the standard procedures of literary history. It is apparent that these do not quite suit his purpose; this might make a case not only against them, but also against his topic.

Anyone who undertakes an analysis, Goethe reminds us, should ensure that it has a valid underlying synthesis.[5] Attractive as Béguin's topic may be, the question remains to what extent the author's attitude in approaching it can be reconciled with Goethe's advice. Achieving a synthesis is the privilege of historical knowledge. The topic indicated by the book's title does indeed lead us to expect a historical construction. This would have more adequately reflected the state of awareness available to the author and to us than his fashionable references to Surrealism and existentialist philosophy. It would have revealed that Romanticism marked the culmination of a process begun in the eighteenth century: the secularization of the mystical tradition. Alchemists, Illuminati, and Rosicrucians had prepared the way for what Romanticism completed.[6] That the mystical tradition did not survive

this process undamaged can be seen in the excrescences of Pietism and in the theurgy of figures like Cagliostro and Saint-Germain.[7] Mystical teachings and needs were just as corrupted in the higher classes as in the lower classes.

Romantic esotericism grew out of these circumstances. It was a restoration movement, with all the violence that such movements entail. But in Novalis, and still more in Ritter, mysticism had finally been able to achieve a weightless existence, floating above the mainland of religious experience. By the end of late Romanticism, yet even in the work of Friedrich Schlegel, occult science is seen returning to the bosom of the church.[8] The early stages of a type of social and industrial development—one that called into question a mystical experience no longer rooted in the sacramental—coincided with a period in which mystical experience was entirely secularized. The consequence, for a Friedrich Schlegel, a Clemens Brentano, a Zacharias Werner, was conversion.[9] Others, like Troxler or Schindler, took refuge in an invocation of the dream life, and of the vegetal and animal manifestations of the unconscious.[10] Evacuating the regions of higher mystical life to consolidate those founded in nature, they conducted a strategic withdrawal. Their appeal to the dream life was a distress flare; it lit up less the soul's way back to its motherland than the obstructions that had already blocked it.

Béguin has not arrived at such a view. He has not reckoned with the possibility that the real, synthetic core of his object, as disclosed by historical knowledge, might emit a light in which the dream theories of Romanticism would disintegrate. This deficiency has left traces in the methodology of his work. By dealing with each Romantic writer separately, it betrays a less than unlimited confidence in the synthesizing power of its approach. Yet this weakness has its compensations. It gives the author the chance to prove himself a truly fascinating portraitist. These character studies, regardless of the book's intentions, are what make it worth reading. The first of them, describing the relationship of the quick-witted G. C. Lichtenberg to the dream-life of his fellows, and to his own, already reveals the author's uncommon powers of characterization.[11] In his treatment of Victor Hugo in the second volume, he gives us a masterpiece in a few pages.[12] The further the reader explores the details of these masterly physiognomic cameos, the more corrections he finds to the inherent prejudice which might otherwise have undermined the book. A figure like G. H. Schubert, especially as described by Béguin, shows how little significance can be ascribed to certain esoteric speculations of the Romantics, and accomplishes this with a clarity that does all the more honor to the historian's integrity, the more modest its service to the book's immediate purpose.[13]

Published in *Mass und Wert*, January–February 1939. *Gesammelte Schriften*, III, 557–560. Translated by Edmund Jephcott.

Notes

1. Albert Béguin (1901–1957) was a Swiss literary critic. The book in question, a revision of his doctoral dissertation submitted to the faculty at Geneva, was a major success in France. He taught French literature at Basel between 1937–1946, when he moved to Paris in order to devote himself to writing. He was the editor first of *Les Cahiers du Rhône,* a journal he had founded in 1942, and, after 1950, of the review *L'Esprit.* He championed a wide variety of writers, but was best known for his advocacy of Charles Péguy, Jules Supervielle, and Emmanuel Mounier.

2. The French critic André Thérive (1891–1967) is best remembered for his call for a revival of Naturalist literature, with its depiction of workers and the underclass.

3. Johann Wilhelm Ritter (1776–1810), German physicist and writer, discovered the existence of ultraviolet rays and conducted researches in electricity. His book *Fragmente aus dem Nachlasse eines jungen Physikers* (Fragments from the Posthumous Papers of a Young Physicist) was published in 1810. In a letter to Gerhard Scholem of March 5, 1924, Benjamin discusses the appendix to this book, which contains a Romantic theory of language.

4. Novalis (pseudonym of Friedrich Leopold, Freiherr von Hardenberg; 1772–1801) was a poet, theorist, and central figure of the early German Romantic period. His major works include *Blütenstaub* (Pollen; 1798), *Hymnen an die Nacht* (Hymns to the Night; 1800), and *Heinrich von Ofterdingen* (1802). Novalis plays a major role in Benjamin's dissertation, "The Concept of Criticism in German Romanticism" (reproduced in Volume 1 of this edition). Caroline von Günderode (1780–1806) was a German writer whose friendship with Bettine and Clemens Brentano led her into the circles of early (Jena) Romanticism. Her works include several volumes of poems and the drama *Udohle* (1805). Her unhappy love for the married scholar of myth Friedrich Creuzer led to her suicide.

5. In his autobiography, *Dichtung und Wahrheit,* Goethe writes: "Whoever feels truly pregnant with a synthesis is the one who has the real right to analyze, because he tests and legitimates his inner wholeness by relying on the external detail."

6. The Illuminati were a secret society founded in Bavaria in 1776. Their express goal was world domination, and their intended methods included assassination, blackmail, bribery, and political conspiracy. The Rosicrucians were a secret society claiming to possess esoteric wisdom handed down from ancient times. The name derives from the order's symbol, which combined a rose and a cross. The teachings of Rosicrucianism were an eclectic mixture derived from the major world religions.

7. Pietism was a widespread religious reform movement that began in German Lutheranism in the seventeenth century. Emphasizing personal—especially internal, emotionally based—faith as a protest against secularization in the church, Pietism soon spread and later expanded its emphases to include social and educational concerns. Theurgy is a system of magic, originally practiced by the Egyp-

tian Platonists, devoted to establishing contact with the spirit world. More generally, the term refers to the operation of a divine or supernatural agency in human affairs. Count Alessandro di Cagliostro (born Giuseppe Balsamo; 1743–1795) was an Italian impostor who posed as a physician, alchemist, and freemason. The comte de Saint-Germain (died ca. 1784) was a French adventurer and a confidential diplomat under Louis XV. He claimed to possess the philosopher's stone and the elixir of life.

8. Friedrich von Schlegel (1772–1829) was one of the central figures of the early Romantic movement. With his elder brother August Wilhelm, he founded and edited the literary journal *Athenäum,* in which he published some of his most important philosophical and critical aphorisms. He also published works on Indo-Germanic philology and the philosophy of history. In later life he was the editor of the right-wing Catholic journal *Concordia.* His unfinished novel *Lucinde* was published in 1799. Discontinuous in technique, it fuses philosophical reflection with moral and religious allegory in formulating a Romantic ideal of marriage. Benjamin's dissertation, "The Concept of Criticism in German Romanticism," is in large part a study of Schlegel's cultural theory; see Volume 1 of this edition.

9. Clemens Brentano (1778–1842) was a German Romantic poet and short-story writer. While studying at Halle and Jena he met Wieland, Herder, and Goethe, but his sympathies were with the younger German Romantics. With Achim von Arnim (who married Clemens' sister Bettina), he collaborated on *Des Knaben Wunderhorn* (The Boy's Magic Horn; 1806–1808), a folk-song collection that influenced a number of writers and composers, notably Mahler. Brentano wrote plays, lyric poems, fairy tales, and such novellas as *Geschichte vom braven Kasperl und dem schönen Annerl* (The Story of Just Casper and Fair Annie; 1817). Friedrich Leopold Zacharias Werner (1768–1823) was a German dramatist best known for the "fate drama" *(Schicksalstragödie),* a popular form in which destiny draws a protagonist into a web of crime. Werner's play *Der vierundzwanzigste Februar* (The Twenty-Fourth of February; 1806) is among the best-known examples.

10. Ignaz Paul Vital Troxler (1780–1866) was a German professor of philosophy. Heinrich Bruno Schindler (1797–1859) was a psychologist and cultural historian who studied parapsychological phenomena in in such works as *Das magische Geistesleben: Ein Beitrag zur Psychologie* (The Magical Mode of Thought: A Contribution to Psychology; 1857) and *Der Aberglaube des Mittelalters: Ein Beitrag zur Culturgeschichte* (Superstition in the Middle Ages: A Contribution to Cultural History; 1858).

11. Georg Christoph Lichtenberg (1742–1799) was a German physicist and satirist who investigated electrical phenomena. He lampooned Lavater's science of physiognomy and the excesses of the Sturm und Drang movement, and is remembered today as the first great German aphorist.

12. Victor Hugo (1802–1885), French diplomat, dramatist, novelist, and poet, was the most important of the Romantic writers. While his novels (*Les Misérables,* 1862, *Notre-Dame de Paris,* 1831) remain his best-known works, his legacy to the nineteenth century was his lyric poetry.

13. Gotthilf Heinrich Schubert (1780–1860) was a German Romantic physician, biologist, and natural philosopher. He became prominent through a series of lectures, encouraged by the writer Heinrich von Kleist and the economist Adam Müller, on nature's "night side": magnetism, clairvoyance, dreams.

Note on Brecht

Blücher points out very rightly that certain passages in the *Lesebuch für Städtebewohner* are no more than formulations of the methods of the GPU.[1] This confirms, from a point of view opposite to my own, what I call the prophetic character of these poems. The fact is that in the verses I am referring to, we can indeed see the procedures in which the worst elements of the Communist party resonate with the most unscrupulous ones of National Socialism. Blücher is right when he objects to my commentary on the third poem of the *Lesebuch* on the grounds that Hitler was not the first to import sadism into the practice described, by applying it to the Jews instead of to the exploiters; rather, he argues, a sadistic element was already implicit in the "expropriation of the expropriators" as described by Brecht. And the parenthesis which concludes the poem ("That is how we speak to our fathers") proves conclusively that what is involved here is an expropriation of the expropriators which is not in favor of the proletariat but in favor of stronger expropriators—that is to say, the young. This remark reveals the complicity between this poem and the attitude of the dubious Expressionist clique around Arnolt Bronnen.[2]—It is possible that contact with revolutionary workers could have prevented Brecht from poetically transfiguring the dangerous and momentous errors into which GPU practices had led the workers' movement. At any rate, the commentary, in the form I gave it, is a pious falsification which obscures the extent to which Brecht is implicated in the development in question.

Written either late 1938 or 1939; unpublished in Benjamin's lifetime. *Gesammelte Schriften*, VI, 540. Translated by Edmund Jephcott.

Notes

1. Heinrich Blücher (1899–1970), German art historian and philosopher, became a member of the Communist party in 1919. He worked as a journalist in Berlin during the Weimar Republic, and in Prague, Paris, and New York after 1933. He taught art history, first at the New School for Social Research and then at Bard College. He was married to Hannah Arendt.

 Bertolt Brecht conceived the title *Lesebuch für Städtebewohner* (A Reader for Those Who Live in Cities) for a group of poems composed in 1926–1927; of these, only the first set of ten poems appeared in his *Versuche 2* (1930). For an English translation, see Brecht, *Poems, 1913–1956* (London: Methuen, 1987), pp. 131–150. See also "Commentary on Poems by Brecht," below in this volume.

 The GPU, or State Political Directorate—the Soviet secret police—was created in 1922. Though initially less powerful than its predecessor, the Cheka, under Stalin the GPU again acquired vast punitive powers and in 1934 was renamed the People's Commissariat for Internal Affairs, or NKVD. No longer subject to party control or restricted by law, the NKVD became Stalin's instrument against the party and the country during the Great Terror of the 1930s.

2. Arnolt Bronnen (1895–1959) was a German dramatist who, during the Weimar Republic, combined leftist politics and Expressionism in a series of controversial plays. He collaborated with the National Socialists during Hitler's regime. After the war he worked as a critic and director, first in Austria, then in the German Democratic Republic (East Germany). He and Benjamin had first met in the years before World War I, when both were involved in the German Youth Movement.

Central Park

[1]

Laforgue's hypothesis concerning Baudelaire's conduct in the bordello puts his entire psychoanalytic interpretation of Baudelaire into proper perspective.[1] This view agrees point by point with the conventional approach of "literary history."

*

The special beauty of so many of the openings of Baudelaire's poems lies in this: a rising up from the abyss.

*

In translating "Spleen et idéal" as "Trübsinn und Vergeistigung," George hit upon the true meaning of the ideal in Baudelaire.[2]

*

If it can be said that for Baudelaire modern life is the reservoir of dialectical images, this implies that he stood in the same relation to modern life as the seventeenth century did to antiquity.

*

If we call to mind just how much Baudelaire as a poet had to respect his own precepts, his own insights, and his own taboos, and how strictly circumscribed, on the other hand, the tasks of his poetic labor were, then we may come to see in him a heroic trait.

[2]

Spleen as a bulwark against pessimism. Baudelaire is no pessimist. This is because, with Baudelaire, a taboo is placed on the future. That is what distinguishes his heroism most clearly from Nietzsche's.[3] His writings contain no reflections on the future of bourgeois society—an astonishing fact, in view of the nature of his *Journaux intimes*. From this alone, we can see how little he relied on striking effects for the longevity of his work, and to what extent the structure of *Les Fleurs du mal* is monadological.

*

The structure of *Les Fleurs du mal* is not based on any ingenious arrangement of the individual poems, still less on some secret key. It results from the relentless exclusion of any lyric theme that does not bear the stamp of Baudelaire's own profoundly sorrowful experience. And precisely because Baudelaire was aware that his form of suffering—spleen, the *taedium vitae*—is a very ancient one, he was able to make the signature of his own experience stand out in bold relief against it. One suspects that few things could have given him a greater sense of his own originality than a reading of the Roman satirists.

[3]

The "enshrinement," or apologia, is meant to cover up the revolutionary moments in the course of history. At bottom, it seeks to establish continuity. It sets store only by those elements of a work which have already emerged and played a part in its reception. It ignores the peaks and crags, which offer footing to those who want to move beyond this view.

*

The cosmic shudder in Victor Hugo never has the quality of the naked terror that seized Baudelaire in his spleen.[4] This descended on the poet from a cosmic space that was made for the *intérieur* in which he felt at home. He felt perfectly at home in this spirit-world. It is the complement of the coziness of his domestic existence, which was itself not without its terrors.

*

"Dans le coeur immortel qui toujours veut fleurir": use this to elucidate the meaning of the flowers of evil and of infertility. *Vendanges* in Baudelaire—his most melancholy word ("Semper eadem"; "L'Imprévu").[5]

*

The contradiction between the theory of natural correspondences[6] and the repudiation of nature. How is this to be resolved?

*

Sudden attacks, mystery-mongering, surprising decisions belong to the *raison d'état* of the Second Empire and were characteristic of Napoleon III.[7] They are the crucial gestures [*Gestus*] informing Baudelaire's theoretical pronouncements.

[4]

The decisively new ferment that enters the *taedium vitae* and turns it into spleen is self-estrangement. In Baudelaire's melancholy [*Trauer*], all that is left of the infinite regress of reflection—which in Romanticism playfully expanded the space of life into ever-wider circles and reduced it within ever-narrower frames—is the "somber and lucid tête-à-tête" of the subject with itself. The specific "seriousness" of Baudelaire's work is located here. It prevented the poet from truly assimilating the Catholic worldview, which could be reconciled with allegory only under the aegis of play. Here, unlike the situation in the Baroque, the semblance implicit in allegory is no longer acknowledged.[8]

*

Baudelaire was not based in any style, and he had no school. This greatly impeded his reception.

*

The introduction of allegory is a far more significant response to the crisis in art than the doctrine of art for art's sake, which sought to combat the crisis around 1852. This crisis in art had its roots in both the technological situation and the political situation.

[5]

There are two legends of Baudelaire. One—which he disseminated himself—presents him as the inhuman bogeyman of the solid citizen. The other—which arose with his death and is the basis of his fame—presents him as a martyr. This false theological nimbus should be dispelled right down the line. Monnier has a formula for this nimbus.[9]

*

It can be said that happiness penetrated him like a shudder; the same cannot be said of unhappiness. In the state of nature, misfortune cannot pass into us.

*

Spleen is the feeling that corresponds to catastrophe in permanence.

*

The course of history, seen in terms of the concept of catastrophe, can actually claim no more attention from thinkers than a child's kaleidoscope, which with every turn of the hand dissolves the established order into a new array. There is profound truth in this image. The concepts of the ruling class have always been the mirrors that enabled an image of "order" to prevail.—The kaleidoscope must be smashed.

*

The grave as the secret chamber in which Eros and Sexus settle their ancient quarrel.

*

The stars in Baudelaire represent a picture puzzle of the commodity. They are the ever-same in great masses.

*

The devaluation of the world of things in allegory is surpassed within the world of things itself by the commodity.

[6]

Jugendstil is to be presented as art's second attempt to come to terms with technology.[10] The first attempt was realism. For realism, the problem was more or less present in the consciousness of the artists, who were uneasy about the new processes of technological reproduction. (Loci! Perhaps in the papers for the "Reproducibility" essay.) In Jugendstil, the problem as such was already prey to repression. Jugendstil no longer saw itself threatened by the competing technology; hence, the critique of technology concealed within it was all the more total and aggressive. Its real purpose was to arrest technological development. Its recourse to technological motifs arises from the effort . . .[11]

*

In Rollinat, what was allegory in Baudelaire has lapsed into genre.[12]

*

The motif of the *perte d'auréole*[13] is to be developed as the decisive contrast to Jugendstil.

*

Essence as a motif of Jugendstil.

*

To write history means giving calendar dates their physiognomy.

*

Prostitution of space in hashish, where it serves all that has been (spleen).

*

From the perspective of spleen, the buried man is the "transcendental subject"[14] of historical consciousness.

*

Jugendstil was especially fond of the aureole. Never was the sun more pleased with itself than in its radiant halo; never was the human eye more lustrous than in Fidus.[15]

[7]

The motif of androgyny, the lesbian, the unfruitful woman, should be treated in connection with the destructive power of the allegorical intention.—The rejection of the "natural" must be dealt with earlier—in connection with the city as the poet's subject.

*

Meryon: the sea of buildings, the ruins, the clouds; the majesty and decrepitude of Paris.[16]

*

The interplay between antiquity and modernity must be transferred from the pragmatic context—in which it first appears in Baudelaire—to the context of allegory.

*

Spleen interposes centuries between the present moment and the one just lived. It is spleen that tirelessly generates "antiquity."

*

"Modernity" in Baudelaire is not based solely or primarily on sensibility. It gives expression to extreme spontaneity. Modernity in Baudelaire is a conquest; it has an armature. Apparently Jules Laforgue, speaking of Baudelaire's "Americanism," is the only one who has noticed this.[17]

[8]

Baudelaire did not have the humanitarian idealism of a Victor Hugo or a Lamartine.[18] The emotional buoyancy of a Musset was not at his disposal.[19] He did not, like Gautier, take pleasure in his times, nor could he deceive himself about them like Leconte de Lisle.[20] It was not given to him to find a refuge in devotions, like Verlaine, nor to heighten the youthful vigor of his lyric élan through the betrayal of his adulthood, like Rimbaud.[21] As rich as Baudelaire is in knowledge of his art, he is relatively lacking in stratagems to face the times. How far did even the "modernity" he was so proud of discovering really engage with those times? Those who wielded power in the Second Empire were not modeled on the bourgeois types created by Balzac. Modernity finally became a role which perhaps only Baudelaire himself could fill. A tragic role, in which the dilettante—who, for want of other parts, had to perform it—often cut a comical figure, like the heroes Daumier caricatured with Baudelaire's approbation.[22] All this Baudelaire no doubt recognized. The eccentricities in which he took such pleasure were his way of acknowledging it. Assuredly, therefore, he was not a savior, a martyr, or even a hero. But he had about him something of the mime who apes the "poet" before an audience and a society which no longer need a real poet, and which grant him only the latitude of mimicry.

[9]

Neurosis creates the mass-produced article in the psychic economy. There it takes the form of the obsessional idea, which, manufactured in countless copies, appears in the household of the neurotic mind as the ever selfsame. Conversely, in Blanqui the idea of eternal return itself takes the form of an obsessional idea.[23]

*

The idea of eternal recurrence transforms the historical event itself into a mass-produced article. But this conception also displays, in another re-

spect—on its obverse side, one could say—a trace of the economic circumstances to which it owes its sudden topicality. This was manifest at the moment the security of the conditions of life was considerably diminished through an accelerated succession of crises. The idea of eternal recurrence derived its luster from the fact that it was no longer possible, in all circumstances, to expect a recurrence of conditions across any interval of time shorter than that provided by eternity. The recurrence of quotidian constellations became gradually less frequent and there could arise, in consequence, the obscure presentiment that henceforth one must rest content with cosmic constellations. Habit, in short, made ready to surrender some of its prerogatives. Nietzsche says, "I love short-lived habits";[24] and before this, Baudelaire was throughout his life incapable of developing regular habits.

[10]

On the melancholic's Via Dolorosa, allegories are the stations. The role of the skeleton in Baudelaire's erotology? "L'élégance sans nom de l'humaine armature."[25]

*

It is impotence that makes for the Via Dolorosa of male sexuality. The historical index of this impotence. From this impotence springs [Baudelaire's] attachment to the seraphic image of woman, as well as his fetishism. Witness the clarity and precision of the phenomenon of woman in Baudelaire. Keller's "sin of the poet"—namely, "inventing sweet images of women, / such as bitter earth never harbors"—is certainly not his.[26] Keller's women have the sweetness of chimeras because they are informed by his own impotence. Baudelaire, in his female figures, is more precise and, in a word, more French, because with him the fetishistic and the seraphic elements almost never coincide, as they do in Keller.

*

Social reasons for impotence: the imagination of the bourgeois class ceases to be occupied with the future of the productive forces it has unleashed. (Comparison between classical utopias and those of the mid-nineteenth century.) In order to concern itself further with this future, the bourgeois class in fact would first have had to renounce the idea of private income. In my study on Fuchs, I showed how the specific midcentury "coziness" goes hand in hand with this demonstrable flagging of the social imagination. Compared to the images of the future engendered by the social imagination, the wish to have children is, perhaps, a weaker stimulant to potency. At any

rate, Baudelaire's doctrine of children as the beings closest to original sin is somewhat revealing here.

[11]

Baudelaire's strategy in the literary market: through his deep experience of the nature of the commodity, he was enabled, or compelled, to recognize the market as an objective court of appeals (see his *Conseils aux jeunes littérateurs*). Through his negotiations with editors, he was continuously in contact with the market. His techniques: defamation (Musset), and counterfeit (Hugo). Baudelaire was perhaps the first to conceive of a market-oriented originality, which for that very reason was more original in its day than any other *(créer un poncif)*.[27] This *création* entailed a certain intolerance. Baudelaire wanted to make room for his poems, and to this end he had to push aside others. He managed to devalue certain poetic liberties of the Romantics through his classical deployment of the alexandrine, and to devalue classicist poetics through the characteristic ruptures and defects he introduced into classical verse. In short, his poems contained special provisions for the elimination of competitors.

[12]

The figure of Baudelaire plays a decisive part in his fame. For the petty-bourgeois mass of readers, his story was an *image d'Epinal*,[28] an illustrated "life history of a libertine." This image has contributed greatly to Baudelaire's reputation, little though its purveyors may have numbered among his friends. Over this image another was laid, one that has had a much less widespread but—for that very reason—perhaps more lasting effect: it shows Baudelaire as the exemplar of an aesthetic Passion, such as Kierkegaard conceived of around the same time (in *Either-Or*).[29] No study of Baudelaire can fully explore the vitality of its subject without dealing with the image of his life. This image was actually determined by the fact that he was the first to realize, and in the most productive way, that the bourgeoisie was about to annul its contract with the poet. Which social contract would replace it? That question could not be addressed to any class; only the market and its crises could provide an answer. What concerned Baudelaire was not manifest and short-term demand but latent and long-term demand. *Les Fleurs du mal* demonstrates that he correctly assessed this demand. But the medium of the market through which it revealed itself to him dictated a mode of production and of living which differed sharply from those known to earlier poets. Baudelaire was obliged to lay claim to the dignity of the poet in a society that had no more dignity of any kind to confer. Hence the *bouffonerie* of his public appearances.

[13]

In Baudelaire, the poet for the first time stakes a claim to exhibition value. Baudelaire was his own impresario. The *perte d'auréole* concerned the poet first of all. Hence his mythomania.

*

The elaborate theorems with which the principle of "art for art's sake" was enunciated—not only by its original proponents but above all by literary history (not to mention its present devotees)—ultimately came down to a specific thesis: that sensibility is the true subject of poetry. Sensibility, by its nature, is involved in suffering. If it experiences its highest concretization, its richest determination, in the sphere of the erotic, then it must find its absolute consummation, which coincides with its transfiguration, in the Passion. The poetics of *l'art pour l'art* issued directly in the poetic Passion of *Les Fleurs du mal*.

*

Flowers adorn the individual stations of this Calvary. They are flowers of evil.

*

That which the allegorical intention has fixed upon is sundered from the customary contexts of life: it is at once shattered and preserved. Allegory holds fast to the ruins. It offers the image of petrified unrest.[30] Baudelaire's destructive impulse is nowhere concerned with the abolition of what falls prey to it.

*

The description of confusion is not the same as a confused description.[31]

*

Victor Hugo's "Attendre c'est la vie": the wisdom of exile.

*

The new *desolation* of Paris (see the passage on *croque-morts*) is an essential moment in the image of modernity (see Veuillot; D2,2).[32]

[14]

The figure of the lesbian is, in the precise sense, one of Baudelaire's heroic exemplars. He himself says as much in the language of his satanism. It is no less comprehensible in the unmetaphysical, critical language in which he de-

clares his adherence to "modernity" in its political sense. The nineteenth century began openly and without reserve to include woman in the process of commodity production. All the theoreticians were united in their opinion that her specific femininity was thereby endangered; masculine traits must necessarily manifest themselves in women after a while. Baudelaire affirms these traits; at the same time, however, he seeks to free them from the domination of the economy. Hence the purely sexual accent which he comes to give this developmental tendency in women. The paradigm of the lesbian woman represents the protest of "modernity" against technological development. (One would have to determine how his aversion to George Sand[33] had its roots in this context.)

*

Woman in Baudelaire: the most precious booty in the "triumph of allegory"—the life which signifies death. This quality is most inalienably the whore's. It is the only thing about her that cannot be bought, and for Baudelaire it is the only thing that matters.

[15]

To interrupt the course of the world—that was Baudelaire's deepest intention. The intention of Joshua. Not so much the prophetic one, for he gave no thought to any sort of reform. From this intention sprang his violence, his impatience, and his anger; from it, too, sprang the ever-renewed attempts to stab the world in the heart or sing it to sleep. In this intention he provides death with an accompaniment: his encouragement of its work.

*

One must assume that the subjects at the center of Baudelaire's poetry could not be arrived at by a planned, purposeful effort; thus, he does not aim at these radically new subjects—the big city, the masses—as such. The melody he seeks is not in them. It is in satanism, spleen, and deviant eroticism. The true subjects of *Les Fleurs du mal* are found in inconspicuous places. To pursue the image: they are in the previously untouched strings of the instrument whose sound had never been heard before and on which Baudelaire's works were improvised.

[16]

The labyrinth is the right path for the person who always arrives early enough at his destination. This destination is the marketplace.

*

Games of chance, flânerie, collecting—activities pitted against spleen.

*

Baudelaire shows how the bourgeoisie in its decline can no longer assimilate asocial elements. When was the Garde Nationale dissolved?[34]

*

With the new manufacturing processes that lead to imitations, semblance is consolidated in commodities.

*

For people as they are now, there is only one radical novelty—and always the same one: death.

*

Petrified unrest is also the formula for Baudelaire's life history, which knows no development.

[17]

One of the arcana which prostitution came to possess with the advent of the big city is the phenomenon of the masses.[35] Prostitution opens the possibility of a mythical communion with the mass. The masses came into being at the same time as mass production. Prostitution seems to offer the possibility of enduring a life in which the most immediate objects of our use have turned more and more into mass commodities. In big-city prostitution, the woman herself becomes a mass-produced article. It is this wholly new characteristic of urban life which gives Baudelaire's reception of the dogma of original sin its true significance. The oldest concept seemed to him just proven enough to master a thoroughly new and disconcerting phenomenon.

*

The labyrinth is the habitat of the dawdler. The path followed by someone reluctant to reach his goal easily becomes labyrinthine. A drive, in the stages leading to its satisfaction, acts likewise. But so, too, does a humanity (a class) which does not want to know where its destiny is taking it.

*

If it is imagination that presents correspondences to the memory, it is thinking that consecrates allegories to it. Memory brings about the convergence of imagination and thought.

[18]

The magnetic attraction which a few basic situations continually exerted on the poet is one of the symptoms of his melancholy. Baudelaire's imagination is occupied by stereotyped images. He seems to have been subject to a very general compulsion to return at least once to each of his motifs. This is doubtless comparable to the compulsion which repeatedly draws the felon back to the scene of his crime. Baudelaire's allegories are sites where he atoned for his destructive drive. This may explain the unique correspondence between so many of his prose pieces and particular poems from *Les Fleurs du mal.*

*

To attempt (like Lemaître) to judge Baudelaire's intellectual powers on the basis of his philosophical digressions would be a grave error.[36] Baudelaire was a bad philosopher, a good theoretician; but only as a brooder was he incomparable. He has the characteristics of the brooder: the stereotypic quality of his motifs, his imperturbability in warding off disturbance, his perpetual readiness each time to put the image at the beck and call of thought. The brooder, as a historically distinct type of thinker, is at home among allegories.

*

For Baudelaire, prostitution is the yeast that causes the great urban masses to rise in his imagination.

[19]

Majesty of the allegorical intention: to destroy the organic and the living— to eradicate semblance [*Schein*]. One must note the highly revealing passage where Baudelaire writes about his fascination with painted stage back-drops.[37] The renunciation of the magic of distance is a decisive moment in Baudelaire's lyric poetry. It has found its sovereign formulation in the first stanza of "Le Voyage."

*

Regarding the eradication of semblance: "L'Amour du mensonge."[38]

*

"Une Martyre" and "La Mort des amants"—Makart interior and Jugendstil.[39]

*

The wrenching of things from their familiar contexts—the normal state for goods on display—is a procedure highly characteristic of Baudelaire. It is linked to the destruction of organic contexts in the allegorical intention. See the nature motifs in "Une Martyre," third and fifth stanzas, and in the first stanza of "Madrigal triste."[40]

*

Derivation of the aura as the projection of a human social experience onto nature: the gaze is returned.

*

The dissolution of semblance [*die Scheinlosigkeit*] and the decay of the aura are identical phenomena. Baudelaire places the artistic device of allegory in their service.

*

It belongs to the Via Dolorosa of male sexuality that Baudelaire regarded pregnancy as a kind of unfair competition.

*

The stars, which Baudelaire banished from his world, are for Blanqui precisely the theater of eternal recurrence.

[20]

More and more relentlessly, the objective environment of human beings is coming to wear the expression of the commodity. At the same time, advertising seeks to disguise the commodity character of things. What resists the mendacious transfiguration of the commodity world is its distortion into allegory. The commodity wants to look itself in the face. It celebrates its incarnation in the whore.

*

The refunctioning [*Umfunktionierung*] of allegory in the commodity economy must be described. Baudelaire's enterprise was to make manifest the peculiar aura of commodities. He sought to humanize the commodity heroically. This endeavor has its counterpart in the concurrent bourgeois attempt to humanize the commodity sentimentally: to give it, like the human being, a home. The means used were the étuis, covers, and cases in which the domestic utensils of the time were sheathed.

*

The Baudelairean allegory—unlike the Baroque allegory—bears traces of the rage needed to break into this world, to lay waste its harmonious structures.

*

In Baudelaire, the heroic is the sublime manifestation—while spleen is the abject manifestation—of the demonic. Yet these categories of his aesthetic must be deciphered. They cannot be taken at face value.—Connection of the heroic to Latin antiquity.

[21]

Shock as a poetic principle in Baudelaire: the urban scene traced out by the *fantasque escrime*[41] of "Tableaux parisiens" is no longer a homeland. It is a spectacle, a foreign place.

*

How well can the image of the big city turn out when the inventory of its physical dangers is as incomplete as it is in Baudelaire?

*

Emigration as a key to the big city.

*

Baudelaire never wrote a poem on prostitution from the standpoint of the prostitute (compare [Brecht's] *Lesebuch für Städtebewohner 5*).[42]

*

The solitude of Baudelaire and the solitude of Blanqui.

*

Baudelaire's physiognomy as that of the mime.

*

Depict Baudelaire's misery against the background of his "aesthetic Passion."

*

Baudelaire's violent temper goes hand in hand with his destructive animus. We get nearer the matter when we recognize that here, too, in these bursts of anger, there is *un étrange sectionnement du temps*.[43]

*

The basic motif of Jugendstil is the transfiguration of infertility. The body is portrayed, preferably, in its prepubescent forms. This idea is to be linked to the regressive interpretation of technology.

*

Lesbian love carries spiritualization forth into the very womb of the woman. There it raises its lily-banner of "pure" love, which knows no pregnancy and no family.

*

The title *Les Limbes* should perhaps be dealt with in the first part, so that each part contains a commentary on a title; *Les Lesbiennes*, in the second part; and *Les Fleurs du mal*, in the third.[44]

[22]

Baudelaire's reputation—unlike the more recent fame of Rimbaud, for example—has not yet waned. The uncommon difficulty one encounters when approaching the core of Baudelaire's poetry can be summed up by the formula: in this poetry, nothing yet is outdated.

*

The signature of heroism in Baudelaire: to live in the heart of unreality (semblance). In keeping with this is the fact that Baudelaire knew nothing of nostalgia. Kierkegaard!

*

Baudelaire's poetry reveals the new in the ever-selfsame, and the ever-selfsame in the new.

*

Show with maximum force how the idea of eternal recurrence emerged at about the same time in the worlds of Baudelaire, Blanqui, and Nietzsche. In Baudelaire, the accent is on the new, which is wrested with heroic effort from the "ever-selfsame"; in Nietzsche, it is on the "ever-selfsame" which the human being faces with heroic composure. Blanqui is far closer to Nietzsche than to Baudelaire; but in his work, resignation predominates. In Nietzsche, this experience is projected onto a cosmological plane, in his thesis that nothing new will occur.

[23]

Baudelaire would never have written poems if he'd had nothing more than the usual motives poets have for writing poetry.

*

This study will need to furnish the historical projection of the experiences underlying *Les Fleurs du mal*.

*

Some very precise observations by Adrienne Monnier: his specifically French quality: *la rogne*.[45] She sees him as a man in revolt, comparing him to Fargue: "maniacal, rebelling against his own impotence, and aware of doing so."[46] She also mentions Céline. *Gauloiserie* is the French quality in Baudelaire.[47]

*

Another observation by Adrienne Monnier: Baudelaire's readers are men. His work does not appeal to women. For men, he represents the image and transcendence of the *côté ordurier* of their instinctual life.[48] Indeed, the Passion of Baudelaire takes on this aspect for many readers, as a redemption of certain sides of their instinctual life.

*

For the dialectician, what matters is having the wind of world history in one's sails. For him, thinking means setting the sails. What is important is *how* they are set. Words are for him merely the sails. The way they are set turns them into concepts.

[24]

The uninterrupted resonance which *Les Fleurs du mal* has found up through the present day is closely linked to a certain aspect of the big city, which here entered poetry for the first time. It is the aspect least of all expected. What makes itself felt through the evocation of Paris in Baudelaire's verse is the infirmity and decrepitude of this great city. This is perhaps nowhere more perfectly conveyed than in "Crépuscule du matin"; but the aspect itself is common to almost all the poems in "Tableaux parisiens." It is expressed in the transparency of the city, as conjured up by "Le Soleil," no less than in the effect of contrast in "Rêve parisien."

*

The crucial basis of Baudelaire's production is the tension between an extremely heightened sensitivity and an extremely intense contemplation. This tension is reflected theoretically in the doctrine of *correspondances* and in the principle of allegory. Baudelaire never made the slightest attempt to establish any sort of relations between these two forms of speculation, both of the greatest concern to him. His poetry springs from the interaction of the two tendencies, which are rooted in his temperament. What first aroused interest in his work (Pechméja),[49] and lived on in *poésie pure,* was the sensitive side of his genius.

[25]

Silence as aura. Maeterlinck pushes the unfolding of the auratic to the point of absurdity.[50]

*

Brecht remarked that, in speakers of Romance languages, a refinement of the sensorium does not diminish the power of apprehension. In those who speak German, on the other hand, the refinement and development of the capacity for enjoyment is always purchased with a decline in the power of apprehension. The capacity for pleasure loses in concentration what it gains in sensibility. This observation apropos of the *odeur de futailles* in "Le Vin des chiffonniers."[51]

*

Still more important is the following observation: the eminent sensual refinement of a Baudelaire has nothing at all to do with any sort of coziness. This fundamental incompatibility of sensual pleasure with what is called *Gemütlichkeit* is the criterion for a true culture of the senses. Baudelaire's snobbism is the eccentric formula for this steadfast repudiation of complacency, and his "satanism" is nothing other than the constant readiness to subvert this habit of mind wherever and whenever it should appear.

[26]

Les Fleurs du mal does not contain even the rudiments of a visual description of Paris. That is enough to distinguish it emphatically from later "city poetry." Baudelaire mingles his voice with the roar of the city as one might mingle one's voice with the breakers on the shore. His speech is clear to the extent that it is perceptible. But something merging with it muffles its sound. And it remains mingled with this roar, which carries it onward while endowing it with a dark meaning.

*

For Baudelaire, the *fait divers* is the yeast that causes the great urban masses to rise in his imagination.

*

What proved so fascinating to Baudelaire in Latin literature, particularly that of the late period, may have been, in part, the way in which late Latin literature used the names of gods—a usage that was less abstract than allegorical. In this he may have recognized a procedure with affinities to his own.

*

Baudelaire's opposition to nature involves first and foremost a deep-seated protest against the "organic." Compared to the inorganic, organic nature has only the most limited instrumental quality. It is less available for use. Compare Courbet's testimony that Baudelaire's appearance was different every day.[52]

[27]

The heroic bearing of Baudelaire is intimately related to that of Nietzsche. Although Baudelaire adheres to Catholicism, his experience of the universe is in exact accord with the experience comprehended by Nietzsche in the phrase "God is dead."

*

The sources nourishing Baudelaire's heroic bearing spring from the deepest foundations of the social order that was being established in the mid-nineteenth century. They consist solely of the experiences which apprised Baudelaire of the radical changes taking place in the conditions of artistic production. These changes consisted in the fact that the commodity form was being far more directly and forcefully expressed in the work of art—and the form of the masses expressed in its public—than ever before. These changes, in conjunction with others in the realm of art, contributed more than anything else to the decline of lyric poetry. It is the unique distinction of *Les Fleurs du mal* that Baudelaire responded to these altered conditions with a book of poems. This is also the most extraordinary example of heroic conduct to be found in the course of his existence.

*

"L'appareil sanglant de la Destruction"[53]: the household effects scattered, in the innermost chamber of Baudelaire's poetry, at the feet of the whore who has inherited all the powers of Baroque allegory.

[28]

The brooder whose startled gaze falls on the fragment in his hand becomes an allegorist.

*

A question to be reserved until the end: How is it possible that a stance seemingly so "untimely" as allegory should have taken such a prominent place in the poetic work of the century?

*

Allegory should be shown as the antidote to myth. Myth was the comfortable route from which Baudelaire abstained. A poem like "La Vie antérieure," whose very title invites every sort of compromise, shows how far removed Baudelaire was from myth.

*

End with the Blanqui quotation, "Hommes du dix-neuvième siècle . . ."[54]

*

To the image of "rescue" belongs the firm, seemingly brutal grasp.

*

The dialectical image is that form of the historical object which satisfies Goethe's requirements for a synthetic object.[55]

[29]

As someone dependent on handouts, Baudelaire put this society continuously to the test. His artificially maintained dependence on his mother had not only a psychological cause (underscored by psychoanalysts) but a social one.

*

Important to the idea of eternal recurrence is the fact that the bourgeoisie no longer dared count on the future development of the system of production which they had set in motion. Zarathustra's idea of eternal recurrence, and the embroidered pillowcase-motto "Just fifteen little minutes," are complementary.

*

Fashion is the eternal recurrence of the new.—Yet can motifs of redemption be found specifically in fashion?

*

The interior, in Baudelaire's poems, is often inspired by the dark side of the bourgeois interior. Its opposite is the transfigured interior of Jugendstil. Proust, in his observations, touched only on the former.[56]

*

Baudelaire's aversion to travel makes the preponderance of exotic images in many of his poems all the more remarkable. In this predominance his melancholy finds expression. It also attests to the strength of the claim which the auratic element made on his sensibility. "Le Voyage" is an abjuration of travel.

*

The correspondence between antiquity and modernity is the sole constructive concept of history in Baudelaire. It excluded, more than contained, a dialectical conception.

[30]

An observation by Leiris: the word *familier* in Baudelaire is full of mystery and disquiet, standing for something it had never stood for before.[57]

*

One of the hidden anagrams of Paris in "Spleen (I)" is the word *mortalité*.[58]

*

The first line of "La Servante au grand coeur": the words "dont vous étiez *jalouse*"[59] do not carry the stress one would expect. The voice draws back, as it were, from *jaloux*. And this ebbing of the voice is something highly characteristic of Baudelaire.

*

A remark by Leiris: the noise of Paris is not communicated through the numerous literal references—such as *lourds tombereaux*[60]—but penetrates the rhythm of Baudelaire's verse.

*

The line "Où tout, même l'horreur, tourne aux enchantements" could hardly be better exemplified than by Poe's description of the crowd.[61]

*

Leiris remarks that *Les Fleurs du mal* is the most irreducible book of poetry. This could be understood to mean that the experience underlying it has scarcely at all been converted into something else.

[31]

Male impotence: the key figure of solitude. Under its aegis the stagnation of productive forces is enacted—an abyss divides the human being from others.

*

Fog as the consolation of solitude.

*

The "vie antérieure"[62] opens a temporal abyss within things; solitude opens a spatial abyss before the human being.

*

The tempo of the flâneur should be compared with that of the crowd, as described by Poe. It is a protest against the tempo of the crowd. Compare the fashion for tortoises in 1839 (D2a,1).[63]

*

Boredom in the production process arises as the process accelerates (through machinery). The flâneur protests against the production process with his ostentatious nonchalance.

*

One encounters an abundance of stereotypes in Baudelaire, as in the Baroque poets.

*

A series of types, from the national guardsman Mayeux through Vireloque and Baudelaire's ragpicker to Gavroche and the *lumpen*-proletarian Ratapoil.[64]

*

Look for an invective against Cupid. In connection with the allegorist's invectives against mythology, which so precisely match those of early-medieval clerics. In the passage in question, Cupid might have the epithet *joufflu*.[65] Baudelaire's aversion to this figure has the same roots as his hatred for Béranger.[66]

*

Baudelaire's candidacy for the Académie was a sociological experiment.

*

The doctrine of eternal recurrence as a dream of the immense discoveries imminent in the field of reproduction technology.

[32]

If, as generally agreed, the human longing for a purer, more innocent, more spiritual existence than the one given to us necessarily seeks some pledge of that existence in nature, this is usually found in some entity from the plant or animal kingdom. Not so in Baudelaire. His dream of such an existence disdains community with any terrestrial nature and holds only to clouds. This is explicit in the first prose poem in *Le Spleen de Paris*. Many of his poems contain cloud motifs. What is most appalling is the defilement of the clouds ("La Béatrice").

*

Les Fleurs du mal bears a hidden resemblance to Dante in the emphatic way it traces the itinerary of a creative life. There is no other book of poems in which the poet presents himself with so little vanity and so much force. According to Baudelaire's experience, autumn is the true ground of creative genius. The great poet is, as it were, a creature of autumn. "L'Ennemi," "Le Soleil."

*

"De l'essence du rire"[67] contains nothing other than the theory of satanic laughter. In this essay, Baudelaire goes so far as to view even smiling from the standpoint of such laughter. Contemporaries often testified to something frightful in his own manner of laughing.

*

The dialectic of commodity production: the product's novelty (as a stimulant to demand) takes on a significance hitherto unknown; in mass production the ever-selfsame manifests itself overtly for the first time.

[32a]

The souvenir [*Andenken*] is a secularized relic.

*

The souvenir is the complement to "isolated experience."[68] In it is precipitated the increasing self-estrangement of human beings, whose past is inventoried as dead effects. In the nineteenth century, allegory withdrew from the world around us to settle in the inner world. The relic comes from the cadaver; the souvenir comes from the defunct experience [*Erfahrung*] which thinks of itself, euphemistically, as living [*Erlebnis*].

*

Les Fleurs du mal is the last book of poems to have had an impact throughout Europe. Before that, perhaps Ossian? *Das Buch der Lieder?*[69]

*

Allegorical emblems return as commodities.

*

Allegory is the armature of modernity.

*

There is, in Baudelaire, a reluctance to awaken echoes—whether in the soul or in space. His poetry is occasionally coarse, but is never sonorous. His mode of expression deviates as little from his experience as the gestures of a consummate prelate deviate from his person.

[33]

Jugendstil appears as the productive misunderstanding by which the "new" became the "modern." Naturally, this misunderstanding originates in Baudelaire.

*

Modernity stands opposed to antiquity; the new, to what is always the same. (Modernity: the masses. Antiquity: the city of Paris.)

*

The streets of Paris, in Meryon's rendering: chasms—and high above them float the clouds.

*

The dialectical image is an image that flashes up. The image of what has been—in this case, the image of Baudelaire—must be caught in this way, flashing up in the now of its recognizability.[70] The redemption enacted in this way, and solely in this way, is won only against the perception of what

is being irredeemably lost. The metaphorical passage from the introduction to Jochmann should be introduced here.[71]

[34]

The concept of exclusive copyright was not nearly so widely accepted in Baudelaire's day as it is today. Baudelaire often republished his poems two or three times without having anyone object. He ran into difficulties with this only toward the end of his life, with the *Petits poèmes en prose*.

*

Inspiration for Hugo: words present themselves to him, like images, as a surging mass. Inspiration for Baudelaire: words appear in their place as if by magic—the result of a highly studied procedure. In this procedure, the image plays a decisive role.

*

Something that must be clarified: the importance of heroic melancholy for intoxication [*Rausch*] and for the inspiration of images.

*

When yawning, the human being himself opens like an abyss. He makes himself resemble the time stagnating around him.

*

What good is talk of progress to a world sinking into rigor mortis? Baudelaire found the experience of such a world set down with incomparable power in the work of Poe, who thus became irreplaceable for him. Poe described the world in which Baudelaire's whole poetic enterprise had its prerogative. Compare the Medusa's head in Nietzsche.

[35]

Eternal recurrence is an attempt to combine the two antinomic principles of happiness: that of eternity and that of the "yet again."—The idea of eternal recurrence conjures the speculative idea (or phantasmagoria) of happiness from the misery of the times. Nietzsche's heroism has its counterpoint in the heroism of Baudelaire, who conjures the phantasmagoria of modernity from the misery of philistinism.

*

The concept of progress must be grounded in the idea of catastrophe. That things are "status quo" *is* the catastrophe. It is not an ever-present possibil-

ity but what in each case is given. Strindberg's idea: hell is not something that awaits us, but *this life here and now.*

*

Redemption depends on the tiny fissure in the continuous catastrophe.

*

The reactionary attempt to turn technologically determined forms—that is, dependent variables—into constants can be found not only in Jugendstil but in Futurism.

*

The development which led Maeterlinck, in the course of a long life, to an attitude of extreme reaction is a logical one.

*

Explore the question of how far the extremes to be encompassed within redemption are those of "too early" and "too late."

*

That Baudelaire was hostile to progress was the indispensable condition for his ability to master Paris in his verse. Compared to his poetry of the big city, later work of this type is marked by weakness, not least where it sees the city as the throne of progress. But: Walt Whitman??

[36]

It was the weighty social grounds for male impotence which in fact turned the Golgotha-way trod by Baudelaire into one socially ordained. Only this explains why, to sustain him on his travels, he received a precious old coin from the treasury amassed by European society. On its face it showed the figure of Death; on its reverse, Melancholia sunk in brooding meditation. This coin was allegory.

*

Baudelaire's Passion as an *image d'Epinal* in the style of the usual Baudelaire literature.

*

"Rêve parisien" as a fantasy about productive forces that have been shut down.

*

Machinery in Baudelaire becomes a figure for destructive powers. The human skeleton is not the least part of such machinery.

*

The residential character of the rooms in early factories, despite all their impractical barbarity, has this one peculiarity: the factory owner can be imagined in them as a kind of incidental figure in a painting, sunk in contemplation of his machines and dreaming not only of his own future greatness but of theirs. Fifty years after Baudelaire's death, this dream was over.

*

Baroque allegory sees the corpse only from the outside. Baudelaire sees it also from within.

*

That the stars are absent from Baudelaire's poetry is the most conclusive sign of its tendency to eradicate semblance [*Tendenz seiner Lyrik zur Scheinlosigkeit*].

[37]

That Baudelaire was attracted to late Latin culture may have been linked to the strength of his allegorical intention.

*

Considering the importance of forbidden forms of sexuality in Baudelaire's life and work, it is remarkable that the bordello plays not the slightest part in either his private documents or his work. There is no counterpart, within this sphere, to a poem such as "Le Jeu." (But see "Les Deux Bonnes Soeurs.")[72]

*

The introduction of allegory must be deduced from the situation in which art is conditioned by technological development; and the melancholic temper of this poetry can be portrayed only in terms of allegory.

*

In the flâneur, one might say, is reborn the sort of idler that Socrates picked out from the Athenian marketplace to be his interlocutor. Only, there is no longer a Socrates, so there is no one to address the idler. And the slave labor that guaranteed him his leisure has likewise ceased to exist.

*

The key to Baudelaire's relationship with Gautier should be sought in the younger man's more or less clear awareness that even in art his destructive impulse encounters no inviolable limit. For the allegorical intention, this limit was certainly not absolute. Baudelaire's reactions to the neo-pagan school reveal this situation clearly. He could hardly have written his essay on Dupont, had not his own critique of the concept of art been at least as radical as Dupont's.[73] Baudelaire tried successfully to conceal these tendencies with his invocation of Gautier.

[38]

The peculiarities both of Hugo's faith in progress and of his pantheism were surely not unrelated to the messages received in spiritualist séances. This dubious circumstance, however, pales before that of the constant communication between his poetry and the world of poltergeists. In fact, the special quality of his poetry lay far less in its real or apparent adoption of motifs of spiritualist revelation than in the fact that his poetry was exhibited, so to speak, before the spirit-world. This spectacle is difficult to reconcile with the attitude of other poets.

*

In Hugo, it is through the crowd that nature exercises its elemental rights over the city. (J32,1.)

*

On the concept of the *multitude* and the relationship between "the crowd" and "the masses."

*

Baudelaire's original interest in allegory is not linguistic but optical. "Les images, ma grande, ma primitive passion."[74]

*

Question: When does the commodity begin to emerge in the image of the city? Here it would be very important to have statistics on the intrusion of display windows into building façades.

[39]

Mystification, in Baudelaire, is a form of apotropaic magic, similar to the lie among prostitutes.

*

Many of his poems have their incomparable moment at the beginning—
where they are, so to speak, new. This has often been pointed out.

*

The mass-produced article was Baudelaire's model. His "Americanism" has
its firmest foundation here. He wanted to create a *poncif*. Lemaître assured
him that he had succeeded.

*

The commodity has taken the place of the allegorical mode of apprehen-
sion.

*

In the form which prostitution has taken in big cities, the woman appears
not only as a commodity but, in the most graphic sense, as a mass-produced
article. This can be seen in the way the individual expression is artificially
concealed by a professional one, as happens with the use of cosmetics. That
this aspect of the whore was sexually crucial for Baudelaire is indicated not
least by the fact that the background for his numerous evocations of the
whore is never the bordello, but often the street.

[40]

In Baudelaire, it is very important that the "new" in no way contributes to
progress. At any rate, serious attempts to come to terms with the idea of
progress are hardly ever found in his work. His hatred was directed above
all at "faith in progress," as at a heresy, a false teaching, not a common-
place error. Blanqui, on the other hand, displays no antipathy to the belief
in progress; he quietly heaps scorn on the idea. One should not necessarily
conclude from this that he was untrue to his political credo. The activities
of a professional conspirator like Blanqui certainly do not presuppose any
belief in progress—they merely presuppose a determination to do away
with present injustice. This firm resolve to snatch humanity at the last mo-
ment from the catastrophe looming at every turn is characteristic of
Blanqui—more so than of any other revolutionary politician of the time. He
always refused to develop plans for what comes "later." One can easily see
how Baudelaire's conduct in 1848 accords with all this.

[41]

Confronted with the scant success of his work, Baudelaire threw himself
into the bargain. He flung himself after his work, and thus, to the end,
confirmed in his own person what he had said: that prostitution was an un-
avoidable necessity for the poet.

*

One of the decisive questions for an understanding of Baudelaire's poetry is how the face of prostitution was changed by the rise of the great cities. For this much is certain: Baudelaire gives expression to the change—it is one of the great themes of his poetry. With the emergence of big cities, prostitution comes to possess new arcana. Among the earliest of these is the labyrinthine character of the city itself. The labyrinth, whose image has become part of the flâneur's flesh and blood, seems to have been given, as it were, a colored border by prostitution. The first arcanum known to prostitution is thus the mythical aspect of the city as labyrinth. This includes, as one would expect, an image of the Minotaur at its center. That he brings death to the individual is not the essential fact. What is crucial is the image of the deadly power he embodies. And this, too, for inhabitants of the great cities, is something new.

[42]

Les Fleurs du mal as an arsenal: Baudelaire wrote certain of his poems in order to destroy others written before his own. Valéry's well-known remarks could be developed further in this direction.[75]

*

To elaborate on Valéry's comments: It is highly significant that Baudelaire encountered competitive relations in the production of poetry. Of course, personal rivalries between poets are as old as the hills. But here the rivalry is transposed into competition on the open market. The goal was victory in that arena, not the patronage of a prince. In this context, it was a real discovery for Baudelaire that he was not competing against *individuals*. The disorganization of poetic schools, of "styles," is the complement of the open market, which reveals itself to the poet as his audience. In Baudelaire, the public as such comes into view for the first time—this was the reason he did not fall victim to the "semblance" of poetic schools. And conversely, because the "school" was for him a mere epiphenomenon, he experienced the public as a more authentic reality.

[43]

Difference between allegory and parable.

*

Baudelaire and Juvenal. The decisive difference is that when Baudelaire describes degeneracy and vice, he always includes himself. The gestus of the

satirist is foreign to him. Admittedly, this applies only to *Les Fleurs du mal,* which differs entirely in this regard from the prose pieces.

*

Fundamental observations on the relation between the theoretical writings of poets and their poetry. In the latter, they disclose a region of their inner life which is not generally available to their reflection. This should be demonstrated in Baudelaire—with reference to others such as Kafka and Hamsun.[76]

*

The lastingness of a literary work's effect is inversely proportional to the obviousness of its material content. (Its truth content? See the study on *Elective Affinities.*)[77]

*

Les Fleurs du mal undoubtedly gained importance from the fact that Baudelaire left no novel.

[44]

Melanchthon's phrase "Melencolia illa heroica" provides the most perfect definition of Baudelaire's genius.[78] But melancholy in the nineteenth century was different from what it had been in the seventeenth. The key figure in early allegory is the corpse. In late allegory, it is the "souvenir" [*Andenken*]. The "souvenir" is the schema of the commodity's transformation into an object for the collector. The *correspondances* are, objectively, the endlessly varied resonances between one souvenir and the others. "J'ai plus de souvenirs que si j'avais mille ans."[79]

*

The heroic tenor of Baudelairean inspiration lies in the fact that in his work memory gives way to the souvenir. In his work, there is a striking lack of "childhood memories."

*

Baudelaire's eccentric individuality was a mask behind which he tried to conceal—out of shame, one might say—the supra-individual necessity of his way of life and, to a certain extent, his fate.

*

From the age of seventeen, Baudelaire led the life of a *littérateur.* One cannot say that he ever thought of himself as an "intellectual" [*Geistiger*], or

devoted himself to "the life of the mind" [*das Geistige*]. The registered trademark for artistic production had not yet been devised.

[45]

On the truncated endings of materialist studies (in contrast to the close of the book on the Baroque.)[80]

*

The allegorical viewpoint, which generated literary style in the seventeenth century, had lost this role by the nineteenth. As an allegorist, Baudelaire was isolated, and his isolation was in a sense that of a straggler. (In his theories, this belatedness is sometimes provocatively emphasized.) If the stylistic impetus of allegory in the nineteenth century was slight, so too was its tendency to encourage routine, which left such diverse traces in the seventeenth century. To some extent, this routine mitigated the destructive tendency of allegory—its stress on the artwork's fragmentary nature.

Written ca. April 1938–February 1939; unpublished in Benjamin's lifetime. *Gesammelte Schriften*, I, 655–690. Translated by Edmund Jephcott and Howard Eiland.

Notes

1. These passages on Baudelaire were composed in part as preparatory studies for Benjamin's planned book on Baudelaire, tentatively titled *Charles Baudelaire: Ein Lyriker im Zeitalter des Hochkapitalismus* (Charles Baudelaire: A Lyric Poet in the Age of High Capitalism). They are closely linked to the material developed in "The Paris of the Second Empire in Baudelaire" and "On Some Motifs in Baudelaire" (both translated in this volume), and they give some idea of the tenor of the unwritten parts of the Baudelaire book: "Baudelaire as Allegorist" (the first section) and "The Commodity as Poetic Object" (the third section).

 The source of most of the reflections and commentaries in "Central Park" is Benjamin's *Arcades Project*, particularly Convolute J, "Baudelaire," from which Benjamin extracted numerous passages, often only slightly revising them. The arrangement of the forty-six loose-leaf sheets on which the fragments of "Central Park" were originally written—that is, the arrangement reproduced here and in the German edition of Benjamin's works—may or may not derive from Benjamin himself. Benjamin's title points to the central importance he ascribed to these fragments in the context of his work on Baudelaire, as well as to his hopes for resettling in America, where his friends spoke of finding an apartment for him in proximity to Central Park in New York.

 In the opening passage of "Central Park," he refers to René Laforgue, *L'Echec de Baudelaire: Etude psychoanalytique sur la névrose de Charles Baudelaire* (Paris, 1931); in English as *The Defeat of Baudelaire: A Psycho-Analytical Study*

of the Neurosis of Charles Baudelaire, trans. Herbert Agar (London, 1932). The relevant passage is cited in Walter Benjamin, The Arcades Project, trans. Howard Eiland and Kevin McLaughlin (Cambridge, Mass.: Harvard University Press, 1999), Convolute J17,4. René Laforgue (1894–1962), French psychoanalyst, was one of the founders of the Société Psychoanalytique de Paris, in which he taught for many years.

The editors have consulted the previous translation of "Central Park" by Lloyd Spencer in New German Critique, 34 (Winter 1985), pp. 28–58.

2. Stefan George (1868–1933) was a German lyric poet and the editor of the influential Blätter für die Kunst, a periodical that ran from 1892 to 1918 and aimed at revitalizing the German literary language, which George felt was in decline. He founded a literary school, the "George circle," which was held together by his authoritarian personality and a Symbolist aesthetic. His translation of Baudelaire's Fleurs du mal appeared in 1901. "Spleen et idéal," or, in George's rendering, "Trübsinn und Vergeistigung" (Melancholy and Spiritualization), is the title of the first section of Les Fleurs du mal; in the first edition of 1857, it contained seventy-seven poems, and in the second, enlarged edition of 1861, eighty-five poems. On the tense interplay of melancholy and the ideal in Baudelaire, see the brief essay "Baudelaire" in Benjamin, Selected Writings, Volume 1: 1913–1926 (Cambridge, Mass.: Harvard University Press, 1996), p. 362.

3. For Baudelaire's concept of modern heroism, see section 3 of "The Paris of the Second Empire in Baudelaire," printed above in this volume. See also sections 14, 20, 22, 27, 35, and 44 of "Central Park," below. On Baudelaire's monadological conception (referred to immediately below, in section 2 of "Central Park"), see The Arcades Project, Convolute J38a,7 and J44,5 (cited in note 43 below); also Convolute N10,3.

4. Victor Hugo (1802–1885), French dramatist, novelist, and poet, was the most important of the Romantic writers. While his novels (such as Les Misérables, 1862; and Notre-Dame de Paris, 1831) remain his best-known works, his legacy to the nineteenth century was his lyric poetry.

5. The line "Dans le coeur immortel qui toujours veut fleurir" ("In the immortal heart that always wants to flower") occurs in Baudelaire's poem "Le Soleil" (The Sun). The word vendanges ("grape harvest") is found in the poem "Semper Eadem" (Always the Same), in the lines "Quand notre coeur a fait une fois sa vendange, / Vivre est un mal" ("When once our heart has harvested its fruit, / Then living is an evil"); and in "L'Imprévu" (The Unforeseen), in the line "Dans ces soirs solennels de célestes vendanges" ("In those solemn evenings of heaven's harvest").

6. Baudelaire's idea of natural correspondences—reflected in his poem "Correspondances"—derives mainly from the Swedish mystic Emanuel Swedenborg (1688–1772), who envisioned a universal language in which everything outward and visible in nature was a symbol pointing to an inward spiritual cause.

7. Louis-Napoléon Bonaparte (1808–1873), nephew of Napoleon Bonaparte, was president of the Second Republic from 1850 to 1852 and thereafter, as Napoleon III, was emperor in the Second Empire. His reign combined authoritarianism and economic liberalism; it ended with France's defeat in the Franco-Prussian War of 1870–1871.

8. Benjamin cites Baudelaire's poem "L'Irrémédiable" (The Irremediable), in the "Spleen et idéal" section of *Les Fleurs du mal*: "Tête-à-tête sombre et limpide / Qu'un coeur devenu son miroir!" ("Tête-à-tête as somber and lucid / As a heart that has become its own mirror!"). On Benjamin's theory of Baroque allegory, which emphasizes the dissociative and estranging character of allegorical perception, as well as the fragmentary character of the allegorical emblem, see his *Ursprung des deutschen Trauerspiels* (published 1928), in Benjamin *Gesammelte Schriften*, vol. 1 (Frankfurt: Suhrkamp, 1974), pp. 203–430; in English, *The Origin of German Tragic Drama*, trans. John Osborne (London: Verso, 1977).

9. Henri Monnier (1805–1877), French caricaturist and playwright, created the popular character Joseph Prudhomme, the typical bourgeois (1830). He is discussed in Baudelaire's essay "Quelques caricaturistes français" (Some French Caricaturists).

10. Jugendstil was the German and Austrian variant of the Art Nouveau style of the 1890s. The movement took its name from the Munich journal *Die Jugend* (Youth). It typically represented organic forms, fluid curving lines, and stylized nature motifs—often in the most modern, technologically advanced materials.

11. Convolute S8a,1 in *The Arcades Project* gives the continuation of the sentence: ". . . to sterilize them ornamentally."

12. Maurice Rollinat (1846–1903) was a French poet known for his recitations at the Chat Noir café in Paris. His collection of poems *Névroses* (1883) shows the influence of Baudelaire.

13. Title of prose poem 46 in Baudelaire's *Spleen de Paris* (published posthumously in 1869). It means "loss of halo" or "loss of aura." See *The Arcades Project*, Convolute J59,7.

14. An allusion to a concept in the later philosophy of Edmund Husserl (1859–1938).

15. "Fidus" was the pseudonym of Hugo Höppener (1868–1948), German architect and painter in the Jugendstil movement.

16. Charles Meryon (1821–1868), French etcher and engraver, was a friend of Baudelaire's. His highly detailed portraits of the city of Paris are discussed in Baudelaire's essay "Salon de 1859" (excerpted in *The Arcades Project*, Convolute J2,1).

17. Jules Laforgue (1860–1887), French poet and critic, was a Symbolist master of lyrical irony. For his comment on Baudelaire's "Americanism," see *The Arcades Project*, Convolute J9,4. It is a question of "crude comparisons which suddenly, in the midst of a harmonious period, cause him to put his foot in his plate; . . . disconcerting purplish flash and dazzle. . . . This is Americanism superimposed on the metaphorical language of the 'Song of Songs'" (trans. William Jay Smith).

18. Alphonse de Lamartine (1790–1869), French Romantic poet, novelist, and statesman, is best known for his *Méditations poétiques* (1820), which includes the famous poem "Le Lac." He briefly led the provisional government following the revolution of 1848. His history of the Girondists appeared in 1847.

19. Alfred de Musset (1810–1857), French poet, playwright, and translator, ranks alongside Hugo, Lamartine, and Vigny as one of the great Romantic poets. He

combined an intense lyricism with a propensity to shock through revelation of his vices: laziness, self-indulgence, a facile talent, and an attraction to opium.

20. Théophile Gautier (1811–1872), French poet and man of letters, was a leader of the Parnassians, a poetic school that strove for detachment, technical perfection, and precise description in its verse. The school derives its name from its anthology, *Le Parnasse contemporain* (1866–1876). Charles-Marie Leconte de Lisle (pseudonym of Charles-Marie Lecomte; 1818–1894), French poet and leading figure among the Parnassians, is renowned for his translations of Homer, Aeschylus, and Euripides. He was elected to the Académie Française in 1886.

21. Paul Verlaine (1844–1896) is generally considered to be one of the major French poets of the second half of the nineteenth century. With Baudelaire, Rimbaud, and Mallarmé, he is sometimes seen as a precursor of the French Symbolist poets of the 1880s. His main works include *Poèmes saturniens* (1866), *Fêtes galantes* (1869), *Romances sans paroles* (1873–1874), *Sagesse* (1880–1881), and *Les Poètes maudits* (1884). Arthur Rimbaud (1854–1891) was a French Symbolist poet and adventurer whose poetry had a profound influence on modern literature. His major works include *Une Saison en enfer* (1873), a hallucinatory work of autobiography, and *Les Illuminations,* prose poems.

22. Honoré Daumier (1808–1879), French caricaturist, painter, and sculptor, was initially a resolutely political caricaturist. The September Laws eliminated most venues for publishing his political work, and he turned for the remainder of his life to the representation of scenes from everyday life.

23. Louis-Auguste Blanqui (1805–1881), French revolutionary socialist and militant anticlerical, was active in all three major upheavals in nineteenth-century France—the revolutions of 1830 and 1848 and the Paris Commune—and was imprisoned following each series of events. Quotations from Blanqui and Benjamin's commentary on him play a key role in *The Arcades Project.*

24. Nietzsche says this in the fourth book of *Die fröhliche Wissenschaft* (The Gay Science), aphorism 295.

25. "The nameless elegance of the human frame." The line is from Baudelaire's poem "Danse Macabre," in the second section of *Les Fleurs du mal,* "Tableaux parisiens" (Parisian Scenes), which was added in the second edition of 1861.

26. Gottfried Keller (1819–1890), Swiss writer, was one of the great German-language prose stylists of the nineteenth century. After failing to establish himself as a painter in Munich, he returned to Zurich and inaugurated a career in literature. *Der grüne Heinrich* (Green Henry; 1854–1855, revised version 1879–1880) and the story collection *Die Leute von Seldwyla* (The People of Seldwyla; first volume 1856, second volume 1874) are his best-known works.

27. *Créer un poncif:* to create a stereotype. See Baudelaire's "Fusées," no. 20: "To create a new commonplace [*poncif*]—that's genius. I must create a commonplace."

28. Epinal images were sentimental religious posters. They were named after the town of Epinal in northeastern France, where this art was produced.

29. Sören Kierkegaard (1813–1855), Danish philosopher and theologian, presented

his idea of the aesthetic life in volume 1 of *Either-Or* (1843), especially in the famous concluding section, "Diary of the Seducer."

30. Benjamin's phrase comes from Gottfried Keller's poem "Verlorenes Recht, verlorenes Glück" (Lost Right, Lost Happiness): "War wie ein Medusenschild / der erstarrten Unruh Bild" ("Was like a Medusa-shield, / image of petrified unrest"). On Keller, see note 26 above.

31. In *The Arcades Project*, Convolute J56a,7, Benjamin illustrates this point by referring to Poe's portrayal of the crowd.

32. *Croque-morts* are hired mourners. Benjamin refers to a passage at the end of Baudelaire's "Salon de 1846": with their black suits and frock coats, the men of the modern city form "an endless procession of hired mourners" (cited in *The Arcades Project*, Convolute J31a,3). Louis Veuillot (1813–1883), French journalist, was the editor of *L'Univers Religieux* (1843). He was also the author of *Le Pape et la diplomatie* (1861) and *Les Odeurs de Paris* (1866). Convolute D2,2, in *The Arcades Project,* quotes a passage from the latter work complaining that the architecture of the new Paris, despite its eclecticism, is uniformly tedious in its recourse to "the emphatic and the aligned."

33. "George Sand" was the pseudonym of Aurore Dudevant (1804–1876), a Romantic novelist who stood for free association in all social relations, and whose protagonists are generally virtuous peasants or workmen. In Convolute J49a,1 of *The Arcades,* Benjamin suggests that Baudelaire could not forgive George Sand for "having profaned, through her humanitarian convictions, this image [of the lesbian or the masculine woman] whose traits she bore."

34. After 1799, the Garde Nationale, which had been formed to support the French Revolution, was a reserve army that was mobilized in times of crisis. During the Revolution of 1848, many of its members defected to the antigovernment side. It was formally dissolved in the summer of 1848.

35. An arcanum is a deep secret, a mystery. The plural "arcana" (Benjamin's term is *Arkana*) refers to specialized knowledge or detail that is mysterious to the average person. See section 41 below.

36. Jules Lemaître (1853–1914) was a French author and critic whose highly influential evaluations of his contemporaries led to his election to the Académie Française in 1895. In later years he adopted the right-wing stance of Action Française. For his assessment of Baudelaire's intellectual powers, see *The Arcades Project*, Convolute J15,1.

37. The passage comes from section 8 of the "Salon de 1859," and is cited in *The Arcades Project*, Convolute Q4a,4: "I would rather return to the dioramas, whose brutal and enormous magic has the power to impose on me a useful illusion. I would rather go to the theater and feast my eyes on the scenery, in which I find my dearest dreams artistically expressed and tragically concentrated. These things, because they are false, are infinitely closer to the truth" (trans. Jonathan Mayne).

38. "L'Amour du mensonge" (Love of Falsehood) is a poem in the second section of *Les Fleurs du mal,* "Tableaux parisiens." The poem celebrates beauty as mask.

39. "Une Martyre," a poem in the fourth section of *Les Fleurs du mal,* "Fleurs du mal," describes the dead body and severed head of a murdered young woman;

the poet imagines her bedroom, with its luxurious décor and morbid hothouse atmosphere, as the scene of necrophiliac love. "La Mort des amants" (The Death of Lovers), from the sixth section of *Les Fleurs du mal,* "La Mort," presents the lovers' vision of their own death in a room furnished with delicately scented beds, divans deep as tombs, and shelves decked with strange flowers. Hans Makart (1840–1884), Austrian painter, gained his reputation with vast historical and allegorical canvases that made his name a byword for empty monumentality. On Jugendstil, see note 10 above.

40. "Madrigal triste" (Sad Madrigal) was written in 1861 and published in *Le Parnasse Contemporain* in 1866, as part of the collection of sixteen new poems entitled "Nouvelles Fleurs du mal." It was incorporated in the first posthumous edition of *Les Fleurs du mal,* issued by the poet's friends Charles Asselineau and Théodore de Banville in 1868.

41. *Fantasque escrime:* "fantastical swordplay" ("Le Soleil").

42. *Lesebuch für Städtebewohner* (A Reader for Those Who Live in Cities) is the title of a group of poems written by Bertolt Brecht in 1926–1927. For an English translation, see Brecht, *Poems, 1913–1956,* ed. John Willett and Ralph Manheim (New York: Methuen, 1987), pp. 131–150. The prostitute poem is the fifth of the series, pp. 135–136.

43. In his essay "A Propos de Baudelaire" (1921), Marcel Proust writes: "The world of Baudelaire is a strange sectioning of time in which only the red-letter days [*rares jours notables*] can appear." Cited by Benjamin in *The Arcades Project,* Convolute J44,5.

44. In 1846, Baudelaire announced, in advertisements, the appearance of a collection of poems to be called *Les Lesbiennes,* a title which primarily denoted the female inhabitants of the island of Lesbos in ancient times (the subject of his poem "Femmes damnées"). Two years later, during the period of revolutionary activity, he announced the forthcoming publication of some twenty-six poems under the title *Les Limbes* (Limbo). Neither of these projected volumes actually appeared. The first use of the title "Les Fleurs du mal" occurred with the publication of eighteen poems in the *Revue des Deux Mondes,* a bastion of conservative Romanticism, in 1855. The new title was suggested to the poet by his friend, the critic and novelist Hippolyte Babou.

45. Adrienne Monnier (1892–1955) was a poet, autobiographer, and bookseller. Her bookshop on the rue de l'Odéon in Paris, La Maison des Amis des Livres, was the meeting place for a wide circle of important early twentieth-century writers, including André Gide, Paul Valéry, Rainer Maria Rilke, Paul Claudel, James Joyce, and Ernest Hemingway. *La rogne* means "ill-humor."

46. Léon-Paul Fargue (1876–1947) was a French poet and essayist whose work spanned numerous literary movements. By the age of nineteen, he had published a major poem, "Tancrède," in the magazine *Pan* and had become a member of the Symbolist circle connected with *Le Mercure de France.* After 1930, he devoted himself almost exclusively to journalism, writing newspaper columns and longer, lyrical essays about Parisian life. His best-known work is the prose-poem memoir *Le Piéton de Paris* (The Parisian Pedestrian; 1939).

47. Céline (pseudonym of Louis-Ferdinand Destouches; 1894–1961), French au-

thor best known for the novel *Voyage au bout de la nuit* (Journey to the End of Night; 1932), was a lifelong anti-Semite and nationalist. *Gauloiserie* translates as "salaciousness" and "coarse jesting."

48. *Côté ordurier:* "obscene side."

49. Ange Pechméja (1819–1887) was a French poet exiled for his opposition to Napoleon III. He lived in Rumania during the Second Empire, and was in correspondence with Flaubert, Gautier, and Baudelaire. He published the first article on Baudelaire to appear beyond the Danube.

50. Maurice Maeterlinck (1862–1949), Belgian poet, dramatist, and essayist, lived in Paris after 1896 and was influenced by the Symbolists. His major works include *Pelléas et Mélisande* (1892), *Le Trésor des humbles* (1896), and *L'Oiseau bleu* (1908). In 1911 he was awarded the Nobel Prize in Literature.

51. *Odeur de futailles* means "odor of wine-casks." The phrase figures in Baudelaire's vivid evocation of the Parisian ragpickers in "Le Vin des chiffonniers" (The Ragpickers' Wine), a poem composed before 1843 and first published in a wine-growers' journal in 1854. It is included in section 3 of *Les Fleurs du mal,* "Le Vin."

52. Gustave Courbet (1819–1877), French realist painter, presided over the Committee of Fine Arts during the Commune (1871). He was imprisoned six months for helping to destroy the column in the Place Vendôme, and had to comply with a court order (1875) to pay for restoration of the column. He painted a portrait of Baudelaire ca. 1847.

53. "The bloody apparatus of Destruction": this is the last line of the poem "La Destruction" in *Les Fleurs du mal.*

54. "Men of the nineteenth century, the hour of our apparitions is fixed forever, and always brings us back the very same ones." From Auguste Blanqui, *L'Eternité par les astres* (Paris, 1872), pp. 74–75. This quotation appears as an epigraph at the conclusion of the Exposé of 1939, in *The Arcades Project.*

55. See Convolute N9a,4 in *The Arcades Project.*

56. For Proust's remarks on the Baudelairean *intérieur,* see Convolute I2a,6 in *The Arcades Project.*

57. Michel Leiris (1901–1990), French writer, was a pioneer in modern confessional literature as well as a noted anthropologist, poet, and art critic. For more on the word *familier* in Baudelaire, see *The Arcades Project,* Convolute J60,1.

58. Compare Convolute J60,4 in *The Arcades Project.*

59. Poem 100 in *Les Fleurs du mal* (it is untitled) begins: "La servante au grand coeur dont vous étiez jalouse" ("That good-hearted servant of whom you were jealous"). The poem is addressed to Baudelaire's mother, with whom he lived for a time, along with his nursemaid Mariette, in a house in Neuilly, just outside Paris, after his father's death in 1827 (when he was six).

60. The phrase *lourds tombereaux* (heavily laden wagons) occurs in the third stanza of "Les Sept Vieillards" (The Seven Old Men), in the "Tableaux parisiens" section of *Les Fleurs du mal.*

61. "Where everything, even horror, turns to magic." From "Les Petites Vieilles" (The Little Old Women) in *Les Fleurs du mal.* Poe's description of the crowd is found in his story "The Man of the Crowd."

62. "La Vie antérieure" (The Previous Life) is the title of a poem in the "Spleen et idéal" section of *Les Fleurs du mal*. The phrase can also be translated as "past life."

63. Convolute D2a,1, in *The Arcades Project*, mentions that a rage for tortoises overcame Paris in 1839. Benjamin comments: "One can well imagine the elegant set mimicking the pace of this creature more easily in the arcades than on the boulevards." See also "The Paris of the Second Empire in Baudelaire," in this volume, for Benjamin's contextualization of this idea.

64. Mayeux is a hunchbacked character of popular farce; described as a "priapic puppet," he personified the patriotic petty bourgeois. Vireloque is a character created by the illustrator Paul Gavarni. Gavroche is a heroic street urchin in Victor Hugo's novel *Les Misérables* (part IV, book 6). Ratapoil is a figure created by Daumier to caricature militarism; he bore a resemblance to Napoleon III.

65. *Joufflu:* "chubby-cheeked." See Baudelaire's "Salon of 1859" in *The Mirror of Art,* trans. Jonathan Mayne (New York: Phaidon, 1955), p. 251 ("Religion, History, Fantasy"). Baudelaire refers to Cupid's *joues rebondissantes* ("fat wobbling cheeks").

66. Pierre Béranger (1780–1857) was an immensely popular lyric poet of liberal political sympathies.

67. "De l'essence du rire" (On the Essence of Laughter) was first published in 1855 in *Le Portefeuille,* and later incorporated in the volume of Baudelaire's critical writings that was titled *Curiosités esthétiques* (1868).

68. Benjamin draws here on the distinction, developed in the essay "On Some Motifs in Baudelaire," between the "isolated experience" [*Erlebnis*] and traditional, cohesive, and cumulative experience [*Erfahrung*]. He plays on the derivation of *Erlebnis* from *leben* ("to live").

69. The name "Ossian" became known throughout Europe in 1762, when the Scottish poet James Macpherson "discovered" and published the poems of Ossian, first with the epic *Fingal* and the following year with *Temora;* both of these works were supposedly translations from third-century Gaelic originals, but were largely composed by Macpherson himself. Heinrich Heine's *Buch der Lieder* (Book of Songs) appeared in 1827.

70. On the "now of recognizability" *(Jetzt der Erkennbarkeit),* see especially Convolute N3,1 in *The Arcades Project;* also Convolute K2,3.

71. See "The Regression of Poetry," in this volume.

72. "Le Jeu" (Gaming), a poem in the "Tableaux parisiens" section of *Les Fleurs du mal,* evokes a gambling den and its ravaged occupants, as seen in a dream. "Les Deux Bonnes Soeurs" (The Two Kind Sisters), in the section entitled "Fleurs du mal," concerns the "amiable" pair Death and Debauch, the tomb and the brothel.

73. Pierre-Antoine Dupont (1821–1870) was a popular poet and republican songwriter whose socialist humanism stopped short of full political opposition. Until 1852, he associated with Hugo, Gautier, and Baudelaire. Baudelaire in particular praised Dupont's devotion to liberty. After Louis Napoleon's coup d'état of December 2, 1851, Dupont—who had avoided arrest by fleeing to Savoy—was condemned in absentia to seven years of exile. Impoverished without the support of his Parisian audience, Dupont in 1852 pledged support for the re-

gime and lived quietly thereafter in Paris. Baudelaire's first essay on Dupont was written in 1851, at a time when he was imbued with the ideals that had inspired the Revolution of 1848. Within a year, however, he was evincing a more aristocratic conception of literature and society, and his second essay on Dupont, in 1861, is less enthusiastic.

74. In the notes toward a never-completed critical-autobiographical volume entitled *Mon coeur mis à nu* (My Heart Laid Bare), published posthumously together with other fragments (the so-called *Fusées*) in the *Journaux intimes* (Intimate Journals; 1909), Baudelaire writes: "Glorifier le culte des images (ma grande, mon unique, ma primitive passion"—"Praise the cult of images (my great, my unique, my primitive passion)." *Primitive passion* can also be translated as "earliest passion." The note could refer to the importance that pictures *(images)* had for Baudelaire when he was a child; his father was an art lover and amateur painter.

75. Valéry's remarks are cited in *The Arcades Project,* Convolute J1,1. "Baudelaire's problem . . . must have . . . posed itself in these terms: 'How to be a great poet, but neither a Lamartine nor a Hugo nor a Musset.' . . . These words . . . must have been . . . his *raison d'état.*" It was partly a matter of gleaning "the impurities, the imprudences" in the work of his predecessors, "everything that might scandalize, and thereby instruct, . . . a pitiless young observer in the way of his own future art."

76. Franz Kafka (1883–1924), born in Prague of Jewish parentage, was the author of startling and haunting works of fiction, such as the short stories "Die Verwandlung" (The Metamorphosis; 1915) and "In der Strafkolonie" (In the Penal Colony; 1919), and the posthumously published novels *Der Prozess* (The Trial; 1925) and *Das Schloss* (The Castle; 1926). Knut Hamsun (1859–1952) was a Norwegian novelist who criticized the American way of life and idealized rural existence. He supported the German invasion of Norway and in 1947 was condemned for treason. His most famous novel—a great popular success—was *Hunger* (1890).

77. See Walter Benjamin, "Goethe's Elective Affinities," in *Selected Writings, Volume 1: 1913–1926* (Cambridge, Mass.: Harvard University Press, 1996), pp. 297–360. On the distinction between "truth content" and "material content," see especially pp. 297–300.

78. The phrase translates as "that heroic melancholy." The German humanist Philip Schwartzerd (1497–1560) used the pseudonym "Melanchthon," a Greek translation of his surname, which means "black earth." A reformer, theologian, and educator, he was a friend of Martin Luther and defended his views. In 1521 he published *Loci communes,* the first systematic treatment of evangelical doctrine. Because of his academic expertise, he was asked to help in establishing schools, and he virtually reorganized the whole educational system of Germany, founding or reforming several of its universities.

79. This is the first line of "Spleen (II)" in *Les Fleurs du mal:* "I have more souvenirs than if I'd lived a thousand years." In French, *souvenir* can mean "souvenir" (keepsake) as well as "memory." See section 32a above and Convolute J53,1 in *The Arcades Project.*

80. Benjamin refers to the grand synthesizing conclusion of his book *Ursprung des deutschen Trauerspiels,* composed in 1924–1925. See note 8 above.

Exchange with Theodor W. Adorno on "The Flâneur" Section of "The Paris of the Second Empire in Baudelaire"

[New York] February 1, 1939

Dear Walter,

This time my delay in writing has nothing to do with theoretical questions. It is explained by the latest events in Germany.[1] I do not know if you are aware how deeply my parents have been affected by them. We have managed to get my father released from jail, but during the pogrom he received an injury to his eye, which was already affected by illness; his offices were wrecked, and a short time after that his right of control over all his assets was suspended. My mother, who is seventy-three, was also in custody for two days. Just when they were both beginning to recover from these dreadful experiences, my father suffered a severe attack of pneumonia. He seems to have survived the crisis, but it will keep him in Germany for weeks, perhaps even months, although, with the help of some American friends, we have now succeeded in obtaining an entry visa to Cuba for my parents.[2] I need hardly mention that we shall be extremely apprehensive as long as they remain in that terrible country, and that the attempt to help them has completely absorbed my attention for many weeks.

There can be no doubt that a new European crisis is approaching, and this time I am no longer as sure as I was in August that the outcome will not be war. All the same, I believe that, this time too, the likelihood is very great that the Germans will be given everything they want, even if they themselves do not yet know exactly what they want. Although I am more convinced than ever that Germany is in no position to fight a war, I think the decisive factor is that the English ruling class, fearing what could come after Hitler, will risk nothing which might entail even so much as damaging his

prestige. France has entirely lost its readiness to respond—there is no other explanation for the events in Spain.[3] No doubt the French will have to pay the price, and they will to some extent suffer the fate of Czechoslovakia, though it is still not quite clear whether France will remain in England's sphere of influence or move to that of Germany, by becoming increasingly Fascist. In short, the prospect of peace at this point is hardly less worrying than war—although, as I said, even war doesn't seem to me as absolutely out of the question as it did last autumn: first, because this time Germany's demands collide with Britain's interests, which the capitalists, even those with the worst intentions, will hardly be able to discount; and, second, because their assessment of the internal situation in Germany may induce them to offer resistance which may change inadvertently from bluff into serious threat. I mention this possibility purely as my own private opinion; at the institute, they really continue to believe in peace at any price, although Max is also of the opinion that this price will be the entire European order.[4] While I do not wish to drive you into a panic, I felt I could not conceal my view of these matters from you.

Regarding the Baudelaire piece: if I understand you correctly, you are proposing that we publish the second part of the portion of the manuscript we have (the part bearing the general title "The Flâneur"), with certain changes—that is, in a form sufficiently modified to take into account the theoretical issues I raised with you. In principle, we are in agreement with this proposal, with the single proviso that this part not significantly exceed its current length. If additional material proves necessary in some places, perhaps cuts could be made in other passages that would be difficult to develop fully within the limits of such an essay (I am thinking in particular of the concluding section).

Perhaps it would be appropriate for me to make some detailed observations on your text—comments that would indicate the kind of changes I have in mind. In particular, it seems to me that the first sentence of "The Flâneur" risks subjectifying the phantasmagoria; here, some carefully considered sentences on its historical-philosophical character would no doubt be very helpful. The transition from the physiologies to the habitus of the flâneur (page 19) does not seem to me very convincing, first because the metaphorical character of going "botanizing on the asphalt" does not seem to me in complete agreement with the claim to reality which the historical-philosophical categories in your text necessarily assume; and, second, because the somewhat technological reference to the narrow pavements as an explanation for the arcades does not seem to me to achieve the goal you set yourself here. I do not think one can ignore at this point the specific interests which led the owners of the buildings to cooperate in building arcades. Moreover, this desideratum precisely links up with that of introducing the category of the arcade not as a "mode of behavior" of the strolling writer,

but in an objective way. The conclusion of the passage on the arcades (page 19) again suffers gravely from the risk of the metaphorical: the playful comparison seems not to assist but to oppose the strict identification. I do not quite understand the opening sentence of the next paragraph ("dubious"). Aren't the physiological aspects quite *far* from being dubious? I have already mentioned my misgivings about the subsequent deduction associated with the passage from Simmel.[5] It again implies that in a particular environment the immediate reactions of human beings—here the fear of what is visible but inaudible—are directly responsible for phenomena which can be understood only as socially mediated. If the explanation of the physiologies in terms of the distracting tendency of these reactions is too general for you (which I can very well understand), it might perhaps be made concrete by the fact that in this phase human beings themselves wear the aspect of commodity-like display articles—the aspect illuminated by the physiologies; perhaps this could be introduced in connection with fashion as the idea of universal viewability. I cannot help thinking that, among the treasures of the Arcades study, there are keener blades than the quotation from Simmel. Regarding the extremely curious quotation from Foucaud which follows (page 20),[6] I will say only that the context in which it appears gives the impression you are merely poking fun at it, whereas I think you would do better to wrest a grain of truth from its very fraudulence—that is, to note rightly the proletarian distaste for "recreation" and for the bourgeois' idea of nature as mere complements of exploitation. Concerning the following paragraph (page 20)—and I'm sure you will agree with me here—I would like to express my idiosyncratic aversion to the concept of "genuine empiricism." I need only recall Kracauer's endorsement of this phrase to be certain that you'll place it on the Index of Proscribed Terms.[7]

Regarding the following section, roughly from the Balzac quotation (page 21) to page 23, I would like to pass on some reflections which have been stimulated by your work, as well as by my reading of Sade and my rereading of Balzac not long ago. But I would like to say in advance that although the greatest problem arising in connection with the "type"—namely, that in the phantasmagoria the people belonging to a particular type are actually *the same*—seems to me to have been touched on in your work, it has by no means been resolved. There is, after all, no compass to tell me that the point at which the essay really communicates with the secret intentions of the Arcades Project is located here (for example, in Poe's description of the lowly employee).—I would like to take as my starting point your critique of the antithesis Lukács establishes between Balzac and Don Quixote.[8] Balzac is himself a Don Quixote type. His generalizations, in effect, magically convert the alienation of capitalism into "meaning" much the way Don Quixote does with the barber's advertising sign. Balzac's ten-

dency to make unqualified statements has its origin here. It stems from the fear evoked by the sameness of bourgeois dress. When he says, for example, that genius can be recognized at a glance in the street, he is trying—despite the uniformity of people's dress—to assure himself of immediacy in the adventure of guessing. Yet adventure and the Balzacian enchantment of the world of things are profoundly bound up with the act of buying. Just as a shopper appraises the goods displayed in a shopwindow, trying to determine through the glass pane whether they are worth the price, whether they are what they appear to be, so Balzac does this with human beings: he assesses them in terms of their purchase price, while at the same time stripping off the mask that bourgeois standardization has placed on them. Common to both procedures is the speculative impulse. Just as, in an age of financial speculation, there can be price fluctuations that may make the acquisition of the commodity in the shopwindow either an intoxicating gain for the buyer or a fraudulent trap, the same applies to the writer of physiologies. The risk that Balzac's unqualified statements incur is the same one the speculator assumes at the stock exchange. Thus, it's no coincidence that the Balzac-like, unqualified statement I adduce from Sade relates precisely to the financial speculator. A masked ball in Balzac and a rally on the stock exchange of his time must have been very similar. An analysis of the Don Quixote-like elements could probably be mediated via Daumier, whose character-types, as you yourself have remarked in your piece on Fuchs,[9] resemble Balzacian figures to the same extent that Don Quixote is central to the vocabulary of motifs in Daumier's oil paintings. It seems to me highly probable that Daumier's "types" are closely related to the unqualified statements of Balzac; indeed, I'm inclined to say that they are the same thing. A caricature by Daumier is a speculative adventure very similar to the subterfuges of identification which Balzac permits himself. They are an attempt to break through the shell of sameness by physiognomic means. The physiognomic gaze, which extravagantly highlights the distinguishing detail in contrast to featureless uniformity, has no other purpose than to rescue the particular within the general. Daumier must produce caricatures and depict "types" so that he can speculatively present the world of eversame attire as no less adventurous or fantastic than, in the early days of the emerging bourgeoisie, the world appeared to Don Quixote. In doing so, he assigns a very special status to the concept of the type: in each image of the particular, as rendered in an outsize nose or a set of bony shoulders, an image of the general is to be captured at the same time, much the way Balzac, in describing Nucingen, tends to present his eccentricities as those of the species of the banker in general. Here, it seems to me, one sees the motif that the type is intended not merely to emphasize the individual against the uniform, but to make the masses themselves commensurable with the alien gaze of the speculator, since mass categories, ordered according to types, are in a

sense put forward as natural species and varieties. I might add that an analogous tendency is likewise found in Poe, in the thesis which gave rise to "The Gold Bug" (which, by the way, was the only major commercial success that Poe had in his life)—namely, that it is possible to decipher any code, no matter how complicated. The code, here, is clearly an image of the masses, and its ciphers would correspond precisely to the "types" of Balzac and Daumier. There's scarcely any need to point out how much this, and the notion of the crowd as a secret code, accords with the allegorical intention in Baudelaire. Moreover, Poe actually kept his promise to decipher every code presented to him. One could hardly imagine the same of Baudelaire, any more than of Balzac, and it might well contribute something to your theory on why there are detective stories by Poe but none by Baudelaire. The concept of human beings as ciphers also plays a role in Kierkegaard; one might well mention his concept of the "spy."

I am delighted with page 22—it is certainly a revealing index to your work that the excerpt from the publisher's brochure, especially the conclusion, reads as if it were already your interpretation. At this point, the relation between material content and truth content has indeed become quite transparent.—Valéry's compilation of elements from Poe (page 23) sounds slightly abrupt when rendered in German and presented without interpretation. Toward the bottom of page 23, I find the differentiation between Baudelaire and the detective story with reference to the "structure of his drives" not quite compelling. I am sure that an attempt to accomplish this differentiation with objective categories would be extremely fruitful. The sections on the poem "A une passante," and especially on the trace, seem to me particularly successful. The conclusion on page 27, just before the discussion of "The Man of the Crowd," is magnificent.

What I have to say on "The Man of the Crowd" is already contained in my remarks on the type. I would merely like to add, with reference to page 27, that in the nineteenth century there were coffeehouses in Berlin but not in London, and that there are still none there, any more than in America. (Poe himself, of course, never visited London.)

Your interpretation of the uniformity of types might best be introduced on page 29, where you discuss the exaggeration of uniformity; this very exaggeration and its relation to caricature would then become the object of interpretation. Your description of the Senefelder lithograph (page 30) is exceptionally beautiful, but likewise calls for interpretation. Of course, I found the passage on reflex behavior (page 30) particularly appealing; it was entirely unknown to me when I wrote my study of the fetish.[10] Since this is a historical-philosophical and political motif of great importance, one might well say at this point that, much as the beginning of a detective story contains the figure of its end, we here find a perspective which proceeds from the ornamental display of fascism into the torture chambers of the concentration camp.

(In this context, few things seem to me as symptomatic as the repetition in Barcelona of what happened a year ago in Vienna: the fascist conquerors were jubilantly greeted by the same crowds that, just the day before, had been cheering their opponents.)

As to the rest, I'll refrain from going into detail. In the case of the commodity theory, I am, in a sense, an interested party and therefore do not feel properly qualified to make suggestions. All the same, it does not seem to me that the concept of empathy with inorganic matter yields anything decisive. In this area, of course, we at the *Zeitschrift*[11] are on particularly demanding ground, for an absolute Marxist pertinence is postulated—and rightly so— of every statement we publish. In cooperation with Max, and after endless toil, I reformulated my own passage on the substitution of exchange value in the light of your more audacious version in your first draft; and if ever there was a case of spatial distance making itself felt as an objectively disruptive factor, it is to be found in your theory of the commodity soul. At this point, I would simply ask you to give this theory your closest attention, and in particular to compare it with Marx's chapter on the fetish in his first volume.[12] Otherwise there is likely to be trouble, especially at the end of the penultimate paragraph and the beginning of the last paragraph on page 31. Regarding the Baudelaire quotation in the text (page 32), I would just like to say that the concept of the *imprévu* is the linchpin of Berlioz's musical aesthetic (which dominates the whole school of Berlioz, particularly Richard Strauss). I do not consider the quotation from Engels such a great *trouvaille,* and if I were to think of making cuts they might well be applied to this passage first. (Löwenthal has already proposed deleting the first half of the quotation; I, for my part, would prefer to see it sacrificed entirely.)[13] Regarding the passage on labor power as a commodity (page 33), let me repeat what I said earlier: Caution! I am not entirely comfortable with your characterization of Baudelaire in terms of the petty bourgeoisie. In general, it seems to me that the paragraph on the crowd has not quite the same density as the preceding material, and that this passage would benefit from the introduction of some treasures from your store. In connection with the last section before Hugo (page 34), I would like to express some slight doubt as to whether the extraordinary stanza by Brecht is really indebted to Shelley.[14] Directness and harshness are not exactly salient traits in Shelley's work. At any rate, comparison with the original is needed.

I am slightly at a loss when it comes to your conclusion (beginning on the bottom of page 34). I hope you will not be angry with me if I say that the whole section on Hugo, though I read it many times with the closest care, did not really become vivid for me or find its proper place in the structure of the whole. I've no doubt that it contains extremely important motifs. But when I mentioned that some motifs would be difficult to develop in the framework of this essay, I was thinking primarily of the section on Hugo. It could be integrated into a text focusing on the image of the masses. But if

we decided to publish the second chapter with certain changes, the historical-philosophical aspect of the image of the masses would in any case not be thematically central enough to support the excursus on Hugo. The basic fact that a limited essay on Baudelaire should not give disproportionate space to a different author surely cannot be overlooked. My suggestion would therefore be to expand the passages I have indicated, develop the section on the crowd to the point where it provides a compelling conclusion, and save the Hugo passages either for the book on Baudelaire or for the Arcades Project itself.

Just a few words, finally, on what you said about my fetish essay. I agree with you that the difference in accent in our approaches to film and jazz is due primarily to the materials, though one should bear in mind that film presents a fundamentally new material whereas jazz does not. The main weakness of my essay is only too apparent to me. It lies, to put it bluntly, in the tendency to engage in jeremiads, in invective. Lamenting the present state is fruitless (in this, you are certainly right), just as, conversely, I would say, the historical-philosophical aspect of that state today prevents its "redemption." It seems to me that the question one can actually pose today is that of an *experiment:* What will become of human beings and their aesthetic apperception if they are exposed to the conditions of monopoly capitalism? But when I wrote the essay, my nerves were not up to coping with any such devilishly behaviorist question. Basically, the piece should be understood as an expression of the American experiences that may one day lead me to grapple with what we both rightly find lacking in our works on mass art in monopoly capitalism. I agree with your views on sound film—something closely analogous can be observed in jazz; but I think this has less to do with maneuvers in the industry than with objectively emerging tendencies. Regarding music's becoming comical: I actually see this, and the "dissolution of sacral conciliation," as something highly positive, and my essay undoubtedly communicates with your work on "reproducibility" more closely here than at any other point. If this has remained ambiguous in the text, I would consider it a very grave defect. As regards the crucial theoretical point, the relation between aesthetic apperception and commodity character, I ask you to be patient a little longer.

Please forgive the abstruse length of this letter; at least the length may help to make up for its lateness.

Warmest regards from us both. We are gazing at the Hudson and are amazed to see the ice floes drifting upstream.

Yours ever,
Teddie

Might I just add two small suggestions? One of them I owe to Schapiro: you should take a look at Villiers de l'Isle Adam, a wonderful representative of

the nineteenth century—who, by the way, was the source for Péladan.[15] I wager you'll bag some fine game there.

The other recommendation is both much closer and much more remote. Have you given any thought to Auguste Comte, especially his late period with the religion of humanity?[16] I read an American book (by Hawkins)[17] on the history of (Comtean) positivism in America from 1853 to 1861—some of the most remarkable material I have come across in a long time. Poe was clearly influenced by Comte, and the scientific claims made for poetry may have their origin there. What is Comte's relation to Saint-Simon, and Baudelaire's to both?[18] Comte wanted to incorporate "fetishism," among other things, into his religion of humanity. If you're interested, I'll have Hawkins' book sent to you. It contains, above all, Comte's correspondence with his American apostle Edger,[19] who, with his clearly reactionary political sympathies, was converted from Fourierism to Comte's religion of humanity. The whole thing just as if we'd concocted it ourselves!

Very cordially!

Paris, February 23, 1939

Dear Teddie,

On est philologue ou on ne l'est pas.[20] After I'd studied your most recent letter, the first thing I did was to go back to the important bundle of papers containing your remarks on the Arcades. Reading these letters, some of which go back a long way, strengthened me a great deal: I recognized once more that the foundations of the work are neither eroded nor damaged. But above all, those earlier remarks shed light on your most recent letter, especially on your reflections concerning the type.

"All hunters look the same," you wrote on June 5, 1935, in connection with a reference to Maupassant.[21] This gives access to a corner of the subject matter in which I shall be able to settle as soon as I know that editorial expectations are focused on an essay on the flâneur. By pointing in that direction, you have given my letter the happiest interpretation. Without sacrificing the chapter's essential place in the book on Baudelaire, I can now—having made sure of the more obvious sociological findings—turn my attention to defining the flâneur within the overall context of the Arcades Project, in the usual monographic way. In what follows, I give two indications of how this is to be understood.

Sameness is a category of cognition; strictly speaking, it is not to be found in plain, sober-minded perception. Even in extreme cases, perception that is sober in the strictest sense, free of all prejudgment, would at most encounter similarity. The degree of prejudgment which can normally accompany per-

ception without detriment can be harmful in certain special cases. It can reveal the perceiver as one who is *not* sober-minded. This is the case with Don Quixote, for example: chivalric romances have gone to his head. He can encounter the most diverse phenomena and see them all as the same thing: an adventure awaiting the knight errant. Now for Daumier.[22] As you rightly suggest, he paints his own likeness in Don Quixote. Daumier constantly encounters sameness. In the faces of all the politicians, ministers, and lawyers, he perceives the same thing—namely, the meanness and mediocrity of the bourgeois class. But here, one thing is all-important: Daumier, like Cervantes, imparts a comic aspect to the hallucination of sameness (which caricature disrupts only so that it can immediately reestablish it—for the further removed a grotesque nose is from the norm, the better it will show, as a nose per se, the typical character of the human being with a nose). In *Don Quixote,* the reader's laughter saves the honor of the bourgeois world, next to which chivalric honor appears uniform and simple-minded. Daumier's laughter, however, is aimed at the bourgeoisie; it sees through the sameness this class prides itself on, revealing it as the fatuous *égalité* which flaunted itself in Louis Philippe's nickname.[23] In laughter, both Cervantes and Daumier do away with sameness and thus fix it as a form of historical semblance [*Schein*]. Sameness has a very different stamp in Poe, to say nothing of Baudelaire. In "The Man of the Crowd," the possibility of comic exorcism may still flash up. In Baudelaire, this is out of the question. Instead, he gave artificial assistance to the historical hallucination of sameness which had taken root with the commodity economy. And the images in his work that relate to hashish are decipherable in this context.

The commodity economy reinforces the phantasmagoria of sameness which, as an attribute of intoxication, at the same time proves a central figure of semblance. "With this drink in your blood, you'll soon see / In every wench a Helen of Troy."[24] The price makes the commodity identical to all the other commodities that can be purchased for the same amount. The commodity empathizes (and this is the key correction to last summer's text)[25] not only and not so much with buyers as with its price. But precisely by this means, the flâneur becomes attuned to the commodity; he emulates it entirely. In the absence of any market demand for him—that is, of any price attached to his services—, he makes himself at home in purchasability. In venality of this kind, the flâneur outdoes the whore; one might say that he takes the abstract concept of "For Sale"-ness on a stroll through the streets. He fulfills this concept only in his last incarnation: I mean, in the figure of the sandwich man.

From the standpoint of the Baudelaire study, the restructured text looks like this: The definition of flânerie as a state of intoxication is fully developed, together with its links to Baudelaire's drug experiences. The concept of the ever-selfsame is already introduced in the second book as ever-self-

same *appearance,* whereas in its definitive form as ever-selfsame *happening* it continues to be reserved for the third.

You can see that I am indebted to you for your suggestions on types. Where I have gone beyond them, I have done so in the original spirit of the Arcades Project. This has, so to speak, unburdened me of Balzac. He is merely of anecdotal importance here, since he exemplifies neither the comic nor the dreadful side of the type. (I believe that only in Kafka are both realized together in the novel. In his work, the Balzacian types have taken up firm lodgings in semblance: they have become "the assistants," "the officials," "the villagers," "the advocates." In contrast to them, K. is presented as the only human being, and consequently as atypical for all his averageness.)[26]

Next, I shall deal briefly with your suggestion that I introduce the arcades as something more than the milieu of the flâneur. Your confidence in my archive is well founded; I will be able to give voice to the remarkable daydreams that built the city of Paris in the mid-nineteenth century as a succession of glass galleries—of winter-gardens, as it were. The name of the Berlin cabaret (I'll try to find out when it first opened) indicates what life in this dream-city might have been like.—This will bring the chapter on the flâneur closer to the form it took in the physiognomic cycle,[27] where it was surrounded by studies on the collector, the counterfeiter, and the gambler.

At the moment, I'd rather not respond in detail to your comments on individual passages. Briefly: The one on the quotation from Foucaud I found enlightening. Among those I cannot agree with is the question you raise about Baudelaire's social designation as a petty bourgeois. Baudelaire lived on a small income from a plot of land in Neuilly—income that he had to share with a stepbrother. His father was a fop who under the Restoration had a sinecure as an administrator of the Luxembourg.[28] The decisive fact is that throughout his life Baudelaire was cut off from all dealings with the world of finance and the high bourgeoisie.

Regarding your skeptical view of Simmel: Isn't it time he got some respect as one of the ancestors of "cultural Bolshevism"?[29] (I do not say this to defend the quotation, which I'd prefer not to delete but which is too strongly emphasized in its current position.) I recently had a look at his *Philosophy of Money.* Certainly, it is no accident that Simmel dedicated the book to Reinhold and Sabine Lepsius; and it is no accident that he wrote it right around the time he was allowed to "approach" the George circle.[30] Nevertheless, if one disregards its basic idea, very interesting things are to be found in the book. I was particularly struck by the critique of Marx's theory of value.

The reflections on the philosophy of absolute concentration in the most recent issue of the *Zeitschrift* were a true delight.[31] Homesickness for Germany has its problematic aspects; nostalgia for the Weimar Republic (and

what else is this philosophy?) is simply asinine.[32] The references to France in the text accord with my own reflections and personal experience. In my last literary report to Max, I was able to say a few things on this point.[33] A *fait divers* will show you which way the wind is blowing: the newspaper of the party's Parisian branch is now displayed in the Hotel Littré—I came across it when I was visiting Kolisch.[34] I listened to the quartet's recital and spent a pleasant hour with him before he left. Once again, I found his girlfriend uncommonly winning. Incidentally, that same evening I saw Soma Morgenstern,[35] who had managed to get out of Vienna at the last minute.

If you can spare it, I would like to look at the book by Hawkins.[36] To trace a link from Poe to Comte would undoubtedly be attractive. As far as I know, there is no connection between Baudelaire and Comte, or between Baudelaire and Saint-Simon. But when he was about twenty, Comte was for a time a *disciple attitré* of Saint-Simon. Among other things, he took over the mother-speculation[37] from the Saint-Simonians, but gave it a positivist twist—confidently asserting that nature would find some way to produce a Virgin-Mother, a female being who fertilized herself. It may interest you to know that in the coup d'état of September 2,[38] Comte succumbed no less promptly than the Paris aesthetes. On the other hand, his "religion of humanity" had already set aside one day in the year for the solemn malediction of Napoleon I.

On the subject of books, you drew my attention earlier to Maupassant's "La Nuit, un cauchemar." I have looked through about twelve volumes of his short stories without finding this text. Could you shed some light on this? A no less urgent request: please send me the Kierkegaard book, if you still have a copy available.[39] I would also be grateful if you could lend me *Theory of the Novel*.[40]

I am very sorry to hear what your parents have gone through—Kolisch told me about it too. I hope they have succeeded in escaping by now.

I confirm receipt of the Hauff, with warmest thanks.[41] I will write to Felicitas next week.

<div align="right">Cordially,
Walter</div>

Benjamin's letter unpublished in his lifetime. Both letters from Theodor W. Adorno and Walter Benjamin, *Briefwechsel, 1928–1940* (Frankfurt: Suhrkamp, 1994), pp. 388–407. Translated by Edmund Jephcott.

Notes

1. Adorno is thinking of the night of violence against Jews and Jewish property carried out by the Nazis on November 9–10, 1938, and its aftermath. The event is

often referred to as "Kristallnacht," in ironic reference to the broken glass left in its wake.

2. Adorno's parents, Maria (Calvello-Adorno) and Oskar Wiesengrund, did succeed in emigrating to Cuba in early 1939, and then, in early 1940, to the United States.

3. The Catalan capital of Barcelona had fallen to General Franco's forces in January 1939, and the supporters of the Spanish Republic had been forced to flee in large numbers over the Pyrenees to France. At the same time, the French government had opened negotiations with Fascist Spain concerning diplomatic recognition of the Franco regime. On January 30 it issued an edict preventing able-bodied men from crossing the border.

4. Adorno refers to Max Horkheimer (1895–1973), German philosopher and sociologist, who was the director of the Institute of Social Research from 1930 to 1958. He played an important role in the development of critical theory and Western Marxism. In *Zur Kritik der instrumentellen Vernuft* (Critique of Instrumental Reason; 1947, also translated as *Eclipse of Reason*) and *Dialektik der Aufklärung* (Dialectic of Enlightenment; 1947, written with Theodor Adorno), he developed a critique of scientific positivism, whose "instrumental rationality" had become a form of domination in both capitalist and socialist countries. Against an older, deterministic Marxism, he argued that culture and consciousness are partly independent of economics, and his ideas about liberation and consumer society continue to influence empirical sociologists today.

5. Georg Simmel (1858–1918), German sociologist and neo-Kantian philosopher, developed a theory of modernity, starting with his *Philosophie des Geldes* (Philosophy of Money; 1900) and continuing through classic essays such as "Die Großstadt und das Geistesleben" (The Metropolis and Mental Life). His work exerted enormous influence on the next generation of social philosophers, some of whom were his students: Georg Lukács, Ernst Cassirer, Ernst Bloch, Siegfried Kracauer, and Benjamin.

6. Benjamin refers to Edouard Foucaud's *Paris inventeur: Physiologie de l'industrie française* (1844), as showing "what a thoroughly limited vision these physiologies offered when the need arose," and says of the passage quoted: "The entrepreneur who read this description may have gone to bed more relaxed than usual."

7. Siegfried Kracauer (1889–1966), German critic and cultural theorist, friend of both Benjamin and Adorno, wrote cultural criticism for a number of newspapers and journals during the Weimar Republic; he was most closely associated with the *Frankfurter Zeitung,* for which he served as culture editor from 1924 to 1933. An extensive selection of his writings from the 1920s and 1930s is available in *The Mass Ornament*, trans. Thomas Y. Levin (Cambridge, Mass.: Harvard University Press, 1995). Kracauer and his wife emigrated first to France in 1933 and then to America in 1941. He worked as a freelance critic in the United States until the early 1950s, when he was named research director at the Bureau of Applied Social Re- search, Columbia University. He is perhaps better known in the English-language world for his work as a film critic, and especially for the book *From Caligari to Hitler.*

8. Georg Lukács, *Die Theorie des Romans: Philosophischer Versuch über die*

Formen der großen Epik (Berlin, 1916). In English, *Theory of the Novel,* trans. Anna Bostock (Cambridge, Mass.: MIT Press, 1971); see pp. 113–131.

9. See Benjamin's essay "Eduard Fuchs, Collector and Historian" (1937) in *Selected Writings, Volume 3: 1935–1938* (Cambridge, Mass.: Harvard University Press, 2002), pp. 260–302.

10. Adorno's essay "Über den Fetischcharakter in der Musik und die Regression des Hörens" (On the Fetish Character of Music and the Regression of Hearing) was published in 1938 in the *Zeitschrift für Sozialforschung,* the official journal of the Institute of Social Research.

11. See note 10 above.

12. Adorno refers to the section entitled "Der Fetischcharakter der Ware und sein Geheimnis" (The Fetishism of Commodities and the Secret Thereof), in *Kapital,* vol. 1 (section 4 of chapter 1).

13. Leo Löwenthal (1900–1993), German literary sociologist, was an important member of the Institute of Social Research. He worked part time for the institute starting in 1925, and in 1930 became a full-time member, emigrating with Max Horkheimer as the institute moved first to Switzerland and then to the United States. In 1949 he became director of the research division at the Voice of America; in 1955 he was named professor of sociology at the University of California, Berkeley.

14. Benjamin quotes Shelley's verse in a translation by Brecht which follows the diction of Shelley's original very closely. "Die Hölle ist eine Stadt, sehr ähnlich London— / Eine volksreiche und eine rauchige Stadt; / Dort gibt es alle Arten von ruinierten Leuten / Und dort ist wenig oder gar kein Spaß / Wenig Gerechtigkeit und noch weniger Mitleid."

15. Meyer Schapiro (1904–1996), American art historian, taught at Columbia University. His writings, particularly those on high modernist art, are considered classics of art history. Schapiro was acquainted with Adorno and Horkheimer. Philippe-Auguste, comte de Villiers de l'Isle-Adam (1839–1889), French writer, was best known for his *Contes cruels* and his novel *L'Eve future.* Joséphin Péladan (1859–1919), French writer, produced a cycle of novels in twenty-one volumes entitled *La Décadence latine: Ethopée.*

16. Auguste Comte (1798–1857), French philosopher, was the founder of the school of philosophy known as positivism. He came under the influence of Henri de Saint-Simon in his early years, and remained a social reformer throughout his life. His goal was a society in which individuals and nations could live in harmony and comfort. His system for achieving such a society is presented in his *Cours de philosophie positive* (1830–1842; translated as *The Course of Positive Philosophy,* 1896).

17. Richmond Hawkins, *Positivism in the United States, 1853–1861* (Cambridge, Mass.: Harvard University Press, 1938).

18. Henri de Saint-Simon (1760–1825), French social theorist, is credited with founding Christian socialism. His most important work, *Le Nouveau Christianisme* (1825), insisted that human fraternity must accompany any scientific restructuring of society.

19. Henry Edger (1820–1888) was a British-born, naturalized American writer

whose correspondence with Comte spanned the years 1854–1857. He was the author of *Modern Times, the Labor Question, and the Family* (1855).

20. "One is a philologist or one is not a philologist."

21. Guy de Maupassant (1850–1893) was a French Naturalist writer of short stories and novels.

22. Honoré Daumier (1808–1879) was a French caricaturist, painter, and sculptor. As government censorship eased following the Revolution of 1830, he turned his attention to political cartoons. Of the 250 lithographs he produced between July 1830 and September 1835 (when strict censorship was reimposed), only nine are not political in nature. His work during the next forty years consisted primarily of scenes drawn from daily life.

23. Louis-Philippe (1773–1850) was king of France from 1830 to 1848. Basing his rule on the support of the upper bourgeoisie, he ultimately fell from power because he could not win the allegiance of the new industrial classes. He affected democratic manners and lived a middle-class family life, for which he was dubbed "the Citizen King." Benjamin is referring to this sobriquet.

24. "Du siehst, mit diesem Trank im Leibe, / Bald Helenen in jedem Weibe." Benjamin cites from the "witch's kitchen" scene in the first part of Goethe's *Faust* (lines 2603–2604).

25. See "The Paris of the Second Empire in Baudelaire," in this volume (section entitled "The Flâneur," the two paragraphs beginning at note 145).

26. Franz Kafka (1883–1924), born in Prague of Jewish parentage, was the author of short and longer works of fiction that characteristically blend the comic with the nightmarish. The assistants, officials, villagers, and advocates are "types" that populate his fiction. See Benjamin's essay "Franz Kafka" (1934) in Volume 2 of this edition.

27. Benjamin may allude here to an early conception of "The Paris of the Second Empire in Baudelaire," in which a number of sections would have been given over to various physiognomic "types." Such a conception might well have been discussed with Adorno.

28. After Napoleon's abdication in 1814, François Baudelaire (1759–1827), the poet's father, became head clerk of the Internal Administration of the Palais de la Chambre des Pairs, residing in a house by one of the gates leading into the Luxembourg Gardens. He retired from the civil service two years later and was rewarded with a pension of 4,000 francs.

29. On Simmel, see note 5 above.

30. Reinhold Lepsius (1857–1922) and Sabine Lepsius (1864–1942) were German painters associated with the circle around Stefan George. George (1868–1933) was a German poet whose high-modernist verse appeared in such volumes as *Das Jahr der Seele* (The Year of the Soul; 1897) and *Der siebente Ring* (The Seventh Ring; 1907). His attempt to "purify" German language and culture exerted a powerful influence on a group of conservative artists, critics, and philosophers who became known as the "George circle."

31. Max Horkheimer, "Die Philosophie der absoluten Konzentration," *Zeitschrift für Sozialforschung,* 7 (1938): 376–387. On Horkheimer, see note 4 above.

32. In his article, Horkheimer had attacked the book *Der Neuhumanismus als*

politische Philosophie (Neo-humanism as Political Philosophy; 1938), by Siegfried Marck (1889–1957), a Neo-Kantian philosopher and a member of the German Social Democratic party during the Weimar Republic.

33. In a recent letter to Horkheimer, Benjamin had included a detailed evaluation of contemporary French letters.

34. Rudolf Kolisch (1896–1978), a violinist and the leader of the Kolisch Quartet, was the brother-in-law of the composer Arnold Schoenberg.

35. Soma Morgenstern, a Polish-born writer and lawyer who lived in Vienna between the wars, had been a contributor to the *Frankfurter Zeitung*. He emigrated to New York via Paris.

36. See note 17 above.

37. Certain of the Saint-Simonians, followers of Henri de Saint-Simon (see note 18 above), idealized the figure of "La Mère," the bestower of life and source of saving grace. See Benjamin, *The Arcades Project,* trans. Howard Eiland and Kevin McLaughlin (Cambridge, Mass.: Harvard University Press, 1999), pp. 594, 601–602 (Convolute U13a,7 and U17,2–U17a,2).

38. A slip of the pen. Benjamin means the coup d'état of December 2, 1851, when Louis Napoleon, soon to be known as Napoleon III, made himself dictator of the French, having assumed the presidency of the Republic in 1848.

39. Adorno's *Kierkegaard: Konstruktion des Aesthetischen* (1933).

40. Georg Lukács' book of 1916, *Theorie des Romans*. See note 8 above.

41. Benjamin had asked Gretel Adorno to send a volume of fairy tales by Wilhelm Hauff (1802–1827), German author who wrote novellas and novels and who is best-known for his fairy tales.

Commentary on Poems by Brecht

The Form of the Commentary

A commentary, as we know, is different from an assessment. The assessment evaluates its subject, sorting out light from obscurity. The commentary takes for granted the classical status of the work under discussion and thus, in a sense, begins with a prejudgment. It also differs from the assessment in that it concerns itself only with the beauty and positive content of the text. So the situation becomes highly dialectical when the commentary, a form that is both archaic and authoritarian, is applied to a body of poetry that not only has nothing archaic about it but defies what is recognized as authority today.

This situation coincides with another, which is summed up in an old dialectical maxim: overcome difficulties by multiplying them. The difficulty to be overcome here is the following: How, in this day and age, can one read lyric poetry at all? Now, what if we countered this difficulty by reading such a text exactly as if it were a much-discussed piece of work, heavily freighted with ideas—in short, a classical text? And what if we went even further, taking the bull by the horns and bearing in mind the special circumstance that the difficulty of reading poetry today is matched precisely by the difficulty of writing it today? What if we took a *present-day collection of poetry* and tried to read the contemporary lyric like a classical text?

If anything could encourage such an undertaking, it would be what sparks the courage of desperation in other areas as well these days: the knowledge that tomorrow could bring destruction on such a scale that yesterday's texts and creations might seem as distant from us as centuries-old

artifacts. (The commentary which is such a tight fit today may hang like classical drapery by tomorrow. Wherever it might seem almost indecently precise now, it could be full of mystery tomorrow.)

The commentary below may also be of interest from another point of view. To those people for whom Communism seems to bear the stigma of one-sidedness, a close reading of a collection of poems such as Brecht's may come as a surprise. Yet we should not forgo that surprise in advance—as would happen, for example, if one stressed only the "development" of Brecht's poetry from the *Hauspostille* [Devotions for the Home] to the *Svendborger Gedichte* [Svendborg Poems].[1] Whereas the attitude in the *Hauspostille* is asocial, in the *Svendborger Gedichte* it becomes socially responsible. But this is not the same as a conversion. Nothing that was previously worshiped is burned. Rather, we should note what these collections have in common. Among the diverse attitudes they express, one in particular is nowhere to be found: a stance that is unpolitical and nonsocial. It is the business of a commentary to demonstrate the political content of the very passages that are purely lyrical in tone.

Hauspostille [Devotions for the Home]

The title *Hauspostille* is, of course, ironic. The word comes neither from Sinai nor from the Gospels. The source of its inspiration is bourgeois society. The lessons an onlooker draws from this society could not differ more radically from those the society itself disseminates. The *Hauspostille* is concerned solely with the former lessons. If anarchy is trumps, thinks the poet, if it encapsulates the law of bourgeois life, then let's at least call it by its name. And for him the poetic forms with which the bourgeoisie adorns its life are not too lofty to give undistorted expression to the nature of its dominion. The chorale that edifies the congregation, the folk song designed to dupe the populace, the patriotic ballad that accompanies soldiers to the fields of slaughter, the love song that touts the cheapest solace—they are all given new content here by the fact that an irresponsible, asocial person speaks of these things (God, the people, the homeland, the bride) the way they should be spoken of before irresponsible, asocial people: without shame, either false or genuine.

Mahagonnygesängen [Mahagonny Songs][2]

Second Song

Wer in Mahagonny blieb
Brauchte jeden Tag fünf Dollar
Und wenn er's besonders trieb

Brauchte er vielleicht noch extra.
Aber damals blieben alle
In Mahagonnys Pokerdrinksaloon.
Sie verloren in jedem Falle
Doch sie hatten was davon.

1

Auf der See und am Land
Werden allen Leuten ihre Häute abgezogen
Darum sitzen alle Leute
Und verkaufen alle Häute
Denn die Häute werden jederzeit mit Dollars aufgewogen.

Wer in Mahagonny blieb
Brauchte jeden Tag fünf Dollar
Und wenn er's besonders trieb
Brauchte er vielleicht noch extra.
Aber damals blieben alle
In Mahagonnys Pokerdrinksaloon.
Sie verloren in jedem Falle
Doch sie hatten was davon.

2

Auf der See und am Land
Ist drum der Verbrauch von frischen Häuten ungeheuer
Immer beißt es euch im Fleische
Doch wer zahlt euch eure Räusche?
Denn die Häute, die sind billig, und der Whisky, der ist teuer.

Wer in Mahagonny blieb
Brauchte jeden Tag fünf Dollar
Und wenn er's besonders trieb
Brauchte er vielleicht noch extra.
Aber damals blieben alle
In Mahagonnys Pokerdrinksaloon.
Sie verloren in jedem Falle
Doch sie hatten was davon.

3

Auf der See und am Land
Siehet man die vielen Gottesmühlen langsam mahlen
Und drum sitzen viele Leute
Und verkaufen viele Häute
Denn sie wolln so gern bar leben und so ungern bar bezahlen.

Wer in seinem Kober bleibt
Braucht nicht jeden Tag fünf Dollar
Und falls er nicht unbeweibt
Braucht er auch vielleicht nicht extra.
Aber heute sitzen alle
In des lieben Gottes billigem Salon.
Sie gewinnen in jedem Falle
Und sie haben nichts davon.

[Anyone who stayed in Mahagonny / Needed five dollars a day / And if he took things especially far / Maybe he needed more. / But in those days everyone stayed / In Mahagonny's pokerdrinkingsaloon / They lost every time / But got something back all the same.

1

By sea and on land / Everyone is skinned / That's why they all sit / Selling their skins / For dollars always weigh more than skins.

Anyone who stayed in Mahagonny . . .

2

So by sea and on land / Fresh skins are used up in huge quantities / That always cuts into your flesh / But who is to pay for your binges? / For skins are cheap and whiskey is dear.

Anyone who stayed in Mahagonny . . .

3

By sea and on land / You see God's many mills slowly grinding / And that's why many people sit / Selling many skins / For they so like living in style and so dislike paying in cash.

Anyone who stays in his kennel / Doesn't need five dollars a day / And if he's without a woman / Maybe he doesn't need extra. / But today they all sit / In the Good Lord's cheap saloon. / They win every time / And get nothing back at all.]

Third Song

An einem grauen Vormittag
Mitten im Whisky
Kam Gott nach Mahagonny
Kam Gott nach Mahagonny.

Mitten im Whisky
Bemerkten wir Gott in Mahagonny.

1

Sauft ihr wie die Schwämme
Meinen guten Weizen Jahr für Jahr?
Keiner hat erwartet, daß ich käme;
Wenn ich komme jetzt, ist alles gar?
Ansahen sich die Männer von Mahagonny.
Ja, sagten die Männer von Mahagonny.
 An einem grauen Vormittag
 Mitten im Whisky
 Kam Gott nach Mahagonny
 Kam Gott nach Mahagonny.
 Mitten im Whisky
 Bemerkten wir Gott in Mahagonny.

2

Lachtet ihr am Freitag abend?
Mary Weemann sah ich ganz von fern
Wie 'nen Stockfisch stumm im Salzsee schwimmen
Sie wird nicht mehr trocken, meine Herrn.
Ansahen sich die Männer von Mahagonny.
Ja, sagten die Männer von Mahagonny.
 An einem grauen Vormittag
 Mitten im Whisky
 Kam Gott nach Mahagonny
 Kam Gott nach Mahagonny.
 Mitten im Whisky
 Bemerkten wir Gott in Mahagonny.

3

Kennt ihr diese Patronen?
Schießt ihr meinen guten Missionar?
Soll ich wohl mit euch im Himmel wohnen
Sehen euer graues Säuferhaar?
Ansahen sich die Männer von Mahagonny.
Ja, sagten die Männer von Mahagonny.
 An einem grauen Vormittag
 Mitten im Whisky
 Kam Gott nach Mahagonny
 Kam Gott nach Mahagonny.

Mitten im Whisky
Bemerkten wir Gott in Mahagonny.

4

Gehet all zur Hölle
Steckt jetzt die Virginien in den Sack!
Marsch mit euch in meine Hölle, Burschen
In die schwarze Hölle mit euch Pack!
Ansahen sich die Männer von Mahagonny,
Ja, sagten die Männer von Mahagonny.
 An einem grauen Vormittag
 Mitten im Whisky
 Kommst du nach Mahagonny,
 Kommst du nach Mahagonny.
 Mitten im Whisky
 Fängst an du in Mahagonny!

5

Rühre keiner den Fuß jetzt!
Jedermann streikt! An den Haaren
Kannst du uns nicht in die Hölle ziehen:
Weil wir immer in der Hölle waren.
Ansahen Gott die Männer von Mahagonny.
Nein, sagten die Männer von Mahagonny.

[One gray morning / In the middle of the whiskey / God came down to Mahagonny / God came down to Mahagonny / In the middle of the whiskey / We caught sight of God in Mahagonny.

1

Are you swigging like sponges / My good brew year after year? / None of you expected me to come / And now that I'm here, have you had your fill? / The men of Mahagonny looked at one another. / Yes, said the men of Mahagonny.

One gray morning . . .

2

Did you have a laugh on Friday night? / From far off I was watching Mary Weeman / Floating and still like a cod in the salt lake / She won't dry out again, Gentlemen. / The men of Mahagonny looked at one another. / Yes, said the men of Mahagonny.

One gray morning . . .

3

Do you recognize these cartridges? / Did you shoot my good missionary? / Am I supposed to live with you in Heaven / Looking at your gray boozers' hair? / The men of Mahagonny looked at one another. / Yes, said the men of Mahagonny.

One gray morning . . .

4

To hell now, all of you / Put your cigars back in the bag! / Off you march to hell, my boys / Off to black hell with you, you rabble! / The men of Mahagonny looked at one another. / Yes, said the men of Mahagonny.

One gray morning . . .

5

Let no one move a foot, now! / We're all on strike! Not even by the hair / Can you drag us down to hell— / *Because we've always been in hell.* / The men of Mahagonny looked at God. / No, said the men of Mahagonny.]

The "men of Mahagonny" form a troupe of eccentrics. Only men are eccentrics. Only subjects endowed by nature with male potency can be used to demonstrate conclusively how far the natural reflexes of human beings have been blunted by life in present-day society. The eccentric is simply a washed-up average man. Brecht has brought together several of them to form the troupe. Their reactions are as nondescript as can be, and even these they can muster only as a collective. To be able to react at all, they need to feel like a "compact mass"—and here, too, they mirror the average man, alias the petty bourgeois. The "men of Mahagonny" exchange glances before they express an opinion. The resulting opinion follows the line of least resistance. The "men of Mahagonny" limit themselves to saying yes to everything God tells them, asks them, or imposes on them. This, according to Brecht, is no doubt how a collective which accepts God must be constituted. Moreover, their God is himself a reduced version. This is indicated by the phrase "We caught sight of God" in the refrain of the Third Song, and confirmed by its last stanza.

Their first assent is to the statement, "None of you expected me to come." But it is obvious that even the effect of surprise is lost on the dulled reactions of the Mahagonny troupe. Similarly, it does not occur to them later that their shooting of a missionary has hurt their prospects for entering Heaven. In the fourth stanza it turns out that God takes a different view.

"To hell now, all of you." This is the hinge or—in the language of the drama—the peripeteia of the poem. In issuing his fiat, God has committed a

faux pas. To get an idea of its magnitude, one must picture the setting of "Mahagonny" in greater detail. It is described in the closing stanza of the Second Song. And in the image that characterizes this setting, the poet is addressing his age: "But today they all sit / In the Good Lord's cheap saloon."

The epithet "cheap" [*billig*] carries a good deal of meaning.[3] Why is the saloon [*Salon*] cheap? It's cheap because its customers, appropriately, are God's guests. It's cheap because the people in it approve [*billigen*] everything. It's cheap because it is fitting that people come into it. The Good Lord's "cheap saloon" is hell. The phrase has the trenchancy of images devised by the mentally ill. "Cheap saloon" is a phrase that might well be used by any ordinary man, once he has finally gone mad, to describe hell as the only piece of heaven accessible to him. (Abraham a Sancta Clara might have spoken of "the Good Lord's cheap saloon.")[4] But God has grown too chummy with the regulars in his saloon. His threat to send them all to hell carries no more weight than that of a pub owner who threatens to throw out his customers.

The "men of Mahagonny" understand this. Even they are not stupid enough to be impressed by a threat to send them to hell. The anarchy of bourgeois society is an infernal anarchy. For the people caught up in it, there simply cannot be anything more terrifying than this society. As the Third Song says, "Not even by the hair / Can you drag us down to hell— / *Because we've always been in hell.*" The only difference between hell and this social order is that, in the petty bourgeois (the eccentric), the dividing line between a poor soul and a devil is blurred.

The Poem "Gegen Verführung" [Against Temptation]

1

Laßt euch nicht verführen!
Es gibt keine Wiederkehr.
Der Tag steht in den Türen;
Ihr könnt schon Nachtwind spüren:
Es kommt kein Morgen mehr.

2

Laßt euch nicht betrügen!
Das Leben wenig ist.
Schlürft es in vollen Zügen!
Es wird euch nicht genügen
Wenn ihr es lassen müßt!

3

Laßt euch nicht vertrösten!
Ihr habt nicht zu viel Zeit!
Laßt Moder den Erlösten!
Das Leben ist am größten:
Es steht nicht mehr bereit.

4

Laßt euch nicht verführen!
Zu Fron und Ausgezehr!
Was kann euch Angst noch rühren?
Ihr sterbt mit allen Tieren
Und es kommt nichts nachher.

[1

Don't let yourselves be tempted! / There's no coming back. / Day is in the doorway, leaving; / Already you feel the night wind— / Tomorrow will not come.

2

Don't let yourselves be cheated! / Life doesn't amount to much. / Gulp it down in great helpings! / It won't be enough for you / When you have to leave it behind!

3

Don't let yourselves be solaced! / You haven't much time! / Leave the redeemed to molder! / Life is what is greatest— / It's no longer laid out and waiting.

4

Don't let yourselves be tempted! / To labor and exhaustion! / How can fear still touch you? / You'll die with all the animals / And afterward comes nothing.]

The poet grew up in a suburb that was predominantly Catholic but whose petty-bourgeois elements were already mixed with workers from the large factories nearby. This explains the attitude and vocabulary of "Gegen Verführung." The clergy has been warning the people against temptations that could cost them dear in a second life after death. The poet warns them against temptations that are costing them dear in their lives here and now. He denies that there is a second life. His warnings are uttered no less solemnly than those of the clergy; his assurances are just as apodictic. Like the

clergy, he uses the term "temptation" in the absolute sense, without qual-
ification; he appropriates its edifying tone. The rhythmic flow of the poem
may lead the reader to overlook certain passages that lend themselves to
more than one interpretation and that contain hidden beauties.

"There's no coming back." First interpretation: don't be misled into be-
lieving that something will come back. Second interpretation: don't make
mistakes—you have only one life to live.

"Day is in the doorway." First interpretation: day is turning away to
leave. Second interpretation: it is at the height of its splendor (though the
night wind is already making itself felt).

"Tomorrow will not come." First interpretation: there will be no tomor-
row. Second interpretation: there will be no dawn—night has the last
word.[5]

"Life doesn't amount to much." The version of this line in the limited edi-
tion published by Kiepenheuer—"*Daß* Leben wenig ist"—differs in two re-
spects from the version in the later, trade edition: "*Das* Leben wenig ist."[6]
The first difference is that the former version completes the sense of the first
line of the stanza—"Don't let yourselves be cheated"—by stating the thesis
of the tempters explicitly: that life really amounts to very little. The second
difference can be seen in the fact that the line "Life doesn't amount to
much" beautifully conveys the paltriness of existence, thus underscoring the
demand that it should not be whittled down further.

"It's no longer laid out and waiting." The first interpretation of this line is
that life is *no longer* waiting; this adds nothing to the preceding line, "Life is
what is greatest." Second interpretation: "It's no longer laid out and *wait-
ing*"—that is, you've already let this greatest opportunity partly slip away.
Your life is no longer waiting before you; it has already begun, has been put
into play.

The poem aims to shock the reader with the brevity of life. It is worth
pointing out that the word *Erschütterung* ["shock"] contains the word
schütter ["thin," "sparse"]. Wherever something collapses, rifts and gaps
appear. As analysis has shown, the poem contains numerous passages in
which words combine in a loose, unstable way to form the meaning. This
contributes to its shocking [*erschütternd*] effect.

The Poem "Von den Sündern in der Hölle"
[On the Sinners Down in Hell]

1

Die Sünder in der Hölle
Haben's heißer, als man glaubt.
Doch fließt, wenn einer weint um sie
Die Trän' mild auf ihr Haupt.

2

Doch die am ärgsten brennen
Haben keinen, der drum weint
Die müssen an ihrem Feiertag
Drum betteln gehn, daß einer greint.

3

Doch keiner sieht sie stehen
Durch die die Winde wehn.
Durch die die Sonne scheint hindurch
Die kann man nicht mehr sehn.

4

Da kommt der Müllereisert
Der starb in Amerika
Das wußte seine Braut noch nicht
Drum war kein Wasser da.

5

Es kommt der Kaspar Neher
Sobald die Sonne scheint
Dem hatten sie, Gott weiß warum
Keine Träne nachgeweint.

6

Dann kommt George Pflanzelt
Ein unglückseliger Mann
Der hatte die Idee gehabt
Es käm nicht auf ihn an.

7

Und dort die liebe Marie
Verfaulet im Spital
Kriegt keine Träne nachgeweint:
Der war es zu egal.

8

Und dort im Lichte steht Bert Brecht
An einem Hundestein
Der kriegt kein Wasser, weil man glaubt
Der müßt im Himmel sein.

9

Jetzt brennt er in der Höllen
Oh, weint, ihr Brüder mein!
Sonst steht er am Sonntagnachmittag
Immer wieder dort an seinem Hundestein.

[1

For sinners in hell / It's hotter than you think. / Yet if someone weeps for them / The tears fall soothingly on their heads.

2

Yet those that burn the hottest / Have no one to weep for them / So when they have a holiday / They must go around begging for someone to cry.

3

But no one sees them standing / Blown through by the wind. / Those who are shone through by the sun / You can't see any more.

4

Here comes Müllereisert / Who died in America / But his fiancée didn't know / So water there was none.

5

Kaspar Neher comes along / As soon as the sun is up; / God only knows the reason why / No one sent tears after him.[7]

6

Now comes George Pflanzelt / A most unhappy man / He had had the notion that / He was of no account.

7

And over there our dear Marie / Rots in the poorhouse / Not a tear is wept for her— / It was all the same to her.

8

And in the light there stands Bert Brecht / Next to a dog-stone / He'll get no water, since people think / That he must be in heaven.

9

He's burning now in hell / Oh, weep, you brothers of mine! / Or else on Sundays he will stand / Forever by that dog-stone.]

This poem shows especially clearly how far the poet of the *Hauspostille* has come, and how, having come so far, he reaches casually for what is closest to hand. What is closest to hand is Bavarian folklore. The poem names the friends enduring the flames of hell, the way certain Bavarian roadside markers list people who have died unshriven and request passers-by to intercede for them. Yet despite its local origin, the poem really does point back a long way. Its lineage is the lament, one of the greatest forms of medieval literature. We might say that it harks back to old laments in order to lament something new: that even lamentation no longer exists. "Here comes Müllereisert / Who died in America / But his fiancée didn't know / So water there was none." But the poem does not properly lament this lack of tears. Nor can one assume that Müllereisert is dead, since—according to Brecht's "Instructions for Using the Poems"—this section of the book is dedicated to Müllereisert himself, not to his memory.

The roadside marker set up here describes the friends named as enduring hellfire; but at the same time (the two things can be combined in the poem) it addresses them as passers-by, to remind them that they can expect no intercession. The poet describes all this to them very calmly. But his calm ultimately deserts him when he comes to speak of his own poor soul, the epitome of desolation. It is standing—in broad daylight, on a Sunday afternoon—by a "dog-stone." What exactly this is, we do not know; perhaps a stone on which dogs urinate. To the poor soul, this is something as familiar as the damp patch on the wall of a prisoner's cell. The game ends with the poet, who, after displaying so much callousness, asks—callously—for tears.

The Poem "Vom armen B.B." [Of Poor B.B.]

1

Ich, Bertolt Brecht, bin aus den schwarzen Wäldern.
Meine Mutter trug mich in die Städte hinein
Als ich in ihrem Leibe lag. Und die Kälte der Wälder
Wird in mir bis zu meinem Absterben sein.

2

In der Asphaltstadt bin ich daheim. Von allem Anfang
Versehen mit jedem Sterbsakrament:

Mit Zeitungen. Und Tabak. Und Branntwein.
Mißtrauisch und faul und zufrieden am End.

3

Ich bin zu den Leuten freundlich. Ich setze
Einen steifen Hut auf nach ihrem Brauch.
Ich sage: Es sind ganz besonders riechende Tiere
Und ich sage: Es macht nichts, ich bin es auch.

4

In meine leeren Schaukelstühle vormittags
Setze ich mir mitunter ein paar Frauen
Und ich betrachte sie sorglos und sage ihnen:
In mir habt ihr einen, auf den könnt ihr nicht bauen.

5

Gegen abends versammle ich um mich Männer
Wir reden uns da mit "Gentlemen" an.
Sie haben ihre Füße auf meinen Tischen
Und sagen: Es wird besser mit uns. Und ich frage nicht: Wann?

6

Gegen Morgen in der grauen Frühe pissen die Tannen
Und ihr Ungeziefer, die Vögel, fängt an zu schrein.
Um die Stunde trink ich mein Glas in der Stadt aus und schmeiße
Den Tabakstummel weg und schlafe beunruhigt ein.

7

Wir sind gesessen ein leichtes Geschlechte
In Häusern, die für unzerstörbare galten
(So haben wir gebaut die langen Gehäuse des Eilands Manhattan
Und die dünnen Antennen, die das Atlantische Meer unterhalten).

8

Von diesen Städten wird bleiben: der durch sie hindurchging, der Wind!
Fröhlich machet das Haus den Esser: er leert es.
Wir wissen, daß wir Vorläufige sind
Und nach uns wird kommen: nichts Nennenswertes.

9

Bei den Erdbeben, die kommen werden, werde ich hoffentlich
Meine Virginia nicht ausgehen lassen durch Bitterkeit
Ich, Bertolt Brecht, in die Asphaltstädte verschlagen
Aus den Schwarzen Wäldern in meiner Mutter in früher Zeit.

Ich, Bertolt Brecht, bin aus den schwarzen Wäldern.
Meine Mutter trug mich in die Städte hinein
Als ich in ihrem Leibe lag. Und die Kälte der Wälder
Wird in mir bis zu meinem Absterben sein.

[1

I, Bertolt Brecht, come from the black forests. / My mother carried me into the cities / As I lay in her body. And the cold of the woods / Will be in me until my extinction.

2

In the asphalt city I'm at home. From the very start / Provided with every last sacrament— / With newspapers. And tobacco. And brandy. / Mistrustful and idle and in the end content.

3

I'm courteous to people. I wear / A stiff hat, as is their custom. / I say: These are very peculiar-smelling animals / And I say: That's all right, I'm one as well.

4

Some mornings, in my empty rocking chairs / I sit me a few women now and then / And look at them untroubled, and tell them: / In me, you've got someone you can't build on.

5

As evening comes, I gather men around me / We address each other as "Gentleman." / They put their feet up on my tables / And say: Things are getting better for us. And I don't ask: When?

6

Toward morning, in the gray dawn the pine trees piss / And their vermin, the birds, start to screech. / Around that time, I drain my glass in the city and toss / My cigar-butt away and sink into a troubled sleep.

7

We have installed ourselves, a lightweight race / In houses thought to be inde-structible / (That's how we built the tall boxes of Manhattan Island / And the thin antennae that entertain the Atlantic Ocean).

8

Of these cities, what will remain is that which passed through them: the wind! / The house makes glad the eater: he empties it. / We know that we're only stop-gaps / And after us will come nothing worth mentioning.

9

In the earthquakes that will come, I hope / I won't let my cigar go out from bit-terness / I, Bertolt Brecht, cast up in the asphalt cities / From the black forests in my mother long ago.

I, Bertolt Brecht, come from the black forests. / My mother carried me into the cities / As I lay in her body. And the cold of the woods / Will be in me until my extinction.]

It is cold in the forests; it cannot be colder in the cities. Even in his mother's womb, the poet was as cold as in the asphalt cities in which he was to live.

"Around that time, I drain my glass in the city and toss / My cigar-butt away and sink into a troubled sleep." A not inconsiderable cause of this worry may be sleep itself, which relaxes the limbs and bestows peace. Will sleep be any kinder to the sleeper than the mother's womb is to the unborn child? Probably not. Nothing is more conducive to restless sleep than the fear of waking.

"(That's how we built the tall boxes of Manhattan Island / And the thin antennae that entertain the Atlantic Ocean)." The antennae doubtless "en-tertain" the Atlantic Ocean not with music or news bulletins but with short and long waves, with the molecular processes constituting the physical workings of the radio. In these lines of the poem, mankind's present-day ex-ploitation of technological resources is dismissed with a shrug.

"Of these cities, what will remain is that which passed through them: the wind!" If the wind that passed through these cities is all that is left of them, it will not be the old wind, which knew nothing of cities. After they have crumbled and been destroyed, the cities—with their asphalt, their series of streets, and their myriad windows—will live on in the wind.

"The house makes glad the eater: he empties it." Here, the eater stands for the destroyer. To eat means not only to feed oneself, but to bite and de-stroy. The world is immensely simplified if it is tested less for the enjoyment it gives than for the destruction it deserves. This is the bond that harmoni-ously holds together all that exists. The spectacle of this harmony makes the

poet glad. He is the eater with the iron jaw who empties the house of the world.

"We know that we're only stop-gaps / And after us will come nothing worth mentioning." "Stop-gaps" [*Vorläufige*]—perhaps they were forerunners [*Vorläufer*]. But how could they be, since nothing worth mentioning comes after them? It isn't really their concern if they pass anonymously and unsung into history. (Ten years afterward, the series of poems "To Those Born Later" would take up a similar idea.)

"I, Bertolt Brecht, cast up in the asphalt cities / From the black forests in my mother long ago." The accumulation of prepositions denoting place—three in two lines—has an unusually disorienting effect. The temporal qualification limping along behind—"long ago" [*in früher Zeit*]—heightens the impression of abandonment. The poet speaks as if he were exposed even in his mother's womb.

Anyone who has read this poem has passed through the poet as if through a gate bearing the weather-worn inscription "B.B." Like the gate, the poet does not want to hold up the person passing through. The arch of the gateway may have been built centuries ago; it remains standing because it hasn't been in anyone's way. B.B., who has never stood in anyone's way, would honor the epithet "poor B.B." For those who have never stood in the way and who do not count, the future contains nothing important—except the decision to put themselves in the way and make themselves matter. The later poem-cycles bear witness to that decision. Their cause is the class struggle. Those who will stand firmest in this cause are those who started by letting themselves fall.

Lesebuch für Städtebewohner [Reader for Those Who Live in Cities]

First Poem

Trenne dich von deinen Kameraden auf dem Bahnhof
Gehe am Morgen in die Stadt mit zugeknöpfter Jacke
Such dir Quartier, und wenn dein Kamerad anklopft:
Öffne, o öffne die Tür nicht
Sondern
Verwisch die Spuren!

Wenn du deinen Eltern begegnest in der Stadt Hamburg oder sonstwo
Gehe an ihnen fremd vorbei, biege um die Ecke, erkenne sie nicht
Zieh den Hut ins Gesicht, den sie dir schenkten
Zeige, o zeige dein Gesicht nicht
Sondern
Verwisch die Spuren!

Iß das Fleisch, das da ist! Spare nicht!
Gehe in jedes Haus, wenn es regnet, und setze dich auf jeden Stuhl, der da ist
Aber bleibe nicht sitzen! Und vergiß deinen Hut nicht!
Ich sage dir:
Verwisch die Spuren!

Was immer du sagst, sag es nicht zweimal
Findest du deinen Gedanken bei einem anderen: verleugne ihn.
Wer seine Unterschrift nicht gegeben hat, wer kein Bild hinterließ
Wer nicht dabei war, wer nichts gesagt hat
Wie soll der zu fassen sein!
Verwisch die Spuren!

Sorge, wenn du zu sterben gedenkst
Daß kein Grabmal steht und verrät, wo du liegst
Mit einer deutlichen Schrift, die dich anzeigt
Und dem Jahr deines Todes, das dich überführt!
Noch einmal:
Verwisch die Spuren!

(Das wurde mir gesagt.)

[Part from your buddies at the station / In the morning go into town with your coat buttoned up / Find yourself a room, and when your buddy knocks— / Don't open, O don't open the door / But / Erase the traces!

If you meet your parents in the city of Hamburg or somewhere else / Pass them like a stranger, turn a corner, don't acknowledge them / Pull the hat they gave you down over your face / Don't show, O don't show your face / But / Erase the traces!

Eat the meat that's there! Don't save! / Go into any house if it rains, and sit on any chair that's there / But don't stay sitting! And don't forget your hat! / I tell you, / Erase the traces!

Whatever you say, don't say it twice / If you find your ideas in anyone else, disown them. / He who has signed nothing, who has left no picture behind / Who was not there at the time, who has said nothing / How are they to catch him! / Erase the traces!

Make sure, when you turn your thoughts to dying / That no gravestone divulges where you lie / With a clear inscription indicting you / And the year of your death, which convicts you! / Once again, / Erase the traces!

(That's what I was told.)]

Arnold Zweig has remarked that this sequence of poems has taken on new meaning in the past few years.[8] It depicts the city as it is experienced by the émigré in a foreign country. This is correct. But we should not forget that he who fights for the exploited class is an emigrant in his own country. For

Brecht—a Communist aware of his situation—the last five years of his political work in the Weimar Republic amounted to a crypto-emigration. He experienced them as such. This may have provided the most immediate impulse for writing this cycle of poems. Crypto-emigration prefigured the real one; it also prefigured illegality.

"Erase the traces": A rule for those who are illegal.

"If you find your ideas in anyone else, disown them": A curious rule for an intellectual in 1928, but crystal-clear for the illegal intellectual.

"Make sure, when you turn your thoughts to dying / That no gravestone divulges where you lie": This is the only rule that might be obsolete. Thanks to Hitler and his people, members of illegal parties have been relieved of this worry.

In the *Reader,* the city appears as a vast theater—of the struggle for survival, and of the class struggle. The former lends the cycle an anarchistic perspective linking it to the *Hauspostille,* while the latter contributes a revolutionary perspective pointing forward to the poem "Die drei Soldaten" [The Three Soldiers]. In both cases, cities are battlefields. One cannot imagine any onlooker more insensitive to the charms of the countryside than a person trained in battle strategy. One cannot imagine any observer who has responded to the charms of the city—the endless sea of its buildings, the breathtaking speed of its traffic, or its entertainment industry—with less feeling than Brecht. This numbness in response to the urban décor, combined with extreme sensitivity to the specific reactions of city-dwellers, distinguishes Brecht's cycle from all preceding big-city poetry. Walt Whitman intoxicated himself with the human masses; they are not mentioned in Brecht. In Paris, Baudelaire perceived the decrepitude of the city; but in Parisians, he saw only the stigma it left on them. Verhaeren attempted an apotheosis of cities.[9] To Georg Heym, they were rife with portents of the catastrophes which threatened them.[10]

A disregard for city-dwellers has been the distinguishing feature of all significant urban poetry. When they have come within the poet's field of vision, as in the case of Dehmel, the accompanying admixture of petty-bourgeois illusions has been fatal to the poetry's success.[11] Brecht is probably the first major lyric poet to say anything meaningful about city people.

Third Poem

Wir wollen nicht aus deinem Haus gehen
Wir wollen den Ofen nicht einreißen
Wir wollen den Topf auf den Ofen Setzen.
Haus, Ofen und Topf kann bleiben
Und du sollst verschwinden wie der Rauch im Himmel

Den niemand zurückhält.

Wenn du dich an uns halten willst, werden wir weggehen
Wenn deine Frau weint, werden wir unsere Hüte ins Gesicht ziehen
Aber wenn sie dich holen, werden wir auf dich deuten
Und werden sagen: Das muß er sein.

Wir wissen nicht, was kommt und haben nichts Besseres
Aber dich wollen wir nicht mehr.
Vor du nicht weg bist
Laßt uns verhängen die Fenster, daß es nicht morgen wird.

Die Städte dürfen sich ändern
Aber du darfst dich nicht ändern.
Den Steinen wollen wir zureden
Aber dich wollen wir töten
Du mußt nicht leben.
Was immer wir an Lügen glauben müssen:
Du darfst nicht gewesen sein.

(So sprechen wir mit unsern Vätern.)

[We do not want to leave your house / We do not want to smash the stove / We want to put the pot on the stove. / House, stove, and pot can remain / And you must disappear like smoke in the sky / That no one holds back.

If you try to hold onto us, we shall go away / If your wife weeps, we shall pull our hats over our eyes / But when they come to fetch you, we will point you out / And say: He must be the one.

We do not know what is coming and have nothing better / But we no longer want you. / Until you have gone / Let's cover the windows so that morning does not come.

The cities are allowed to change / But you are not allowed to change. / We want to argue with the stones / But you we want to kill / You do not need to live. / Whatever lies we are forced to believe: / You are not allowed to have been.

(That is how we speak to our fathers.)]

The attitude expressed in this poem is the one that motivated the expulsion of the Jews from Germany (prior to the pogroms of 1938).[12] The Jews were not killed where they were found. They were dealt with on the following principle: "We do not want to smash the stove / We want to put the pot on the stove. / House, stove, and pot can remain / And you must disappear."

Brecht's poem is revealing to the present-day reader. It shows with utmost clarity why National Socialism needs anti-Semitism. It needs it as a parody. The attitude toward the Jews that is artificially elicited by the rulers is pre-

cisely the one that would have been adopted naturally by the oppressed toward the rulers. Hitler wants the Jew to be treated as the great exploiter ought to have been treated. And because his actions against the Jews are not meant really seriously, because his treatment is a caricature of a genuine revolutionary process, sadism gets mixed in. Parody, which aims at exposing historical models to ridicule (expropriating the expropriators), cannot do without it.

Ninth Poem: Vier Aufforderungen an einen Mann von verschiedener Seite zu verschiedenen Zeiten [Four Invitations to a Man at Different Times from a Different Quarter]

Hier hast du ein Heim
Hier ist Platz für deine Sachen
Stelle die Möbel um nach deinem Geschmack
Sage, was du brauchst
Da ist der Schlüssel
Hier bleibe.

Es ist eine Stube da für uns alle
Und für dich ein Zimmer mit einem Bett
Du kannst mitarbeiten im Hof
Du hast deinen eigenen Teller
Bleibe bei uns.

Hier ist deine Schlafstelle
Das Bett ist noch ganz frisch
Es lag erst ein Mann drin.
Wenn du heikel bist
Schwenke deinen Zinnlöffel in dem Bottich da
Dann ist er wie ein frischer
Bleibe ruhig bei uns.

Das ist die Kammer
Mach schnell, oder du kannst auch dableiben
Eine Nacht, aber das kostet extra.
Ich werde dich nicht stören
Übrigens bin ich nicht krank.
Du bist hier so gut aufgehoben wie woanders.
Du kannst also dableiben.

[Here you have a home / Here's a space for your things / Rearrange the furniture according to your taste / Ask for whatever you need / There is the key / Stay here.

There is a room for each of us / And for you a room with a bed / You can work with us in the yard / You have a plate of your own / Stay with us.

Here's the place where you'll sleep / The bed is still quite clean / Only one man has slept in it. / If you're fussy / Rinse your tin spoon in the tub there / Then it'll be like new / You're welcome to stay with us.

There's the room / Be quick about it. You could even stay / The night, but that costs extra. / I won't disturb you / I have no diseases, by the way. / You're as well off here as anywhere else. / So you might as well stay.]

As we have seen, the *Reader for Those Who Live in Cities* contains object lessons in exile and living outside the law. The Ninth Poem deals with a social process which emigrants and those outside the law inevitably share with those who are exploited without resisting. With a few brief strokes, the poem illustrates what impoverishment in a big city means. At the same time, it reflects back on the first poem of the cycle.

Each of the "four invitations to a man at different times from a different quarter" reveals the current financial situation of this man. He becomes poorer and poorer. Those providing quarters take note of this; the right to leave traces is granted ever more sparingly. The first time, they still acknowledge his belongings. On the second occasion, only a plate of his is mentioned, and this is something he probably did not bring with him. The tenant's labor power is now at his landlord's disposal ("You can work with us in the yard"). On his third appearance, the man is evidently unemployed. His personal situation is symbolized by the rinsing of a tin spoon. The fourth invitation is that of a prostitute to an obviously poor client. Now there is no question of a long-term stay. These are quarters for one night at most, and the trace the man might leave is best left unmentioned.—The rule in the First Poem, "Erase the traces!" can be completed by the reader of the Ninth: "It's better than having them erased for you."

What is noticeable is the friendly indifference with which all the invitations are proffered. That the harshness of their terms still leaves room for this friendliness shows us that social circumstances impinge on people from outside, as something alien. The friendliness with which the man is judged by his fellow human beings shows that they do not feel solidarity with the social circumstances. The person addressed seems to accept what is said to him; and those who address him have likewise had to make the best of their circumstances. The inhumanity to which they are condemned has not been able to stifle human decency [*die Höflichkeit des Herzens*]. This might be a basis either for hope or for despair. On this point, the poet does not offer an opinion.

Studien [Studies]

Über die Gedichte des Dante auf die Beatrice
[On Dante's Poems to Beatrice]

Noch immer über der verstaubten Gruft
In der sie liegt, die er nicht vögeln durfte
So oft er auch um ihre Wege schlurfte
Erschüttert doch ihr Name uns die Luft.

Denn er befahl uns, ihrer zu gedenken
Indem er auf sie solche Verse schrieb
Daß uns fürwahr nichts anderes übrig blieb
Als seinem schönen Lob Gehör zu schenken.

Ach, welche Unsitt bracht er da in Schwang!
Als er mit so gewaltigem Lobe lobte
Was er nur angesehen, nicht erprobte!

Seit dieser schon beim bloßen Anblick sang
Gilt, was hübsch aussieht und die Straße quert
Und was nie naß wird, als begehrenswert.

[Even today, above the dusty crypt / In which she lies—the woman he could never screw / No matter how often he trailed after her— / For us, her name still makes the air tremble.

For he commanded us to remember her / By writing such poems about her / That we in truth had no choice / But to lend an ear to his beautiful praise.

Alas, what a bad habit he brought into vogue! / By praising with such mighty praise / What he had merely seen and had not tried!

Since he sang after just a glimpse / Whatever looks pretty and crosses the street / Without getting wet, passes for something to be coveted.]

Sonett über Kleists Stück *Prinz von Homburg*
[Sonnet on Kleist's Play *The Prince of Homburg*]

Oh Garten, künstlich in dem märkischen Sand!
Oh Geistersehn in preußisch blauer Nacht!
Oh Held, von Todesfurcht ins Knien gebracht!
Ausbund von Kriegerstolz und Knechtsverstand!

Rückgrat, zerbrochen mit dem Lorbeerstock!
Du hast gesiegt, doch wars dir nicht befohlen.

Ach, da umhalst nicht Nike dich. Dich holen
Des Fürsten Büttel feixend in den Block.

So sehen wir ihn denn, der da gemeutert
Von Todesfurcht gereinigt und geläutert
Mit Todesschweiß kalt unterm Siegeslaub.

Sein Degen ist noch neben ihm: in Stücken
Tot ist er nicht, doch liegt er auf dem Rücken;
Mit allen Feinden Brandenburgs im Staub.

[O garden, artificial in the Brandenburg sand! / O to see spirits in the Prussian-
blue night! / O hero brought to his knees by mortal fear! / Model of warrior
pride and slavish mind!

Backbone broken with the laurel stick! / You triumphed, yet were not com-
manded to. / Alas, it is not Nike[13] now embracing you. Coming / to fetch you
to the block are the prince's smirking minions.

Thus we see the man who rebelled / Cleansed and purified by mortal fear /
With death's cold sweat beneath the victor's wreath.

His sword is still beside him: in pieces / He is not dead, but lies on his back— /
In the dust, with all the foes of Brandenburg.]

The title *Studien* presents us with the fruits not so much of diligent effort as
of *otium cum dignitate*.[14] Just as, even at rest, the graphic artist's hand casu-
ally makes little sketches on the border of the plate, here images from ear-
lier times are recorded in the margins of Brecht's work. Looking up from his
work, the poet finds himself gazing beyond the present into the past. "For
the sonnet's tightly braided wreaths / Seem to entwine beneath my hands /
While in far distances my eyes abide," writes Mörike.[15] What meets the ca-
sual glance as one looks into the distance has been captured here in the
most rigorous poetic form.

In the context of Brecht's later poetry, the *Studien* bear an especially close
relation to the *Hauspostille,* which criticizes our morality on divers grounds
and expresses reservations about a number of traditional injunctions. But it
has no intention of stating these reservations outright. They are presented
as variants of moral attitudes and gestures which, in their current form, are
no longer considered quite acceptable. The *Studien* deal in the same way
with a number of literary documents and works. They express misgivings
which, in relation to these works, are appropriate. But by using the sonnet
form to present their content, they put this content itself to the test. That
these reservations can withstand being encapsulated in this way proves their
viability.

The reservations in these "studies" are not voiced irreverently. But un-
qualified appreciation, which reflects a barbaric notion of culture, has given
way to an appreciation rife with misgivings.

Svendborger Gedichte [Svendborg Poems]

From the "Deutsche Kriegsfibel" [German War Primer]

5

Die Arbeiter schreien nach Brot.
Die Kaufleute schreien nach Märkten.
Der Arbeitslose hat gehungert. Nun
Hungert der Arbeitende.
Die Hände, die im Schoße lagen, rühren sich wieder:
Sie drehen Granaten.

13

Es ist Nacht. Die Ehepaare
Legen sich in die Betten. Die jungen Frauen
Werden Waisen gebären.

15

Die Oberen sagen:
Es geht in den Ruhm.
Die Unteren sagen:
Es geht ins Grab.

18

Wenn es zum Marschieren kommt, wissen viele nicht
Daß ihr Feind an ihrer Spitze marschiert.
Die Stimme, die sie kommandiert
Ist die Stimme ihres Feindes.
Der da vom Feind spricht
Ist selber der Feind.

[5

The workers cry out for bread. / The merchants cry out for markets. / The out-of-work were hungry. Now / The worker is hungry. / The hands which were folded in the lap and are busy again— / They are machining mortar shells.

13

It is night. The married couples / Lie down in their beds. The young wives / Will give birth to orphans.

15

Those at the top say: / This is the way to glory. / Those at the bottom say: / This way to the grave.

18

When the time for marching comes, many do not know / That their enemy marches at their head. / The voice that commands them / Is the voice of their enemy. / The one who talks of the enemy / Is himself the enemy.]

The "Kriegsfibel" is written in a "lapidary" style. This word comes from the Latin *lapis*, meaning "stone," and refers to the style which was developed for inscriptions. Its most important characteristic was brevity. This resulted, first, from the difficulty of inscribing words in stone, and, second, from an awareness that anyone addressing subsequent generations ought not to waste words.

Since the natural, material conditions of the lapidary style do not apply to these poems, one is entitled to ask what corresponding factors are present here. How can the inscription style of these poems be explained? One of them hints at the answer. It runs:

Auf der Mauer stand mit Kreide:
Sie wollen den Krieg.
Der es geschrieben hat
Ist schon gefallen.

[On the wall was written in chalk: / They want war. / The man who wrote it / Has already fallen.]

The first line of this poem could preface each of the poems in the "Kriegsfibel." Their inscriptions are made not for stone, like those of the Romans, but, like those of outlawed fighters, for palisades.

Accordingly, the character of the "Kriegsfibel" can be seen as arising from a unique contradiction: words which through their poetic form will conceivably survive the coming apocalypse preserve the gesture of a message hastily scrawled on a fence by someone fleeing his enemies. The extraordinary artistic achievement of these sentences composed of primitive words resides in this contradiction. A proletarian at the mercy of the rain and Gestapo agents scribbles some words on a wall with chalk, and the poet invests them with Horace's *aere perennius*.[16]

The Poem "Vom Kind, das sich nicht waschen wollte"
[On the Child Who Didn't Want to Wash]

Es war einmal ein Kind
Das wollte sich nicht waschen

Und wenn es gewaschen wurde, geschwind
Beschmierte es sich mit Aschen.

Der Kaiser kam zu Besuch
Hinauf die sieben Stiegen
Die Mutter suchte nach einem Tuch
Das Schmutzkind sauber zu kriegen.

Ein Tuch war grad nicht da.
Der Kaiser ist gegangen
Bevor das Kind ihn sah:
Das Kind konnts nicht verlangen.

[Once there was a child / Who didn't want to wash / And whenever it was washed, it would quickly / Smear itself with ashes.

The emperor came to visit / Climbed the seven flights / The mother searched for a cloth / To wipe the dirty child clean.

No cloth could be found just then. / The emperor went away / Before the child could see him— / The child could not expect to.]

The poet sides with the child who did not want to wash. An extraordinary series of coincidences would be needed, he argues, before a child really suffered damage from not washing. It's not enough that the emperor does not haul himself up seven flights of stairs every day; on top of that, he has to choose to make an appearance in a household which cannot even put its hands on a towel. The disjointed diction of the poem conveys the impression that such an accumulation of coincidences has something actually dreamlike about it.

Here we might recall someone else who sympathized with and defended dirty children: Fourier, whose "phalanstery" was not only a socialist utopia but a pedagogical one as well.[17] Fourier divided the children in the phalanstery into two main groups: the *petites bandes* and the *petites hordes*. The *petites bandes* were assigned to gardening and other pleasant duties. The *petites hordes* had to perform the unwholesome tasks. Each child was free to choose between the two groups. Those who chose to join the *petites hordes* were more highly honored. No work was undertaken in the phalanstery until they had begun it; cases of cruelty to animals were under their jurisdiction; they had miniature ponies on which they tore through the phalanstery at an impetuous gallop; and when they assembled for work, the gathering was marked by a deafening cacophony of trumpet blasts, steam whistles, bell ringing, and drums. In the members of the *petites hordes*, Fourier saw four great passions at work: pride, shamelessness, insubordination, and—most important of all—*le goût de la saleté*, the joy in filth.

Readers will think back to the dirty child in the poem and wonder if he doesn't smear himself with ashes simply because society fails to channel his passion for dirt toward any good and useful purpose. They may wonder if

he doesn't do so only because he wishes to be in the way, a stumbling block, a dark admonition to the established order (not unlike the little hunchback in the old song, who disrupts smoothly running households). If Fourier is right, the child did not lose much by missing the meeting with the emperor. An emperor who wants to see only clean children is worth no more than the benighted subjects he visits.

On the Poem "Der Pflaumenbaum" [The Plum Tree]

Im Hofe steht ein Pflaumenbaum
Der ist so klein, man glaubt es kaum.
Er hat ein Gitter drum
So tritt ihn keiner um.

Der Kleine kann nicht größer wer'n
Ja, größer wer'n, das möcht er gern.
's ist keine Red davon
Er hat zu wenig Sonn.

Den Pflaumenbaum glaubt man ihm kaum
Weil er nie eine Pflaume hat
Doch er ist ein Pflaumenbaum
Man kennt es an dem Blatt.

[In the yard stands a plum tree / It's so small, you can scarcely believe your eyes. / It has a railing all around / So that no one steps on it.

The little tree cannot grow taller / Though to grow taller is what it would like. / Not a chance of that— / It gets too little sun.

You'd hardly believe it's a plum tree / Because it never bears a plum / Yet it's a plum tree all the same / You can tell by the leaf.]

One example of the internal unity of this lyric poetry, and of the richness of its perspectives, can be seen in the way landscape enters the various poem-cycles. In the *Hauspostille* it appears primarily as a clean, seemingly freshly washed sky in which delicate clouds occasionally float and beneath which plants, outlined with a hard stylus, are examined. In the *Lieder Gedichte Chöre* [Songs Poems Choruses], there is nothing left of landscape;[18] it has been blanketed over by the "wintry snowstorm" which passes through this poem-cycle. In the *Svendborger Gedichte,* it appears now and then, looking pale and timid. So pale that the posts hammered into the ground in the yard "for the children's swings" are already a part of it.

The landscape in the *Svendborger Gedichte* resembles the one that Herr Keuner expresses a fondness for, in one of Brecht's stories.[19] He has told friends that he loves the tree which grows in the courtyard of his apartment

block. They invite him to go with them to the forest, and are surprised when Herr Keuner declines. Didn't he say that he loved trees? "I said I loved the tree *in my courtyard*," Herr Keuner replies. This tree might well be the one named "Green" that appears in the *Hauspostille*, where it is honored with a morning invocation:

Es war wohl keine Kleinigkeit, so hoch heraufzukommen
Zwischen den Häusern,
So hoch herauf, Green, daß der
Sturm so zu Ihnen kann, wie heute nacht?

[Was it no small achievement to grow so tall / Between the houses, / To grow so tall, Green, that the / Storm can reach you, as it did last night?]

This tree, Green, which meets the storm with its tip, remains something out of a "heroic landscape." (The poet keeps his distance from it, all the same, by politely using the formal mode of address, *Sie*.) Over the years, Brecht's lyric sympathy for the tree was directed more and more at its resemblances to the people whose windows look out on its courtyard—the ways in which it is mediocre and stunted. A tree that no longer has anything at all heroic about it appears in the *Svendborger Gedichte*, in the form of a plum tree. A railing has to be placed around it to prevent people from knocking it over. It never bears any fruit. "You'd hardly believe it's a plum tree / Because it never bears a plum / Yet it's a plum tree all the same / You can tell by the leaf." (The internal rhyme [*Pflaumenbaum-kaum*] in the first line of this stanza makes the last word of the third line [*Pflaumenbaum*] useless as a rhyme, indicating that the plum tree is beyond hope, even though it has hardly begun to grow.)

The courtyard tree that Herr Keuner loved was of this kind. From the landscape, and from everything it offered the lyric poet in days gone by, all that comes to him now is a leaf. Today, perhaps only a great lyric poet would refrain from trying to grab more.

On the "Legende von der Entstehung des Buches *Taoteking* auf dem Weg des Laotse in die Emigration" [Legend of the Origin of the Book *Tao-te-Ching* on Lao-tzu's Road into Exile]

1

Als er siebzig war und war gebrechlich
Drängte es den Lehrer doch nach Ruh
Denn die Güte war im Lande wieder einmal schwächlich
Und die Bosheit nahm an Kräften wieder einmal zu.
Und er gürtete den Schuh.

2

Und er packte ein, was er so brauchte:
Wenig. Doch es wurde dies und das.
So die Pfeife, die er immer abends rauchte
Und das Büchlein, das er immer las.
Weißbrot nach dem Augenmaß.

3

Freute sich des Tals noch einmal und vergaß es
Als er ins Gebirg den Weg einschlug.
Und sein Ochse freute sich des frischen Grases
Kauend, während er den Alten trug.
Denn dem ging es schnell genug.

4

Doch am vierten Tag im Felsgesteine
Hat ein Zöllner ihm den Weg verwehrt:
"Kostbarkeiten zu verzollen?"—"Keine."
Und der Knabe, der den Ochsen führte, sprach: "Er hat gelehrt."
Und so war auch das erklärt.

5

Doch der Mann in einer heitren Regung
Fragte noch: "Hat er was rausgekriegt?"
Sprach der Knabe: "Daß das weiche Wasser in Bewegung
Mit der Zeit den mächtigen Stein besiegt.
Du verstehst, das Harte unterliegt."

6

Daß er nicht das letzte Tageslicht verlöre
Trieb der Knabe nun den Ochsen an.
Und die drei verschwanden schon um eine schwarze Föhre
Da kam plötzlich Fahrt in unsern Mann
Und er schrie: "He, du! Halt an!

7

Was ist das mit diesem Wasser, Alter?"
Hielt der Alte: "Intressiert es dich?"
Sprach der Mann: "Ich bin nur Zollverwalter
Doch wer wen besiegt, das intressiert auch mich.
Wenn du's weißt, dann sprich!

8

Schreib mir's auf! Diktier es diesem Kinde!
Sowas nimmt man doch nicht mit sich fort.
Da gibt's doch Papier bei uns und Tinte
Und ein Nachtmahl gibt es auch: ich wohne dort.
Nun, ist das ein Wort?"

9

Über seine Schulter sah der Alte
Auf den Mann: Flickjoppe. Keine Schuh.
Und die Stirne eine einzige Falte.
Ach, kein Sieger trat da auf ihn zu.
Und er murmelte: "Auch du?"

10

Eine höfliche Bitte abzuschlagen
War der Alte, wie es schien, zu alt.
Denn er sagte laut: "Die etwas fragen
Die verdienen Antwort." Sprach der Knabe: "Es wird auch schon kalt."
"Gut, ein kleiner Aufenthalt."

11

Und von seinem Ochsen stieg der Weise
Sieben Tage schrieben sie zu zweit.
Und der Zöllner brachte Essen (und er fluchte nur noch leise
Mit den Schmugglern in der ganzen Zeit).
Und dann war's so weit.

12

Und dem Zöllner händigte der Knabe
Eines Morgens einundachtzig Sprüche ein
Und mit Dank für eine kleine Reisegabe
Bogen sie um jene Föhre ins Gestein.
Sagt jetzt: kann man höflicher sein?

13

Aber rühmen wir nicht nur den Weisen
Dessen Name auf dem Buche prangt!
Denn man muß dem Weisen seine Weisheit erst entreißen.
Darum sei der Zöllner auch bedankt:
Er hat sie ihm abverlangt.

[1

When he was seventy years old and was frail / The teacher longed for rest, in spite of everything / For goodness had again grown feeble in the land / And wickedness was gathering its strength again. / And he buckled on his shoe.

2

And he packed what he would need: / Little. But it included this and that. / The pipe he smoked every evening / And the little book he always read. / Bread as much as he judged by eye.

3

Looked back gladly at the valley and forgot it / As he took the path into the mountains. / And his ox enjoyed the fresh grass / Chewing as it carried the old man / For whom the pace was fast enough.

4

But on the fourth day in the rocky hills / A customs man barred his way: "Valuables to declare?"—"None." And the boy who led the ox said, "He taught." / So that was explained as well.

5

But the man, on a happy impulse, / Asked further: "Did he find out anything?" / Said the boy: "That the soft water, as it moves / Vanquishes in time the mighty stone. / You understand—what is hard must yield."

6

So as not to lose the last of the daylight / The boy now goaded the ox onward. / Already the three were disappearing round a dark pine / When our man suddenly came to life / And called out: "Hey, you! Wait!"

7

"What's that about the water, old man?" / The old man stopped. "Does it interest you?" / Said the man, "I'm only a customs officer / But who defeats whom—that interests me too. / If you know, then tell!"

8

Write it down for me! Dictate it to this child! / Something like that you don't just carry off with you. / There's paper here, and ink / And a supper, too—I live over there. / Now, is that a fair request?"

9

Over his shoulder, the old one / Looked at the man. Patched jacket. No shoes. / And the brow a single furrow. / No, this was not a victor coming toward him. / And he murmured, "You as well?"

10

To turn down a polite request / The old man was, it seems, too old. / For he said aloud, "Those who ask / Deserve an answer." Said the boy, "It's also getting cold." / "All right—just a brief stop."

11

And the sage dismounted from his ox. / Seven days they wrote, the two of them. / And the customs man brought food (and merely cursed quietly / At smugglers that whole time). / And then they were done.

12

And the boy handed the customs man / One morning, eighty-one sayings / And thanking him for the travel alms / They went around that pine tree along the rocky way. / Now tell me: Can anyone be more polite than that?

13

But let's not praise only the sage / Whose name shines forth on the book! / For wisdom must first be wrung from the wise. / So let the customs man also be thanked / He demanded it of him.]

This poem gives us an opportunity to note the special role played by courtesy and friendliness in the world of the poet's imagination. Brecht values these qualities highly. If we examine the legend he recounts, it is apparent that on the one hand there is the wisdom of Lao-tzu[20] (who, incidentally, is not mentioned by name in the poem)—wisdom that is in the process of earning him exile. On the other hand, there is the thirst for knowledge on the part of the customs man, who is thanked at the end for having prised the sage's wisdom from him. He could not have succeeded in this without a third thing: namely, *friendliness*. Though it would be going too far to say that friendliness is the very subject of the *Tao-te-Ching*, one would nevertheless be right in saying that, according to the legend, the *Tao-te-Ching* was passed down through the ages by virtue of the spirit of friendliness. In the poem, we find out all kinds of things about this friendliness.

First of all, it is not dispensed without due reflection: "Over his shoulder, the old one / Looked at the man. Patched jacket. No shoes." No matter

how polite the man's request, Lao-tzu first makes sure it comes from a worthy person.

In the second place, friendliness consists not in performing an incidental and trivial service, but in rendering a great service as if it were trivial. Once Lao-tzu has established the customs man's right to ask, he resolves to take some time from his journey to oblige him, and places these world-historical days under the motto: "All right—just a brief stop."

The third thing we find out about friendliness is that it does not abolish the distance between people, but brings it to life. After the sage does such a great thing *for* the customs man, he has little more to do *with* him; and it is not he who hands the eighty-one sayings to him, but the boy.

"The classical writers," wrote an ancient Chinese philosopher, "lived in the bloodiest, darkest times, but they were the most courteous and cheerful people imaginable." The Lao-tzu in this version of the legend seems to spread cheerfulness wherever he goes. His ox, which the old man's weight does not prevent from enjoying the fresh grass, is happy. The boy, who cannot resist explaining Lao-tzu's poverty with the dry remark, "He taught," is light-hearted. This puts the customs man at the checkpoint in a cheerful mood, and his cheerfulness inspires him to make the auspicious inquiry about the results of Lao-tzu's researches. So why shouldn't the sage himself be cheerful? And what use would his wisdom be if he who forgot the valley (which he had just looked on with pleasure again) when he rounded the next corner did not also forget his anxieties about the future almost as soon as he felt them?

In the *Hauspostille,* Brecht included a ballad on the courtesies and kindnesses of the world.[21] There are a total of three: the mother diapers the child; the father takes the child by the hand; people throw handfuls of earth onto the grave. And that's enough. For the poem closes with the lines: "Fast ein jeder hat die Welt geliebt / Wenn man ihm zwei Hände Erde gibt" ["Almost everyone has loved the world / When he is given two handfuls of earth"].

Kindness is displayed at the hardest points in life: at birth; at the first step into life; and at the last step, which leads out of life. This is a minimum program for humaneness. We find it again in the Lao-tzu poem, where it takes the form of the statement, "What is hard must yield."

The poem was written at a time when this statement rang in the ears like a promise nothing short of messianic. And for the present-day reader it contains not only a promise but a lesson: "That the soft water, as it moves / Vanquishes in time the mighty stone." This teaches us that we should not lose sight of the inconstant, mutable aspect of things, and that we should make common cause with whatever is unobtrusive and plain but relentless, like water.[22] Here the materialist dialectician will think of the cause of the oppressed. (For those in power, this is an unobtrusive matter; for the op-

pressed, it is a plain and sober circumstance; as far as its consequences go, it is a most relentless fact.) Third and last, in addition to the promise and the theory, there is the moral to be drawn from the poem. Anyone who wishes to see hardness yield should not let slip any opportunity for displaying friendliness.

Written ca. Fall 1938–March 1939; partial publication in the *Schweizer Zeitung am Sonntag,* April 1939. *Gesammelte Schriften,* II, 539–572. Translated by Edmund Jephcott.

Notes

1. Bertolt Brecht, *Die Hauspostille* (Berlin, 1927); for a verse translation in English, see *Die Hauspostille: Manual of Piety,* trans. Eric Bentley (New York: Grove Press, 1966). Bertolt Brecht, *Svendborger Gedichte* (London, 1939); for a verse translation in English, see *Svendborg Poems,* trans. and ed. John Willett and Ralph Manheim, in Brecht, *Poems* (London: Methuen, 1976).
2. The first collaboration between Brecht and the German composer Kurt Weill produced the opera (or, in Brecht's phrase, the *Songspiel*) *Mahagonny,* which was a succès de scandale at the Baden-Baden Festival in 1927. Weill (1900–1950) worked with Brecht to develop a revolutionary operatic form based on sharp social criticism.
3. The adjective *billig* means not only "cheap" but "fitting."
4. Abraham a Sancta Clara (1644–1709) was a south German Catholic who became the most prominent preacher of his day. His sermons, mostly delivered in Vienna, were addressed to ordinary people and were famous for their earthy wit, their wealth of puns, and their rhetorical power.
5. The word *Morgen* means both "morning" and "tomorrow."
6. *Bertolt Brechts Taschenpostille* (Bertolt Brecht's Pocket Devotions; Potsdam, 1926). Twenty-five copies were produced. Benjamin highlights the difference between the subordinate conjunction *daß* ("that") and the definite article *das* ("the").
7. Otto Müllereisert, Kaspar Neher, and George Pflanzelt were all friends from Brecht's youth in Augsburg. Neher (1897–1962) was a prominent stage designer in the Weimar Republic and a frequent collaborator with Brecht.
8. Arnold Zweig (1887–1968) was a German-Jewish writer best known for his novel *Der Streit um den Sergeanten Grischa* (The Case of Sergeant Grischa; 1927). This novel, a depiction of the German army during World War I, tells the story of a Russian prisoner's tragic encounter with the machine of Prussian military bureaucracy. Zweig emigrated to Palestine in 1933 and returned to East Germany in 1948.
9. Emile Verhaeren (1855–1916) was a Belgian poet who wrote in French. His work is remarkable for its emotional vigor and expressive range.
10. Georg Heym (1887–1912) was a German poet whose visionary, apocalyptic po-

ems lent decisive impulses to Expressionism. He died in an accident while ice skating on the Havel River in Berlin.

11. Richard Dehmel (1863–1920) was a German poet whose work combined an interest in the plight of workers and the underclass with a Nietzschean individualism. He was known not only for the frequent excesses of his rhetoric, but also for his frank depiction of a mystically tinged sexuality.

12. Benjamin refers here to the Nazi violence against Jewish homes and businesses on November 9 and 10, 1938, an event now generally known as "Kristallnacht." The name is an ironic reference to the litter of broken glass it left in its wake.

13. Nike was the goddess of victory in Greek mythology.

14. *Otium cum dignitate:* "Leisure with dignity," an exhortation from Cicero.

15. Eduard Friedrich Mörike (1804–1875) was an important German post-Romantic poet and prose writer. His best-known works include the novel *Maler Nolten* (Nolten the Painter; 1832) and the multiple editions of his poems (1838, 1847, 1856, and 1867).

16. *Aere perennius:* "More lasting than brass."

17. Charles Fourier (1772–1837), French social theorist and reformer, called for a reorganization of society based on communal agrarian associations which he called "phalansteries." In each community, the members would continually change roles within different systems of production. Fourier was much on Benjamin's mind in the late 1930s, and became an important figure in the Arcades Project.

18. The volume *Lieder Gedichte Chöre* was first published in Paris in 1934.

19. Herr Keuner, the protagonist in a series of Brecht's stories, also appears in the poem "Morgendliche Rede an den Baum Green" (Morning Address to the Tree Green), from the *Hauspostille*.

20. Lao-tzu ("Master Lao," or "old master") was the first philosopher of Chinese Taoism and the reputed author of the *Tao-te Ching,* a primary Taoist writing. Ssu-ma Ch'ien, China's first great historian (who lived in the second century B.C.), claimed that Lao-tzu was a curator of the Imperial Chinese archives in the sixth century B.C. Modern scholars discount the possibility that the *Tao-te Ching* was written by only one person, but readily acknowledge the influence of Taoism on the development of Buddhism. Lao-tzu is venerated as a philosopher by Confucianists and as a saint or god by many ordinary people. He was worshiped as an imperial ancestor during the T'ang dynasty (618–907).

21. The poem is entitled "Von der Freundlichkeit der Welt."

22. "Was unscheinbar und nüchtern, auch unversieglich ist wie das Wasser." *Unversieglich* literally means "inexhaustible," "everflowing."

The Work of Art in the Age of Its Technological Reproducibility

Third Version

Our fine arts were developed, their types and uses were established, in times very different from the present, by men whose power of action upon things was insignificant in comparison with ours. But the amazing growth of our techniques, the adaptability and precision they have attained, the ideas and habits they are creating, make it a certainty that profound changes are impending in the ancient craft of the Beautiful. In all the arts, there is a physical component which can no longer be considered or treated as it used to be, which cannot remain unaffected by our modern knowledge and power. For the last twenty years, neither matter nor space nor time has been what it was from time immemorial. We must expect great innovations to transform the entire technique of the arts, thereby affecting artistic invention itself and perhaps even bringing about an amazing change in our very notion of art.

—Paul Valéry, *Pièces sur l'art* ("La Conquête de l'ubiquité")

Introduction

When Marx undertook his analysis of the capitalist mode of production, this mode was in its infancy.[1] Marx adopted an approach which gave his investigations prognostic value. Going back to the basic conditions of capitalist production, he presented them in a way which showed what could be expected of capitalism in the future. What could be expected, it emerged, was not only an increasingly harsh exploitation of the proletariat but, ultimately, the creation of conditions which would make it possible for capitalism to abolish itself.

Since the transformation of the superstructure proceeds far more slowly than that of the base, it has taken more than half a century for the change in

the conditions of production to be manifested in all areas of culture. How this process has affected culture can only now be assessed, and these assessments must meet certain prognostic requirements. They do not, however, call for theses on the art of the proletariat after its seizure of power, and still less for any on the art of the classless society. They call for theses defining the tendencies of the development of art under the present conditions of production. The dialectic of these conditions of production is evident in the superstructure, no less than in the economy. Theses defining the developmental tendencies of art can therefore contribute to the political struggle in ways that it would be a mistake to underestimate. They neutralize a number of traditional concepts—such as creativity and genius, eternal value and mystery—which, used in an uncontrolled way (and controlling them is difficult today), allow factual material to be manipulated in the interests of fascism. *In what follows, the concepts which are introduced into the theory of art differ from those now current in that they are completely useless for the purposes of fascism. On the other hand, they are useful for the formulation of revolutionary demands in the politics of art* [*Kunstpolitik*].

I

In principle, the work of art has always been reproducible. Objects made by humans could always be copied by humans. Replicas were made by pupils in practicing for their craft, by masters in disseminating their works, and, finally, by third parties in pursuit of profit. But the technological reproduction of artworks is something new. Having appeared intermittently in history, at widely spaced intervals, it is now being adopted with ever-increasing intensity. The Greeks had only two ways of technologically reproducing works of art: casting and stamping. Bronzes, terracottas, and coins were the only artworks they could produce in large numbers. All others were unique and could not be technologically reproduced. Graphic art was first made technologically reproducible by the woodcut, long before written language became reproducible by movable type. The enormous changes brought about in literature by movable type, the technological reproducibility of writing, are well known. But they are only a special case, though an important one, of the phenomenon considered here from the perspective of world history. In the course of the Middle Ages the woodcut was supplemented by engraving and etching, and at the beginning of the nineteenth century by lithography.

Lithography marked a fundamentally new stage in the technology of reproduction. This much more direct process—distinguished by the fact that the drawing is traced on a stone, rather than incised on a block of wood or etched on a copper plate—first made it possible for graphic art to market its products not only in large numbers, as previously, but in daily changing

variations. Lithography enabled graphic art to provide an illustrated accompaniment to everyday life. It began to keep pace with movable-type printing. But only a few decades after the invention of lithography, graphic art was surpassed by photography. For the first time, photography freed the hand from the most important artistic tasks in the process of pictorial reproduction—tasks that now devolved solely upon the eye looking into a lens. And since the eye perceives more swiftly than the hand can draw, the process of pictorial reproduction was enormously accelerated, so that it could now keep pace with speech. A cinematographer shooting a scene in the studio captures the images at the speed of an actor's speech. Just as the illustrated newspaper virtually lay hidden within lithography, so the sound film was latent in photography. The technological reproduction of sound was tackled at the end of the last century. These convergent endeavors made it possible to conceive of the situation that Paul Valéry describes in this sentence: "Just as water, gas, and electricity are brought into our houses from far off to satisfy our needs with minimal effort, so we shall be supplied with visual or auditory images, which will appear and disappear at a simple movement of the hand, hardly more than a sign."[2] *Around 1900, technological reproduction not only had reached a standard that permitted it to reproduce all known works of art, profoundly modifying their effect, but it also had captured a place of its own among the artistic processes.* In gauging this standard, we would do well to study the impact which its two different manifestations—the reproduction of artworks and the art of film—are having on art in its traditional form.

II

In even the most perfect reproduction, *one* thing is lacking: the here and now of the work of art—its unique existence in a particular place. It is this unique existence—and nothing else—that bears the mark of the history to which the work has been subject. This history includes changes to the physical structure of the work over time, together with any changes in ownership.[3] Traces of the former can be detected only by chemical or physical analyses (which cannot be performed on a reproduction), while changes of ownership are part of a tradition which can be traced only from the standpoint of the original in its present location.

The here and now of the original underlies the concept of its authenticity. Chemical analyses of the patina of a bronze can help to establish its authenticity, just as the proof that a given manuscript of the Middle Ages came from an archive of the fifteenth century helps to establish its authenticity. *The whole sphere of authenticity eludes technological—and, of course, not only technological—reproducibility.*[4] But whereas the authentic work retains its full authority in the face of a reproduction made by hand, which it

generally brands a forgery, this is not the case with technological reproduction. The reason is twofold. First, technological reproduction is more independent of the original than is manual reproduction. For example, in photography it can bring out aspects of the original that are accessible only to the lens (which is adjustable and can easily change viewpoint) but not to the human eye; or it can use certain processes, such as enlargement or slow motion, to record images which escape natural optics altogether. This is the first reason. Second, technological reproduction can place the copy of the original in situations which the original itself cannot attain. Above all, it enables the original to meet the recipient halfway, whether in the form of a photograph or in that of a gramophone record. The cathedral leaves its site to be received in the studio of an art lover; the choral work performed in an auditorium or in the open air is enjoyed in a private room.

The situations into which the product of technological reproduction can be brought may leave the artwork's other properties untouched, but they certainly devalue the here and now of the artwork. And although this can apply not only to art but (say) to a landscape moving past the spectator in a film, in the work of art this process touches on a highly sensitive core, more vulnerable than that of any natural object. That core is its authenticity. The authenticity of a thing is the quintessence of all that is transmissible in it from its origin on, ranging from its physical duration to the historical testimony relating to it. Since the historical testimony is founded on the physical duration, the former, too, is jeopardized by reproduction, in which the physical duration plays no part. And what is really jeopardized when the historical testimony is affected is the authority of the object.[5]

One might encompass the eliminated element within the concept of the aura, and go on to say: what withers in the age of the technological reproducibility of the work of art is the latter's aura. The process is symptomatic; its significance extends far beyond the realm of art. *It might be stated as a general formula that the technology of reproduction detaches the reproduced object from the sphere of tradition. By replicating the work many times over, it substitutes a mass existence for a unique existence. And in permitting the reproduction to reach the recipient in his or her own situation, it actualizes that which is reproduced.* These two processes lead to a massive upheaval in the domain of objects handed down from the past—a shattering of tradition which is the reverse side of the present crisis and renewal of humanity. Both processes are intimately related to the mass movements of our day. Their most powerful agent is film. The social significance of film, even—and especially—in its most positive form, is inconceivable without its destructive, cathartic side: the liquidation of the value of tradition in the cultural heritage. This phenomenon is most apparent in the great historical films. It is assimilating ever more advanced positions in its spread. When Abel Gance fervently proclaimed in 1927, "Shakespeare, Rembrandt,

Beethoven will make films. . . . All legends, all mythologies, and all myths, all the founders of religions, indeed, all religions, . . . await their celluloid resurrection, and the heroes are pressing at the gates," he was inviting the reader, no doubt unawares, to witness a comprehensive liquidation.[6]

III

Just as the entire mode of existence of human collectives changes over long historical periods, so too does their mode of perception. The way in which human perception is organized—the medium in which it occurs—is conditioned not only by nature but by history. The era of the migration of peoples, an era which saw the rise of the late-Roman art industry and the Vienna Genesis, developed not only an art different from that of antiquity but also a different perception. The scholars of the Viennese school Riegl and Wickhoff, resisting the weight of the classical tradition beneath which this art had been buried, were the first to think of using such art to draw conclusions about the organization of perception at the time the art was produced.[7] However far-reaching their insight, it was limited by the fact that these scholars were content to highlight the formal signature which characterized perception in late-Roman times. They did not attempt to show the social upheavals manifested in these changes of perception—and perhaps could not have hoped to do so at that time. Today, the conditions for an analogous insight are more favorable. And if changes in the medium of present-day perception can be understood as a decay of the aura, it is possible to demonstrate the social determinants of that decay.

The concept of the aura which was proposed above with reference to historical objects can be usefully illustrated with reference to an aura of natural objects. We define the aura of the latter as the unique apparition of a distance, however near it may be.[8] To follow with the eye—while resting on a summer afternoon—a mountain range on the horizon or a branch that casts its shadow on the beholder is to breathe the aura of those mountains, of that branch. In the light of this description, we can readily grasp the social basis of the aura's present decay. It rests on two circumstances, both linked to the increasing significance of the masses in contemporary life. Namely: *the desire of the present-day masses to "get closer" to things spatially and humanly, and their equally passionate concern for overcoming each thing's uniqueness [Überwindung des Einmaligen jeder Gegebenheit] by assimilating it as a reproduction.*[9] Every day the urge grows stronger to get hold of an object at close range in an image [*Bild*], or better, in a facsimile [*Abbild*], a reproduction. And the reproduction [*Reproduktion*], as offered by illustrated magazines and newsreels, differs unmistakably from the image. Uniqueness and permanence are as closely entwined in the latter as are transitoriness and repeatability in the former. The stripping of the veil from the

object, the destruction of the aura, is the signature of a perception whose "sense for sameness in the world"[10] has so increased that, by means of reproduction, it extracts sameness even from what is unique. Thus is manifested in the field of perception what in the theoretical sphere is noticeable in the increasing significance of statistics. The alignment of reality with the masses and of the masses with reality is a process of immeasurable importance for both thinking and perception.

IV

The uniqueness of the work of art is identical to its embeddedness in the context of tradition. Of course, this tradition itself is thoroughly alive and extremely changeable. An ancient statue of Venus, for instance, existed in a traditional context for the Greeks (who made it an object of worship) that was different from the context in which it existed for medieval clerics (who viewed it as a sinister idol). But what was equally evident to both was its uniqueness—that is, its aura. Originally, the embeddedness of an artwork in the context of tradition found expression in a cult. As we know, the earliest artworks originated in the service of rituals—first magical, then religious. And it is highly significant that the artwork's auratic mode of existence is never entirely severed from its ritual function.[11] In other words: *the unique value of the "authentic" work of art has its basis in ritual, the source of its original use value.* This ritualistic basis, however mediated it may be, is still recognizable as secularized ritual in even the most profane forms of the cult of beauty.[12] The secular worship of beauty, which developed during the Renaissance and prevailed for three centuries, clearly displayed that ritualistic basis in its subsequent decline and in the first severe crisis which befell it. For when, with the advent of the first truly revolutionary means of reproduction (namely, photography, which emerged at the same time as socialism), art felt the approach of that crisis which a century later has become unmistakable, it reacted with the doctrine of *l'art pour l'art*—that is, with a theology of art. This in turn gave rise to a negative theology, in the form of an idea of "pure" art, which rejects not only any social function but any definition in terms of a representational content. (In poetry, Mallarmé was the first to adopt this standpoint.)[13]

No investigation of the work of art in the age of its technological reproducibility can overlook these connections. They lead to a crucial insight: for the first time in world history, technological reproducibility emancipates the work of art from its parasitic subservience to ritual. To an ever-increasing degree, the work reproduced becomes the reproduction of a work designed for reproducibility.[14] From a photographic plate, for example, one can make any number of prints; to ask for the "authentic" print makes no sense. *But as soon as the criterion of authenticity ceases to be ap-*

plied to artistic production, the whole social function of art is revolution-ized. Instead of being founded on ritual, it is based on a different practice: politics.

V

The reception of works of art varies in character, but in general two polar types stand out: one accentuates the artwork's cult value; the other, its exhibition value.[15] Artistic production begins with figures in the service of a cult. One may assume that it was more important for these figures to be present than to be seen. The elk depicted by Stone Age man on the walls of his cave is an instrument of magic. He exhibits it to his fellow men, to be sure, but in the main it is meant for the spirits. Cult value as such tends today, it would seem, to keep the artwork out of sight: certain statues of gods are accessible only to the priest in the cella; certain images of the Madonna remain covered nearly all year round; certain sculptures on medieval cathedrals are not visible to the viewer at ground level. *With the emancipation of specific artistic practices from the service of ritual, the opportunities for exhibiting their products increase.* It is easier to exhibit a portrait bust that can be sent here and there than to exhibit the statue of a divinity that has a fixed place in the interior of a temple. A panel painting can be exhibited more easily than the mosaic or fresco which preceded it. And although a Mass may have been no less suited to public presentation than a symphony, the symphony came into being at a time when the possibility of such presentation promised to be greater.

The scope for exhibiting the work of art has increased so enormously with the various methods of technologically reproducing it that, as happened in prehistoric times, a quantitative shift between the two poles of the artwork has led to a qualitative transformation in its nature. Just as the work of art in prehistoric times, through the absolute emphasis placed on its cult value, became first and foremost an instrument of magic which only later came to be recognized as a work of art, so today, through the absolute emphasis placed on its exhibition value, the work of art becomes a construct [*Gebilde*] with quite new functions. Among these, the one we are conscious of—the artistic function—may subsequently be seen as incidental.[16] This much is certain: today, photography and film are the most serviceable vehicles of this new understanding.

VI

In photography, exhibition value begins to drive back cult value on all fronts. But cult value does not give way without resistance. It falls back to a last entrenchment: the human countenance. It is no accident that the por-

trait is central to early photography. In the cult of remembrance of dead or absent loved ones, the cult value of the image finds its last refuge. In the fleeting expression of a human face, the aura beckons from early photographs for the last time. This is what gives them their melancholy and incomparable beauty. But as the human being withdraws from the photographic image, exhibition value for the first time shows its superiority to cult value. To have given this development its local habitation constitutes the unique significance of Atget, who, around 1900, took photographs of deserted Paris streets.[17] It has justly been said that he photographed them like scenes of crimes. A crime scene, too, is deserted; it is photographed for the purpose of establishing evidence. With Atget, photographic records begin to be evidence in the historical trial [*Prozess*]. This constitutes their hidden political significance. They demand a specific kind of reception. Free-floating contemplation is no longer appropriate to them. They unsettle the viewer; he feels challenged to find a particular way to approach them. At the same time, illustrated magazines begin to put up signposts for him—whether these are right or wrong is irrelevant. For the first time, captions become obligatory. And it is clear that they have a character altogether different from the titles of paintings. The directives given by captions to those looking at images in illustrated magazines soon become even more precise and commanding in films, where the way each single image is understood appears prescribed by the sequence of all the preceding images.

VII

The nineteenth-century dispute over the relative artistic merits of painting and photography seems misguided and confused today.[18] But this does not diminish its importance, and may even underscore it. The dispute was in fact an expression of a world-historical upheaval whose true nature was concealed from both parties. Insofar as the age of technological reproducibility separated art from its basis in cult, all semblance of art's autonomy disappeared forever. But the resulting change in the function of art lay beyond the horizon of the nineteenth century. And even the twentieth, which saw the development of film, was slow to perceive it.

Though commentators had earlier expended much fruitless ingenuity on the question of whether photography was an art—without asking the more fundamental question of whether the invention of photography had not transformed the entire character of art—film theorists quickly adopted the same ill-considered standpoint. But the difficulties which photography caused for traditional aesthetics were child's play compared to those presented by film. Hence the obtuse and hyperbolic character of early film theory. Abel Gance, for instance, compares film to hieroglyphs: "By a remarkable regression, we are transported back to the expressive level of the

Egyptians. . . . Pictorial language has not matured, because our eyes are not yet adapted to it. There is not yet enough respect, not enough *cult,* for what it expresses."[19] Or, in the words of Séverin-Mars: "What other art has been granted a dream . . . at once more poetic and more real? Seen in this light, film might represent an incomparable means of expression, and only the noblest minds should move within its atmosphere, in the most perfect and mysterious moments of their lives."[20] Alexandre Arnoux, for his part, concludes a fantasy about the silent film with the question: "Do not all the bold descriptions we have given amount to a definition of prayer?"[21] It is instructive to see how the desire to annex film to "art" impels these theoreticians to attribute elements of cult to film—with a striking lack of discretion. Yet when these speculations were published, works like *A Woman of Paris* and *The Gold Rush* had already appeared. This did not deter Abel Gance from making the comparison with hieroglyphs, while Séverin-Mars speaks of film as one might speak of paintings by Fra Angelico.[22] It is revealing that even today especially reactionary authors look in the same direction for the significance of film—finding, if not actually a sacred significance, then at least a supernatural one. In connection with Max Reinhardt's film version of *A Midsummer Night's Dream,* Werfel comments that it was undoubtedly the sterile copying of the external world—with its streets, interiors, railroad stations, restaurants, automobiles, and beaches—that had prevented film up to now from ascending to the realm of art. "Film has not yet realized its true purpose, its real possibilities. . . . These consist in its unique ability to use natural means to give incomparably convincing expression to the fairy-like, the marvelous, the supernatural."[23]

VIII

The artistic performance of a stage actor is directly presented to the public by the actor in person; that of a screen actor, however, is presented through a camera, with two consequences. The recording apparatus that brings the film actor's performance to the public need not respect the performance as an integral whole. Guided by the cameraman, the camera continually changes its position with respect to the performance. The sequence of positional views which the editor composes from the material supplied him constitutes the completed film. It comprises a certain number of movements, of various kinds and duration, which must be apprehended as such through the camera, not to mention special camera angles, close-ups, and so on. Hence, the performance of the actor is subjected to a series of optical tests. This is the first consequence of the fact that the actor's performance is presented by means of a camera. The second consequence is that the film actor lacks the opportunity of the stage actor to adjust to the audience during his performance, since he does not present his performance to the audience in

person. This permits the audience to take the position of a critic, without experiencing any personal contact with the actor. *The audience's empathy with the actor is really an empathy with the camera. Consequently, the audience takes the position of the camera; its approach is that of testing.*[24] This is not an approach compatible with cult value.

IX

In the case of film, the fact that the actor represents someone else before the audience matters much less than the fact that he represents himself before the apparatus. One of the first to sense this transformation of the actor by the test performance was Pirandello. That his remarks on the subject in his novel *Si gira* [Shoot!] are confined to the negative aspects of this change, and to silent film only, does little to diminish their relevance. For in this respect, the sound film changed nothing essential. What matters is that the actor is performing for a piece of equipment—or, in the case of sound film, for two pieces of equipment. "The film actor," Pirandello writes, "feels as if exiled. Exiled not only from the stage but from his own person. With a vague unease, he senses an inexplicable void, stemming from the fact that his body has lost its substance, that he has been volatilized, stripped of his reality, his life, his voice, the noises he makes when moving about, and has been turned into a mute image that flickers for a moment on the screen, then vanishes into silence. . . . The little apparatus will play with his shadow before the audience, and he himself must be content to play before the apparatus."[25] The situation can also be characterized as follows: for the first time—and this is the effect of film—the human being is placed in a position where he must operate with his whole living person, while forgoing its aura. For the aura is bound to his presence in the here and now. There is no facsimile of the aura. The aura surrounding Macbeth on the stage cannot be divorced from the aura which, for the living spectators, surrounds the actor who plays him. What distinguishes the shot in the film studio, however, is that the camera is substituted for the audience. As a result, the aura surrounding the actor is dispelled—and, with it, the aura of the figure he portrays.

It is not surprising that it should be a dramatist such as Pirandello who, in reflecting on the special character of film acting, inadvertently touches on the crisis now affecting the theater. Indeed, nothing contrasts more starkly with a work of art completely subject to (or, like film, founded in) technological reproduction than a stage play. Any thorough consideration will confirm this. Expert observers have long recognized that, in film, "the best effects are almost always achieved by 'acting' as little as possible. . . . The development," according to Rudolf Arnheim, writing in 1932, has been toward "using the actor as one of the 'props,' chosen for his typicalness and . . . introduced in the proper context."[26] Closely bound up with this devel-

opment is something else. *The stage actor identifies himself with a role. The film actor very often is denied this opportunity.* His performance is by no means a unified whole, but is assembled from many individual performances. Apart from incidental concerns about studio rental, availability of other actors, scenery, and so on, there are elementary necessities of the machinery that split the actor's performance into a series of episodes capable of being assembled. In particular, lighting and its installation require the representation of an action—which on the screen appears as a swift, unified sequence—to be filmed in a series of separate takes, which may be spread over hours in the studio. Not to mention the more obvious effects of montage. A leap from a window, for example, can be shot in the studio as a leap from a scaffold, while the ensuing fall may be filmed weeks later at an outdoor location. And far more paradoxical cases can easily be imagined. Let us assume that an actor is supposed to be startled by a knock at the door. If his reaction is not satisfactory, the director can resort to an expedient: he could have a shot fired without warning behind the actor's back on some other occasion when he happens to be in the studio. The actor's frightened reaction at that moment could be recorded and then edited into the film. Nothing shows more graphically that art has escaped the realm of "beautiful semblance," which for so long was regarded as the only sphere in which it could thrive.

X

The film actor's feeling of estrangement in the face of the apparatus, as Pirandello describes this experience, is basically of the same kind as the estrangement felt before one's appearance [*Erscheinung*] in a mirror. But now the mirror image [*Bild*] has become detachable from the person mirrored, and is transportable. And where is it transported? To a site in front of the public.[27] The screen actor never for a moment ceases to be aware of this. *While he stands before the apparatus, the screen actor knows that in the end he is confronting the public, the consumers who constitute the market.* This market, where he offers not only his labor but his entire self, his heart and soul, is beyond his reach. During the shooting, he has as little contact with it as would any article being made in a factory. This may contribute to that oppression, that new anxiety which, according to Pirandello, grips the actor before the camera. Film responds to the shriveling of the aura by artificially building up the "personality" outside the studio. The cult of the movie star, fostered by the money of the film industry, preserves that magic of the personality which has long been no more than the putrid magic of its own commodity character. So long as moviemakers' capital sets the fashion, as a rule the only revolutionary merit that can be ascribed to today's cinema is the promotion of a revolutionary criticism of traditional concepts of art.

We do not deny that in some cases today's films can also foster revolutionary criticism of social conditions, even of property relations. But the present study is no more specifically concerned with this than is western European film production.

It is inherent in the technology of film, as of sports, that everyone who witnesses these performances does so as a quasi-expert. This is obvious to anyone who has listened to a group of newspaper boys leaning on their bicycles and discussing the outcome of a bicycle race. It is no accident that newspaper publishers arrange races for their delivery boys. These arouse great interest among the participants, for the winner has a chance to rise from delivery boy to professional racer. Similarly, the newsreel offers everyone the chance to rise from passer-by to movie extra. In this way, a person might even see himself becoming part of a work of art: think of Vertov's *Three Songs of Lenin* or Ivens' *Borinage*.[28] *Any person today can lay claim to being filmed.* This claim can best be clarified by considering the historical situation of literature today.

For centuries it was in the nature of literature that a small number of writers confronted many thousands of readers. This began to change toward the end of the past century. With the growth and extension of the press, which constantly made new political, religious, scientific, professional, and local journals available to readers, an increasing number of readers—in isolated cases, at first—turned into writers. It began with the space set aside for "letters to the editor" in the daily press, and has now reached a point where there is hardly a European engaged in the work process who could not, in principle, find an opportunity to publish somewhere or other an account of a work experience, a complaint, a report, or something of the kind. Thus, the distinction between author and public is about to lose its axiomatic character. The difference becomes functional; it may vary from case to case. At any moment, the reader is ready to become a writer. As an expert—which he has had to become in any case in a highly specialized work process, even if only in some minor capacity—the reader gains access to authorship. In the Soviet Union, work itself is given a voice. And the ability to describe a job in words now forms part of the expertise needed to carry it out. Literary competence is no longer founded on specialized higher education but on polytechnic training, and thus is common property.[29]

All this can readily be applied to film, where shifts that in literature took place over centuries have occurred in a decade. In cinematic practice—above all, in Russia—this shift has already been partly realized. Some of the actors taking part in Russian films are not actors in our sense but people who portray *themselves*—and primarily in their own work process. In western Europe today, the capitalist exploitation of film obstructs the human being's legitimate claim to being reproduced. Under these circumstances, the

film industry has an overriding interest in stimulating the involvement of the masses through illusionary displays and ambiguous speculations.

XI

The shooting of a film, especially a sound film, offers a hitherto unimaginable spectacle. It presents a process in which it is impossible to assign to the spectator a single viewpoint which would exclude from his or her field of vision the equipment not directly involved in the action being filmed—the camera, the lighting units, the technical crew, and so forth (unless the alignment of the spectator's pupil coincided with that of the camera). This circumstance, more than any other, makes any resemblance between a scene in a film studio and one onstage superficial and irrelevant. In principle, the theater includes a position from which the action on the stage cannot easily be detected as an illusion. There is no such position where a film is being shot. The illusory nature of film is of the second degree; it is the result of editing. That is to say: *In the film studio the apparatus has penetrated so deeply into reality that a pure view of that reality, free of the foreign body of equipment, is the result of a special procedure, namely, the shooting by the specially adjusted photographic device and the assembly of that shot with others of the same kind.* The equipment-free aspect of reality has here become the height of artifice, and the vision of immediate reality the Blue Flower in the land of technology.[30]

This state of affairs, which contrasts so sharply with that which obtains in the theater, can be compared even more instructively to the situation in painting. Here we have to pose the question: How does the camera operator compare with the painter? In answer to this, it will be helpful to consider the concept of the operator as it is familiar to us from surgery. The surgeon represents the polar opposite of the magician. The attitude of the magician, who heals a sick person by a laying-on of hands, differs from that of the surgeon, who makes an intervention in the patient. The magician maintains the natural distance between himself and the person treated; more precisely, he reduces it slightly by laying on his hands, but increases it greatly by his authority. The surgeon does exactly the reverse; he greatly diminishes the distance from the patient by penetrating the patient's body, and increases it only slightly by the caution with which his hand moves among the organs. In short: unlike the magician (traces of whom are still found in the medical practitioner), the surgeon abstains at the decisive moment from confronting his patient person to person; instead, he penetrates the patient by operating.—Magician is to surgeon as painter is to cinematographer. The painter maintains in his work a natural distance from reality, whereas the cinematographer penetrates deeply into its tissue.[31] The images obtained by each differ enormously. The painter's is a total image, whereas that of the cine-

matographer is piecemeal, its manifold parts being assembled according to a new law. *Hence, the presentation of reality in film is incomparably the more significant for people of today, since it provides the equipment-free aspect of reality they are entitled to demand from a work of art, and does so precisely on the basis of the most intensive interpenetration of reality with equipment.*

XII

The technological reproducibility of the artwork changes the relation of the masses to art. The extremely backward attitude toward a Picasso painting changes into a highly progressive reaction to a Chaplin film.[32] The progressive reaction is characterized by an immediate, intimate fusion of pleasure—pleasure in seeing and experiencing—with an attitude of expert appraisal. Such a fusion is an important social index. As is clearly seen in the case of painting, the more reduced the social impact of an art form, the more widely criticism and enjoyment of it diverge in the public. The conventional is uncritically enjoyed, while the truly new is criticized with aversion. With regard to the cinema, the critical and uncritical attitudes of the public coincide. The decisive reason for this is that nowhere more than in the cinema are the reactions of individuals, which together make up the massive reaction of the audience, determined by the imminent concentration of reactions into a mass. No sooner are these reactions manifest than they regulate one another. Again, the comparison with painting is fruitful. A painting has always exerted a claim to be viewed primarily by a single person or by a few. The simultaneous viewing of paintings by a large audience, as happens in the nineteenth century, is an early symptom of the crisis in painting, a crisis triggered not only by photography but, in a relatively independent way, by the artwork's claim to the attention of the masses.

Painting, by its nature, cannot provide an object of simultaneous collective reception, as architecture has always been able to do, as the epic poem could do at one time, and as film is able to do today. And although direct conclusions about the social role of painting cannot be drawn from this fact alone, it does have a strongly adverse effect whenever painting is led by special circumstances, as if against its nature, to confront the masses directly. In the churches and monasteries of the Middle Ages, and at the princely courts up to about the end of the eighteenth century, the collective reception of paintings took place not simultaneously but in a manifoldly graduated and hierarchically mediated way. If that has changed, the change testifies to the special conflict in which painting has become enmeshed by the technological reproducibility of the image. And while efforts have been made to present paintings to the masses in galleries and salons, this mode of reception gives the masses no means of organizing and regulating their re-

sponse.[33] Thus, the same public which reacts progressively to a slapstick comedy inevitably displays a backward attitude toward Surrealism.[34]

XIII

Film can be characterized not only in terms of man's presentation of himself to the camera but also in terms of his representation of his environment by means of this apparatus. A glance at occupational psychology illustrates the testing capacity of the equipment. Psychoanalysis illustrates it in a different perspective. In fact, film has enriched our field of perception with methods that can be illustrated by those of Freudian theory. Fifty years ago, a slip of the tongue passed more or less unnoticed. Only exceptionally may such a slip have opened a perspective on depths in a conversation which had seemed to be proceeding on a superficial plane. Since the publication of *Zur Psychopathologie des Alltagslebens* (On the Psychopathology of Everyday Life), things have changed.[35] This book isolated and made analyzable things which had previously floated unnoticed on the broad stream of perception. A similar deepening of apperception throughout the entire spectrum of optical—and now also auditory[36]—impressions has been accomplished by film. One is merely stating the obverse of this fact when one says that actions shown in a movie can be analyzed much more precisely and from more points of view than those presented in a painting or on the stage. In contrast to what obtains in painting, filmed action lends itself more readily to analysis because it delineates situations far more precisely. In contrast to what obtains on the stage, filmed action lends itself more readily to analysis because it can be isolated more easily. This circumstance derives its prime importance from the fact that it tends to foster the interpenetration of art and science. Actually, if we think of a filmed action as neatly delineated within a particular situation—like a flexed muscle in a body—it is difficult to say which is more fascinating, its artistic value or its value for science. *Demonstrating that the artistic uses of photography are identical to its scientific uses—these two dimensions having usually been separated until now—will be one of the revolutionary functions of film.*[37]

On the one hand, film furthers insight into the necessities governing our lives by its use of close-ups, by its accentuation of hidden details in familiar objects, and by its exploration of commonplace milieux through the ingenious guidance of the camera; on the other hand, it manages to assure us of a vast and unsuspected field of action [*Spielraum*]. Our bars and city streets, our offices and furnished rooms, our railroad stations and our factories seemed to close relentlessly around us. Then came film and exploded this prison-world with the dynamite of the split second, so that now we can set off calmly on journeys of adventure among its far-flung debris. With the close-up, space expands; with slow motion, movement is extended. And

just as enlargement not merely clarifies what we see indistinctly "in any case," but brings to light entirely new structures of matter, slow motion not only reveals familiar aspects of movements, but discloses quite unknown aspects within them—aspects "which do not appear as the retarding of natural movements but have a curious gliding, floating character of their own."[38] Clearly, it is another nature which speaks to the camera as compared to the eye. "Other" above all in the sense that a space informed by human consciousness gives way to a space informed by the unconscious. Whereas it is a commonplace that, for example, we have some idea what is involved in the act of walking (if only in general terms), we have no idea at all what happens during the split second when a person actually takes a step. We are familiar with the movement of picking up a cigarette lighter or a spoon, but know almost nothing of what really goes on between hand and metal, and still less how this varies with different moods. This is where the camera comes into play, with all its resources for swooping and rising, disrupting and isolating, stretching or compressing a sequence, enlarging or reducing an object. It is through the camera that we first discover the optical unconscious, just as we discover the instinctual unconscious through psychoanalysis.

XIV

It has always been one of the primary tasks of art to create a demand whose hour of full satisfaction has not yet come.[39] The history of every art form has critical periods in which the particular form strains after effects which can be easily achieved only with a changed technical standard—that is to say, in a new art form. The excesses and crudities of art which thus result, particularly in periods of so-called decadence, actually emerge from the core of its richest historical energies. In recent years, Dadaism has abounded in such barbarisms. Only now is its impulse recognizable: *Dadaism attempted to produce with the means of painting (or literature) the effects which the public today seeks in film.*

Every fundamentally new, pioneering creation of demand will overshoot its target. Dadaism did so to the extent that it sacrificed the market values so characteristic of film in favor of more significant aspirations—of which, to be sure, it was unaware in the form described here. The Dadaists attached much less importance to the commercial usefulness of their artworks than to the uselessness of those works as objects of contemplative immersion. They sought to achieve this uselessness not least by thorough degradation of their material. Their poems are "word-salad" containing obscene expressions and every imaginable kind of linguistic refuse. It is not otherwise with their paintings, on which they mounted buttons or train tickets. What they achieved by such means was a ruthless annihilation of the aura

in every object they produced, which they branded as a reproduction through the very means of production. Before a painting by Arp or a poem by August Stramm, it is impossible to take time for concentration and evaluation, as one can before a painting by Derain or a poem by Rilke. Contemplative immersion—which, as the bourgeoisie degenerated, became a breeding ground for asocial behavior—is here opposed by distraction [*Ablenkung*] as a variant of social behavior.[40] Dadaist manifestations actually guaranteed a quite vehement distraction by making artworks the center of scandal. One requirement was paramount: to outrage the public.

From an alluring visual composition or an enchanting fabric of sound, the Dadaists turned the artwork into a missile. It jolted the viewer, taking on a tactile [*taktisch*] quality. It thereby fostered the demand for film, since the distracting element in film is also primarily tactile, being based on successive changes of scene and focus which have a percussive effect on the spectator. Let us compare the screen [*Leinwand*] on which a film unfolds with the canvas [*Leinwand*] of a painting. The painting invites the viewer to contemplation; before it, he can give himself up to his train of associations. Before a film image, he cannot do so. No sooner has he seen it than it has already changed. It cannot be fixed on. Duhamel, who detests the cinema and knows nothing of its significance, though he does know something about its structure, describes the situation as follows: "I can no longer think what I want to think. My thoughts have been replaced by moving images."[41] Indeed, the train of associations in the person contemplating these images is immediately interrupted by new images. This constitutes the shock effect of film, which, like all shock effects, seeks to induce heightened attention.[42] *By means of its technological structure, film has freed the physical shock effect—which Dadaism had kept wrapped, as it were, inside the moral shock effect—from this wrapping.*[43]

XV

The masses are a matrix from which all customary behavior toward works of art is today emerging newborn. Quantity has been transformed into quality: *the greatly increased mass of participants has produced a different kind of participation.* The fact that the new mode of participation first appeared in a disreputable form should not mislead the observer. Yet some people have launched spirited attacks against precisely this superficial aspect of the matter. Among these critics, Duhamel has expressed himself most radically. What he objects to most is the kind of participation which the movie elicits from the masses. Duhamel calls the movie "a pastime for helots, a diversion for uneducated, wretched, worn-out creatures who are consumed by their worries . . . , a spectacle which requires no concentration and presupposes no intelligence . . . , which kindles no light in the heart and

awakens no hope other than the ridiculous one of someday becoming a 'star' in Los Angeles."[44] Clearly, this is in essence the ancient lament that the masses seek distraction, whereas art demands concentration from the spectator.[45] That is a commonplace. The question remains whether it provides a basis for the analysis of film. This calls for closer examination. Distraction and concentration [*Zerstreuung und Sammlung*] form an antithesis, which may be formulated as follows. A person who concentrates before a work of art is absorbed by it; he enters into the work, just as, according to legend, a Chinese painter entered his completed painting while beholding it.[46] By contrast, the distracted masses absorb the work of art into themselves. This is most obvious with regard to buildings. Architecture has always offered the prototype of an artwork that is received in a state of distraction and through the collective. The laws of architecture's reception are highly instructive.

Buildings have accompanied human existence since primeval times. Many art forms have come into being and passed away. Tragedy begins with the Greeks, is extinguished along with them, and is revived centuries later, though only according to its "rules." The epic, which originates in the early days of peoples, dies out in Europe at the end of the Renaissance. Panel painting is a creation of the Middle Ages, and nothing guarantees its uninterrupted existence. But the human need for shelter is permanent. Architecture has never had fallow periods. Its history is longer than that of any other art, and its effect ought to be recognized in any attempt to account for the relationship of the masses to the work of art. Buildings are received in a twofold manner: by use and by perception. Or, better: tactilely and optically. Such reception cannot be understood in terms of the concentrated attention of a traveler before a famous building. On the tactile side, there is no counterpart to what contemplation is on the optical side. Tactile reception comes about not so much by way of attention as by way of habit. The latter largely determines even the optical reception of architecture, which spontaneously takes the form of casual noticing, rather than attentive observation. Under certain circumstances, this form of reception shaped by architecture acquires canonical value. *For the tasks which face the human apparatus of perception at historical turning points cannot be performed solely by optical means—that is, by way of contemplation. They are mastered gradually—taking their cue from tactile reception—through habit.*

Even the distracted person can form habits. What is more, the ability to master certain tasks in a state of distraction proves that their performance has become habitual. The sort of distraction that is provided by art represents a covert measure of the extent to which it has become possible to perform new tasks of apperception. Since, moreover, individuals are tempted to evade such tasks, art will tackle the most difficult and most important

tasks wherever it is able to mobilize the masses. It does so currently in film. *Reception in distraction—the sort of reception which is increasingly noticeable in all areas of art and is a symptom of profound changes in apperception—finds in film its true training ground.* Film, by virtue of its shock effects, is predisposed to this form of reception. It makes cult value recede into the background, not only because it encourages an evaluating attitude in the audience but also because, at the movies, the evaluating attitude requires no attention. The audience is an examiner, but a distracted one.

Epilogue

The increasing proletarianization of modern man and the increasing formation of masses are two sides of the same process. Fascism attempts to organize the newly proletarianized masses while leaving intact the property relations which they strive to abolish. It sees its salvation in granting expression to the masses—but on no account granting them rights.[47] The masses have a right to changed property relations; fascism seeks to give them *expression* in keeping these relations unchanged. *The logical outcome of fascism is an aestheticizing of political life.* The violation of the masses, whom fascism, with its *Führer* cult, forces to their knees, has its counterpart in the violation of an apparatus which is pressed into serving the production of ritual values.

All efforts to aestheticize politics culminate in one point. That one point is war. War, and only war, makes it possible to set a goal for mass movements on the grandest scale while preserving traditional property relations. That is how the situation presents itself in political terms. In technological terms it can be formulated as follows: only war makes it possible to mobilize all of today's technological resources while maintaining property relations. It goes without saying that the fascist glorification of war does not make use of *these* arguments. Nevertheless, a glance at such glorification is instructive. In Marinetti's manifesto for the colonial war in Ethiopia, we read:

> For twenty-seven years we Futurists have rebelled against the idea that war is anti-aesthetic. . . . We therefore state: . . . War is beautiful because—thanks to its gas masks, its terrifying megaphones, its flame throwers, and light tanks—it establishes man's dominion over the subjugated machine. War is beautiful because it inaugurates the dreamed-of metallization of the human body. War is beautiful because it enriches a flowering meadow with the fiery orchids of machine-guns. War is beautiful because it combines gunfire, barrages, cease-fires, scents, and the fragrance of putrefaction into a symphony. War is beautiful because it creates new architectures, like those of armored tanks, geometric squadrons of aircraft, spirals of smoke from burning villages, and much more. . . . Poets and artists of Futurism, . . . remember these principles of an aesthetic

of war, that they may illuminate . . . your struggles for a new poetry and a new sculpture![48]

This manifesto has the merit of clarity. The question it poses deserves to be taken up by the dialectician. To him, the aesthetic of modern warfare appears as follows: if the natural use of productive forces is impeded by the property system, then the increase in technological means, in speed, in sources of energy will press toward an unnatural use. This is found in war, and the destruction caused by war furnishes proof that society was not mature enough to make technology its organ, that technology was not sufficiently developed to master the elemental forces of society. The most horrifying features of imperialist war are determined by the discrepancy between the enormous means of production and their inadequate use in the process of production (in other words, by unemployment and the lack of markets). *Imperialist war is an uprising on the part of technology, which demands repayment in "human material" for the natural material society has denied it.* Instead of draining rivers, society directs a human stream into a bed of trenches; instead of dropping seeds from airplanes, it drops incendiary bombs over cities; and in gas warfare it has found a new means of abolishing the aura.

"Fiat ars—pereat mundus,"[49] says fascism, expecting from war, as Marinetti admits, the artistic gratification of a sense perception altered by technology. This is evidently the consummation of *l'art pour l'art.* Humankind, which once, in Homer, was an object of contemplation for the Olympian gods, has now become one for itself. Its self-alienation has reached the point where it can experience its own annihilation as a supreme aesthetic pleasure. *Such is the aestheticizing of politics, as practiced by fascism. Communism replies by politicizing art.*

Written spring 1936–March or April 1939; unpublished in this form in Benjamin's lifetime. *Gesammelte Schriften*, I, 471–508. Translated by Harry Zohn and Edmund Jephcott.

Notes

Benjamin began work on this version of "Das Kunstwerk im Zeitalter seiner technischen Reproduzierbarkeit" in Paris, in connection with the French translation of the essay in early 1936, intending to publish it in a German periodical. He made numerous modifications over the next two years, before allowing it to be copied by Gretel Adorno. It was this significantly revised version—which Benjamin, as late as 1939, could still regard as a work in progress, rather than a completed essay—that served as source for the first publication of the German text in 1955 in Benjamin's *Schriften.*

1. The German political philosopher Karl Marx (1818–1883) analyzed the capital-

ist mode of production in his most famous and influential work, *Das Kapital* (3 vols., 1867, 1885, 1895), which was carried to completion by his collaborator Friedrich Engels (1820–1895). The translation of Benjamin's epigraph is from Paul Valéry, "The Conquest of Ubiquity," in *Aesthetics,* trans. Ralph Manheim (New York: Pantheon, 1964), p. 225. Valéry (1871–1945), French man of letters, is the author of books of verse, such as *Charmes* (1922), and prose writings, such as *Soirée avec M. Teste* (1895) and *Analecta* (1927).

2. Paul Valéry, *Pièces sur l'art* (Paris), p. 105 ("La Conquête de l'ubiquité"). [Benjamin's note. In English in *Aesthetics,* p. 226. Benjamin made use of the third, augmented edition of *Pièces sur l'art,* published in January 1936.—*Trans.*]

3. Of course, the history of a work of art encompasses more than this. The history of the *Mona Lisa,* for instance, encompasses the kinds and number of copies made of it in the seventeenth, eighteenth, and nineteenth centuries. [Benjamin's note. The *Mona Lisa (La Gioconda)* was painted in 1503–1506 by the Florentine artist and scientist Leonardo da Vinci (1452–1519). It now hangs in the Louvre.—*Trans.*]

4. Precisely because authenticity is not reproducible, the intensive penetration of certain (technological) processes of reproduction was instrumental in differentiating and gradating authenticity. To develop such differentiations was an important function of the trade in works of art. Such trade had a manifest interest in distinguishing among various prints of a woodblock engraving (those before and those after inscription), of a copperplate engraving, and so on. The invention of the woodcut may be said to have struck at the root of the quality of authenticity even before its late flowering. To be sure, a medieval picture of the Madonna at the time it was created could not yet be said to be "authentic." It became "authentic" only during the succeeding centuries, and perhaps most strikingly so during the nineteenth. [Benjamin's note]

5. The poorest provincial staging of Goethe's *Faust* is superior to a film of *Faust,* in that, ideally, it competes with the first performance at Weimar. The viewer in front of a movie screen derives no benefit from recalling bits of tradition which might come to mind in front of a stage—for instance, that the character of Mephisto is based on Goethe's friend Johann Heinrich Merck, and the like. [Benjamin's note. The first performance of Parts I and II of Goethe's *Faust* took place in Weimar in 1876. Johann Heinrich Merck (1741–1791), a German writer, critic, and translator, as well as a professional pharmacist, helped found the periodical *Frankfurter gelehrte Anzeigen* (1722), in which some of Goethe's earliest pieces were published. For his portrait of Mephisto in *Faust,* Goethe drew on certain personality traits of this friend of his youth (who later committed suicide)—namely, his cool analytic mind, his unconstrained love of mockery and derision, and his destructive, nihilistic view of human affairs.—*Trans.*]

6. Abel Gance, "Le Temps de l'image est venue!" (It Is Time for the Image!), in Léon Pierre-Quint, Germaine Dulac, Lionel Landry, and Abel Gance, *L'Art cinématographique,* vol. 2 (Paris, 1927), pp. 94–96. [Benjamin's note. Gance (1889–1981) was a leading French film director, whose epic films *J'Accuse* (1919), *La Roue* (1922), and *Napoléon* (1927) made innovative use of such devices as superimposition, rapid intercutting, and split screen.—*Trans.*]

7. Alois Riegl (1858–1905) was an Austrian art historian who argued that different

formal orderings of art emerge as expressions of different historical epochs. He is the author of *Stilfragen: Grundlegungen zu einer Geschichte der Ornamentik* (Questions of Style: Toward a History of Ornament; 1893) and *Die Spätrömische Kunst-Industrie nach den Funden in Österreich-Ungarn* (1901). The latter has been translated by Rolf Winks as *Late Roman Art Industry* (Rome: Giorgio Bretschneider Editore, 1985). Franz Wickhoff (1853–1909), also an Austrian art historian, is the author of *Die Wiener Genesis* (The Vienna Genesis; 1922), a study of the sumptuously illuminated, early sixth-century A.D. copy of the biblical book of Genesis preserved in the Austrian National Library in Vienna.

8. "Einmalige Erscheinung einer Ferne, so nah sie sein mag." In Greek, *aura* means "air," "breath."

9. Getting closer (in terms of human interest) to the masses may involve having one's social function removed from the field of vision. Nothing guarantees that a portraitist of today, when painting a famous surgeon at the breakfast table with his family, depicts his social function more precisely than a painter of the seventeenth century who showed the viewer doctors representing their profession, as Rembrandt did in his *Anatomy Lesson*. [Benjamin's note. The Dutch painter and etcher Rembrandt van Rijn (1606–1669) painted *The Anatomy Lesson of Dr. Nicolaes Tulp* in 1632. It hangs in the Mauritshuis in the Hague.—*Trans.*]

10. Benjamin is quoting Johannes V. Jensen, *Exotische Novellen,* trans. Julia Koppel (Berlin: S. Fischer, 1919), pp. 41–42. Jensen (1873–1950) was a Danish novelist, poet, and essayist who won the Nobel Prize for Literature in 1944. See "Hashish in Marseilles," in Benjamin, *Selected Writings, Volume 2: 1927–1934* (Cambridge, Mass.: Harvard University Press, 1999), p. 677.

11. The definition of the aura as the "unique apparition of a distance, however near it may be," represents nothing more than a formulation of the cult value of the work of art in categories of spatiotemporal perception. Distance is the opposite of nearness. The *essentially* distant is the unapproachable. Unapproachability is, indeed, a primary quality of the cult image; true to its nature, the cult image remains "distant, however near it may be." The nearness one may gain from its substance [*Materie*] does not impair the distance it retains in its apparition. [Benjamin's note]

12. To the extent that the cult value of a painting is secularized, the impressions of its fundamental uniqueness become less distinct. In the viewer's imagination, the uniqueness of the phenomena holding sway in the cult image is more and more displaced by the empirical uniqueness of the artist or of his creative achievement. To be sure, never completely so—the concept of authenticity always transcends that of proper attribution. (This is particularly apparent in the collector, who always displays some traits of the fetishist and who, through his possession of the artwork, shares in its cultic power.) Nevertheless, the concept of authenticity still functions as a determining factor in the evaluation of art; as art becomes secularized, authenticity displaces the cult value of the work. [Benjamin's note]

13. Stéphane Mallarmé (1842–1898), French poet, translator, and editor, was an

originator and leader of the Symbolist movement, which sought an incantatory language cut off from all referential function. Among his works are *L'Après-Midi d'un faune* (Afternoon of a Faun; 1876) and *Vers et prose* (Poetry and Prose; 1893).

14. In film, the technological reproducibility of the product is not an externally imposed condition of its mass dissemination, as it is, say, in literature or painting. *The technological reproducibility of films is based directly on the technology of their production. This not only makes possible the mass dissemination of films in the most direct way, but actually enforces it.* It does so because the process of producing a film is so costly that an individual who could afford to buy a painting, for example, could not afford to buy a [master print of a] film. It was calculated in 1927 that, in order to make a profit, a major film needed to reach an audience of nine million. Of course, the advent of sound film [in that year] initially caused a movement in the opposite direction: its audience was restricted by language boundaries. And that coincided with the emphasis placed on national interests by fascism. But it is less important to note this setback (which in any case was mitigated by dubbing) than to observe its connection with fascism. The simultaneity of the two phenomena results from the economic crisis. The same disorders which led, in the world at large, to an attempt to maintain existing property relations by brute force induced film capital, under the threat of crisis, to speed up the development of sound film. Its introduction brought temporary relief, not only because sound film attracted the masses back into the cinema but because it consolidated new capital from the electricity industry with that of film. Thus, considered from the outside, sound film promoted national interests; but seen from the inside, it helped internationalize film production even more than before. [Benjamin's note. By "the economic crisis," Benjamin refers to the devastating consequences, in the United States and Europe, of the stock market crash of October 1929.]

15. This polarity cannot come into its own in the aesthetics of Idealism, which conceives of beauty as something fundamentally undivided (and thus excludes anything polarized). Nonetheless, in Hegel this polarity announces itself as clearly as possible within the limits of Idealism. We quote from his *Vorlesungen zur Philosophie der Geschichte* [Lectures on the Philosophy of History]: "Images were known of old. In those early days, piety required them for worship, but it could do without *beautiful* images. Such images might even be disturbing. In every beautiful image, there is also something external—although, insofar as the image is beautiful, its spirit still speaks to the human being. But religious worship, being no more than a spiritless torpor of the soul, is directed at a *thing*. . . . Fine art arose . . . in the church . . . , though art has now gone beyond the ecclesiastical principle." Likewise, the following passage from the *Vorlesungen über die Ästhetik* [Lectures on Aesthetics] indicates that Hegel sensed a problem here: "We are beyond the stage of venerating works of art as divine and as objects deserving our worship. Today the impression they produce is of a more reflective kind, and the emotions they arouse require a more stringent test." The transition from the first kind of artistic reception to the second defines the history of artistic reception in general. Moreover, a certain oscillation between

these two polar modes of reception can be demonstrated for each work of art. Take the *Sistine Madonna*. Hubert Grimme showed that the *Madonna* was originally painted for exhibition. His research was inspired by the question: What is the purpose of the molding in the foreground of the painting—the molding that the two cupids are leaning on? And, Grimme asked further, what led Raphael to furnish the sky with two draperies? Research proved that the *Madonna* had been commissioned for the public lying-in-state of Pope Sixtus. Popes traditionally lay in state in a certain side-chapel of St. Peter's. On that occasion, Raphael's picture had been hung in a niche-like area toward the back of the chapel, and positioned just above the coffin. In this picture Raphael portrays the cloud-borne Madonna approaching the papal coffin from the rear of the niche, which was framed by green drapes. The funeral service for Pope Sixtus was thus able to take advantage of a primary exhibition value of Raphael's picture. The painting was subsequently moved to the high altar in the Church of the Black Friars at Piacenza. This exile was a result of Roman Catholic doctrine, which stipulates that paintings exhibited at funeral services cannot be used as objects of worship on the high altar. The rule meant that Raphael's picture had declined in value; but in order to obtain a satisfactory price for the work, the Papal See decided to facilitate the sale by tacitly tolerating display of the picture above the high altar. To avoid attracting undue attention, the painting was turned over to the monks in that far-off provincial town. [Benjamin's note. The German Idealist philosopher Georg Wilhelm Friedrich Hegel (1770–1831) accepted the chair in philosophy at Berlin in 1818. His lectures on aesthetics and the philosophy of history (delivered 1820–1829) were later published by his editors, with the text based mainly on notes taken by his students. The Italian painter and architect Raphael Santi (1483–1520) painted the *Sistine Madonna* in 1513; it now hangs in Dresden. See Hubert Grimme, "Das Rätsel der *Sixtinischen Madonna*" (The Riddle of the *Sistine Madonna*), *Zeitschrift für bildende Kunst*, 57 [33 in the new series] (1922), pp. 41–49.—Trans.]

16. Bertolt Brecht, on a different level, engaged in analogous reflections: "If the concept of 'work of art' can no longer be applied to the thing that emerges once the work is transformed into a commodity, we have to eliminate this concept with due caution but without fear, lest we liquidate the function of the very thing as well. For it has to go through this phase unswervingly; there is no viable detour from the straight path. Rather, what happens here with the work of art will change it fundamentally, will erase its past to such an extent that— should the old concept be taken up again (and it will be; why not?)—it will no longer evoke any memory of the thing it once designated." Brecht, *Versuche* (Experiments), 8–10, no. 3 (Berlin, 1931), pp. 301–302 ("Der Dreigroschenprozess" [The Threepenny Trial]). [Benjamin's note. The German poet and playwright Bertolt or Bert (Eugen Berthold Friedrich) Brecht (1898–1956) was the author of *Die Dreigroschenoper* (The Threepenny Opera; 1928), with music by Kurt Weill, *Mutter Courage und ihre Kinder* (Mother Courage and Her Children; 1941), and *Der kaukasische Kreidekreis* (The Caucasian Chalk Circle; 1948). Benjamin became friends with Brecht in 1929 and, during the

Thirties, was considerably influenced by the younger man's thinking on the subject of politics and art.

At this point in the text, Benjamin struck two paragraphs on the distinction between a first and a second technology. See the second version of "The Work of Art in the Age of Its Technological Reproducibility," in Benjamin, *Selected Writings, Volume 3: 1935–1938* (Cambridge, Mass.: Harvard University Press, 2002), pp. 107–108.—*Trans.*]

17. Eugène Atget (1857–1927), recognized today as one of the leading photographers of the twentieth century, spent his career in obscurity making pictures of Paris and its environs. See Benjamin's "Little History of Photography," in Walter Benjamin, *Selected Writings, Volume 2: 1927–1934* (Cambridge, Mass.: Harvard University Press, 1999), pp. 518–519 (trans. Edmund Jephcott and Kingsley Shorter).

18. On the nineteenth-century quarrel between painting and photography, see the "Little History of Photography," in Benjamin, *Selected Writings, Volume 2,* pp. 514–515, 526–527; and Benjamin, *The Arcades Project,* trans. Howard Eiland and Kevin McLaughlin (Cambridge, Mass.: Harvard University Press, 1999), pp. 684–692.

19. Abel Gance, "Le Temps de l'image est venu," in *L'Art cinématographique,* vol. 2, p. 101. [Benjamin's note. On Gance, see note 6 above.—*Trans.*]

20. Séverin-Mars, cited ibid., p. 100. [Benjamin's note. Séverin-Mars (1873–1921) was a playwright and distinguished film actor who starred in three of Gance's films: *La Dixième Symphonie, J'Accuse,* and *La Roue.*—*Trans.*]

21. Alexandre Arnoux, *Cinéma* (Paris, 1929), p. 28. [Benjamin's note. Arnoux (1884–1973) was a novelist, playwright, film critic, and screenwriter. He founded and edited the film journal *Pour Vous* (1928–1929), and wrote the screenplay for *Maldone* (1927), a silent film directed by Jean Grémillon.—*Trans.*]

22. *A Woman of Paris* (Benjamin refers to this film by its French title, *L'Opinion publique*) and *The Gold Rush* were written and directed in 1923 and 1925, respectively, by Charlie Chaplin (Charles Spencer Chaplin; 1889–1977), London-born actor who was on stage from the age of five. He came to the United States with a vaudeville act in 1910, and made his motion picture debut there in 1914, eventually achieving worldwide renown as a comedian. He was the director of such films as *The Kid* (1921), *The Circus* (1928), *City Lights* (1931), *Modern Times* (1936), and *The Great Dictator* (1940). See Benjamin's short pieces "Chaplin" (1929) and "Hitler's Diminished Masculinity" (1934) in Volume 2 of this edition. Giovanni da Fiesole, known as Fra Angelico (real name, Guido di Pietro; 1387–1455) was an Italian Dominican friar, celebrated for his "angelic" virtues, and a painter in the early Renaissance Florentine style. Among his most famous works are his frescoes at Orvieto, which reflect a characteristically serene religious attitude.

23. Franz Werfel, "Ein Sommernachtstraum: Ein Film von Shakespeare und Reinhardt," *Neues Wiener Journal,* cited in *Lu,* November 15, 1935. [Benjamin's note. Werfel (1890–1945) was a Czech-born poet, novelist, and playwright associated with Expressionism. He emigrated to the United States in 1940.

Among his works are *Der Abituriententag* (The Class Reunion; 1928) and *Das Lied von Bernadette* (The Song of Bernadette; 1941). Max Reinhardt (born Maximilian Goldman; 1873–1943) was Germany's most important stage producer and director during the first third of the twentieth century and the single most significant influence on the classic German silent cinema, many of whose directors and actors trained under him at the Deutsches Theater in Berlin. His direct film activity was limited to several early German silents and to the American movie *A Midsummer Night's Dream* (1935), which he codirected with William Dieterle.—*Trans.*]

24. "Film . . . provides—or could provide—useful insight into the details of human actions. . . . Character is never used as a source of motivation; the inner life of the persons represented never supplies the principal cause of the plot and seldom is its main result" (Bertolt Brecht, "Der Dreigroschenprozess," *Versuche*, p. 268). The expansion of the field of the testable which the filming apparatus brings about for the actor corresponds to the extraordinary expansion of the field of the testable brought about for the individual through economic conditions. Thus, vocational aptitude tests become constantly more important. What matters in these tests are segmental performances of the individual. The final cut of a film and the vocational aptitude test are both taken before a panel of experts. The director in the studio occupies a position identical to that of the examiner during aptitude tests. [Benjamin's note. The theme of testing is treated at greater length in the second version of the "Work of Art" essay (section X), in Volume 3 of this edition.—*Trans.*]

25. Luigi Pirandello, *Si Gira*, cited in Léon Pierre-Quint, "Signification du cinéma," *L'Art cinématographique*, vol. 2, pp. 14–15. [Benjamin's note. Pirandello (1867–1936) was an Italian playwright and novelist who achieved a series of successes on the stage that made him world famous in the 1920s. He is best known for his plays *Sei personaggi in cerca d'autore* (Six Characters in Search of an Author; 1921) and *Enrico IV* (Henry IV; 1922).—*Trans.*]

26. Rudolf Arnheim, *Film als Kunst* (Berlin, 1932), pp. 176–177. In this context, certain apparently incidental details of film directing which diverge from practices on the stage take on added interest. For example, the attempt to let the actor perform without makeup, as in Dreyer's *Jeanne d'Arc*. Dreyer spent months seeking the forty actors who constitute the Inquisitors' tribunal. Searching for these actors was like hunting for rare props. Dreyer made every effort to avoid resemblances of age, build, and physiognomy in the actors. (See Maurice Schultz, "Le Maquillage" [Makeup], in *L'Art cinématographique*, vol. 6 [Paris, 1929], pp. 65–66.) If the actor thus becomes a prop, the prop, in its turn, not infrequently functions as actor. At any rate, it is not unusual for films to allocate a role to a prop. Rather than selecting examples at random from the infinite number available, let us take just one especially revealing case. A clock that is running will always be a disturbance on the stage, where it cannot be permitted its role of measuring time. Even in a naturalistic play, real-life time would conflict with theatrical time. In view of this, it is very revealing that film—where appropriate—can readily make use of time as measured by a clock. This feature, more than many others, makes it clear that—circumstances permitting—each and every prop in a film may perform decisive functions. From here it is

but a step to Pudovkin's principle, which states that "to connect the perfor-
mance of an actor with an object, and to build that performance around the ob-
ject, . . . is always one of the most powerful methods of cinematic construction"
(V. I. Pudovkin, *Film Regie und Filmmanuskript* [Film Direction and the Film
Script] (Berlin, 1928), p. 126). Film is thus the first artistic medium which is
able to show how matter plays havoc with human beings [*wie die Materie dem
Menschen mitspielt*]. It follows that films can be an excellent means of material-
ist exposition. [Benjamin's note. See, in English, Rudolf Arnheim, *Film as Art*
(Berkeley: University of California Press, 1957), p. 138. Arnheim (1904–),
German-born Gestalt psychologist and critic, wrote on film, literature, and art
for various Berlin newspapers and magazines from the mid-1920s until 1933.
He came to the United States in 1940 and taught at Sarah Lawrence, the New
School for Social Research, Harvard, and the University of Michigan. Besides
his work on film theory, his publications include *Art and Visual Perception*
(1954), *Picasso's Guernica* (1962), and *Visual Thinking* (1969). *La Passion de
Jeanne d'Arc*, directed by Carl Theodor Dreyer, was released in 1928. Dreyer
(1889–1968), Danish director-writer and film critic, is known for the exacting,
expressive design of his films, his subtle camera movement, and his concentra-
tion on the physiognomy and inner psychology of his characters. Among his
best-known works are *Vampyr* (1931), *Vredens Dag* (Day of Wrath; 1943) and
Ordet (1955). Vsevolod I. Pudovkin (1893–1953), one of the masters of Soviet
silent cinema, wrote and directed films—such as *Mother* (1926), *The End of St.
Petersburg* (1927), and *Storm over Asia* (1928)—that showed the evolution of
individualized yet typical characters in a social environment. He also published
books on film technique and film acting.—*Trans.*]

27. The change noted here in the mode of exhibition—a change brought about by
reproduction technology—is also noticeable in politics. The present crisis of the
bourgeois democracies involves a crisis in the conditions governing the public
presentation of leaders. Democracies exhibit the leader directly, in person, be-
fore elected representatives. The parliament is his public. But innovations in re-
cording equipment now enable the speaker to be heard by an unlimited number
of people while he is speaking, and to be seen by an unlimited number shortly
afterward. This means that priority is given to presenting the politician before
the recording equipment. Parliaments are becoming depopulated at the same
time as theaters. Radio and film are changing not only the function of the pro-
fessional actor but, equally, the function of those who, like the leaders, present
themselves before these media. The direction of this change is the same for the
film actor and for the leader, regardless of their different tasks. It tends toward
the exhibition of controllable, transferable skills under certain social condi-
tions. This results in a new form of selection—selection before an apparatus—
from which the star and the dictator emerge as victors. [Benjamin's note. In his
revision, Benjamin toned down the anticapitalist tenor of this paragraph from
section X. Compare the corresponding passage in section XII of the second ver-
sion of the essay, in Benjamin, *Selected Writings, Volume 3: 1935–1938*, p. 113;
see also pp. 114–115 for a passage Benjamin cut from the end of section XIII of
the second version, corresponding to the end of section X of the third.—*Trans.*]

28. *Three Songs of Lenin*, directed by the Russian filmmaker Dziga Vertov, was re-

leased in 1934. Vertov (born Denis Arkadyevich Kaufman; 1896–1954), one of the most important experimenters in the history of film, expounded his theory of the "kino-eye" (by which photographed fragments of daily life are recomposed within a thematically organized cinematic discourse) in a series of manifestos published in the early 1920s and in such films as *Man with a Movie Camera* (1929) and *Three Songs of Lenin. Borinage* (1933), a film about a bitter miners' strike in Belgium, was directed by the Dutch documentary filmmaker Joris Ivens (born Georg Henri Ivens; 1898–1989), whose work is distinguished by the fluid rhythms of his imagery.

29. The privileged character of the respective techniques is lost. Aldous Huxley writes: "Advances in technology have led . . . to vulgarity. . . . Process reproduction and the rotary press have made possible the indefinite multiplication of writing and pictures. Universal education and relatively high wages have created an enormous public who know how to read and can afford to buy reading and pictorial matter. A great industry has been called into existence in order to supply these commodities. Now, artistic talent is a very rare phenomenon; whence it follows . . . that, at every epoch and in all countries, most art has been bad. But the proportion of trash in the total artistic output is greater now than at any other period. That it must be so is a matter of simple arithmetic. The population of Western Europe has a little more than doubled during the last century. But the amount of reading—and seeing—matter has increased, I should imagine, at least twenty and possibly fifty or even a hundred times. If there were *n* men of talent in a population of *x* millions, there will presumably be 2*n* men of talent among 2*x* millions. The situation may be summed up thus. For every page of print and pictures published a century ago, twenty or perhaps even a hundred pages are published today. But for every man of talent then living, there are now only two men of talent. It may be of course that, thanks to universal education, many potential talents which in the past would have been stillborn are now enabled to realize themselves. Let us assume, then, that there are now three or even four men of talent to every one of earlier times. It still remains true to say that the consumption of reading—and seeing—matter has far outstripped the natural production of gifted writers and draftsmen. It is the same with hearing-matter. Prosperity, the gramophone and the radio have created an audience of hearers who consume an amount of hearing-matter that has increased out of all proportion to the increase of population and the consequent natural increase of talented musicians. It follows from all this that in all the arts the output of trash is both absolutely and relatively greater than it was in the past; and that it must remain greater for just so long as the world continues to consume the present inordinate quantities of reading-matter, seeing-matter, and hearing-matter." (Aldous Huxley, *Beyond the Mexique Bay: A Traveller's Journal* [1934; rpt. London, 1949], pp. 274ff.) This mode of observation is obviously not progressive. [Benjamin's note. Aldous Huxley (1894–1963), English novelist and critic, was the author of *Antic Hay* (1923), *Point Counter Point* (1928), *Brave New World* (1932), *Eyeless in Gaza* (1936), and other works. Benjamin quotes the passage above in a French translation published in 1935.— Trans.]

30. Benjamin alludes here to *Heinrich von Ofterdingen,* an unfinished novel by the

German Romantic writer Novalis (Friedrich, Freiherr von Hardenberg; 1772–1801) first published in 1802. Von Ofterdingen is a medieval poet in search of the mysterious Blue Flower, which bears the face of his unknown beloved. See Benjamin's "Dream Kitsch," in Benjamin, *Selected Writings,* vol. 2, p. 3.

31. The boldness of the cameraman is indeed comparable to that of the surgeon. Luc Durtain lists, among the manual procedures that count as technical feats, those "which are required in surgery in the case of certain difficult operations. I could cite as an example a case from otorhinolaryngology, . . . the so-called endonasal perspective procedure; or I could mention the acrobatic tricks of larynx surgery, which have to be performed with the aid of a reverse-image provided by the laryngoscope. I might also speak of ear surgery, which is analogous to the precision work of watchmakers. What a range of extremely subtle muscular acrobatics is required from the person who wants to repair or save the human body! We have only to think of the couching of a cataract, where there is virtually a duel between steel and nearly fluid tissue, or of major abdominal operations (laparotomy)." Luc Durtain, "La Technique et l'homme," *Vendredi,* 19 (March 13, 1936). [Benjamin's note. Luc Durtain (born André Nepveu; 1881–1959), French writer, was the author of *L'Autre Europe: Moscou et sa foi* (The Other Europe: Moscow and Its Faith; 1927), *La Guerre n'existe pas* (The War Doesn't Exist; 1939), and other works of prose and poetry.—*Trans.*]

32. Pablo Picasso (1881–1973), Spanish-born painter, sculptor, printmaker, ceramicist, and stage designer, was one of the creators of Cubism (see note 43 below) and the best-known and most influential artist of the twentieth century. On Chaplin, see note 22 above.

33. This mode of observation may seem crude [*plump*]; but as the great theoretician Leonardo has shown, crude modes of observation may at times prove useful. Leonardo compares painting and music as follows: "Painting is superior to music because, unlike unfortunate music, it does not have to die as soon as it is born. . . . Music, which is consumed in the very act of its birth, is inferior to painting, which the use of varnish has rendered eternal." Leonardo da Vinci, *Frammenti letterari e filosofici* (Literary and Philosophical Fragments), cited in Fernand Baldensperger, "Le Raffermissement des techniques dans la littérature occidentale de 1840" [The Strengthening of Techniques in Western Literature around 1840], *Revue de Littérature Comparée,* 15–16 (Paris, 1935): 79, note 1. [Benjamin's note. On Leonardo, see note 3 above.—*Trans.*]

34. Surrealism was an influential movement in art, literature, and film which flourished in Europe between World Wars I and II. Rooted most immediately in the ideas of the Dadaists (see note 39 below), it represented a protest against the rationalism that had guided European culture and politics in the past; it sought a reunification of conscious and unconscious realms of experience, such that the world of dream and fantasy would merge with the everyday world in "a surreality." See Benjamin's essays "Dream Kitsch" (1927) and "Surrealism" (1929) in Volume 2 of this edition.

35. The Austrian neurologist and founder of psychoanalysis, Sigmund Freud (1856–1939), published *Zur Psychopathologie des Alltagslebens* in 1901.

36. The sound era in motion pictures effectively began in 1927, the year of *The Jazz singer* (with Al Jolson) and the talkie revolution.

37. Renaissance painting offers a revealing analogy to this situation. The incomparable development of this art and its significance depended not least on the integration of various new sciences, or at least various new scientific data. Renaissance painting made use of anatomy and perspective, of mathematics, meteorology, and chromatology. Valéry writes: "What could be further from us than the amazing ambition of a Leonardo, who, considering painting as a supreme end, a supreme display of knowledge, and deciding that it called for omniscience, did not hesitate to embark on a universal analysis whose depth and precision leave us overwhelmed?" Paul Valéry, "Autour de Corot," in *Pièces sur l'art,* p. 191. [Benjamin's note. See, in English, Valéry, "About Corot," in *Degas, Manet, Morisot,* trans. David Paul (Princeton: Princeton University Press, 1960), p. 152. On Valéry, see note 1 above. On Leonardo, see note 3 above.—*Trans.*]

38. Rudolf Arnheim, *Film als Kunst,* p. 138. [Benjamin's note. In English in Arnheim, *Film as Art,* pp. 116–117. On Arnheim, see note 26 above.—*Trans.*]

39. "The artwork," writes André Breton, "has value only insofar as it is alive to reverberations of the future." And indeed every highly developed art form stands at the intersection of three lines of development. First, technology is working toward a particular form of art. Before film appeared, there were little books of photos that could be made to flit past the viewer under the pressure of the thumb, presenting a boxing match or a tennis match; then there were coin-operated peepboxes in bazaars, with image sequences kept in motion by the turning of a handle. Second, traditional art forms, at certain stages in their development, strain laboriously for effects which later are effortlessly achieved by new art forms. Before film became established, Dadaist performances sought to stir in their audience reactions which Chaplin then elicited more naturally. Third, apparently insignificant social changes often foster a change in reception which benefits only the new art form. Before film had started to create its public, images (which were no longer motionless) were received by an assembled audience in the Kaiserpanorama. Here the audience faced a screen into which stereoscopes were fitted, one for each spectator. In front of these stereoscopes single images automatically appeared, remained briefly in view, and then gave way to others. Edison still had to work with similar means when he presented the first film strip—before the movie screen and projection were known; a small audience gazed into an apparatus in which a sequence of images was shown. Incidentally, the institution of the Kaiserpanorama very clearly manifests a dialectic of development. Shortly before film turned the viewing of images into a collective activity, image viewing by the individual, through the stereoscopes of these soon outmoded establishments, was briefly intensified, as it had been once before in the isolated contemplation of the divine image by the priest in the cella. [Benjamin's note. André Breton (1896–1966), French critic, poet, and editor, was the chief promoter and one of the founders of the Surrealist movement (1918–1939; see note 34 above), publishing his first *Manifeste du surréalisme* in 1924. His novel *Nadja* appeared in 1928. The Dada movement arose in Zurich, in 1916, as an anti-aesthetic engendered by disgust with bourgeois values and despair over World War I; it quickly spread to New York, Berlin, Cologne,

Hannover, and Paris, recruiting many notable artists, writers, and performers whose strove to shock their audiences at public gatherings. Dadaism began to lose steam after 1922, and the energies of the group turned toward Surrealism. On Chaplin, see note 22 above. Thomas Alva Edison (1847–1931) patented more than a thousand inventions over a sixty-year period, including the microphone, the phonograph, the incandescent electric lamp, and the alkaline storage battery. He supervised the invention of the Kinetoscope in 1891; this boxlike peep-show machine allowed individuals to view moving pictures on a film loop running on spools between an electric lamp and a shutter. He built the first film studio, the Black Maria, in 1893, and later founded his own company for the production of projected films. On the Kaiserpanorama, see the section bearing that name in *Berlin Childhood around 1900,* in Volume 3 of this edition.— *Trans.*]

40. The theological archetype of this contemplation is the awareness of being alone with one's God. Such awareness, in the heyday of the bourgeoisie, fostered a readiness to shake off clerical tutelage. During the decline of the bourgeoisie, this same awareness had to take into account the hidden tendency to remove from public affairs those forces which the individual puts to work in his communion with God. [Benjamin's note. Hans Arp (1887–1966), Alsatian painter, sculptor, and poet, was a founder of the Zurich Dada group in 1916 and a collaborator with the Surrealists for a time after 1925. August Stramm (1874–1915) was an early Expressionist poet and dramatist, a member of the circle of artists gathered around the journal *Der Sturm* in Berlin. André Derain (1880–1954), French painter, was a leader of the Postimpressionist school and, later, one of the Fauvists. Rainer Maria Rilke (1875–1926), Austro-German writer born in Prague, was one of the great lyric poets in the German language. His *Duineser Elegien* (Duino Elegies) and *Sonette an Orpheus* (Sonnets to Orpheus) were published in 1923.—*Trans.*]

41. Georges Duhamel, *Scènes de la vie future,* 2nd ed. (Paris, 1930), p. 52. [Benjamin's note. Georges Duhamel (1884–1966), a physician who served as a frontline surgeon during World War I, published novels, poetry, plays, and criticism in which he sought to preserve what he thought was best in civilization and to encourage individual freedom in an age of growing standardization.— *Trans.*]

42. Film is the art form corresponding to the increased threat to life that faces people today. Humanity's need to expose itself to shock effects represents an adaptation to the dangers threatening it. Film corresponds to profound changes in the apparatus of apperception—changes that are experienced on the scale of private existence by each passerby in big-city traffic, and on a historical scale by every present-day citizen. [Benjamin's note. "Attention," in the text, translates *Geistesgegenwart,* which also means "presence of mind." A more literal translation of the phrase in question is: "seeks to be buffered by intensified presence of mind."—*Trans.*]

43. Film proves useful in illuminating Cubism and Futurism, as well as Dadaism. Both appear as deficient attempts on the part of art to take into account the pervasive interpenetration of reality by the apparatus [*Durchdringung der*

Wirklichkeit mit der Apparatur]. Unlike film, these schools did not try to use the apparatus as such for the artistic representation of reality, but aimed at a sort of alloy of represented reality and represented apparatus. In Cubism, a premonition of the structure of this apparatus, which is based on optics, plays a dominant part; in Futurism, it is the premonition of the effects of the apparatus—effects which are brought out by the rapid coursing of the band of film. [Benjamin's note. Cubism, a movement in painting and sculpture that arose in Paris in the years 1907–1914, reduced and fragmented natural forms into abstract, often geometric structures, sometimes showing several sides of an object simultaneously. Futurism was an artistic movement originating in Italy in 1911 (see note 48 below) whose aim was to oppose traditionalism and to express the dynamic and violent quality of contemporary life, especially as embodied in the motion and force of modern machinery and modern warfare.—*Trans.*]

44. Duhamel, *Scènes de la vie future*, p. 58. [Benjamin's note. On Duhamel, see note 41 above.—*Trans.*]

45. On the notion of a "reception in distraction" *(Rezeption in der Zerstreuung),* compare "Theater and Radio" (1932) and "The Author as Producer" (1934), in Benjamin, *Selected Writings,* vol. 2, pp. 583–586 and 768–782, respectively; and "Theory of Distraction" (1936), in Benjamin, *Selected Writings,* vol. 3, pp. 141–142. *Zerstreuung* also means "entertainment."

46. Benjamin relates the legend of the Chinese painter in the earlier version of "The Mummerehlen," a section of *Berlin Childhood around 1900* (included in Volume 3 of this edition).

47. A technological factor is important here, especially with regard to the newsreel, whose significance for propaganda purposes can hardly be overstated. *Mass reproduction is especially favored by the reproduction of the masses.* In great ceremonial processions, giant rallies, and mass sporting events, and in war, all of which are now fed into the camera, the masses come face to face with themselves. This process, whose significance need not be emphasized, is closely bound up with the development of reproduction and recording technologies. In general, mass movements are more clearly apprehended by the camera than by the eye. A bird's-eye view best captures assemblies of hundreds of thousands. And even when this perspective is no less accessible to the human eye than to the camera, the image formed by the eye cannot be enlarged in the same way as a photograph. This is to say that mass movements, including war, are a form of human behavior especially suited to the camera. [Benjamin's note]

48. Cited in *La Stampa Torino.* [Benjamin's note. The German editors of Benjamin's *Gesammelte Schriften* argue that this passage is more likely to have been excerpted from a French newspaper than from the Italian newspaper cited here. Futurism (see note 43 above) was founded by the Italian writer Emilio Filippo Tomaso Marinetti (1876–1944), whose "Manifeste de Futurisme," published in the Paris newspaper *Le Figaro* in 1909, called for a revolutionary art and total freedom of expression. Marinetti's ideas had a powerful influence in Italy and in Russia, though he himself, after serving as an officer in World War I, went on to join the Fascist party in 1919 and to become an enthusiastic supporter of Mussolini. Among his other works are a volume of poems, *Guerra sola igiene del*

mundo (War the Only Hygiene of the World; 1915) and a political essay, *Futurismo e Fascismo* (1924), which argues that Fascism is the natural extension of Futurism—*Trans.*]

49. "Let art flourish—and the world pass away." This is a play on the motto of the sixteenth-century Holy Roman emperor Ferdinand I: "Fiat iustitia et pereat mundus" ("Let justice be done and the world pass away").

Germans of 1789

The voices of the witnesses we are about to hear are stifled in Germany to-day, but they were distinctly audible for nearly a century. A sense of community with the Great Revolution was kept alive among the leading bourgeois groups in Germany by two revolutions, the July Revolution and especially the Revolution of 1848. In 1830, when Börne wrote on arriving in Paris, "I'd have liked to take off my boots—truly, one ought to tread these sacred cobbles only in bare feet," the thought of 1789 was still vibrant within him.[1] And these sentiments were understood for a long time afterward. As late as 1870, Justus Liebig, who had fled to Paris in 1848 to escape persecution as a political agitator, stood firm against the chauvinism of the hour in an address to the Bavarian Academy of Sciences.[2] In Nietzsche's eyes, Paris was undoubtedly the capital of good Europeans.[3] It was only the establishment of the First Empire which destroyed the German bourgeoisie's traditional image of Paris. Feudal Prussia made the city of the Great Revolution and the Commune into a Babylon whose neck it clamped under its jackboot. At that time, in 1871, Blanqui wrote in his book *La Patrie en danger:* "The fame of Paris is its downfall. . . . They want to put out its light, thrust its ideas back into oblivion. . . . Berlin is to be the holy city of the future, the radiance of its nimbus spreading across the world. Paris is the brazen, corrupt Babylon, the great whore that will be . . . swept from the face of the earth by God's exterminating angel. Don't you know that the Lord has anointed the Germanic race as his elect?"[4] The dreadful topicality of these words shows only too well that the testimony of the Germans who witnessed the Great Revolution lives on, with or without jubilees.[5]

Christian Friedrich Daniel Schubart, 1739–1791

Throughout his life, Schubart never emerged from the shadow of Klopstock.[6] His originality is located not so much in any individual work as in the curious alliance between lyric poetry and journalism that is forged in his writing. These were the two modes in which his enthusiasm naturally expressed itself. One can understand how that freak of nature, the singing journalist, could be found only in the early days of the press. The fact that his sober awareness of the living conditions of his class was at odds with his boundless imagination, inflamed with the means of ameliorating those conditions, made Schubart a representative of the Sturm und Drang movement.[7] The ten years of confinement imposed on him by Karl-Eugen of Württemberg, without any legal trial, made this tendency still more manifest.[8] Released in 1787, Schubart resumed his great journalistic work, *Deutsche Chronik,* whose articles he mostly wrote himself. But in 1790 he removed the adjective from the title. Henceforth he called his newspaper, then concerned above all with the French people's struggle for freedom, simply *Chronik.* Schubart's fidelity to his idol Klopstock is also apparent in his enthusiasm for the Declaration of the Rights of Man.[9] It should not be forgotten that at least a fifth of Klopstock's later odes dealt with the French Revolution. Schubart did not live to see its decisive phase, the Terror. There is no reason to suppose that he would have understood it any better than Klopstock, who compared the Jacobin Club[10] to a serpent: "Its head rages in Paris, while its coils twist across the whole of France."

> I and a goodly number of my compatriots used to feel violent indignation toward the French. I railed against their fecklessness, their mania for fashion. But now I salute the genius of the French people, for it is a spirit of liberty and grandeur, and truth follows in its wake. All you empty-headed people of this country, amusing yourselves with French poodles, talking of German freedom, and bowing when your lord and master's greyhound passes, or, like those myriad slaves who are called citizens of the empire, raising your hat to the burgomaster's wig-box! Come here . . . to the school of the French, to learn the true feeling of human dignity, the true spirit of freedom![11]

Johann Gottfried Herder, 1744–1803

Modern nationalism has its source in France.[12] "France represents a secular Protestantism," wrote Novalis.[13] "Is the Revolution to remain French, as the Reformation was Lutheran?" . . . "Blood will be spilled all across Europe," the poet went on, "until the joyously mingled nations . . . return to the forsaken altars." A reactionary critic, Novalis failed to perceive that the nationalism of the French revolutionary army had historical right on its

side. The god of these armies was "the French Mars, protector of the world's freedom." As Marx put it, the French Revolution brought about "the victory of nationhood over provincialism" and "the proclamation of the political order for modern European society." To this proclamation the old European society, with Prussia at its head, opposed its own kind of nationalism, which was to be regarded as reactionary a priori, and which marshaled its forces in the service of counter-revolution. Herder saw this nationalism coming, and realized at first glance how strongly it was inclined to ally itself with terror. And indeed, nationalism has become the principal instrument of terror under the Third Reich. It is a terror aimed directly at the German proletariat, but indirectly at the international proletariat. A similar equivocation was latent in the Reign of Terror. Horkheimer has demonstrated this convincingly in his essay "Egoismus und Freiheitsbewegung," which he calls "a contribution to the anthropology of the bourgeois era":[14] "Masses which had been mobilized under the watchwords of liberty and justice . . . and who yearned to improve their lot . . . were to be incorporated [by Robespierre] into a new society that would be anything but classless."[15] To the extent that their aspirations were disappointed (and Babeuf's movement indicates how radically disappointed they were),[16] spiritual aims were substituted for social objectives. There were some who, having denied these masses immediate satisfaction, were not displeased to see them vaunting their "virtue." The naive belief that "after the bourgeois regime had been consolidated, justice would depend on a return to virtue" cannot be divorced from the institution of terror; it made the practice of virtue doubtful, and helped its enemies misrepresent it. But the fact remains that the fusion of the nationalist idea [l'idée nationale] with the rule of virtue, despite all the illusory factors it contains, marks Robespierre as the true leader of the bourgeoisie's heroic age. The fusion of the nationalist idea with racial madness is the hallmark of the "leader" in the age of bourgeois decadence. Nothing was more foreign to French nationalism than the "mystique" of blood which Herder pilloried as the most sinister form of insanity. His words, so prophetic in 1794, are today a perfect inventory of the lessons of National Socialism.

It is known, alas, that almost nothing in the world is more contagious than aberration and folly. Truth must be sought with great effort, through an investigation into causes; error is acquired through imitation (often unawares), through complaisance, or simply through frequenting a deluded person and sharing his other, sound opinions in good faith. Error is as contagious as a yawn; it is communicated the same way the moods of the soul pass into the facial features, or the way one string responds harmoniously to the vibration of another. If we add the zeal with which the deluded person entrusts his most cherished opinions to us—and he knows very well how to go about this—who among us could avoid innocently falling into error ourselves, to oblige a

friend? Which of us would not quickly adopt those opinions and convey our faith to others with precisely the same zeal? It is good faith that governs human intercourse. Through it, we have learned most—if not all—things; certainly, the most useful. And, as they say, being wrong doesn't make you a fraud. Folly loves company precisely because it is folly; it takes comfort there, since on its own it would lack subject matter and confidence. In the end, for folly the worst company is also the best. Nationalist insanity is a terrible thing. Once an idea has taken root in a nation, is respected and held in high esteem, how could it not be truth? Who would even dare to doubt it? Language, law, education, the course of daily life—everything confirms it. Whoever does not share in the folly of others is an idiot, an enemy, a heretic, an alien. And if—as is usually the case—this folly is a boon to certain prominent people, or even is thought to benefit all classes; if it has been sung by poets, demonstrated by philosophers; if fame has trumpeted it as the glory of the nation—who would want to contradict it? Who would not prefer, out of courtesy, to share in this folly? Even the vague doubts of an opposing folly serve only to reinforce an established one. The disparate natures of peoples, sects, classes, and individuals jostle against one another, and each clings all the more tenaciously to its own point of view. Folly becomes a national emblem, a coat-of-arms, a guild banner. It is frightening to see how strongly folly becomes attached to words, once it has been forcefully imprinted on them. A judicial scholar has noted how many harmful and illusory images are evoked by the words *Blut* [blood], *Blutschande* [incest], *Blutsfreunde* [blood brothers], *Blutgericht* [criminal court]. It is often the same with words such as "heritage," "property," and "possessions." When taken over by political parties, watchwords previously associated with no concept, signs which meant nothing at all, have plunged minds into madness, sundered friendships and families, assassinated men, devastated countries. History is full of such demonic words—it could yield an entire glossary of human error and folly, an inventory of the most abrupt deviations and blatant contradictions.[17]

Johann Georg Forster, 1754–1794

When the French occupied Mainz in 1792, Georg Forster was the librarian at the electoral court there.[18] He was in his thirties. Behind him lay a rich life; as a youth he had been a member of his father's retinue on the voyage around the world led by Captain Cook, in 1772–1775; but as a young man—making a living on translations and odd jobs—he had also felt the harshness of the struggle for existence. In long years of travel Forster had become as well acquainted with the poverty of the German intellectual of his time as had men like Bürger, Hölderlin, or Lenz.[19] His penury, however, was not that of a private tutor at a minor court; its theater was Europe, so that he was almost the only German predestined to understand in depth the European response to the conditions which caused this poverty. In 1793 he went as a delegate of the city of Mainz to Paris, where, after the Germans

had recaptured Mainz and banned him from returning, he remained until his death in January 1794.[20]

In those days, hardly anyone other than Forster knew what revolutionary freedom is, or how much renunciation it demands, and no one formulated it the way he did: "I no longer have a homeland, a fatherland, or friends; all those who were close to me have left me to form other attachments, and if I think of the past and still feel myself bound, that is merely my choice and my idea, not something imposed by circumstance. Happy turns of fate can give me much; unhappy ones can take nothing from me, except the satisfaction of writing these letters, should I be unable to afford the postage." The following letter is addressed by Forster to his wife.

Paris; July 26, 1793

Mainz has indeed fallen into the hands of the enemy. I am certainly not insensitive to the humiliation which the victors' jubilation will no doubt evoke in many people. But I am heartbroken when I think of the fate of the unfortunate inhabitants. Their heroism, their suffering, the calamity which has befallen them—none of these will have any effect on men who are unable to appreciate such effort and who seek only to slake their passions. How many poor martyrs of freedom will now have to shed their blood or—even worse—lead lives devoid of hope. This is the moment when one needs courage and patience if one is not to despair of everything good, or believe that one's principles are chimeras. As far as my own affairs are concerned, I now expect the worst. I strongly doubt whether I shall ever see my personal papers again, which is as much as to say that the rest of my life will amount to nothing from a literary point of view. I must admit that if all my papers were burned or destroyed in some way, I would be glad. Now it seems likely that people will have a good laugh at my works, and will be able to poke fun at many things intended only for my eyes. I have the strength to endure everything, yet I feel this loss to the full, in its most harrowing depth. I do not understand it, since it goes beyond all my conceptions of justice, which at least ought not to destroy what is useful in a man, though hardships in the name of justice may strengthen and perfect the soul. In fact, it even shows that the life of a scholar may not be exactly a vocation bestowed by providence, and that we also need to be men. Who, at any rate, could claim that the humanity of each of us takes on its individual color— which distinguishes us from the multitude and makes us what we should be in the place we occupy—solely from our studies and occupations? . . . Nevertheless, do not be anxious on my behalf; all is not yet lost, and if all is lost, then I have nothing more to lose. If anyone wants something further, it should be asked of those who still have something to lose, and not of me. What *do* people want? And whom do they want it from? As for me, it may be that in the end I will keep within myself more than all I have lost—but I will be able to give from it only what people wish to take. And good people like you probably have no idea what it means to be a man in my situation—a man who has been so utterly frustrated in his very capacity for action and who has to take up an entirely different way of living, confined to perpetual resistance to the power of

the fate which assails him. I am no less besieged than Mainz; I have attempted sorties no less resolute; and, if I may pursue the comparison further, I believe that I too shall defend myself to the bitter end.

Johann Gottfried Seume, 1763–1810

In the forum of German literary history, incorruptible vision and revolutionary consciousness have always needed an excuse: youth or genius. Minds which could claim neither of these—manly and, in the strict sense, prosaic minds like those of Forster and Seume[21]—have never attained more than a shadowy existence in the antechamber of educated opinion. That Seume was not a great poet is beyond doubt. But this is not what distinguishes him from many others who have been given prominent places in the history of German literature. What sets him apart is his blameless response to every crisis and the unswerving way in which—having been abducted into the military by Hessian recruiters—he at all times conducted himself with civic valor, even long after he had laid aside his officer's uniform. For Seume, moreover, the honor of the officer was not so far removed from that of the generous brigand, as revered by his contemporaries in Rinaldo Rinaldini.[22] Thus, on his walk to Syracuse he was able to admit: "My friend, if I were a Neapolitan, I should be tempted, from outraged honesty, to become a bandit—and I would start with the government minister." Seume wandered throughout Europe as a judicious observer. The Baltic countries were particularly conducive to a study of the decay of feudalism. It is said that as Seume entered the living quarters of some Latvian peasants, his attention was caught by a large whip hanging on the wall. He asked what it meant, and recorded the reply he received. "That," he was told, "is the law of our land." The letter which follows shows how deeply Seume was moved by the liberation of the French peasants, which had considerable influence on the Baltic states. Seume contributed a poem to Merkel's book *Die Letten* [The Latvians], which supported the serfs and which came out in 1797.[23] In the letter to Karl Böttiger reproduced below, the poet declines the offer to collaborate on a patriotic almanac.[24]

> Leipzig; early November 1805
>
> Through our friend Carus, I have received an astonishing invitation from you, which does honor to your heart and shows your confidence in mine. But I regret that I cannot accept it, since my soul utterly lacks what you seek. It seems to me that the public spirit you would like to see and plan to awaken is impossible, at least as a national aim. In our old, half-barbaric, half-political institutions, there is so little of what I understand by "justice" and "liberty" that a man, or at least a man such as I am, cannot feel any enthusiasm for an objective foreign to his soul. The French are beating us partly through the rights which the revolution has brought into being. Their spirit is triumphing over

ours because, although their lives may be controlled by the arbitrary personal power of an usurper, their state nevertheless contains more justice and reason than ours and, as a consequence, more spirit of action. Whether this will be maintained for long is another question. In France, all contributions are calculated in proportion to wealth, according to the rule of three. What all bear equally, all bear with strength. I am not exactly an opponent of the monarchy, but until my dying day I will oppose injustice, oppression, privilege, fettered justice, and all the excesses of unreason which afflict us. It may be true that things could be worse; but only an imbecile or a rank egotist could fail to see that they are bad enough as they are. Now the peasant is expected to fight. For whom? Is he fighting for himself? Won't this make the victor bear down on him still more harshly? A grenadier is obliged to hurl himself against the bayonets while his sister or his fiancée in the country are forced to serve their gracious squire for eight florins a year; while his mother and his aged aunt, who seldom have sufficient bread or salt, have to wear out their almost-blind eyes spinning the quota of thread that the court forces them to produce; while his little brother has to run the streets several times a week for one sou, carrying messages for Their Lordships? We are heading toward war. Heavens above! The nobles who are exempted from taxes will never give anything. As long as the mansion can roll along on the peasants, its wheels will never start turning. That people are still kind and honest under such circumstances, that they accede to their contributions and fight in the army, shows on the one hand how much divinity there is in our nature, and on the other how thick-headed we are. A German has to fight so that, if he is not killed on the spot, his master will find him wonderfully docile and fit for forced labor. Likewise, he clings from century to century to the stupid honor of being the sole bearer of the state. There can be no courage where there is no justice.

And I am expected to sing? Have you ever heard of anything coming out of me that was not really in me? A man can have enthusiasm, lasting enthusiasm, only for freedom and justice—all the rest amounts to no more than fitful ephemera and base passions. Fate has driven me here and there. But have you ever heard that, as a Hessian or a Russian, I have composed a war-song? As a citizen of my German homeland, I am willing to fight, if I have to, for as long as I can stand upright. I regard this as my absolute duty; I will perform it without reservations. But to sing? . . . To be sure, Bonaparte is misusing the most divine things for his dark designs, but we are doing more: we are zealously mounting guard on every side to ensure that nothing divine can grow. To the best of my ability, I watch the struggle calmly. . . . Where the peasant is regarded and treated as virtually a slave and the petty bourgeois as a beast of burden, I have nothing to say and nothing to sing. . . . Your other request—that I allow my name to be used—would be natural if it were a question of poems. But shouldn't we also avoid such allusions? They would make everything so pretty, so obliging, refined, anodyne; all the privileged people would praise the allusion, and I would be truly so happy to receive a pension of 150 talers for it someday! . . . You'd prefer it if I said no more, isn't that right? And indeed I will stop here, since I dislike wasting my energy on foolishness. . . .

Pardon my blunt language; the matter cannot be smoothed over. With thanks and friendly greetings.[25]

Caroline Michaelis, 1763–1809

Caroline Michaelis was the daughter of a Göttingen orientalist.[26] Her first marriage had little importance for her; the second, to A. W. Schlegel, was rather unhappy; in the third, to Schelling, she found happiness.[27] Motivated by her friendship with the Forsters, Caroline traveled to Mainz in 1792. The enthusiasm she felt for the revolution—this woman who was to hold a brilliant position among the Romantics, and who was highly regarded not only by her husband but by her brother-in-law Friedrich Schlegel—is evident in her letters from Mainz, and also in her brief liaison with an officer of the revolutionary army. Her wish to legitimize the child born from this affair was Caroline's primary reason for marrying Schlegel. The letter which follows was written to a colleague of her father's at the University of Göttingen. Mayer must have given Caroline the impression that he took no pleasure in corresponding with a woman who belonged to the Jacobin Club (though it is not certain that she was a member). However that may be, she wrote to him on December 17: "I suspected you felt nothing but aversion for us. But who gives you, a pilgrim in this vale of tears, the right to heap scorn on anyone? You yourself are free under every sky and happy under none. How dare you mock when the poor peasant who toils three days out of four for his master and, at nightfall, wipes the sweat from his brow with resentment—when this peasant, I say, feels that he could and should be happier?" It must be said that such passages, such flashes of light, are very rare in the letters of the German Romantics. How they viewed things, and how unreceptive the Romantic circles associated with her husbands must have been to young Caroline's views, can be imagined if we read a letter written by Hülsen, a friend of the Schlegels, to one of the brothers ten years later. This letter criticizes the Romantics' research into the age of chivalry: "May heaven preserve us from seeing the old castles rebuilt! . . . Rather than having those past times called back, I wish that the mob we call the people would hit each of us scholars and knights over the head, since our greatness and advantages are founded solely on their wretchedness." "The ignorant man is the bread eaten by the scholar," Victor Hugo was to say magnificently fifty years later. Hülsen's letter is an echo of the language of Schubart, Hölderlin, and Forster.[28] The Romantics did not understand that language.

Mainz; October 27, 1792

If perchance you believe that one can write here in complete security, you are mistaken. . . . Perhaps a letter to Mainz is regarded as high treason in Berlin. I'm impatient to know how your righteous anger has turned into equanimity. As easily, I hope, as we have passed into the hands of the enemy, . . . —if, that is, we can call our courteous and valiant hosts the enemy. What a change in only a week! . . . General Custine[29] is lodging in the castle of the electors of Mainz, where the German Jacobin Club meets in the parade hall. . . . The na-

tional cockade is seen everywhere in the streets. Voices which used to curse liberty cry out, "Live freely or die!" If only I had the patience to write, and you to read, I'd have a lot to tell you. We have more than 10,000 men in the city, yet peace and order reign. All the aristocrats have fled; the citizens are treated with extreme gentleness. This is for political reasons. But if these men were merely wretched beggars, as we have been led to believe; if there were not strict discipline; if they were not animated and taught generosity by the proud spirit of their cause, it would have been impossible to avoid all excesses and confrontations in this way. These people look very unkempt because they have waged a long campaign, but they are by no means poor. The men and horses are well fed, in contrast to the state of our army. . . . Goethe, who is not in the habit of exaggerating, wrote to his mother: "No tongue, no pen, can describe the sad condition of the army." .. And a Prussian officer speaks of "the impressive situation of their armies and the deplorable state of ours." . . . No doubt, the lower orders want to shake off their yoke . . . , while the bourgeois isn't happy unless he can feel it on his neck. It is impossible to overstate how far he still has to go to attain the level of education and dignity of the least sans-culotte[30] down there in the camp! Trade is slowing down at the moment, and that is all he sees. . . . He misses fine society. . . . Heaven knows how many there are who, after going bankrupt, failed to pay their artisans. . . . Custine is consolidating his position, and swears that he will never relinquish the keys of Germany unless a peace treaty forces him to. Hardly four months have passed since the Congress of Europe met to decide the loss of France, . . . and now you can read on the theater posters here: "Approved by Citizen Custine."[31]

Friedrich Hölderlin, 1770–1843

How deeply the fate of Schubart distressed his contemporaries can be seen from a few lines addressed by Hölderlin to his friend Neuffer in 1792:[32] "There is a horrible rumor here about Schubart in his grave. You must know something. Please write to me about it." There was indeed a rumor that Schubart had been buried alive. When he wrote these lines, Hölderlin was about to begin the life of a private tutor which, with a few periods of respite, would be his lot until his health gave out. For young, educated middle-class Germans, this mode of life was the training ground for political will and revolutionary experience. A harsh school! Hölderlin entered it in 1793, on the estate of Frau von Kalb; he left it, and the household of a Bordeaux merchant, in 1801.[33] From Bordeaux, suffering from incurable madness, he returned to his homeland, Württemberg. In one of the few letters he wrote from France, he poignantly formulated the rule of conduct that enabled him to endure this kind of life: "To be afraid of nothing, and to accept many affronts." For Hölderlin, the road to Bordeaux was the road into exile. Before setting off, he wrote to a friend: "My heart is heavy now with my departure. I had not wept for a long time. But it cost me bitter tears to decide to leave my homeland now, perhaps forever. What do I have in the

world that is dearer to me? But they have no need of me. All the same, I shall and must remain a German, even if want and famine drive me as far as Tahiti." Like an echo in the mountains, reverberating from valley to valley, this lament of Hölderlin's resounds through the century. "You still have to learn what a German is capable of when he is hungry" (Büchner).[34] "German governments, I must add, . . . act in such a way that all outstanding Germans come to expect recognition of their achievements—and the reward and even the protection due them—only from foreign governments" (Jochmann).[35] "Truly, these Germans would let us die of hunger" (Gregorovius).[36] One must recall the conditions prevailing in Germany at that time to understand the passion with which these young sons of the bourgeoisie seized the opportunity to give meaning to their privations by becoming the infantrymen of their class. It is from this that the ideal of Jacobin sobriety, and the asceticism of the sans-culotte, derived their persuasive power. "Luxury and splendor," wrote Forster, "no longer bring honor to a man; they dishonor him." And after living in the house of a Frankfurt banker,[37] Hölderlin sums up his impressions as follows: "The more horses a man harnesses before him, the more numerous the rooms in which he shuts himself up, and the greater the number of servants surrounding him, the more deeply he has dug the grave he lies in, suffering a living death; the people around him no longer hear him, and he no longer hears them, despite all the din that he and those others make." The three passages which follow are taken from letters to his sister, his mother, and his friend Neuffer.

Tübingen; June 19, 1792

So it will soon be decided. Believe me, my dear sister, that we shall live through some painful days if the Austrians are victorious. The princes will abuse their power terribly. Believe me, and pray for the French, the champions of human rights.

Tübingen; late November 1792

It is a fine and moving thing that the French army before Mainz contains whole ranks of young men of fifteen and sixteen—I know this for certain. If someone expresses surprise at their youth, they say: "To kill us, the enemy needs the same bullets and the same swords as for grown-up soldiers. We perform our drills as smartly as anyone, and we give our brothers marching in the main army behind us the right to kill the first of us who flinches from combat."

Waltershausen; early April 1794

Your fight will no doubt earn you the gratitude of the German nation, with its short-lived memory! And it will certainly win you friends. It seems to me, too, that in the past few years, in spite of everything, our people have acquired the habit of taking an interest in ideas and aims lying beyond the horizon of immediate utility. Once the cries of war die down, truth and art will assume an unprecedented range of action. . . . But even if we poor devils are forgotten, even if we shall never fully live in people's memories, . . . what does it matter, pro-

vided the sacred foundations of right, and of a purer knowledge, are fully alive in those same memories! What does it matter, provided the human being is thus improved![38]

Georg Wilhelm Friedrich Hegel, 1770–1831

Hegel, Schelling, and Hölderlin were in the same year at the seminary in Tübingen. A tradition at the seminary maintains, no doubt correctly, that they were members of a secret political society founded within the seminary. According to this tradition, members of the society gave speeches against Duke Karl-Eugen and sang freedom songs, including the "Marseillaise." It is said that one day they planted a tree of liberty and celebrated it with dances; whereupon the duke appeared at the seminary in person to deal severely with the offenders. As late as 1795, Hegel wrote from Switzerland to Schelling: "I believe there is no better sign of the times than to see humanity as such represented in so respectable a way [as in Kant and Fichte]; it is proof that the halo is vanishing from the heads of the oppressors and gods of the earth. The philosophers demonstrate this dignity; the peoples will learn to feel it. And instead of asking for the rights which are now trampled underfoot, . . . they will appropriate them." As we know, this revolutionary tendency is not manifest in the content of Hegel's philosophy. But it is all the more deeply anchored in his method. Marx understood this. It can even be said that he discovered the revolutionary tendency in Hegel's method and that (to use Karl Korsch's apt formulation) he made the Hegelian antithesis into the struggle of social classes, the Hegelian negation into the proletariat, and the Hegelian synthesis into the classless society.[39]

> At that moment, the idea of right suddenly came into force, causing the old fabric of injustice to crumble. A constitution founded on law was drawn up. Henceforth, everything was to be based on this foundation. Since the sun first appeared in the firmament, since the planets first circled around it, such a thing had never been seen: the human species relying on its head, its thought, and using it to interpret reality. . . . That was indeed a magnificent sunrise. All thinking people joined in celebrating this event. A sublime emotion had taken hold in men. A shiver of enthusiasm ran around the world, as if through this alone the true reconciliation of the divine and the temporal had been achieved.[40]

Carl Gustav Jochmann, 1789–1830

The men who formed the vanguard of the bourgeoisie in Germany have been more or less consigned to oblivion. But none of them has vanished from public awareness as completely as Jochmann, and for a special reason. Even within the vanguard, he was utterly isolated. Younger than his comrades-in-arms, Jochmann experienced Romanticism at its zenith. "The Ro-

mantics," writes Valéry, "rebelled against the eighteenth century, thought-lessly leveling a charge of superficiality against men who were infinitely better informed, more curious about facts and ideas, more tireless in pursuit of anticipations and large-scale ideas than they had ever been themselves."[41] With Jochmann, the philosophical century launched a counter-attack. He speaks of the "toilsome idleness . . . that we call scholarship," referring to the composition of works such as Tieck's *Kaiser Octavianus,* Brentano's *Romanzen vom Rosenkranz,* and perhaps even Novalis' *Hymnen an die Nacht.*[42] It can be stated with certainty that Jochmann was a hundred years ahead of his time, and almost as certainly that his contemporaries regarded him as lagging fifty years behind them. Indeed, his attitude, unlike that of most adversaries of the Romantic movement, was in no way determined by a narrow classical rigor. Jochmann's critique had been shaped by Vico's conception of human history; and in his ability to use dialectics to break the fetters of received ideas, he showed a kinship to Hegel. The fixed reference points of his political reflections were the American War of Independence and the French Revolution—Jochmann was a Balt. While still quite young, he was able to live an independent life in London, and at thirty he saw his homeland for the last time. From then until the end of his life, he spent his time in France, southwest Germany, and Switzerland. In Paris he befriended Oelsner, the chargé d'affaires from Frankfurt-am-Main, who in turn was in close touch with Sieyès.[43] That the members of his circle entrusted their memoirs of the Revolution and the National Convention to Jochmann throws even more light on his political stance, since the early years of the Restoration were hardly conducive to such communications. In the passage that follows, Jochmann is concerned with the development of the French language under the Revolution.

This language—foreign to lofty concerns and the serious deliberations of pub-lic life, formed under the tutelage of women of wit, in small gatherings and for the limited needs of fops—had all the merits and gifts of the man of good breeding, without ever attaining the verbal authority of the orator or the statesman. It had no access to deep feelings, and offered no welcome to the wisdom sprung fully armed from the head of Zeus. The most profound specu-lations and the most sincere raptures were banished from it, as from good soci-ety. It provided not armor for thought but a peaceful robe of state, which al-ways makes a clear, sensible, fitting impression. Its literature, in accord with its qualities and faults, was like the local chronicle of Europe. And like a local chronicle, it furnished entertainment for busy idlers but touched scarcely or not at all on the infinitely larger mass of those involved in the struggle for exis-tence. Rousseau, the only French writer to have had an influence not only through his thought but through a literary form whose ascendancy none of his contemporaries could escape, Rousseau, the child of solitude rather than of so-ciety, was a citizen of Geneva. He thus formed part of that small republic

whose citizens, having acquired a more virile temper in the school of political and religious struggles, had nothing in common with the French except their language. In our time, French writers have marshaled their forces with renewed vigor; among them, historians are aware of higher tasks than the panegyric, statesmen of higher goals than the ardor inspired by questions of precedence. And more significant thoughts have bolder expression at their disposal. . . . Such changes occur in this way, issuing clearly from the heightened significance acquired by language in its most immediate sphere of activity, as the spoken word. The spoken language of Mirabeau, more vigorous than his pen, broke the chains of writers in breaking its own. Barnave and Vergniaud planted the laurels gathered by Constant and Chateaubriand. Lanjuinais wrote as he spoke. On the rostrum, at the lectern, or in the solitude of his room, Say defended the cause of reason, inseparable from all justice and truth, with equal success. . . . From 1789, the National Assemblies were academies in which this new school of French literature was shaped; the orator's platform provided the press with its form and its content. The writer's gift, a reflection of freedom of speech, will live as long as that freedom lives, and will die when it dies.[44]

Written in French; published in *Europe: Revue mensuelle,* July 1939. *Gesammelte Schriften,* IV, 863–880. Translated by Edmund Jephcott.

Notes

1. Ludwig Börne (born Löb Baruch; 1786–1837), a writer and social critic, lived in exile in Paris after 1830. A member of the Young Germany movement, he was one of the first writers to use the feuilleton section of the newspaper as a forum for social and political criticism.
2. Baron Justus von Liebig (1803–1873) was a chemist who made important contributions to biochemistry and is considered the founder of agricultural chemistry. He established at Giessen the first practical chemical teaching laboratory, where he introduced methods of organic analysis. See his letter to August von Platen, with Benjamin's comments, in *German Men and Women,* in Benjamin, *Selected Writings, Volume 3: 1935–1938* (Cambridge, Mass.: Harvard University Press, 2002), pp. 196–197.
3. The German philosopher Friedrich Nietzsche (1844–1900) developed his idea of "the good European"—largely to counter the ever more rabid nationalism and "racial self-admiration" he saw in the Europe of his day—in a number of his highly influential works, such as *Menschliches—Allzu Menschliches* (Human, All Too Human; 1878–1880 [section 475]) and *Die Fröhliche Wissenschaft* (The Gay Science; 1882 [sections 357 and 377]}. Homeless in an "honorable" sense, mixed in race and culturally manifold, heirs to millennia of European thought, the good Europeans were called upon to work actively for "the amalgamation of nations."
4. Louis-Auguste Blanqui (1805–1881) was a radical activist and writer committed to permanent revolution. After a classical lyceum education in Paris, he studied

law and medicine but devoted himself to conspiracy in the Carbonari and other secret societies, becoming a leading socialist agitator. He was often wounded in street fighting and spent a total of forty years in prison, yet maintained a fiery patriotism. He was the author of *L'Eternité par les astres* (1872) and *Critique social* (1885).

5. Benjamin is writing on the 150th anniversary of the French Revolution.

6. Christian Friedrich Daniel Schubart (1739–1791), German journalist, poet, and musician, is best known as the publisher of *Deutsche Chronik* (1774–1777), an anti-Catholic newspaper, in Ulm in southern Germany. In 1777 he was lured to Blaubeuren (Württemberg territory) and imprisoned without trial for ten years in the fortress of Hohenasperg. The probable reason for this savage treatment was Schubart's satirical references to the duke of Württemberg and his mistress, Franziska von Hohenheim, in his paper. Friedrich Gottlieb Klopstock (1724–1803) was the most important lyric poet of the eighteenth century before Goethe. With his remarkable linguistic gifts and prosodic creativity, he virtually reinvented German poetry, pointing the way to a more natural and expressive use of language.

7. Sturm und Drang (Storm and Stress) is the name commonly given to a revolutionary literary movement that flourished in Germany from the late 1760s to the early 1780s. With its revaluation of the primitive, its cult of original genius, and its conception of nature as a demonic force not entirely accessible to reason, it hastened the flowering of German Romanticism in the 1790s.

8. Karl Eugen, Herzog von Württemberg (1728–94), assumed his title in 1737 and took over active government in 1744. He gave himself up to extravagance and dissipation, undertaking a building program intended to rival Versailles, and indulging in sexual promiscuity which made him notorious. Ministers retained his favor as long as they raised the vast sums he needed. A long conflict with the Estates (representative assembly) of Württemberg ended with a compromise in 1775, and Karl Eugen emerged in a new role as an enlightened despot. Under the influence of his mistress, Franziska von Hohenheim, he founded a military academy (Karlsschule), which became one of his principal interests. Among its alumni was the poet Friedrich von Schiller. In 1777 Karl Eugen again became notorious, this time for his vindictive arrest and imprisonment of the poet and musician C. F. D. Schubart.

9. The seventeen articles of the Declaration of the Rights of Man and of the Citizen, containing the principles that inspired the French Revolution, were adopted by France's National Assembly in August 1789. The declaration provided for all citizens' equality of rights before the law.

10. The Jacobins constituted the most famous political group of the French Revolution. Members of the group led the revolutionary government from mid-1793 to mid-1794 and were instrumental in establishing the Reign of Terror during this period, when thousands of people were executed for counterrevolutionary activity. Organized in 1789, the Jacobin Club boasted some 500,000 members throughout France by 1793. It was officially banned after the fall of Robespierre, architect of the Terror, in the summer of 1794 (see note 15 below).

11. "Français" (1789), extract from *Chronik*. [Benjamin's note]

12. Johann Gottfried von Herder (1744–1803) was a critic, theologian, and philos-

opher. His innovations in the philosophy of history and culture lent the initial impulse to the young writers gathered around him in Strasbourg, who went on to form the core of the Sturm und Drang movement.

13. Novalis (pseudonym of Friedrich Leopold, Freiherr von Hardenberg; 1772–1801), a major poet and theorist of the early German Romantic period, was the author of *Blütenstaub* (Pollen; 1798), *Hymnen an die Nacht* (Hymns to the Night; 1800), and *Heinrich von Ofterdingen* (1802). Benjamin quotes from Novalis' essay "Die Christenheit oder Europa" (Christendom or Europe; 1799).

14. "Egoismus und Freiheitsbewegung" (Egoism and Freedom Movements), *Zeitschrift für Sozialforschung* (Paris: Alcan, 1936), vol. 2. [Benjamin's note. Max Horkheimer (1895–1973), German philosopher and sociologist, was the director (1930–1958) of the Institute of Social Research in Frankfurt, Geneva, and New York. Coauthor (with Theodor W. Adorno) of *Dialektik der Aufklärung* (Dialectic of Enlightenment; 1947), he went on to develop a critique of scientific positivism.—*Trans.*]

15. Maximilien de Robespierre (1758–1794), radical Jacobin leader, was one of the principal figures in the French Revolution. In the latter months of 1793 he came to dominate the Committee of Public Safety, the principal organ of the revolutionary government during the Reign of Terror, but in 1794 he was overthrown and executed in the Thermidorian Reaction.

16. François Babeuf (1760–1797) was an agitator and journalist during the French Revolution, advocating equal distribution of land and income. Author of a manifesto on social equality (1796), he organized a conspiracy to overthrow the Directory and return to the constitution of 1793. He committed suicide before being summoned to the guillotine.

17. *Briefe zu Beförderung der Humanität* (Letters for the Advancement of Humanity), vol. 4 (Riga, 1794), p. 89. [Benjamin's note]

18. Johann Georg Forster (1754–1794), German traveler and writer, published in 1777 an account of his voyage around the world with Captain Cook. His father, Johann Reinhold Forster (1729–1798), was also a travel writer. See Benjamin's comments on Georg Forster in "German Letters," in Benjamin, *Selected Writings, Volume 2: 1927–1934* (Cambridge, Mass.: Harvard University Press, 1999), p. 467.

19. Gottfried August Bürger (1747–1794) was one of the first German poets to translate the contemporary interest in European folk song into new forms, especially the ballad; his best-known work is "Leonore" (1773). Friedrich Hölderlin (1770–1843) was the greatest German poet of the nineteenth century. His major works include the novel *Hyperion* (1797–1799). He created a body of seminal poems in a number of forms, such as odes, elegies, and hymns, and composed an important drama fragment, *The Death of Empedokles.* Suffering from mental illness, he spent the final thirty-six years of his life in the care of a master carpenter in Tübingen. J. M. R. Lenz (1751–1792), Russian-born German dramatist and poet, was, after Goethe, the most important of the writers of the Sturm und Drang movement. His plays from his years in Strasbourg include a didactic comedy, *Der Hofmeister* (The Tutor; published 1774, performed 1778), and the bourgeois tragedy *Die Soldaten* (The Soldiers; performed 1773, published 1776). He ended his life as a vagabond, and finally in insanity.

20. Mainz, in southwestern Germany, was occupied by the French revolutionary army in October 1792. Georg Forster had championed the republican government in Mainz, and in 1793 he went to Paris to negotiate on its behalf. While he was there, Mainz was successfully besieged by the Prussians and Austrians; they are "the enemy" he refers to at the beginning of his letter. Forster spent his final days in Paris, reviled among Germans as a traitor and disillusioned by the excesses of the Reign of Terror.

21. Johann Gottfried Seume (1763–1810) was the author of poems, plays, travel accounts, aphorisms, and an autobiography. His best-known work is *Spaziergang nach Syrakus im Jahre 1802* (A Journey on Foot to Syracuse in 1802; 1803). See his letter to an unnamed gentleman, part of *German Men and Women,* in Volume 3 of this edition.

22. Rinaldo Rinaldini is the main character in Christian August Vulpius' fantastic novel *Rinaldo Rinaldini* (1797–1800). He belongs to the "noble robber" type.

23. Garlieb Merkel (1769–1850), a journalist and cultural historian of Baltic origin, edited the newspaper *Der Zuschauer* (The Observer), which for decades informed the German-speaking middle-class public in Riga, Latvia, of developments in science, literature, and the arts, effectively initiating the tradition of the feuilleton. His book *Die Letten, vorzüglich in Liefland, am Ende des philosophischen Jahrhunderts* (The Latvians, Especially in Livonia, at the End of the Philosophical Century) was a sympathetic portrait of the Latvian people and their folklore. It helped make his reputation as a founding father of the Latvian nation.

24. Karl August Böttiger (1760–1835), was headmaster of the Weimar *Gymnasium* from 1791–1804. He contributed to the periodicals *Die Horen* and *Die Propyläen* and in 1797 became the editor of *Der neue teutsche Merkur.*

25. Oskar Planer and Camillo Reissmann, *Johann Gottfried Seume* (Leipzig, 1898), pp. 530–533. [Benjamin's note]

26. Caroline Schlegel, née Michaelis, was a writer who married A. W. Schlegel in 1796, but left him in 1803 for the philosopher Friedrich Wilhelm Schelling (see note 27 below).

27. August Wilhelm von Schlegel (1767–1845), German scholar and critic, was one of the most influential disseminators of the ideas of the German Romantic movement, and the finest German translator of William Shakespeare. He was also an Orientalist, a poet, and the coeditor, with his brother Friedrich, of the Romantic journal the *Athenäum.* Friedrich Wilhelm Joseph von Schelling (1775–1854), German philosopher and educator, was a major figure of German Idealism in the post-Kantian development of German philosophy. He was ennobled (with the addition of *von*) in 1806.

28. August Ludwig Hülsen (1765–1810), German philosopher and educator, was a member of the Romantic circle around Fichte and the Schlegels in Jena after 1795.

29. Comte Adam Philippe de Custine (1740–1793) was a French army officer who, as commander of one of the revolutionary armies, captured Mainz in October 1792. Soon afterward, he was charged with conspiring with the enemy to bring about a counterrevolution, and was guillotined in Paris.

30. An extreme radical republican during the French Revolution. *Sans-culotte* (lit-

erally, "without breeches") was a term of contempt applied by the aristocrats to the republicans of the poorly clad French revolutionary army, who substituted pantaloons for knee breeches.

31. Caroline Michaelis Schelling, *Caroline: Briefe aus der Frühromantik* (Letters from Early German Romanticism), ed. Erich Schmidt (Leipzig, 1913), p. 274. [Benjamin's note]

32. Christian Ludwig Neuffer (1769–1839), German poet and translator, was educated at the Tübingen seminary, where he became a friend of Hölderlin. A fragmentary ode by Hölderlin ("An Neuffer") is addressed to him.

33. Charlotte von Kalb (1761–1843), German writer and aristocrat, befriended and aided a series of writers, including Schiller, Hölderlin, and Jean Paul.

34. Georg Büchner (1813–1837) produced, during his brief life, a body of dramatic work that played a major role in shaping the modern European stage. His best-known works are *Dantons Tod* (Danton's Death; written and published 1835; performed 1903) and *Woyzeck* (written after 1835; published 1879; performed 1913).

35. Carl Gustav Jochmann (1789–1830), a German writer of Baltic origin, lived in England, France, Switzerland, and Germany. He is known today mainly as the author of *Über die Sprache* (On Language; 1828), though he also produced a wide range of essays, political, sociological, literary, and theological. See "'The Regression of Poetry,' by Carl Gustav Jochmann," below in this volume, as well as the final section of the present essay.

36. Ferdinand Adolf Gregorovius (1821–1891), German historian, was the author of works on medieval Rome and Athens and on Lucrezia Borgia.

37. Reference is to J. F. Gontard, a wealthy Frankfurt banker in whose house Hölderlin worked as tutor from January 1796 to September 1798. During this time, he fell in love with the banker's wife, Susette Gontard, who returned his affection, and who appears in his poems and in his novel *Hyperion* under the name "Diotima," an embodiment of the spirit of ancient Greece. He left Frankfurt after a painful scene with the banker, and later, on the verge of mental breakdown, learned of Susette Gontard's death in June 1802.

38. Hölderlin, *Sämtliche Werke,* vol. 1 (Munich and Leipzig, 1913), pp. 258, 264, 295. [Benjamin's note]

39. Karl Korsch (1886–1961), German legal and Marxist theorist, was an outspoken opponent of Stalinist Russia, and settled in the United States after the Nazis rose to power. His interpretations of Marx had a deep influence on Benjamin.

40. Hegel, *Vorlesungen zur Philosophie der Geschichte* (Lectures on the Philosophy of History), in Werke, vol. 9 (Berlin, 1837), p. 441. [Benjamin's note]

41. Paul Valéry, introduction to Baudelaire, *Les Fleurs du mal* (Paris, 1928), pp. xviii ff. Valéry (1871–1945), French man of letters, is best known for essayistic fictions such as *La Soirée avec Monsieur Teste* (An Evening with Monsieur Teste; 1896) and major poems of the Symbolist and post-Symbolist periods.

42. Johann Ludwig Tieck (1773–1853), German writer and critic, produced a huge corpus of fanciful work in many genres. His works include *Franz Sternbalds Wanderungen* (The Wanderings of Franz Sternbald; 1798), one of the first German Romantic novels; fairy tales and folktales, notably *Der blonde Eckbert* (Fair Eckbert; 1796) and *Volksmärchen* (Popular Legends and Fairy Tales;

1797); and the verse drama *Kaiser Octavianus* (Emperor Octavianus; 1804), an allegory of the rise of Christianity that exemplifies the Romantic glorification of the Middle Ages. Clemens Brentano (1778–1842) was a German poet of the Romantic school. He collaborated with Achim von Arnim on *Des Knaben Wunderhorn* (The Boy's Magic Horn; 1806–1808), a folk-song collection that influenced many writers and composers, notably the Brothers Grimm and Mahler. Brentano wrote plays, lyric poems, fairy tales, and novellas, as well as leaving unfinished an epic poem of love and redemption, *Romanzen vom Rosenkranz* (A Romantic Garland of Roses), which he worked on from 1803 to 1812 and which was published posthumously in 1852. On Novalis, see note 13 above.

43. Konrad Engelbert Oelsner (1764–1828) was a German journalist and writer. Emmanuel-Joseph Sieyès (1748–1836) was a cleric and constitutional theorist whose concept of popular sovereignty guided the French bourgeoisie in their struggle against the monarchy and nobility during the opening months of the French Revolution. He later played a major role in organizing the coup d'état that brought Napoleon Bonaparte to power (1799).

44. Carl Gustav Jochmann, "Wodurch bildet sich eine Sprache?" (By What Means Is a Language Formed?), in Jochmann, *Über die Sprache* (Heidelberg, 1828), p. 191. [Benjamin's note. See note 35 above.—*Trans.*]

What Is the Epic Theater? (II)

I. The Relaxed Audience

"There is nothing more pleasant than to lie on a sofa and read a novel," wrote a nineteenth-century narrator, indicating the extent to which a work of fiction can provide relaxation for the reader who is enjoying it. The image of a man attending a theatrical performance is the opposite: one pictures a man who follows the action with every fiber of his being at rapt attention. The concept of the epic theater, originated by Brecht as the theoretician of his poetic practice, emphasizes that this theater seeks an audience which is relaxed and which follows the action without strain. This audience, to be sure, always appears as a collective, and this differentiates it from the reader, who is alone with the text. Also, this audience, being a collective, will usually feel impelled to take a stand promptly. But this stance, according to Brecht, ought to be a well-considered and therefore relaxed one—in short, the stance of people who have an interest in the matter. Two objects are provided for this interest. The first is the action: it has to be of a sort that the audience can validate [*kontrollieren*] at crucial points on the basis of its own experience. The second is the performance: it should be mounted artistically in a transparent manner. (This manner of presentation is anything but artless; in fact, it presupposes artistic sophistication and acumen on the part of the director.) The epic theater appeals to an interest group which "does not think without cause." Brecht never loses sight of the masses, whose limited engagement with thinking is probably alluded to in this phrase. In the endeavor to interest his audience in the theater by an appeal to their expertise, but definitely not by way of mere cultural involvement, a political will has prevailed.

II. The Plot

The epic theater aims to "deprive the stage of the sensation it derives from subject matter." Thus, an old story will often do more for it than a new one. Brecht asks whether it mightn't be better if the incidents presented by the epic theater were already familiar. The theater would have the same relationship to the plot as a ballet teacher has to a student: the teacher's first task would be to loosen the dancer's joints to the greatest possible extent. This is how the Chinese theater actually proceeds. In his essay "The Fourth Wall of China,"[1] Brecht describes what he owes to Chinese theater. If the theater is to cast about for familiar events, "historical incidents would be the most suitable." Their epic extension through a particular style of acting, through placards, and through onstage captions is intended to rid them of the character of sensation.

In this vein, Brecht takes up the life of Galileo as the subject of his latest play.[2] Brecht presents Galileo primarily as a great teacher who not only teaches a new physics, but does so in a new way. In his hands, experiments are not only a scientific achievement but a pedagogical tool. The main emphasis of this play is not on Galileo's recantation; rather, the truly epic method is evident in the headnote to the penultimate scene: "1633 to 1642. As a prisoner of the Inquisition, Galileo continues his scientific work until his death. He succeeds in smuggling his main works out of Italy."

The epic theater has a relation to the passage of time which is entirely different from that of the tragic theater. Because its suspense is a function less of the dénouement than of particular scenes, the epic theater can cover enormous spans of time. (The same is true of the medieval mystery plays. The dramaturgy of *Oedipus* or *The Wild Duck* is the polar opposite of the epic method.)[3]

III. The Untragic Hero

The French classical theater reserved a space close to the players for persons of rank, who sat in armchairs on the open stage. To us, this seems inappropriate. According to familiar notions of "the dramatic," a nonparticipating third party—a dispassionate observer or "thinker"—should not be associated with the action onstage. Yet Brecht often had something like this in mind. One can go still further and say that Brecht undertook to make the thinker, or even the wise man, the hero of the drama. It is from this perspective that one can define his theater as epic theater. The undertaking is at its most advanced in the character of Galy Gay, the packer. Galy Gay, the protagonist of the play *A Man's a Man*,[4] is nothing but a bodying forth of the contradictions which make up our society. One might go so far as to see the "wise man," in the Brechtian sense, as the perfect bodying forth of its dialectics. In any case, Galy Gay is a wise man. Plato long ago recognized the

undramatic quality of that most excellent man, the sage. In his dialogues, he took this figure to the threshold of the drama; in his *Phaedo,* to the threshold of the Passion play. The medieval Christ, who also represented the wise man (we find this in the church fathers), is the untragic hero par excellence.[5] But in Western secular drama, too, the search for the untragic hero has been unceasing. In ways that are ever new, and frequently in conflict with its theoreticians, this drama has differed from the authentic—that is, ancient Greek—form of tragedy. This important but poorly marked road, which may here serve as the image of a tradition, wound its way through the Middle Ages in the works of Roswitha and the mystery plays, and through the Baroque period in the works of Gryphius and Calderón; later it can be traced in Lenz and Grabbe, and finally in Strindberg.[6] Scenes in Shakespeare are its roadside monuments, and Goethe crosses it in the second part of *Faust.* It is a European road, but a German one as well—if indeed we can say that the legacy of medieval and Baroque drama has reached us by a road, and not by some obscure smugglers' path. It is this mule track, neglected and overgrown, which in our day comes to light in the dramas of Brecht.

IV. The Interruption

Brecht distinguishes his epic theater from dramatic theater in the narrower sense, whose theory was formulated by Aristotle. Appropriately, Brecht introduces his art of the drama as non-Aristotelian, just as Riemann introduced a non-Euclidian geometry.[7] This analogy helps to show that what is at issue is not competition between the theatrical forms in question. Riemann eliminated the parallel postulate; Brecht's drama eliminates the Aristotelian catharsis, the purging of the emotions through empathy with the stirring fate of the hero.

What is unique about the relaxed interest which the epic theater tries to evoke in its audience is that hardly any appeal is made to the viewer's empathy. The art of the epic theater consists in producing not empathy but astonishment. In a word: instead of identifying with the protagonist, the audience should learn to feel astonished at the circumstances under which he functions.

The task of the epic theater, according to Brecht, is less the development of the action than the representation of situations. "Representation" [*Darstellung*] here does not mean "reproduction" as the theoreticians of Naturalism understood it.[8] Rather, the truly important thing is to discover the situations for the first time. (One might equally well say "defamiliarize" them.)[9] This discovery (or defamiliarization) of situations is fostered through interruption of the action. The most basic example would be a family scene that is suddenly interrupted by the entrance of a stranger. The

mother is just about to seize a bronze bust and hurl it at her daughter; the father is in the act of opening a window in order to call a policeman. At this moment, the stranger appears in the doorway. "Tableau" is what it would have been called around 1900. In other words, the stranger is confronted with the situation: troubled faces, an open window, the furniture in disarray. But there is a gaze before which even more ordinary scenes of middle-class life look almost equally startling.

V. The Quotable Gesture [*Gestus*]

In one of his didactic poems on dramatic art, Brecht says: "The effect of every sentence was anticipated and laid bare. And the anticipation was prolonged until the audience had carefully weighed the sentences." In short, the play was interrupted. We can extend this thought in recalling that interruption is one of the fundamental devices of all structuring. It goes far beyond the sphere of art. To give only one example, it is the basis of quotation. Quoting a text entails interrupting its context. It is therefore understandable that the epic theater, being based on interruption, is, in a specific sense, a quotable form of drama. There is nothing special about the quotability of its texts. The difference lies in the gestures which are built into the play.

"Making gestures quotable" is one of the signal achievements of the epic theater. An actor must be able to space his gestures the way a typesetter spaces type. This effect may be achieved, for instance, when an actor quotes his own gesture on the stage. Thus, in *Happy End* we saw Carola Neher,[10] playing a sergeant in the Salvation Army, sing a proselytizing song in a sailors' tavern—where it was more appropriate than it would have been in a church—and later quote this song and act out the gestures before a council of the Salvation Army. Similarly, in *The Measure Taken*[11] the party tribunal not only receives the report of the comrades but also sees some of the gestures of the accused comrade acted out. A device that is extremely subtle in the epic theater becomes a forthright aim in the specific case of the didactic play. Epic theater is by definition a gestic theater. For the more frequently we interrupt someone engaged in acting, the more gestures result.

VI. The Didactic Play

The epic theater is always meant for the actors as much as for the spectators. The didactic play is a special case largely because it facilitates and suggests the interchange between audience and actors, and vice versa, through an extreme economy of theatrical devices. Every spectator can become a participant. And it is easier to play the "teacher" than the "hero."

In the first version of *Lindbergh's Flight*, which appeared in a periodical, the flier was still presented as a hero. That version strove to glorify him. The

second version—and this is revealing—was written after Brecht revised his ideas.[12] What enthusiasm there was on both continents in the days following that flight! But the enthusiasm petered out as a mere sensation. *The Flight of the Lindberghs* is an exercise in refraction in which Brecht uses the spectrum of the "singular experience" [*Erlebnis*] as a source for the hues of "experience" [*Erfahrung*]—the experience that could be obtained only from Lindbergh's effort, not from the public's excitement, and that was to be transmitted to his work on "the Lindberghs."

T. E. Lawrence, the author of *The Seven Pillars of Wisdom,* wrote to Robert Graves when he joined the air force that such a step was for modern man what entering a monastery was for medieval man. In this remark we perceive the same tension that appears in *The Flight of the Lindberghs* and Brecht's later didactic plays. A clerical sternness is applied to instruction in modern techniques—here, those of aviation; later, those of class struggle. The latter application can be seen most clearly in *Mother.*[13] It was particularly daring of Brecht to divorce social drama from the empathetic response that audiences were used to. He knew this, and said so in an epistolary poem that he sent to a workingmen's theater in New York when *Mother* was produced there. "We have been asked: Will a worker understand this? Will he be able to do without his accustomed intoxicant: his mental participation in someone else's uprising, the rise of others—the illusion that whips him up for a few hours and leaves him all the more exhausted, filled with vague memories and even vaguer hopes?"

VII. The Actor

Like the images in a film, the epic theater moves in spurts. Its basic form is that of the shock with which the individual, well-defined situations of a play collide. The songs, the captions, the gestic conventions set off one situation from another. This creates intervals which, if anything, undermine the illusion of the audience and paralyze its readiness for empathy. These intervals are provided so that the audience can respond critically to the player's actions and the way they are presented. Regarding the manner of presentation, the actor's task in the epic theater is to demonstrate through his acting that he is cool and relaxed. He has virtually no use for empathy either. The "player" in conventional dramatic theater is not always fully prepared for this kind of acting. Perhaps the most open-minded approach to epic theater is to think of it in terms of "putting on a show."

Brecht wrote: "The actor must show his subject, and he must show himself. Of course, he shows his subject by showing himself, and he shows himself by showing his subject. Although the two tasks coincide, they must not coincide in such a way that the difference between them disappears." In other words, an actor should reserve to himself the possibility of stepping

out of character artistically. At the proper moment, he should insist on portraying an individual who reflects on his part. It would be wrong to think at such a moment of Romantic irony, as employed by Tieck in his *Puss in Boots*.[14] Romantic irony has no didactic aim. Basically, it demonstrates only the philosophical sophistication of the author who, in writing his plays, always keeps in mind that the world may ultimately prove to be a theater.

The extent to which artistic and political interests coincide in the epic theater is evident in the style of acting appropriate to this genre. A case in point is Brecht's cycle *The Private Life of the Master Race*.[15] Obviously, if a German actor in exile were assigned the part of an SS man or a member of the *Volksgericht*,[16] his feelings about it would be quite different from those of a devoted father and husband asked to portray Molière's Don Juan.[17] For the former, empathy can hardly be seen as an appropriate method, since he presumably cannot identify with the murderers of his comrades-in-arms. A different mode of performance—one based on distancing—would in such cases be more fitting, and perhaps more successful. This is the epic mode.

VIII. Theater on a Dais

The aims of the epic theater can be defined more easily in terms of the stage than in terms of a new form of drama. Epic theater takes account of a circumstance that has been generally overlooked. It might be called the filling in of the orchestra pit. This abyss, which separates the players from the audience as though separating the dead from the living; this abyss, whose silence in a play heightens the sublimity, whose resonance in an opera heightens the intoxication; this abyss, which of all the theater's elements is the one that bears the most indelible traces of its origin in ritual, has steadily decreased in significance. The stage is still raised, but it no longer rises from unfathomable depths. It has become a dais. The didactic play and the epic theater are attempts to take a seat on this dais.

Published in *Mass und Wert*, July–August 1939. *Gesammelte Schriften*, II, 532–539. Translated by Harry Zohn.

Notes

1. *Life and Letters Today*, 15, no. 6 (1936). [Benjamin's note]
2. Brecht completed the first version of *Leben des Galilei* (Life of Galileo) in 1938.
3. Mystery plays were medieval dramatic representations of biblical events, especially in the life of Jesus. Originating in church liturgy, they were later presented by craft guilds on improvised platforms or wagons in public places. *Oedipus Rex* (ca. 430 B.C.), by Sophocles, and *The Wild Duck* (1884), by Henrik Ibsen, both exemplify the classical ideal of unity of action.

4. Brecht's *Mann ist Mann* was first performed in 1926 and in a revised form, with music by Kurt Weill, in 1931 (with Peter Lorre in the role of Galy Gay). The first version was published in 1927, the second in 1938.

5. Plato's dialogue *Phaedo* gives an account of the last hours of Socrates. A Passion play is a dramatic performance, of medieval origin, that represents the events associated with the Passion of Jesus. The church fathers were authoritative writers in the early Christian church who formulated doctrines and codified religious observances.

6. Roswitha was a tenth-century German Benedictine nun, poet, and chronicler, the author of the chronicles of Otto I (in verse) and of six comedies in Latin. Andreas Gryphius (1616–1664) was the preeminent German dramatist of the seventeenth century. Pedro Calderón de la Barca (1600–1681), Spanish dramatist, was the last important figure of the Spanish Golden Age. He is best known today for his philosophical dramas, such as *El mágico prodigioso* (The Wonderful Magician) and *La vida es sueño* (Life Is a Dream), which deal with the themes of fate, prognostication, and free will. J. M. R. Lenz (1751–1792) was a German dramatist, poet, and critic. He is best known for his plays *Der Hofmeister* (The Tutor; 1774) and *Die Soldaten* (The Soldiers; 1776), and for critical works, notably *Anmerkungen übers Theater* (Remarks on the Theater; 1774). He is a principal representative of the Sturm und Drang movement. Christian Dietrich Grabbe (1801–1836), German dramatist and journalist, is best known for his comedies, such as *Scherz, Satire, Ironie und tiefere Bedeutung* (Comedy, Satire, Irony, and Deeper Meaning; 1822) and *Don Juan und Faust* (1829). August Strindberg (1849–1912) wrote novels and plays, including *Miss Julie* (1888) and *The Dance of Death* (1901), which are noted for their psychological realism and which marked the beginning of modern Swedish literature.

7. Georg Friedrich Bernhard Riemann (1826–1866), German mathematician, made significant contributions to the theory of the functions of complex variables. He laid the foundations for a non-Euclidean system of geometry (Riemannian geometry), thus creating the basic tools for the mathematical expression of the general theory of relativity.

8. Naturalism was a late nineteenth- and early twentieth-century movement in literature and graphic art that extended the tradition of Realism, aiming at an even more faithful representation of ordinary reality, a "slice of life" presented without moral judgment. Naturalist works often depicted working class milieus. Its leading exponent was the French novelist Emile Zola, whose treatise *Le Roman expérimental* (The Experimental Novel; 1880) became the literary manifesto of the movement.

9. Benjamin refers to the well-known "alienation effect" of Brechtian dramaturgy. See Brecht's essay of 1936 "Verfremdungseffekte in der chinesischen Schauspielkunst," translated by John Willett as "Alienation Effects in Chinese Acting," in *Brecht on Theatre* (New York: Hill and Wang, 1964), pp. 91–99. According to Brecht, the "A-effect" depends on the actor's performing "in such a way that nearly every sentence could be followed by a verdict of the audience and practically every gesture is submitted for the public's approval" (95).

10. Carola Neher (1905–1942) was a German actress who starred in several Brecht

plays, including *The Threepenny Opera,* in which she played the part of Polly Peachum. She left Germany in 1934 to live in Moscow, where her employment opportunities were limited. In 1937 she was condemned by a Stalinist court to ten years in a labor camp, where she died of typhus. *Happy End* (Brecht's original title), with music by Kurt Weill, was performed and published in 1929.

11. *Die Massnahme,* a *Lehrstück* (didactic play) with music by Hanns Eisler, was first performed in 1930 and published in 1931.

12. The first version of Brecht's work on Charles Lindbergh, *Der Lindberghflug,* with music by Kurt Weill and Paul Hindemith, was performed at the Baden-Baden music festival in 1929, subsequently broadcast on German radio, and published as "Lindbergh: Ein Radio-Hörspiel für die Festwoche in Baden-Baden," in *Uhu,* 5, no. 7 (April 1929): 10–16. This version celebrated the charismatic figure of the American flier who had made the first nonstop solo flight over the Atlantic in 1927. In a second version, entitled *Der Flug der Lindberghs: Radiolehrstück für Knaben und Mädchen* (The Flight of the Lindberghs: A Didactic Radio Play for Boys and Girls; broadcast and published 1930), Brecht sought to shift the emphasis from the individual figure to the work process involved in the event. During the next two decades, Brecht became angry at Lindbergh's isolationist stance and his fascination with Nazi social and technological engineering, and after the war he produced a third version of the text (1950) in which he restored his original working title, *Der Ozeanflug* (The Flight across the Ocean), and removed all mention of Lindbergh's name.

13. *Die Mutter,* a didactic play *(Lehrstück)* with music by Hanns Eisler, was adapted from Maxim Gorky's novel *Mother* (1907). It was first performed in 1932 and published in 1933.

14. Ludwig Tieck (1773–1853), German Romantic novelist and dramatist, was a leader of the Romantic movement. He is best known for the novel *Franz Sternbalds Wanderungen* (The Wanderings of Franz Sternbald; 1798), one of the first German Romantic novels, and for his fairy tales and folk tales, notably *Der blonde Eckbert* (Fair Eckbert; 1796) and *Volksmärchen* (Popular Legends and Fairy Tales; 1797). Tieck published the play *Der gestiefelte Kater* (Puss in Boots) in 1797.

15. *Furcht und Elend des dritten Reich,* a series of short scenes linked by poems, with music by Hanns Eisler, was performed in 1937 and partially published in Moscow in 1941, with a fuller version published 1945 in New York and a revised version published 1948 in Berlin. The first version was translated as *The Private Life of the Master Race* (1944), the revised version as *Fear and Misery of the Third Reich* (1970).

16. The SS (*Schutzstaffel,* literally "defense echelon") was an elite quasi-military unit of the Nazi party that served as Hitler's personal guard and as a special security force in Germany and the occupied countries. The *Volksgerichtshof* (People's Court) to which Benjamin refers was established in Germany in April 1934 to deal with enemies of the state. It dispensed with trial by jury and the right of appeal.

17. Reference is to Molière's play *Dom Juan* (Don Juan; 1665).

Materialist Theology, 1940

Walter Benjamin's library card, Bibliothèque Nationale, Paris, 1940. Courtesy of the Bibliothèque Nationale de France, copyright © BnF.

On Some Motifs in Baudelaire

Baudelaire envisaged readers to whom the reading of lyric poetry would present difficulties. The introductory poem of *Les Fleurs du mal* is addressed to these readers. Willpower and the ability to concentrate are not their strong points. What they prefer is sensual pleasure; they are familiar with the "spleen" which kills interest and receptiveness. It is strange to come across a lyric poet who addresses himself to such readers—the least rewarding type of audience. There is of course a ready explanation for this. Baudelaire wanted to be understood; he dedicates his book to those who are like him. The poem addressed to the reader ends with the salutation: "Hypocrite lecteur,—mon semblable,—mon frère!"[1] It might be more fruitful to put it another way and say: Baudelaire wrote a book which from the very beginning had little prospect of becoming an immediate popular success. The kind of reader he envisaged is described in the introductory poem, and this turned out to have been a far-sighted judgment. He would eventually find the reader his work was intended for. This situation—the fact, in other words, that the conditions for the reception of lyric poetry have become increasingly unfavorable—is borne out by three particular factors, among others. First of all, the lyric poet has ceased to represent the poet per se. He is no longer a "minstrel," as Lamartine still was; he has become the representative of a genre.[2] (Verlaine is a concrete example of this specialization; Rimbaud must already be regarded as an esoteric figure, a poet who, ex officio, kept a distance between his public and his work.)[3] Second, there has been no success on a mass scale in lyric poetry since Baudelaire. (The

lyric poetry of Victor Hugo was still capable of evoking powerful reverberations when it first appeared. In Germany, Heine's *Buch der Lieder* marks a watershed.)[4] The third factor follows from this—namely, the greater coolness of the public, even toward the lyric poetry that has been handed down as part of its own cultural heritage. The period in question dates back roughly to the mid-nineteenth century. Throughout this span, the fame of *Les Fleurs du mal* has steadily increased. This book, which the author expected would be read by the least indulgent of readers and which was at first read by only a few indulgent ones, has, over the decades, acquired the stature of a classic and become one of the most widely printed ones as well.

If conditions for a positive reception of lyric poetry have become less favorable, it is reasonable to assume that only in rare instances does lyric poetry accord with the experience of its readers. This may be due to a change in the structure of their experience. Even though one may approve of this development, one may find it difficult to specify the nature of the change. Turning to philosophy for an answer, one encounters a strange situation. Since the end of the nineteenth century, philosophy has made a series of attempts to grasp "true" experience, as opposed to the kind that manifests itself in the standardized, denatured life of the civilized masses. These efforts are usually classified under the rubric of "vitalism." Their point of departure, understandably enough, has not been the individual's life in society. Instead they have invoked poetry, or preferably nature—most recently, the age of myths. Dilthey's book *Das Erlebnis und die Dichtung* represents one of the earliest of these efforts, which culminate with Klages and Jung, who made common cause with fascism.[5] Towering above this literature is Bergson's early monumental work, *Matière et mémoire.*[6] To a greater extent than the other writings in this field, it preserves links with empirical research. It is oriented toward biology. As the title suggests, it regards the structure of memory [*Gedächtnis*] as decisive for the philosophical structure of experience [*Erfahrung*].[7] Experience is indeed a matter of tradition, in collective existence as well as private life. It is the product less of facts firmly anchored in memory [*Erinnerung*] than of accumulated and frequently unconscious data that flow together in memory [*Gedächtnis*]. Of course, the historical determination of memory is not at all Bergson's intention. On the contrary, he rejects any historical determination of memory. He thus manages to stay clear of that experience from which his own philosophy evolved, or, rather, in reaction to which it arose. It was the alienating, blinding experience of the age of large-scale industrialism. In shutting out this experience, the eye perceives a complementary experience—in the form of its spontaneous afterimage, as it were. Bergson's philosophy represents an attempt to specify this afterimage and fix it as a permanent record. His philosophy thus indirectly furnishes a clue to the experience which presented itself undistorted to Baudelaire's eyes, in the figure of his reader.

II

The reader of *Matière et mémoire,* with its particular definition of the nature of experience in *durée,*[8] is bound to conclude that only a poet can be the adequate subject of such an experience. And it was indeed a poet who put Bergson's theory of experience to the test. Proust's work *A la Recherche du temps perdu* may be regarded as an attempt to produce experience, as Bergson imagines it, in a synthetic way under today's social conditions, for there is less and less hope that it will come into being in a natural way. Proust, incidentally, does not evade the question in his work. He even introduces a new factor, one that involves an immanent critique of Bergson. Bergson emphasized the antagonism between the *vita activa* and the specific *vita contemplativa* which arises from memory. But he leads us to believe that turning to the contemplative realization of the stream of life is a matter of free choice. From the start, Proust indicates his divergent view in his choice of terms. In his work the *mémoire pure* of Bergson's theory becomes a *mémoire involontaire.* Proust immediately confronts this involuntary memory with a voluntary memory, one that is in the service of the intellect. The first pages of his great novel are devoted to making this relationship clear. In the reflection which introduces the term, Proust tells us that for many years he had a very indistinct memory of the town of Combray, where he had spent part of his childhood. One afternoon, the taste of a kind of pastry called a *madeleine* (which he later mentions often) transported him back to the past, whereas before then he had been limited to the promptings of a memory which obeyed the call of conscious attention. This he calls *mémoire volontaire.* Its signal characteristic is that the information it gives about the past retains no trace of that past. "It is the same with our own past. In vain we try to conjure it up again; the efforts of our intellect are futile." In sum, Proust says that the past is situated "somewhere beyond the reach of the intellect and its field of operations, in some material object . . . , though we have no idea which one it is. And whether we come upon this object before we die, or whether we never encounter it, depends entirely on chance."[9]

According to Proust, it is a matter of chance whether an individual forms an image of himself, whether he can take hold of his experience. But there is nothing inevitable about the dependence on chance in this matter. A person's inner concerns are not by nature of an inescapably private character. They attain this character only after the likelihood decreases that one's external concerns will be assimilated to one's experience. Newspapers constitute one of many indications of such a decrease. If it were the intention of the press to have the reader assimilate the information it supplies as part of his own experience, it would not achieve its purpose. But its intention is just the opposite, and it is achieved: to isolate events from the realm in which

they could affect the experience of the reader. The principles of journalistic information (newness, brevity, clarity, and, above all, lack of connection between the individual news items) contribute as much to this as the layout of the pages and the style of writing. (Karl Kraus never tired of demonstrating the extent to which the linguistic habitus of newspapers paralyzes the imagination of their readers.)[10] Another reason for the isolation of information from experience is that the former does not enter "tradition." Newspapers appear in large editions. Few readers can boast of having any information that another reader may need from them.—Historically, the various modes of communication have competed with one another. The replacement of the older relation by information, and of information by sensation, reflects the increasing atrophy of experience. In turn, there is a contrast between all these forms and the story, which is one of the oldest forms of communication. A story does not aim to convey an event per se, which is the purpose of information; rather, it embeds the event in the life of the storyteller in order to pass it on as experience to those listening. It thus bears the trace of the storyteller, much the way an earthen vessel bears the trace of the potter's hand.

Proust's eight-volume novel gives some idea of the effort it took to restore the figure of the storyteller to the current generation. Proust undertook this task with magnificent consistency. From the outset, this involved him in a fundamental problem: reporting on his own childhood. In saying that it was a matter of chance whether the problem could be solved at all, he took the measure of its difficulty. In connection with these reflections, he coined the phrase *mémoire involontaire*. This concept bears the traces of the situation that engendered it; it is part of the inventory of the individual who is isolated in various ways. Where there is experience [*Erfahrung*] in the strict sense of the word, certain contents of the individual past combine in the memory [*Gedächtnis*] with material from the collective past.[11] Rituals, with their ceremonies and their festivals (probably nowhere recalled in Proust's work), kept producing the amalgamation of these two elements of memory over and over again. They triggered recollection[12] at certain times and remained available to memory throughout people's lives. In this way, voluntary and involuntary recollection cease to be mutually exclusive.

III

In seeking a more substantial definition of what appears in Proust's *mémoire de l'intelligence* as a by-product of Bergson's theory, we would do well to go back to Freud. In 1921 Freud published his essay *Beyond the Pleasure Principle*, which hypothesizes a correlation between memory (in the sense of *mémoire involontaire*) and consciousness.[13] The following re-

marks, though based on that essay, are not intended to confirm it; we shall have to content ourselves with testing the fruitfulness of Freud's hypothesis in situations far removed from the ones he had in mind when he wrote. Such situations are more likely to have been familiar to Freud's pupils. Some of Reik's writings on his own theory of memory are in line with Proust's distinction between involuntary and voluntary recollection.[14] "The function of memory [*Gedächtnis*]," Reik writes, "is to protect our impressions; reminiscence [*Erinnerung*] aims at their dissolution. Memory is essentially conservative; reminiscence, destructive."[15] Freud's fundamental thought, on which these remarks are based, is the assumption that "emerging consciousness takes the place of a memory trace."[16] Therefore, "it would be the special characteristic of consciousness that, unlike what happens in all other systems of the psyche, the excitatory process does not leave behind a permanent change in its elements, but expires, as it were, in the phenomenon of becoming conscious." The basic formula of this hypothesis is that "becoming conscious and leaving behind a memory trace are incompatible processes within one and the same system." Rather, vestiges of memory are "often most powerful and most enduring when the incident which left them behind was one that never entered consciousness." Put in Proustian terms, this means that only what has not been experienced explicitly and consciously, what has not happened to the subject as an isolated experience [*Erlebnis*], can become a component of *mémoire involontaire*. According to Freud, the attribution of "permanent traces as the basis of memory" to processes of stimulation is reserved for "other systems," which must be thought of as different from consciousness. In Freud's view, consciousness as such receives no memory traces whatever, but has another important function: protection against stimuli. "For a living organism, protection against stimuli is almost more important than the reception of stimuli. The protective shield is equipped with its own store of energy and must above all strive to preserve the special forms of conversion of energy operating in it against the effects of the excessive energies at work in the external world—effects that tend toward an equalization of potential and hence toward destruction." The threat posed by these energies is the threat of shocks. The more readily consciousness registers these shocks, the less likely they are to have a traumatic effect. Psychoanalytic theory strives to understand the nature of these traumatic shocks "in terms of how they break through the shield that protects against stimuli." According to this theory, fright gains "significance" in proportion to the "absence of any preparedness for anxiety."

Freud's investigation was occasioned by the sort of dream that may afflict accident survivors—those who develop neuroses which cause them to relive the catastrophe in which they were involved. Dreams of this kind, accord-

ing to Freud, "endeavor to master the stimulus retroactively, by developing the anxiety whose omission was the cause of the traumatic neurosis." Valéry seems to have had something similar in mind. The coincidence is worth noting, for Valéry was among those interested in the special functioning of psychic mechanisms under present-day conditions.[17] (Moreover, Valéry was able to reconcile this interest with his poetic production, which remained exclusively lyric. He thus emerges as the only author who goes back directly to Baudelaire.) "The impressions and sense perceptions of humans," Valéry writes, "actually belong in the category of surprises; they are evidence of an insufficiency in humans. . . . Recollection is . . . an elemental phenomenon which aims at giving us the time for organizing 'the reception of stimuli' which we initially lacked."[18] The reception of shocks is facilitated by training in coping with stimuli; if need be, dreams as well as recollection may be enlisted. As a rule, however—so Freud assumes—this training devolves upon the wakeful consciousness, located in a part of the cortex which is "so frayed by the effect of the stimulus" that it offers the most favorable situation for the reception of stimuli. That the shock is thus cushioned, parried by consciousness, would lend the incident that occasions it the character of an isolated experience [Erlebnis], in the strict sense. If it were incorporated directly in the register of conscious memory, it would sterilize this incident for poetic experience [Erfahrung].

One wonders how lyric poetry can be grounded in experience [einer Erfahrung] for which exposure to shock [Chockerlebnis] has become the norm. One would expect such poetry to have a large measure of consciousness; it would suggest that a plan was at work in its composition. This is indeed true of Baudelaire's poetry; it establishes a connection between him and Poe, among his predecessors, and with Valéry, among his successors. Proust's and Valéry's reflections on Baudelaire complement each other providentially. Proust wrote an essay on Baudelaire which is actually surpassed in significance by certain reflections in his novels. In his "Situation de Baudelaire," Valéry supplies the classic introduction to Les Fleurs du mal. "Baudelaire's problem," he writes, "must have posed itself in these terms: 'How to be a great poet, but neither a Lamartine nor a Hugo nor a Musset.'[19] I do not say that this ambition was consciously formulated, but it must have been latent in Baudelaire's mind; it even constituted the essential Baudelaire. It was his raison d'état."[20] There is something odd about referring to "reason of state" in the case of a poet. There is something remarkable about it: the emancipation from isolated experiences [Erlebnisse]. Baudelaire's poetic production is assigned a mission. Blank spaces hovered before him, and into these he inserted his poems. His work cannot be categorized merely as historical, like anyone else's, but it intended to be so and understood itself as such.

IV

The greater the shock factor in particular impressions, the more vigilant consciousness has to be in screening stimuli; the more efficiently it does so, the less these impressions enter long experience [*Erfahrung*] and the more they correspond to the concept of isolated experience [*Erlebnis*]. Perhaps the special achievement of shock defense is the way it assigns an incident a precise point in time in consciousness, at the cost of the integrity of the incident's contents. This would be a peak achievement of the intellect; it would turn the incident into an isolated experience. Without reflection, there would be nothing but the sudden start, occasionally pleasant but usually distasteful, which, according to Freud, confirms the failure of the shock defense. Baudelaire has portrayed this process in a harsh image. He speaks of a duel in which the artist, just before being beaten, screams in fright. This duel is the creative process itself. Thus, Baudelaire placed shock experience [*Chockerfahrung*] at the very center of his art. This self-portrait, which is corroborated by evidence from several contemporaries, is of great significance. Since Baudelaire was himself vulnerable to being frightened, it was not unusual for him to evoke fright. Vallès tells us about his eccentric grimaces; on the basis of a portrait by Nargeot, Pontmartin establishes Baudelaire's alarming appearance; Claudel stresses the cutting quality he could give to his utterances; Gautier speaks of the italicizing Baudelaire indulged in when reciting poetry; Nadar describes his jerky gait.[21]

Psychiatry is familiar with traumatophile types. Baudelaire made it his business to parry the shocks, no matter what their source, with his spiritual and physical self. This shock defense is rendered in the image of combat. Baudelaire describes his friend Constantin Guys,[22] whom he visits when Paris is asleep: "How he stands there, bent over his table, scrutinizing the sheet of paper just as intently as he does the objects around him by day; how he *stabs away* with his pencil, his pen, his brush; how he spurts water from his glass to the ceiling and tries his pen on his shirt; how he pursues his work swiftly and intensely, as though he were afraid his images might escape him. Thus, he is combative even when alone, parrying his own blows." In the opening stanza of "Le Soleil," Baudelaire portrays himself engaged in just such fantastic combat; this is probably the only passage in *Les Fleurs du mal* that shows the poet at work.

Le long du vieux faubourg, où pendent aux masures
Les persiennes, abri des secrètes luxures,
Quand le soleil cruel frappe à traits redoublés
Sur la ville et les champs, sur les toits et les blés,
Je vais m'exercer seul à ma fantasque escrime,

Flairant dans tous les coins les hasards de la rime,
Trébuchant sur les mots comme sur les pavés,
Heurtant parfois des vers depuis longtemps rêvés.

[Through decrepit neighborhoods on the outskirts of town, where
Slatted shutters hang at the windows of hovels that shelter secret lusts;
At a time when the cruel sun beats down with redoubled force
On city and countryside, on rooftops and cornfields,
I go out alone to practice my fantastical fencing,
Scenting chances for rhyme on every street corner,
Stumbling over words as though they were cobblestones,
Sometimes knocking up against verses dreamed long ago.]

Shock is among those experiences that have assumed decisive importance for Baudelaire's personality. Gide has dealt with the intermittences between image and idea, word and thing, which are the real site of Baudelaire's poetic excitation.[23] Rivière has pointed to the subterranean shocks by which Baudelaire's poetry is shaken; it is as though they caused words to collapse.[24] Rivière has indicated such collapsing words.

Et qui sait si les fleurs nouvelles que je rêve
Trouveront dans ce sol lavé comme une grève
Le mystique aliment qui *ferait* leur vigueur.

[And who knows whether my dreams' new flowers
Will find within this soil, washed like a shore,
The mystic nourishment that *would make* them strong?]

Or: "Cybèle, qui les aime, *augmente ses verdures*" ["Cybele, who loves them, *augments her verdure*"]. Another example is this famous first line: "La servante au grand coeur dont vous étiez *jalouse*" ["That good-hearted servant of whom you were *jealous*"].

To give these covert laws their due outside his verses as well was Baudelaire's intention in *Spleen de Paris,* his collection of prose poems. In the book's dedication to the editor-in-chief of *La Presse,* Arsène Houssaye,[25] Baudelaire wrote: "Who among us has not dreamed, in his ambitious moments, of the miracle of a poetic prose, musical, yet without rhythm and without rhyme, supple and resistant enough to adapt to the lyrical stirrings of the soul, the undulations of reverie, and the sudden leaps of consciousness. This obsessive ideal is born, above all, from the experience of giant cities, from the intersecting of their myriad relations."

This passage suggests two insights. For one thing, it tells us about the close connection in Baudelaire between the figure of shock and contact with the urban masses. For another, it tells us what is really meant by these masses. They do not stand for classes or any sort of collective; rather, they

are nothing but the amorphous crowd of passers-by, the people in the street.[26] This crowd, whose existence Baudelaire is always aware of, does not serve as the model for any of his works; but it is imprinted on his creativity as a hidden figure, just as it constitutes the figure concealed in the excerpt quoted above. We can discern the image of the fencer in it: the blows he deals are designed to open a path for him through the crowd. To be sure, the neighborhoods through which the poet of "Le Soleil" makes his way are deserted. But the hidden constellation—in which the profound beauty of that stanza becomes thoroughly transparent—is no doubt a phantom crowd: the words, the fragments, the beginnings of lines, from which the poet, in the deserted streets, wrests poetic booty.

V

The crowd: no subject was more worthy of attention from nineteenth-century writers. It was getting ready to take shape as a public consisting of broad strata that had acquired facility in reading. It gave out commissions; it wished to find itself portrayed in the contemporary novel, as wealthy patrons did in the paintings of the Middle Ages. The most successful author of the century met this demand out of inner necessity. To him, "the crowd" meant—almost in the ancient sense—the crowd of clients, the public. Victor Hugo was the first to address the crowd in his titles: *Les Misérables, Les Travailleurs de la mer.* In France, Hugo was the only writer able to compete with the serial novel. As is generally known, Eugène Sue was the master of this genre, which came to be the source of revelation for the man in the street. In 1850 an overwhelming majority elected him to the Chamber of Deputies as a representative from the city of Paris. It is no accident that the young Marx chose Sue's *Mystères de Paris* for an attack.[27] At an early date, he realized it was his task to forge the amorphous masses—then being wooed by an aesthetically appealing socialism—into the iron of the proletariat. Engels' description of these masses in his early writings may be regarded as a prelude, however modest, to one of Marx's themes. In his book *The Condition of the Working Class in England,* Engels writes:

> A town such as London, where a man may wander for hours together without reaching the beginning of the end, without meeting the slightest hint which could lead to the inference that there is open country within reach, is a strange thing. This colossal centralization, this heaping together of two and a half million human beings at one point, has multiplied the power of these two and a half million people a hundredfold. . . . But the sacrifices which all this has cost become apparent later. After roaming the streets of the capital for a day or two, making headway with difficulty through the human turmoil and the endless lines of vehicles, after visiting the slums of the metropolis, one realizes for the first time that these Londoners have been forced to sacrifice the best qualities of

their human nature in order to bring to pass all the marvels of civilization which crowd their city; that a hundred powers which slumbered within them have remained inactive, have been suppressed. . . . The very turmoil of the streets has something repulsive about it, something against which human nature rebels. The hundreds of thousands of people of all classes and ranks crowding past one another—are they not all human beings with the same qualities and powers, and with the same interest in being happy? . . . And still they crowd by one another as though they had nothing in common, nothing to do with one another, and their only agreement is a tacit one: that each should keep to his own side of the pavement, so as not to delay the opposing streams of the crowd, while it occurs to no man to honor another with so much as a glance. The brutal indifference, the unfeeling isolation of each person in his private interest becomes the more repellent and offensive, the more these individuals are crowded together within a limited space.[28]

This description differs markedly from those found in minor French masters, such as Gozlan, Delvau, or Lurine.[29] It lacks the skill and nonchalance which the flâneur displays as he moves among the crowds in the streets and which the journalist eagerly learns from him. Engels is dismayed by the crowd. He responds with a moral reaction, and an aesthetic one as well; the speed with which people rush past one another unsettles him. The charm of his description lies in the blend of unshakable critical integrity with old-fashioned views. The writer came from a Germany that was still provincial; he may never have been tempted to lose himself in a stream of people. When Hegel went to Paris for the first time, not long before his death, he wrote to his wife: "When I walk through the streets, people look just as they do in Berlin. They wear the same clothes, and their faces are about the same—they have the same aspect, but in a populous mass."[30] To move in this mass of people was natural for a Parisian. No matter how great the distance an individual wanted to keep from it, he still was colored by it and, unlike Engels, was unable to view it from without. As for Baudelaire, the masses were anything but external to him; indeed, it is easy to trace in his works his defensive reaction to their attraction and allure.

The masses had become so much a part of Baudelaire that it is rare to find a description of them in his works. His most important subjects are hardly ever encountered in descriptive form. As Desjardins so aptly put it, he was "more concerned with implanting the image in the memory than with adorning and elaborating it."[31] It is futile to search in Les Fleurs du mal or in Spleen de Paris for any counterpart to the portrayals of the city that Victor Hugo composed with such mastery. Baudelaire describes neither the Parisians nor their city. Avoiding such descriptions enables him to invoke the former in the figure of the latter. His crowds are always the crowds of a big city; his Paris is invariably overpopulated. It is this that makes him so superior to Barbier, whose descriptive method divorced the masses from the

city.[32] In *Tableaux parisiens,* the secret presence of a crowd is demonstrable almost everywhere. When Baudelaire takes the dawn as his theme, the deserted streets emit something of that "silence of a throng" which Hugo senses in nocturnal Paris. As Baudelaire looks at the illustrations in the books on anatomy being sold on the dusty banks of the Seine, a crowd of departed souls takes the place of the singular skeletons on those pages. In the figures of the *danse macabre,* he sees a compact mass on the move. The heroism of the wizened old women whom the cycle "Les Petites Vieilles" follows on their rounds consists in their standing apart from the urban crowd, unable to keep up with it, no longer mentally participating in the present. The masses were an agitated veil, and Baudelaire views Paris through this veil. The presence of the masses informs one of the most famous poems in *Les Fleurs du mal.*

In the sonnet "A une passante," the crowd is nowhere named in either word or phrase. Yet all the action hinges on it, just as the progress of a sailboat depends on the wind.

La rue assourdissante autour de moi hurlait.
Longue, mince, en grand deuil, douleur majestueuse,
Une femme passa, d'une main fastueuse
Soulevant, balançant le feston et l'ourlet;

Agile et noble, avec sa jambe de statue.
Moi, je buvais, crispé comme un extravagant,
Dans son oeil, ciel livide où germe l'ouragan,
La douceur qui fascine et le plaisir qui tue.

Un éclair . . . puis la nuit!—Fugitive beauté
Dont le regard m'a fait soudainement renaître,
Ne te verrai-je plus que dans l'éternité?

Ailleurs, bien loin d'ici! Trop tard! *Jamais* peut-être!
Car j'ignore où tu fuis, tu ne sais où je vais,
O toi que j'eusse aimée, ô toi qui le savais!

[The deafening street was screaming all around me.
Tall, slender, in deep mourning—majestic grief—
A woman made her way past, with fastidious hand
Raising and swaying her skirt-border and hem;

Agile and noble, with her statue's limbs.
And me—I drank, contorted like a wild eccentric,
From her eyes, that livid sky which gives birth to hurricanes,
Gentleness that fascinates, pleasure that kills.

A lightning-flash . . . then night!—O fleeting beauty
Whose glance suddenly gave me new life,
Shall I see you again only in eternity?

Far, far from here! Too late! Or maybe *never?*
For I know not where you flee, you know not where I go,
O you whom I would have loved, O you who knew it too!]

In a widow's veil, mysteriously and mutely borne along by the crowd, an unknown woman crosses the poet's field of vision. What this sonnet conveys is simply this: far from experiencing the crowd as an opposing, antagonistic element, the city dweller discovers in the crowd what fascinates him. The delight of the urban poet is love—not at first sight, but at last sight. It is an eternal farewell, which coincides in the poem with the moment of enchantment. Thus, the sonnet deploys the figure of shock, indeed of catastrophe. But the nature of the poet's emotions has been affected as well. What makes his body contract in a tremor—"crispé comme un extravagant," Baudelaire says—is not the rapture of a man whose every fiber is suffused with eros; rather, it is like the sexual shock that can beset a lonely man. The fact that "these verses could have been written only in a big city," as Thibaudet put it, is not very meaningful.[33] They reveal the stigmata which life in a metropolis inflicts upon love. Proust read the sonnet in this light, and that is why he gave to his own echo of the woman in mourning (which appeared to him one day in the form of Albertine) the evocative epithet "La Parisienne." "When Albertine came into my room again, she wore a black satin dress. It made her look pale. She resembled the kind of fiery yet pale Parisian woman who is not used to fresh air and has been affected by living among the masses, possibly in an atmosphere of vice—the kind you can recognize by her gaze, which seems unsteady if there is no rouge on her cheeks."[34] This is the gaze—evident even as late as Proust—of the object of a love which only a city dweller experiences, which Baudelaire captured for poetry, and which one might not infrequently characterize as being spared, rather than denied, fulfillment.[35]

VI

A story by Poe which Baudelaire translated can be seen as the classic example among the older versions of the motif of the crowd. It is marked by certain peculiarities which, upon closer inspection, reveal aspects of social forces of such power and hidden depth that we may include them among the only ones that are capable of exerting both a subtle and a profound effect on artistic production. The story is entitled "The Man of the Crowd." It is set in London, and its narrator is a man who, after a long illness, ventures out again for the first time into the hustle and bustle of the city. On a late afternoon in autumn, he takes a seat by the window in a big London coffeehouse. He gazes around at the other customers and pores over adver-

tisements in the paper, but he is mainly interested in the throng of people he sees through the window, surging past in the street.

> The latter is one of the principal thoroughfares of the city, and had been very much crowded during the whole day. But, as the darkness came on, the throng momently increased; and by the time the lamps were well lighted, two dense and continuous tides of population were rushing past the door. At this particular period of the evening I had never before been in a similar situation, and the tumultuous sea of human heads filled me, therefore, with a delicious novelty of emotion. I gave up, at length, all care of things within the hotel, and became absorbed in contemplation of the scene without.

Important as it is, let us disregard the narrative to which this is the prelude and examine the setting.

The appearance of the London crowd as Poe describes it is as gloomy and fitful as the light of the gas lamps overhead. This applies not only to the riff-raff that is "brought forth from its den" as night falls. The employees of higher rank, "the upper clerks of staunch firms," Poe describes as follows: "They had all slightly bald heads, from which the right ears, long used to pen-holding, had an odd habit of standing off on end. I observed that they always removed or settled their hats with both hands, and wore watches, with short gold chains of a substantial and ancient pattern." Even more striking is his description of the crowd's movements.

> By far the greater number of those who went by had a satisfied business-like demeanour, and seemed to be thinking only of making their way through the press. Their brows were knit, and their eyes rolled quickly; when pushed against by fellow-wayfarers they evinced no symptom of impatience, but adjusted their clothes and hurried on. Others, still a numerous class, were restless in their movements, had flushed faces, and talked and gesticulated to themselves, as if feeling in solitude on account of the very denseness of the company around. When impeded in their progress, these people suddenly ceased muttering, but redoubled their gesticulations, and awaited, with an absent and overdone smile upon the lips, the course of the persons impeding them. If jostled, they bowed profusely to the jostlers, and appeared overwhelmed with confusion.[36]

One might think he was speaking of half-drunken wretches. Actually, they were "noblemen, merchants, attorneys, tradesmen, stock-jobbers."[37]

Poe's image cannot be called realistic. It shows a purposely distorting imagination at work, one that takes the text far from what is commonly advocated as the model of socialist realism. Barbier, perhaps one of the best examples of this type of realism, described things in a less eccentric way. Moreover, he chose a more transparent subject: the oppressed masses. Poe is not concerned with these; he deals with "people," pure and simple. For

him, as for Engels, there was something menacing in the spectacle they presented. It is precisely this image of big-city crowds that became decisive for Baudelaire. If he succumbed to the force that attracted him to them and that made him, as a flâneur, one of them, he was nevertheless unable to rid himself of a sense of their essentially inhuman character. He becomes their accomplice even as he dissociates himself from them. He becomes deeply involved with them, only to relegate them to oblivion with a single glance of contempt. There is something compelling about this ambivalence, wherever he cautiously admits it. Perhaps the charm of his "Crépuscule du soir," so difficult to account for, is bound up with this.

VII

Baudelaire was moved to equate the man of the crowd, whom Poe's narrator follows throughout the length and breadth of nocturnal London, with the flâneur. It is hard to accept this view. The man of the crowd is no flâneur. In him, composure has given way to manic behavior. He exemplifies, rather, what had to become of the flâneur after the latter was deprived of the milieu to which he belonged. If London ever provided it for him, it was certainly not the setting described by Poe. In comparison, Baudelaire's Paris preserved some features that dated back to the old days. Ferries were still crossing the Seine at points that would later be spanned by bridges. In the year of Baudelaire's death, it was still possible for some entrepreneur to cater to the comfort of the well-to-do with a fleet of five hundred sedan chairs circulating about the city. Arcades where the flâneur would not be exposed to the sight of carriages, which did not recognize pedestrians as rivals, were enjoying undiminished popularity.[38] There was the pedestrian who would let himself be jostled by the crowd, but there was also the flâneur, who demanded elbow room and was unwilling to forgo the life of a gentleman of leisure. Let the many attend to their daily affairs; the man of leisure can indulge in the perambulations of the flâneur only if as such he is already out of place. He is as much out of place in an atmosphere of complete leisure as in the feverish turmoil of the city. London has its man of the crowd. His counterpart, as it were, is Nante, the boy who loiters on the street corner, a popular figure in Berlin before the March Revolution of 1848. The Parisian flâneur might be said to stand midway between them.[39]

How the man of leisure views the crowd is revealed in a short piece by E. T. A. Hoffmann, his last story, entitled "The Cousin's Corner Window."[40] It antedates Poe's story by fifteen years and is probably one of the earliest attempts to capture the street scene of a large city. The differences between the two pieces are worth noting. Poe's narrator watches the street from the window of a public coffeehouse, whereas the cousin is sitting at home. Poe's observer succumbs to the fascination of the scene, which finally

lures him out into the whirl of the crowd. The cousin in Hoffmann's tale, looking out from his corner window, has lost the use of his legs; he would not be able to go with the crowd even if he were in the midst of it. His attitude toward the crowd is, rather, one of superiority, inspired as it is by his observation post at the window of an apartment building. From this vantage point he scrutinizes the throng; it is market day, and all the passers-by feel in their element. His opera glasses enable him to pick out individual genre scenes. Employing the glasses is thoroughly in keeping with the inner disposition of their user. He confesses he would like to initiate his visitor in the "principles of the art of seeing."[41] This consists of an ability to enjoy *tableaux vivants*—a favorite pursuit of the Biedermeier period. Edifying sayings provide the interpretation.[42] One can then view Hoffmann's narrative as describing an attempt which at that time was being made. But it is obvious that the conditions under which it was made in Berlin prevented it from being a complete success. If Hoffmann had ever set foot in Paris or London, or if he had been intent on depicting the masses as such, he would not have focused on a marketplace; he would not have portrayed the scene as being dominated by women. He would perhaps have seized on the motifs that Poe derives from the swarming crowds under the gas lamps. Actually, there would have been no need for these motifs in order to bring out the uncanny or sinister elements that other students of the physiognomy of the big city have felt. A thoughtful observation by Heine is relevant here. "He was having a bad time with his eyes in the spring," wrote a correspondent in an 1838 letter to Varnhagen.[43] "On our last meeting, I accompanied him part of the way along the boulevard. The splendor and vitality of that unique thoroughfare moved me to boundless admiration, while, against this, Heine now laid weighty emphasis on the horrors attending this center of the world."[44]

VIII

Fear, revulsion, and horror were the emotions which the big-city crowd aroused in those who first observed it. For Poe, it has something barbaric about it; discipline barely manages to tame it. Later, James Ensor never tired of confronting its discipline with its wildness; he liked to depict military groups amid carnival mobs, and show them getting along in model fashion—that is, according to the model of totalitarian states, in which the police make common cause with looters.[45] Valéry, who had a fine eye for the cluster of symptoms called "civilization," has highlighted one of the pertinent facts. "The inhabitant of the great urban centers," he writes, "reverts to a state of savagery—that is, of isolation. The feeling of being dependent on others, which used to be kept alive by need, is gradually blunted in the smooth functioning of the social mechanism. Any improvement of this

mechanism eliminates certain modes of behavior and emotions."[46] Comfort isolates; on the other hand, it brings those enjoying it closer to mechanization. In the mid-nineteenth century, the invention of the match brought forth a number of innovations which have one thing in common: a single abrupt movement of the hand triggers a process of many steps. This development is taking place in many areas. A case in point is the telephone, where the lifting of a receiver has taken the place of the steady movement that used to be required to crank the older models. With regard to countless movements of switching, inserting, pressing, and the like, the "snapping" by the photographer had the greatest consequences. Henceforth a touch of the finger sufficed to fix an event for an unlimited period of time. The camera gave the moment a posthumous shock, as it were. Haptic experiences of this kind were joined by optic ones, such as are supplied by the advertising pages of a newspaper or the traffic of a big city. Moving through this traffic involves the individual in a series of shocks and collisions. At dangerous intersections, nervous impulses flow through him in rapid succession, like the energy from a battery. Baudelaire speaks of a man who plunges into the crowd as into a reservoir of electric energy. Circumscribing the experience of the shock, he calls this man "a kaleidoscope endowed with consciousness."[47] Whereas Poe's passers-by cast glances in all directions, seemingly without cause, today's pedestrians are obliged to look about them so that they can be aware of traffic signals. Thus, technology has subjected the human sensorium to a complex kind of training. There came a day when a new and urgent need for stimuli was met by film. In a film, perception conditioned by shock [*chockförmige Wahrnehmung*] was established as a formal principle. What determines the rhythm of production on a conveyor belt is the same thing that underlies the rhythm of reception in the film.

Marx had good reason to stress the great fluidity of the connection between segments in manual labor. This connection appears to the factory worker on an assembly line in an independent, objectified form. The article being assembled comes within the worker's range of action independently of his volition, and moves away from him just as arbitrarily. "It is a common characteristic of all capitalist production . . . ," wrote Marx, "that the worker does not make use of the working conditions. The working conditions make use of the worker; but it takes machinery to give this reversal a technologically concrete form."[48] In working with machines, workers learn to coordinate "their own movements with the uniformly constant movements of an automaton." These words shed a peculiar light on the absurd kind of uniformity that Poe wants to impose on the crowd—uniformities of attire and behavior, but also a uniformity of facial expression. Those smiles provide food for thought. They are probably the familiar kind, as expressed these days in the phrase "keep smiling";[49] in Poe's story, they function as a mimetic shock absorber.—"All machine work," says Marx in the same pas-

sage cited above, "requires prior training of the workers." This training must be differentiated from practice. Practice, which was the sole determinant in handcrafting, still had a function in manufacturing. With practice as the basis, "each particular area of production finds its appropriate technical form in *experience* and *slowly* perfects it." To be sure, each area quickly crystallizes this form "as soon as a certain degree of maturity has been attained." On the other hand, this same system of manufacture produces "in every handicraft it appropriates a class of so-called unskilled laborers which the handicraft system strictly excluded. In developing a greatly simplified specialty to the point of virtuosity, at the cost of overall production capacity, it starts turning the lack of any development into a specialty. In addition to rankings, we get the simple division of workers into the skilled and the unskilled." The unskilled worker is the one most deeply degraded by machine training. His work has been sealed off from experience; practice counts for nothing in the factory.[50] What the amusement park achieves with its dodgem cars and other similar amusements is nothing but a taste of the training that the unskilled laborer undergoes in the factory—a sample which at times was for him the entire menu; for the art of the eccentric, an art in which an ordinary man could acquire training in places like an amusement park, flourished concomitantly with unemployment. Poe's text helps us understand the true connection between wildness and discipline. His pedestrians act as if they had adapted themselves to machines and could express themselves only automatically. Their behavior is a reaction to shocks. "If jostled, they bowed profusely to the jostlers."

IX

The shock experience [*Chockerlebnis*] which the passer-by has in the crowd corresponds to the isolated "experiences" of the worker at his machine. This does not entitle us to assume that Poe knew anything about industrial work processes. Baudelaire, at any rate, did not have the faintest notion of them. He was, however, captivated by a process in which the reflexive mechanism that the machine triggers in the workman can be studied closely, as in a mirror, in the idler. To say that this process is represented in games of chance may appear paradoxical. Where could one find a starker contrast than the one between work and gambling? Alain puts this convincingly when he writes: "It is inherent in the concept of gambling . . . that no game is dependent on the preceding one. Gambling cares nothing for any secured position. . . . It takes no account of winnings gained earlier, and in this it differs from work. Gambling gives short shrift to the weighty past on which work bases itself."[51] The work that Alain has in mind here is the highly specialized kind (which, like intellectual effort, probably retains certain features of handicraft); it is not that of most factory workers, and least of all

unskilled work. The latter, to be sure, lacks any touch of adventure, of the mirage that lures the gambler. But it certainly does not lack futility, emptiness, an inability to complete something—qualities inherent in the activity of a wage slave in a factory. Even the worker's gesture produced by the automated work process appears in gambling, for there can be no game without the quick movement of the hand by which the stake is put down or a card is picked up. The jolt in the movement of a machine is like the so-called *coup* in a game of chance. The hand movement of the worker at the machine has no connection with the preceding gesture for the very reason that it repeats that gesture exactly. Since each operation at the machine is just as screened off from the preceding operation as a *coup* in a game of chance is from the one that preceded it, the drudgery of the laborer is, in its own way, a counterpart to the drudgery of the gambler. Both types of work are equally devoid of substance.

There is a lithograph by Senefelder which depicts a gambling club.[52] Not one of the individuals in the scene is pursuing the game in ordinary fashion. Each man is dominated by an emotion: one shows unrestrained joy; another, distrust of his partner; a third, dull despair; a fourth evinces belligerence; another is getting ready to take leave of the world. All these modes of conduct share a concealed characteristic: the figures presented show us how the mechanism to which gamblers entrust themselves seizes them body and soul, so that even in their private sphere, and no matter how agitated they may be, they are capable only of reflex actions. They behave like the pedestrians in Poe's story. They live their lives as automatons and resemble Bergson's fictitious characters who have completely liquidated their memories.

Baudelaire does not seem to have been a devotee of gambling, though he had words of sympathetic understanding, even homage, for those addicted to it. The motif he treats in his night piece "Le Jeu" [The Game] is integral to his view of modernity, and writing this poem formed part of his mission. In Baudelaire, the image of the gambler becomes the characteristically modern counterpart to the archaic image of the fencer; both are heroic figures to him. Ludwig Börne was looking at things through Baudelaire's eyes when he wrote: "If all the energy and passion . . . that are expended every year at Europe's gambling tables . . . were stored up, an entire Roman people and Roman history could be created from them. But this is precisely the point. Because every man is born a Roman, bourgeois society seeks to de-Romanize him, and this is why there are games of chance, as well as parlor games, novels, Italian operas, and fashionable newspapers."[53] Gambling did not become a common diversion among the bourgeoisie until the nineteenth century; in the eighteenth, only the aristocracy gambled. Games of chance, which were disseminated by Napoleon's armies, henceforth became

a pastime "both among the fashionable set and among the thousands of people living unsettled lives in big-city basements"—became part of the spectacle in which Baudelaire claimed he saw the heroic, "as it typifies our age."

If we look at gambling from the psychological as well as the technical point of view, Baudelaire's conception of it appears even more significant. It is obvious that the gambler is out to win. Yet his desire to win and make money cannot really be termed a "wish" in the strict sense of the word. He may be inwardly motivated by greed or by some sinister design. At any rate, his frame of mind is such that he cannot make much use of experience.[54] A wish, however, appertains to an order of experience. "What one wishes for in one's youth, one has in abundance in old age," said Goethe.[55] The earlier in life one makes a wish, the greater one's chances that it will be fulfilled. The further a wish reaches out in time, the greater the hopes for its fulfillment. But it is experience [*Erfahrung*] that accompanies one to the far reaches of time, that fills and articulates time. Thus, a wish fulfilled is the crowning of experience. In folk symbolism, distance in space can take the place of distance in time; that is why the shooting star, which plunges into infinite space, has become the symbol of a fulfilled wish. The ivory ball that rolls into the *next* compartment, the *next* card that lies on top, are the very antithesis of a falling star. The instant in which a shooting star flashes before human eyes consists of the sort of time that Joubert has described with his customary assurance. "Time," he says, "is found even in eternity; but it is not earthly, worldly time. . . . It does not destroy; it merely completes."[56] It is the antithesis of time in hell, which is the province of those who are not allowed to complete anything they have started. The disrepute of games of chance is actually based on the fact that the player himself has a hand in it. (Someone who compulsively buys lottery tickets will not be shunned in the same way as someone who "gambles" in the stricter sense.)

This process of continually starting all over again is the regulative idea of gambling, as it is of work for wages. Thus, it is highly significant that in Baudelaire the second-hand of the clock—"la Seconde"—appears as the gambler's partner:

> Souviens-toi que le Temps est un joueur avide
> Qui gagne sans tricher, à tout coup! c'est la loi![57]

> [*Keep in mind* that Time is a rabid gambler
> Who wins without cheating—every time! It's the law!]

Elsewhere Satan himself takes the place of this second. In the poem "Le Jeu," compulsive gamblers are relegated to the silent corner of a cave that is doubtless part of Satan's realm:

Voilà le noir tableau qu'en un rêve nocturne
Je vis se dérouler sous mon oeil clairvoyant.
Moi-même, dans un coin de l'antre taciturne,
Je me vis accoudé, froid, muet, enviant,
Enviant de ces gens la passion tenace.

[Here you see the hellish picture that one night in a dream
I saw unfolding before my clairvoyant eyes.
My own self was in a corner of the silent cave;
I saw myself, hunched, cold, wordless, envious,
Envying those people for their tenacious passion.]

The poet does not participate in the game. He stays in his corner, no happier than those who are playing. He too has been cheated out of his experience—a modern man. The only difference is that he rejects the narcotics the gamblers use to dull the consciousness that has forced them to march to the beat of the second-hand.[58]

Et mon coeur s'effraya d'envier maint pauvre homme
Courant avec ferveur à l'abîme béant,
Et qui, soûl de son sang, préférerait en somme
La douleur à la mort et l'enfer au néant!

[And my heart took fright at the idea of envying many a poor man
Who ran avidly to the gaping abyss,
And who, drunk with the pulsing of his blood, preferred
Suffering to death, and hell to nothingness!]

In this last stanza, Baudelaire presents impatience as the substrate of the passion for gambling. He found it in himself in its purest form. His violent temper had the expressiveness of Giotto's *Iracondia* at Padua.[59]

X

According to Bergson, it is the actualization of *durée* that rids man's soul of the obsession with time. Proust shared this belief, and from it he developed the lifelong exercises in which he strove to bring to light past things saturated with all the reminiscences that had penetrated his pores during the sojourn of those things in his unconscious. Proust was an incomparable reader of *Les Fleurs du mal*, for he sensed that it contained kindred elements. Familiarity with Baudelaire must include Proust's experience with his work. Proust writes: "Time is peculiarly dissociated in Baudelaire; only a very few days can appear, and they are significant ones. Thus, it is understandable why turns of phrase like 'if one evening' occur frequently in his works."[60] These significant days are days of the completing time," to para-

phrase Joubert. They are days of recollection [*Eingedenken*], not marked by any immediate experience [*Erlebnis*]. They are not connected with other days, but stand out from time. As for their substance, Baudelaire has defined it in the notion of *correspondances*—a concept that in Baudelaire is concomitant but not explicitly linked with the notion of "modern beauty."[61]

Disregarding the scholarly literature on *correspondances* (the common property of mystics; Baudelaire encountered them in Fourier's writings), Proust no longer fusses about the artistic variations on this phenomenon that result from synaesthesia.[62] The important thing is that *correspondances* encompass a concept of experience which includes ritual elements. Only by appropriating these elements was Baudelaire able to fathom the full meaning of the breakdown which he, as a modern man, was witnessing. Only in this way was he able to recognize it as a challenge meant for him alone, a challenge that he incorporated in *Les Fleurs du mal*. If there really is a secret architecture in the book—and many speculations have been devoted to this question—the cycle of poems that opens the volume is probably oriented toward something irretrievably lost. This cycle includes two sonnets dealing with the same motif. The first, entitled "Correspondances," begins with these lines:

> La Nature est un temple où de vivants piliers
> Laissent parfois sortir de confuses paroles;
> L'homme y passe à travers des forêts de symboles
> Qui l'observent avec des regards familiers.
>
> Comme de longs échos qui de loin se confondent
> Dans une ténébreuse et profonde unité,
> Vaste comme la nuit et comme la clarté,
> Les parfums, les couleurs et les sons se répondent.
>
> [Nature is a temple whose living pillars
> Sometimes give forth a babel of words;
> Man wends his way through forests of symbols
> Which look at him with their familiar glances.
>
> Like resounding echoes that blend from afar
> In a somber, profound unity,
> Vast as the night or as the brightness of day,
> Scents, colors, and sounds respond to one another.]

What Baudelaire meant by *correspondances* can be described as an experience which seeks to establish itself in crisis-proof form. This is possible only within the realm of ritual. If it transcends this realm, it presents itself as the beautiful. In the beautiful, ritual value appears as the value of art.[63] *Corre-*

spondances are the data of recollection—not historical data, but data of prehistory. What makes festive days great and significant is the encounter with an earlier life. Baudelaire recorded this in a sonnet entitled "La Vie antérieure." The images of caves and vegetation, of clouds and waves which are evoked at the beginning of this second sonnet rise from the warm vapor of tears—tears of homesickness. "The wanderer looks into the tear-veiled distance, and hysterical tears well up in his eyes," writes Baudelaire in his review of the poems of Marceline Desbordes-Valmore.[64] There are no simultaneous correspondences, such as were cultivated later by the Symbolists. What is past murmurs in the correspondences, and the canonical experience of them has its place in a previous life:

> Les houles, en roulant les images des cieux,
> Mêlaient d'une façon solennelle et mystique
> Les tout-puissants accords de leur riche musique
> Aux couleurs du couchant reflété par mes yeux.
>
> C'est là que j'ai vécu.
>
> [The breakers, tumbling the images of the heavens,
> Blended, in a solemn and mystical way,
> The all-powerful chords of their rich music
> With the colors of the sunset reflected in my eyes.
>
> There is where I lived.]

The fact that Proust's restorative will remains within the limits of earthly existence, whereas Baudelaire's transcends it, may be regarded as symptomatic of the vastly more elemental and powerful counterforces that announced themselves to Baudelaire. And it is likely he never achieved greater perfection than when he seems resigned to being overcome by them. "Recueillement" [Contemplation] traces the allegories of the old years set off against the deep sky:

> . . . Vois se pencher les défuntes Années
> Sur les balcons du ciel, en robes surannées.
>
> [. . . See the dead departed Years leaning over
> Heaven's balconies, in old-fashioned dresses.]

In these lines, Baudelaire resigns himself to paying homage to bygone times that escaped him in the guise of the outdated. When Proust in the last volume of his novel harks back to the sensation that suffused him at the taste of a madeleine, he imagines the years which appear on the balcony as being loving sisters of the years of Combray. "In Baudelaire . . . these reminiscences are even more numerous. It is obvious they do not occur by chance, and this, to my mind, is what gives them crucial importance. No one else

pursues the interconnected *correspondances* with such leisurely care, fastidiously yet nonchalantly—in a woman's scent, for instance, in the fragrance of her hair or her breasts—*correspondances* which then inspire him with lines like 'the azure of the vast, vaulted sky' or 'a harbor full of flames and masts.'"[65] This passage is a confessional motto for Proust's work. It bears a relation to Baudelaire's work, which has assembled the days of recollection into a spiritual year.

But *Les Fleurs du mal* would not be what it is if all it contained were this success. It is unique because, from the inefficacy of the same consolation, the breakdown of the same fervor, the failure of the same work, it was able to wrest poems that are in no way inferior to those in which the *correspondances* celebrate their triumphs. "Spleen et idéal" is the first of the cycles in *Les Fleurs du mal*. The *idéal* supplies the power of recollection; *spleen* rallies the multitude of the seconds against it. It is their commander, just as the devil is the lord of the flies. One of the "Spleen" poems, "Le Goût du néant" [The Taste of Nothingness], says: "Le Printemps adorable a perdu son odeur!" ["Spring, the beloved, has lost its scent!"] Here Baudelaire expresses something extreme with extreme discretion; this makes the line unmistakably his. The word *perdu* acknowledges that the experience he once shared is now collapsed into itself. The scent is the inaccessible refuge of *mémoire involontaire*. It is unlikely to associate itself with a visual image; out of all possible sensual impressions, it will ally itself only with the same scent. If the recognition of a scent can provide greater consolation than any other memory, this may be because it deeply anesthetizes the sense of time. A scent may drown entire years in the remembered odor it evokes. This imparts a sense of boundless desolation to Baudelaire's verse. For someone who is past experiencing, there is no consolation. Yet it is this very inability to experience that explains the true nature of rage. An angry man "won't listen." His prototype, Timon, rages against people indiscriminately; he is no longer capable of telling his proven friend from his mortal enemy. Barbey d'Aurevilly very perceptively recognized this habit of mind in Baudelaire, calling him "a Timon with the genius of Archilochus."[66] The rage explodes in time to the ticking of the seconds that enslaves the melancholy man.

Et le Temps m'engloutit minute par minute,
Comme la neige immense un corps pris de roideur.

[And, minute by minute, Time engulfs me,
The way an immense snowfall engulfs a body grown stiff.]

These lines immediately follow the ones quoted above. In spleen, time is reified: the minutes cover a man like snowflakes. This time is historyless, like that of the *mémoire involontaire*. But in spleen the perception of time is

supernaturally keen. Every second finds consciousness ready to intercept its shock.[67]

Although chronological reckoning subordinates duration to regularity, it cannot prevent heterogeneous, conspicuous fragments from remaining within it. Combining recognition of a quality with measurement of quantity is the accomplishment of calendars, where spaces for recollection are left blank, as it were, in the form of holidays. The man who loses his capacity for experiencing feels as though he has been dropped from the calendar. The big-city dweller knows this feeling on Sundays; Baudelaire expresses it *avant la lettre* in one of his "Spleen" poems.

> Des cloches tout à coup sautent avec furie
> Et lancent vers le ciel un affreux hurlement,
> Ainsi que des esprits errants et sans patrie
> Qui se mettent à geindre opiniâtrement.

> [Suddenly bells are tossing with fury,
> Hurling a hideous howling to the sky
> Like wandering homeless spirits
> Who break into stubborn wailing.]

The bells, which once played a part in holidays, have been dropped from the calendar like the human beings. They are like the poor souls that wander restlessly but have no history. If Baudelaire in "Spleen" and "Vie antérieure" holds in his hands the scattered fragments of genuine historical experience, Bergson in his conception of *durée* has become far more estranged from history. "Bergson the metaphysician suppresses death."[68] The fact that death has been eliminated from Bergson's *durée* isolates it effectively from a historical (as well as prehistorical) order. Bergson's concept of *action* is in keeping with this. The "sound common sense" which distinguishes the "practical man" is its godfather.[69] The *durée* from which death has been eliminated has the bad infinity of an ornament. Tradition is excluded from it.[70] It is the quintessence of an isolated experience [*Erlebnis*] that struts about in the borrowed garb of long experience [*Erfahrung*]. Spleen, on the other hand, exposes the isolated experience in all its nakedness. To his horror, the melancholy man sees the earth revert to a mere state of nature. No breath of prehistory surrounds it—no aura. This is how the earth emerges in the lines of "Le Goût du néant" which follow the ones quoted above.

> Je contemple d'en haut le globe en sa rondeur,
> Et je n'y cherche plus l'abri d'une cahute.

> [I contemplate, from on high, the globe in its roundness,
> And no longer look there for the shelter of a hut.]

XI

If we think of the associations which, at home in the *mémoire involontaire,* seek to cluster around an object of perception, and if we call those associations the aura of that object, then the aura attaching to the object of a perception corresponds precisely to the experience [*Erfahrung*] which, in the case of an object of use, inscribes itself as long practice. The techniques inspired by the camera and subsequent analogous types of apparatus extend the range of the *mémoire volontaire;* these techniques make it possible at any time to retain an event—as image and sound—through the apparatus. They thus represent important achievements of a society in which long practice is in decline.—To Baudelaire, there was something profoundly unnerving and terrifying about daguerreotypy; he speaks of the fascination it exerted as "cruel and surprising."[71] Thus, he must have sensed—though he certainly did not understand them completely—the connections of which we have spoken. His perpetual willingness to grant the modern its place and, especially in art, to assign it a specific function also determined his attitude toward photography. Whenever he felt photography as a threat, he tried to put this down to "badly applied advances" in the field; yet he admitted that the latter had been promoted by "the stupidity of the masses." "The masses demanded an ideal that would conform to their aspirations and the nature of their temperament. . . . Their prayers were granted by a vengeful god, and Daguerre became his prophet."[72] Still, Baudelaire tried to take a more conciliatory view. Photography should be free to stake a claim on ephemeral things—those that have a right to "a place in the archives of our memory"—so long as it stops short of the "realm of the intangible and the imaginative": that is, the realm of art, in which only those things "granted the imprint of man's soul" are allotted a place. This judgment is not exactly Solomonic. The perpetual readiness of voluntary, discursive memory, encouraged by the technology of reproduction, reduces the imagination's scope for play [*Spielraum*]. "Imagination" can perhaps be defined as an ability to give expression to desires of a special kind—desires that have "something beautiful" as their intended fulfillment. Valéry has set out the conditions for this fulfillment: "We recognize a work of art by the fact that no idea it inspires in us, no mode of behavior it suggests we adopt, could ever exhaust it or dispose of it. We may inhale the smell of a sweet-smelling flower as long as we like; we cannot rid ourselves of the fragrance that has aroused our senses, and no recollection, no thought, no mode of behavior can obliterate its effect or release us from the hold it has on us. Anyone who undertakes to create a work of art aims at the same effect."[73] According to this view, the painting we look at reflects back at us that of which our eyes will never have their fill. What it contains that fulfills the original desire would be the very same stuff on which the desire continu-

ously feeds. The distinction between photography and painting is therefore clear. It is also clear why there can be no comprehensive principle of "form-endowing" [*Gestaltung*] which is applicable to both: to the gaze that will never get its fill of a painting, photography is rather like food for the hungry or drink for the thirsty.

The crisis of artistic reproduction that emerges in this way can be seen as an integral part of a crisis in perception itself.—What makes our delight in the beautiful unquenchable is the image of the primeval world, which for Baudelaire is veiled by tears of nostalgia. "Ah—in times gone by, you were my sister or my wife!"[74]—this declaration of love is the tribute which the beautiful as such is entitled to claim. Insofar as art aims at the beautiful and, on however modest a scale, "reproduces" it, it retrieves it (as Faust does Helen) out of the depths of time.[75] This does not happen in the case of technological reproduction. (The beautiful has no place in it.) Proust, complaining of the barrenness and lack of depth in the images of Venice that his *mémoire volontaire* presented to him, notes that the very word "Venice" made those images seem to him as vapid as an exhibition of photographs. If the distinctive feature of the images arising from *mémoire involontaire* is seen in their aura, then photography is decisively implicated in the phenomenon of a "decline of the aura." What was inevitably felt to be inhuman—one might even say deadly—in daguerreotypy was the (prolonged) looking into the camera, since the camera records our likeness without returning our gaze. Inherent in the gaze, however, is the expectation that it will be returned by that on which it is bestowed. Where this expectation is met (which, in the case of thought processes, can apply equally to an intentional gaze of awareness and to a glance pure and simple), there is an experience [*Erfahrung*] of the aura in all its fullness. "Perceptibility," as Novalis puts it, "is an attentiveness."[76] The perceptibility he has in mind is none other than that of the aura. Experience of the aura thus arises from the fact that a response characteristic of human relationships is transposed to the relationship between humans and inanimate or natural objects. The person we look at, or who feels he is being looked at, looks at us in turn. To experience the aura of an object we look at means to invest it with the ability to look back at us.[77] This ability corresponds to the data of *mémoire involontaire*. (These data, incidentally, are unique: they are lost to the memory that seeks to retain them. Thus, they lend support to a concept of the aura that involves the "unique apparition of a distance."[78] This formulation has the advantage of clarifying the ritual character of the phenomenon. The essentially distant is the unapproachable; and unapproachability is a primary quality of the ritual image.) That Proust was quite familiar with the problem of the aura needs no emphasis. It is nonetheless notable that he sometimes alludes to it in concepts that comprehend its theory: "People who are fond of secrets occasionally flatter themselves that objects retain something of the gaze that

has rested on them." (The objects, it seems, have the ability to return the gaze.) "They believe that monuments and pictures appear only through a delicate veil which centuries of love and reverence on the part of so many admirers have woven about them. This chimera," Proust concludes evasively, "would become truth if they related it to the only reality that is valid for the individual—namely, the world of his emotions."[79] Akin to this, but reaching further because of its objective orientation, is Valéry's characterization of perception in dreams as an auratic perception: "To say 'Here I see such-and-such an object' does not establish an equation between me and the object. . . . In dreams, however, there *is* an equation. The things I look at see me just as much as I see them."[80] Of a piece with perception in dreams is the nature of temples, which Baudelaire was describing when he wrote:

> L'homme y passe à travers des forêts de symboles
> Qui l'observent avec des regards familiers.[81]

> [Man wends his way through forests of symbols
> Which look at him with their familiar glances.]

The greater Baudelaire's insight into this phenomenon, the more unmistakably was his lyric poetry marked by the disintegration of the aura. This occurred in the form of a sign, which we encounter in nearly all those passages of *Les Fleurs du mal* where the gaze of the human eye is invoked. (That Baudelaire was not following some preconceived scheme goes without saying.) What happens here is that the expectation aroused by the gaze of the human eye is not fulfilled. Baudelaire describes eyes that could be said to have lost the ability to look. Yet this gives them a charm which to a large, perhaps overwhelming extent serves as a means of defraying the cost of his instinctual desires. It was under the spell of these eyes that *sexus* in Baudelaire detaches itself from *eros*. If in "Selige Sehnsucht"[82] the lines

> Keine Ferne macht dich schwierig,
> Kommst geflogen und gebannt

> [No distance weighs you down;
> You come flying and entranced]

must be regarded as the classic description of love that is sated with the experience of the aura, then lyric poetry could hardly effect a more decisive repudiation of those lines than the following ones from Baudelaire:

> Je t'adore à l'égal de la voûte nocturne,
> O vase de tristesse, o grande taciturne,
> Et t'aime d'autant plus, belle, que tu me fuis,
> Et que tu me parais, ornement de mes nuits,

Plus ironiquement accumuler les lieues
Qui séparent mes bras des immensités bleues.[83]

[I adore you as much as the vault of night,
O vessel of sorrow, O deeply silent one,
And I love you even more, my lovely, because you flee me
And because you seem, ornament of my nights,
More ironically, to multiply the miles
That separate my arms from blue immensities.]

Glances may be all the more compelling, the more complete the viewer's absence that is overcome in them. In eyes that look at us with mirrorlike blankness, the remoteness remains complete. It is precisely for this reason that such eyes know nothing of distance. Baudelaire incorporated the glassiness of their stare in a cunning rhyme:

Plonge tes yeux dans les yeux fixes
Des Satyresses ou des Nixes.[84]

[Let your eyes plunge into the fixed stare
Of Satyresses or Water Sprites.]

Female satyrs and water sprites are no longer members of the family of man. Theirs is a world apart. Significantly, Baudelaire's poem incorporates the look of the eye encumbered by distance as *un regard familier*. The poet who never founded a family imbues the word *familier* with a tone of mingled promise and renunciation. He has yielded to the spell of eyes-without-a-gaze, and submits to their sway without illusions.

Tes yeux, illuminés ainsi que des boutiques
Et des ifs flamboyants dans les fêtes publiques,
Usent insolemment d'un pouvoir emprunté.[85]

[Your eyes, lit up like shopwindows
Or like yew-trees illuminated for public celebrations,
Insolently wield borrowed power.]

"Dullness," says Baudelaire in one of his earliest publications, "is frequently one of beauty's adornments. This is the reason eyes may be sad and translucent like blackish swamps, or their gaze may have the oily inertness of tropical seas."[86] When such eyes come alive, it is with the self-protective wariness of a carnivore hunting for prey. (Thus, the eye of a prostitute scrutinizing passers-by is at the same time on the lookout for police. The physiognomic type bred by this kind of life, Baudelaire noted, is delineated in Constantin Guys' numerous drawings of prostitutes. "Her eyes, like those of a wild animal, are fixed on the distant horizon; they have the rest-

lessness of a wild animal . . . , but sometimes also the animal's sudden tense vigilance.")[87] That the eye of the city dweller is overburdened with protective functions is obvious. Georg Simmel refers to some of its less obvious tasks. "Someone who sees without hearing is much more uneasy than someone who hears without seeing. In this, there is something characteristic of the sociology of the big city. Interpersonal relationships in big cities are distinguished by a marked preponderance of visual activity over aural activity. The main reason for this is the public means of transportation. Before the development of buses, railroads, and trams in the nineteenth century, people had never been in situations where they had to look at one another for long minutes or even hours without speaking to one another."[88]

In the protective eye, there is no daydreaming surrender to distance and to faraway things. The protective eye may bring with it something like pleasure in the degradation of such distance. This is probably the sense in which the following curious sentences should be read. In his "Salon of 1859" Baudelaire lets the landscapes pass in review, concluding with this admission: "I long for the return of the dioramas, whose brutal and enormous magic has the power to impose on me a useful illusion. I would rather go to the theater and feast my eyes on the scenery, in which I find my dearest dreams treated with consummate skill and tragic concision. These things, because they are false, are infinitely closer to the truth, whereas the majority of our landscape painters are liars, precisely because they fail to lie."[89] One is inclined to attach less importance to the "useful illusion" than to the "*tragic* concision." Baudelaire insists on the magic of distance; he goes so far as to judge landscapes by the standard of paintings sold in booths at fairs. Does he mean the magic of distance to be broken through, as necessarily happens when the viewer steps too close to the depicted scene? This motif enters into a great passage from *Les Fleurs du mal*:

Le Plaisir vaporeux fuira vers l'horizon
Ainsi qu'une sylphide au fond de la coulisse.[90]

[Nebulous Pleasure horizonward will flee
Like a sylph darting into the wings.]

XII

Les Fleurs du mal was the last lyric work that had a broad European reception; no later writings penetrated beyond a more or less limited linguistic area. Added to this is the fact that Baudelaire expended his productive capacity almost entirely on this one volume. And finally, it cannot be denied that some of his motifs—those which the present study has discussed— render the possibility of lyric poetry problematic. These three facts define

Baudelaire historically. They show that he held steadfastly to his cause and focused single-mindedly on his mission. He went so far as to proclaim as his goal "the creation of a cliché [*poncif*]."[91] He saw in this the condition for any future lyric poetry, and had a low opinion of those poets who were not equal to the task. "Do you drink beef tea made of ambrosia? Do you eat cutlets from Paros? How much can you get for a lyre, at the pawnshop?"[92] To Baudelaire, the lyric poet with his halo is antiquated. In a prose piece entitled "Perte d'auréole" [Loss of a Halo], which came to light at a late date, Baudelaire presents such a poet as a supernumerary. When Baudelaire's literary remains were first examined, this piece was rejected as "unsuitable for publication"; to this day, it has been neglected by Baudelaire scholars.

> "What do I see, my dear fellow? *You—here?* I find *you* in a place of ill repute—a man who sips quintessences, who consumes ambrosia? Really! I couldn't be more surprised!"
>
> "You know, my dear fellow, how afraid I am of horses and carriages. A short while ago I was hurrying across the boulevard, and amid that churning chaos in which death comes galloping at you from all sides at once I must have made an awkward movement, for the halo slipped off my head and fell into the mire of the macadam. I didn't have the courage to pick it up, and decided that it hurts less to lose one's insignia than to have one's bones broken. Furthermore, I said to myself, every cloud has a silver lining. Now I can go about incognito, do bad things, and indulge in vulgar behavior like ordinary mortals. So here I am, just like you!"
>
> "But you ought to report the loss of your halo or inquire at the lost-and-found office."
>
> "I wouldn't dream of it. I like it here. You're the only person who has recognized me. Besides, dignity bores me. And it amuses me to think that some bad poet will pick up the halo and straightway adorn himself with it. There's nothing I like better than to make someone happy—especially if the happy fellow is someone I can laugh at. Just picture X wearing it, or Y! Won't that be funny?"[93]

The same scene is found in Baudelaire's diaries, except that the ending is different. The poet quickly picks up his halo—but now he is troubled by the feeling that the incident may be a bad omen.[94]

The man who wrote these pieces was no flâneur. They embody, in ironic form, the same experience that Baudelaire put into the following sentence without any embellishment: "Perdu dans ce vilain monde, *coudoyé par les foules,* je suis comme un homme lassé dont l'oeil ne voit en arrière, dans les années profondes, que désabusement et amertume, et, devant lui, qu'un orage où rien de neuf n'est contenu, ni enseignement ni douleur."[95] ["Lost in this base world, jostled by the crowd, I am like a weary man whose eye,

looking backward into the depths of the years, sees only disillusion and bitterness, and looking ahead sees only a tempest which contains nothing new, neither instruction nor pain."] Of all the experiences which made his life what it was, Baudelaire singled out being jostled by the crowd as the decisive, unmistakable experience. The semblance [*Schein*] of a crowd with a soul and movement all its own, the luster that had dazzled the flâneur, had faded for him. To heighten the impression of the crowd's baseness, he envisioned the day on which even the fallen women, the outcasts, would readily espouse a well-ordered life, condemn libertinism, and reject everything except money. Betrayed by these last allies of his, Baudelaire battled the crowd—with the impotent rage of someone fighting the rain or the wind. This is the nature of the immediate experience [*Erlebnis*] to which Baudelaire has given the weight of long experience [*Erfahrung*]. He named the price for which the sensation of modernity could be had: the disintegration of the aura in immediate shock experience [*Chockerlebnis*]. He paid dearly for consenting to this disintegration—but it is the law of his poetry. This poetry appears in the sky of the Second Empire as "a star without atmosphere."⁹⁶

Written February–July 1939; published in the *Zeitschrift für Sozialforschung,* January 1940. *Gesammelte Schriften,* I, 605–653. Translated by Harry Zohn.

Notes

1. Charles Baudelaire, *Oeuvres,* ed. Yves-Gérard Le Dantec (Paris: Bibliothèque de la Pléiade, 1931–1932), vol. 1, p. 18. [Benjamin's note. "Hypocrite reader—my fellow creature—my brother!" The quotation is from "Au lecteur" (To the Reader), the introductory poem of *Les Fleurs du mal* (first edition 1857; second and enlarged edition 1861).—*Trans.*]

2. Alphonse Prat de Lamartine (1790–1869), popular poet and orator, helped shape the Romantic movement in French literature. He served as foreign minister in the provisional government of 1848, and was the author of *Méditations poétiques* (Poetic Meditations; 1820), *La Chute d'une ange* (The Fall of an Angel; 1838), and *Histoire des Girondins* (History of the Girondists; 1846).

3. Paul Verlaine (1844–1896) was one of the major French poets of the later nineteenth century. His main works include *Fêtes galantes* (Elegant Diversions; 1869), *Romances sans paroles* (Songs without Words; 1873–1874), *Sagesse* (Wisdom; 1880–1881), and *Les Poètes maudits* (Accursed Poets; 1884). Arthur Rimbaud (1854–1891) was a French poet and adventurer whose poetry had a profound influence on modern literature. His major works include *Une Saison en enfer* (A Season in Hell; 1873), a hallucinatory work of autobiography, and *Les Illuminations* (1886), prose poems.

4. Victor Hugo (1802–1885), poet, novelist, dramatist, and statesman, was the

most important of the French Romantic writers. While his novels, such as *Les Misérables* (1862) and *Notre-Dame de Paris* (1831), remain his best-known works, his legacy to the nineteenth century was his lyric poetry. Heinrich Heine (1797–1856), German poet and critic, fled Germany because of his liberal views and lived in Paris after 1831. His best-known works include *Reisebilder* (Travel Images; 1826–1831), *Buch der Lieder* (Book of Songs; 1827), and *Romanzero* (Ballad Collection; 1851).

5. Wilhelm Dilthey (1833–1911) was a German philosopher and historian of ideas. His book *Das Erlebnis und die Dichtung* (Experience and Poetry; 1906) put forward a hermeneutics based on empathetic understanding as an active, productive process. Ludwig Klages (1872–1956), German philosopher, psychologist, and anthropologist, exerted a wide influence in the first half of the twentieth century. His central thesis—most exhaustively expressed in *Der Geist als Widersacher der Seele* (The Intellect as Opponent of the Soul; 1929–1933, 3 vols.), but also evident in his graphological treatise *Handschrift und Charakter* (Handwriting and Character; 1917)—was that an originary unity of soul and body has been destroyed by the human rational capacity. Strongly influenced by Nietzsche, Bergson, and Bachofen, Klages' ideas have gained notoriety because of their absorption into Nazi ideology, whose anti-Semitism Klages shared. C. G. Jung (1875–1961) was a Swiss psychiatrist who served as president of the International Psychoanalytic Association (1911–1914). He met Freud in 1907 and became his leading collaborator, but grew increasingly critical of his approach. Jung's book *Wandlungen und Symbole der Libido* (1911–1912; translated as *The Psychology of the Unconscious*), which posited the existence of a collective unconscious dominated by archetypes, caused a break between the two men in 1913.

6. Henri Bergson (1859–1941), French philosopher, elaborated what came to be called a process philosophy, which rejected static values in favor of values of motion, change, and evolution. He was also a master literary stylist, of both academic and popular appeal. His *Matière et mémoire: Essai sur la relation du corps à l'esprit* (Matter and Memory: Essay on the Relation of the Body to the Mind) appeared in 1896.

7. Here and elsewhere in this essay, Benjamin distinguishes between two functions of memory, *Gedächtnis* and *Erinnerung,* the former understood as a gathering of often unconscious data, and the latter understood as an isolating of individual "memories" per se. This distinction is roughly paralleled by the one between the terms *Erfahrung* (tradition-bound, long experience) and *Erlebnis* (the isolated experience of the moment.) See note 11 below.

8. Bergson argues that the concrete living present, which consists in the consciousness one has of one's body as a center of action, necessarily occupies a moment of duration very different from our ideas of chronological time. Every perception fills a certain "depth of duration" *(épaisseur de durée),* prolonging the past into the present and thereby preparing the future. As a constantly varying spatiotemporal "rhythm," a flow of states, duration is the basis of matter, which, insofar as it is extended in space, must be seen as a present which is always beginning again. See Bergson, *Matter and Memory,* trans. N. M. Paul and W. S. Palmer (New York: Zone Books, 1991), pp. 137–139, 186, 205, 244, and passim.

9. Marcel Proust, *A la recherche du temps perdu* (Paris: Pléïade, 1962), vol. 1, p. 44 *(Du côté de chez Swann)*.

10. Karl Kraus (1874–1936), Austrian journalist and dramatist, edited and wrote for the journal *Die Fackel* from 1899 to 1936. He is best known for his savage satires of journalistic rhetoric. See Benjamin's essay of 1931, "Karl Kraus," in *Selected Writings, Volume 2: 1927–1934* (Cambridge, Mass.: Harvard University Press, 1999), pp. 433–458.

11. This is Benjamin's most concentrated definition of *Erfahrung,* experience over time. In the pages that follow, he will contrast it with *Erlebnis,* the isolated experience of the moment. In notes connected to the composition of "Über einige Motive bei Baudelaire," Benjamin writes that experiences in the sense of *Erlebnisse* are "by nature unsuitable for literary composition," and "work is distinguished by the fact that it begets *Erfahrungen* out of *Erlebnissen.*" See *Gesammelte Schriften,* vol. 1 (Frankfurt: Suhrkamp, 1974), p. 1183. See also Benjamin, *The Arcades Project,* trans. Howard Eiland and Kevin McLaughlin (Cambridge, Mass.: Harvard University Press, 1999), p. 802 (Convolute m2a,4): *Erfahrung* is inseparable from the representation of a continuity.

12. *Eingedenken* is Benjamin's coinage from the preposition *eingedenk* ("mindful of") and the verb *gedenken* ("recollect," "remember"). The resultant term has a more active sense than *erinnern* ("remember") and often verges on the notion of commemoration.

13. Freud's *Jenseits des Lust-Prinzips* (Beyond the Pleasure Principle) first appeared in 1920. Its primary contribution to psychoanalytic theory is a revision of Freud's early insistence that dreams avoid trauma. Based on his work with war veterans suffering from shell shock, Freud concluded that neurotics are in fact characterized by a compulsion to revisit or relive the traumatic scene.

14. Theodor Reik (1888–1969) was an Austrian psychoanalyst and, after 1911, a collaborator of Freud's.

15. Theodor Reik, *Der überraschte Psychologe* (Leiden, 1935), p. 132. In English, *Surprise and the Psycho-Analyst: On the Conjecture and Comprehension of Unconscious Processes,* trans. Margaret M. Green (New York: Dutton, 1937), p. 131.

16. In the present context, there is no substantial difference between the concepts *Erinnerung* and *Gedächtnis* as used in Freud's essay. [Benjamin's note. Freud's assumption, in the original wording, is that "das Bewußtsein entstehe an der Stelle der Erinnerungsspur."—*Trans.*]

17. Paul Valéry (1871–1945), French man of letters, is best known for his prose work *La Soirée avec Monsieur Teste* (An Evening with Monsieur Teste; 1896) and his verse masterpiece, *La Jeune Parque* (1917). His criticism is often cited in Benjamin's later writings. He was elected to the Académie Française in 1925.

18. Paul Valéry, *Analecta* (Paris, 1935), pp. 264–265. [Benjamin's note]

19. Alfred de Musset (1810–1857), French poet, playwright, and translator, ranks alongside Hugo, Lamartine, and Vigny as one of the great Romantic poets. He combined an intense lyricism with a propensity to shock through revelation of his vices: laziness, self-indulgence, a facile talent, and an attraction to opium.

20. Valéry, "The Place of Baudelaire," in *Leonardo, Poe, Mallarmé,* trans. Malcolm

Cowley and James R. Lawler (Princeton: Princeton University Press, 1972), p. 195. Valéry's introduction dates from 1926.

21. Jules Vallès (1832–1885), French socialist journalist and novelist, was a member of the Paris Commune and founded the revolutionary journal *Le Cri du peuple* (1871). His best-known work is the three-volume autobiographical novel *Jacques Vingtras* (1879–1886). Clara-Agathe Nargeot (née Thénon; 1829–?) was a French painter who did a portrait of Baudelaire. Armand de Pontmartin (1811–1890) was a conservative critic whom Baudelaire called a "drawing-room preacher." Paul Claudel (1868–1955), French poet, dramatist, and diplomat, was associated with the Symbolist movement. Théophile Gautier (1811–1872), French poet and man of letters, was a leader of the Parnassians, a poetic school that strove for detachment, technical perfection, and precise description in its verse. The school derives its name from its anthology *Le Parnasse Contemporain* (1866–1876). Nadar (pseudonym of Gaspard-Félix Tournachon; 1820–1910), French writer, caricaturist, and photographer, was one of the great portraitists of the nineteenth century. Among his many innovations were his natural posing of his subjects, a patent on the use of photographs in mapmaking and surveying, the first aerial photograph (made from a balloon), and the first photographic interview.

22. Constantin Guys (1805–1892), French painter, is the subject of Baudelaire's essay "Le Peintre de la vie moderne" (1859). Guys produced watercolors, engravings, and drawings of café life, military scenes, and the fashionable Parisian society of the Second Empire. For Baudelaire, Guys became the representative modern artist through his ability to capture and combine the ephemeral and the eternal in the modern world.

23. André Gide, "Baudelaire et M. Faguet," in *Morceaux choisis* (Paris, 1921), p. 128. [Benjamin's note. Gide (1869–1951), French novelist and man of letters, received the Nobel Prize for Literature in 1947. See "André Gide and Germany" and "Conversation with André Gide," in Benjamin, *Selected Writings, Volume 2: 1927–1934* (Cambridge, Mass.: Harvard University Press, 1999), pp. 80–84 and 91–97.—*Trans.*]

24. Jacques Rivière, *Etudes*[, 18th ed. (Paris, 1948), p. 14]. [Benjamin's note. Rivière (1886–1925), French novelist and critic, edited the *Nouvelle Revue Française* from 1919 until his death. He championed such figures as Proust, Stravinsky, and Nijinsky.—*Trans.*]

25. François-Arsène Houssaye (1815–1897), French journalist, was befriended by Gautier and met, through him, the leading writers of his day. His criticism appeared in virtually every leading newspaper and journal. *La Presse,* the first mass-circulation newspaper, made important innovations. It mixed traditional coverage of politics and the arts with elements of fashion, gossip, and scandal; and it introduced the *feuilleton-roman* (the serial novel), which supplied a new mass readership with sensationalist literature.

26. To endow this crowd with a soul is the very special purpose of the flâneur. His encounters with it are the experience that he never tires of telling about. Certain reflexes of this illusion are an integral part of Baudelaire's work. It has continued to be an active force to this day. Jules Romains' *unanimisme* is an admirable late flowering of it. [Benjamin's note. Jules Romains (1885–1972), French nov-

elist, poet, and playwright, was the author of *Les Hommes de bonne volonté* (Men of Good Will; 27 vols., 1932–1946) and other works. He moved to the United States in 1940.—*Trans.*]

27. Eugène Sue (1804–1857), French author, is known for his serial novels which attracted a wide readership. His most popular were *Les Mystères de Paris* (The Mysteries of Paris; 1842–1843) and *Le Juif errant* (The Wandering Jew; 1844–1845).

28. Friedrich Engels, *Die Lage der arbeitenden Klasse in England: Nach eigner Anschauung und authentischen Quellen*, 2nd ed. (Leipzig, 1848), pp. 36–37. [Benjamin's note. In English, *The Condition of the Working Class in England*, trans. Florence Wischnewetzky (1886; rpt. London: Penguin, 1987), pp. 68–69. Engels' study was first published in 1845.—*Trans.*]

29. Léon Gozlan (1803–1866) was a journalist, novelist, and playwright. He was the author of *Le Triomphe des omnibus: Poëme héroï-comique* (Triumph of the Omnibuses: Heroic-Comic Poem; 1828) and *Balzac en pantoufles* (Balzac in Slippers; 1865). Alfred Delvau (1825–1867) was a journalist and a friend of Baudelaire's. Among his works is *Les Heures parisiennes* (The Parisian Hours; 1866). Louis Lurine (1816–1860), French writer, was the editor of the anthology *Les Rues de Paris* (The Streets of Paris; 1843–1844).

30. Georg Wilhelm Friedrich Hegel, *Werke,* vol. 19, *Briefe von und an Hegel* (Letters to and from Hegel), ed. Karl Hegel (Leipzig, 1887), part 2, p. 257. [Benjamin's note]

31. Paul Desjardins, "Poètes contemporains: Charles Baudelaire," in *Revue Bleue: Revue Politique et Littéraire* (Paris), vol. 14, no. 1 (July 2, 1887): 23. [Benjamin's note. Paul Desjardins (1859–1940), a literary critic and professor of rhetoric, was the organizer, from 1910 to 1940, of the "Decades of Pontigny," a series of meetings at the abbey in Pontigny attended by intellectuals from across Europe and designed to further the tradition of European humanism. Benjamin directed a meeting on his own writings at the abbey in May 1939. On Benjamin's relationship to Desjardins and his institution, see the "Chronology" at the end of this volume.—*Trans.*]

32. Characteristic of Barbier's method is his poem "Londres," which in twenty-four lines describes the city, awkwardly closing with the following verses:

> Enfin, dans un amas de choses, sombre, immense,
> Un peuple noir, vivant et mourant en silence.
> Des êtres par milliers, suivant l'instinct fatal,
> Et courant après l'or par le bien et le mal.
>
> [Finally, within a huge and somber mass of things,
> A blackened people, who live and die in silence.
> Thousands of beings, who follow a fatal instinct,
> Pursuing gold by good and evil means.]

Auguste Barbier, *Iambes et poèmes* (Paris, 1841).

Barbier's tendentious poems, particularly his London cycle, *Lazare* [Lazarus], influenced Baudelaire more profoundly than people have been willing to admit. Baudelaire's "Crépuscule du soir" [Half-Light of Evening] concludes as follows:

ils finissent
Leur destinée et vont vers le gouffre commun;
L'hôpital se remplit de leurs soupirs.—Plus d'un
Ne viendra plus chercher la soupe parfumée,
Au coin du feu, le soir, auprès d'une âme aimée.

[they accomplish
Their fate and draw near the common pit;
Their sighs fill the hospital ward.—More than one
Will come no more to get his fragrant soup,
At the fireside, in the evening, by the side of a loved one.]

Compare this with the end of the eighth stanza of Barbier's "Mineurs de New-castle" [Miners of Newcastle]:

Et plus d'un qui rêvait dans le fond de son âme
Aux douceurs du logis, à l'oeil bleu de sa femme,
Trouve au ventre du gouffre un éternel tombeau.

[And more than one who in his heart of hearts had dreams
Of home, sweet home, and of his wife's blue eyes,
Finds, within the belly of the pit, an everlasting tomb.]

With some masterful retouching, Baudelaire turns a "miner's fate" into the commonplace end of big-city dwellers. [Benjamin's note. Henri Auguste Barbier (1805–1882) was a French poet and satirist whom Baudelaire admired but criticized for moralistic tendencies. His *Iambes* (1831) satirized the monarchy of Louis Philippe.]

33. Albert Thibaudet, *Intérieurs* (Paris, 1924), p. 22. [Benjamin's note. Thibaudet (1874–1936) was an eminent French literary historian.—*Trans.*]

34. Proust, *A la recherche du temps perdu* (Paris, 1923), vol. 6, p. 138 *(La Prisonnière)*. [Benjamin's note]

35. The motif of love for a woman passing by occurs in an early poem by Stefan George. The poet has missed the important thing: the stream in which the woman moves past, borne along by the crowd. The result is a self-conscious elegy. The poet's glances—so he must confess to his lady—have "moved away, moist with longing / before they dared mingle with yours" ("feucht vor sehnen fortgezogen / eh sie in deine sich zu tauchen trauten"). From Stefan George, "Von einer Begegnung" (Encounter), in *Hymnen; Pilgerfahrten; Algabal* (Berlin, 1922). Baudelaire leaves no doubt that *he* looked deep into the eyes of the passer-by. [Benjamin's note]

36. This passage has a parallel in "Un Jour de pluie." Even though it bears the name of another writer, this poem must be ascribed to Baudelaire. The last verse, which gives the poem its extraordinarily somber quality, has an exact counterpart in "The Man of the Crowd." Poe writes: "The rays of the gas lamps, feeble at first in their struggle with the dying day, had now at length gained ascendancy, and threw over everything a fitful and garish luster. All was dark yet splendid—as that ebony to which has been likened the style of Tertullian." The

coincidence here is all the more astonishing as the following verses were written in 1843 at the latest, a period when Baudelaire did not know Poe.

Chacun, nous coudoyant sur le trottoir glissant,
Egoïste et brutal, passe et nous éclabousse,
Ou, pour courir plus vite, en s'éloignant nous pousse.
Partout fange, déluge, obscurité du ciel.
Noir tableau qu'eût rêvé le noir Ezéchiel!

[Each one, elbowing us on the slippery sidewalk,
Selfish and savage, goes by and splashes us,
Or, to run the faster, gives us a push as he makes off.
Mud everywhere, deluge, darkness in the sky.
A somber scene that Ezekiel the somber might have dreamed!]

[Benjamin's note]

37. There is something demonic about Poe's businessmen. One is reminded of Marx, who blamed the "feverishly youthful pace of material production" in the United States for the lack of "either time or opportunity . . . to abolish the old world of the spirit." Baudelaire describes how, as darkness descends, "baleful demons" awaken in the air "sluggish as a bunch of businessmen." This passage, from "Crépuscule du soir," may have been inspired by Poe's text. [Benjamin's note]

38. A pedestrian knew how to display his nonchalance provocatively on certain occasions. Around 1840 it was briefly fashionable to take turtles for a walk in the arcades. The flâneurs liked to have the turtles set the pace for them. If they had had their way, progress would have been obliged to accommodate itself to this pace. But this attitude did not prevail. Taylor—who popularized the slogan "Down with dawdling!"—carried the day. [Benjamin's note. Frederick Winslow Taylor (1856–1915), American efficiency engineer, devoted the last fifteen years of his life to developing the so-called Taylor system, expounded in his book *The Principles of Scientific Management* (1911).—*Trans.*]

39. In Glassbrenner's character, the man of leisure appears as a paltry scion of the *citoyen*. Nante, Berlin's street-corner boy, has no reason to bestir himself. He makes himself at home on the street, which naturally does not lead him anywhere, and is as comfortable as the philistine is within his four walls. [Benjamin's note. Adolf Glassbrenner (1810–1876) was a German writer best known for his humorous and satirical sketches of Berlin life.—*Trans.*]

40. Ernst Theodor Amadeus Hoffmann (1776–1822), German writer, composer, and civil servant, is best-known for his short tales, many of which combine Romantic and gothic elements. "Des Vetters Eckfenster" (The Cousin's Corner Window) is a late tale (1822), a dialogue in which a poet attempts to instruct his cousin in the art of seeing.

41. What leads up to this confession is remarkable. The visitor notes that the cousin watches the bustle down below only because he enjoys the changing play of colors; in the long run, he says, this must be tiring. In a similar vein, and probably not much later, Gogol wrote the following line about a fair in the Ukraine: "So many people were on their way there that it made one's eyes

swim." The daily sight of a lively crowd may once have constituted a spectacle to which one's eyes needed to adapt. On the basis of this supposition, one may assume that once the eyes had mastered this task, they welcomed opportunities to test their newly acquired ability. This would mean that the technique of Impressionist painting, whereby the image is construed from a riot of dabs of color, would be a reflection of experiences to which the eyes of a big-city dweller have become accustomed. A picture like Monet's *Cathedral of Chartres,* which looks like an image of an ant-hill of stone, would be an illustration of this hypothesis. [Benjamin's note. Nikolai Gogol (1809–1852) is known as the father of realism in Russian literature. He was the author of *The Inspector General* (1836), *Cossack Tales* (1836), and *Dead Souls* (1842). Benjamin quotes from his story "Propavshaya gramota" (The Lost Letter). Claude Monet (1840–1926) was one of the greatest of the French Impressionist painters.—*Trans.*]

42. In his story, E. T. A. Hoffmann makes some edifying reflections—for instance, on the blind man who turns his face toward the sky. In the last line of "Les Aveugles" [The Blind], Baudelaire, who knew Hoffmann's story, modifies Hoffmann's reflections in such a way as to deny their edifying quality: "Que cherchent-ils au Ciel, tous ces aveugles?" ["What are all those blind people looking for in the heavens?"] [Benjamin's note. Biedermeier refers to a middle-class style of furniture and interior decoration popular in early nineteenth-century Germany; it is similar to Empire style, but simpler and more sober. A *tableau vivant* (literally, "living picture") is a scene presented onstage by costumed actors who remain silent and still as if in a picture.—*Trans.*]

43. Karl Varnhagen von Ense (1785–1858) was a German diplomat and man of letters. His wife, Rahel, was a leading intellectual and salon figure in early nineteenth-century Berlin.

44. Heinrich Heine, *Gespräche: Briefe, Tagebücher, Berichte seiner Zeitgenossen* (Heine in Conversation: Letters, Diaries, Accounts of His Contemporaries), ed. Hugo Bieber (Berlin, 1926), p. 163. [Benjamin's note]

45. James Sydney Ensor (1860–1949) was a Belgian painter and printmaker whose works are characterized by their troubling fantasy, explosive colors, and subtle social commentary.

46. Valéry, *Cahier B* (Paris, 1910), pp. 88–89. [Benjamin's note]

47. Baudelaire, *Oeuvres,* vol. 2, p. 333 ("Le Peintre de la vie moderne"). [Benjamin's note]

48. Karl Marx, *Das Kapital,* vol. 1 (Berlin, 1932), p. 404. [Benjamin's note]

49. In English in the original.

50. The shorter the training period of an industrial worker, the longer the basic training of a military man. It may be part of society's preparation for total war that training is shifting from techniques of production to techniques of destruction. [Benjamin's note]

51. Alain, *Les Idées et les âges* (Paris, 1927), vol. 1, p. 183 ("Le Jeu"). [Benjamin's note. Alain (pen name of Emile Chartier; 1868–1951), French essayist, took his pseudonym from a fifteenth-century poet. His collected essays, *Propos,* found a primarily youthful audience.—*Trans.*]

52. Aloys Senefelder (1771–1834), Czech-born inventor, was the first to devise pro-

cesses of lithography (1796) and color lithography (1826). He served as inspector of maps at the royal Bavarian printing office in Munich.

53. Ludwig Börne, *Gesammelte Schriften,* vol. 3 (Hamburg and Frankfurt, 1862), pp. 38–39. [Benjamin's note. Börne (born Löb Baruch; 1786–1837), writer and social critic, lived in exile in Paris after 1830. A member of the Young Germany movement, he was one of the first writers to use the feuilleton section of the newspaper as a forum for social and political criticism.—*Trans.*]

54. Gambling nullifies the lessons of experience [*Ordnungen der Erfahrung*]. It may be due to an obscure sense of this that the "vulgar appeal to experience" (Kant) has particular currency among gamblers. A gambler says "my number" in the same way a man-about-town says "my type." Toward the end of the Second Empire, this attitude was widespread. "On the boulevards it was customary to attribute everything to chance." This way of thinking is fortified by betting, which is a device for giving events the character of a shock, detaching them from the contexts of experience. For the bourgeoisie, even political events were apt to assume the form of incidents at a gambling table. [Benjamin's note]

55. Johann Wolfgang Goethe, *Dichtung und Wahrheit,* part 2, book 9. In the sentence preceding, Benjamin writes: "Der Wunsch . . . gehört . . . den Ordnungen der Erfahrung an."

56. Joseph Joubert, *Pensées,* vol. 2 (Paris, 1883), p. 162. [Benjamin's note. Joubert (1754–1824), French thinker and moralist, was an associate of Diderot and Chateaubriand. He took part in the first phase of the Revolution as a justice of the peace in his hometown, Montignac, but withdrew from politics in 1792. His *Pensées,* culled from his journals, were first published in 1838.—*Trans.*]

57. These lines come from Baudelaire's poem "L'Horloge" (The Clock), the last poem in the "Spleen et idéal" section of *Les Fleurs du mal.* The third stanza of the poem begins: "Trois mille six cents fois par heure, la Seconde / Chuchote: *Souviens-toi!*" ("Three thousand six hundred times an hour, the second-hand / Whispers: 'Remember!'")

58. The narcotic effect that is involved here is time-specific, like the malady it is supposed to alleviate. Time is the material into which the phantasmagoria of gambling has been woven. In *Les Faucheurs de nuit* [Reapers by Night; 1860], [Edouard] Gourdon writes: "I assert that the mania for gambling is the noblest of all passions, for it includes all the others. A series of lucky *coups* gives me more pleasure than a nongambler can have in years. . . . If you think I see only profit in the gold I win, you are mistaken. I see in it the pleasures it procures for me, and I enjoy them to the full. They come too quickly to make me weary, and there are too many of them for me to get bored. I live a hundred lives in one. When I travel, it is the way an electric spark travels. . . . If I am frugal and reserve my banknotes for gambling, it is because I know the value of time too well to invest them as other people do. A certain enjoyment that I might permit myself would cost me a thousand other enjoyments. . . . I have intellectual pleasures, and want no others." In the beautiful observations on gambling in his *Jardin d'Epicure* [Garden of Epicurus; 1895], Anatole France presents a similar view. [Benjamin's note]

59. Benjamin refers to a quintessential work by the fourteenth-century Italian painter Giotto di Bondone—namely, his portrait of "Wrath" *(Iracondia),* one of

the seven vices depicted in the frescoes of the Arena or Scrovegni Chapel in Padua (ca. 1305–1306). The portrait shows a female figure rending her garments in a fit of rage.

60. Proust, "A propos de Baudelaire," in *Nouvelle Revue Française,* 16 (June 1, 1921): 652. [Benjamin's note. This is a translation of Benjamin's German translation of Proust. For a more literal translation of the original French, see *The Arcades Project,* p. 309 (Convolute J44,5). Proust speaks of "un étrange sectionnement du temps" ("a strange sectioning of time") in the world of Baudelaire.—*Trans.*]

61. Baudelaire's idea of natural correspondences—reflected in his poem "Correspondances," cited below in the text—derives mainly from the Swedish mystic Emanuel Swedenborg (1688–1772), who envisioned a universal language in which everything outward and visible in nature was a symbol pointing to an inward spiritual cause. Baudelaire develops his idea of modern beauty *(beauté moderne)* at the end of his "Salon de 1846" (section 18).

62. Charles Fourier (1772–1837), French social theorist and reformer, called for a reorganization of society based on communal agrarian associations which he called "phalansteries." In each community, the members would continually change roles within different systems of production. Synaesthesia is a condition in which one type of stimulation evokes the sensation of another, as when the hearing of a sound produces the visualization of a color.

63. Beauty can be defined in two ways: in its relationship to history and in its relationship to nature. Both relationships bring out the role of semblance, the aporetic element in the beautiful. (Let us characterize the first relationship briefly. On the basis of its *historical* existence, beauty is an appeal to join those who admired it in an earlier age. Being moved by beauty means *ad plures ire,* as the Romans called dying. According to this definition, "semblance of beauty" means that the identical object which admiration is courting cannot be found in the work. This admiration gleans what earlier generations admired in it. A line by Goethe expresses the ultimate wisdom here: "Everything that has had a great effect can really no longer be evaluated.") Beauty in relation to *nature* can be defined as "that which remains true to its essential nature only when veiled." (See *Neue deutsche Beiträge,* ed. Hugo von Hofmannsthal [Munich], 2, no. 2 [1925]: 161 [Benjamin, "Goethes Wahlverwandtschaften" (Goethe's Elective Affinities).—*Trans.*].) *Correspondances* help us to think about such veiling. We may call it, using a somewhat daring abbreviation, the "reproducing aspect" of the work of art. The *correspondances* constitute the court of judgment before which the art object is found to be a faithful reproduction—which, to be sure, makes it entirely aporetic. If one attempted to reproduce this aporia in the material of language, one would define beauty as the object of experience [*Erfahrung*] in the state of resemblance. This definition would probably coincide with Valéry's formulation: "Beauty may require the servile imitation of what is indefinable in things" (*Autres rhumbs* [Paris, 1934], p. 167). If Proust so readily returns to this object of experience (which in his work appears as time recaptured), one cannot say he is revealing any secrets. It is, rather, one of the disconcerting features of his technique that he continually and loquaciously

builds his reflections around the concept of a work of art as a copy, the concept of beauty—in short, the hermetic aspect of art. He writes about the origin and intentions of his work with a fluency and an urbanity that would befit a refined amateur. This, to be sure, has its counterpart in Bergson. The following passage, in which the philosopher indicates all that may be expected from a visual actualization of the uninterrupted stream of becoming, has a flavor reminiscent of Proust. "We can let our day-to-day existence be permeated with such vision and thus, thanks to philosophy, enjoy a satisfaction similar to that of art; but this satisfaction would be more frequent, more regular, and more easily accessible to ordinary mortals" (*La Pensée et le mouvant: Essais et conférences* [Paris, 1934], p. 198). Bergson sees within reach what Valéry's better, Goethean understanding visualizes as the "here" in which the inadequate becomes an actuality. [Benjamin's note. The last phrase of this note—"in dem das Unzulängliche Ereignis wird"—is an allusion to the Chorus Mysticus that ends Goethe's *Faust, Part II. Ad plus ire* literally means "to go to the many," to join the masses that have died.—*Trans.*]

64. Marceline Desbordes-Valmore (1786–1859), French actress and writer, was the author of children's stories and poetry (collected in *Poésies,* published in 1842). The phrase "hysterical tears" appears in English.

65. Proust, *A la recherche du temps perdu,* vol. 8, pp. 82–83 *(Le Temps retrouvé).* [Benjamin's note]

66. Jules-Amédée Barbey d'Aurevilly, *Les Oeuvres et les hommes (XIXᵉ siècle),* part 3, *Les Poètes* (Paris, 1862), p. 381. [Benjamin's note. Barbey d'Aurevilly (1808–1889), French critic and novelist, was a long-time friend of Baudelaire. Timon, a misanthropic Athenian, is the hero of Shakespeare's *Timon of Athens* (ca. 1607–1608). Archilochus (6th century B.C.) was a Greek lyric poet and writer of lampoons, in whose work the poetry of heroism yields to that of feeling and reflection.—*Trans.*]

67. In the mystical "Colloquy of Monos and Una," Poe has, so to speak, taken the empty time sequence to which the subject in the mood of spleen is delivered up, and copied it into the *durée;* he seems blissfully happy to have rid himself of its horrors. It is a "sixth sense" acquired by the departed, consisting of an ability to derive harmony even from the empty passage of time. To be sure, it is quite easily disrupted by the rhythm of the second-hand. "There seemed to have sprung up in the brain *that* of which no words could convey to the merely human intelligence even an indistinct conception. Let me term it a mental pendulous pulsation. It was the moral embodiment of man's abstract idea of *Time.* By the absolute equalization of this movement—or of such as this—had the cycles of the firmamental orbs themselves been adjusted. By its aid I measured the irregularities of the clock upon the mantel, and of the watches of the attendants. Their tickings came sonorously to my ears. The slightest deviation from the true proportion . . . affected me just as violations of abstract truth are wont, on earth, to affect the moral sense." [Benjamin's note]

68. Max Horkheimer, "Zu Bergsons Metaphysik der Zeit" (On Bergson's Metaphysics of Time), in *Zeitschrift für Sozialforschung,* 3 (1934): 332. [Benjamin's note]

69. See Bergson, *Matière et mémoire: Essai sur la relation du corps à l'esprit* (Paris, 1933), pp. 166–167. [Benjamin's note. See, in English, *Matter and Memory,* p. 139.—*Trans.*]

70. In Proust, the deterioration of experience manifests itself in the complete realization of his ultimate intention. There is nothing more ingenious or more loyal than the way in which he casually, and continually, tries to convey to the reader: Redemption is my private show. [Benjamin's note]

71. Baudelaire, *Oeuvres,* vol. 2, p. 197 ("Quelques Caricaturistes français"). [Benjamin's note]

72. Ibid., pp. 222–224 ("Salon de 1859: Le Public moderne et la photographie"). [Benjamin's note. The quotations from Baudelaire that immediately follow in the text are likewise from this essay (p. 224). Baudelaire's critique of photography is cited at greater length in *The Arcades Project,* pp. 691–692 (Convolute Y10a,1–Y11,1).—*Trans.*]

73. Valéry, "Avant-propos" [Foreword], *Encyclopédie française,* vol. 16: *Arts et littératures dans la société contemporaine,* I (Paris, 1935), 16.04–5/6. [Benjamin's note]

74. "Ach, du warst in abgelebten Zeiten meine Schwester oder meine Frau!" This is a line from Goethe's poem dedicated to Charlotte von Stein, "Warum gabst Du uns die tiefen Blicke" (Why Did You Give Us Deep Gazes). The poem was discovered in 1864 in a letter of April 14, 1776, to Frau von Stein, Goethe's beloved.

75. The moment of such a success is itself marked as something unique. It is the basis of the structural design of Proust's works. Each situation in which the chronicler is touched by the breath of lost time is thereby rendered incomparable and removed from the sequence of days. [Benjamin's note]

76. Novalis, *Schriften* (Berlin, 1901), part 2 (first half), p. 293. [Benjamin's note. Novalis (pseudonym of Friedrich Leopold, Freiherr von Hardenberg; 1772–1801) was a poet and theorist, and a central figure of the early German Romantic period. His works include the verse collections *Blütenstaub* (Pollen; 1798) and *Hymnen an die Nacht* (Hymns to the Night; 1800), and the unfinished novel *Heinrich von Ofterdingen* (1802).—*Trans.*]

77. This conferred power is a wellspring of poetry. Whenever a human being, an animal, or an inanimate object thus endowed by the poet lifts up its eyes, it draws him into the distance. The gaze of nature, when thus awakened, dreams and pulls the poet after its dream. Words, too, can have an aura of their own. This is how Karl Kraus described it: "The closer one looks at a word, the greater the distance from which it looks back." (Karl Kraus, *Pro domo et mundo* [Munich, 1912], p. 164.) [Benjamin's note]

78. See Walter Benjamin, "L'Oeuvre d'art à l'époque de sa reproduction mécanisée," in *Zeitschrift für Sozialforschung,* 5 (1936): 43. [Benjamin's note. See "The Work of Art in the Age of Its Technological Reproducibility" (section III), in this volume.—*Trans.*]

79. Proust, *A la recherche du temps perdu,* vol. 8, p. 33 *(Le Temps retrouvé).* [Benjamin's note]

80. Valéry, *Analecta,* pp. 193–194. [Benjamin's note]

81. From "Correspondances," in *Les Fleurs du mal.*

82. Goethe's poem "Selige Sehnsucht" (Blessed Longing) was published in the volume *West-östlicher Divan* (Divan of West and East; 1819).
83. Baudelaire, *Oeuvres*, vol. 1, p. 40. [Benjamin's note. This is the first stanza of Poem XXIV (untitled) of the "Spleen et idéal" section of *Les Fleurs du mal.—Trans.*]
84. Ibid., vol. 1, p. 190 ("L'Avertisseur" [The Lookout]). [Benjamin's note]
85. Ibid., vol. 1, p. 40 ("Tu mettrais l'univers entier dans ta ruelle" [You'd Take the Whole World to Bed]). [Benjamin's note]
86. Ibid., vol. 2, p. 622 ("Choix de maximes consolantes sur l'amour" [Consoling Maxims on Love]). [Benjamin's note]
87. Ibid., vol. 2, p. 359 ("Le Peintre de la vie moderne" [The Painter of Modern Life]). [Benjamin's note]
88. Georg Simmel, *Mélanges de philosophie rélativiste: Contribution à la culture philosophique,* trans. Alix Guillain (Paris, 1912), pp. 26–27. [Benjamin's note. The original title of Simmel's essay is "Exkurs über die Soziologie der Sinne" (On the Sociology of the Senses; 1911).—*Trans.*]
89. Baudelaire, *Oeuvres,* vol. 2, p. 273 ("Salon de 1859," section 8, "Le Paysage" [Landscape]). [Benjamin's note]
90. Ibid., vol. 1, p. 94 ("L'Horloge" [The Clock]). [Benjamin's note]
91. See Jules Lemaître, *Les Contemporains: Etudes et portraits littéraires* (Paris, 1897), pp. 31–32. [Benjamin's note. Benjamin refers to a passage from Baudelaire's notebooks: "To create a new commonplace [*poncif*]—that's genius. I must create a commonplace." See *"My Heart Laid Bare" and Other Prose Writings,* trans. Norman Cameron (1950; rpt. New York: Haskell House, 1975), p. 168 ("Fusées," no. 20). See also Baudelaire's "Salon de 1846," section 10.—*Trans.*]
92. Baudelaire, *Oeuvres,* vol. 2, p. 422 ("L'Ecole païenne" [The Pagan School]). [Benjamin's note]
93. Ibid., vol. 1, pp. 483–484. [Benjamin's note. "Perte d'auréole" was rejected by the *Revue Nationale et Etrangère* in 1865, two years before Baudelaire's death, and was first published in 1869 in the posthumous edition of his *Petits poèmes en prose,* also known as *Le Spleen de Paris.—Trans.*]
94. It is not impossible that this diary entry was occasioned by a pathogenic shock. The form the entry takes, which links it to Baudelaire's published work, is thus all the more revealing. [Benjamin's note. For the diary entry in question, see *"My Heart Laid Bare" and Other Prose Writings,* p. 165 ("Fusées," no. 17).—*Trans.*]
95. Baudelaire, *Oeuvres,* vol. 2, p. 641. [Benjamin's note. He quotes from the conclusion of the final section of "Fusées."—*Trans.*]
96. This phrase comes from section 8 of Friedrich Nietzsche's uncompleted, posthumously published early work *Die Philosophie im tragischen Zeitalter der Griechen* (Philosophy in the Tragic Age of the Greeks). In its original context, it refers to the Presocratic Greek philosopher Heraclitus, whom Nietzsche presents, in a typically self-reflecting vein, as a proud solitary, flaming inwardly while outwardly looming dead and icy.

The Regression of Poetry, by Carl Gustav Jochmann

Introduction

Access to the text which follows may be made easier by a consideration of the reasons it has been so little known up to now.

The place that intellectual productions hold in the historical tradition is not determined always, or even principally, by their immediate reception. Rather, they are often received indirectly, through the medium of productions left behind by writers with affinities to the ones in question—be it as forerunners, contemporaries, or successors. Popular memory [*Gedächtnis der Völker*] tends to classify the material handed down to it into groups. Such groupings are fluid, and their components also change. But anything that does not become a lasting part of them is consigned to oblivion.

Yet as we look around for writers with affinities to Jochmann, whether among his predecessors or among his contemporaries, we become aware that their outlines, if not their names, seem enveloped in shadow. A generation before Jochmann, there was Georg Forster.[1] His work is cordoned off in the memory of Germans as he himself was once cordoned off by German troops in Koblenz. Even his extraordinary letters from the Paris of the Great Revolution have hardly been able to breach this barrier. Any account that succeeded in tracing the continuity of revolutionary thought among the German emigrants in Paris from Forster to Jochmann would settle a debt to a vanguard of the German bourgeoisie which finds its present-day descendants insolvent. It would come across men like Count Schlabrendorf, whose work began in the mid-eighteenth century and who became a friend of

Jochmann in Paris.[2] The recollections relating to the history of the Revolution which Jochmann set down on the basis of Schlabrendorf's accounts undoubtedly bear comparison with memoirs of the German emigration around 1800. Anyone wishing to pursue them further could probably expect to find Varnhagen's still-unpublished papers, now in the Berlin State Library, especially enlightening.[3]

It was Varnhagen who composed the following description of Schlabrendorf—a portrait worthy of Tacitus:[4] "Statesman without office, citizen without homeland, wealthy man without money." Jochmann, for his part, wrote on October 4, 1820: "Hitherto, I have met only a single independent person: an old man of seventy, who even now does not have a servant; a rich man who has an income of forty thousand thalers but who spends scarcely one thousand, so that he can use the rest to aid the poor; a count who has always wanted to live only in countries and under conditions in which his rank means nothing." Another friend of Jochmann's was Oelsner, Paris chargé d'affaires from Frankfurt-am-Main, who in turn was a close friend of Sieyès.[5] That the members of his circle entrusted to Jochmann their memoirs of the Revolution and especially of the National Convention—chronicles that made their most significant impact in his major essay on Robespierre—throws even more light on his political stance, since the early years of the Restoration were hardly conducive to such communications. The regime of Louis XVIII was intent on discrediting the events of 1789–1815, both to the survivors and to posterity, as a chain of misdeeds and humiliations.

It cannot be supposed that the German bourgeoisie abruptly mislaid its awareness that it had been represented in revolutionary Paris, or that it had provided reliable witnesses to the emancipatory struggle of the middle classes. Not only Gutzkow and Heine but Alexander von Humboldt and Liebig saw Paris as the metropolis of world citizenship; for Nietzsche, it was no doubt still the capital of good Europeans.[6] It was only the establishment of the Prussian Reich which destroyed the German bourgeoisie's traditional image of Paris. Feudal Prussia made the city of the Great Revolution and the Commune into a Babylon whose neck it clamped under its jackboot. "Berlin is to be the holy city of the future, the radiance of its nimbus spreading across the world. Paris is the brazen, corrupt Babylon, the great whore who shall be . . . swept from the face of the earth by God's exterminating angel. Don't you know that the Lord has anointed the Germanic race as his elect?" Thus wrote Blanqui in September 1871, in his vehement call for the defense of Paris.[7] At the same time, again through the foundation of the Empire, the German middle classes lost a second traditional context, no less rich in content, in which the phenomenon of Jochmann might have been preserved. It is the context of the liberation movement in the Baltic provinces. Jochmann was a Balt. He was born in Parnu in 1789, and spent his

childhood in the seclusion of that country town. At thirteen he moved with his family to Riga. After attending the cathedral school there, he studied at the universities of Leipzig, Göttingen, and Heidelberg. Students from the Russian Baltic provinces stuck together at German universities. In Heidelberg, Jochmann became friendly with Löwis of Menar. Blum's biography of the latter contains an account of Jochmann—the most detailed we have from those early years. It includes an episode which is the only extant description of Jochmann's political activity, and which thus provides an apt foil for the ideas set out in his essay reproduced here.

> He was one of the most attractive figures from that turbulent period. Highly gifted by nature, he developed a distinctive character at an early age. He was a wonderful blend of keen intellect and whimsy, bold action and cautious deliberation, practical talent and silent observation. In his early youth, while this remarkable fellow was still at school, his lively mind had conceived projects that he would see realized without his own participation. Once, with a mysterious air, he took a friend of his out of town and into the stillness of the woods, where he revealed his ideas for the liberation of Greece. . . . Now that he was confronted with the triumphant progress of the French in Germany, . . . an old, cherished dream revived within him. He wanted to work for the liberation of Poland, and thought he could do so most readily by following Napoleon's eagles.[8] Although his decision met with no approval from his older friend [Menar], who was the only person he took into his confidence, he nevertheless stuck to it. They both dined one last time with their friends, then slipped away. Löwis kept him company in the darkness that night, and not long afterward received a letter telling him that Jochmann had successfully joined a French regiment. Jochmann later wrote several more letters. . . . Closer acquaintance with the heroic freedom-lovers of the Grande Armée—whose commanders, he realized, would never come to the assistance of Poland—soon convinced him to leave the French. Later he kept the affair so secret that he appears to have said nothing about it even to the excellent Zschokke, for whom he had the highest regard.[9]

The idea of liberating the peasants—an idea that, in conjunction with nationalism, had been given a powerful boost by the French Revolution—finally took hold in Latvia, where it was disseminated by a number of Baltic intellectuals. These included Jochmann's friends in Riga, and among them we come across the name of Garlieb Merkel.[10] Merkel was younger than Forster but older than Jochmann. In the field of literary history, his reputation was low. The Romantics, especially A. W. Schlegel, gave him short shrift—an attitude that he made himself vulnerable to with his inadequate assessments of great works.[11] German literary history noted the inadequacy. What it passed over in silence was the fact that Merkel's treatise on the Latvians, published in Leipzig in 1797, inaugurated the struggle for the abolition of serfdom in Latvia. The book is distinguished not only by its unflinching description of poverty among the Latvian peasants, but also by

valuable information on Latvian folklore. It has been extirpated from the memories of educated people still more radically than the work of Forster, and one may wonder whether the disrepute which Merkel the critic seemed to attract was not directed primarily at Merkel the politician.

Those with an open mind toward such questions can learn about a neglected aspect of the German middle classes at the end of the eighteenth century. They will come across men—of limited creativity but of great importance in the context of world history—whose candor and whose loyalty to their convictions provided the indispensable and unrecognized basis for the more far-reaching but more circumspect revolutionary formulations of Kant and Schiller. In the mid-nineteenth century, this had not yet been forgotten. At that time, the Baltic writer Julius Eckardt had remarked aptly of Merkel's political activity: "How opportune was Merkel's enthusiasm for common sense and the enlightened morality that was to prove so insufferably tedious as a critical yardstick for the evaluation of a *Faust* or even merely a *Genovefa!*[12] . . . The unrelenting rigor with which the young Merkel applied his barely digested wisdom to the conditions around him is an exemplary illustration . . . of the inspiring moral force that animated the much-maligned political and religious rationalism of those days—a rationalism which our radical extremists now consider a fit target . . . for bad jokes."

When, in later years, Merkel took issue with the Romantics and even with Goethe, the die had already been cast for the revolutionary future of the German middle class. That was not the case fifteen years earlier. Behind the Balt Merkel there stood only the small circle around Nicolai; the Balt Jakob Michael Reinhold Lenz figured among the leading lights of the Sturm und Drang and was a spokesman for its revolutionary sentiments.[13] That is how he is evoked by Büchner;[14] and one of the most impressive passages in Jochmann's essay below seems to contain an echo of Lenz from this point of view. An echo, or perhaps just an allusion. Jochmann's comment on the most exquisite flowers of our poetry—"with scarcely two or three exceptions," he said, they sprang from the seed of servility—recalls these moving lines by Lenz:

> Germany, poor Germany!
> From your soil, art put forth sickly stems,
> Just a few lackluster blooms
> Clinging among the corn, dispersed by the wind,
> Containing within them, only now and then,
> A seed or two of genius.

Jochmann kept his distance from his contemporaries. Anyone who is receptive to the linguistic form of the essay below will not be greatly surprised that its author never signed anything he published. Nor did he adopt a

pseudonym; merging anonymously with his writing, he won no immortality from it. More convincingly than Lichtenberg,[15] he could have dedicated his writings "To Your Majesty, Oblivion." He turns his back on the future (which he speaks of in prophetic tones), while his seer's gaze is kindled by the vanishing peaks of earlier heroic generations and their poetry, as they sink further and further into the past. It is thus all the more important to point out the close affinity between this visionary and isolated spirit and the German champions of the bourgeois revolution. The most soldierly among them, Johann Gottfried Seume, leads us back to the Baltic circle.[16] The Baltic countries were particularly conducive to a study of the decay of feudalism. Seume wandered throughout Europe as a judicious observer of social conditions. It is said that as he entered the living quarters of some Latvian peasants, his attention was caught by a large whip hanging on the wall. He asked what it meant, and recorded the reply he received. "That," he was informed, "is the law of our land." From his manuscript, Seume contributed a poem to Merkel's treatise supporting the Latvian serfs; it forms the conclusion to the volume.

Jochmann suffered deeply while living under the conditions in Latvia. After he left Riga in 1819, having accumulated sufficient means through his practice as a lawyer, he never saw the city again. "Jochmann," writes his biographer, "purchased the fine intellectual training and mental clarity gained in his youth with a homelessness which plagued him throughout his life." But, he adds perceptively, "this sickness was also his health, and his discontent with his homeland became an indictment of that country." Until his early death, in 1830, Jochmann lived by turns in Paris, Baden, and Switzerland. In Switzerland he became a friend of Zschokke, who deserves credit for preserving his literary remains.

The names, including Zschokke's, that we come across in Jochmann's sphere of activity show that no special measures were needed to make him a missing person. The members of that isolated vanguard of the German bourgeoisie are all more or less forgotten—even the literary talents who, though they never attained Jochmann's stature, can readily bear comparison with more famous names. But there is a special reason hardly any of them have been as forgotten by the public as Jochmann. It is an objective reason, which also makes it easier to understand his subjective aversion to authorship. He was isolated even among this vanguard. Younger than his comrades-in-arms, Jochmann began writing when Romanticism was at its zenith. Far from keeping his distaste for the movement to himself, he expressed it in such extravagant terms that one is briefly unsure which authors he has in mind when speaking of the "versified writings" that derive their subject matter from "older treasure troves." Yet he obviously believed that the "toilsome idleness . . . we call scholarship" informed the composition of works such as Tieck's *Kaiser Octavianus,* Brentano's *Romanzen vom*

Rosenkranz, and even Novalis' *Hymnen an die Nacht.*[17] And when he scolds unworldly scholars who yearn to be back in the age of the pyramids, he is thinking of Lorenz Oken.[18]

The vanguard of the German bourgeoisie was isolated in its time; Jochmann was isolated among them; and isolated among Jochmann's works is the essay "Über die Rückschritte der Poesie" [On the Regression of Poetry]. Nothing in his other works can compare with the interpretation of history presented in this essay. The measuring out of the essay's philosophic tensions is the source of both its importance and its beauty. To take the latter first: this essay is distinguished by the fact that, while containing philosophical content of the highest order, it eschews philosophical terminology. The survival of Jochmann's ideas is due to his rare literary mastery. "A concise style," writes Joubert, "is proper to reflection. Anyone who has devoted energy to thinking will impart a sculptural terseness to the products of his thought."[19] Jochmann's syntax, one might say, bears the marks of the chisel.

His essay follows the course of humanity from prehistoric times into the distant future. Within this temporal span, poetry comes into being and passes away. Does it really pass away? On this question, Jochmann vacillates in a thought-provoking way. To the extent that he is developing Enlightenment ideas, they lead him to affirm Plato's edict "banishing" poets.[20] But this judgment is clearly reversed in the essay's closing paragraph. When Jochmann speaks of the "more intelligent and thus more rewarding" use of the imagination which he hopes the future will hold, readers should not necessarily see this as a poetic use (though they might well interpret the phrase as envisioning a more humane form of political economy); nevertheless, the concluding passage speaks of a rebirth of the "poetic spirit" which will find its true vocation in "triumphal songs of approaching happiness." This curious hesitation, this almost explicit undecidedness concerning the future development of the poetic faculty, is surely more illuminating than any categorical pronouncement on the subject would have been. Not only is Jochmann's circumspection closely bound up with the peculiar beauty of his essay, but it is unlikely that an essay burdened with categorical statements on such matters would have been successful. Jochmann thus displays admirable wisdom in his choice of words, being content, as early as the second paragraph, to raise the quietly persistent question of whether we are right in considering "everything past as also lost, and everything lost as unreplaced and irreplaceable."

That, in fact, was the view of the Romantics. Jochmann's reflections throw light on some isolated and noteworthy reactions provoked by the Schlegel brothers when they exchanged the humanistic enthusiasms of their youth for their later devotion to the Christian Middle Ages. By about 1800, this change was unmistakable. There is a letter, dating from 1803, which in spirit and form is a worthy prelude to Jochmann's insights. It was written

by A. L. Hülsen to his previously like-minded elder A. W. Schlegel.[21] His appeal is a response to the tendencies which, around the turn of the century, made European chivalry a favorite subject for the Schlegel brothers. Hülsen wrote:

> May heaven preserve us from seeing the old castles rebuilt! Tell me, dear friends—how am I to understand your views on this? I really don't know. . . . Though you may seek out the most dazzling side of the age of knighthood, darkness falls on it again once we consider it as a whole. Friedrich[22] travels to Switzerland, where he visits places such as the Valais; children name the proud castles for him, telling him about the despots of old, and the memory of those tyrants seems indestructible amid the ruins. But this view of the matter is not what's called for. It is enough that that system cannot exist in conjunction with any godly way of life. Rather, I wish that this great multitude we call the people would hit each one of us scholars and knights over the head, since our greatness and advantages are founded solely on their wretchedness. Poorhouses, prisons, armories, and orphanages stand side by side with the temples in which we worship the deity. . . . If we are considered in our capacity as human beings, then none of us, qua philosophers and artists, amounts to anything at all. For the life of a single one of them—even the poorest—is worth far more, in its claim on society, than the greatest fame that any of us might win as high-sounding scholars and quarreling knights.

With Romanticism, the pursuit of false riches began. It was an attempt to assimilate everything belonging to the past—not by furthering the emancipation of humanity (which would have made human beings more keenly aware of their own history and capable of learning things from it) but by unearthing and imitating all the works of extinct peoples and bygone eras. The Romantics boldly took up the form of the medieval epic—but they did so in vain. The Nazarenes tried to emulate the medieval depictions of saints—and likewise failed.[23] In a different historical context, such efforts might doubtless appear more fruitful and significant. Jochmann saw them as barren and meaningless, and thereby acquired a historical perspective that eluded his contemporaries. Only at the end of the century, after those ruinous tendencies had put down deep roots in Europe, especially in architecture, did Jugendstil begin to rebel against that ever more flamboyant, ever more tawdry wealth. The theories of van de Velde began to exert an influence. The Düsseldorf school of Olbrich and the Vienna Werkbund continued the reaction, which has presented its latest theses with the Neue Sachlichkeit and its most important ideas in the work of Adolf Loos.[24]

Loos was an outsider, as Jochmann had been. He felt an instinctive urge to reconnect with the rationalism of the bourgeoisie at its zenith. It is no accident that his dictum "ornamentation is crime" sounds like a résumé of Jochmann's comments on tattooing.[25] Loos's work prepares the way for an awareness of the problematic side of art—an awareness that opposes the

aesthetic imperialism of the nineteenth century, the gold-fever pursuit of "eternal" values in art. From Loos, light falls on Jochmann. The former wrote in order to eradicate a deeply rooted infestation; the latter offered remedies for a malaise that was just at its onset. After World War I, the debate entered its decisive stage: the question had to be either worked through in theory or modishly glossed over. Both solutions had their political equivalents. The first coincides with recent attempts to formulate a materialist theory of art (see Walter Benjamin, "L'Oeuvre d'art à l'époque de sa reproduction mécanisée," *Zeitschrift für Sozialforschung*, 5, no. 1 [1936]). The second has been favored by totalitarian regimes and has appropriated the reactionary elements of Futurism, Expressionism, and to some extent Surrealism. It redefines the problematic of art in order to sanction its bloodiest accomplishments under the sign of the aesthetic. It reveals at the same time how the craving for what is past has exceeded all measure: fascism aims at nothing less than the commandeering of myth.

In contrast, Jochmann writes: "Not everything past is lost." (We do not need to make it anew.) "Not everything lost is unreplaced." (Much has moved into higher forms.) "Not everything unreplaced is irreplaceable." (Much that was once useful is now useless.) It can be stated with certainty that Jochmann was a hundred years ahead of his time, and almost as certainly that his Romantic contemporaries regarded him as lagging fifty years behind them. For, as Paul Valéry writes, "the Romantics rebelled against the eighteenth century, thoughtlessly leveling a charge of superficiality against men who were infinitely better informed, more curious about facts and ideas, more tireless in pursuit of anticipations and large-scale ideas than they had ever been themselves."[26]

The arc of Jochmann's thought extends between gray prehistory and the golden heyday of the human race. He traces the path of several of mankind's virtues, primarily poetic artistry, during that time; he recognizes that the progress of humanity is intimately bound up with the regression of several virtues, above all poetic art. This raises a question. Is the arch which runs from primeval times to the future supported on the columns of Hegelian theory? At present, it is impossible to say with certainty. Hegel's *Phenomenology of Spirit*[27] had undoubtedly been published when Jochmann began his studies. But did he ever come across it? That the relationship Jochmann posits between the progress of the human race and the regression of poetry is dialectical in the Hegelian sense cannot be doubted. But we sometimes find dialectical interpretations in authors of the same period who certainly had no knowledge of Hegel—for example, in Fourier's assertion that all partial improvements in social conditions during the "civilizing" process necessarily cause a deterioration in the status quo overall.[28] There is also some evidence that Fourier's ideas were not unknown to Jochmann. Compare the important reflections on *virtus post nummos* with this passage

in *Le Nouveau Monde industriel et sociétaire:*[29] "This base metal—I mean 'base' in the eyes of moralists—will become a very precious material if it helps to maintain unified systems of production." Similar points of contact can be found in other writings by Jochmann. Yet it would be inadvisable to pursue the comparison, and to ask whether the children's choruses from the phalansteries' operas were mingling with the "triumphal songs of spreading happiness" that Jochmann was straining to hear. Such a confluence, however tempted one might be to imagine it, is highly uncertain.

Jochmann does not adorn future society with the bright colors of the utopian. Rather, he delineates it with the clear classical line used by Flaxman to render the contours of the gods.[30] The severe, privative formulation used by Marx in the same context—that of the "classless" society—seems prefigured in Jochmann's text rather than in those of the utopians. But a historical link emerges still more irrefutably in Jochmann's concept of "songs of the ancient world." According to this idea, imagination is the "original faculty of the soul," from which the capacity for rational thought is clearly distinguished as a later acquisition. Poetry was thus the natural language of the ancient world; prose, being more suited to rational reflection, appeared later. "Song provides the elements of the first language," we read in Book I, Thesis 59, of Vico's *Scienza nuova.*[31]

Jochmann's theory of poetry as the original linguistic faculty of the ancient world has its origin in Vico. According to Vico, the language of images, communicated soundlessly through signs [*Winke*] of a hieroglyphic or allegorical kind, was the language of the first age of the world. It was followed by that of song, of heroic song, which Vico sees as arising from a twofold source: on the one hand from "the poverty of language," and on the other from "the need to achieve intelligible expression despite this poverty." The expressive power of heroic language derives from the fact that, far from replacing prosaic speech, it bursts open speechlessness. Prosaic speech comes third and last, the language of mankind's late period. This is Vico's seminal idea which bore fruit in Jochmann's essay. That Jochmann took it from none other than Vico is proved by the latter's Thesis 58, whose superbly laconic style Jochmann transforms, at one point in his essay, into an especially beautiful sequence of rhetorical periods. This thesis states: "People who cannot speak emit inarticulate sounds which are akin to song. Stutterers use song to increase the mobility of their tongues."

For Jochmann, as for Vico, the images of gods and heroes in which early peoples found fulfillment were not a product of devious priestly fraud or a mendacious fairy tale concocted by power-hungry despots. These images were the first in which the human race, however unclearly, addressed its own nature, drawing from them strength for the long journey ahead. The idea that (in Jochmann's words) "a more poetic quality once pervaded all human opinions and knowledge" and supplied an inexhaustible fund for

poetry is likewise taken from Vico, as is the view that the crudity of the earliest languages inclined their users toward song. "Poetic knowledge," writes Vico, "which in pagan times was the first knowledge, was based on a metaphysic imbued with the sensuous and . . . governed by the imagination. This corresponded to the qualities of the first humans, who were not concerned with reflective thought but possessed immense powers of intuition and an originary imagination. These elements determined the poetry that was spontaneously theirs. It sprang both from their essential nature and from their ignorance."

Jochmann's view of prehistoric times, derived from Vico, divided him as sharply from the Enlightenment as his conception of the future severed him from the Romantics. Only in the light of this double separation can we fully appreciate the isolation in which he wrote the essay below. It explains why the essay was forgotten: nothing seems to weave it back into tradition, and no one was able to pick up its thread afterward. Let us hope that its present revival is no more fortuitous than its earlier obscurity was.

—Walter Benjamin

Carl Gustav Jochmann's, von Pernau, Reliquien: Aus seinen nachgelassenen Papieren

[The Literary Remains of Carl Gustav Jochmann of Parnu: Selections from His Posthumous Papers], ed. Heinrich Zschokke, vol. 1 (Hechingen: Verlag der F. X. Ribler'schen Hofbuchhandlung, 1836).

[From the Foreword] [iii] Following are the literary remains of a deceased noble German—writings which that gifted man had kept for himself as the final result of his observations of a most fateful age. The friend to whom he bequeathed his papers on his deathbed was designated not so much his literary executor as an arbiter who would decide whether those writings were worthy of publication. Any criticisms, whether justified or not, of the makeup of this collection should therefore be directed at the editor alone. Up to now, Jochmann's name has been little heard or known among German readers. This man, whether out of modesty or good judgment, fled literary fame with as much determination as others pursue it, and perhaps not without reason. If he let himself be persuaded to publish this or that work, he always did this with the strict proviso that its author's name be kept secret. [iv] The major part of his literary remains consisted of a mass of diligently collected materials for the continuation or expansion of writings already published, on topics such as the history of Protestantism, hierarchy, and homoeopathy. . . . Another part comprised

numerous diary notebooks, finished or half-finished essays, sketches, and preliminary notes for future works on the French Revolution, the Jesuits, political economy, religion and its history, and a natural history of the nobility. It should be noted, in particular, that the editor of this collection has made no use of any rough drafts, for reasons which can be readily understood. He has contented himself with selecting Jochmann's scattered observations and notes on the world, on scholarship, and on life, and gathering and ordering his completed essays. A number of these were sent for trial publication to a few journals, but are also, as is proper, included in this collection for the sake of completeness, especially since journals seldom attract attention or are worth preserving. . . . [v] Jochmann was as noble in mind as in heart, free of the dictates of prejudice and passion; a man of the most thorough learning and the most diverse knowledge, yet without pretensions. Independently wealthy, he was in touch with outstanding men he had met during his various sojourns in Russia, England, Germany, France, Switzerland, and Italy. Yet he preferred the role of philosophical observer to any other part on the world stage. . . . His style, usually light and congenial, often becomes brilliant, eloquent. Frequently it carries such a dense mass of complex thoughts that each sentence must be examined and weighed separately. Its earnest progression is punctuated by dazzling flashes of truth that strike sparks in the reader's soul. Jochmann is one of the few writers of our time who, unawares, stir the spirit they merely sought to refresh, making it more alive, more penetrating, more creative—who awaken more light within us than they admit from outside.

—Heinrich Zschokke
 Aarau; December 12, 1835

[Information on his life, by the editor] [1] Karl Gustav Jochmann, of Parnu. . . . Parnu is a small town in Livonia, on the bay of Riga. Jochmann was born there on February 10, 1790. It seems that by the time he was thirteen his thirst for knowledge could no longer be satisfied by the local school. His father entrusted him to a friend in Riga, Councilor Kreutzing, so that he could attend the cathedral school in that city. After studying there for four years, he went to the University of Leipzig at seventeen. He subsequently studied at the universities of Göttingen, Heidelberg, and—to improve his knowledge of French—Lausanne. Returning to Riga, he entered the business world as a lawyer. He was successful in his profession. But perhaps his youth was sometimes held against him, or perhaps he regretted taking up a permanent position in life too early; whatever the case, in 1812 he traveled to Great Britain to

gain facility in English as well. He visited Oxford and Edinburgh; he then spent a whole year partly in London and partly in the country, staying with a clergyman. . . . After returning home to Riga, he practiced his profession as a legal consultant; he was highly regarded, but derived little pleasure from his work. Neither the money nor the public respect it earned him could reconcile him with a profession which went against his inclinations. He yearned for a more independent life, beneath a milder sky, among people with a more progressive outlook. . . . Possessing wealth which assured him of independence and an untroubled future, he finally parted from his friends in Riga in April 1819. . . . [3] . . . Once on German soil, where he could again converse with the wise men and artists of the age and luxuriate unhindered in the flowers and fruits of literature, he breathed more freely and happily. But he soon found something inhospitable and alien to his spirit *even in the Germany of that time*. Beneath the somber wings of the Holy Alliance,[32] the atmosphere seemed close and stifling to him. Wherever he went, he met people inflamed by partisan sentiments. It was in those days that the writer Kotzebue was stabbed to death by Sand.[33] Jochmann decided to curtail his stay among the Germans.

[From Zschokke's account of his first meeting with Jochmann, on September 12, 1820] [35] While we sat talking in the garden . . . and he was telling me about his travels and about his plans for the future, I became absorbed in contemplation of his person. He was well built but of scarcely medium height, thin and delicate, and the unhealthy pallor of his otherwise pleasant face testified to his already shattered health. His kind, gentle eyes, even when they brightened in moments of enthusiasm or with feel[36]ings of joy, seemed to speak of hidden sorrow. Gradually his form grew dim and vague before me; though I heard his voice, I paid no attention to his words. At that moment, the course of his earlier life, including the secret history of his heart, down to particular details, became clear to me. When at length he paused for a moment, no doubt expecting a response from me, I once more became aware of my surroundings. Instead of pursuing the conversation, I asked permission to tell him frankly what had just happened involuntarily within me, because it was important to me to learn whether I had merely been deluded by my imagination. I told him of his past, of some special circumstances in his life, of a love which had had a painful outcome for his heart, and so on. His gaze was fixed strangely on me, and he frankly confirmed the various events, even the correctness of some incidental and trivial things I had mentioned. Both equally amazed, we then exhausted ourselves with speculations of all kinds, in our attempt to solve this riddle of the soul.

[Further biographical information and an account of Jochmann's death, according to Zschokke] [36] That incident marked the beginning of a friendship which we preserved unbroken throughout our lives. Jochmann traveled to southern France to restore his health in a milder climate. After almost a year there, he returned to me dissatisfied. He spent part of that summer (1821) in various regions of Switzerland, and subsequently [37] went to Paris, where he spent some wonderful days in the company of Oelsner, Schlabrendorf, Stapfer, and other sages and men of affairs. Then he came back to recuperate in the healthful springs of Baden-Baden, which seemed to do him good; ultimately he settled there almost permanently, dividing his time between Baden-Baden and Karlsruhe. . . . [77] He loved life, terming it a "sweet habit," but did not seriously believe that his own would last very long; [78] nor did he even wish it to, if it turned out to be merely a prolonged wasting away. . . . [80] The eighth clause of his will states: "All my manuscripts—collections of material, essays, and suchlike papers of all kinds, with the sole exception of my correspondence and business documents—I bequeath to my dear and honored friend Herr Heinrich Zschokke in Aarau, who shall be given them at no cost. I doubt that he will be able to make much of them. But I am sure that if this is the case, for the sake of our long-standing friendship he will take the trouble to destroy them."

[From a letter written by Jochmann in Tharand to E. H. von Sengbusch in Riga, June 11, 1819] [4] The English have historiographers. The Italians likewise had them, in the days of their freedom and fame. The French at least have very rich collections on which to base a history—that is to say, memorabilia which escaped the pernicious influence of the authorities of their time only because they were hidden away, and which came to light through later descendants. Only in Germany—thanks to the abject blindness of the low and the genteel ignorance of the high—is there practically nothing except *genealogical charts* and a mass of insignificant *histories of princely families,* to which the history of the people has been reduced. An herbarium instead of a rich landscape! . . . [18] On top of this, the German governments, perhaps through awareness of their insecure position but certainly not to strengthen it, condone the most ridiculous jealousy of native achievement, so that all outstanding Germans regretfully come to expect recognition of their achievements—and the reward and even the protection due them—only from foreign governments.

[On Fichte's notion of the closed commercial state] [141] It's curious that a philosophical mind like Fichte's could advocate a form of society which would obviously bring the development of the human species to the same

standstill we observe in the animal kingdom. China and Japan have been trying this unnatural experiment for a long time. Fortunately, perfecting this system—this annihilation of all links with the rest of the world—would require a new *kind of money,* which, without being paper money, can be of value to only *one* people and no other. Fichte claimed to be in possession of the secret. But he took it with him to his grave. Nature has no self-contained commercial states. Even the planets and solar systems exist through interchange of their light, their mass, and other forces. On earth, everything is designed to promote connections; oceans are the best means of connecting continents. Differences among languages separate peoples only as far as is necessary to set several societies the task of solving the problem of general [*allgemein*] society at the same time. But languages intermingle everywhere, as do [142] linguistic laws—for example, the law of syllables—and these common elements lead back to a general connectedness. The fact that the idea of separation and continuous division, if carried through logically both in the details and in the whole, always leads to unnatural results, to poverty and helplessness, proves that this can be only a *means* and never an end. All political demarcations and borders between nations, estates, trades, literatures, and so on bear eternal witness to our restlessness in a cramped situation. We stretch and twist and try out a thousand positions, but in *this* bed we shall never find rest!

Carl Gustav Jochmann's, von Pernau, Reliquien: Aus seinen nachgelassenen Papieren

[The Literary Remains of Carl Gustav Jochmann of Parnu: Selections from His Posthumous Papers], ed. Heinrich Zschokke, vol. 2 (Hechingen: Verlag der F. X. Ribler'schen Hofbuchhandlung, 1837).

[Jochmann on machinery] [93] The mode of generating wealth by means of machinery spreads the enjoyment otherwise confined to a few to all the families of the nation, becoming a bountiful means of producing riches. But to prevent this from becoming a misfortune for the majority through the increasingly unequal distribution of the wealth produced, nature requires a further restructuring of social forms. To discover this new structure is the task of our time.

"DIE RÜCKSCHRITTE DER POESIE"
[The Regression of Poetry]

There are phenomena in human history which appear at first sight like regression, and which may well be that if taken in isolation. But in the context of other circumstances accompanying them, and in their more distant relations to all epochs, they have proclaimed in the most unmistakable way the progress of our species.

No special acuity of mind is required to convince oneself of this in several such cases. Apart from a few unworldly scholars, few people would be tempted to admire the gigantic works of hoary antiquity—monstrous testaments to an equally monstrous degradation of day-laboring millions—for anything other than their massiveness; and few would be tempted to regard the impossibility of emulating their builders as a misfortune, or to yearn for the days of the grimacing priestly masks of Egypt because the pyramids were erected then. But there is a greater risk of misunderstanding in cases where it is not just violent regimes and their achievements that have diminished, but some sphere of intellectual activity, where principles and faculties have significantly lost power and outward influence, without [250] declining to the same extent in prevailing opinion. The more we continue to prize them and the greater the admiration inspired in us by legends of their earlier omnipotence, the more dismay we feel at their present weakness, and the more inclined we are to view everything past as lost and everything lost as unreplaced and irreplaceable.

More important examples of this kind are afforded by the history of the gradual slackening of many types of moral inspiration, such as patriotism, civic pride, and, more generally, the history of various skills and arts, especially poetry, which have been simultaneously losing their inner perfection and their outward effectiveness.

To convince ourselves of the ancient splendor and influence of poetry, it is unnecessary to point to the legends of its earliest dominion, extending even over the animal world and inanimate nature. . . . [251] . . . The older a people, the more significant its poetry; the more ancient its writers, the more inaccessible their works. A single glance at the songs of the ancient world, and at the written poetry of more recent peoples, proves that the steps taken by the latter along this path were anything but progress, that older treasure troves have provided the material for the inlaid work of our versified writings, that the high seriousness of earlier poetry has been made into a more or less obvious joke, and that the role of teacher of the nation has diminished to the social pastime of a few well-educated people.

But whether the decline of poetry from its earlier heights to its present insignificance—though undeniably a loss in itself—should be regarded as such in other contexts can be judged only from the circumstances which, as effective causes, imparted that predominant and almost exclusive direction to the use and development of the human mind. It should be judged, I say, from *circumstances;* for to refer in this instance to the higher and more universal abilities of the earlier poets would be to presuppose as understood what actually needs to be explained. We are concerned here with the question of why mental faculties which (as experience teaches us) are capable of infinitely varied development are able at certain times to strive toward only a single goal, and with such notable success.

Three main reasons for this phenomenon can be discerned, partly in the subject matter of poetry and partly in the methods determining its form [252]. First, in earlier times all human opinions and knowledge were infused with a more poetic quality, and this was more directly conducive to poetry; second, there was a distinct lack of practical means for preserving and disseminating intellectual possessions; and finally, all comparatively poor and undeveloped languages readily lend themselves to forms using fixed rhythms, whereas when they are applied more freely they encounter more difficulties. . . . [261] . . .

If we glance briefly at the reasons for the greater development and dignity of poetic art—the boundless ability of an imagination, when awakened early, to encompass the whole range of our spiritual and mental life; the lack of reliable means of preserving the word, which forced human beings to entrust all the treasures of knowledge to mere memory in poetic forms; and finally the state of both language and its user, which caused the rule of metrical expression to be perceived and needed earlier than the law of free speech, commending it to both the narrator and his audience—it must be clear to us at once that any change which served to eliminate any one of these circumstances would constitute progress, and that consequently the decline of the poetic imagination from its former heights furnishes proof, in more than one respect, of a more general progression [262] among peoples. . . . [268]

. . . Any attempt to use the imagination, and only the imagination, to perform the tasks of other faculties makes the attainment of the desired end not only more difficult but impossible. Each intervention of the imagination into the sphere of an earlier [should read: later][34] mental capacity is a mistake; each of its creations in the realm of reality is an illusion. And if the physical being, in going beyond the lowest stages of his development, learns only to make better use of the nonpractical possessions and abilities he has acquired, so the intellectual being, in the same situation, must relinquish and unlearn his possessions and abilities if he is to ad-

vance further. Hence the disproportion between our outward progress, which subjects ever-new forces of nature to our will and reveals to us ever-new truths, and our inner development, which consists in an unending struggle against the dominion of old prejudices and errors: the disproportion between constant gains in the realm of appearance and constant losses of alleged acquisitions in the domain of thought. If our reason, as Bayle[35] somewhere remarks, is really not a grounding and constructive force but a disintegrating and destructive one, it has been so, at least up to now, because it has always been preceded by the poetic spirit, and has first had to clear a space for its works. On our path of regression, which may be only apparent but in any case is inevitable, we have not yet reached the point where we can turn onto the better path; but we are drawing near it, and the edict by which Plato banished poets from his imaginary [269] state[36] is being gradually but irrevocably enacted in the real world by an advancing civilization.

Far from lamenting the regression of poetry, therefore, we should be applauding it. Though often due to defects in the poet and his lesser ability, it is far more often the accomplishment of his time. And the weaker the effect of poetry in a particular area of knowledge, the more general the insensitivity toward a specific kind of poetic work, the more certain it is that the intellectual needs in that same area, originally met by poetry, are satisfied now by some more adequate means. . . . [277]

To see that the glory and influence of poetry are vanishing wherever the mind is destined by nature to operate through other means and in different forms, and to regard this as anything but a misfortune, does not mean that we should overlook poetry's peculiar value within its own proper sphere of activity. There are stutterers who can express themselves intelligibly only by singing. We can rejoice [278] if they learn to speak and are not obliged to sing their message or warning, but this does not mean we are any less receptive to the enchantment of song. Rather, our sense of the true dignity and beauty of a particular art will be all the purer and keener, the less that art pleases us when put to an unsuitable use. . . . [308]

Moreover, the overexpansion of the realm of imagination is due not only to the after-effects of its earlier predominance, but also to the influence of conditions persisting in our own day. Its causes lie both in the past and in the present; so that although in the former case it is merely a sign of the eccentricity of our scholars, in the latter it is evidence of a fundamental defect in our society itself.

As long as imagination presents itself as the primary faculty of the soul simply because no other has yet reached a comparable state of development, its prevalence is entirely natural. If, in this state, it alone populates the whole kingdom of our thought with its creations, it does so without

driving out any other inhabitants. If, likewise, it alone rules over all our physical needs and relationships, it does so because they do not yet have any other legitimate ruler; and no matter what bad consequences an artificial creation of the same phenomena under changed circumstances may have, we can nonetheless confidently predict that, as long as we are dealing with a mere imitation of the past, this grasping into emptiness will, if left to itself, soon cease of its own accord, and the nature of things will unfailingly triumph over such daydreams. But there is another situation in which imagination enjoys a similar preeminence, not as the only mental faculty which is alert but as the only one which is free; a situation in which other forces are certainly awake, but in chains; in which the real world with all its treasures and truths is no longer unknown to us, but locked away. And if, in such a state of things—which is most clearly seen in our old Europe, in contrast to the happier regions of the New World— a nation is forced to continue along the wrong paths it has taken because no better ones are open to it, then a sick imagination comes to hold the scepter of one formerly so rich, and the ramblings of a feverish mind replace the inspiration of the poet. Under such conditions, the finest products of so-called higher culture are crutches for a crippled society rather than free expressions of abundant intellectual vitality; are eruptions of a feeling unsatisfied in the artificial desert of the middle-class life around us; are emigrations from reality into the realm of thought which, like those into foreign lands, seldom proclaim the prosperity and more often the wretchedness of the country left behind. Hence, according to an astute observer [310] of the Old and New Worlds, and despite the unquestionable superiority of education in the latter compared to ours, arts and sciences which do not have an immediately rewarding purpose have made negligible progress there, whereas in the declining Roman Empire and among the rabble of old France, both were able to flourish. In the country of Washington and Franklin, everyone can find food and shelter. Why, then, make painful efforts to embellish a superfluity that meets no need, when moderate activity assures a person of all that is necessary— and even more than that—for physical and moral well-being? No one in the United States, unless he is found to be a criminal, is deprived of what is essential not only for preserving but for enjoying life. No one is estranged from those domestic circumstances which make up the most precious advantage of our race; no one is superfluous in life; no one forced to retreat into himself and seek in the realm of thought what his fate on earth has refused him. But the so-called intellectual superiority of old Europe is composed of such things. It has arisen from painful privations like these. . . . [316]

If the regression of imagination from its earlier, natural preeminence can be regarded as an advance on the part of reason, the curtailments of

its enforced prevalence in a later period prove, likewise, to be advances on the part of public well-being. These two, reason and well-being, inward and outward progress, presuppose each other. To be happier, one must become more reasonable; and sometimes not only good fortune but also some happiness is needed, if one is to become more reasonable. And who knows whether, at a certain stage of development, the outward benefits of fortune may not be still more indispensable to people for the expansion of their intellectual possessions than the latter will be for the increase of their fortunes.

Yet no matter how far the vital well-being of the New World may surpass the sterile intellectual luxuries of the Old [317], it is possible to imagine situations more multifaceted and comprehensive than either, in which human beings would not be required to renounce the treasures of reality, which is all-powerful, but would also be capable of an exercise of imagination at once more rewarding and more intelligent. But as we make our way there—and in their straight route toward that goal, the advantages of the sober intellect of the new Europeans of the North American free states are clearly evident—handbooks of taste will be of no use to us. We will need developments in our social forms—developments that are closely bound up with the most important truths of political economy and their application.

A major part—perhaps the greatest part—of our spiritual and intellectual incapacity is explained by our lack of resources; and a major part of our moral deficiency is explained by our material privations. There are truths, someone remarked, which cannot be uttered courteously or effectively in a shabby coat, and that person was right. But truths which are seldom uttered at all in a shabby coat are far more numerous. Gold makes us bold [*Gut macht Muth*]; it makes us candid as much as it makes us haughty. We think like servants because we feel weak, and our judgments are generally as restricted as our circumstances. We start out from poverty in both areas of life, and can attain prosperity only in both together. The first care the savage takes of his body consists in its superstitious embellishment; he thinks he is adorning himself by torturing himself, beautifying himself by self-mutilation. Just as he burns and cuts limbs that are exposed to the hostile attacks of all the elements, and that he can neither nourish nor clothe, he likewise, with the same complacency, distorts and poisons his divine spiritual image with vices and prejudices he takes to be pure merit and wisdom, long before he knows how to protect and preserve that image.

How could our so-called fine arts ascend to the heights they are capable of, so long as they worked as mere hirelings of every base infatuation and passion! For superstition, they have raised and embellished temples; for despots, they have built palaces; for selfishness and arrogance, they

have collected and admired all their treasures. Even today, with scarcely two or three exceptions, the most exquisite flowers of our poetry, when dissected into their components, would lie before us like the fable of La Fontaine which Rousseau put to a similar test: a sickening blend of self-deception and flattery, deifications of their own and others' worthlessness.

And whatever differences may exist in theory among the various acquisitions of human progress, in reality they are all—by virtue of belonging to the same species—one and indivisible, the material advances determining the value of their owners, and the moral advances determining their happiness. Across the gulf which in the nature of things separates physical deprivation from spiritual prosperity [319], imagination vainly erects its multicolored arch; and though an individual genius may occasionally vault over that gulf, an entire people never can. In order for a people to cross, there must be a more substantial bridge—one that can bear the weight of the human body as well. Earthly goods, which now merely pamper us, will beautify life as communal goods; privileges which now corrupt their owner will ennoble him as rights. Only when the value of peripheral things ceases to be inflated by their rarity will our age cease to confuse them with others whose value is not based on chance, and Horace's dictum "Virtus post nummos!" [Virtue after money!]—the watchword of baseness in the mouths of individuals—conveys, when applied to the fate of entire peoples, a more comforting truth than either the poet of Augustus or his patron could have imagined.

To the extent that humanity is learning to use its knowledge more and more as power, and to the extent that it is gaining more understanding, and therefore control, of nature—passing on the menial tasks, which blunt and irritate its finest powers, to subordinate creatures of its hand, machines and tools of all kinds—it is opening the way to a still happier new world, which rewards its carefree immigrants with the challenge to make exertions of greater and greater nobility. In approaching this goal, it doubtless achieves an intellectual and spiritual development which surpasses America's comfortable mediocrity no less than it outstrips our sickly bustlings, and in whose wake [320] the poetic spirit soars all the higher the less it is exhausted by aimless wanderings in alien regions. The leisure of a truly human society would put forth other fruits than the toilsome idleness of our bourgeois society which we call scholarship; the triumphal songs of spreading happiness would sound different from the sighs of unrequited longing; and the jubilation of unbound Prometheus would have a ring very different from the laments of the god in chains.

—Carl Gustav Jochmann, *Über die Sprache: "Rede, dass ich dich sehe"* [On Language: "Speak, That I May See Thee"][37] (Heidelberg: C. F. Winter, 1828)

Abridged version published in the *Zeitschrift für Sozialforschung,* 1940. *Gesammelte Schriften,* II, 572–598. Translated by Edmund Jephcott.

Notes

1. Johann Georg Forster (1754–1794), German traveler and writer, published in 1777 an account of his voyage around the world with Captain Cook. His father, Johann Reinhold Forster (1729–1798), was also a travel writer. Forster was a strong advocate of the French Revolution and of democratic government. See Benjamin's comments on Georg Forster in "German Letters," in Benjamin, *Selected Writings, Volume 2: 1927–1934* (Cambridge, Mass.: Harvard University Press, 1999), p. 467. See also "Germans of 1789," in this volume.
2. Christian Gustav von Schlabrendorf (1750–1824), German author, published works on a wide variety of topics, including the theory of language, religious history, and medicine.
3. Karl Varnhagen von Ense (1785–1858) was a German diplomat and writer, and a prominent Berlin intellectual. Varnhagen's "still-unpublished papers" are now in Krakow, Poland. His wife, Rahel Varnhagen, led the most important Romantic salon in Berlin.
4. Cornelius Tacitus (A.D. 55?–117?), Roman orator, politician, and historian, was one of the greatest prose stylists to write in Latin.
5. Konrad Engelbert Oelsner (1764–1828) was a German businessman and writer. Emmanuel-Joseph Sieyès (1748–1836), French churchman and constitutional theorist, developed a concept of popular sovereignty which guided the French bourgeoisie in their struggle against the monarchy and nobility during the opening months of the French Revolution. He later played a major role in organizing the coup d'état that brought Napoleon Bonaparte to power (1799).
6. Karl Gutzkow (1811–1878) was a German journalist, novelist, and playwright. From 1830 to 1850 he was a leader of the group of writers known as Young Germany, which opposed nationalist monarchy and literary Romanticism. Heinrich Heine (1797–1856), one of the great German lyric poets, was forced to emigrate to Paris because of his radical democratic views. Friedrich Wilhelm Heinrich Alexander, Freiherr von Humboldt (1769–1859), German naturalist, explorer, and educational reformer, was a major figure in the classical period of physical geography and biogeography—areas of science now included in the earth sciences and ecology. Baron Justus von Liebig (1803–1873) was a chemist who made important contributions to biochemistry and is considered the founder of agricultural chemistry. He established at Giessen the first practical chemical teaching laboratory, where he introduced methods of organic analysis. On the idea of the "good European" in the philosophy of Friedrich Nietzsche (1844–1900), see his book *Die fröhliche Wissenschaft* (The Gay Science; 1882), sections 357 and 377.
7. Louis-Auguste Blanqui (1805–1881), French political activist and writer, was committed to permanent revolution. After a classical lyceum education in Paris, he studied law and medicine, but devoted himself to conspiracy in the Carbonari

and other secret societies, becoming a leading socialist agitator. He was often wounded in street fighting and spent a total of forty years in prison, yet maintained a fiery patriotism. He was the author of *L'Eternité par les astres* (Eternity via the Stars; 1872) and *Critique social* (Social Critique; 1885). The passage cited in the text comes from his book *La Patrie en danger*.

8. An image of an eagle, a traditional symbol of war and imperial power, was borne on the standards of Napoleon's armies.

9. Julius Eckardt, *Die baltischen Provinzen Rußlands: Politische und culturgeschichtliche Aufsätze* (The Baltic Provinces of Russia: Political and Cultural-Historical Essays), 2nd ed. (Leipzig, 1869), pp. 327ff., citing Karl Ludwig Blum, *Ein Bild aus den Ostsee-Provinzen; oder Andreas von Löwis of Menar* (A Picture from the Baltic Provinces, or Andreas von Löwis of Menar; Berlin 1846). Andreas von Löwis of Menar (1777–1839), born in Estonia and educated in Germany, was an engraver and etcher, as well as a writer who specialized in agronomy and economics. Johann Heinrich Daniel Zschokke (1771–1848), German author and journalist, emigrated to Switzerland in 1796 after the failure of his academic aspirations. He produced work in a wide variety of genres, including novels, dramas, and works of moral edification.

10. Garlieb Merkel (1769–1850), a journalist and cultural historian of Baltic origin, edited the newspaper *Der Zuschauer* (The Observer), which for decades informed the German-speaking middle-class public in Riga, Latvia, of developments in science, literature, and the arts, effectively initiating the tradition of the feuilleton. His book *Die Letten, vorzüglich in Liefland, am Ende des philosophischen Jahrhunderts* (The Latvians, Especially in Livonia, at the End of the Philosophical Century) was a sympathetic portrait of the Latvian people and their folklore. It helped make his reputation as a founding father of the Latvian nation.

11. August Wilhelm Schlegel (1767–1845), German scholar, critic, and translator, was one of the main disseminators of German Romantic thought. He is best known for his editorship (with his brother Friedrich) of the Romantic journal *Athenäum* and for his brilliant translations of Shakespeare.

12. Eckardt refers to Goethe's verse drama *Faust* (Part I, 1808; Part II, 1832) and to the popular story "Genovefa" (1810), by Christoph von Schmid (1768–1854). Schmid's tale is based on the life of Saint Geneviève, patron saint of Paris, who saved that city from the Huns in 451.

13. Friedrich Nicolai (1733–1811), German writer, played a prominent role alongside Gotthold Ephraim Lessing and Moses Mendelssohn in the spread of Enlightenment thought in Germany. His journal, the *Allgemeine deutsche Bibliothek* (German General Library), was a central organ of the Enlightenment. J. M. R. Lenz (1751–1792), Russian-born German poet and dramatist, was, after Goethe, the most talented of the authors of the Sturm und Drang movement.

14. Georg Büchner (1813–1837), German dramatist, produced two landmarks of European theater, *Dantons Tod* (Danton's Death; 1835) and *Woyzeck* (1836), both of which combine harsh psychological realism with a suggestive episodic structure.

15. Georg Christoph Lichtenberg (1742–1799) was a German writer and experi-

mental psychologist. Although he was a feared satirist in his time, he is remembered today as the first great German aphorist.

16. Johann Gottfried Seume (1763–1810) was the author of poems, plays, travel accounts, aphorisms, and an autobiography. His best-known work is *Spaziergang nach Syrakus im Jahre 1802* (A Journey on Foot to Syracuse in 1802; 1803).

17. Ludwig Tieck (1773–1853), German Romantic novelist and dramatist and a leader of the Romantic movement, is best known for the novel *Franz Sternbalds Wanderungen* (Franz Sternbald's Wanderings; 1798), one of the first German Romantic novels, and for his fairy tales and folktales, notably *Der blonde Eckbert* (Fair Eckbert; 1796) and *Volksmärchen* (Folktales; 1797). Tieck published the verse drama *Kaiser Octavianus* (Emperor Octavianus) in 1804. Clemens Brentano (1778–1842), German poet of the Romantic school, produced—with Achim von Arnim—*Des Knaben Wunderhorn* (The Boy's Magic Horn; 1806–1808), an influential collection of poems based on folk songs. Brentano also wrote plays, lyric poems, fairy tales, and such novellas as *Geschichte vom braven Kasperl und dem schönen Annerl* (The Story of Just Casper and Fair Annie; 1817). The *Romanzen vom Rosenkranz* (A Romantic Garland of Roses; written 1803–1812, published 1852) is an unfinished poetic work of legendary religious character in the form of a succession of verse romances. Novalis (pseudonym of Friedrich Leopold, Freiherr von Hardenberg; 1772–1801) was a poet, theorist, and central figure of the early German Romantic period. Among his works are the verse collections *Blütenstaub* (Pollen; 1798) and *Hymnen an die Nacht* (Hymns to the Night; 1800), and the unfinished novel *Heinrich von Ofterdingen* (1802).

18. Lorenz Oken (1779–1851), German scientist, philosopher, and physician, taught medicine and physiology at Jena and Munich. His main work is the thirteen-volume *Naturgeschichte für alle Stände* (Natural History for All Social Ranks; 1833–1841).

19. Joseph Joubert (1754–1824), French writer and moralist, was an associate of Diderot and Chateaubriand. His *Pensées,* culled from his journals, were first published in 1838.

20. Plato discusses poetry in Books 2, 3, and 10 of *The Republic* (ca. 380 B.C.). "Imitative poetry" is banned from the ideal state because such imitations are at three removes from the truth grasped by philosophy and because the uncontrolled emotions of literary characters have a deleterious effect on audiences.

21. August Ludwig Hülsen (1765–1810), German philosopher and educator, was a member of the Romantic circle around Fichte and the Schlegel brothers in Jena. His philosophy, which is focused on the problem of consciousness, was shaped by Romantic notions of pantheism.

22. Reference is to Friedrich Schlegel.

23. The Nazarenes were a group of young German painters active from 1809 to 1830. Intent on restoring a religious spirit to art, they established themselves in Rome under the leadership of Johann Overbeck, Philipp Veit, and Franz Pforr.

24. Jugendstil was a style of architectural, figurative, and applied art that flourished

in the last decade of the nineteenth century and the early years of the twentieth. After 1896, it was associated in Germany with the periodical *Die Jugend* (Youth). Akin to Art Nouveau, it signified not only a crossing of the cultural barrier separating "higher" from "lower" arts, but an educational movement intent on restructuring the human environment. Benjamin often uses the term broadly to include literature as well. Henry van de Velde (1863–1957), Belgian architect and craftsman, was an important contributor to Jugendstil. He was the author of the influential book *Vom neuen Stil* (On the New Style; 1907). Joseph Maria Olbrich (1867–1908) was a German architect and a cofounder of the Vienna Secession, the Austrian manifestation of the Art Nouveau movement. Olbrich was a student of Otto Wagner, one of the founders of modern architecture in Europe.

The German Werkbund was one of the first attempts to bring artists together with industry in the attempt to foster high-quality design and craftsmanship for mass-produced goods and architecture. Founded in Munich in 1907, the Werkbund was composed of artists, artisans, and architects who designed industrial, commercial, and household products. The Werkbund was disbanded in 1933, with the advent of Nazi rule in Germany, but was revived after World War II.

Neue Sachlichkeit ("New Objectivity," "New Matter-of-Factness") designates the work produced by a group of German artists in the 1920s who espoused a representational approach (in contrast to the prevailing stylized modes of Expressionism and Abstraction) and who reflected what was characterized as the resignation and cynicism of the post–World War I period in Germany. The term was coined in 1924 by Gustav F. Hartlaub, director of the Mannheim Kunsthalle (art museum). In a 1925 exhibition assembled at the Kunsthalle, Hartlaub displayed the works of George Grosz, Otto Dix, Max Beckmann, Georg Schrimpf, Alexander Kanoldt, Carlo Mense, and Georg Scholz. Adolf Loos (1870–1933), Austrian architect, led the movement away from Art Nouveau and toward a modern, rectilinear style that anticipated the International Style. His best-known writing is the essay collection *Ornament und Verbrechen* (Ornament and Crime; 1908).

25. See Jochmann's essay "Die Rückschritte der Poesie," printed below.
26. Paul Valéry (1871–1945), French poet and essayist, is best known for essayistic fictions such as *La Soirée avec Monsieur Teste* (An Evening with Monsieur Teste; 1896) and major poems of the Symbolist and post-Symbolist periods.
27. G. W. F. Hegel (1770–1831), German philosopher, was professor at Heidelberg (1816–1818) and Berlin (1818–1831). His system of philosophy, centered in the idea of the absolute spirit, was the leading system of metaphysics during the second quarter of the nineteenth century. His work *Die Phänomenologie des Geistes* appeared in 1807.
28. Charles Fourier (1772–1837), French social theorist and reformer, called for a reorganization of society based on communal agrarian associations which he called "phalansteries." In each community, the members would continually change roles within different systems of production.
29. *Le Nouveau Monde industriel et sociétaire* (The New Industrial and Societary

World) was published in 1829–1830. The Latin phrase means "virtue after money."

30. John Flaxman (1755–1826), English sculptor, illustrator, and designer, was a leading practitioner of the Neoclassical style.

31. Giambattista Vico (1668–1744), Italian philosopher of cultural history and law, first articulated the concept of historicism. He attempted, especially in his *Scienza nuova* (New Science; 1725), to unite history and the emerging study of society.

32. The Holy Alliance was an alliance formed in 1815 by the rulers of Russia, Austria, and Prussia to suppress the democratic revolutionary movement in Europe.

33. August von Kotzebue (1761–1819) was a German playwright who was widely influential in popularizing poetic drama. Forced into exile in 1781, he entered government service in Russia, where he eventually became director of the German theater in St. Petersburg. In 1817 he was sent abroad by the Russian emperor to report on current Western ideas in politics, finance, and education. Execrated by radicals as a spy in the pay of a reactionary power, he was assassinated by Karl Sand, a member of a radical student association. The assassin was executed, and German universities were placed under strict control.

34. Benjamin's emendation.

35. Pierre Bayle (1647–1706), French philosopher, regarded as the founder of eighteenth-century rationalism, taught philosophy and history at the University of Rotterdam (1681–1693), where he defended liberty of thought and religious toleration; he was eventually deprived of his professorship because of his skeptical teachings. Thereafter he devoted himself to compiling the *Dictionnaire historique et critique* (1697), in which he analyzed and criticized accepted historical and philosophical tenets.

36. See note 20 above.

37. The phrase in quotation marks is found in two texts by the German writer J. G. Hamann (1730–1788), *Aesthetica in Nuce* (Aesthetics in a Nutshell; 1762) and *Zwey Scherflein zur neusten deutschen Literatur* (Two Small Contributions to Contemporary German Literature; 1780). It is plausible that Jochmann is quoting one of these texts. Hamann probably got the formula from Desiderius Erasmus' *Apophthegmata* (iii, 70), a book of maxims published in 1540. Erasmus, in turn, may have come upon the greeting in the second fragment of *Florida*, a literary work of the second century A.D. by Lucius Apuleius, author of *The Golden Ass*, who was presumably paraphrasing a passage in Plato's dialogue *Charmides* (154d–155a), where Socrates wishes to speak to the young man Charmides in order to see if he is truly beautiful.

Curriculum Vitae (VI): Dr. Walter Benjamin

I was born on July 15, 1892, in Berlin, the son of the merchant Emil Benjamin.[1] I received my education at a classical *Gymnasium* and graduated in 1912.[2] I studied philosophy, along with German literature and psychology, at the universities of Freiburg-im-Breisgau, Munich, and Berlin. In 1917 I went to Switzerland to continue my studies at the University of Bern.

In the course of my studies my thinking was decisively influenced by a number of writings, some of which lay far from my main field of study. These included Alois Riegl's *Spätrömische Kunstindustrie,* Rudolf Borchardt's *Villa,* and Ernst Petzold's analysis of Hölderlin's "Brot und Wein."[3] Lectures by the Munich philosopher Moritz Geiger, and by Ernst Lewy, a Berlin lecturer on Finno-Ugric languages, made a lasting impression on me.[4] Lewy's classes on Humboldt's study *Über den Sprachbau der Völker,* and the ideas he developed in his own study *Zur Sprache des alten Goethe,* awakened my interest in the philosophy of language.[5] In 1919 I obtained my doctorate *summa cum laude* at the University of Bern. My dissertation has been published under the title *Der Begriff der Kunstkritik in der deutschen Romantik* (Bern, 1920).[6]

My first book published after my return to Germany was a translation of Baudelaire's *Tableaux Parisiens* (Heidelberg, 1923). It included a preface entitled "Die Aufgabe des Übersetzers," the first precipitate of my reflections on the theory of language.[7] From the outset, my primary interest has been the philosophy of language, along with the theory of art. The former led me to pursue Mexican studies during my years at the University of Munich—a decision I owe to my acquaintance with Rilke, who was also studying the Mexican language in 1915. Similarly, my interest in the philos-

ophy of language played a part in my growing interest in French literature. Here I was especially engaged by the theory of language which emerges from the works of Stéphane Mallarmé.

In the years immediately following the end of the war, I was still primarily concerned with German literature. My essay "Goethes Wahlverwandtschaften" (Munich, 1924–1925) is the first study of relevance here.[8] This work earned me the friendship of Hugo von Hofmannsthal, who published it in his *Neue deutsche Beiträge*. Hofmannsthal also took a very lively interest in my next work, *Ursprung des deutschen Trauerspiels* (Berlin, 1928).[9] This book set out to offer a new view of seventeenth-century German drama. Its aim was to distinguish *Trauerspiel* [mourning play] from *Tragödie* [tragedy], and it attempted to demonstrate the affinity between *Trauerspiel* as a literary form and allegory as a graphic art.

In 1927 a German publishing house approached me with a commission to translate Proust's great novel. I had read the first volumes of this work with passionate interest in Switzerland in 1919, and I accepted the commission. This work led to several extended stays in France. I had first visited Paris in 1913, and had returned there in 1923. From 1927 to 1933 no year passed without my spending several months in Paris. I gradually made the acquaintance of a number of leading French writers, including André Gide, Jules Romains, Pierre Jean Jouve, Julien Green, Jean Cassou, Marcel Jouhandeau, and Louis Aragon.[10] In Paris I came across Rilke's traces, and became acquainted with the friends and colleagues of his translator, Maurice Betz. At the same time, I undertook to keep the German public informed about intellectual life in France with regular reports which appeared in the *Frankfurter Zeitung* and the *Literarische Welt*. Three volumes of my translation of Proust (Berlin, 1927; and Munich, 1930) appeared before Hitler's accession to power.

For me the inter-war years fall naturally into two periods, before and after 1933. In the first I traveled extensively and came to know Italy, the Scandinavian countries, Russia, and Spain. The literary output of those years, apart from the writings already mentioned, comprises a series of studies [*Charakteristiken*] of works by important poets and writers of our time. These include lengthy studies of Karl Kraus, Franz Kafka, and Bertolt Brecht, as well as Marcel Proust, Julien Green, and the Surrealists.[11] A collection of aphorisms, *Einbahnstraße* (Berlin, 1928), is also from this period.[12] In addition, I was pursuing bibliographical studies. I prepared, for a commission, a complete bibliography of the writings of and about G. C. Lichtenberg, which has not been published.[13]

I left Germany in March 1933. Since then, all my major writings have been published in the journal of the Institute of Social Research. My essay "Probleme der Sprachsoziologie" (*Zeitschrift für Sozialforschung*, 1935) gives a critical overview of the current state of philosophical theories on

language.[14] The essay "Carl Gustav Jochmann" (ibid., 1939) is a postscript to my studies on the history of German literature.[15] (A collection of German letters from the nineteenth century, which I published in Lucerne in 1937, belongs in the same context.)[16] My article "Zum gegenwärtigen gesellschaftlichen Standort des französischen Schriftstellers" (ibid., 1934) grew out of my studies on recent French literature.[17] The essays "Eduard Fuchs, der Sammler und der Historiker" (ibid., 1937) and "Das Kunstwerk im Zeitalter seiner technischen Reproduzierbarkeit" (ibid., 1936) are contributions to the sociology of the visual arts.[18] The latter work seeks to derive certain art forms, especially film, from the change in function that art in general has undergone in the course of social development. (My essay "Der Erzähler," published in a Swiss journal in 1936, deals with analogous problems in the field of literature.)[19] My most recent study, "Über einige Motive bei Baudelaire" (ibid., 1939), is a fragment forming part of a series of investigations aimed at making the poetry of the nineteenth century a medium for a critical understanding of that century.[20]

Written in late 1939 or early 1940; unpublished in Benjamin's lifetime. *Gesammelte Schriften*, VI, 225–228. Translated by Edmund Jephcott.

Notes

1. Emil Benjamin was born in 1866 and died in 1926.
2. Benjamin attended a *humanistisches* Gymnasium—a secondary school emphasizing Latin and Greek.
3. Alois Riegl (1858–1905), art historian born in Austria, argued that different formal and stylistic orderings of art gradually emerge as expressions of different historical periods. In his major work, *Spätrömische Kunstindustrie* [Late Roman Art Industry; 1901], Riegl sets out his concept of the *Kunstwollen*—the manner in which a given culture at a given time wishes to see its cultural objects. The notion posed a significant challenge to reigning theories of art, which derived from the notion of a classical ideal. Rudolf Borchardt (1877–1945), German-Jewish essayist and poet, produced a body of work notable for its nationalist-conservative tenor and its great formal refinement. *Villa* (1908) is a study of the history of landscape architecture. Ernst Petzold's *Hölderlins "Brot und Wein"* [Hölderlin's "Bread and Wine"; 1895–1896, 1896–1897] was the first monographic commentary on Hölderlin's work.
4. Moritz Geiger (1880–1937), German philosopher, taught at the universities of Munich and Göttingen until 1933, when he was dismissed because he was a Jew. He emigrated to America and taught in New York until his death. Geiger was best known for his phenomenological study of aesthetic pleasure. Ernst Lewy (1881–1966) was a German linguist.
5. Benjamin presumably refers to Wilhelm von Humboldt's highly influential monograph *Über die Verschiedenheit des menschlichen Sprachbaues und ihren*

Einfluss auf die geistige Entwickelung des Menschengeschlechts (On the Structural Variety of Human Language and Its Influence on the Intellectual Development of Mankind; 1836), which Humboldt originally wrote in 1827–1829 as the introduction to his three-volume study of the ancient Kawi language of Java, *Über die Kawisprache auf der Insel Jawa* (published posthumously, 1836–1840). Ernst Lewy's study *Zur Sprache des alten Goethe: Ein Versuch über die Sprache des Einzelnen* (Goethe's Late Style: An Inquiry into the Language of the Individual) was published in 1913.

6. This work has been published in English as *The Concept of Criticism in German Romanticism*. See Walter Benjamin, *Selected Writings, Volume 1: 1913–1926* (Cambridge, Mass.: Harvard University Press, 1996), pp. 116–200.

7. Benjamin omits mention here of his 1916 essay "Über Sprache überhaupt und über die Sprache des Menschen" (On Language as Such and on the Language of Man), unpublished in his lifetime and translated in Volume 1 of this edition.

8. Translated as "Goethe's Elective Affinities," in Volume 1 of this edition.

9. In English as *Origin of German Tragic Drama*, trans. John Osborne (London: New Left Books, 1977). Hugo von Hofmannsthal (1874–1929), Austrian poet, dramatist, and essayist, made his reputation with lyrical poems, stories, and plays in the last decade of the nineteenth century. His operatic collaborations with the German composer Richard Strauss made him world famous. He founded the journal *Neue deutsche Beiträge* in 1922. See "Hofmannsthal and Aleco Dossena," in Benjamin's *Selected Writings, Volume 2: 1927–1934* (Cambridge, Mass.: Harvard University Press, 1999), pp. 421–422.

10. André Gide (1869–1951), French writer, humanist, and moralist, produced a series of remarkable novels, including *L'Immoraliste* (The Immoralist; 1902) and *Les Faux Monnayeurs* (The Counterfeiters; 1926). A cofounder of the *Nouvelle Revue Française,* he received the Nobel Prize for literature in 1947. See "André Gide and Germany," "Conversation with André Gide," and "The Present Social Situation of the French Writer," in Volume 2 of this edition. Jules Romains (pseudonym of Louis Farigoule; 1885–1972), French novelist, dramatist, poet, and essayist, was elected to the Académie Française in 1946. His outstanding work remains his *roman-fleuve, Les Hommes de bonne volonté* (Men of Good Will; 1932–1947). Pierre Jean Jouve (1887–1976), French poet, novelist, and critic, is best known for a series of poetry collections, including *Noces* (1931) and *Matière céleste* (1937). Julien Green (1900–1998), French Catholic novelist, dramatist, and memoirist, was the child of American parents but was born and raised in Paris. His early novels, such as *Mont-Cinère* (1926), *Adrienne Mesurat* (1927), and *Léviathan* (1928), evoke a claustrophobic world in which the characters' attempts to escape turn to passion, violence, and madness; they reflect Green's difficulties in reconciling sexuality, particularly homosexuality, with Catholicism. Jean Cassou (1897–1986) was an eminent art historian and director of the Musée de l'Art Moderne in Paris. A native of the Spanish Basque country, he translated many texts from Spanish. His novels, such as *Les Inconnus dans la cave* (The Strangers in the Cellar; 1933) are marked by a discreet Romanticism and a protest against modern alienation. Marcel Jouhandeau (1888–1979), French Catholic novelist and autobiographer, was closely allied with the writers affiliated with the *Nouvelle Revue*

Française. He is best known for his biting portraits of small-town life in the French provinces. Louis Aragon (pseudonym of Louis Andrieux; 1897–1982), French poet, novelist, and essayist, was one of the most politically active of the Surrealists. His novel *Le Paysan de Paris* (Paris Peasant; 1926) was a key text in Benjamin's early thinking about *Das Passagen-Werk* (The Arcades Project). Aragon joined the French Communist party in 1927, visited the Soviet Union in 1930, and broke with the Surrealists in 1933 over issues of party orthodoxy.

11. See the essays "Karl Kraus," "Franz Kafka," "Surrealism," "On the Image of Proust," "Julien Green," "A Family Drama in the Epic Theater," and "Bert Brecht" in Volume 2 of this edition.

12. Translated as *One-Way Street,* in Volume 1 of this edition.

13. Georg Christoph Lichtenberg (1742–1799), German author and experimental psychologist, was a feared satirist in his time. Yet he is best remembered today as the first great German aphorist. More than 1,500 pages of his notes were published posthumously. In addition to jokes, linguistic paradoxes, puns, metaphors, and excerpts from other writers, they contain thousands of memorable aphorisms.

14. Translated as "Problems in the Sociology of Language," in Benjamin, *Selected Writings, Volume 3: 1935–1938* (Cambridge, Mass.: Harvard University Press, 2002).

15. Translated as "'The Regression of Poetry,' by Carl Gustav Jochmann," in this volume.

16. Translated as *German Men and Women,* in Volume 3 of this edition.

17. Translated as "The Present Social Situation of the French Writer," in Volume 2 of this edition.

18. Translated as "Eduard Fuchs, Collector and Historian" and "The Work of Art in the Age of Its Technological Reproducibility," in Volume 3 of this edition.

19. Translated as "The Storyteller," in Volume 3 of this edition.

20. Translated as "On Some Motifs in Baudelaire," in this volume.

On Scheerbart

Paul Scheerbart had already published about twenty books when, one fine morning in August 1914, an article by him appeared in *Zeit-Echo*—a weekly that German artists and writers had quickly founded in order to embellish the assaults of the German army with the élan of their pen or brush.[1] This article, which went against prevailing opinion, was phrased with sufficient skill to escape censorship. Here is its opening, which is engraved in my memory: "Let me protest first against the expression 'world war.' I am sure that no heavenly body, however near, will involve itself in the affair in which we are embroiled. Everything leads me to believe that deep peace still reigns in interstellar space."

Scheerbart's books attracted hardly more attention from the public than these sentences did from the censor. That was only natural. This poet's work is imbued with an idea which could not have been more foreign to the notions then widespread. This idea—or rather, this image—was of a humanity which had deployed the full range of its technology and put it to humane use. To achieve this state of affairs, Scheerbart believed that two conditions were essential: first, people should discard the base and primitive belief that their task was to "exploit" the forces of nature; second, they should be true to the conviction that technology, by liberating human beings, would fraternally liberate the whole of creation.

Let us now consider the most important of his novels, entitled *Lesabéndio*. The action takes place on an asteroid called Pallas. The beings that populate it have no gender. "Newborn" Pallasians find themselves enclosed in nutshells in the interior of the asteroid. The first sounds they emit on en-

countering light will be their names—such as Biba, Bombimba, Labu, Sofanti, Lesabéndio. Pallas is small; two huge hollows are located on its north and south sides. The asteroid's several hundred thousand inhabitants live inside them. The Pallasians attach importance to embellishing their asteroid; they model its surfaces, endowing it with "sites" which have crystalline or other forms. Now, Lesabéndio has the idea of erecting a tower over the northern hollow (which is connected to the southern hollow by a tunnel). Initially, this structure has no precise purpose. Its use will not become apparent until later. (In a similar way, the Eiffel Tower did not find its current use until thirty years after it was built.)[2] Lesabéndio's tower is designed to connect the body of the asteroid with its head, which floats above it in the form of a luminous cloud. But this *restitutio in integrum* of Pallas can succeed only at a price: Lesabéndio must allow himself to be dissolved in the body of the asteroid. Up to this point, the people of Pallas have never known what it is to die a painful death; they have simply dissolved into the body of a younger Pallasian. But now they will comprehend pain thanks to Lesabéndio, who, when he dies, will be the first to experience it. The tower, which grows higher day by day through the zeal of the Pallasians, will bring about changes in the stellar order. At the same time, the dissolution of its architect in the asteroid will begin to change the rhythm of this heavenly body. It will awaken to a new life and will reach out to its brother stars. It will dream only of uniting with them, forming a link in the chain of asteroids which one day will encircle the sun.

Scheerbart's great discovery was that the stars could be used to plead the cause of creation before an audience of humans. He had already used the voices of animals to plead this cause. The fact that a poet is enlisting heavenly bodies to speak on behalf of creation bears witness to a very powerful emotion. It also shows to what extent the author had succeeded in shedding the dross of sentimentality. This is confirmed by his style, which has the freshness of a nursling's cheeks. At the same time, Scheerbart's prose is of such transparency that one understands why he was the first to welcome the glass architecture which, after his death, would be banished from his country as subversive.

The serene and gentle amazement with which the author tells of the strange natural laws of other worlds, the great cosmic works undertaken there, and the naively noble conversations of their inhabitants makes him one of those humorists who, like Lichtenberg or Jean Paul, seem never to forget that the earth is a heavenly body.[3] In relating the great deeds of creation, he sometimes seems like the twin brother of Fourier.[4] In Fourier's extravagant fantasies about the world of the Harmonians, there is as much mockery of present-day humanity as there is faith in a humanity of the future. In the German poet we find these elements in the same proportions. It

is unlikely that the German utopian knew the work of his French counterpart. But we can be sure that the image of the planet Mercury teaching the Harmonians their mother tongue would have delighted Paul Scheerbart.

Written, in French, in the late 1930s or 1940; unpublished in Benjamin's lifetime. *Gesammelte Schriften,* II, 630–632. Translated by Edmund Jephcott.

Notes

1. Paul Scheerbart (1863–1915), German author, produced poetry and prose oriented toward a gently fantastic science fiction. In 1919, Benjamin had written an unpublished review of Scheerbart's novel *Lesabéndio* (1913). *Zeit-Echo: Ein Kriegs-Tagebuch der Künstler* (Time-Echo: An Artists' War Diary) was published from 1914 to 1917. Two pieces by Scheerbart appeared in the journal. Benjamin's quotation here is actually a very free paraphrase of at least two separate passages from Scheerbart's short story (not an article) "In einem Privatzirkel" (A Private Gathering).
2. Designed by the noted bridge engineer Alexandre-Gustave Eiffel (1832–1923), the Eiffel Tower was built for the International Exposition of 1889. When the exposition concession expired in 1909, the tower escaped demolition only because its value as an antenna for the new radio technology was demonstrated.
3. Georg Christoph Lichtenberg (1742–1799), German author and experimental psychologist, was a feared satirist in his time. Yet he is best remembered today as the first great German aphorist. More than 1,500 pages of his notes were published posthumously; along with jokes, linguistic paradoxes, puns, metaphors, and excerpts from other writers, they contain thousands of memorable aphorisms. Jean Paul Richter (pen name Jean Paul; 1763–1825) wrote a series of wildly extravagant, humorous novels that, with their blend of fantasy and realism, continue to defy categorization.
4. Charles Fourier (1772–1837), French social theorist and reformer, called for a reorganization of society based on communal agrarian associations known as "phalansteries." He devoted a series of books, written in a bizarre style, to the minute elaboration of his utopian vision as set in an ideal realm which he called Harmony. The inhabitants of this realm, the Harmonians, would continually change roles within different systems of production.

On the Concept of History

I

There was once, we know, an automaton constructed in such a way that it could respond to every move by a chess player with a countermove that would ensure the winning of the game.[1] A puppet wearing Turkish attire and with a hookah in its mouth sat before a chessboard placed on a large table. A system of mirrors created the illusion that this table was transparent on all sides. Actually, a hunchbacked dwarf—a master at chess—sat inside and guided the puppet's hand by means of strings. One can imagine a philosophic counterpart to this apparatus. The puppet, called "historical materialism,"[2] is to win all the time. It can easily be a match for anyone if it enlists the services of theology, which today, as we know, is small and ugly and has to keep out of sight.

II

"It is one of the most noteworthy peculiarities of the human heart," writes Lotze, "that so much selfishness in individuals coexists with the general lack of envy which every present day feels toward its future."[3] This observation indicates that the image of happiness we cherish is thoroughly colored by the time to which the course of our own existence has assigned us. There is happiness—such as could arouse envy in us—only in the air we have breathed, among people we could have talked to, women who could have given themselves to us. In other words, the idea of happiness is indissolubly bound up with the idea of redemption. The same applies to the idea of the

past, which is the concern of history. The past carries with it a secret index by which it is referred to redemption. Doesn't a breath of the air that pervaded earlier days caress us as well? In the voices we hear, isn't there an echo of now silent ones? Don't the women we court have sisters they no longer recognize? If so, then there is a secret agreement between past generations and the present one. Then our coming was expected on earth. Then, like every generation that preceded us, we have been endowed with a *weak* messianic power, a power on which the past has a claim. Such a claim cannot be settled cheaply. The historical materialist is aware of this.

III

The chronicler who narrates events without distinguishing between major and minor ones acts in accord with the following truth: nothing that has ever happened should be regarded as lost to history. Of course only a redeemed mankind is granted the fullness of its past—which is to say, only for a redeemed mankind has its past become citable in all its moments. Each moment it has lived becomes a *citation à l'ordre du jour.*[4] And that day is Judgment Day.

IV

Seek for food and clothing first; then
shall the Kingdom of God be granted to you.
—Hegel, 1807[5]

Class struggle, which for a historian schooled in Marx is always in evidence, is a fight for the crude and material things without which no refined and spiritual things could exist. But these latter things, which are present in class struggle, are not present as a vision of spoils that fall to the victor. They are alive in this struggle as confidence, courage, humor, cunning, and fortitude, and have effects that reach far back into the past. They constantly call into question every victory, past and present, of the rulers. As flowers turn toward the sun, what has been strives to turn—by dint of a secret heliotropism—toward that sun which is rising in the sky of history. The historical materialist must be aware of this most inconspicuous of all transformations.

V

The true image of the past flits by. The past can be seized only as an image that flashes up at the moment of its recognizability, and is never seen again. "The truth will not run away from us": this statement by Gottfried Keller

indicates exactly that point in historicism's image of history where the image is pierced by historical materialism.[6] For it is an irretrievable image of the past which threatens to disappear in any present that does not recognize itself as intended in that image.

VI

Articulating the past historically does not mean recognizing it "the way it really was."[7] It means appropriating a memory as it flashes up in a moment of danger. Historical materialism wishes to hold fast that image of the past which unexpectedly appears to the historical subject in a moment of danger. The danger threatens both the content of the tradition and those who inherit it. For both, it is one and the same thing: the danger of becoming a tool of the ruling classes. Every age must strive anew to wrest tradition away from the conformism that is working to overpower it. The Messiah comes not only as the redeemer; he comes as the victor over the Antichrist. The only historian capable of fanning the spark of hope in the past is the one who is firmly convinced that *even the dead* will not be safe from the enemy if he is victorious. And this enemy has never ceased to be victorious.

VII

Consider the darkness and the great cold
In this vale resounding with mystery.
—Brecht, *The Threepenny Opera*[8]

Addressing himself to the historian who wishes to relive an era, Fustel de Coulanges recommends that he blot out everything he knows about the later course of history.[9] There is no better way of characterizing the method which historical materialism has broken with. It is a process of empathy. Its origin is indolence of the heart, that *acedia* which despairs of appropriating the genuine historical image as it briefly flashes up. Among medieval theologians, acedia was regarded as the root cause of sadness. Flaubert, who was familiar with it, wrote: "Peu de gens devineront combien il a fallu être triste pour ressusciter Carthage!"[10] The nature of this sadness becomes clearer if we ask: With whom does historicism actually sympathize? The answer is inevitable: with the victor. And all rulers are the heirs of prior conquerors. Hence, empathizing with the victor invariably benefits the current rulers. The historical materialist knows what this means. Whoever has emerged victorious participates to this day in the triumphal procession in which current rulers step over those who are lying prostrate. According to traditional practice, the spoils are carried in the procession. They are called "cultural treasures," and a historical materialist views them with cautious detach-

ment. For in every case these treasures have a lineage which he cannot contemplate without horror. They owe their existence not only to the efforts of the great geniuses who created them, but also to the anonymous toil of others who lived in the same period. There is no document of culture which is not at the same time a document of barbarism. And just as such a document is never free of barbarism, so barbarism taints the manner in which it was transmitted from one hand to another. The historical materialist therefore dissociates himself from this process of transmission as far as possible. He regards it as his task to brush history against the grain.

VIII

The tradition of the oppressed teaches us that the "state of emergency" in which we live is not the exception but the rule. We must attain to a conception of history that accords with this insight. Then we will clearly see that it is our task to bring about a real state of emergency, and this will improve our position in the struggle against fascism. One reason fascism has a chance is that, in the name of progress, its opponents treat it as a historical norm.—The current amazement that the things we are experiencing are "still" possible in the twentieth century is *not* philosophical. This amazement is not the beginning of knowledge[11]—unless it is the knowledge that the view of history which gives rise to it is untenable.

IX

My wing is ready for flight,
I would like to turn back.
If I stayed everliving time,
I'd still have little luck.
—Gerhard Scholem, "Greetings from the Angelus"[12]

There is a picture by Klee called *Angelus Novus*. It shows an angel who seems about to move away from something he stares at.[13] His eyes are wide, his mouth is open, his wings are spread. This is how the angel of history must look. His face is turned toward the past. Where a chain of events appears before *us, he* sees one single catastrophe, which keeps piling wreckage upon wreckage and hurls it at his feet. The angel would like to stay, awaken the dead, and make whole what has been smashed. But a storm is blowing from Paradise and has got caught in his wings; it is so strong that the angel can no longer close them. This storm drives him irresistibly into the future, to which his back is turned, while the pile of debris before him grows toward the sky. What we call progress is *this* storm.

X

The themes which monastic discipline assigned to friars for meditation were designed to turn them away from the world and its affairs. The thoughts we are developing here have a similar aim. At a moment when the politicians in whom the opponents of fascism had placed their hopes are prostrate, and confirm their defeat by betraying their own cause, these observations are intended to extricate the political worldlings from the snares in which the traitors have entangled them. The assumption here is that those politicians' stubborn faith in progress, their confidence in their "base in the masses," and, finally, their servile integration in an uncontrollable apparatus are three aspects of the same thing. This consideration is meant to suggest the high price our customary mode of thought will have to pay for a conception of history that avoids any complicity with the concept of history to which those politicians still adhere.

XI

The conformism which has marked the Social Democrats[14] from the beginning attaches not only to their political tactics but to their economic views as well. It is one reason for the eventual breakdown of their party. Nothing has so corrupted the German working class as the notion that it was moving with the current. It regarded technological development as the driving force of the stream with which it thought it was moving. From there it was but a step to the illusion that the factory work ostensibly furthering technological progress constituted a political achievement. The old Protestant work ethic was resurrected among German workers in secularized form. The Gotha Program already bears traces of this confusion, defining labor as "the source of all wealth and all culture."[15] Smelling a rat, Marx countered that "the man who possesses no other property than his labor power" must of necessity become "the slave of other men who have made themselves owners." Yet the confusion spread, and soon thereafter Josef Dietzgen proclaimed: "The savior of modern times is called work. The . . . perfecting . . . of the labor process constitutes the wealth which can now do what no redeemer has ever been able to accomplish."[16] This vulgar-Marxist conception of the nature of labor scarcely considers the question of how its products could ever benefit the workers when they are beyond the means of those workers. It recognizes only the progress in mastering nature, not the retrogression of society; it already displays the technocratic features that later emerge in fascism. Among these is a conception of nature which differs ominously from the one advocated by socialist utopias prior to the Revolution of 1848. The new conception of labor is tantamount to the exploitation of nature, which, with naive complacency, is contrasted with the ex-

ploitation of the proletariat. Compared to this positivistic view, Fourier's fantasies, which have so often been ridiculed, prove surprisingly sound.[17] According to Fourier, cooperative labor would increase efficiency to such an extent that four moons would illuminate the sky at night, the polar ice caps would recede, seawater would no longer taste salty, and beasts of prey would do man's bidding. All this illustrates a kind of labor which, far from exploiting nature, would help her give birth to the creations that now lie dormant in her womb. The sort of nature that (as Dietzgen puts it) "exists gratis," is a complement to the corrupted conception of labor.

XII

We need history, but our need for it differs from that of the jaded idlers in the garden of knowledge.
—Nietzsche, *On the Advantages and Disadvantages of History for Life*[18]

The subject of historical knowledge is the struggling, oppressed class itself. Marx presents it as the last enslaved class—the avenger that completes the task of liberation in the name of generations of the downtrodden. This conviction, which had a brief resurgence in the Spartacus League,[19] has always been objectionable to Social Democrats. Within three decades they managed to erase the name of Blanqui almost entirely, though at the sound of that name the preceding century had quaked.[20] The Social Democrats preferred to cast the working class in the role of a redeemer of *future* generations, in this way cutting the sinews of its greatest strength. This indoctrination made the working class forget both its hatred and its spirit of sacrifice, for both are nourished by the image of enslaved ancestors rather than by the ideal of liberated grandchildren.

XIII

Every day, our cause becomes clearer and people get smarter.
—Josef Dietzgen, *Social Democratic Philosophy*[21]

Social Democratic theory and to an even greater extent its practice were shaped by a conception of progress which bore little relation to reality but made dogmatic claims. Progress as pictured in the minds of the Social Democrats was, first of all, progress of humankind itself (and not just advances in human ability and knowledge). Second, it was something boundless (in keeping with an infinite perfectibility of humanity). Third, it was considered inevitable—something that automatically pursued a straight or spiral course. Each of these assumptions is controversial and open to criticism. But when the chips are down, criticism must penetrate beyond these assumptions and focus on what they have in common. The concept of man-

kind's historical progress cannot be sundered from the concept of its progression through a homogeneous, empty time. A critique of the concept of such a progression must underlie any criticism of the concept of progress itself.

XIV

Origin is the goal.
—Karl Kraus, *Words in Verse*, vol. 1[22]

History is the subject of a construction whose site is not homogeneous, empty time, but time filled full by now-time [*Jetztzeit*]. Thus, to Robespierre ancient Rome was a past charged with now-time, a past which he blasted out of the continuum of history. The French Revolution viewed itself as Rome reincarnate. It cited ancient Rome exactly the way fashion cites a bygone mode of dress. Fashion has a nose for the topical, no matter where it stirs in the thickets of long ago; it is the tiger's leap into the past.[23] Such a leap, however, takes place in an arena where the ruling class gives the commands. The same leap in the open air of history is the dialectical leap Marx understood as revolution.

XV

What characterizes revolutionary classes at their moment of action is the awareness that they are about to make the continuum of history explode. The Great Revolution introduced a new calendar. The initial day of a calendar presents history in time-lapse mode. And basically it is this same day that keeps recurring in the guise of holidays, which are days of remembrance [*Tage des Eingedenkens*]. Thus, calendars do not measure time the way clocks do; they are monuments of a historical consciousness of which not the slightest trace has been apparent in Europe, it would seem, for the past hundred years. In the July Revolution an incident occurred in which this consciousness came into its own.[24] On the first evening of fighting, it so happened that the dials on clocktowers were being fired at simultaneously and independently from several locations in Paris. An eyewitness, who may have owed his insight to the rhyme, wrote as follows:

Qui le croirait! on dit, qu'irrités contre l'heure,
De nouveaux Josués, au pied de chaque tour,
Tiraient sur les cadrans pour arrêter le jour.

[Who would believe it! It is said that, incensed at the hour,
Latter-day Joshuas, at the foot of every clocktower,
Were firing on clock faces to make the day stand still.][25]

XVI

The historical materialist cannot do without the notion of a present which is not a transition, but in which time takes a stand [*einsteht*] and has come to a standstill. For this notion defines the very present in which he himself is writing history. Historicism offers the "eternal" image of the past; historical materialism supplies a unique experience with the past.[26] The historical materialist leaves it to others to be drained by the whore called "Once upon a time" in historicism's bordello. He remains in control of his powers—man enough to blast open the continuum of history.

XVII

Historicism rightly culminates in universal history. It may be that materialist historiography differs in method more clearly from universal history than from any other kind. Universal history has no theoretical armature. Its procedure is additive: it musters a mass of data to fill the homogeneous, empty time. Materialist historiography, on the other hand, is based on a constructive principle. Thinking involves not only the movement of thoughts, but their arrest as well. Where thinking suddenly comes to a stop in a constellation saturated with tensions, it gives that constellation a shock, by which thinking is crystallized as a monad. The historical materialist approaches a historical object only where it confronts him as a monad. In this structure he recognizes the sign of a messianic arrest of happening, or (to put it differently) a revolutionary chance in the fight for the oppressed past.[27] He takes cognizance of it in order to blast a specific era out of the homogeneous course of history; thus, he blasts a specific life out of the era, a specific work out of the lifework. As a result of this method, the lifework is both preserved and sublated *in* the work, the era *in* the lifework, and the entire course of history *in* the era. The nourishing fruit of what is historically understood contains time in its *interior* as a precious but tasteless seed.

XVIII

"In relation to the history of all organic life on earth," writes a modern biologist, "the paltry fifty-millennia history of *homo sapiens* equates to something like two seconds at the close of a twenty-four-hour day. On this scale, the history of civilized mankind would take up one-fifth of the last second of the last hour." Now-time, which, as a model of messianic time, comprises the entire history of mankind in a tremendous abbreviation, coincides exactly with the figure which the history of mankind describes in the universe.

A[28]

Historicism contents itself with establishing a causal nexus among various moments in history. But no state of affairs having causal significance is for that very reason historical. It became historical posthumously, as it were, through events that may be separated from it by thousands of years. The historian who proceeds from this consideration ceases to tell the sequence of events like the beads of a rosary. He grasps the constellation into which his own era has entered, along with a very specific earlier one. Thus, he establishes a conception of the present as now-time shot through with splinters of messianic time.

B

The soothsayers who queried time and learned what it had in store certainly did not experience it as either homogeneous or empty. Whoever keeps this in mind will perhaps get an idea of how past times were experienced in remembrance—namely, in just this way. We know that the Jews were prohibited from inquiring into the future: the Torah and the prayers instructed them in remembrance. This disenchanted the future, which holds sway over all those who turn to soothsayers for enlightenment. This does not imply, however, that for the Jews the future became homogeneous, empty time. For every second was the small gateway in time through which the Messiah might enter.[29]

Written February–May 1940; unpublished in Benjamin's lifetime. *Gesammelte Schriften*, I, 691–704. Translated by Harry Zohn.

Notes

1. The first documented chess-playing automaton, known as the Turk, was made in 1770 by the Hungarian polymath scholar and inventor Baron Wolfgang von Kempelen (1734–1804) to entertain his sovereign Maria Theresa and the Viennese court. Powered by clockwork and capable of a variety of expressive movements, the mustached mannequin, wearing a fur-trimmed cloak and a turban and holding a long Turkish pipe in his mouth, was seated atop a maplewood cabinet mounted on wheels, an inlaid chessboard before him; inside the cabinet, hidden in a cramped, stuffy space lit by candlelight, a very small man operated the controls and played the chess game. The automaton toured the great cities of Europe in 1783–1784, winning most of its matches. On Kempelen's death, it passed to the Viennese showman Johann Maelzel, under whose management it gained its greatest fame, becoming the subject of books, pamphlets, and articles, including a detailed eyewitness account and analysis by Edgar Allen Poe, "Maelzel's Chess

Player" (1836). In 1809 it defeated Napoleon in a game, and from 1817 to 1837 it regularly toured England and America. The secret of the cabinet was exposed in 1834 by a former operator of the mechanism, but it continued to draw crowds. After Maelzel died in 1838, the Turk became an exhibit in a small museum in Philadelphia, where it was gradually forgotten. It was destroyed by a fire in 1854.

2. On Benjamin's concept of historical materialism, see in particular section I of his essay "Eduard Fuchs, Collector and Historian," in *Selected Writings, Volume 3: 1935–1938* (Cambridge, Mass.: Harvard University Press, 2002); and Convolute N in Benjamin, *The Arcades Project*, trans. Howard Eiland and Kevin McLaughlin (Cambridge, Mass.: Harvard University Press, 1999).

3. Hermann Lotze, *Mikrokosmos*, vol. 3 (Leipzig, 1864), p. 49. See Convolute N13a,1 in Benjamin's *Passagen-Werk* (Arcades Project). Lotze (1817–1881), German philosopher, is best known for his polemic against vitalism and for his religious philosophy, which attempted to delineate human values against the backdrop of a modern understanding of existence. He also helped found the science of physiological psychology.

4. The French phrase *citation à l'ordre du jour* means "a citation to be taken up as (part of) the business of the day," "a citation of pressing concern at a given moment." The phrase *à l'ordre du jour* can also refer, in a military context, to something mentioned in the day's dispatches.

5. From a letter of Hegel to K. L. von Knebel, August 30, 1807, in *K. L. von Knebel's literarischer Nachlass und Briefwechsel*, vol. 2 (Leipzig, 1840), p. 446. "Granted" here translates *zufallen*—Hegel is literally saying that the kingdom of God will "fall to your share"—just as it does in the second sentence of section III above, where Benjamin is literally saying that, in the case of a redeemed humanity, its past abundantly "falls to its share."

6. This sentence and the next are taken from Benjamin's essay "Eduard Fuchs, Collector and Historian." See Benjamin's *Selected Writings, Volume 3: 1935–1938* (Cambridge, Mass.: Harvard University Press, 2002), p. 262. Gottfried Keller (1819–1890) was one of the great German-language prose stylists of the nineteenth century, best known for his novel *Der grüne Heinrich* (Green Henry; 1854–1855, revised version 1879–1880) and the story collection *Die Leute von Seldwyla* (The People of Seldwyla; first volume 1856, second volume 1874). See Benjamin's essay "Gottfried Keller" in Volume 2 of this edition.

7. This is the historian's task as defined by Leopold von Ranke (1795–1886), perhaps the leading German historian of the nineteenth century, whose scholarly method and way of teaching (he was the first to give seminars in history) had a great influence on Western historiography. His work, which for Benjamin epitomizes nineteenth-century historicism, exhibits a bias against political and social change.

8. Act 3, scene 9 (the last words of the play).

9. Numa Denis Fustel de Coulanges (1830–1889) was a French historian who specialized in ancient and medieval history.

10. "Few will suspect how sad one had to be to undertake the resuscitation of Carthage." The line as Flaubert actually wrote it is: "Peu de gens devineront

combien il a fallu être triste pour entreprendre de ressusciter Carthage!" Letter to Ernest Feydeau, November 29–30, 1859, in Gustave Flaubert, *Correspondance,* new enlarged edition (Paris: L. Conard, 1926–1933), *Volume 4: 1854–1861,* p. 348.

11. An allusion to Aristotle's dictum that philosophy begins in wonder (*Metaphysics,* 982b).

12. Scholem composed his poem "Gruss vom Angelus" for Benjamin's twenty-ninth birthday, July 15, 1921. The text of the entire poem is printed in *The Correspondence of Walter Benjamin,* trans. Manfred R. Jacobson and Evelyn M. Jacobson (Chicago: University of Chicago Press, 1994), pp. 184–185. On Klee's *Angelus Novus,* which Scholem had hanging in his Munich apartment for a while, see note 13 below.

13. The reference is to Paul Klee's ink-wash drawing *Angelus Novus* (1920), which Benjamin owned for a time.

14. The Sozialdemokratische Partei Deutschlands (Social Democratic Party of Germany), or SPD, was founded by Wilhelm Liebknecht and August Bebel in 1863, originally as a Marxist revolutionary organization. In the course of the nineteenth century, partly in response to Chancellor Otto von Bismarck's anti-Socialist laws of the 1880s, its policy shifted from revolutionary to social-reformist. Becoming Germany's largest political party after World War I, it adopted a moderate reformist policy and participated in the government of the Weimar Republic. The party was banned by the Nazis in 1933.

15. In 1875, the Thuringian town of Gotha was the scene of a congress that united the two leading German socialist groups as the Socialist Labor party. The new party adopted the so-called Gotha Program, drafted by Wilhelm Liebknecht and Ferdinand Lassalle. It was severely criticized by Marx in his "Randglossen zum Programm der deutschen Arbeiterpartei" (written 1875, first published 1891; translated as *Critique of the Gotha Program*).

16. Josef Dietzgen, *Sämtliche Schriften* (Wiesbaden, 1911), vol. 1, p. 175 *(Sozialdemokratische Philosophie).* Dietzgen (1828–1888) was a self-educated German leatherworker who interpreted Marx for the workers and won fame as the "philosopher of the proletariat," later emigrating to the United States (1884), where he edited socialist newspapers in New York and Chicago. He set out his philosophy of democratic socialism in *Das Wesen der menschlichen Kopfarbeit* (The Nature of Man's Mental Labor; 1869). He sent the manuscript to Marx, who in turn forwarded it to Engels with the following comment: "My opinion is that J. Dietzgen would do better to condense all his ideas into two printer's sheets and have them published under his own name as a tanner. If he publishes them in the size he is proposing, he will discredit himself with his lack of dialectical development and his way of going round in circles." (Letter to Engels of October 4, 1868.)

17. Charles Fourier (1772–1837), French social theorist and reformer, called for a reorganization of society based on communal agrarian associations which he called "phalansteries." In each community, the members would continually change roles within different systems of production.

18. Nietzsche's *Vom Nutzen und Nachteil der Historie für das Leben* was written in

1873 and published in 1874 as the second part of his *Unzeitgemässe Betrachtungen* (Untimely Meditations). Benjamin quotes from the opening paragraph of Nietzsche's preface.

19. The Spartacus League was a radical leftist group founded by Karl Liebknecht and Rosa Luxemburg during World War I. In 1918 it became the German Communist party.

20. Louis-Auguste Blanqui (1805–1881), French revolutionary socialist and militant anticlerical, was active in all three major upheavals in nineteenth-century France—the revolutions of 1830 and 1848 and the Paris Commune—and was imprisoned following each series of events. Quotations from Blanqui and Benjamin's commentary on him play a key role in *The Arcades Project*.

21. Dietzgen, *Sämtliche Schriften,* vol. 1, p. 176.

22. Karl Kraus, *Worte in Versen,* vol. 1, 2nd ed. (Leipzig, 1919), p. 69, "Der sterbende Mensch" (The Dying Man). Kraus (1874–1936) was an Austrian journalist, critic, playwright, and poet. His *Worte in Versen* was published in nine volumes from 1916 to 1930. See Benjamin's essay "Karl Kraus" (1931) in Volume 2 of this edition.

23. "Thickets of long ago" translates "Dickicht des Einst." "Tiger's leap into the past" translates "Tigersprung ins Vergangene."

24. The July Revolution took place July 27–29, 1830. It toppled the government of Charles X and led to the proclamation of Louis Philippe as "Citizen King" (July Monarchy).

25. See Benjamin, *The Arcades Project,* Convolute a21a,2.

26. "A unique experience with the past" translates "eine Erfahrung mit [der Vergangenheit], die einzig dasteht." The last word chimes with *einsteht* in the first sentence of this section.

27. "Messianic arrest of happening" translates "messianische Stillstellung des Geschehens." "Oppressed past" translates "unterdrückte Vergangenheit," which also suggests "suppressed past."

28. These last two sections, which appear under the separate headings "A" and "B" at the end of an early, untitled draft of the theses on history, were dropped in Benjamin's later drafts of the text. On account of their intrinsic interest, they are printed as a supplement to the text in the *Gesammelte Schriften.*

29. "The small gateway" translates "Die kleine Pforte," an echo perhaps of Martin Luther's phrase "die enge Pforte" ("the narrow gate"), in his rendering of Matthew 7:13–14 in the New Testament: "Enter by the narrow gate. . . . For the gate is narrow and the way is hard, that leads to life."

Paralipomena to "On the Concept of History"

Empathy with the past serves not least to make the past seem present. It is no coincidence that this tendency accords very well with a positivist conception of history (as seen in Eduard Meyer).[1] In the field of history, the projection of the past into the present is analogous to the substitution of homogeneous configurations for changes in the physical world [*Körperwelt*]. The latter process has been identified by Meyerson as the basis of the natural sciences (*De l'explication dans les sciences*).[2] The former is the quintessence of the "scientific" character of history, as defined by positivism. It is secured at the cost of completely eradicating every vestige of history's original role as remembrance [*Eingedenken*]. The false aliveness of the past-made-present, the elimination of every echo of a "lament" from history, marks history's final subjection to the modern concept of science.

In other words, the project of discovering "laws" for the course of historical events is not the only means—and hardly the most subtle—of assimilating historiography to natural science. The notion that the historian's task is to make the past "present" [*das Vergangne zu "vergegenwärtigen"*] is guilty of the same fraudulence, and is far less transparent.

XVIIa

In the idea of classless society, Marx secularized the idea of messianic time. And that was a good thing. It was only when the Social Democrats elevated this idea to an "ideal" that the trouble began. The ideal was defined in Neo-Kantian doctrine as an "infinite [*unendlich*] task." And this doctrine was

the school philosophy of the Social Democratic party—from Schmidt and Stadler through Natorp and Vorländer.[3] Once the classless society had been defined as an infinite task, the empty and homogeneous time was transformed into an anteroom, so to speak, in which one could wait for the emergence of the revolutionary situation with more or less equanimity. In reality, there is not a moment that would not carry with it *its* revolutionary chance—provided only that it is defined in a specific way, namely as the chance for a completely new resolution of a completely new problem [*Aufgabe*]. For the revolutionary thinker, the peculiar revolutionary chance offered by every historical moment gets its warrant from the political situation. But it is equally grounded, for this thinker, in the right of entry which the historical moment enjoys vis-à-vis a quite distinct chamber of the past, one which up to that point has been closed and locked. The entrance into this chamber coincides in a strict sense with political action, and it is by means of such entry that political action, however destructive, reveals itself as messianic. (Classless society is not the final goal of historical progress but its frequently miscarried, ultimately [*endlich*] achieved interruption.)

The historical materialist who investigates the structure of history performs, in his way, a sort of spectrum analysis. Just as a physicist determines the presence of ultraviolet light in the solar spectrum, so the historical materialist determines the presence of a messianic force in history. Whoever wishes to know what the situation of a "redeemed humanity" might actually be, what conditions are required for the development of such a situation, and when this development can be expected to occur, poses questions to which there are no answers. He might just as well seek to know the color of ultraviolet rays.

Marx says that revolutions are the locomotive of world history. But perhaps it is quite otherwise. Perhaps revolutions are an attempt by the passengers on this train—namely, the human race—to activate the emergency brake.

Three basic concepts can be identified in Marx's work, and its entire theoretical armature can be seen as an attempt to weld these three concepts together. They are the class struggle of the proletariat, the course of historical development (progress), and the classless society. The structure of Marx's basic idea is as follows: Through a series of class struggles, humanity attains to a classless society in the course of historical development. = But classless society is not to be conceived as the endpoint of historical development. = From this erroneous conception Marx's epigones have derived (among other things) the notion of the "revolutionary situation," which, as we

know, has always refused to arrive. = A genuinely messianic face must be restored to the concept of classless society and, to be sure, in the interest of furthering the revolutionary politics of the proletariat itself.

New Theses B

History deals with connections and with arbitrarily elaborated causal chains. But since history affords an idea of the fundamental citability of its object, this object must present itself, in its ultimate form, as a moment of humanity. In this moment, time must be brought to a standstill.

The dialectical image is an occurrence of ball lightning[4] that runs across the whole horizon of the past.

Articulating the past historically means recognizing those elements of the past which come together in the constellation of a single moment. Historical knowledge is possible only within the historical moment. But knowledge *within* the historical moment is always knowledge *of* a moment. In drawing itself together in the moment—in the dialectical image—the past becomes part of humanity's involuntary memory.

The dialectical image can be defined as the involuntary memory of redeemed humanity.

The notion of a universal history is bound up with the notion of progress and the notion of culture. In order for all the moments in the history of humanity to be incorporated in the chain of history, they must be reduced to a common denominator—"culture," "enlightenment," "the objective spirit," or whatever one wishes to call it.

New Theses C

Only when the course of historical events runs through the historian's hands smoothly, like a thread, can one speak of progress. If, however, it is a frayed bundle unraveling into a thousand strands that hang down like unplaited hair, none of them has a definite place until they are all gathered up and braided into a coiffure.

The basic conception in myth is the world as punishment—punishment which actually engenders those to whom punishment is due. Eternal recurrence is the punishment of being held back in school, projected onto the cosmic sphere: humanity has to copy out its text in endless repetitions (Eluard, *Répétitions*).[5]

The eternity of punishment in hell may have sheared off the most terrible spike from the ancient idea of eternal recurrence. It substitutes an eternity of torment for the eternity of a cycle.

Thinking the idea of eternal recurrence once more in the nineteenth cen-

tury, Nietzsche becomes the figure on whom mythic doom is now carried out. For the essence of mythic happenings is recurrence. (Sisyphus, the Danaides.)[6]

New Theses H

The dissolution into pragmatic history ought not to benefit cultural history. Moreover, the pragmatic conception of history does not founder on the demands made by "strict science" in the name of the law of causality. It founders on a shift in historical perspective. An age that is no longer able to transfigure its positions of power in an original way loses its understanding of the transfigurations which benefited such positions in the past.

The history-writing subject is, properly, that part of humanity whose solidarity embraces all the oppressed. It is the part which can take the greatest theoretical risks because, in practical terms, it has the least to lose.

Universal histories are not inevitably reactionary. But a universal history *without* a structural [*konstruktiv*] principle is reactionary. The structural principle of universal history allows it to be represented in partial histories. It is, in other words, a monadological principle. It exists within salvation history.

The idea of prose coincides with the messianic idea of universal history. (Leskov!)[7]

New Theses K

"For to organize pessimism means . . . to discover in the space of political action . . . image space. This image space, however, can no longer be measured out by contemplation. . . . The long-sought image space . . . , the world of universal and integral actuality" (Surrealism).[8]

Redemption is the *limes* of progress.[9]

The messianic world is the world of universal and integral actuality. Only in the messianic realm does a universal history exist. Not as written history, but as festively enacted history. This festival is purified of all celebration. There are no festive songs. Its language is liberated prose—prose which has burst the fetters of script [*Schrift*]. (The idea of prose coincides with the messianic idea of universal history. Compare the passage in "The Storyteller": the types of artistic prose as the spectrum of historical types.)[10]

The multiplicity of "histories" is closely related, if not identical, to the multiplicity of languages. Universal history in the present-day sense is never more than a kind of Esperanto. (It expresses the hope of the human race no more effectively than the name of that universal language.)[11]

The Now of Recognizability

The saying that the historian is a prophet facing backward[12] can be understood in two ways. Traditionally it has meant that the historian, transplanting himself into a remote past, prophesies what was regarded as the future at that time but meanwhile has become the past. This view corresponds exactly to the historical theory of empathy, which Fustel de Coulanges encapsulated in the following advice: "Si vous voulez reviver une époque, oubliez que vous savez ce qui s'est passé après elle."[13]—But the saying can also be understood to mean something quite different: the historian turns his back on his own time, and his seer's gaze is kindled by the peaks of earlier generations as they sink further and further into the past. Indeed, the historian's own time is far more distinctly present to this visionary gaze than it is to the contemporaries who "keep step with it." The concept of a present which represents the intentional subject matter of a prophecy is defined by Turgot—not without reason—as an essentially and fundamentally political concept. "Before we have learned to deal with things in a given position," says Turgot, "it has already changed several times. Thus, we always find out too late about what has happened. And therefore it can be said that politics is obliged to foresee the present."[14] It is precisely this concept of the present which underlies the actuality of genuine historiography (N8a,3; N12a,1).[15] Someone who pokes about in the past as if rummaging in a storeroom of examples and analogies still has no inkling of how much in a given moment depends on its being made present [*ihre Vergegenwärtigung*].

The Dialectical Image

(If one looks upon history as a text, then one can say of it what a recent author has said of literary texts—namely, that the past has left in them images comparable to those registered by a light-sensitive plate. "The future alone possesses developers strong enough to reveal the image in all its details. Many pages in Marivaux or Rousseau contain a mysterious meaning which the first readers of these texts could not fully have deciphered." (Monglond; N15a,1.)[16] The historical method is a philological method based on the book of life. "Read what was never written," runs a line in Hofmannsthal.[17] The reader one should think of here is the true historian.)

The multiplicity of histories resembles the multiplicity of languages. Universal history in the present-day sense can never be more than a kind of Esperanto. The idea of universal history is a messianic idea.

The messianic world is the world of universal and integral actuality. Only in the messianic realm does a universal history exist. Not as written history, but as festively enacted history. This festival is purified of all celebration.

There are no festive songs. Its language is liberated prose—prose which has burst the fetters of script [*Schrift*] and is understood by all people (as the language of birds is understood by Sunday's children).[18]—The idea of prose coincides with the messianic idea of universal history (the types of artistic prose as the spectrum of universal historical types [the passage in "The Storyteller"]).[19]

A conception of history that has liberated itself from the schema of progression within an empty and homogeneous time would finally unleash the destructive energies of historical materialism which have been held back for so long. This would threaten the three most important positions of historicism. The first attack must be aimed at the idea of universal history. Now that the nature of peoples is obscured by their current structural features as much as by their current relationships to one another, the notion that the history of humanity is composed of peoples is a mere refuge of intellectual laziness. (The idea of a universal history stands and falls with the idea of a universal language. As long as the latter had a basis—whether in theology, as in the Middle Ages, or in logic, as more recently in Leibniz— universal history was not wholly inconceivable. By contrast, universal history as practiced since the nineteenth century can never have been more than a kind of Esperanto.)—The second fortified position of historicism is evident in the idea that history is something which can be narrated. In a materialist investigation, the epic moment will always be blown apart in the process of construction. The liquidation of the epic moment must be accepted, as Marx did when he wrote *Capital*. He realized that the history of capital could be constructed only within the broad, steel framework of a theory. In Marx's theoretical sketch of labor under the dominion of capital, humanity's interests are better looked after than in the monumental, long-winded, and basically lackadaisical works of historicism. It is more difficult to honor the memory of the anonymous than it is to honor the memory of the famous, the celebrated, not excluding poets and thinkers. The historical construction is dedicated to the memory of the anonymous.—The third bastion of historicism is the strongest and the most difficult to overrun. It presents itself as "empathy with the victor." The rulers at any time are the heirs of all those who have been victorious throughout history. Empathizing with the victor invariably benefits those currently ruling. The historical materialist respects this fact. He also realizes that this state of affairs is well-founded. Whoever has emerged victorious in the thousand struggles traversing history up to the present day has his share in the triumphs of those now ruling over those now ruled. The historical materialist can take only a highly critical view of the inventory of spoils displayed by the victors before the vanquished. This inventory is called culture. For in every case these treasures have a lineage which the historical materialist cannot contemplate

without horror. They owe their existence not only to the efforts of the great geniuses who created them, but also to the anonymous toil of others who lived in the same period. There is no document of culture which is not at the same time a document of barbarism. The historical materialist keeps his distance from all of this. He has to brush history against the grain—even if he needs a barge pole to do it.

Categories for developing the concept of historical time.

The concept of historical time forms an antithesis to the idea of a temporal continuum.

The eternal lamp[20] is an image of genuine historical existence. It cites what has been—the flame that once was kindled—in perpetuum, giving it ever new sustenance.

The existence of the classless society cannot be thought at the same time that the struggle for it is thought. But the concept of the present, in its binding sense for the historian, is necessarily defined by these two temporal orders. Without some sort of assay of the classless society, there is only a historical accumulation of the past. To this extent, every concept of the present participates in the concept of Judgment Day.

The saying from an apocryphal gospel—"Where I meet someone, there will I judge him"[21]—casts a peculiar light on the idea of Last Judgment. It recalls Kafka's note: "The Last Judgment is a kind of summary justice."[22] But it adds to this something else: the Day of Judgment, according to this saying, would not be distinguishable from other days. At any rate, this gospel saying furnishes the canon for the concept of the present which the historian makes his own. Every moment is a moment of judgment concerning certain moments that preceded it.

Excerpts from the Fuchs essay.[23]

The passage on Jochmann's visionary gaze should be worked into the basic structure of the Arcades.[24]

The seer's gaze is kindled by the rapidly receding past. That is to say, the prophet has turned away from the future: he perceives the contours of the future in the fading light of the past as it sinks before him into the night of times. This prophetic relation to the future necessarily informs the attitude of the historian as Marx describes it, an attitude determined by actual social circumstances.

Should criticism and prophecy be the categories that come together in the "redemption" of the past?

How should critique of the past (for example, in Jochmann) be joined to redemption of the past?

To grasp the eternity of historical events is really to appreciate the eternity of their transience.

Fragments written in 1940; unpublished in Benjamin's lifetime. *Gesammelte Schriften,* I, 1230–1235, 1237–1238, 1240–1241, 1245–1246. Translated by Edmund Jephcott and Howard Eiland.

Notes

Benjamin wrote these fragments (selected from a larger body of material published in the *Gesammelte Schriften*) in the course of composing "On the Concept of History."

1. Eduard Meyer (1855–1930) was a well-known German historian who attempted to justify Germany's position in World War I. He was the author of *Geschichte des Altertums* (History of the Ancient World; 5 vols., 1884–1902) and other works.

2. Emile Meyerson (1859–1933), French chemist and philosopher, was best known for his work *Identité et réalité* (Identity and Reality; 1908), in which he develops a position opposed to positivism. *De l'explication dans les sciences* (On Explanation in the Sciences) was published in Paris in 1921.

3. The Sozialdemokratische Partei Deutschlands (Social Democratic Party of Germany), or SPD, was founded by Wilhelm Liebknecht and August Bebel in 1863, originally as a Marxist revolutionary organization. In the course of the nineteenth century, partly in response to Chancellor Otto von Bismarck's anti-Socialist laws of the 1880s, its policy shifted from revolutionary to social-reformist. Becoming Germany's largest political party after World War I, it adopted a moderate reformist policy and participated in the government of the Weimar Republic. The party was banned by the Nazis in June 1933.

 Neo-Kantianism arose in the mid-nineteenth century as a many-sided response to both Positivism and Romantic Idealism. Its leading exponents in Germany included the philosophers Hermann Cohen, Wilhelm Windelband, Alois Riehl, and Heinrich Rickert. It was in particular the Marburg school of Neo-Kantianism, under the leadership of Cohen, that propounded the ideal of knowledge as an infinite task *(Aufgabe).* Conrad Schmidt (1863–1932), German economist and philosopher, was initially allied with Marx and Engels, but in the 1890s he lent his support to bourgeois revisionist elements within the Social Democratic party. August Stadler (1850–1910), a Neo-Kantian philosopher, was a disciple of Hermann Cohen. He was the author of *Kants Teleologie und ihre erkenntnistheoretische Bedeutung* (The Epistemological Significance of Kant's Teleology; 1874) and other works. Paul Natorp (1854–1924) was one of the leading Neo-Kantian philosophers, a professor at Marburg and the author, notably, of *Platos Ideenlehre* (Plato's Theory of Ideas; 1903) and *Sozialidealismus* (Social Idealism; 1920). He argued that the development of national education, in the form of a "social pedagogics," necessarily preceded any legitimate social or economic change. Karl Vorländer (1860–1928), German philosopher, attempted to combine the Neo-Kantianism of the Marburg school with Marxian socialism. He edited Kant's collected works (9 vols.; 1901–1924) and published books such as

 Kant und der Sozialismus (Kant and Socialism; 1900) and *Kant und Marx* (1911).

4. Ball lightning *(Kugelblitz)* is a rare form of lightning in the shape of a glowing red ball. It is associated with thunderstorms and thought to consist of ionized gas.

5. Paul Eluard (pseudonym of Eugène Grindel; 1895–1952), French poet, was an early Surrealist and one of the leading lyric poets of the twentieth century. His major collections include *Capitale de la douleur* (Capital of Sorrow; 1926), *Les Yeux fertiles* (The Fertile Eyes; 1936), and *Répétitions* (1922). After the Spanish Civil War, Eluard abandoned Surrealist experimentation.

6. In Greek mythology, the Danaides were the fifty daughters of Danaus. As punishment for murdering their fifty husbands on their wedding night, they were condemned to futile labor in Hades: until the end of time, they would pour water into a vessel that was pierced with holes and thus could never be filled.

7. Nikolai Leskov (1821–1881), Russian prose writer, is best known for his short stories, especially "Lady Macbeth of the Mtsensk District" (1865). See Benjamin's essay on Leskov, "The Storyteller," in *Selected Writings, Volume 3: 1935–1938* (Cambridge, Mass.: Harvard University Press, 2002).

8. A citation from Benjamin's essay "Surrealism," in *Selected Writings, Volume 2: 1927–1934* (Cambridge, Mass.: Harvard University Press, 1999), p. 217.

9. The Latin word *limes,* meaning "boundary line," referred specifically to any of the fortified frontiers of the Roman Empire. These included the Limes Germanicus (marking the limits of Rome's German provinces), the Limes Arabicus (the Arabian frontier), and the Limes Britannicus (the British frontier, or Hadrian's Wall).

10. See the essay "The Storyteller" in Volume 3 of this edition, p. 154.

11. Esperanto is the most important of the international constructed languages. It was created by the Polish ophthalmologist Ludwig Zamenhof (born Lazar Markevitch; 1859–1917), who, under the pseudonym Dr. Esperanto ("one who hopes"), published an expository textbook in Russian in 1887, after years of experiment. His *Fundamento de Esperanto* (Basis of Esperanto; 1905) established the principles of the language's structure and formation. Esperanto is characterized by a simple grammar (its rules have no exceptions) and by logical word-formation, using prefixes and suffixes to build on a small number of roots. Its vocabulary is formed from the most commonly used words of the western European languages: the name "Esperanto," for example, recalls such words as *esperanza, speranza,* and *espoir.*

12. "Der Historiker ist ein rückwärts gekehrter Prophet." This is fragment 80 of Friedrich Schlegel's *Athenäums-Fragmente* (Athenaeum Fragments; 1798).

13. "If you want to relive an epoch, forget that you know what happened after it." The French historian Numa Denis Fustel de Coulanges (1830–1889) specialized in the Greco-Roman and medieval periods.

14. Anne-Robert Turgot, *Oeuvres,* vol. 2 (Paris, 1844), p. 673, "Pensées et fragments." Turgot (1727–1781) was a French statesman and economist who was appointed comptroller general of France by Louis XVI in 1774. His fiscal and political reforms met with opposition from high-ranking circles and led to his

dismissal two years later. Among his works are *Lettres sur la tolérance* (Letters on Tolerance; 1753–1754) and *Réflexions sur la formation et la distribution des richesses* (Reflections on the Formation and Distribution of Wealth; 1766).

15. See Walter Benjamin, *The Arcades Project*, trans. Howard Eiland and Kevin McLaughlin (Cambridge, Mass.: Harvard University Press, 1999), Convolutes N8a,3 and N12a,1.

16. André Monglond, *Le Préromantisme français*, vol. 1, *Le Héros préromantique* (Grenoble, 1930), p. xii. The translation here reflects Benjamin's German translation of the French original. See *The Arcades Project*, Convolute N15a,1. Pierre Carlet de Chamblain de Marivaux (1688–1763) was a French playwright, essayist, and novelist whose light comedies won great popularity in the mid-eighteenth century. His best-known works include plays such as *Le Jeu de l'amour et du hasard* (The Game of Love and Chance; 1730) and *Le Legs* (The Bequest; 1736), and the novel *Le Paysan parvenu* (The Peasant Upstart; 1736). He was elected to the Académie Française in 1742.

17. Hugo von Hofmannsthal (1874–1929), Austrian poet and dramatist, is best known in the English-speaking world for his collaborations with the composer Richard Strauss, including his librettos for the operas *Der Rosenkavalier* and *Ariadne auf Naxos*. The quotation is from his play *Der Tor und der Tod* (Death and the Fool; 1894).

18. In German folk tradition, children born on Sunday, particularly under a new moon, are likely to possess special powers, such as the ability to see spirits, speak with the dead, or have their wishes fulfilled. The term *Sonntagskind* ("Sunday's child") is also used figuratively to refer to someone who is "born under a lucky star," who has an easy time with things that are difficult for others, or for whom each day is imbued with the spirit of Sunday.

19. See Benjamin's essay "The Storyteller" in Volume 3 of this edition, p. 154.

20. In Exodus 27:20, in the Hebrew Bible, God tells Moses on Mount Sinai to maintain a lamp at all times in the sanctuary: "And you shall command the people of Israel to bring to you pure beaten olive oil for the light, that a lamp may be set up to burn continuously." The lamp was to burn continuously as a sign of God's presence.

21. Possibly a reference to a passage in paragraph 5 of the *Revelation of Paul*, part of the New Testament Apocrypha: "My long-suffering bears with them, that they may turn to me; but if not, they shall come to me, and I will judge them."

22. Benjamin refers to number 40 in an untitled sequence of numbered reflections that Kafka composed ca. 1917–1918: "Nur unser Zeitbegriff lässt uns das Jüngste Gericht so nennen, eigentlich ist es ein Standrecht" ("It is only our concept of time that makes us call the Last Judgment by this name. Actually it is a kind of summary justice"). *Standrecht* literally suggests "standing imperative." See Franz Kafka, *Nachgelassene Schriften und Fragmente*, vol. 2 (Frankfurt: Fischer, 1992), p. 122. In English, *Dearest Father: Stories and Other Writings*, trans. Ernst Kaiser and Eithne Wilkins (New York: Schocken, 1954), p. 38. Born in Prague of Jewish parentage, Kafka (1883–1924) is best known for his short stories, such as "Die Verwandlung" (The Metamorphosis; 1915) and "In

der Strafkolonie" (In the Penal Colony; 1919), and his posthumously published novels *Der Prozess* (The Trial; 1925) and *Das Schloss* (The Castle; 1926).

23. See Benjamin's essay "Eduard Fuchs, Collector and Historian," in Volume 3 of this edition.

24. See "'The Regression of Poetry,' by Carl Gustav Jochmann," in this volume, and Convolute N9,7 in Benjamin's *Passagen-Werk* (Arcades Project).

Letter to Theodor W. Adorno on Baudelaire, George, and Hofmannsthal

<div align="right">Paris; May 7, 1940</div>

My dear Teddie,

Thanks for your letter of February 29. Unfortunately, at present we'll have to get used to long intervals like the one that has separated the penning of your lines from the arrival of my reply. And you will easily see that this letter, like Rome, wasn't built in a day.

Naturally, I was (and am) very happy with your assessment of my "Baudelaire."[1] Perhaps you know that the telegram you sent me jointly with Felizitas and Max reached me at last in the internment camp.[2] You can imagine how important it was to me psychologically, for months on end, in that situation.

I have reread the passages on regressive hearing which you singled out, and I can see the affinities between the aims of our investigations.[3] There is no better example of the way in which experience is destroyed by recording than the way in which the lyrics of a hit song are set to its melody. (It becomes apparent here that the individual takes pride in treating the content of possible experience in the same way the political administration treats the elements of a possible society.) There's no reason I should conceal from you that I find the root of my "theory of experience" in a childhood memory. In the towns and villages where my family used to spend the summer, our parents of course took us for walks. We children went in twos or threes.[4] The sibling I'm thinking of here is my brother. When we had made the obligatory excursions from Freudenstadt, Wengen, or Schreiberhau, my brother would say: "So we've done that one now." The saying has impressed itself on me unforgettably. (I'd be surprised, by the way, if you were

correct about my view of your fetish-character essay. Aren't you perhaps thinking of my reaction to your piece on jazz?[5] I did voice some objections to you about the latter. But I have no reservations at all about the former. Just lately, I've been thinking a lot about some comments you make there on "musical progress," in connection with Mahler.)

Introducing the idea of forgetting into the discussion of the aura, as you did, is certainly of great importance. I shall bear in mind the possibility of distinguishing between epic forgetting and reflexive forgetting.[6] Please don't think me evasive if I refrain from going into more detail here. I clearly remembered the passage you mention—the one in the fifth chapter of "Wagner."[7] But if aura were indeed concerned with a "forgotten part of humanity" [ein 'vergessenes Menschliches'], it would not necessarily be the part which is present in labor. The tree and the shrub one leans on were not made by men. So there must be something human in things which is *not* put there by labor. But I shall stop here. I think this question will inevitably crop up again in my work (possibly in the continuation of my "Baudelaire" project, but I'm not sure). First I'll need to go back to the *locus classicus* of the theory of forgetting—which for me, as you probably know, is "Der blonde Eckbert."[8]

I do not think that, to give a true account of forgetting, one needs to call into question the notion of *mémoire involontaire*. The childhood experience of the taste of the madeleine, which returns involuntarily to Proust's memory one day, was indeed unconscious. But his first bite of the madeleine would not have been. (Tasting is a conscious act.) Yet this act no doubt does become unconscious to the extent that a taste becomes more familiar. The "tasting again" by the grown man is, of course, conscious.

You ask me about Maupassant's story "La Nuit"; I read this important work very closely.[9] There is a fragment of my piece on Baudelaire which deals with it—you'll no doubt see it eventually.[10] (In the meantime I'm asking the Paris office [of the Institute of Social Research] to return the Maupassant volume to you, with many thanks.)

Concerning the choice between Gide and Baudelaire, Max has very kindly left it up to me. I've decided on Baudelaire. This is the subject which is most intractable for me at present—meeting its demands is my most urgent task. But I must confess I haven't yet been able to apply myself to it as intensely as I would like. One of the main reasons has been my work on the "Theses," a few fragments of which will reach you in the next few days.[11] Clearly, they represent a certain stage in my thinking as I prepare to continue with my Baudelaire project. I hope to be able to begin a period of uninterrupted work on this in the next few days.[12]

Now for the George-Hofmannsthal correspondence.[13] The way of the world is such that everything has its limits. For once, I'm in a position to meet you on ground where I feel completely at home, but my modest wish

to have first-hand knowledge of the book you write about is unfulfilled. Since I have no such expertise in the field of music, perhaps you should not take my judgments on your essay too categorically. Be that as it may, so far as I can judge, this is the best thing you have ever written. A number of comments on individual points will follow. But I would like to preface them by saying that for me the crucial feature of the essay lies in the uncommonly sure, striking, and surprising sketch of the historical perspective: the spark which leaps between Mach and Jens Peter Jacobsen gives the historical landscape the same plasticity which a flash of lightning in the night sky gives to landscape in the familiar sense.[14]

It seems to me from your account that George's image is stamped more firmly on the correspondence than Hofmannsthal's. The struggle of each writer for a literary position in relation to the other was no doubt a basic undercurrent in this correspondence, and the aggressor was always George. I find something like a complete portrait of George in your essay, but with Hofmannsthal a good deal remains in the background. In some passages it's quite clear that you chose to illuminate certain parts of this background. Your observations on the actor in Hofmannsthal, and still more on the child in Hofmannsthal (culminating for me in the wonderful quotation from *Ariadne*,[15] which has a very moving effect because of the way you've positioned it in your text), all raise deeper issues. I would have liked to know your views on the forlorn echoes from the world of childhood that occur here and there in George—for example, in "Lied des Zwergen" or "Die Entführung."[16]

One aspect of Hofmannsthal which is important to me goes unmentioned in the essay. I don't know whether the remarks I'd like to make about this (perhaps not for the first time) will say anything really new to you. Even if they do, I'm not sure how convincing they will seem to you. But even though these formulations are fragmentary, I shall put them in the mail. There are really two texts which, taken together, delineate the area that concerns me. You quote from one of them yourself: the Chandos Letter.[17] In this context, I have the following passage in mind: "I do not know how often this Crassus with his moray eel has come into my mind, across the abyss of the centuries, as a reflection of myself. . . . Crassus . . . shedding tears over his tame eel. And something unnameable forces me to think about this figure—strikingly absurd and contemptible amid the most sublime deliberations of a senate devoted to governing the world—in a way that seems to me utterly foolish as soon as I try to express it in words." (The same motif is found in *Der Turm*, in the passage on the slit-open belly of the slaughtered pig which the prince had to look at when he was a child.)[18] And the second of the passages I spoke of is also in *Der Turm*: it is the conversation between the doctor and Julian. Julian—the man whom nothing except a minute relaxation of the will, a single moment of abandonment, prevents from at-

taining the pinnacle of life—is a self-portrait of Hofmannsthal. Julian betrays the prince: Hofmannsthal here turned away from the task presented in the Chandos Letter. His own "speechlessness" was a kind of punishment. The language Hofmannsthal denied himself may well have been the one that was given to Kafka about the same time. For Kafka took up the task which Hofmannsthal had failed at morally, and therefore poetically. (The dubious theory of sacrifice you refer to, so unsteady on its legs, bears all the traces of this failure.)

I believe that throughout his life Hofmannsthal had the same attitude toward his gifts that Christ would have had toward his kingdom had he owed it to his negotiations with Satan. Hofmannsthal's unusual versatility, it seems to me, is inseparable from his awareness of having betrayed what was best in him. For this reason, consorting with the dregs of society could hold no terrors for him.

All the same, I am convinced that it won't do to assign Carossa to a "school" supposedly headed by Hofmannsthal, and then speak of the political coordination of German writers as having taken place "under the aegis" of this school and therefore under that of Hofmannsthal himself.[19] Hofmannsthal died in 1928. His death won him a verdict of *non liquet* in the case you prosecute against him. I think you should reconsider this passage; I am close to asking you to do so.[20]

You are right, of course, to mention Proust. I have recently been having thoughts of my own about his work; and once again, it turns out that they converge with yours.[21] You write very beautifully about the meaning of the phrase "It isn't that"—the very experience which makes time into time lost. It seems to me now that there was a deeply hidden (but not therefore unconscious) model for this basic experience of Proust's—"It isn't that"—in the assimilation of the French Jews.[22] You are aware of the famous passage in *Sodome et Gomorrhe* where the mutual understanding among inverts is compared to the special constellation governing the behavior of Jews toward one another. The very fact that Proust was only half-Jewish enabled him to understand the precarious structure of assimilation—an understanding which was imposed on him from outside by the Dreyfus Affair.

Concerning George, there is no text that, even with the advantage of historical distance, could approach yours. I have no reservations at all on this point, and I don't mind admitting that I was most delightfully surprised. If it now seems extremely difficult to speak of George in any other way than as the poet who, with *Der Stern des Bundes*,[23] helped choreograph in advance the St. Vitus' dance currently spreading across Germany's desecrated ground, this was certainly not to be expected of you. And the untimely and thankless task of "rehabilitating" George you have performed as definitively as possible and as unobtrusively as required. In identifying defiance as the poetic and political core of George's work, you have illuminated its

most essential features both in terms of commentary (the importance of translation) and in terms of critique (monopoly and elimination of the market). It is all of a piece, all convincing; and there are some passages which in themselves would prove that the effort you expended on this text, however long it may have taken, was not in vain. I'm thinking of your outstanding glosses on the "gentleman" and on such resonant quotations as "Es ist worden spät."[24] Your study has made conceivable something which was previously inconceivable and which will inaugurate George's afterlife: an anthology of his poems. Some of them are more effective in your text than in their original setting.

I do not wish to pass over an important point on which we should (and no doubt could) come to an agreement. It concerns what you discuss under the rubric of "attitude" or "bearing" [Haltung]. The comparison with cigarette-smoking hardly does justice to the matter—one might be misled into thinking that an attitude is always something "put on display" or "adopted." But it can also exist unconsciously, without being any less an attitude. And obviously you too take this point of view, since under the same rubric you include gracefulness [Anmut], which seldom benefits from being consciously put on display. (In this connection, I'm speaking only of children; and I have no wish to emancipate a natural phenomenon from the society in which it occurs, since this would be to treat it abstractly in the bad sense. Children's charm and grace exist, and they exist, above all, as a corrective to society—they serve as pointers to "a happiness free of discipline." The childlike innocence which, in an unkind mood, one might accuse Hofmannsthal of clinging to—the innocence that allowed him to value Salten's feuilletons hardly less highly than my book on the Baroque—does not entitle us to abandon what we can find in it to love.)[25] I'd like to explain my reservations about your remarks on "attitude" in the narrower sense by using a phrase from your own text. It occurs in the passage where you refer to my Baudelaire essay with the fine formulation that "the solitary person is the dictator of all who are solitary like him." I don't think it would be going too far to say that we encounter attitude or bearing whenever the essential solitariness of a person comes into our field of vision. Solitude, far from being the locus of a man's individual fullness, might well be that of his historically determined emptiness, the locus of the persona that is his misfortune. I understand and share all the reservations one might have about bearing as the attitude of fullness put on display (this is actually how George understood it). But there is also the inalienable bearing of emptiness (as in the features of the late Baudelaire). In short, "bearing," as I understand it, differs from the sort you denounce the same way a brand differs from a tattoo.

The last two pages of your essay were, for me, a birthday-party table whose centerpiece [Lebenslicht] was the passage about "happiness free of discipline." In fact, the whole essay resembles a gift-laden table. The

ideas in it are as free of terminological labels as a birthday present is of any price tag.

In conclusion, I'll adopt your good habit of pointing out some things as if making marginal notes. George's sentence "Eben geht der letzte zug ins gebirge" inhabits the atmosphere of Schwabing just like Kubin's dream-city, Perle.[26] Perle is the very site of the "temple" whose walls, now infested with dry-rot, guard the Seventh Ring.[27]

The reference to Kraus could be given still more weight if you linked it to Kraus's comments on George's translation of the sonnets of Shakespeare, especially since you also touch on the problem of translation.[28]

George's laudatory verdict on Hofmannsthal precisely echoes Victor Hugo's assessment of Baudelaire: "Vous avez créé un frisson nouveau."[29] When George speaks of the granite-like, Germanic quality of Hofmannsthal's work, his tone and subject matter may owe something to a passage from Hölderlin's letter to Böhlendorf of December 4, 1801.[30]

One might briefly consider the question of whether their correspondence might not have been influenced by the one between Goethe and Schiller—a correspondence that documented the friendship between two princes of letters and as such contributed so greatly to the tainted air hovering especially around the literary peaks in Germany.[31]

As a pendant to your aphorism, "The noble is noble by virtue of the ignoble": Victor Hugo's magnificent dictum, "The ignorant man is the bread eaten by the wise."

Your cameos on Carossa and Rudolf Borchardt are most skillfully crafted, and the motto you dedicate to Symbolism—"lucus a non lucendo" —delighted me, as you can imagine.[32] The supporting analysis of "Voyelles" also seems to me entirely valid.[33] The intertwining of technology with the esoteric that you detect so early has become obvious, under a regime that provides fighter pilots with castles worthy of Teutonic Knights.

Finally, I very much like the part Jacobsen plays in your essay. Earlier motifs may well be involved here. At any rate, his name, in the context of your reflections, gives the impression of a ruddy-cheeked boy racing toward us from the woods into a cool avenue of trees.

You ask about my English lessons. By the time I received the address of a teacher from Felizitas, I had already begun working with another tutor. I fear that my progress, which is less than precipitate, still runs far ahead of the conversational application of my knowledge. I, too, thought that Miss Razovsky's affidavit[34] was a "considerable asset," as you put it. Unfortunately, I've had to change my opinion. All the information I gathered on the current procedures of the American consulate (from which I've heard nothing so far) confirms that the processing of normal cases is very slow. And now my case, through no action of mine, has unfortunately become a "normal" one, as a result of the affidavit. Had this not happened, I could have

applied for a visitor's visa, like the one recently issued to the writer Hermann Kesten.[35] (He'll be arriving in New York in the near future, and will get in touch with Max.)

Kesten, too, knows Soma Morgenstern.[36] Unfortunately, I haven't seen Morgenstern for many weeks. What you call "his tendency to mediocrity, even toward himself," appears to have made exchanges with me so difficult for him that they could have been maintained only with great effort on my part. I am incapable of that. If I do see him again, I'll keep your request in mind.

To return to the visa question. In order to obtain a non-quota visa (the only kind that would enable me to come over in the near future), I would have to furnish proof of public teaching activity, regardless of any offer of a future post. There's a clause in the regulations that says the proof must apply to *the two years prior to the granting of the visa,* and the clause is now being interpreted very strictly. This makes me very hesitant to write to Schapiro at this stage.[37] I do not wish to approach him until I'm certain I could take full advantage of his interest. This will be possible only when the date of my arrival there has been moved up, either because immigration applications are being processed more quickly or because the requirements for a non-quota visa have been relaxed. As things stand now, I fear that even if I'm offered an appointment these conditions would work against me. But of course I wouldn't hesitate to write to Schapiro if you think he could do anything to facilitate the offer of a position.

May I burden you with an administrative (or perhaps more than administrative) question? Why has the *Zeitschrift* proved so inflexible with regard to several of my reviews? I'm thinking primarily of the Sternberger review, but also of the Hönigswald; I haven't received proofs for either of these.[38]

A book on Baudelaire by Georges Blin[39]—a young man from the Ecole Normale—has just come out from the NRF publishing house. I find it neither useful nor interesting, and I suppose that says something. I'm not planning to review it.

Do you know Faulcner [*sic*]? If so, I'd like to know what you think of his work. I am currently reading *Lumière d'août.*[40]

Your letter reached me without any unusual delay. I think you can write to me in German, and so you should write more often. Letters from me, however, can be only occasionally in German. Please send me a copy of your "Rickert."[41] As you know, I'm a former student of his (as you are of Cornelius), and I greatly look forward to reading your essay.[42]

<div style="text-align: right">

Yours very cordially,
Walter Benjamin

</div>

Written in May 1940; unpublished in Benjamin's lifetime. Theodor W. Adorno and Walter Benjamin, *Briefwechsel, 1928–1940* (Frankfurt: Suhrkamp, 1994), 424–434. Translated by Edmund Jephcott.

Notes

1. Benjamin's essay "Über einige Motive bei Baudelaire" (On Some Motifs in Baudelaire) had appeared at the beginning of January 1940 in Volume 8, numbers 1–2, of the *Zeitschrift für Sozialforschung,* the periodical of the Institute of Social Research. The essay is translated above in this volume.

2. "Felizitas" was Benjamin's nickname for Adorno's wife, Gretel; "Max" is Max Horkheimer, the director of the Institute of Social Research. Benjamin had been interned from mid-September through the end of November 1939 in a French camp for political prisoners near Nevers, until a petition signed by a number of prominent French intellectuals secured his release. (See Chronology.)

3. Benjamin is referring to Adorno's essay "Über den Fetischcharakter in der Musik und die Regression des Hörens" (On the Fetish Character in Music and the Regression of Listening), first published in the *Zeitschrift für Sozialforschung* in 1938.

4. Emil Benjamin (1856–1926) and his wife, Pauline Elise Schoenflies (1869–1930), had three children: Walter (1892–1940), Georg (1895–1942), and Dora (1901–1946).

5. Adorno had published his essay "Über Jazz" under the pseudonym "Hektor Rottweiler" in the *Zeitschrift für Sozialforschung* in 1937. In a conversation with Adorno during the latter's visit to Paris in October 1936, Benjamin voiced some objections to the essay, which he had read in manuscript.

6. On Adorno's distinction between "epic forgetting" and "reflexive forgetting," see his letter of February 29, 1940, in Adorno and Benjamin, *The Complete Correspondence, 1928–1940,* trans. Nicholas Walker (Cambridge, Mass.: Harvard University Press, 1999), p. 321.

7. Part of Adorno's study on Wagner had appeared under the title "Fragmente über Wagner" in the *Zeitschrift für Sozialforschung* in 1939. The full study appeared only in 1952 under the title *Versuch über Wagner* (In Search of Wagner).

8. "Der blonde Eckbert" (Fair Eckbert)," by Ludwig Tieck (1773–1853), appeared in his *Volksmärchen* (Folktales) in 1797. It deals, in proto-psychoanalytic terms, with an obsessive fear and its repression. Tieck, who wrote plays, novels, and short stories, was one of the most important of the early Romantics.

9. Guy de Maupassant (1850–1893), French author, is known for his short stories. "La Nuit, un cauchemar" (The Nightmare) appeared in his collection *Contes du jour et de la nuit* (Tales of Day and Night; 1885).

10. This fragment of a revision of the second part of Benjamin's essay "Das Paris des Second Empire bei Baudelaire" was recently discovered. It was published as "Noctambulisme II," in *Frankfurter Adorno Blätter,* vol. 4 (Munich, 1995), pp. 10ff. His book, which bore the working title *Charles Baudelaire: Ein Lyriker im Zeitalter des Hochkapitalismus* (Charles Baudelaire: A Lyric Poet in the Era of High Capitalism) but which was never completed, would have had three parts: (1) Baudelaire as Allegorist; (2) The Paris of the Second Empire in Baudelaire; (3) The Commodity as Poetic Object. See the first essay in this volume.

11. The reference is to Benjamin's piece "Über den Begriff der Geschichte" (On the Concept of History), included in this volume. When first translated into Eng-

lish, it bore the title "Theses on the Philosophy of History," based on Benjamin's informal designation for the work.

12. Work on the Baudelaire project was halted by the approach of German troops, which forced Benjamin to flee Paris for Lourdes in June 1940.

13. Benjamin is referring to Adorno's essay "George und Hofmannsthal: Zum Briefwechsel" (The George-Hofmannsthal Correspondence), written in 1939–1940 and first published in 1942; it was reprinted in *Prismen* (Prisms; 1955). Stefan George (1868–1833), German lyric poet, did his most important work around the turn of the twentieth century. In his verse and through his remarkable personal influence, he strove to "purify" German language and culture. See "Stefan George in Retrospect," in Walter Benjamin, *Selected Writings, Volume 2: 1927–1934* (Cambridge, Mass.: Harvard University Press, 1999), pp. 706–711. Hugo von Hofmannsthal (1874–1929), Austrian poet, dramatist, and essayist, made his reputation in the 1890s with lyric poems, stories, and plays in a neo-Romantic mode. During that period, he maintained a close intellectual relationship with George, with whom he broke at the end of the decade.

14. Ernst Mach (1838–1916) was an Austrian physicist and philosopher whose work was of great importance in aeronautic design and the science of projectiles (a unit of velocity, the Mach number, bears his name). His writings exerted a broad influence on the work of scientists (such as Albert Einstein), novelists (such as Robert Musil, who wrote his dissertation on Mach), and philosophers, especially in the field of logical positivism. Jens Peter Jacobsen (1847–1885), Danish novelist and poet, was a leading figure in the Naturalist movement in Denmark.

15. Benjamin is referring to Hofmannsthal's libretto for Richard Strauss's opera *Ariadne auf Naxos* (1912).

16. "Lied des Zwergen" (Song of the Dwarf) first appeared in the collection *Die Bücher der Hirten- und Preisgedichte, der Sagen und Sänge und der Hängende Garten* (The Books of Shepherd- and Praise-Poems, of Legends and Songs, and of the Hanging Garden), which was privately published in 1895. "Die Entführung" (The Abduction) appeared in the collection *Das Jahr der Seele* (The Year of the Soul; 1897).

17. Hofmannsthal's "Ein Brief" (1902), generally referred to as "The Lord Chandos Letter," is an essay in the form of a fictive letter from Phillip Lord Chandos to Francis Bacon. It is Hofmannsthal's most concentrated presentation of one of his major themes: the "crisis of language"—his conviction that language is inadequate as an expression of mental and spiritual states.

18. Hofmannsthal's last play, *Der Turm* (The Tower), was first published in 1925. See "Hugo von Hofmannsthal's *Der Turm*," in Volume 2 of this edition; Benjamin alludes to his own essay in this passage.

19. Hans Carossa (1878–1956), German writer and physician, became prominent in the 1920s for a series of largely autobiographical writings. After the Nazis seized power, Carossa allowed himself to be used for their ends; he was named president of the European Writers' Union, a Nazi creation. Hofmannsthal's writings were certainly conservative in tenor, but hardly proto-fascist. Benjamin's intervention here on behalf of Hofmannsthal owes something to their intellectual friendship in the 1920s. Hofmannsthal was the first major voice to

recognize Benjamin's literary achievement, and published the essay "Goethes Wahlverwandtschaften" in his journal *Neue deutsche Beiträge*. See "Goethe's Elective Affinities," in Benjamin, *Selected Writings, Volume 1: 1913–1926* (Cambridge, Mass.: Harvard University Press, 1996), pp. 297–360.

20. In Roman law, a verdict of *non liquet* ("it is not proved") indicated doubt as to the facts or to where the truth lay. (Benjamin gives the wrong year in this passage: Hofmannsthal died in 1929.) Adorno did in fact modify the wording of his essay.

21. Benjamin is referring to Proust's novel *A la recherche du temps perdu* (In Search of Time Lost; translated as *Remembrance of Things Past*). See the essay "On the Image of Proust" in Volume 2 of this edition.

22. Benjamin's "Das ist es nicht" is a direct translation of Proust's "Ce n'est pas cela" in Part 2, Chapter 4, of Proust's novel *Sodome et Gomorrhe,* published 1921–1923. In English as *Cities of the Plain,* trans. C. K. Scott Moncrieff and Terence Kilmartin (New York: Vintage, 1982), p. 1168. The passage in which Proust compares the interrelations among homosexuals to those among Jews appears on p. 639.

23. George's volume of poems *Der Stern des Bundes* (The Star of the Union) was privately printed in 1913.

24. George's phrase smooths the rhythms but roughens the syntax of the ordinary expression "Es ist spät geworden": "It has gotten to be late." For Adorno's glosses on the word "gentleman" in George and the phrase "Es ist worden spät," see Adorno, *Prisms*, trans. Samuel Weber and Shierry Weber (Cambridge, Mass.: MIT Press, 1981), pp. 199, 207. The line is from George's poem "Ihr tratet zu dem Herde" (You Walked to the Hearth), which is included in his volume *Das Jahr der Seele* (The Year of the Soul; 1897).

25. Felix Salten (pseudonym of Siegmund Salzmann; 1869–1945), Austrian writer and journalist, belonged to the circle around Hofmannsthal, Arthur Schnitzler, Richard Beer-Hofmann, and Hermann Bahr. He later became editor-in-chief of the *Berliner Morgenpost*. Salten's works include historical novels and a series of animal stories, the most famous of which became the film *Bambi*. Benjamin refers here to his own book *Ursprung des deutschen Trauerspiels* (Origin of the German Trauerspiel; 1928).

26. The line "Eben geht der letzte zug ins gebirge" ("The last train is just going into the mountains") is from a dream protocol that George published in a volume of notes and sketches entitled *Tage und Taten* (Days and Deeds; 1903). Alfred Kubin (1877–1959), Austrian painter, is best known for his dreamlike mythological landscapes. In 1909 he published the novel *Die andere Seite* (The Other Side), which he also illustrated. Characteristically fantastic and grotesque, the book describes the travels of a graphic artist in a fictional Asian country called Traumreich Perle (Dream-Empire Pearl), whose destruction he witnesses. Schwabing is the university section of Munich, a neighborhood formerly inhabited by artists and bohemians.

27. *Der siebente Ring* (The Seventh Ring) is the title of a poetry volume by George which appeared in 1907. It calls for reinvigorating civilization through a new culture of youth.

28. The reference is to an article by Karl Kraus entitled "Sakrileg an George oder

Sühne an Shakespeare" (Sacrilege to George, or Atonement for Shakespeare), which appeared in *Die Fackel* in December 1932. Kraus (1874–1936) was an Austrian journalist and dramatist. As the editor and main writer of *Die Fackel,* he acted as a self-appointed watchdog against the journalistic debasement of the German language. See Benjamin's essay "Karl Kraus," in Volume 2 of this edition.

29. "You have created a new type of shudder." Hugo's comment comes from his letter to Baudelaire of August 30, 1857, in response to the poems "Les Sept Vieillards" and "Les Petites Vieilles."

30. Hölderlin (1770–1843) was a German lyric poet, essayist, dramatist, and novelist whose poetry integrates the rhythm and syntax of classical Greek verse into German. His major works include the novel *Hyperion* (1797) and the poems "Brot und Wein," "Wie wenn am Feiertage," and "Patmos." Böhlendorf (1775–1825) was a student with Hölderlin at the University of Jena. He became professor of history at the *Gymnasium* in Bremen in 1800. Hölderlin's letter of December 4, 1801, praises Böhlendorff's efforts as a playwright; he sees them as evidence of an authentically Germanic transformation of ancient Greek forms and themes, pointing to the possibility of a "modern tragedy," although the "free use" of "the national" remains the most difficult of tasks.

31. In 1828–1829, Goethe edited and published his correspondence with Schiller from the years 1794–1805.

32. On Carossa, see note 19 above. Rudolf Borchardt (1877–1945), German-Jewish essayist and poet, produced a body of work notable for its nationalist-conservative tenor and its great formal refinement. The expression *lucus a non lucendo* is used to indicate a non sequitur, an illogical explanation, or an absurd word derivation. It is actually a Latin play on words: *lucus,* "grove," is wrongly derived from *lucere,* "to shine." The phrase literally suggests "a grove, called thus because no light shines there," or, more figuratively, "the light that sheds no light."

33. "Voyelles" (Vowels) is the title of a poem written by Arthur Rimbaud in 1872.

34. Through the good offices of Cecilia Razovsky (1886–1968), who worked with the National Refugee Service, Benjamin received an affidavit from Mr. Milton Starr of Nashville, Tennessee, in January 1940. Such affidavits promised work opportunities for immigrants.

35. Hermann Kesten (1900–1996), German novelist and publisher, emigrated to the Netherlands in 1933 and to the United States in 1940. He is best known for a tetralogy of novels entitled *Bücher der Liebe* (Books of Love). Kesten had been interned with Benjamin at the camp near Nevers.

36. Soma Morgenstern (1890–1976), novelist and journalist, was born and educated in Poland. After studying law at the University of Tarnopol, he moved to Austria, where from 1928 to 1934 he worked as the Viennese cultural correspondent of the *Frankfurter Zeitung,* which published a number of pieces by Benjamin. Like Kracauer and other Jewish staff members, Morgenstern lost his job at the journal. In 1935 he emigrated to France, where he was interned in a camp. He emigrated to America in the late 1930s.

37. Meyer Schapiro (1904–1996) was an American art historian best known for his studies of modernist art. He taught at Columbia University in New York and

was acquainted with Adorno; he had arranged for Adorno to give a lecture at the Brooklyn Institute of Arts and Sciences. In his letter of February 29 to Benjamin, Adorno had mentioned that Schapiro was in the process of "setting up some courses or other for you here, in order to improve your financial circumstances," and he urged Benjamin to write to Schapiro.

38. See Benjamin's reviews of Dolf Sternberger's *Panorama* and of Richard Hönigswald's *Philosophie und Sprache,* in this volume.

39. The book is Georges Blin's *Baudelaire,* preface by Jacques Crépet (Paris, 1939). Blin (born 1917), the author of *Stendhal et les problèmes de la personnalité* (1958) and other books on French literature, taught at the Sorbonne.

40. *Lumière d'août,* trans. Maurice E. Coindreau (Paris, 1935), is a translation of William Faulkner's novel *Light in August* (1932).

41. Adorno's review "Heinrich Rickert: Unmittelbarkeit und Sinndeutung" (Heinrich Rickert: Immediacy and the Interpretation of Meaning) appeared in *Studies in Philosophy and Social Science,* 9 (1941): 479–482. The philosopher Heinrich Rickert (1863–1936) founded, together with Wilhelm Windelband, one of the principal schools of Neo-Kantian philosophy in Germany. His work in epistemology emphasized the role of transcendental subjectivity in the acquisition of knowledge. Both Benjamin and Martin Heidegger studied with Rickert in 1912 at the University of Freiburg.

42. Hans Cornelius (1863–1947), German philosopher, taught first at Marburg and, beginning in 1910, at Frankfurt, where Adorno studied with him. Benjamin's own experience with Cornelius was less memorable: Cornelius had overseen the submission of Benjamin's "Ursprung des deutschen Trauerspiels" (Origin of the German Trauerspiel) as his *Habilitationsschrift,* the second dissertation required of all academics with aspirations to a professorial position. For an account of the failure of this process, see the "Chronology" to Volume 1 of this edition.

A Note on the Texts

In the years 1938–1940, Benjamin struggled to remain productive and to find publishing venues for his work as the shadow of war spread across Europe. "Every line we succeed in publishing today . . . ," he wrote in 1940, "is a victory wrested from the powers of darkness." Yet however insistently the idea of catastrophe hangs over the writings Benjamin produced in the final years of his life, the "victories wrested" in this period nonetheless make for the most remarkable analysis of the emergence of modern society and culture offered in the twentieth century. The writings on Charles Baudelaire included in this volume are the distillation of a lifetime of thinking about the nature of modernity. In the essays "The Paris of the Second Empire in Baudelaire" and "On Some Motifs in Baudelaire" and in the collection of fragments "Central Park," the avatars of modernity for which Benjamin is most famous—the flâneur, the detective, the conspirator, the collector, and the ragpicker—all play their role. These writings, together with the final version of "The Work of Art in the Age of Its Technological Reproducibility" and the late meditation on the philosophy of history "On the Concept of History," record the crisis of meaning experienced by a civilization sliding into the abyss, even as they testify to Benjamin's own indomitable faith in the word and in the continuing viability of artistic and critical enterprise. The volume also contains important work here translated for the first time, including Benjamin's commemoration of the French Revolution, "Germans of 1789," and his commentary on an early nineteenth-century essay on the social history of literature: "The Regression of Poetry," by Carl Gustav Jochmann. Like the previous volumes in this edition, Volume 4 also includes a representative selection of unpublished writings from the period. Some are fragments that Benjamin composed in the course of producing a published essay, but others simply were not published prior to his death.

The German edition of Benjamin's collected writings groups texts generically (volumes of essays, of reviews, of fragments, and so on). In the present edition, all texts

are arranged chronologically by date of composition; if this differs markedly from the date of publication, both dates are given. Each text is accompanied by the following information: date of composition and/or publication; place of publication, or a statement that the piece was unpublished during Benjamin's lifetime; and the word "Fragment" if the text is designated as such in the German edition. All endnotes other than Benjamin's were produced by the editors.

The *Selected Writings* aims to present to English-language readers a very broad and representative selection from Benjamin's oeuvre. Every major text published during Benjamin's lifetime is included in this edition. We have attempted to supplement these major texts with examples of every *form* in which Benjamin worked: thought figures, radio plays, autobiographical writings, book reviews, letter collections, essays, fragments, cultural histories, travel accounts. Examples of each of the remarkable number of *fields* to which Benjamin contributed are likewise included: cultural theory; epistemology; art history; the French avant-garde, especially Surrealism; the new Soviet Union; cinema; radical pedagogy; contemporary writers ranging from André Gide and Julien Green through Karl Kraus and Hugo von Hofmannsthal (to say nothing of Proust and Kafka, the subjects of two of Benjamin's most famous essays); graphology; political and social analysis; media theory; the study of children's toys; the theory of experience; marginalized popular forms such as novels by the mentally ill and penny romances; photography; and the theory of language. We hope that the English-language reader will for the first time be able to assess the remarkable breadth and intensity of Benjamin's achievement.

All translations are based on the text of the standard German edition: Walter Benjamin, *Gesammelte Schriften,* seven volumes (Frankfurt: Suhrkamp Verlag, 1972–1989), edited by Rolf Tiedemann et al. The editors of the present volume are indebted to Benjamin's German editors for the meticulous dating and preparation of his texts. The entire editorial team—Maria Ascher, Howard Eiland, Michael Jennings, and Lindsay Waters—are grateful to the late Dr. Siegfried Unseld and the late Frau Helene Ritzerfeld of Suhrkamp Verlag for their help with all four volumes of the edition.

The editors would like to thank a number of friends, colleagues, and collaborators who provided information and assistance at crucial stages of the project. Above all, an immense debt of gratitude is due Daniel Magilow, whose vigorous research formed the basis for a number of the notes to the text. Eduardo Cadava, Bo-Mi Choi, Stanley Corngold, Michael Curschmann, Eli Friedlander, Barbara Hahn, Kenneth Haynes, Thomas Levin, Arnd Wedemeyer, and Christian Wildberg answered our questions with patience and generosity. Miriam Hansen offered her time and expertise to make a great many valuable improvements in the translation of "The Work of Art in the Age of Its Technological Reproducibility." Very special thanks are due our colleagues at Harvard University Press. The idea for an expanded edition of Benjamin's writings came from Lindsay Waters, and without his now patient, now insistent godfathering, the edition would certainly never have been completed. And Maria Ascher—through her consistently resourceful and meticulous editing of the final manuscript, work to which she brings a highly developed ear for the sound of English prose—improved not just the texts themselves but the conception and the apparatus of this fourth volume of the edition. Her name should appear not here, but on the title page.

Chronology, 1938–1940

1938

Benjamin departed Paris on June 21, bound for an extended visit to Skovsbostrand, Denmark, Bertolt Brecht's chosen place of exile. Upon his arrival, he moved into the house next door to Brecht, where his landlord was a police official, a circumstance which he hoped might be an advantage should he be forced to extend his visa. The first days in Skovsbostrand promised a nearly ideal working environment; he looked forward, he wrote (quoting Baudelaire), to living in the "contemplation opiniâtre de l'oeuvre de demain."[1] The house had a large garden, and the window by his desk looked out on the sound. "The little ships that pass by are my only distraction—aside from my daily chess pause with Brecht" (*GB*, 130).

Benjamin had left Paris for several reasons. Germany was becoming increasingly aggressive, tensions in France were growing, and his status as an exile gave him only a tenuous foothold there. Above all, he hoped to find the right environment in which to complete what he now saw as a full-scale book on Charles Baudelaire. This book, which bore the working title *Charles Baudelaire: Ein Lyriker im Zeitalter des Hochkapitalismus* (Charles Baudelaire: A Lyric Poet in the Age of High Capitalism), would be based on his decade-long research for the *Passagen-Werk* (Arcades Project). Several statements in letters from the early days in Denmark reveal that Benjamin saw the Baudelaire project as a direct continuation of his work in the 1920s. He tells his sister that he is "again involved—after a hiatus of ten years—in writing a book." In 1928, Ernst Rowohlt had published Benjamin's book on the German *Trauerspiel* (mourning play), as well as his carefully ordered series of thought figures, *Einbahnstraße* (One-Way Street). And it is to *One-Way Street* that Benjamin refers, however unconsciously, when he tells Friedrich Pollock that *Charles Baudelaire* will afford "a view—arranged perspectivally—into the depths of the nineteenth century" (*GB*, 133)—a phrase virtually identical to his description of *One-Way Street* in a 1926 letter to Scholem. As early as the end of July, though, he

knew that he would not have the work completed by September 15—the deadline given to him by the Institute of Social Research. He had agreed to this date while still in Paris, thinking that the outline he had composed there would accelerate the writing process. But once in Denmark he realized that the initial schematization, produced during a period when he'd been suffering from severe migraines, would have to be completely redone.

In late July, August, and September of 1938, Benjamin worked with full intensity on his study of Baudelaire. The new schematization had three parts: an introductory, highly theoretical section entitled "Baudelaire als Allegoriker" (Baudelaire as Allegorist), which linked Baudelaire to Benjamin's own brilliant reading of Baroque allegory; a central section, "Das Paris des Second Empire bei Baudelaire" (The Paris of the Second Empire in Baudelaire), which would provide the social "data" or "antithesis" to that theory; and a concluding section, "Die Ware als poetischer Gegenstand" (The Commodity as Poetic Object), which would examine the posthistory of Baudelaire's age through analyses not just of commodity fetishism but also of Art Nouveau and the notion of the eternal return in Baudelaire, Blanqui, and Nietzsche. In early August, Benjamin suggested to Max Horkheimer, director of the Institute of Social Research, that section 2—which would articulate a series of analogies linking Baudelaire, Louis Napoleon, and the Parisian *bohème*, "the relation of the metropolitan crowd to modern literature," and the complex intertwining of antiquity and modernity in Baudelaire's poems—might be most suitable for publication in the institute's journal, the *Zeitschrift für Sozialforschung* (*GB*, 150).

Work on the Baudelaire essay was accompanied by the intensive discussions with Brecht that were characteristic of their relationship. Much of their talk was of literature: Virgil, Dante, Goethe, Anna Seghers, Brecht's own epic theater and most recent poetry.[2] But increasingly, their time and energy were given over to discussions of recent developments in the Soviet Union. In a letter to Horkheimer, Benjamin attempted to explain the views he held in common with Brecht: "We have up to now been able to view the Soviet Union as a power that does not determine its foreign policy according to imperialist interests—hence as an anti-imperialist power. We continue to do so, at least for now, because—despite the gravest possible reservations—we still view the Soviet Union as the agent of our interests in a coming war, as well as in the delaying of this war; I assume that this corresponds to your sense of the situation. That this agent is the costliest imaginable, in that we have to pay for it with sacrifices diminishing the interests that matter most to us as producers, Brecht would never think of disputing." Even Brecht had come to regard the newest developments—the show trials, the purges, the cowering before Hitler—as "catastrophic for everything we've stood for over the past twenty years" (*GB*, 148, 139).

This more public solidarity with Brecht and his vigorous, engaged Marxism continued to worry Benjamin's colleagues at the institute, where a more mediated understanding of engagement reigned. Benjamin's commitment to Brecht also exacted more personal costs. He reported to Gretel Adorno, for example, that he was reading much more "party line" literature in Denmark than he did ordinarily. And he commented to Kitty Marx-Steinschneider that his room was coming to resemble a monk's cell—not because of its furnishings, but because of its intellectual isolation. "In spite of all my friendship with Brecht, I need to pursue my work in strict seclusion. There are certain very distinct elements in it which are unassimilable for him"

(*GB*, 142–143). And even the idyll in the policeman's house had, under the pressure of pushing forward the Baudelaire, begun to sour. He confided to the Adornos in late August that the noise of the children in the house might force him to leave. He was considering renting rooms from a mentally ill man, despite his antipathy to such illnesses. Strung between Brecht, the institute, and his own as yet unrealized but profound hopes for the Baudelaire, Benjamin exhibited signs of increasing strain. Philosophical discussions with his old friend Gershom Scholem, he wrote, had evidently left Scholem with an image of him "not unlike that of a man who has, with iron determination, opened a crocodile's jaws, only to settle down comfortably between them" (*GB*, 142). In fact, his relations with Scholem had reached a new low. Having departed Paris a few weeks before Scholem could meet him there on his way back to Jerusalem from New York, Benjamin now informed his friend that their planned meeting in the fall would not take place either, since he had to remain in Denmark to complete the Baudelaire. They would be unable to discuss their recent work, and Benjamin would miss the opportunity to meet Scholem's new wife. His embarrassment over his repeated failings soon faded, however. On September 30 he sent an aggrieved letter to Scholem: "I find it astonishing that I have heard nothing from you. Your silence has been worrying me for quite some time" (*GB*, 165).

One sign of Benjamin's concentration in this period—he described his three months of work on the Baudelaire essay as "extremely intense"—is the relative paucity of references to his reading habits. He mentions with amusement and no little dismay that he had come across a recent issue of the Moscow periodical *Internationale Literatur* in which the writer Alfred Kurella, an old associate from the Youth Movement, had characterized him as a follower of Heidegger (Kurella had reviewed the excerpt from Benjamin's essay "Goethes Wahlverwandtschaften" [Goethe's Elective Affinities] published in translation in the French journal *Les Cahiers du Sud*). But otherwise, his comments refer to his reading *plans*. Benjamin did consent with enthusiasm to the publication of excerpts from an earlier letter to Horkheimer—a "letter from Paris" on recent developments in French writing. He asked only that a highly critical account of Georges Bataille, with whom he enjoyed cordial relations, and through whom he had come into contact with the circle of intellectuals around the Collège de Sociologie,[3] be excised before publication.

In September, as Benjamin worked toward concluding "The Paris of the Second Empire in Baudelaire," his letters reveal profound anxiety, which was fully justified by developments in Europe. Germany's insistence on the annexation of the Sudetenland made war in Europe seem inevitable. He told several of his correspondents that he would rather await the war in Scandinavia than in France, and asked Horkheimer for names of Scandinavian friends in case his visa expired. It was against this horizon that Benjamin concluded three months of "the most intensive labor" (*GB*, 165) and, near the end of the month, left Skovsbostrand for Copenhagen in order to dictate and mail the final version of "The Paris of the Second Empire in Baudelaire." This last stage of composition coincided precisely with what Benjamin called "the provisional European dénouement": the signing of the Munich accords on September 29 and Germany's immediate invasion of the Sudetenland. Benjamin thus saw only that part of his "beloved" Copenhagen which lay between his "hotel room and the radio in the hotel's common room" (*GB*, 167).

On October 4, shortly after his return to Skovsbostrand, Benjamin reported to

Adorno that the completion of the essay had been "a race against the war; and despite the fear that choked me, I experienced a feeling of triumph on the day I brought the 'flâneur'—which had been planned for almost fifteen years—safely under a roof (even if only the fragile one of a manuscript!)" (GB, 168). In a letter to Horkheimer confirming the mailing of the manuscript, Benjamin reaffirmed the centrality of the essay to his work: it set forth "decisive philosophical elements of the Arcades Project in what I hope are their final state." And he restated a conviction betraying a certain anxiety about the essay's reception in New York: his belief that "the philosophical bases of the *entire* book will be visible only from section 3, 'The Commodity as Poetic Object'" (GB, 162).

As he prepared to leave Denmark, Benjamin arranged—not without misgivings—to have his books shipped to Paris. He was convinced that war was unavoidable, that the Munich accords promised anything but "peace in our time," and that the fascist alliance would simply shift its greedy gaze to new acquisitions. He thus strongly suspected that Paris itself would become yet another of the "transfer points" for himself and his possessions. "How long the European air will remain breathable—in a material way—I don't know. Spiritually, it is no longer so after the events of the past weeks. . . . One thing, at least, has now been irrefutably demonstrated: Russia has allowed its European extremity to be amputated" (GB, 167). He was somewhat heartened by the fact that his twenty-year-old son Stefan had settled down in the relative safety of England, and his former wife, Dora, was selling her property in San Remo, Italy.

Benjamin left Denmark around October 15. His stay with Brecht had been unusually free of strife—which was itself a cause for concern, since he read Brecht's newfound willingness to listen as a sign of his friend's increasing isolation. "I don't wish to wholly exclude the more banal interpretation of this fact—that his isolation has diminished the pleasure he takes from certain provocative subterfuges, which he always inclined to in conversation. But another reading is more authentic: he recognizes, in this growing isolation, the consequences of his loyalty to that which we hold in common" (GB, 168).

Back in Paris, Benjamin found a series of changes that exceeded even those he had feared. His thirty-seven-year-old sister Dora, who had been in generally poor health, was now suffering from arteriosclerosis and was all but incapacitated (she would die in a Swiss clinic in 1946). His younger brother Georg, arrested by the Nazis in 1933 for his Communist sympathies, had been transferred to the prison at Bad Wilsnack in Brandenburg, where he was part of a crew doing street repair. "The nightmare that hangs over people in his situation is, as I often hear from Germany, not so much the coming day in prison as the transfer to a concentration camp, which has been threatened for years" (GB, 174). Georg would in fact perish in the Sachsenhausen concentration camp in 1942.

Benjamin now also feared the definitive loss of his personal archives in Berlin. He had asked a friend, perhaps Helen Hessel, to make one last attempt to retrieve the books and papers that remained in his apartment, but this attempt met with no success. Benjamin wrote to Gretel Adorno lamenting the loss of the papers of the brothers Fritz and Wolf Heinle (Benjamin's friends from the German Youth Movement), his own unpublished essay on Friedrich Hölderlin, and an "irreplaceable" archive of the left-liberal wing of the Youth Movement, to which he had belonged.[4] More gen-

erally, he feared the consequences of any French-German rapprochement in the wake of the Munich accords, and especially its potential effects on the relations between French and German residents in Paris. Lacking any alternative, though, he continued to pursue his application for French citizenship, "carefully but without illusions. If my chances of success were doubtful before, now even their usefulness has become questionable. The decline of the rule of law in Europe makes every kind of legalization deceptive" (*GB,* 175). At his death, his application was still in process.

He was soon back in contact with his network of French friends. In November he attended a banquet for contributors to *Les Cahiers du Sud* at the brasserie "L'Alsacienne," where he saw Paul Valéry, Léon-Paul Fargue, Jules Supervielle, Jean Wahl, Rolland de Renéville, and Roger Caillois. He also enjoyed more frequent contact with Pierre Missac, whom he had met in 1937 through Bataille; they shared an interest in film. Of all his French friends, it was Missac who would later do the most to keep Benjamin's memory and reputation alive in France. But Benjamin's French relationships were fragile. He asked Horkheimer, for example, to publish his negative review of Caillois' *Aridité* under the pseudonym "Hans Fellner" rather than risk incurring the displeasure of Callois' friend Renéville, who was shepherding Benjamin's citizenship application through his ministry. The review in fact appeared under the pseudonym "J. E. Mabinn," an anagram of "Benjamin." More of his German friends were now in Paris. Franz Hessel was the latest to emigrate, "with impeccable credentials and under powerful protection"; Jean Giraudoux, then a high-ranking official in the French foreign ministry, had procured a visa for him.

In mid-November Benjamin received what was arguably the most crushing rejection of his career: the news, conveyed in an extensive critique by Theodor W. Adorno, that the Institute of Social Research would not publish "The Paris of the Second Empire in Baudelaire." In his letter of November 10, Adorno, speaking for Horkheimer as well, accused Benjamin of neglecting the mediation that must relate elements within a dialectical structure. He recognized the intentional fragmentariness through which Benjamin sought to reveal the "secret affinities" between the general manifestations of industrial capitalism in big-city life and the specific details of Baudelaire's work, but he found the essay's constructive principle a failure. Benjamin's approach was methodologically unfeasible because it sought to place "isolated and obvious features from the realm of the base" in an "unmediated and even causal relationship with corresponding features of the superstructure."[5] Writing from the secure vantage of New York City, where he formed part of the inner circle of the institute, Adorno felt fully justified in rejecting not just a specific essay, but the most important example of Benjamin's mature, highly innovative methodology—the methodology developed for the Arcades Project. The reversal in their positions was now complete. Adorno had, not long before, been Benjamin's disciple, composing a series of essays, and a book on Kierkegaard, that were deeply indebted to Benjamin's work, delivering his inaugural lecture in Frankfurt as an homage, and teaching his first seminar on the *Trauerspiel* book. Now, aware that Benjamin was wholly dependent upon his support from the institute, he felt he could dictate not just the course but the theory of Benjamin's work. Adorno's material and moral support for Benjamin in these years was generous and consistent, but their intellectual exchange never fully recovered from their disagreement over Baudelaire.

It is hardly surprising that it took Benjamin almost a month to answer; the letter had plunged him into a deep depression from which he emerged only in the spring of 1939. As he would later explain to Scholem, his near-total isolation made him morbidly sensitive to the reception of his work. In a letter dated December 9, Benjamin answered, point by point, Adorno's criticisms; but his main goal was to save the present *structure* of the book from Adorno's pressure to return to an earlier conception of the Arcades Project. "If . . . I refused, in the name of my own production-interests, to develop my ideas in an esoteric direction and thereby to address the issues of the day at the expense of dialectical materialism and the institute, that was not just out of solidarity with the institute or loyalty to dialectical materialism but also out of solidarity with the experiences we have all shared over the past fifteen years. My most personal production-interests are also at stake here; I will not deny that they sometimes try to do violence to the project's original interests. An antagonism between them does exist, but . . . resolving it is the central problem of this work, and it is a problem of construction." Far from the "wide-eyed presentation of facticity" that Adorno claimed was the result of Benjamin's method, the mode of construction aimed at constituting the historical object as a monad. "In the monad, the textual detail which was frozen in a mythical rigidity comes alive." Sensing in advance that his local arguments would have little effect, Benjamin concluded with the plea that a wider audience—and history—be allowed to judge his work.

1939

On January 5, Benjamin learned that the few things of value he had left behind at his home in Berlin—a large secretary, a rug, and, most important of all, shelves full of books and a manuscript case—would have to be moved, since his acquaintance Werner von Schoeller was moving out of the apartment. Benjamin's friend Käthe Krauß saw to the sale of the secretary and rug, which paid his debt to his landlord; she agreed to take care of the books and manuscript case. Neither the books nor the manuscript case—to say nothing of its possible contents—were ever heard of again. On February 14, this material loss was followed by a more harrowing bureaucratic loss: the Gestapo initiated a procedure leading to the revocation of his German citizenship following their discovery of an article—Benjamin's first "Pariser Brief" (Letter from Paris)—which had been published in 1936 under his own name in the Moscow journal *Das Wort*. The decision on Benjamin's expatriation was communicated to the German embassy in Paris in a letter dated May 26. He was henceforth stateless.

Suffering from persistent depression, Benjamin struggled to resume work on the revision of the Baudelaire materials, from which he now felt "alienated" (*GB,* 216). In February, he put aside the notes, reflections, and excerpts that constitute "Zentralpark" (Central Park), which he had begun composing while at work on "The Paris of the Second Empire in Baudelaire." He turned in earnest to the revision of the Baudelaire essay itself. He read the economist Anne-Robert Turgot and the philosopher Hermann Lotze as he thought about the concept of progress in relation to his understanding of the nineteenth century, and Georg Simmel's *Philosophie des Geldes* (Philosophy of Money) as he considered the materialist bases of his work. On February 1, Adorno sent what can only be characterized as an astonishingly in-

trusive letter agreeing to the publication of a revised version of the middle section of "The Paris of the Second Empire in Baudelaire" ("The Flâneur"), but dictating long lists of major and minor changes to the text. Benjamin's reply, dated February 23, rose to the defense of several formulations—the presentation of Baudelaire within a series of analogous types, the issue of fetishism, the concept of phantasmagoria—but in general acceded to Adorno's demands while passing in silence over the question of the essay's methodology and structure. Still believing that he was working on the central section of a book-length study, he asserted in a letter to Scholem that the "key positions" of the Baudelaire project remained untouched by the interference from New York (*GB*, 217).

Benjamin persisted, despite lingering depression, with his work on other projects. Early in the year, he sent extensive reviews of three books (by Dolf Sternberger, Richard Hönigswald, and Louis Dimier) to the *Zeitschrift für Sozialforschung*. As always, he was reading and thinking about Kafka. He sent Scholem a brief but extraordinarily rich series of observations: for Benjamin in 1939, the essence of Kafka was humor, though Kafka was clearly no ordinary humorist. "He was, rather, a man destined to encounter people everywhere who made a career of humor—namely, clowns. . . . Kafka, as Laurel, felt the burdensome responsibility of seeking out his Hardy—and that was Brod."[6] Thus, "the key to Kafka" would belong to whoever could "extract from Jewish theology its comic side [*komischen Seiten*]" (*GB*, 220). He also made progress with a series of texts related to Brecht. These included the brief "Notiz über Brecht" (Note on Brecht), a significant essay on the writer, as well as the lengthy "Kommentare zu Gedichten von Brecht" (Commentary on Poems by Brecht), to which he attached enormous importance. The latter would be one of the texts that Benjamin entrusted to Georges Bataille before fleeing Paris in June 1940. His allegiance to Brecht remained unshakable, even as his disillusionment with the Soviet Union and its leadership of the left became entrenched. He reported to Gretel Adorno in March that two discouraging texts had crossed his desk on the same day: Willi Münzenberg's open letter announcing his resignation from the Communist party and an anonymous propaganda pamphlet called "Der Weg zum Sturze Hitlers" (The Way to Hitler's Fall). He described the latter as a testimony to the party's ignorance and weakness. The leftist writer Bernhard von Brentano told him of a Zurich avant-garde group (consisting, by his own admission, only of himself and Ignazio Silone) whose motto was "Things are a thousand times worse in Russia than in Germany" (*GB*, 249).

The breadth and depth of Benjamin's reading remained unaffected by the political turmoil around him. He reported to Scholem, with some amusement, how he was acquiring new reading material: the widow of the Russian writer Lev Shestov lived in his building, surrounded by uncut copies of her husband's collected works, and as she made room for herself by discarding volumes, Benjamin added to his library. He was also reading Jean Giono and the German novelist Elisabeth Langgässer—both of whom came in for acerbic commentary.

On January 24 he sent the second of his long reports on French letters to Horkheimer. Although they remained unpublished, these reports were eagerly awaited in New York, and not only by the institute's research staff: Horkheimer informed Benjamin that they were being circulated among the Columbia University faculty. Benjamin's report is unusually critical. Alluding to the legacy of Surrealism,

he opens with the remark that "the contemporary process of decomposition in French literature has weakened even those seeds that seemed to contain the potential for long-term development" (GB, 201). His most extensive commentary is reserved for La Conspiration (The Conspiracy), by Paul Nizan, an editor of the socialist daily L'Humanité. This well-received work—at once political novel and novel of education—expresses Nizan's disillusionment with socialism, looking back at the formation of the Popular Front and its consequences. Benjamin calls the book an "éducation sentimentale of the Class of 1909" (GB, 198). He recommends Raymond Queneau's Enfants du limon (Children of Clay) with moderate enthusiasm; he faults Queneau, the former Surrealist, for a certain timidity in taking up the legacy of Apollinaire. In commenting on a special issue of the Nouvelle Revue Française that dealt with the Collège de Sociologie and contained articles by Bataille, Callois, and Michel Leiris, he singles out Callois' contribution, "Le Vent d'hiver" (The Wind of Winter) for particular scorn. He is surprisingly ambivalent regarding an article on anti-Semitism by his close friend Adrienne Monnier published in the Gazette des Amis du Livre; he finds that she is too careful and too willing to compromise, perhaps with an eye to her own wealthy clientele. He concludes with a series of ironic remarks on Paul Claudel's last publication—a Catholic allegory of precious stones, issued as an exquisitely produced brochure available only at fashionable jewelry shops.

Despite regular meetings with such friends as Hannah Arendt and her companion Heinrich Blücher to compare reading notes and test new ideas, Benjamin frequently lamented his intellectual isolation. Friends and acquaintances continued to visit him, but their visits were brief, their destinations elsewhere. He did see Germaine Krull, who had returned to Paris, as well as Alfred Polgar and Wilhelm Speyer (one of Benjamin's favorite traveling companions in better days), who passed through the city. After a meeting with Ernst Rowohlt, Benjamin reserved words of particular praise for his old publisher, who had been forced to close his press and was taking his family to safety in Brazil; Benjamin fully appreciated the risks Rowohlt had taken in support of Jewish authors like Franz Hessel long after 1933. And two of his friends from the Brecht circle, the filmmaker Slatan Dudow and the novelist Bernhard von Brentano, were in Paris, Brentano to be feted by his French publisher, Grasset, on the occasion of the appearance of his novel Theodor Chindler in French translation.

Early March brought a severe blow to Benjamin's waning confidence and resolve. Horkheimer had written, apologetically, with bleak news on the financial state of the Institute of Social Research; he told Benjamin that the institute would, in all likelihood, be forced to cancel his stipend in the near future. Benjamin replied on March 13, saying he had read the letter "with horror." He of course wished all the best for the institute's staff, but hinted that Horkheimer might not understand the difference between a reduction in stipend for the New York colleagues and its cessation for him in Paris: "We are all isolated individuals. And for the isolated individual the perspective opened by your letter, with its terrifying earnestness, overshadows all other plans" (GB, 231). That same day, he sent off a second exposé of the Arcades Project, hoping to aid Horkheimer in his search for a patron for the project;[7] and he began to cast about—though conscious of the futility of the enterprise—for sources of support in France. He explained his situation to Gretel Adorno a few days later:

"I have followed the developments here long enough to know that, since the beginning of the emigration, no one who works in a similar line and under similar conditions has been able to secure a livelihood" (*GB*, 239). A letter to Scholem betrays his frustration with the situation in New York, and renews his appeals for support from Palestine. A contract with Salman Schocken's publishing house (now in Palestine) for a book on Kafka might enable him to carry on under halfway human conditions, which he equates with 2,400 francs per month. "I would hardly be able, *à la longue*, to bear sinking below that level. The charms of the world around me are too weak, the rewards of posterity too uncertain" (*GB*, 236). With truly Benjaminian timing, a letter arrived from Scholem as he was about to seal his own; it brought the news of chocken's rejection of his book prospectus. Schocken had celebrated the publication of a new edition of Karl Kraus's drama *Die letzten Tage der Menschheit* (The Last Days of Mankind) with a public reading and talks by Scholem and by Benjamin's former friend Werner Kraft. Scholem had filled his allotted time by reading from Benjamin's essay "Karl Kraus," which moved everyone in the room—except Schocken, who was mystified.

Although the financial collapse of the Institute of Social Research never came about, and although Benjamin's stipend was neither terminated nor reduced, he spent more and more of his time sending out appeals for help (to Scholem and Kitty Marx-Steinschneider in Palestine, who might find employment for him there; to Sigmund Morgenroth, the wealthy father of his young friend Stephan Lackner, who might intercede with the institute to accelerate the effort to bring him to America), and writing dutiful reports on his failed attempts to elicit support in France. His previously "only moderate" desire to emigrate to America or Palestine had been heightened not just by the new financial developments, but by the fear of impending war and by the increasingly blatant anti-Semitism in France. Hannah Arendt also sought help for her friend; her efforts were driven by a new appreciation for his latest ideas. In a letter to Scholem she noted that Benjamin's "production has changed, right down to the stylistic details. Everything now appears more directly, with much less hesitation. It often seems to me that he is only now approaching the things that are decisive for him. It would be horrible if he were hindered at this stage."[8] Genuinely moved by the support of his friends, Benjamin wrote to Gretel Adorno that "Europe is a continent whose atmosphere, heavy with tears, is illuminated all too seldom by flares of consolation." He noted dryly that "even the poorest devils" were doing what they could to get to the New World (*GB*, 246, 247).

In the late spring, as Benjamin worked to revise his Baudelaire essay, he brought a new element into the foreground: idleness. The flâneur would now appear "in the context of an investigation of the specific features acquired by idleness in the bourgeois age, amid the prevailing work ethic" (*GB*, 247). At about this time, Benjamin began a new convolute in the Arcades materials: a folder labeled "Idleness." In late April, he learned that he had been awarded a grant from the Caisse des Recherches Scientifiques to spend a few weeks at the Foyer International d'Etude et Repos, a library and study center housed in the restored Abbaye de Pontigny, near the town of Auxerre, southeast of Paris; the center was run by the writer Paul Desjardins and his wife. Benjamin hoped to take advantage of the magnificent library to advance the Baudelaire. He also looked forward to the financial succor afforded by the visit: room and board were included in the invitation. Arriving at the abbey in early May,

he was encouraged by the "charming site" and the "magnificent complex" of ancient monastic buildings (*GB, 276*). Even in such an idyllic setting, however, Benjamin was plagued by his acute sensitivity to noise: his hope that work and recovery would be "one and the same" was disappointed by a visiting group of boisterous young people. He listened to a guest lecture by Emilie Lefranc, an official in a socialist educational organization, and commented that he hadn't previously known the extent to which vulgar Marxism could serve purely counterrevolutionary ends. He himself spoke about his work on Baudelaire, apparently before a small audience. Among his discoveries in the library were the *Pensées* of Joseph Joubert, "the last of the great French moralists"; excerpts from this text play a key role in several sections of the Arcades Project. His leisure reading at Pontigny bridged, in one particular book, Europe and America: Henry James's novel *The Aspern Papers*, in French translation.

In late May, Benjamin returned to a Paris rife with rumors of war and the coming internment of foreign nationals. His financial situation, even after his stay as a guest at Pontigny, had grown more desperate. He wrote to friends asking for small amounts of money (and for tobacco), and he renewed his pleas to Stefan Lackner to pursue the sale of his Klee in America.[9] His mood can be read very clearly from a number of passages in his letters. He comments with obsessive fascination on the deaths of the authors Joseph Roth, who drank himself to death, and Ernst Toller, who hanged himself. And he passes along a morbid anecdote to Margarete Steffin: "Karl Kraus really did die too soon. Listen: in Vienna, the gas company has ceased delivering gas to Jews. Gas consumption by the Jewish population was causing the company to lose money, since it was precisely the largest consumers who failed to pay their bills. The Jews used the gas—in preference to other methods—for committing suicide" (*GB, 294–295*).

The Baudelaire material yielded only grudgingly to Benjamin's efforts to shape it. He attempted to work at a table on his balcony, so as to escape the noise of the elevator in his building, but found that a "good-for-nothing" painter on the opposite balcony whistled to himself constantly. He tried stopping his ears with "wagonloads" of wax, paraffin, and even concrete, to no avail (*GB, 293–294*). As a distraction from his woes and from the Baudelaire, and as a tribute to the 150th anniversary of the French Revolution, he composed "Allemands de quatre-vingt-neuf" (Germans of 1789), a montage of letters by Germans of the period that expressed their reactions to the events in France. Modeled on his 1936 compilation *Deutsche Menschen* (German Men and Women), the work brought him considerable pleasure and the discovery that the second volume of odes by the great German poet Friedrich Klopstock contained numerous poems about the revolution, a fact that German literary history had "systematically veiled" (*GB, 294*). It was only on June 24 that he could report some progress on the Baudelaire: he sent Horkheimer an abstract of the new essay, an expanded version of the notes that had formed the basis for his talk at Pontigny.

That summer, Benjamin expanded his reading and viewing program. Some texts, like Karl Korsch's *Karl Marx*, flowed directly into the Baudelaire. But much of his reading simply kept him afloat on the alien sea of French letters: Léon-Paul Fargue's *Piéton de Paris*, Maurice Sachs's *Souvenirs du boeuf sur le toit*, Georges Simenon's *La Marie du port*, Sartre's *Le Mur*, and Valéry's "Pièces sur l'art." Yet even the

search for diversions proved unsatisfying. Frank Capra's 1938 film *You Can't Take It with You* struck Benjamin as implicitly reactionary, provoking him to contradict Lenin: it is not religion that is the opiate of the masses, but rather "a certain kind of harmlessness—a narcotic in which the 'education of the heart' and 'silliness' are the most important ingredients" (*GB*, 305). He saw the movie as evidence of the film industry's complicity with fascism, "even over there" (that is, in the U.S.).

Benjamin took comfort in frequent visits with his former companion in libertin- age, Franz Hessel, and Hessel's wife, Helen, one of Benjamin's staunchest friends in his last years. Helen Hessel—a journalist best known as one of the models for the character Catherine in Henri-Pierre Roché's novel *Jules et Jim,* the basis for François Truffaut's film of the same name—worked tirelessly to help Benjamin, and secured him a number of invitations for weekends and meals among her friends. And he en- countered the writer Alfred Döblin, once the target of his wrath because of Döblin's rather misty left-liberal views. This time, Benjamin regarded him more sympatheti- cally. On June 23, in an address at the Cercle des Nations, Döblin remarked on the "inconceivable" assimilation of many bourgeois Jews to Hitler's side.

As Benjamin approached the end of the Baudelaire essay—newly titled "Über einige Motive bei Baudelaire" (On Some Motifs in Baudelaire)—his eagerness to flee Europe grew stronger. His focus was now on America, and he made every effort to assemble the money for his passage, trusting that his colleagues in New York would secure him some minimal livelihood once he had crossed the Atlantic. He saw the Baudelaire essay as a kind of reentry visa to the Institute of Social Research, yet its completion in late July and posting on August 1 brought not the joy and relief that had accompanied the conclusion of other major projects, but more anxiety and an- ticipation. He felt that the revision united, to an unprecedented extent, virtually all of his "reflections, which have come from such divergent directions"; in a letter to Gretel Adorno, he emphasized the connection of this version to the main motifs of his great essays on the work of art and the storyteller (*GB*, 308). He could indulge in a bit of irony a week after the essay was sent off: "I'm allowing my Christian Baudelaire to be carried into heaven by nothing but Jewish angels. Preparations have already been made, though, so that in the last third of the ascension, just before the entrance into glory, they will let him fall—as if by accident" (*GB*, 317).

On completion of the revision, he had little time to turn to other matters. The Hit- ler-Stalin pact was signed on August 23, and on September 1 the German army in- vaded Poland. Benjamin, along with thousands of other Germans and Austrians of military age (that is, between the ages of eighteen and forty-nine), was interned in early September at Paris' Olympic arena, the Stade de Colombes; placards had been posted throughout the city on September 3 calling for all Germans and Austrians to report to the stadium with a blanket. The poet and critic Hans Sahl, a fellow in- ternee, has left a vivid account of Benjamin's two months of confinement. The sta- dium itself, with its partially roofed stands, afforded shelter from the elements to only a fraction of the detainees; they were fed a steady diet of cheap liver pâté spread on bread; and they were forced to build their own makeshift latrines. Sahl reports that the conditions were difficult even for the young and healthy; for Benjamin, who at forty-seven was one of the oldest detainees, they were life- threatening. His life was no doubt saved by a young man, Max Aron, who came to his aid. "I noticed an older man," Aron remembered later, "on the first evening

there, sitting quietly, motionless, on one of the benches. Was he really not yet fifty? . . . It was only when I noticed him the next morning, still sitting (as it seemed to me) in the same place, that I began to be concerned. There was something dignified both in his silence and in his posture. He simply didn't fit into those surroundings."[10] It seemed to Sahl that, "in the younger man's care for this physically frail individual, helpless in all things practical, [there was] an almost biblical respect for the spiritual in a time of plagues and dangers."[11]

After ten days of confinement, the detainees were divided into groups and sent to internment camps *(camps des travailleurs volontaires)* throughout France. Benjamin and his friends, who included not only Aron and Sahl but the playwright Hermann Kesten, were transported, first by train and then by forced march, to the abandoned Château de Vernuche, near Nevers. Sahl reports that the march was a torture for Benjamin, whose heart was taxed to the limit of its capacities; Aron carried his paltry belongings for him. The 300 detainees found the château absolutely empty, and slept on the floor until straw was brought a few days later. The series of shocks took a heavy toll on Benjamin; he needed more time than most of his fellows to adjust to the hardships, which included filth, cold, and hunger. His health continued to suffer; there were days on which he stayed prostrate, unable even to read. He wrote to Gretel Adorno that he was only occasionally heartened by a game of chess or by the "beneficial spirit of camaraderie" that prevailed in the château (*GB, 336–337*). Yet even the harsh conditions could not stifle his anxieties about the Baudelaire essay: he wrote repeatedly, asking whether he would see proofs prior to publication. With Adorno and Horkheimer's comments on the first version still fresh in his mind, he obviously feared unauthorized changes to his work.

By mid-October, Benjamin could report to Brentano that he had recovered "the moral strength" to read and write (*GB, 347*). Many friends, above all Adrienne Monnier, Sylvia Beach, and Helen Hessel, sent him chocolate, cigarettes, journals, and books. His reading consisted mainly of what was sent to him: Rousseau's *Confessions* and Cardinal Retz's *Mémoires*. In what Sahl called "true Boy Scout spirit" [*Wandervögelgeist*], the internees began to organize, soon after their arrival, a full array of activities. These included an unusual diversity of intellectual opportunities. Sahl offered readings of his poetry (for example, his "Elegy for the Year 1939"); Benjamin delivered lectures (one of them was on the concept of guilt) and offered, for a fee, philosophical seminars. The fees were paid by his "students" in the currency of the camp: nails, cigarettes, and buttons.[12]

At some point during the incarceration, a group of "film people" convinced the commandant to give them day passes (they were issued armbands) in order to make a pro-French documentary; they returned from Nevers and regaled their envious co-detainees with stories of French wine and food. Inspired by the hope for an armband, Benjamin set out for the third time in his life—following his failed attempts with *Angelus Novus* in the early 1920s and *Krisis und Kritik* (Crisis and Criticism) in the early 1930s—to found a journal. As editor of the projected *Bulletin de Vernuche: Journal des Travailleurs du 54e Régiment,* he assembled a first-class team of writers and editors from the camp population. The drafts for the first issue, which are held in the Akademie der Künste in Berlin, included sociological studies of camp life, critiques of camp art (chorales, amateur theatricals, etc.), and a study of the inmates' reading habits. Sahl's own proposed contribution, an analysis of the

creation of a "society ex nihilo," might have taken the form of a chronicle along the lines of Defoe's *Robinson Crusoe*. The journal was never published.

As Benjamin's fixation on the armband shows, thoughts of freedom were never far from his mind. He had already collected testimonials from Paul Valéry and Jules Romains in support of his citizenship application; he now attempted to use these to effect his release. Adrienne Monnier worked devotedly to the same end, ultimately convincing PEN, an international organization of writers and editors, to intervene with the Ministry of the Interior on behalf of Benjamin and Siegfried Kracauer, who was being held in another camp. By early November, the first detainees were released. Benjamin's own liberation was pronounced by an interministerial commission on November 20, following the intervention of the diplomat Henri Hoppenot, a friend of Monnier's.

By November 25, Benjamin was back in Paris. He had lost weight, and was frequently forced to stop "in the middle of the street, too weak to walk in any direction" (*GB*, 361). But he wrote to Scholem that he felt relatively well. And as one of the first detainees to be released, he was very sensible of his good fortune: he sent packages to a number of acquaintances still held in Vernuche. Back at his desk in his apartment on the rue Dombasle, his thoughts turned to new projects; he sent a proposal to the Institute of Social Research for an essay on Rousseau's *Confessions* and Gide's journals, "a sort of historical critique of 'sincerity.'"

Benjamin still felt a deep attachment to Paris, which after all had been his home for seven years and would remain the focus of what he still considered his life's work: writing the primal history of the nineteenth century as it appeared in the murky light of the Parisian arcades. He knew that "nothing in the world can replace the Bibliothèque Nationale for me" (*GB*, 373). Yet he was quite aware that his freedom was only an interlude, and that he needed to leave the city soon if he were to leave at all. His French friends (with the notable exception of Adrienne Monnier) urged him to go, and he remembered that his reluctance to cut all ties to another homeland—Germany—in 1933 had been overcome only at the strong urging of Gretel Adorno. He thus undertook a number of new initiatives aimed at his eventual departure from France. One of these was an attempt to learn English. He told Gretel that he had no difficulty reading her letters in English; and he composed, no doubt with a friend's help, a letter of thanks in English to Cecilia Razovsky, a social worker with the National Refugee Service in Paris. On November 17, Razovsky had submitted a visa application for Benjamin to the American consul in Paris; it included affidavits of support from Milton Starr of Nashville, Tennessee, a wealthy businessman and patron of the arts. Perhaps out of gratitude for PEN's willingness to intervene on his behalf, but certainly in an effort to acquire new allies, Benjamin also proposed his candidacy to the organization's division for German exiles; he was admitted as a member in early January. Around the turn of the year he twice saw his former wife, Dora. She tried, without success, to convince him to come to London, where she and a partner were opening a boarding house.

1940

As the new year began, Benjamin was still preoccupied with the details of a life that he had to reconstruct after his internment—details such as reopening his bank ac-

count, renewing his privileges at the Bibliothèque Nationale, attempting to keep alive his dwindling opportunities for publication. And his living conditions (an underheated, noisy apartment, a heart that would not allow him to take his customary long walks) continued to impede his work. Yet he was driven forward by a sense of foreboding. On January 11 he wrote to Scholem: "Every line we succeed in publishing today—given the uncertainty of the future to which we consign it—is a victory wrested from the powers of darkness" (GB, 379). The last such major victory was surely the publication of "On Some Motifs in Baudelaire" in the Zeitschrift für Sozialforschung, in the first days of 1940.[13] Yet Benjamin had almost nothing to say about this event; a brief mention to Scholem asking for an opinion was typical of his comments. The real enthusiasm was expressed by Adorno, whose "bad conscience" had now given way to "a rather vain feeling of pride" at "the most perfect thing you have done since the book on Trauerspiel and the essay on Kraus."[14]

Although he never ceased to refine and augment his great project on the nineteenth century, Benjamin's thoughts, understandably, turned increasingly to the present, and to the political situation. While he missed the fiery political debates he'd been waging with Scholem since 1924, he told Scholem in January that there was no longer any point to them, presumably because he had lost all sympathy with the politics of the Soviet Union after the conclusion of the Hitler-Stalin pact. His sense of a renewed accord with Scholem undoubtedly sprang in some measure from the text he was working on in early 1940, a "certain number of theses on the concept of history" (GB, 400) that brought together political, historical, and theological motifs in an absolutely original way. These theses ultimately became "Über den Begriff der Geschichte" (On the Concept of History), Benjamin's last major work. He told a number of correspondents that they were motivated by the experience of his generation in the years leading up to the war; the theses themselves derived in part from the beginning of the essay "Eduard Fuchs, der Sammler und der Historiker" and in part from reflections included in the Arcades manuscripts. He hoped that the theses would provide the theoretical armature for the Baudelaire book; as they approached completion, they assumed the character of an independent text.

Not even the coming of the war could bring a change in Benjamin's reading habits. An essay by Caillois on Hitler prompted the ironic observation that Caillois would spend the war years in Argentina, where he had followed the Argentine celebrity Victoria Ocampo. Benjamin was reading not only Rousseau and Gide for his projected essay, but, with real absorption, Michel Leiris' L'Age d'homme, a book that he recommended to several friends. He offered Adorno—in a letter to Gretel—a series of comments on Adorno's manuscript "Fragmente über Wagner" (Fragments on Wagner); Adorno's theorization of reduction as a phenomenon of phantasmagoria reminded him of his own, early remarks on Goethe's tale "Die neue Melusine" (The New Melusine). And he told Brentano that he had read his new novel, Die ewigen Gefühle (Eternal Feelings) in "forty-eight hours." On March 23, Benjamin sent a new overview of contemporary French letters to Horkheimer in New York. The bulk of the letter concerns three texts: a portrait of his adopted city entitled Paris: Notes d'un Vaudois, by the Swiss author Charles-Ferdinand Ramuz; Michel Leiris' L'Age d'homme; and a series of comments on the proto-Surrealist writer Lautréamont by Gaston Bachelard, presumably from his Psychanalyse du feu

(Psychoanalysis of Fire). Benjamin pays tribute to Ramuz's study of Paris, which differs sufficiently in approach from his own Arcades Project to permit a genuine sympathy. The letter to Horkheimer is particularly useful as it articulates the nature of Benjamin's interest in Leiris: in the same way that much of Benjamin's work in the 1930s explores paths opened by Surrealism, Leiris and the Collège de Sociologie follow lines of inquiry that parallel Benjamin's own—at a distance. The Bachelard, too, is examined from a perspective derived from Benjamin's innermost concerns: he lauds Bachelard's interpretations of the latent content of Symbolist poetry—a series of "puzzle images" *(Vexierbilder)* which carry an unconscious energy and potential meaning. The letter also contains shorter critiques of Jean Guéhenno's *Journal d'une "révolution"* (Diary of a "Revolution"); *Le Regard* (The Gaze), by Georges Salles, to which Benjamin devoted a review (a second version of which appeared as a letter in Adrienne Monnier's *Gazette des Amis des Livres*); and Caillois' "Théorie de la fête" (Theory of Festival).

Benjamin continued to meet with friends and acquaintances, though most were now in transit. Gustav Glück, his close friend and the inspiration for his 1931 essay "Der destruktive Charakter" (The Destructive Character), had escaped with his family to Buenos Aires. Pierre Klossowski, his friend and translator, had left Paris for Bordeaux, where he had taken a post with the municipal administration. The German-Czech journalist Egon Erwin Kisch had passed through on his way to exile in Mexico. And Benjamin's old friend Hans Bruck was still in a camp. Other friends and acquaintances were now dead: Paul Desjardins, the "spiritus rector" of the center at Pontigny, as well as the young illustrator Augustus Hamburger and his companion Carola Muschler (who had killed themselves). These circumstances led Benjamin to speculate that an "ingenious synthesis" was in the process of being forged by history—a combination of Nietzsche's "good European" and his "last man." This synthesis "would result in the last European—something we are all striving not to become" (*GB*, 442).[15]

By late April or early May, Benjamin had completed "On the Concept of History." He was quite aware that these theses contained an explosive blend of historical materialism and theology. "I have kept them safe for almost twenty years," he wrote to Gretel Adorno. "Indeed, I have kept them safe from myself." Despite their importance, he had no intention of publishing them: they would open the door to "enthusiastic misunderstanding" (*GB*, 435, 436). Remarkably, he failed to mention the theses in his long letter to Adorno dated May 7 (included in this volume). This letter, one of Benjamin's last major statements on literature, combines insights into Kafka, Proust, and Baudelaire with a consideration of the neo-Romanticism of Stefan George and Hugo von Hofmannsthal, authors who were the focus of Adorno's writing at the time. Actual publications were now rare events for Benjamin. He hoped to see a French version of his 1936 essay "Der Erzähler" (The Storyteller) appear in the journal *L'Esprit*, but this never materialized.

The aim of finding a safe haven in the United States now dominated Benjamin's thought and activity. He reported proudly on his first attempt to read an English text: Bacon's *Examples of the Antitheta* (from his *Advancement of Learning*). And he accompanied this with a reading of a book more closely related to the American experience: William Faulkner's novel *Light in August* (in French translation). But hopes for escape were clouded by his deteriorating health. A prominent cardiologist

had diagnosed tachycardia, high blood pressure, and an enlarged heart; the recommended treatment, prescribed apparently without irony, was rest in the country. As the cost of medical care strained Benjamin's already precarious finances, he once again cast about for help. The Institute of Social Research responded with a generous special payment of 1,000 francs. The only positive side of the whole situation was his being pronounced unfit for military service—an ironic echo of his repeated and ultimately successful attempts to simulate illness in order to avoid service in World War I.

As the German armies attacked first Belgium and the Netherlands and then France in early May, the French government began a new round of internments. Benjamin—together with Kracauer, the journalist Hanns-Erich Kaminski, and the writer Arthur Koestler—was spared through the renewed intervention of Monnier's friend Henri Hoppenot. But more than two million people were now in flight before the Nazi armies. Benjamin hurriedly emptied his apartment and saw to the safekeeping of the bulk of his papers. The least important of these were simply left behind in his apartment, and vanished. A second group was left with a series of friends. We know very little about the fate of these papers during the war, but in 1946 they were in Zurich with his sister Dora, who later sent them to Adorno in New York. The papers most precious to Benjamin—the Arcades materials, the manuscript of *Berliner Kindheit um neunzehnhundert* (Berlin Childhood around 1900), "The Storyteller," the third version of "Das Kunstwerk im Zeitalter seiner technischen Reproduzierbarkeit" (The Work of Art in the Age of Its Technological Reproducibility), his sonnets,[16] the Brecht commentaries, and several theoretically central letters from Adorno—he gave to Georges Bataille. Bataille entrusted the greater part of this material to two librarians at the Bibliothèque Nationale in Paris, where it remained during the war; after the war, Pierre Missac tracked it down, retrieved it from Bataille, and arranged for its transfer to Adorno. A final trove, consisting of the most advanced drafts and notes for the partially completed *Charles Baudelaire: A Lyric Poet in the Age of High Capitalism,* seemed for many years to be lost. In 1981, Benjamin's Italian editor Giorgio Agamben discovered a body of material in Benjamin's hand in the Bataille archive at the Bibliothèque Nationale; this proved to be the notes and drafts for the Baudelaire book. It remains unclear whether Bataille after the war had mistakenly retrieved only part of the manuscript collection left with him by Benjamin, or whether this material had been stored separately and forgotten.

With the help of French friends, Benjamin and his sister Dora, who had been released only days before from an internment camp at Gurs, were able to secure places on a train leaving Paris on or around June 14—one of the last trains to carry refugees out of the city toward the south. They got off the train at Lourdes, in the Pyrenees, where they found inexpensive accommodations and a warm welcome from the townspeople and municipal officials. Benjamin had with him a few toilet articles, an oxygen mask, and one book—the memoirs of Cardinal Retz. Three weeks after his arrival in Lourdes, he wrote to Hannah Arendt that La Rochefoucauld's description of the cardinal furnished an apt portrait of Benjamin himself: "His idleness sustained him in glorious style for many years, in the obscurity of an errant and secluded life." Despite the support of the townspeople, life in those weeks soon reached a state of utmost precariousness. Dora suffered from advanced arterioscle-

rosis and was all but immobile; Benjamin himself found that his heart condition was exacerbated not just by his general situation and the strains of daily existence, but by the elevation as well. Benjamin sensed a "glacial quiet" descending around him; he wrote to Gretel Adorno that he would normally experience joy at receipt of a letter, "but I don't know if I could recognize that emotion after so long" (GB, 471, 469). His most pressing worry was reinternment, which would have led directly to a transfer into German custody; but simply day-to-day living, with little money and even less contact with those close to him, posed an increasingly insuperable challenge. "In the past months," he wrote to Adorno, "I have seen a number of lives not just sink but from one day to the next *plummet* from bourgeois existence" (GB, 475). His sole comfort seems to have been derived from literature: a rereading of Stendhal's novel Le Rouge et le noir (The Red and the Black).

Contact with the world beyond Lourdes was intermittent. Letters and postcards from the Institute of Social Research had arrived in Paris after his departure; some were lost, some reached him only weeks later. Benjamin thus did not learn until July that Horkheimer, despairing of quickly obtaining an American visa, had attempted to make possible his residence and employment in Santo Domingo or Havana. Word trickled through of the ongoing internment of a number of friends, including Heinrich Blücher and Fritz Fränkel, the elderly physician who had once presided over his hashish experiments in Berlin. Other friends, including Kracauer and Kesten, were gradually making their way to Marseilles, where great numbers of refugees were gathering, all with the hope of escaping across the Pyrenees into Spain.

It took more than two months before Benjamin could join his friends in Marseilles. On July 10, negotiations between the French and German governments resulted in the dissolution of the Third Republic and the formation of the Vichy regime under the collaborationist Marshal Philippe Pétain. The preceding cease-fire agreement, signed on June 22, had already included an article that effectively abolished the right of asylum for foreigners in France.[17] Benjamin now began to cast about for any solution that might afford even temporary relief, including emigration to Switzerland—hardly the safest of havens for a German Jew; he had written to Hofmannsthal's friend Carl Jacob Burckhardt, a Swiss diplomat and historian, asking him to intercede on his behalf. Burckhardt later told Benjamin's friend Max Rychner that he had done what he could. Benjamin's last letter to Adorno conveys his clear grasp of the situation: "I am condemned to read every newspaper . . . as a summons addressed to me, and to hear the voice of the bringer of ill tidings in every radio program. . . . My fear is that the time at our disposal may be far more limited than we supposed. . . . I cannot conceal from myself the peril of this situation. I fear that only a few will be able to save themselves" (GB, 475–476). Finally, in early August, Benjamin learned that the institute had secured a non-quota visa enabling him to enter the United States, and that the consulate in Marseilles had been duly informed. With this precondition satisfied, he obtained a safe-conduct pass and arrived in Marseilles in mid-August. His sister Dora remained in Lourdes; she was able to find a hiding place on a farm in the country, and made her way to Switzerland in 1941.

Arriving in Marseilles, Benjamin was issued not only an entry visa for the United States, but also transit visas for Spain and Portugal. What he could not obtain was an exit visa for France. Lists of German Jews and opponents of the regime were now

posted at harbors and border crossings; Vichy militiamen searched internment camps, freeing Nazi supporters and handing over "enemies of the state" to the Gestapo.[18] We know almost nothing of the month Benjamin spent in Marseilles. He may have attempted, with Fritz Fränkel, to bribe his way onto a freighter, disguised as a French sailor.[19] On September 17, Benjamin wrote to Alfred Cohn that these weeks were a "terrible test of nerves" and that he was weighed down by a powerful depression (*GB*, 482). There are indications, however, that even this urgent state of affairs could not extinguish his intellectual interests. The novelist Soma Morgenstern tells of a lunch date with Benjamin in Marseilles at this time, during which the two writers talked about Flaubert, one of whose characters (Madame Arnoux in *L'Education sentimentale*) happened to share her name with the restaurant they were patronizing.[20]

In late September, Benjamin—accompanied by two acquaintances from Marseilles, German-born Henny Gurland and her son Joseph—took the train from Marseilles into the countryside near the Spanish border. The prospects for a legal exit from France seemed nonexistent, and Benjamin chose to attempt an illegal crossing into Spain; from there, he hoped to make his way through Spain to an embarkation point in Portugal, and on to the United States. In Port Vendres, they joined Lisa Fittko, a thirty-one-year-old political activist from Berlin, whose husband Benjamin knew from the internment camp at Vernuche. Fittko was hardly a professional guide, but had explored the possibilities for escape with real thoroughness. She could find her way along a path across the spurs of the Pyrenees and into the border town of Port Bou, Spain, with the aid of a description she had obtained from the mayor of Banyuls-sur-Mer, close to Port Vendres. From nearby Cerbère, there was a more direct route to Port Bou which had served many refugees as their highway out of France; but the Germans had learned of this path and were closely guarding it. Refugees were now forced westward, higher into the mountains, along the "Route Lister" from Banyuls. Lion Feuchtwanger, Heinrich and Golo Mann, Franz Werfel, and Alma Mahler-Werfel had all escaped by means of this rugged trail. Fittko asked Benjamin whether, in view of his fragile heart, he wanted to risk the exertion. "The real risk would be not to go," he replied.[21]

Benjamin and the Gurlands probably left Banyuls on September 25, guided by Fittko.[22] She noted Benjamin's carefully calculated pace—ten minutes of walking, followed by one minute's rest—and his refusal to have anyone else carry his heavy black attaché case, which contained, he said, a "new manuscript" that was "more important than I am."[23] Speculation has run wild as to the identity of this manuscript. Some have thought that it might be a completed version of the Arcades or of the Baudelaire book; in all likelihood it was the final text of "On the Concept of History," which survived in two other typescript versions. Benjamin must have suffered terribly on that walk through the Pyrenees. He was forced to stop and spend a night alone in the open, high in the mountains; his companions, having acquainted themselves with the first third of the trail and then returned to Banyuls to sleep in an inn, rejoined him next morning for the final, most difficult portion of the climb and the descent into Port Bou. On the afternoon of September 26, when they were within sight of Port Bou, Fittko left the little party—which had grown larger as they encountered other refugees, some of them acquaintances from Marseilles. She returned to France and later served as guide for other fleeing groups, before she herself

escaped in 1941, eventually settling in the United States (where she lives today, in Chicago).

In Port Bou, Benjamin and the Gurlands reported to the small Spanish customs office in order to obtain the necessary stamp on their papers. For reasons that will now never be discovered, the Spanish government had recently closed the border to illegal refugees from France; Benjamin and his companions were told they would be returned to French soil—to face probable internment and transfer to a concentration camp. Perhaps out of consideration for Benjamin's manifestly deteriorating health, the customs officials allowed him and the Gurlands to spend the night in Port Bou. Benjamin took a room in the small Hotel de Francia. He composed a note for Henny Gurland:

> In a situation presenting no way out, I have no other choice but to make an end of it. It is in a small village in the Pyrenees, where no one knows me, that my life will come to a close [va s'achever].
>
> I ask you to transmit my thoughts [pensées] to my friend Adorno and to explain to him the situation in which I find myself. There is not enough time remaining for me to write all the letters I would like to write.[24]

And sometime during the night, he took a massive dose of morphine.

At this point the record of Walter Benjamin's last hours, and the fate of his body, becomes impervious to historical inquiry. Henny Gurland later recalled that she received an urgent message from Benjamin early on the morning of September 27.[25] She found him in his room, where he asked her to depict his condition as the result of illness and gave her the note; he then lost consciousness. Gurland summoned a doctor, who pronounced him beyond help. According to Gurland, Benjamin died sometime on September 27. The municipal death certificate confirms some aspects of Gurland's recollections but not others.[26] Identifying the deceased as "Dr. Benjamin Walter," it attributes his death to a cerebral hemorrhage; the Spanish doctor who examined Benjamin may have acceded to his final wish, hoping to conceal the suicide. But it gives the date of death as September 26.

The next day, the border was reopened. Before leaving Port Bou, Henny Gurland followed Benjamin's last wishes and destroyed a number of letters—and perhaps, inadvertently, the manuscript he had carried over the Pyrenees. She also left enough money to rent a crypt for him in the communal cemetery for five years. The municipal death certificate records the burial on September 27; the ecclesiastical record, however, places the burial on September 28. Perhaps because the death certificate transposed his names, Benjamin was buried in the Catholic section of the cemetery, and not in the area reserved for those of other faiths (to say nothing of suicides), but the municipal and ecclesiastical records again yield contradictory information on the exact number of the rented crypt. A list of his belongings, though not the belongings themselves, was discovered many years later in the municipal records, likewise under the name "Benjamin Walter." It mentions a leather attaché case (but no manuscript), a man's watch, a pipe, six photographs, an X-ray, a pair of glasses, a few letters and newspapers, along with other papers, and a bit of money.

At the conclusion of the five-year lease, a new body was placed in the crypt in the cemetery at Port Bou. Benjamin's remains were in all probability transferred to a

mass grave. A memorial by the Israeli artist Dani Karavan now looks out from the cemetery toward the Mediterranean.

Notes

1. Walter Benjamin, *Gesammelte Briefe* (Collected Letters), vol. 6: 1938–1940, ed. Christoph Gödde and Henri Lonitz (Frankfurt: Suhrkamp, 2000), p. 136. Subsequent references to this work will appear in the text as *GB* followed by a page number. The French phrase, meaning "stubborn contemplation of tomorrow's work," comes from section 6 of Baudelaire's article "Conseils aux jeunes littérateurs" (Advice to Young Men of Letters; 1846).
2. See "Diary Entries, 1938," in Walter Benjamin, *Selected Writings, Volume 3: 1935–1938*, ed. Howard Eiland and Michael W. Jennings (Cambridge, Mass.: Harvard University Press, 2002), pp. 335–343.
3. Founded by Georges Bataille, Roger Caillois, and Michel Leiris in March 1937, the Collège de Sociologie centered on an effort to redefine a "science of the sacred" that would replace functionalist sociology. Benjamin was scheduled to give a lecture in the 1939–1940 series, but the war put an end to the Collège. See Georges Bataille et al., *The College of Sociology, 1937–1939*, ed. Denis Hollier, trans. Betsy Wing (Minneapolis: University of Minnesota Press, 1988).
4. More of this material survived than Benjamin could have known. Scholem had a copy of the Hölderlin essay in Jerusalem, and much of the material impounded by the Gestapo survived the war and lay for years in the archives of the Berlin Akademie der Künste in the German Democratic Republic (East Germany).
5. See "Exchange with Theodor W. Adorno Concerning 'The Paris of the Second Empire in Baudelaire,'" in this volume.
6. The writer Max Brod (1884–1968) came to know Kafka as a student in 1902–1903, and remained a devoted friend to the end of Kafka's life, afterward editing his writings. See Benjamin's "Review of Brod's *Franz Kafka*" (1938), in Volume 3 of this edition.
7. See "Paris, Capital of the Nineteenth Century: Exposé of 1939," in Walter Benjamin, *The Arcades Project*, trans. Howard Eiland and Kevin McLaughlin (Cambridge, Mass.: Harvard University Press, 1999), pp. 14–26.
8. Hannah Arendt in a letter to Gershom Scholem, May 29, 1939; cited in Benjamin, *Gesammelte Briefe*, p. 255.
9. Paul Klee's watercolor *Angelus Novus*, which Benjamin had purchased in Munich in 1921, hung in his apartment at 10, rue Dombasle at the end of the Thirties. When, in June 1940, he fled from Paris, he cut the picture out of its frame and stored it in one of the two suitcases containing his papers which he gave to Georges Bataille to hide in the Bibliothèque Nationale. After the war, it was conveyed, together with these papers, to Adorno in New York and later in Frankfurt. It hangs today in the Israel Museum in Jerusalem.
10. Memoirs of Max Aron, 1939, Jewish National and University Library, Jerusa-

lem; cited in Ingrid Scheurmann and Konrad Scheurmann, eds., *Für Walter Benjamin* (Frankfurt: Suhrkamp, 1992), p. 115.

11. Hans Sahl, "Walter Benjamin in the Internment Camp," trans. Deborah Johnson, in Gary Smith, ed., *On Walter Benjamin* (Cambridge, Mass.: MIT Press, 1988), p. 348.

12. Ibid., pp. 349–350.

13. The essay appeared in *Zeitschrift für Sozialforschung*, 8, nos. 1–2 (1939); but this issue did not appear until 1940.

14. Theodor W. Adorno and Walter Benjamin, *The Complete Correspondence, 1928–1940*, trans. Nicholas Walker (Cambridge, Mass.: Harvard University Press, 1999), p. 319.

15. On the good European, see Nietzsche's *Human, All Too Human*, aphorism 475. On the last man, see the fifth section of the prologue to Nietzsche, *Thus Spoke Zarathustra*.

16. Benjamin's sonnets are printed in his *Gesammelte Schriften*, vol. 7 (Frankfurt: Suhrkamp, 1989), pp. 27–67. They were composed ca. 1913–1922, though the dating is uncertain.

17. Ingrid Scheurmann, "Als Deutscher in Frankreich: Walter Benjamins Exil, 1933–1940," in Scheurmann and Scheurmann, eds., *Für Walter Benjamin*, p. 96.

18. Ruth Fabian and Corinna Coulmas, *Die deutsche Emigration in Frankreich nach 1933* (Munich: K. G. Saur, 1978), pp. 85ff.; cited in Ingrid Scheurmann, "Als Deutscher in Frankreich," p. 97.

19. See Lisa Fittko, "The Story of Old Benjamin," in Walter Benjamin, *The Arcades Project*, p. 947. This essay is reprinted in Fittko, *Escape through the Pyrenees*, trans. David Koblick (Evanston, Ill.: Northwestern University Press, 1991). Fittko's recollections of Benjamin's crossing of the Pyrenees in September 1940 constitute much of what we know about Benjamin's last days.

20. Soma Morgenstern to Gershom Scholem, December 21, 1972. Cited in Hans Puttnies and Gary Smith, *Benjaminiana* (Giessen, Germany: Anabas Verlag, 1991), pp. 203–205.

21. Fittko, "The Story of Old Benjamin," p. 947.

22. The exact dates of Benjamin's walk across the Pyrenees, arrival in Port Bou, and death are not certain. The evidence for the dates used here—memoirs by Lisa Fittko and Henny Gurland, municipal and ecclesiastical records, Benjamin's own last letter—is itself contradictory.

23. Fittko, "The Story of Old Benjamin," pp. 950, 948.

24. *Gesammelte Briefe*, vol. 6, p. 483. Translated by Howard Eiland in *The Arcades Project*, p. 946.

25. Many of the details that follow are found in a letter from Henny Gurland written in October 1940; see Benjamin, *Gesammelte Schriften*, vol. 5, pp. 1195–96. The letter is translated by Harry Zohn in Gershom Scholem, *Walter Benjamin: The Story of a Friendship* (New York: Schocken, 1981), pp. 224–226.

26. For facsimiles of this and other relevant documents, see Scheurmann and Scheurmann, eds., *Für Walter Benjamin*, pp. 101ff.

List of Writings in Volumes 1–4

This list includes all the works by Benjamin appearing in the four volumes of the *Selected Writings*. Angle brackets (< >) indicate an insertion by the German editors. Numerals at right designate the volume, and the page on which the piece begins. An alphabetical list of the writings by their German and French titles follows the list of English titles.

Index

Actor, 259–260, 261, 276nn24,26, 277n27, 306–307. *See also* Film; Stage/theater

Adorno, Gretel Karplus, 103, 113n17, 429, 430, 433, 434, 435, 437, 438, 439, 440, 443

Adorno, Theodor Wiesengrund, 112n7, 146, 150nn1,2, 429, 431, 440, 442; Letter to Benjamin (February 1, 1939), 200–207, 432–433; Letter to Benjamin (November 10, 1938), 99–105, 431, 432; "On the Fetish Character of Music and the Regression of Listening," 104, 110

Alain [Emile Chartier], 329, 350n51

Allegory, 146, 148, 164, 171, 172; and Baudelaire, 62, 95, 97, 163, 165, 169, 172, 173, 174, 177, 178, 179, 185, 186, 187, 191, 204; and commodity, 173, 183, 188

Angelico, Fra, 259, 275n22

Angelus Novus. See Klee, Paul

Apollinaire, Guillaume, 48, 85n221

Aragon, Louis, 282n45, 382, 384n10

Arcade, 19, 28, 30, 31, 100, 101, 102, 106, 107, 109, 201–202, 326, 349n38

Arcades Project, 99, 100, 206, 207, 209, 407, 430, 431, 432, 435

Archilochus, 335, 353n66

Arendt, Hannah, 434, 435, 442

Arnheim, Rudolf, 260, 276n26

Arnoux, Alexandre, 259

Aron, Max, 437–438

Arp, Hans, 281n40

Art: and allegory, 163; and Benjamin, 381, 383; and Breton, 280n39; cult value of, 257, 272n12; degenerate, 147, 150n9; and demand, 266–267; exhibition value of, 257, 273n15; and fascism, 269, 270; here-and-now of, 253, 254; and history, 253, 254, 271n3; and *l'art pour l'art,* 12, 65, 67n6, 118, 163, 169, 256, 270; and masses, 254, 264, 267, 268; and National Socialism, 147, 148, 150n9; and photography, 121; and politics, 252, 257; pure, 256; and reception, 257, 268, 269, 273n15; and representation, 256; and ritual, 256, 257; and society, 121, 256, 257; and technological reproduction, 164, 252–253, 254, 256, 257, 258, 260, 264, 271n4, 273n14, 280n39; and technology, 163; and tradition, 254, 256; and uniqueness, 256. *See also* Culture

Atget, Eugène, 258, 275n17

Auerbach, Erich, 117, 119n8

Aura, 106, 337, 338, 413; and art, 254; and Baudelaire, 165, 169, 173, 180, 339; and commodity, 173; and cult, 256, 272n11; and Dadaism, 266–267; decay of, 173, 255; derivation of, 173; destruction of, 256; and distance, 272n11; and film, 260, 261; and nature, 173, 255; and photogra-